WINSLOW HOMER

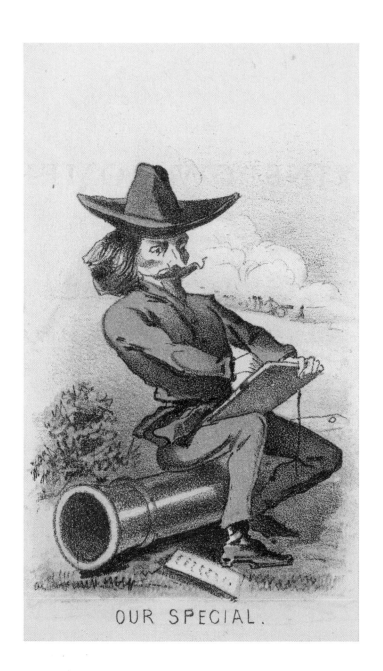

OUR SPECIAL.

WINSLOW HOMER

American Passage

WILLIAM R. CROSS

FARRAR, STRAUS AND GIROUX

NEW YORK

Farrar, Straus and Giroux
120 Broadway, New York 10271

Illustration credits can be found on pages 543–50.

Library of Congress Cataloging-in-Publication Data
Names: Cross, William R., 1959– author.
Title: Winslow Homer : American passage / William R. Cross.
Description: First edition. | New York : Farrar, Straus and Giroux, 2022. | Includes
 bibliographical references and index.
Identifiers: LCCN 2021057038 | ISBN 9780374603793 (hardcover)
Subjects: LCSH: Homer, Winslow, 1836–1910. | Artists—United States—Biography.
Classification: LCC N6537.H58 C76 2022 | DDC 759.13 [B]—dc23/eng/20211217
LC record available at https://lccn.loc.gov/2021057038

Designed by Gretchen Achilles

www.fsgbooks.com
www.twitter.com/fsgbooks • www.facebook.com/fsgbooks

1 3 5 7 9 10 8 6 4 2

Figure 1 (frontispiece): *Life in Camp. Part 2. Our Special*, 1864.
Chromolithograph on off-white card, 4⅛ × 2⁵⁄₁₆ in.

For those I love, near and far—Ellen, Gavin, and Ben

CONTENTS

WINSLOW HOMER

PROLOGUE

FIVE FEET SEVEN AND SLENDER, the apprentice in the lithography workshop was easily overlooked, as he preferred to be. The brown eyes set deep in his tan face observed more when he was himself unnoticed. But he had a sense of purpose, and no shortage of confidence, that day in 1854 as he learned his trade—drawing on paper and on stone. His name was Winslow Homer (1836–1910). Fresh from the confines of his family, he was determined to make his mark.

Just down the street in the same Boston neighborhood, at a clothing store across from the majestic Brattle Street Church, another young man was hard at work, equally disinclined to draw attention to himself, but for a different reason. About the same age, and handsome despite a scar on his cheek, he was tall and broad-chested, with a gleam in his eye reflecting his own confidence, intelligence, and purpose. The store's owner, Coffin Pitts (1798–1871), a deacon at the African Meeting House, had hired him on the spot. This other young man had experienced far more severe confines than Homer had. His name was Anthony Burns (1834–1862), and he had freshly escaped the bonds of slavery.

Born in Virginia, Burns had clambered aboard a ship bound for Boston. Upon his arrival, he had written to his brother, taking care to send the letter by way of Canada lest he reveal his true coordinates. On a bank of the Potomac River, the letter fell into the hands of the man who claimed Burns as his property, Charles F. Suttle (c. 1818–1881), who took immediate action, as by law he could. In 1850, President Millard Fillmore (1800–1874)

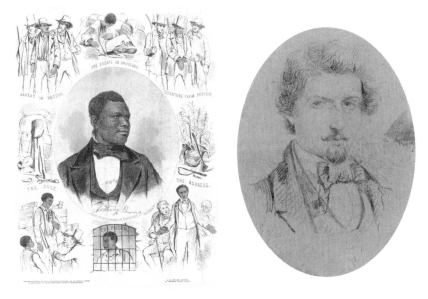

LEFT: Figure 2: After Charles A. Barry (1830–1892), *Anthony Burns*, 1855.
Wood engraving, 16⅞ × 13¹⁄₁₆ in.

RIGHT: Figure 3: Joseph E. Baker (1837–1914), *Winslow Homer at the Age of 21*, 1857.
Drawing in graphite on wove paper, 6⅞ × 4⅞ in.

had signed the Fugitive Slave Act, expanding federal power "to seize or arrest and transport such person to the State or Territory from which he escaped." Suttle intended to retrieve the man and to use the U.S. government to effectuate that retrieval.

It was Burns's practice to neaten Pitts's shop at the end of the day, to close up, lock the doors, and walk home to the room he rented in Pitts's house near their church. On the evening of Wednesday, May 24, 1854, the spring weather invited a stroll and Pitts departed without his young employee. Burns was cautious, though; his freedom was still new. As he ambled up Brattle Street, he saw nothing out of the ordinary. Then suddenly, outside Peter Brigham's tavern, the hand of a man named Asa O. Butman (1814–1894) fell upon his shoulder. Burns had noticed him in the store that day, eyeing the Virginian with suspicion. Now half a dozen men emerged from the shadows. With Butman, they grabbed Burns, lifted him atop their shoulders, and marched six hundred feet to the steps of the courthouse where a U.S. marshal stood waiting with drawn sword.

Winslow Homer knew well the streets Burns walked that day and had

observed the political currents now threatening Burns's freedom. This was the neighborhood, and the world, into which Homer had been born in 1836 and where he had spent his earliest years. Cargo arrived each day from southern ports: cotton that slaves had picked, lumber that slaves had cut, tobacco that slaves had seasoned to northern tastes. On these wharves and streets, his uncles and cousins discussed the trades that comprised the warp and woof of their days as merchants: commodities and manufactured goods, from crockery to farm tools, bought well and sold better. Merchants like the Homers depended on open seas and open markets. They were Whigs, pragmatic and realistic, disliking the idea of slavery but depending upon it, as a system embedded in everyday commerce. Most Boston merchants were Whigs, who placed economic matters above all others. They favored high tariffs on imported products, and they believed prosperity depended on protecting American manufacturers from foreign competition. They distrusted the federal government's executive branch, and shared a particular distaste for President Andrew Jackson (1767–1845), for populism generally, and for all other forces threatening to disrupt their ordered control of the entrepreneurial affluence in which they basked in Boston.[1] Controversies are by nature disruptive, and nothing stirred controversy like the subject of slavery. Around the dinner table, in his school, from the pulpit of his church, Winslow had heard the same message: slavery was ugly, but so was sanctimony on the subject of the "peculiar institution." Those who disagreed kept their opinions mostly to themselves.

A few spoke up. Homer had spent a childhood summer with his mother's sister Clara Thurston (1803–1886) and her family in Maine; her husband, Stephen Thurston (1797–1884), was an ardent abolitionist and eager to discuss the matter with his nephew, or with anyone else who would listen. Homer's mother, long a worshiper at Boston's evangelical Park Street Church, knew others there who shared Thurston's point of view. And down the street from Homer's Cambridge home across the Charles River lived another defender of the enslaved: the lawyer Richard Henry Dana, Jr. (1815–1882). Just after his nineteenth birthday, he had sailed around Cape Horn to California and wrote a book about the journey called *Two Years Before the Mast*. When Dana learned of Burns's arrest, he offered to serve as his attorney; the young Virginian was exactly the age Dana had been when he took that voyage.

Newspapers that week were filled with detailed predictions of an

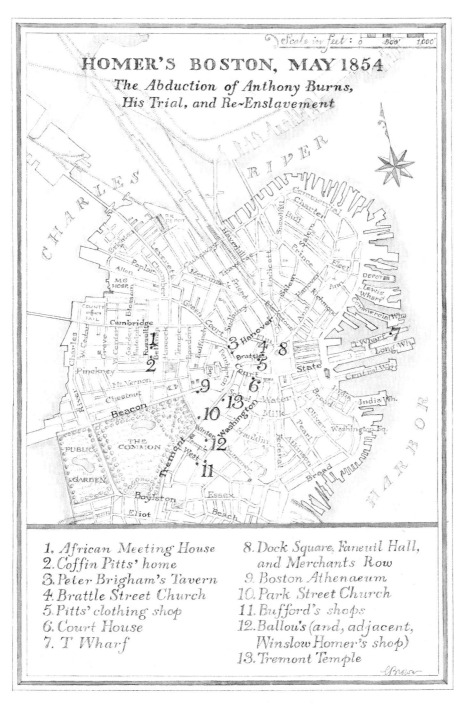

Figure 4: Homer's Boston (May 1854)

electrifying event—a solar eclipse—but the trial of Anthony Burns proved even more dramatic. Burns was not alone in the dock. Also under indictment was the commercial system, dependent on slavery, in which all Americans were complicit. Dana called it "the venomous beast that carries the poison to life and liberty and hope in its fangs."[2] The bantam orator cast his fiery eyes on a packed courtroom at rapt attention and implored the judge: "The eyes of many millions are upon you, Sir. You are to do an act which will hold its place in the history of America, in the history of the progress of the human race. May your judgment be for liberty and not for slavery; for happiness, and not for wretchedness; for hope and not for despair."[3]

Dana's defense failed. The judge ruled that Burns be remanded to Suttle, the Virginian who claimed he owned the man and who was awaiting him on the sleek and speedy U.S. revenue cutter *Morris*, now docked expectantly in Boston Harbor. No less a personage than the president himself, Franklin Pierce (1804–1869), approved the order.

From the earliest hours on the morning of Friday, June 2, all around the courthouse, thousands of men, women, and children began arriving, many from great distances. Boston had never seen such a crowd. Some 50,000 persons—one third of Boston's population—gathered, mostly in sorrow and support, to catch a final glimpse of Burns on northern soil. Fearing a riot, a rescue, or both, judiciary officials, the federal marshal, the governor, and Boston's mayor had commandeered the First Division of the Massachusetts Volunteer Militia, an entire brigade of soldiers, on horse and on foot, as many as 5,000 men, their weapons on prominent display. Never before in U.S. history, except in war, had the country called out so many military men. At 2:15 that afternoon, Burns appeared on the steps of the courthouse, cast his eyes to the open sky, and began his march in shackles down State Street, five hundred yards to the wharf. The crowd wedged into every alley, every balcony, every rooftop. One merchant hung from his window a coffin labeled "The Funeral of Liberty." Another, declaring his country "eternally disgraced by this day's proceedings," in protest hung the American flag across State Street—upside down.

Burns, surrounded by soldiers, walked beneath that flag. Suttle, already on the waiting boat, had completed his abduction, to the approval of many across the country. In Hannibal, Missouri, the boyhood home of Homer's contemporary Samuel Clemens, the *Missouri Courier* affirmed with satis-

faction that through the Burns trial "the right of property was clearly established."[4]

Clemens (Mark Twain) wasn't in Boston. Homer was—perhaps staring from a State Street sidewalk, peering from a balcony on Washington Street, or craning over the heads of those, taller than he, packed into his father's longtime haunt at Merchants Row. No one in Boston would ever be the same again, and least of all this observant boy Burns's age whose neighbor was Burns's lawyer. It was a coming-of-age for Homer as well as for his country. The drama of Anthony Burns radicalized many who had been previously indifferent. A prominent businessman confessed, "We went to bed one night old fashioned, conservative, compromise, Union Whigs & waked up stark mad Abolitionists." A clear question had emerged: In ful-filling Suttle's demand, had the United States itself inflicted a crime—both against one teenage boy and against the core of its own ideals?

Frederick Douglass (1818–1895), himself escaped from slavery at the age of twenty-one, believed so, and he wrote of the event with dripping sarcasm: "How sweet to the ear and heart of every true American are the shrieks of Anthony Burns, as the American eagle sends his remorseless beak and bloody talons into him!!" In his "Boston Ballad," Walt Whitman (1819–1892) wrote that the Burns verdict betrayed the ideals of the Amer-ican revolution. In Worcester, a young minister named Thomas Wentworth Higginson (1823–1911) declared, "Freedom did not die without a strug-gle . . . Our souls and bodies are both God's, and resistance to tyrants is obedience to Him." A rising Black poet, Charlotte Forten (1837–1914), just arrived in Salem from her native Philadelphia, wrote that the court had sent Burns "back to a bondage worse, a thousand times worse than death."[5]

Winslow Homer, the quiet young Bostonian, left us no words describ-ing the trial. Nor did Homer create images of it; as an apprentice in the first year of his craft, he knew that his employer, not he, controlled his time and the choice of his subjects. Before long, however, he left the lithography shop and won the freedom to make work reflecting his witness to the con-flicts within which American identity would be forged. Like Clemens, Homer came of age where and when the country's political, racial, and economic fractures emerged so visibly that nothing could paper them over; eruption was inevitable.

Six years after the Burns trial, Homer was living in New York. He was

back in Boston, however, on December 3, 1860, when again the citizens of Boston faced the fractious conflict aroused by slavery. A large crowd met at an integrated church, Tremont Temple, to commemorate the execution a year earlier of John Brown (1800–1859) as punishment for his raid on Harpers Ferry. Although William Lloyd Garrison (1805–1879) and other abolitionists had called the meeting, it fomented not moral courage but its opposite. In four distinct resolutions the throng condemned the "piratical and bloody attempt" by John Brown to cause an uprising among slaves in Virginia, and commended the value both of the free labor of the North and of the slave labor of the South to "the interests of commerce, manufactures, and agriculture." Frederick Douglass rose to declaim that the resolutions amounted to "serving the slaveholders," and he exhorted the people of Boston to recall that "the freedom of all mankind was written on the heart by the finger of God." The meeting's organizers recognized that Douglass's oratory was quickly turning the sentiment of the crowd. They called up fifty policemen, who forcibly evicted Douglass and other abolitionists from the building.

This time Homer made a wood engraving of the event, which appeared in *Harper's Weekly*. The publisher described the print as an eyewitness account, documenting Homer's presence at the church. The illustration presents the tumult at its climactic moment, as Douglass continues to speak from the edge of the stage, even as a constable, a star upon his top hat, apprehends him.

It is the moment at which free speech itself is on the brink of suppression, but Homer leaves this for the viewer to surmise. He operates by inductive reasoning, observing the behavior of those around him and inviting his viewers into his scene, that they may draw their own conclusions. It is a technique exactly opposite the deductive reasoning of a cartoonist, and in its subtlety more engaging and compelling. The viewer is invited to join in the process of Homer's storytelling—and in this case the storytelling of his protagonist, Douglass. Homer's affinity for Douglass places the young orator perilously close to the edge of the stage yet determined that his voice be heard above the havoc. As Homer observes Douglass's poise and grace, he offers the viewer—very likely white—the option of identifying with this courageous Black man, and of hearing his eloquent voice, or of choosing instead the anodyne merchants of Boston, whom he portrays at right. Homer reveals that choice to his viewers at what the historian

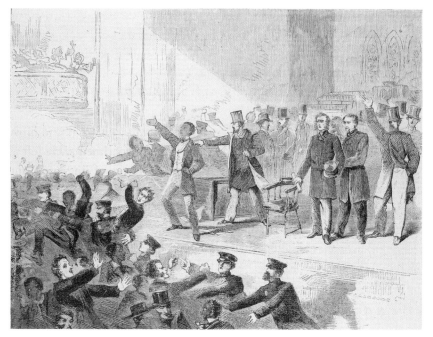

Figure 5: After Winslow Homer, "Expulsion of Negroes and Abolitionists from
Tremont Temple, Boston, Massachusetts, on December 3, 1860," from
Harper's Weekly, December 15, 1860. Wood engraving on paper, 7 × 9¼ in.

Peter H. Wood has described as "an incendiary moment," but he does not
force it.

The tension with which Homer grew up in Boston became more visible
with the outbreak of the Civil War. His distinctive illustrations became
nationally renowned, shaping millions of readers' sense of war's reality: not
only death and disease but boredom, hunger, and loneliness. He went on to
create his first oil paintings on the same subjects: ordinary men placed in
conditions with which the viewers could empathize. Inductive logic worked
well in his paintings, too. Homer left them unfinished enough that critics
called them "sketchy." His lack of polish was wholly intentional, however,
to allow his viewers' epiphanies of heart and mind to complete his work.
Whether they were wood engravings, watercolors, or oil paintings, the im-
ages Homer would develop were distinctively his, distinctively American,
yet address the elemental hopes and fears of all people everywhere. Homer
noticed what and whom others overlooked, finding in the particularities of
the world around him the seeds of universal meaning.

Who was Winslow Homer? Like the lives of his elders Whitman and Douglass and that of his contemporary Clemens, Homer's life in all its circumstances shaped and informed his work. That life reveals a quest for order and peace amid tension—a tension he experienced from birth to death. The pressures he faced were varied and abundant: economic, social, sexual, and cultural, and always threatening to crush him. The balance he found was intermittent and often elusive. Its pursuit fueled him, and drove him into improbable circumstances and unending experiments. He left us many images but few words. He told stories in layers of line, tone, and color—in the focus of his frame, and its omissions.

Homer was a misfit by nature, and intensely private. He aspired to observe but be unobserved, a kind of human periscope, both subjective and precise. Homer was agile, facile, always on the move. The surface was not enough for him. He looked below, above, and all around. There, hidden in the polarities of the moment, a passage might open, to another America imagined, glimpsed, and not yet realized.

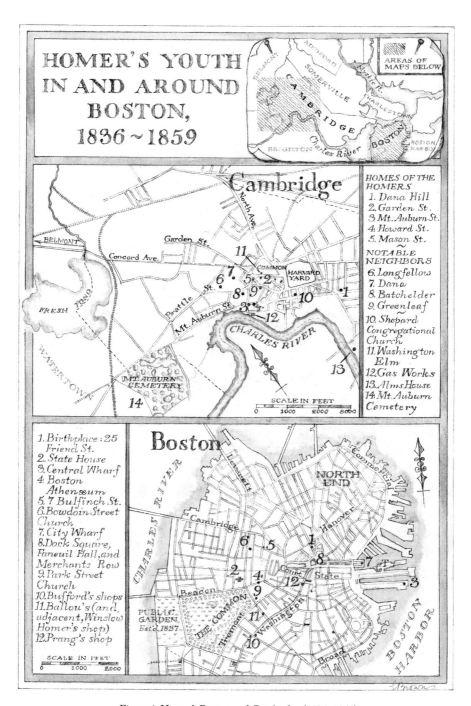

Figure 6: Homer's Boston and Cambridge (1836–1859)

1

MIDDLE SON
(1836–1859)

BOSTON FACES THE SEA. The city perches on the bulbous end of a narrow peninsula, fewer than two miles broad and a mile deep. Water encircles it, with the fresh stream of the Charles River on one side and the salt brew of the Atlantic on the other. In the 1830s Boston's 75,000 inhabitants crowded the city, the nation's fifth largest. Their carts and animals flooded the twisting streets of the North End, and the busy wharves that extended those streets into Boston's harbor.[1] The dome of the elegant State House loomed high on Beacon Hill, a proud emblem of democracy fulfilling John Winthrop's vision: "a City on a Hill." But for most people, the constant flow of goods absorbed all their attention—up and down those streets, on and off those wharves. Over the streets and around the wharves, the gulls of Boston circled, their eyes ever attentive. But the city's men and women had little time, or space, for gazing.

As the sun rose on Wednesday, February 24, 1836, it began to melt the heavy snows fallen on the busy streets, crowded also with talk of politics and commerce that last full winter of Andrew Jackson's presidency.[2] Among the least of North End houses was a well-visited one on Friend Street. Charles and Henrietta Homer lived there, amid a swarm of relatives who were quick to arrive that first day in the life of a boy whose parents named him Winslow.[3] He was their second son; their first, Charles Jr., was bright-eyed and nearly two. The baby's grandmother Mary Bartlett Homer lived a few doors down on Hanover Street with her husband, Eleazer, for many years Boston's Surveyor of Lumber, responsible for the quality of all lum-

ber sold in the city.[4] His longtime post had assured both stable income and wide contact with merchants. He was a fixture in the North End and on the noisy, smelly wharves studding Boston's edges like jagged teeth. As a young man he risked his capital investing in Boston ships, which sailed far in the first years of the American republic.[5] Some of those investments were more rewarding than others. Still working at seventy-five, now he could be found at the State House as an agent in the Pension Office.

Mary Bartlett Homer had ample firsthand experience with childbirth, and Henrietta may well have asked her mother-in-law for help. Mary was now sixty-six and had lived in the North End for nearly fifty years.[6] She was sixteen the day she married Eleazer; their first child, Jacob, was born five months later, and for twenty-five years she produced children: eight sons and six daughters.[7] Life had not been easy. She was a child of ten when she lost her own mother, and twelve when her father died.[8] The War of Independence was ending then and for some it was a time of hope. But for an orphaned daughter, prospects were dim. Marriage to Eleazer, nine years her senior, offered the best path forward.

She had lost both a son and a daughter as children, but the five daughters and seven sons who had grown to adulthood over this half-century of marriage brought her many joys. Each of the first four daughters had married Boston merchants and between them had produced eleven sons and ten daughters. Her youngest child, Almira (twenty-four in 1836), was still unmarried and not happy about it.[9] But Mary counseled patience, a virtue she knew better herself with each passing year.

It was not by chance that her daughters all married merchants. She and Eleazer raised them to know it was trade that mattered in the world. But Mary's sons listened more attentively than perhaps she'd intended to the stories she told them in their boyhood. The stories were of the sea, particularly of her father, Abraham Bartlett. He had commanded four of the eight hundred ships the Continental authorities authorized as privateers to capture British merchant vessels. Bartlett served the Patriot cause by harassing British commerce, while standing to make a profit through the sale of cargoes his privateers seized.

Three of the seven sons became sea captains. The eldest, Jacob, settled in Mobile, Alabama, and died there at forty-two, in 1829, leaving a ten-year-old son.[10] Around the time of Jacob's death (and perhaps because of it), his younger brother, Abraham Bartlett Homer, now thirty-six, had

moved to Mobile, too.[11] Despite Abraham's northern roots, he and his Nantucket-born wife were raising their children to be Alabamians. The last of Mary's three sea captain sons, James, thirty-two in 1836, was nominally a resident of Massachusetts. But like those of his brothers, James's cargoes were closely tied to the plantation economies of the American South. The vessels he captained carried commodities of all kinds, from yellow pine floorboards to vegetables to tin plate.[12] Not only did Abraham own slaves, he transported them as commodities. James, who lived with Abraham for a while, may have done so as well.[13]

James served as captain between the southern ports and Boston and along the cargo corridors of the South. One of his ships was the *William*, "a staunch fast sailing brig," which James captained on behalf of his older brother.[14] The vessel typically sailed as a "regular trader" on the route connecting New Orleans, Mobile, and Havana. Her principal use was for cargo but she also offered "handsome accommodation" for six cabin passengers.

On occasion, James ventured farther, to more remote parts of the Caribbean and even to South America, seeking even higher returns. These forays didn't always work out. Just a year earlier, in 1835, he had sailed all the way to Rio de Janeiro and made it back as far north as the Virgin Islands, only to be shipwrecked in the Bahamas.[15] Stranded, he saved his life but lost both his ship and her cargo. Storms arose often in the tropics. Only with risk—to capital and to life—did goods make their way to the Boston wharves the Homers knew so well.

In this city where trade was the lifeblood of the economy, Mary's sons included several merchants. Eleazer Bartlett Homer sold lumber, likely often bought from his brother Abraham and delivered on ships skippered by James.[16] William Flagg Homer sold crockery from his large store near Faneuil Hall.[17] Henry, the sole bachelor son, may have achieved the greatest commercial success.[18] Active in the Whig party, he traveled as a ship's officer, but also invested in Boston real estate. Three months after Winslow's birth, an advertisement appeared for 800,000 square feet of land for sale in South Boston. "A rare chance for speculators and capitalists," the notice crowed.[19] Winslow's grandfather Eleazer was credited as the seller, but by then, at seventy-five, he showed no other indications of the independent entrepreneurship characterizing his sons, for one or more of whom he was probably fronting. The businesses of his merchant sons depended on the

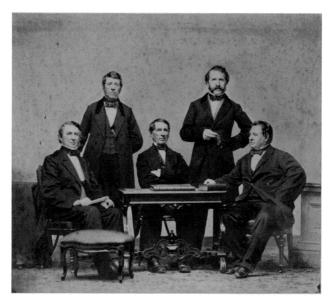

Figure 7: Unidentified photographer, *William Flagg Homer (1802–1883),*
Henry Homer (1807–1878), Eleazer Bartlett Homer (1796–1869), Charles Savage Homer
(1809–1898), and James Bartlett Homer (1804–1885), in Boston, 1858.
Photograph, 10⅞ in. × 10⁷⁄₁₆ in.

success of ships commanded by his sea captain sons, or by other men like
them. Merchants' businesses also depended on open seas for those ships, on
peace, and on light government oversight. They needed commodities from
the South, the Caribbean, and South America to move freely to the North,
and manufactured goods—particularly American—to move freely also, in
and out of Boston and to southern ports.[20]

The youngest of the seven sons was Winslow's father, Charles Savage
Homer (1809–1898). In 1836, he was twenty-six and eager to make his
way in the world. But the prosperity Charles projected was paper thin. He
shared his brothers' desire for independence, but lacked their commercial
instincts, so necessary to be a successful entrepreneur. He didn't know what
he didn't know and kept trying, again and again, for a business break-
through. He was a dreamer, overshadowed by his brothers, and forever
frustrated. Chafing under his parents' roof at seventeen, he had begun
boarding at the home of a hardware merchant, John C. Proctor.[21]

There, Charles experienced a religious conversion. Proctor attended the
Bowdoin Street Church, whose pastor was the eloquent Lyman Beecher.

By contrast to the Unitarianism then on the rise in Boston, Beecher preached an ardent Christian faith lived out in daily life. His sermons were famous. He was a passionate advocate for temperance, but also railed against the slave trade and those who benefited from it, and praised the courageous men and women who fought it. That commerce had been "sanctioned by custom, defended by argument, and, still more powerfully, by a vast monied capital embarked in the trade."[22]

Charles committed to Christ and to Beecher's church. In a spiritual autobiography, he confessed that he "felt deeply his lost and ruined condition . . . loves the Bible and can understand it—rejoices that God rules and reigns in heaven and on earth."[23] He followed his mentor Proctor into the hardware business, working initially with another church member at his store, near Proctor's.[24] And at twenty-five, Charles established a new hard-ware dealership on Dock Square in partnership with William Gray, another young man at the church.[25] Among their first ad-vertisements was one for a vari-ety of circular saws, indispensable to housewrights in the rapidly growing city.

Figure 8: Unidentified photographer, *Dock Square, Boston*, c. 1850. Albumen stereograph print, detail.

By the time of Winslow's birth in 1836, Charles and his partner seem to have already been flailing. The men had ac-quired a wide range of metal products with little regard for the market segments they wished to serve: cutlery for pantries, scythes and hay forks for farmers, and shovels for builders.[26] The firm's pleas for cash discounts grew louder. Charles was imaginative but had little realistic grasp of his markets. Somehow the other merchants selling hardware in Dock Square had a gritty understanding of their customers that Charles's brothers possessed but he did not. The part-nership with William Gray did not last. The hardware dealerships Charles established over the following years all seem to have ended in failure.[27]

Charles's heart was in another place: invention. In 1840, the U.S. Patent Office awarded him a patent for a garden hoe designed to be more durable

and stronger than other such tools available in the United States. In a detailed claim, he offered tangible evidence of his ingenuity. "My improvements consist principally in the modes of attaching the plate and shank of a hoe to each other," he explained. "As a garden tool it is exceedingly simple . . . yet some slight or what is apparently a slight change in the mode of connection of the shank and plate may render it much more durable, effective and useful, and be productive of highly beneficial results."[28] Yet there is no evidence he was able to turn this invention, or others following, into commercial success.

Winslow's mother, Henrietta Maria Benson (1808–1884), like her husband, Charles, grew up in a large family dependent on the sea. Born in 1808, three months before Charles, she spent the first twelve years of her life in the village of Bucksport, Maine, located at a strategic spot on the Penobscot River where it flows into the sea.[29] Her father, John Benson, was a New Hampshire native who made his way to Bucksport not long after the village was founded in 1792.[30] In 1802, at twenty-six, he married Sally Buck, whose father had given the town its name. Sally was seventeen on her wedding day, and (like Mary Bartlett Homer) pregnant; her daughter Clara was born five months later. Over two decades, the Bensons had five sons and three more daughters. John became a West Indies merchant, traveling repeatedly to the Caribbean to purchase commodities such as molasses and sugar, and then sailing back to sell them in New England.

By land, Bucksport was remote. By sea, however, well-established trade routes connected it to distant shores and weaned its merchants from parochialism. By the early nineteenth century, Maine had a thriving Black community, working primarily as mariners. Stevedores, shipwrights, and mates—and even some captains—had come from the West Indies and the Cape Verde Islands and had settled with their families in Portland and other Maine ports.[31] Some may well have served on Benson's ships. Many of these Black mariners were ardent Christians who may also have contributed to the evangelical theology Benson and his children practiced, including an early orientation toward abolitionism.[32]

Bucksport's mariners were vulnerable to dangers of many kinds. As tensions rose between the young American nation and the stronger British forces up and down the Atlantic coast, import businesses such as Benson's became more attractive targets for both British warships and American vessels seeking to commandeer them. But John Benson was savvy, knew

Maine's many hidden coves well, and proved himself a stealthy seaman. During the War of 1812, he served in the defense of Machias, eighty miles east of Bucksport, and was forever after called "Colonel."[33] His business entailed considerable risk, too, both to his capital and his life; in one case, the ship on which he was sailing was imprisoned in ice, and his rescue was noteworthy enough to make the newspaper in Portland, some sixty miles away.[34]

In 1821, the Bensons moved from the Maine coast to facilitate the expansion of John's West Indies import business. They lived partly in Kingston, Massachusetts, a South Shore town fronting Duxbury Bay, and in Bradford, where oceangoing ships

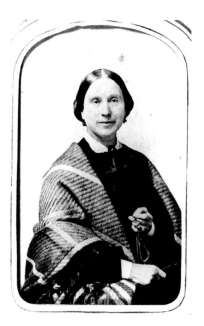

Figure 9: Unidentified photographer, *Henrietta Benson Homer*, 1847. Gelatin silver print on paper, 4⅞ × 3½ in.

found safe harbor on the Merrimack River. Although Bradford was thirty miles north of John's offices at Central Wharf, Boston, the Bensons could educate their children at a renowned evangelical Christian school there, Bradford Academy.[35] The Bensons also occupied a home in the North End, where their ninth and final child, John, was born in 1824, and where, fewer than two years later, in July 1826, Sally died.[36]

Henrietta was seventeen at her mother's death; her eight siblings ranged in age from two to twenty-three years old.[37] Within a year, the eldest, Clara, married the recently ordained Congregational minister Rev. Stephen Thurston and moved with him to his parsonage in Searsport, Maine (then called West Prospect).[38] Clara left Henrietta and her two older brothers to support their father in raising their two younger sisters and three younger brothers.

Henrietta's family was active at the Park Street Church, which in 1826 called as senior pastor a twenty-three-year-old prodigy, Edward Beecher, a son of Charles's pastor, Lyman. Henrietta joined the church a year later, the summer her sister married there. She recalled being "much opposed to

religion" prior to her attending Bradford Academy during these teenage years.[39] Her commitment to Park Street Church, where she and her husband married, was strong. Over those years, the identities of the two churches diverged. Park Street Church insisted on the inextricable connections between personal Christian conviction and the application of Christian principles to a just and equitable society. The church hosted both a series of evangelical revival events and abolitionist leaders such as William Lloyd Garrison.[40] By contrast, particularly after Rev. Hubbard Winslow succeeded Lyman Beecher in 1832, the Bowdoin Street Church shirked engagement with politically charged subjects, especially slavery. With increasing enthusiasm, Hubbard Winslow deployed Scripture to condemn abolitionists as agents who would "fill the land with violence and blood."[41] He praised the Kentuckian Whig Henry Clay and offered excuses for slavery, drawing Garrison's full-throated ire: "Is it any wonder that the land is filled with all manner of crime, when such prophets of Baal as Hubbard Winslow are found ministering at the altar?"[42] The diverging positions of the two churches probably contributed to Henrietta's remaining at Park Street Church for a total of nine years, even as Charles worshipped at Bowdoin Street Church.

But in the summer of 1836, Henrietta resigned her membership at Park Street and joined her husband's church, the one more congenial to merchant interests. Notably, when her second son was born earlier that year, in February, she agreed to name him Winslow. Although Boston had many Winslows, the circumstantial evidence is overwhelming: the baby was named for his pastor.[43] Unlike the other members of his family, whose first and middle names reflected the Homers' and Bensons' awareness of their ancestry, this boy had no middle name. From the beginning he was distinct, but also linked to an identity beyond his blood relations.

Not long after Winslow's birth, Charles and Henrietta moved to another house closer to the church, at 7 Bulfinch Street. Their third son, and final child, Arthur Benson Homer, was born there on October 28, 1842.[44] He was named after one of Henrietta's remarkable brothers.

Arthur W. Benson was exactly three years younger than Henrietta; in the year before Winslow's younger brother's birth, Arthur had a breakthrough of his own—one of many to follow.[45] At age twenty-nine, he and an older brother, Alfred G. Benson (then thirty-five), had become secret agents for a scheme hatched by Daniel Webster (1782–1852), secretary of

state, who was intent on fulfilling the manifest destiny of the United States, facing west. Through an exclusive contract, in 1841 the brothers became the U.S. Navy's designated shippers for all supplies on the Pacific coast—at a 20 percent premium to the average freight pricing the Navy had paid over the previous ten years. An essential component of this advantageous arrangement was the Bensons' agreement "to convey, passage free, all the emigrants that might offer, of both sexes (not exceeding fifty at each shipment), to the Oregon territory as permanent settlers therein."[46] The settlers on Benson ships took on a brutal 24,000-mile journey: east and south nearly to the Cape Verde Islands, then south and west around Cape Horn, north on the Pacific coast of South and Central America, sometimes as far west as the Hawaiian Islands, and only then to the Oregon Territory. But together with settlers traveling overland on the Oregon Trail, these settlers would effectuate de facto what the 1818 treaty that stipulated joint American and British control of the Oregon Territory had forbidden de jure: escalating United States dominion.[47] Through this secret Benson contract, Webster used settlement activities in Oregon to widen support in Congress for formal annexation and a termination of the treaty. Within two years, the settlement had begun to achieve Webster's objective, expanding at a rapid rate; in 1846, Britain and the United States signed the Treaty of Oregon,[48] which paved the way for much wider U.S. expansion. Within two years, the United States had fought and concluded the Mexican-American War, by which Mexico ceded 55 percent of its territory to the United States, including all of Alta California.[49]

If Charles Homer had proven a poor fit with the demands of commercial life, his wife's brothers fit those demands to perfection.[50] The Bensons' fleet of ships was well situated for further shipment of supplies and settlers both to the formerly Mexican territory and to Oregon. Among those ships was the *Brooklyn*, chartered by a group of 230 Mormon settlers who arrived in San Francisco on July 31, 1846. Just seventeen months later, gold was discovered at Sutter's Mill, and the demand for transport of passengers and freight on Benson-owned ships increased substantially.

Henrietta Homer's younger brother John Benson, twenty-four, was among those departing for San Francisco in January 1849 on a ship repurposed from its usual packet duties between Boston and Mobile.[51] The same month, Henrietta's twenty-two-year-old first cousin, Franklin A. Buck, also headed to California on a vessel owned by their uncle Richard P. Buck.[52]

The two young men appear to have been on an informal assignment for Richard Buck and Alfred Benson.[53] By the end of 1849, newspapers were already reporting the winnings Richard Buck and others were achieving in the Gold Rush.[54]

By the summer of 1850, John Benson was well settled into his life as a trader in Butte County, California, serving miners sifting for gold in the foothills of the Sierra.[55] Winslow's father followed him, likely with more focused commercial intentions than guided most on the Gold Rush.[56] By then he and his wife had both recognized the successes of the Bensons and the Bucks, and the opportunities those relatives might afford Charles in a role subordinate to them.

Winslow, aged fourteen, memorialized the voyage with an imaginative sketch of an intrepid argonaut riding across the country in an airship, his wheelbarrow and other tools tied behind him. The drawing appears to be inspired by a lithograph Nathaniel Currier had published in 1849.[57] At first glance, it appears little more than a doodle. The stick-figure pilot guides his rocket over farms, hills, and towering mountains, his top hat lost to the winds. But the responses of the boy's earthbound stick figures are telling. They open a narrative that Currier's print closes, as they pull the viewer into the science fiction spectacle. Some of Homer's figures salute the airship with a celebratory greeting, one dances a jig, while another looks closely through his telescope. It's all about vision—or lack thereof. As the pilot makes his precipitous descent over the Sierra Nevada range, some miners react in alarm, while others naively fail to see the impending disaster. Winslow already knew the power of sight, the power of storytelling, the language of risk, and the effective role that sly humor might play in communicating ideas.

He also knew by now that the dreams of his father far exceeded

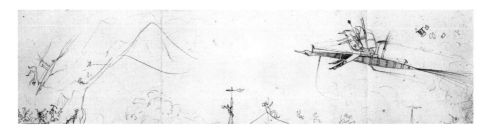

Figure 10: *Rocket Ship*, 1849–1850. Graphite pencil on cream wove paper, 3¾ × 15⅛ in.

Charles's ability to execute them. Charles was not an easy partner for any-one, including his own relatives. Just four months after his arrival in Cali-fornia, he headed home.[58]

The boy's early promise as a draftsman had surely already benefited from the affirming attention of his mother, who was a gifted artist herself. Henrietta specialized in detailed watercolor studies of flowers and foliage, highly similar to those made by a younger artist, Ellen Robbins (1828–1905), who began offering art classes in Boston about the time Charles journeyed to San Francisco.[59]

Robbins had grown up with few economic resources but possessed both manifold artistic gifts and entrepreneurial savvy. As a young woman, she won as her greatest patron the famed preacher and abolitionist Henry Ward Beecher (1813–1887), another of Lyman's sons. Instruction for art-ists was scarce in Boston, and Robbins capitalized on her opportunity. She also probably benefited from exhibiting at Anti-Slavery Bazaars of the

LEFT: Figure 11: Henrietta Benson Homer (1808–1884), *Meadow-Beauty*, 1860s–1870s.
Watercolor, 14 × 10¹⁵⁄₁₆ in.

RIGHT: Figure 12: Ellen Robbins (1828–1905), "Sumac," from *Autumnal Leaves*, 1868.
Watercolor, 19³⁄₁₆ × 15¾ in.

kind supported by many Park Street Church parishioners, and by Henry Ward Beecher and his siblings.[60] Boston institutions such as the Boston Athenaeum, a private library, offered ample occasion for women to view landscapes, portraits, and religious paintings. But with only rare exceptions, women could not exhibit in those high-ceilinged halls. By contrast, at these less-formal exhibitions, the art that women made was welcome. The bazaars blurred the line between amateur art and professional art, as did the work of Henrietta Benson Homer and Ellen Robbins.[61] It was women, and only women, who ran the exhibitions. They could make their own rules. Henrietta may have studied with Robbins and attended these popular expositions. She may have even exhibited in them, over the objections of her husband and the many other Whigs in her life.

Henrietta and Charles and their three boys had moved across the Charles River from Boston in about 1844, when Winslow was eight years old.[62] Their first home in Cambridge was on Dana Hill, a rapidly industrializing area near the almshouse southeast of Harvard Yard.[63] Noisy printing plants for publishers such as Little, Brown were quickly dominating the area. Henrietta's father, John Benson, had moved by 1848 with his second wife and their teenage son into a house in a quiet area almost a mile northwest, past Harvard Yard and near the Cambridge Common. About a year later, Charles and his family followed him and rented a house facing the Common at 8 Garden Street.

The Homers' neighbors at their new residence were quite different from those on Dana Hill. Within a three-minute walk of the Homer family's door were the poet Henry Wadsworth Longfellow (1807–1882); the lawyer Richard Henry Dana, Jr.; the inventor and abolitionist Samuel Batchelder II (1784–1879); and the law professor and evangelist Simon Greenleaf (1783–1853). These were persons of weighty influence, among the leading intellectuals of the entire country.

After about five years of commuting every Sunday across the Charles River to Boston to worship at Bowdoin Street, in 1848 the Homers concluded that their church needed to be closer to home. They joined the Shepard Congregational Church, around the corner from their new house, and whose culture, like that of the Bowdoin Street Church, was aligned with the family's mercantile interests.[64] The lay and clerical leadership deliberately avoided conflict and prized unity—an endangered virtue in the world around it. They implored moderation, agreeing with

Daniel Webster, who observed in 1847, "Liberty exists in proportion to wholesome restraint; the more restraint on others to keep off from us, the more liberty we have."[65] This spirit of conflict avoidance was consistent with the political agenda of the Whigs, who dominated the commercial establishment of Boston through the 1840s. Charles played a minor role in Whig political organizing, while his brother Henry was more prominent.[66]

Finding an apolitical church that accepted them must have been particularly welcome to the Homers. As ferment increased in Boston and as the businesses of both Henrietta's and Charles's brothers prospered, the entrepreneurial ventures of Winslow's father faltered. In 1853, the owner of the Garden Street house terminated the Homers' lease and the family moved to the first of two houses nearby, each downwind from the noxious gas works along the Charles River. Charles and Henrietta Homer knew many wealthy people, some of them close relations, but they were far from wealthy themselves. They recognized the residents of the almshouse when they saw them in the street. Despite appearances, their own condition was perilously close to that of these neighbors.

Winslow's older brother, Charles Jr., prospered in Cambridge. He was just fourteen in the summer of 1849 when he won a prestigious scholarship to the Hopkins Grammar School. He was one of three boys whose poverty and intellectual gifts warranted both special instruction in their high school years and a reserved future seat at Harvard. Like the other two prodigies then admitted, John Buttrick Noyes and Francis Channing Barlow, Charles was recognized as worthy of high expectations, and his perfor-

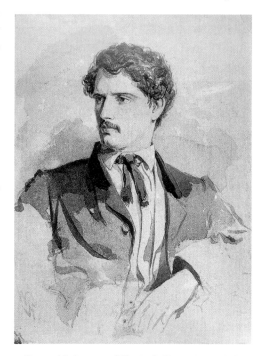

Figure 13: *Portrait of Charles S. Homer, Jr.*, c. 1860. Watercolor on paper, 7 × 5 in.

mance over time would validate that confidence.[67] He and Barlow both went on to graduate from Harvard in 1855, with Charles one of fifteen members of the elite Lawrence Scientific School. The members of the Harvard College class that year included the financier and philanthropist Henry Lee Higginson (1834–1919) and the famed preacher Phillips Brooks (1835–1893), both of whom would become nationally renowned and prominent patrons of the arts.

By contrast, the performance of Winslow and Arthur in the Cambridge public schools suggests they were not natural students. Neither boy seems to have graduated from high school.[68] Arthur was known as "Beetle"; he was affable but unintellectual, more similar to their father than their mother. Nearly seven years younger than Winslow, from an early age he was excluded from the close bond his two older brothers shared.

By the summer of 1853, when Winslow was seventeen, he had already begun work for John Henry Bufford (1810–1870), a prominent Boston lithographer.[69] Some twenty-five years later, Homer told a story about how he entered Bufford's employ:

> When the time came for [Winslow] to choose a business or profession, his parents never once thought of his becoming an artist, and of course did not recognize the fact that he was already one. It chanced on a certain morning that his father, while reading a newspaper, caught sight of the following brief advertisement: *"Boy wanted: apply to Bufford, lithographer. Must have a taste for drawing. No other wanted."* Now, Bufford was a friend of the elder Homer, and a member of the fire company of which the latter was the foreman—in those days the fire department in New England towns was conducted by gentlemen. "There's a chance for Winslow," exclaimed the author of Winslow's being. Application was made forthwith to Bufford: and the furnishing-store across the way where they sold dickeys, etc., and where, at one time, it was seriously thought that Winslow had better begin life as clerk, was abandoned for the headquarters of Cambridge lithography. The boy was accepted on trial for two weeks. He suited, and stayed for two years, or until he was twenty-one.[70]

While this story is engaging, it is largely fiction. By the early 1850s, Homer's parents had long since recognized his talent; Bufford did not ad-

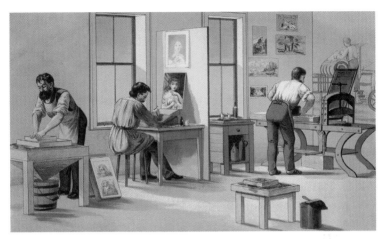

Figure 14: Louis Prang (1824–1909), "Lithographer," Plate 5 from
Prang's *Aids for Object Teaching*, 1874. Chromolithograph, 12 × 20 in.

vertise for help wanted; neither Bufford nor Charles Homer served as fire-
men; Bufford's wife, Anna Thayer (1808–1878), and her brother Benjamin
(1814–1875), another lithographer, had long been active with the Homers
at the Bowdoin Street Church; Bufford's shop was not in Cambridge but
at 260 Washington Street, Boston; and Homer's work for Bufford appears
to have lasted about three and a half years, concluding around the time of
his twenty-first birthday in February 1857.[71]

Homer's embroidered tale conceals as much as it reveals. He had al-
ready discovered a talent for creating a compelling narrative, finding that
a good illustrator could deploy that talent to reap economic rewards—
perhaps more predictably than his father had done.

Homer's obvious skill as a draftsman and his family's relationship with
Bufford likely improved the financial terms of his employment. In a cus-
tomary apprenticeship arrangement, apprentices paid their masters a fee
for their instruction, in addition to providing their masters with plentiful
cheap labor. Bufford may well have forgone some or all of this payment. It
is also possible that Homer's first work for Bufford preceded whatever for-
mal apprenticeship Homer served. Lithography was labor-intensive and
Bufford's business was brisk. A few trained lithographic draftsmen had
arrived in Boston from Europe, fleeing political turmoil, but not many.
Bufford needed hands who could draw, and draw obediently for long hours.
It made good business sense to train his own.[72]

The lithographic printing process was introduced into the United States in 1825 to meet a growing appetite for affordable products of all kinds, from advertisements to finished works of fine art. Lithography, like many artistic processes, is intrinsically collaborative. It began with 300-pound limestone blocks that, for each new project, muscled apprentices ground down to gleaming fresh surfaces. The draftsman deployed a greasy crayon directly on the printing stone to create both line and tone, offering considerable opportunity to display artistic talent—and for his employer to profit from it.[73] A bath of nitric acid and gum arabic fixed the design, which was then bathed a second time in water. Printing ink, rolled on the stone, repelled the water and therefore adhered to the image.

Not only was lithography labor-intensive, primarily in grinding, but it was capital-intensive, with high fixed costs for both stones and presses.[74] So to leverage those fixed costs, a lithographer needed to sell a high volume of projects. Their businesses were sweatshops with daily occupational hazards, from grinding down the stones to handling chemicals and working with heavy equipment. Bufford's printed a wide range of products, from concert tickets to political cartoons, using a variety of sheet sizes. Homer later called it "a treadmill existence."[75] Bufford valued the young man's considerable skill as a draftsman; he valued even more Winslow's willingness to dedicate long hours to the demands of production in his small industrial worksite just a block from Park Street Church.

Many of Bufford's projects were essentially glorified advertisements intended to sell the products they decorated. That is true of a number of Homer's lithographs for the firm, including eleven covers for sheet music, from "Katy Darling" (1853) to "Minnie Clyde" (1857).[76] But Homer delivered several startlingly inventive compositions, with wit, complexity, and character development far exceeding what either Bufford's shop or its customers had any reason to expect. These illustrations didn't always follow closely the content of the songs they were selling. In the design to decorate the cover of the song "The Ratcatcher's Daughter," for example, Homer conjured up a picture within a picture, of a strange hero with one black eye, patched pants, and an ambiguous smile. The young man stands astride a London landscape including both dreamy classical architecture and polluting factories; a rat trap is set on each side.[77] He is far more prominent in the design than the young woman of the title, whose minuscule form appears under a bridge, evidently drowned but with her legs raised and bared as her

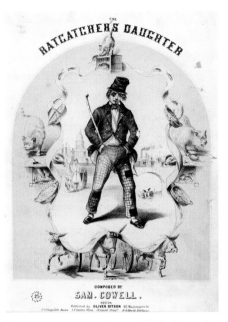

Figure 15: *The Ratcatcher's Daughter*, c. 1855. Lithograph, 13 × 10 in.

disconsolate beau, leading his donkey to market, prepares (as the song explains) to "cut 'is throat with a pane of glass." Three hungry cats in the ratcatcher's employ display their skill, as rats tumble into the carrying boxes the unlikely hero will use to transport them to their next destination: a rat fight.

Homer's imaginative illustrations for sheet music decoration opened up other avenues at Bufford's. Among his earliest landscape designs, for example, are the studies he developed of scenic views around Ottawa, Canada. For an 1855 book by William F. Hunter, Jr. (1823–1894), a prolific Canadian author, he drew a series of lithographs copied from sketches that an Ottawa artist had made.[78]

One of Bufford's specialties was lithographic portraits based on photographs and engravings. Demand was growing for affordable representations of heroes such as the British abolitionist George Thompson (1804–1878).[79] Bufford also served authors such as Abner Morse, who sought portraits for genealogies; Homer designed at least twenty-five of these as well.[80] An ambitious large lithograph containing tiny individual portraits of forty-two members of the Massachusetts Senate must have been an especially time-consuming application of the boy's newfound skills in copying photographs.[81]

The charged political environment of Boston gave Bufford additional commercial opportunities, especially after the 1854 trial of Anthony Burns. In one particularly renowned case, the shop recalled the subject of Paul Revere's famous 1770 engraving of the Boston Massacre, but cast it in a new light. A dramatic 1856 Bufford's chromolithograph by William L. Champney, Jr., sets the scene at the same location and from the same perspective as does the Revere engraving. But now the action is centered on Crispus Attucks, an African American killed in the attack.[82] The print was published the year after Attucks was first correctly identified pictorially as a person of color.[83]

That year, 1856, the country's widening political fissures led to violence on the floor of the U.S. Senate, when Rep. Preston Brooks of South Carolina bludgeoned Senator Charles Sumner of Massachusetts shortly after Sumner delivered his speech "The Crime Against Kansas." Bufford capitalized on this foment, commissioning Homer to design another large independent lithograph entitled *Arguments of the Chivalry*. Across the top of the print, Bufford ran a quote from Henry Ward Beecher: *"The symbol of the North is the pen; the symbol of the South is the bludgeon."*[84] Homer portrays several key figures to the left standing by idly, among them Senator Stephen Douglas, who wasn't present. Homer took liberties to create a sense

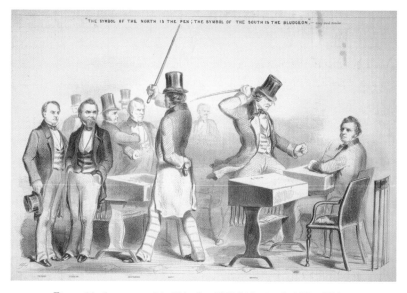

Figure 16: *Arguments of the Chivalry*, 1856. Lithograph, 13⅞ × 20⅜ in.

of dramatic tension as Brooks's accomplice, Laurence M. Keitt (another congressman from South Carolina), conceals a pistol in his left hand while raising his cane in his right.

The weapons are both factual and symbolic. They allude to a stark and ugly truth at the core of chattel slavery. It was the horrific fact to which Sumner alluded, and which provoked such violence: slavery licensed and encouraged rape.[85] The "Peculiar Institution" was a legal and unholy alliance of violence, power, and sexual domination. It gave slave-owning men such as Keitt and Brooks the right to subjugate Black women. Homer witnessed an emerging choice: to align with Whigs such as he found in his own family, or to align with the heroic abolitionists Sumner and Dana.

The experience at Bufford's provided Homer ample practice at drawing on paper and on stone. In an article for a children's magazine, *Our Young Folks*, Thomas Bailey Aldrich (1836–1907), the Bostonian poet, editor, and author of *The Story of a Bad Boy*, explained that Homer learned "to draw before he plunged into colors, as more impatient aspirants usually do . . . a better school of instruction could not have been devised for him."[86] Bufford's also introduced Homer to other young apprentices whose interests converged with his own. Two of them, Joseph Edwin Baker (1837–1914) and Joseph Foxcroft Cole (1837–1892), were Maine natives a year younger than Homer. Both became close friends for decades to come. The trio probably made many visits together to the Boston Athenaeum, the private library close to the Bufford shop, which also served as progenitor to both the Museum of Fine Arts and the Boston Public Library. From its inception in 1807, the Athenaeum's leaders believed their high standard of literary and artistic excellence would be the model for New England and America, "a shrine of learning," and "a force for righteousness and for inspiration."[87] The Athenaeum's elegant 1849 building was astonishing in itself, as one critic declaimed in 1852: "grand and imposing . . . magnificent— we have nothing equal to it in the country."[88] The annual exhibitions the Athenaeum hosted were indispensable destinations. "Every visitor to the City of Boston will of course call at the Athenaeum, for it would be as absurd to leave Boston without seeing this, one of its chief attractions, as it would be to come within the roar of Niagara and turn back without seeing the stupendous falls."[89]

These exhibitions could occur only with the participation of a broad spectrum of artists and patrons—including many who were not members

of the Athenaeum.[90] In 1857, for example, the works included a watercolor and five oil paintings by the twenty-seven-year-old William Bradford (1823–1892), already gaining recognition as a master of marine painting; the luminous *Manchester Harbor* of Fitz Henry Lane (1804–1865); and another marine painting by the English-born Thomas Birch (1779–1851).

Among the painters who exhibited at the Athenaeum was a French-born landscape specialist named Louis Frederic Rondel (1826–1892). Rondel had lived in London prior to his immigrating to the United States in 1853.[91] After a brief period in Philadelphia, he settled in Boston, where he became close to Homer's friend the English-born Alfred R. Waud

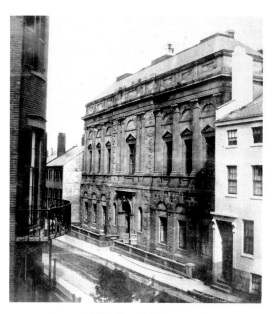

Figure 17: Unidentified photographer,
The Boston Athenaeum, 1852.
Salted paper print, 13⅛ × 11 in.

(1828–1891).[92] Waud wrote that Rondel "has lived Bohemian fashion in Paris for years, helped build barricades in 1848, stood sentinel over the pictures at the Louvre or Luxembourg and much more. Has no perceptible French accent to his English . . ."[93]

The Washer-Woman by Jean-François Millet (1814–1875) was among the works by living French painters exhibited at the Athenaeum. Homer's friend Cole took great inspiration from the French paintings; he went on to spend much of the next two decades in France and became an advocate for French Barbizon painting on the model of the more celebrated William Morris Hunt (1824–1879). Another French painting, *Shelling Peas*, by Pierre Edouard Frère (1819–1886), appeared at the Athenaeum in 1858.[94] One of Homer's colleagues recalled Homer standing in front of Frère's picture and declaring concisely, "I am going to paint." When a portraitist asked him in what subject he would specialize, Homer pointed to the Frère painting and said, "Something like that, only a [damn] sight better."[95]

Homer's work for Bufford's proved he could fulfill the demands of increasingly complex illustration assignments with captivating compositions. It did not prove he could make a living unless he operated within the structure of a shop selling these assignments, and under a supervisor guiding his development. But like his father, he considered himself "unfitted for further bondage," independent by nature. As Homer recalled a quarter-century later, he "called no man master" once he completed his apprenticeship.[96]

Just as the facts of his joining Bufford's are different from Homer's description of them, so the oft-repeated "facts" of his leaving Bufford's are also different. Homer seems to have begun his entrepreneurial career slightly more cautiously than he later admitted. As Homer neared his twenty-first birthday on February 24, 1857, he received some surprising paternal advice. The counsel may have come from across the Atlantic, where Charles had traveled at least twice in the 1850s in pursuit of elusive commercial success.[97] Charles wrote to his son Winslow:

> I am informed that you think of leaving Mr. B and I wish to caution you against a desire to be your own master . . . You may as well take my own experience for an example. It is my deliberate conviction, corroborated by a rough experience, that had I not left the direction of other wiser heads to follow my own undeveloped inexperienced brains until some years later, I should have known more of men and of the realities of life: and should not have had to pay so dearly as I have done for that experience which I now have attained and which you lack. I wish to give you credit for being a clever artist. But I fear that you are not sufficiently up in worldly wisdom to undertake the responsibilities of business on your own account. And I therefore advise you to remain with Mr. B for another year . . . if you keep your eyes open, attend diligently to your profession, *adding to it* [emphasis his] any artistic attainment in your power, by proper use of your time, especially your evenings, you may before you are 24 years of age . . . be competent to undertake some occupation.
>
> "Money Makes the Man!" It matters not what your profession may be so long as money is wanting you are a nobody . . . Mark—don't get

engaged . . . chiefly it stops the advance of a man by means of the stern
necessity of *having to provide for others* . . . In conclusion, have a care of
your habits—eschew Tobacco! Charles chews it, or did, a filthy vile
habit and of all others the most difficult to break off. And as for Ardent
spirits & wine beware! Of them for the Scriptures are correct in saying
they sting as the serpent & bite like an adder . . . In short no Gentle-
man can drink & chew and continue to be a Gentleman.

Affectionately Your Father[98]

Homer appears to have rejected much of his father's advice, leaving
Bufford's around the time of his twenty-first birthday, and over the years
frequently enjoying wine and spirits.[99] But he appears to have accepted
two other parts of that advice. He never did marry lest he "have to provide
for others," and he seems briefly to have deferred hanging out his own shin-
gle. He spent some or all of the next year working on the staff of another
"Mr. B"—a formidable newspaper editor named Maturin Murray Ballou
(1820–1895). Homer's name appeared for the first time in the Boston city
directory in 1857, but he was not working in his own office. He was at
Ballou's office at 22 Winter Street. He was still working within an organi-
zation, albeit with more independence than Bufford's had afforded. And
now he was drawing on wood, not stone, as part of a publishing revolution
that would allow a far broader range of printed product.

Fifteen years earlier, in 1842, the *Illustrated London News* had created a
new type of publication: the mass-produced illustrated newspaper. Through
a process of preparing its pages to include text and image side-by-side, the
newspaper offered a bold claim: "The public will have henceforth under
their glance, and within their grasp, the very form and presence of events
as they transpire, in all their substantial reality."[100] The images were wood
engravings. Unlike woodcuts, which artists had been carving since the
fifteenth century and earlier, these prints were made using close-grained
seasoned end-blocks of boxwood.[101] Because the individual blocks were
relatively small, a wood engraving might be made from a grid of six or
more blocks, bolted together.

The wood engraving process was fivefold. First, an artist developed a
drawing. Second, that draftsman (or others) would reproduce the drawing
on an assemblage of woodblocks, whitened for the artist to draw again in
graphite and watercolor. Normally, the draftsman would replicate his de-

sign (including verbal elements such as signs or the artist's signature) in mirror image, in order that, once printed, it would resemble as closely as possible the appearance of his drawing on paper. Third, one or more specialized artisans known as wood engravers would use hand tools such as gouges, burins, chisels, and other tools to cut into the wood, leaving raised lines, albeit with less tone than was possible with lithography.[102] Fourth, the engraved woodblocks would be assembled with the text around them and used to form an electrotype metal plate for printing the entire page. Fifth and last, the pressmen mounted the electrotype plate onto a press and printed the finished product on paper. They planed down the expensive woodblocks for reuse once the metal plate was made. The work of the wood engravers was technically demanding, and more time-consuming than was the work of the artists, and warranted at least comparable payment—if not higher.[103]

In 1851, Ballou had founded an American imitation of the *Illustrated London News* in Boston with a German-born entrepreneur, Frederick Gleason (c. 1816–1896).[104] Ballou (the managing editor) and Gleason called their newspaper *Gleason's Pictorial Drawing-Room Companion*. Gleason sold his interest in 1855 to Ballou, who renamed the newspaper *Ballou's Pictorial Drawing-Room Companion*. The newspaper served a national audience of readers, with a tone evoking a spirit of admiring wonder, not analytical critique. For its sub-

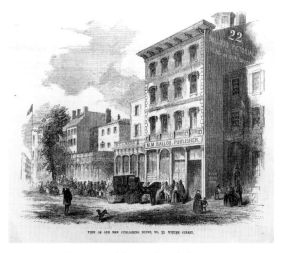

Figure 18: After unidentified artist, "View of Our New Publishing House, No. 22 Winter Street," from *Ballou's Pictorial Drawing-Room Companion*, December 6, 1856. Wood engraving on paper, 9 ½ × 9 ¼ in.

jects, *Ballou's* cast a wide net around the world, but generally eschewed discussion of political tensions lest such disclosure offend its readers. One issue in 1857, four years before the Civil War, included a commendation of Mobile, Alabama, with four illustrations; depictions of a new hospital in

St. Louis, of a new church in Constantinople, and of the Catholic cathedral in Cincinnati, with brief approbations for each; a tribute to a Boston physician with his portrait; "a correct and striking representation of the Persian army as it lately appeared when encamped under the walls of Shiraz" with a related illustration; several short poems; and a section of a lengthy novel.[105] The staff of thirty-four in 1857 included six printers, five clerks, nine wood engravers, two bookbinders, and just three artists: Homer made the transition from Bufford's to *Ballou's* along with Champney (the designer of the *Boston Massacre* lithograph) and Alfred R. Waud. Bal-

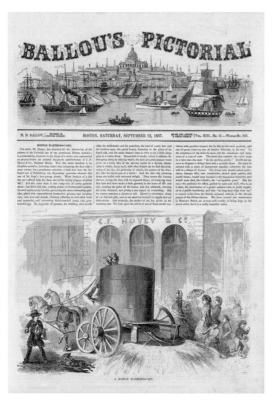

Figure 19: After Winslow Homer, "A Boston Watering-Cart," from *Ballou's Pictorial Drawing-Room Companion*, September 12, 1857. Wood engraving on paper, 6⁷⁄₁₆ × 9⁷⁄₁₆ in.; sheet, 14¹⁵⁄₁₆ × 10¹³⁄₁₆ in.

lou employed no writers, as each was freelance—paid by the story.

Winslow learned quickly how to illustrate in wood engravings. Over the course of just six months, from early June 1857 to late November of that year, *Ballou's* published sixteen wood engravings based on Homer designs: six portraits, six urban scenes, and a set of four Thanksgiving illustrations contrasting urban and rural life. His illustrations were not only prolific but superior to those of the other artists contributing to *Ballou's*. Despite Winslow's youth, his portraits were more empathetic, his landscapes filled with more subtle observations, and his street scenes more complex and layered with meaning. He used geometric forms to communicate in fresh, innovative ways. In a depiction of a watering machine intended to settle down the granite dust of Boston streets, for example, he contrasted the curves of the

cylindrical machine with the curves on the façade of a nearby clothing store. It wasn't just any store, but one founded by the prominent Boston abolitionist Charles Fox Hovey (1807–1859). Homer quietly laid into his illustrations such subtle details to draw his readers into his narratives on multiple levels. Doing so depended not only on his innovative designs but also on the execution of the two wood engravers with whom he worked most often: the London-born Charles F. Damoreau (1828–1885) and William Jackson Peirce (1829–1909), a Vermont native.[106]

Within a year, Homer had established a new office of his own, shared with two other creative men: William Waud (1831–1878), the younger brother of the *Ballou's* artist Alfred R. Waud, and Frederic L. Lay, a photographer born in Germany in about 1823.[107] It was adjacent to the office of *Ballou's*, but a separate space. At last, Homer had the independence he sought, with a publisher next door eager for his designs and the freedom to sell his illustrations to other firms.

In fact, while still working directly for *Ballou's*, he had already sold some illustrations to another publisher. Fewer than two months after *Ballou's* first published his work, an issue of the New York–based *Harper's Weekly* included a group of five humorous Homer illustrations of Harvard students.[108] While no letters survive, the twenty-one-year-old Homer probably depended on the hand delivery of one or more drawings proposing these illustrations; enough Bostonian artists and wood engravers had already migrated to New York, and to *Harper's*, that they would have been happy to act as his emissary. The *Harper's* editors probably liked the idea that his brother's experience at Harvard (including a postgraduate stint in a chemistry lab) had given Winslow special insight into campus life. His contract with *Ballou's*, however, likely prohibited moonlighting for the competition. Homer did not sell another illustration to *Harper's* until eight and a half months later, in the spring of 1858, when he was set up in his new office. The two scenes he sold then of the bourgeoisie of Boston (one set on the Common and the other in the downtown shopping district) are full of vital flair, from obstreperous dogs, to a hat flying in the wind, to a boy selling newspapers (*Harper's*, of course). Homer sold another thirteen illustrations to *Harper's* that fall, including a more elaborate version of the Thanksgiving series he had contributed to *Ballou's* the previous year. By the end of 1858, *Harper's* had bought fifteen illustrations, and *Ballou's* nine. As the circulation of *Harper's* grew, *Ballou's* declined. In 1859, its final year of

publication, *Ballou's* published twenty-eight Homer wood engravings, including six landscapes and six miscellaneous illustrations, one depicting a pair of cowed lions in a cramped cage. Most (sixteen) of the twenty-eight were portraits, made primarily from photographs, such as that of the Bostonian merchant Robert Bennet Forbes (1804–1889), from which Homer created a penetrating, independent work of art.[109]

Homer's eight illustrations for *Harper's* in this period were all either landscapes or urban scenes. The newspaper's New York editors seem to have elicited from Homer narrative touches beyond those he included in his work for *Ballou's*. In one scene, an affluent young couple stands by a window next to their sleeping child, with a Christmas stocking at the foot of his bed overflowing with gifts. On the same page, another scene appears, of the sidewalk in front of perhaps the same window, which frames the same couple in silhouette. Snow flies, as a fur-collared young woman observes a boy begging for pennies. In their wealth, the young parents are oblivious to the poverty just outside their window. But Homer notices it and is intent that the reader see it, too.

He also developed an active practice serving the publishers of children's books, centered in Boston. Homer drew seventeen illustrations for *The Eventful History of Three Little Mice and How They Became Blind* (E. O. Libby & Co., 1858), and fourteen other drawings for eight other books intended for children.[110] These designs display his inventive gifts for narrative humor, appealing to readers of all ages.

Boston had nurtured Winslow Homer. It was home not only to his large family but to a circle of artistic peers such as Rondel and the Waud brothers. He enjoyed increasing patronage from its book publishers, and *Ballou's* had given him ample opportunity both to continue improving his draftsmanship and to earn a good

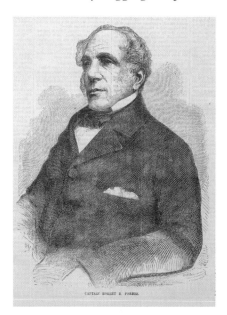

Figure 20: After Winslow Homer, "Captain Robert B. Forbes," from *Ballou's Pictorial, Drawing-Room Companion*, August 20, 1859. Wood engraving on paper, 7¹³⁄₁₆ × 5¹⁵⁄₁₆ in.

living. These were designs engaging his creativity deeply and providing him with ample autonomy, as he wished. Despite his brief infidelity with the 1857 *Harper's* Harvard illustrations, he was loyal by nature, as he would demonstrate throughout his life—often more loyal than circumstances warranted.

As an enterprise, though, *Ballou's* was doomed. With its studiously temperate, risk-averse tone, the Bostonian gazette was losing market share to its brash New York competitor with every passing week. Homer had been wise to develop a relationship with *Harper's*, too. He sold the New Yorkers fifteen illustrations in 1858 and eight in 1859. By the end of the summer of 1859, Homer had moved to New York and set broader sights for his professional future. In Boston he had identified himself as a "designer." When he placed his name in the New York City directory, he called himself something else: "artist."

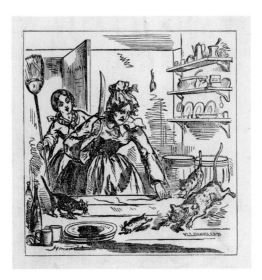

Figure 21: Victor L. L. Chandler (born c. 1837) after Winslow Homer, "She Cuts Off Their Tails," from *Eventful History of Three Little Mice, and How They Became Blind* (Boston: E. O. Libby & Co., 1858). Wood engraving on paper, 5⁵⁄₁₆ × 4⅛ in.

2

A TASTE OF FREEDOM
(1859–1862)

Jane Cushman's house was full, as she wished it to be.[1] A widow for two decades, she was nothing if not practical, and managed well.[2] A staff of five Irish-born servants kept the house humming; they included a cook, a nurse, two chambermaids, and a waitress. Her house on East Sixteenth Street, a block off Union Square, lodged not only her son, his wife, and their three young children but an eclectic mix of fourteen boarders. They included a wealthy widow and her two teenage grandchildren; three single women considered past the age of marriage; the Sardinian vice-consul to New York and his much younger American wife; and half a dozen bachelors. One of those was Winslow Homer, who arrived late in the summer of 1859.

All but one of the young men sharing the house were in their twenties.[3] Several, such as Charles Henry Voorhees (1831–1893), a clerk and future stockbroker, became close to Winslow. And at least one of the bachelors was already a friend from Boston. Alfred Cornelius Howland (1838–1909) had apprenticed for a Boston lithographer prior to moving to New York, where he continued to make lithographs and design wood engravings.[4] Alfred's older brother Henry (1835–1913) was a prodigy who had graduated from Yale College at eighteen, studied at Harvard Law School, and passed the New York Bar exam at twenty-two. He was already on his way to an illustrious legal career.[5] The Howland brothers had moved to New York in 1857, and to Mrs. Cushman's in April 1858.[6]

A year into Homer's stay at the house, in June 1860, Alfred did what many young American artists (Homer included) wished to do. As bellicose

voices rose across the country, Alfred boarded a ship for France and Germany to study painting in Paris and Düsseldorf.[7] He would not return until 1865.

In the meantime, Homer was introduced to many other acquaintances, not only at home but at the offices of his new principal client, *Harper's Weekly*. The new managing editor, Quebec-born John Bonner (1828–1899), had attracted a rapidly growing circulation, built on a strong foundation of talented artists, writers, and wood engravers. Homer's quiet talent quickly won him an honored place among them.

His work as an illustrator had always been collaborative. First, each wood engraving depended on his convincing an editor that his sketch was good—whether the idea for it was his own or suggested to him by someone on the newspaper staff. And the execution of each illustration—moving from that sketch to the finished print—required close teamwork, too, between the artists and one or more wood engravers whose mandate was to complete on wood the artist's work begun on paper. Despite his youth, in Boston Homer had won easy approval of his ideas and a smooth working relationship with the familiar and gifted artisans *Ballou's* employed as wood engravers. One of those, Charles F. Damoreau, moved to New York in early January 1860 on the heels of *Ballou's* closure and soon found work for another illustrated newspaper, *Leslie's*.[8]

Rondel was next; Alfred Waud introduced him: "of French birth, English experience and American residence."[9] Homer later credited Rondel with a unique role in his development. "For a month, in the old Dodworth Building near Grace Church," Homer explained, "Rondel, an artist from Boston, once a week, on Saturdays, taught" him not drawing, which Homer understood, but painting, "how to handle his brush, set his palette, etc."[10] Many others from Boston—both artists and wood engravers—whom Homer had known during his tenure at Bufford's and *Ballou's* followed, including the Waud brothers themselves. The closing of *Ballou's* had been an opening for Homer and his companions. Homer found a studio first on Nassau Street, and then in the fall of 1860 established a second studio space, with William Waud, on Liberty Street.[11] Both were near the southern tip of Manhattan island.

Figure 22: Sarony & Major, *Gift Polka, Souvenir to His Pupils,
by Allen Dodworth*, 1852. Lithograph, 12⁹⁄₁₆ × 9¼ in. The Dodworth Building
still stands at Broadway and East Eleventh Street, just north of Grace Church.

In New York, everything operated at a larger scale. The Harper brothers
had set their sights on a major market they intended to dominate with a
truly national illustrated newspaper. *Harper's* more ambitious editorial
style required more numerous, more complex, and more imaginative
illustrations—and more iterative engagement among the illustrators, the
writers, and the editors. At the end of 1859, for example, Homer devised a
double-page Christmas-themed wood engraving. Shepherds kneel rever-
ently before the luminous Christ Child in the central medallion, titled
"The Origin of Christmas." Around it, Homer depicts two contrasting
scenes of the day's celebration in contemporary New York. In one, a goat-
drawn sleigh, arriving to the overjoyed inhabitants of a hovel on Fifty-
ninth Street (upper right), reflects the poverty in which many of Homer's
neighbors lived. In the other, a splendid horse-drawn carriage on Fifth
Avenue (upper left) exemplifies the lavish level at which other New Yorkers
lived. One of them, a sedate gentleman, emerges from the carriage to enter
a grand indoor party, whose participants occupy the bottom half of the il-
lustration. Homer reserves greater empathy for the Black servants in the

Figure 23: After Winslow Homer, "A Merry Christmas and Happy New Year,"
from *Harper's Weekly*, December 24, 1859. Wood engraving on paper, 15½ × 21½ in.

background of the festive scene than for the dancing children or their bored
parents, who lack the authentic joy of the poor and have none of the shep-
herds' awe at the sight of the newborn Lord. The composition is uniquely
Homer's, incorporating acute observation and firm critique of social and
religious mores. The young man's ambitious composition and subtle, lay-
ered narrative won him much admiration, beginning with his wood engraver
collaborators and other colleagues at *Harper's*, including the many other
illustrators who sought to sell their work to the same editors.

Among the dozens of eager young artists pitching the newspaper was
the German-born Thomas Nast (1840–1902). *Harper's* had published his
drawings for the first time in March 1859, when he was only eighteen
years old: a full-page nine-panel cartoon ridiculing the New York Metro-
politan Police.[12] Nast's drawings were hardly subtle and depended for their
effect on words tightly integrated around them. They offered a stark con-
trast to Homer's work.[13]

Homer furthered his skills as a draftsman by enrolling, with Nast and
Alfred Howland, in the Life School at the National Academy of Design
under the renowned Thomas Seir Cummings (1804–1894).[14] Admission

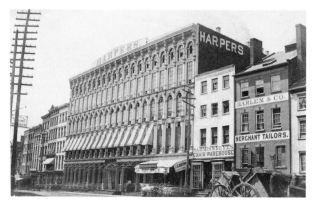

Figure 24: Unidentified photographer, *331 Pearl Street, New York*, c. 1870.
Albumen print, 9 × 14 in.

was itself a mark of distinction, since normally students were allowed to draw from live models only if they had first spent a year in an entry-level class drawing from plaster casts. Homer, as a newcomer to New York, had not attended that first-level class and had probably never before participated in any drawing class with live models; Boston offered no such instruction. Others in the Life School included the Irish-born sculptor Launt Thompson (1833–1894), the painter and critic Eugene Benson (1839–1908), and the landscape painter Samuel Colman (1832–1920), who would later collaborate with Louis Comfort Tiffany (1848–1933) on the decoration of Samuel Clemens's home.[15]

Among the drawings Homer likely made under Cummings's supervision is one that reflects his intense observation of the geometry of the human body. The drawing reveals the ways in which artists of all kinds—including sculptors, architects, and painters—sought out a natural harmony in creation. Human anatomy's intrinsic order begins with the face, which his teacher instructed is composed of three equal parts: 1) the top of the head to the eyebrows; 2) the eyebrows to the nose; and 3) the nose to the chin. The height of the face is the basic measure of the rest of an archetypal person's dimensions; at the chest, a human's breadth is equal to the height of two faces. The order may be revealed down to the very bottom of a person's anatomy, Homer wrote: "Sole of the foot is a fifth part of the figure." As the art historian Elliot Bostwick Davis demonstrated, as a child Homer had studied geometry—which was a standard part of grammar school teaching in Cambridge.[16] It is reasonable to assume that from the age of ten years or younger,

Figure 25: *Sketch of a Male Nude with Notations*, c. 1860.
Graphite on blue-gray laid paper, 7¹³⁄₁₆ × 7⅝ in.

he was familiar with *Graphics: A Manual of Drawing and Writing for the Use of Schools and Families*, which Rembrandt Peale (1778–1860) had published in 1835, the year before Homer's birth.[17] From his earliest career as a young man in Boston and now in New York, Homer had developed illustrations purposefully designed to fit onto grid-like bolted woodblocks. Now he was receiving formal instruction at the height of the American art establishment; this instruction built closely on what he had learned over the years leading up to his teaching from Cummings and others. Peale's book, for example, included an illustration similar to Homer's.[18] The quest for geometric harmony—as found in nature, as expressed by Peale and others on the pages of drawing books, and as preached by academic seers—sustained him for the rest of his life.

Some of his classmates at the Life School became close friends, particularly Benson and William John Hennessy (1839–1917), an Irish-born painter who enrolled the following year. A letter from Benson reveals that he, Homer, and Hennessy ate dinner regularly at the Waverly Inn, in the West Village at the intersection of Bank Street and Waverly Place. Several considerably older painters, including the landscapist John Frederick Kensett (1816–1872), and the genre painter Eastman Johnson (1824–1906),

generally shared the evening meal with them.[19] Homer might have met Johnson in Boston. The well-traveled Maine native would prove catalytic to Winslow's social and commercial development.

His frequent trips to the offices of New York publishers such as Harper & Brothers also exposed Homer to a wide range of novelists, editors, short-story writers, and poets. A few of them, such as the poet Edmund Clarence Stedman (1833–1908) and the journalist William Conant Church (1836–1917), left traces of these times together. Many more, such as Clemens, the novelist William Dean Howells (1837–1920), Stedman's *New York Saturday Press* co-founder Henry Clapp, Jr. (1814–1875), and the poet Walt Whitman, provide no evidence of Homer's probable cross-pollination with them. That said, Clapp's description of the period and Whitman's place in it is equally well suited to Homer, and to the markets both Homer and Whitman addressed:

> On this solid material continent, we are dying for lack of bread and water of thought. Our literature is whipped-cream. The thing before him, whether it be a horseblock or a revolution, is not fine enough to occupy the writer; he must tag it to something other than itself. Poetry becomes a ruffled-shirt on a bean-pole . . . Sermons and poems are mostly trash, and go into the dusthole to-morrow, because they are busy about what shall be or should be, and careless of what already divinely is. They put man's fancies in place of God's fact, and are so essentially impious.

Clapp continued:

> Whitman is great, because for him an old shoe, since it actually exists and has come forward out of chaos under creative, inevitable laws, has more interest and is more venerable than any figment or fiction; because this world as it runs and rolls is the breath of His nostrils who alone lives and invites every creature to share His life.[20]

It fell to Homer, as it fell to Whitman, to mine universal meaning from the particularities of daily life: the old shoe, the Christmas greeting from a goat-drawn sleigh, and the evanescent moment glimpsed—then gone forever, like leaves of grass. As he remarked to a friend years later, "When I have selected the thing carefully, I paint it exactly as it appears."[21] The selection mattered nearly as much as the act of drawing or painting. And despite

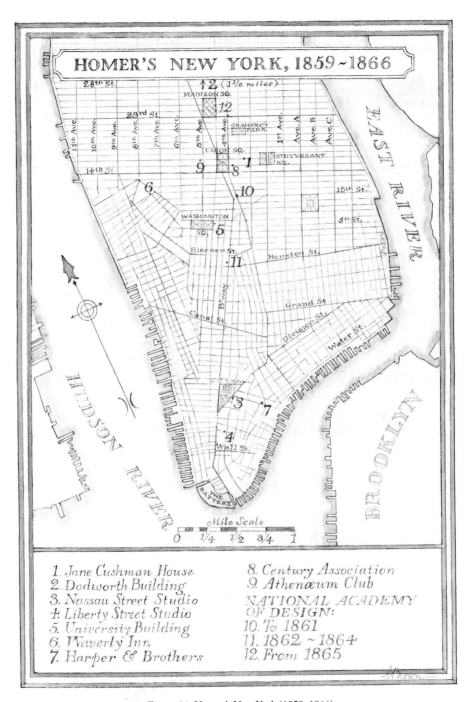

Figure 26: Homer's New York (1859–1866)

Homer's emphatic claim to paint the "simple and absolute truth," he was no cartographer.[22] What interested him was the appearance to his eye of "the thing" he had selected, and therefore the meaning he mined through the art of seeing—a meaning he yearned to share with others, just as Whitman did.

In about 1862 Homer moved his studio, and likely his home, into the large Gothic Revival University Building on Washington Square. "It extended from the Square to Waverly Place, and was built of grey granite, with towers and castellated roof," recalled Homer's friend James Edward Kelly (1855–1933) with nostalgic affection.[23] The building was the site of two scientific breakthroughs. First, around 1839, the British-born chemist, philosopher, and polymath John William Draper (1811–1882) made America's first photographic portrait in it.[24] But Draper was not the only artist-inventor in the building. There, Samuel F. B. Morse (1791–1872) developed the telegraph, leading up to his famous 1844 message, "What hath God wrought," a quotation from Numbers 23:23. "In many cases, the wires on which he experimented remained in position," Kelly remembered.[25] The heritage of the building would have been of intense interest to Homer, as the son and brother of inventors, and invoked a pride of place.[26]

Not everyone liked the University Building, however. Thomas Bailey Aldrich called it "dingy and despondent . . . looming up there stiff and repellant." Speculating that the ghost of a suicidal artist might haunt the place, Aldrich wrote that "few men could pass a week in those lugubrious chambers without adding a morbid streak to their natures."[27] Homer made his studio on the third or fourth floor, with a "splendid view," Aldrich wrote, but "contracted dimensions: it seems altogether too small for a man to have a large idea in."[28] Homer had no such difficulty, perhaps in part because of those around him. By then both Morse and Draper had moved north, to Poughkeepsie and Hastings-on-Hudson, respectively.[29] But Homer had no shortage of illustrious neighbors in the building, including Hennessy, Johnson, Benson, and one of America's greatest antebellum architects, Alexander Jackson Davis (1803–1892), whose firm designed the structure.

Winslow's neighbors at the University Building introduced him to exhibitions and lectures he could never have seen or heard in Boston. He said of these early years in New York that "what I remember best is the smell of paint; I used to love it in a picture gallery."[30] He engaged with painters who are now obscure but then were prominent, such as William Page (1811–1885), whose *Venus*, painted in Italy, "deeply impressed" Homer.[31]

Page's lectures on color theory and geometric composition were re-nowned. When he spoke at New York's Athenaeum Club, around the cor-ner from Mrs. Cushman's, Homer listened closely.[32] Page proclaimed that the process of making art—like religious faith—is founded on a reverence for sacred Truth. "It should be only with knowledge, both theoretical and practical, that one dare tread over the threshold of this subject, and enter its temple, and that with head and feet uncovered, and with a thrill of awe in that presence which must penetrate every true soul with a sense of its grandeur, and his own unworthiness." Page dared Homer and other artists to create work "made vital by the inner life flowing from a knowledge of the only living God."[33] In the oratory of Page, the pursuit of beauty found in the order of nature—whether in human anatomy or the forces shaping the landscapes in which humans live—was no workaday task. It was a calling from on high.[34]

While over the years ahead Homer would engage vigorously in explor-ing the intertwined meaning of art and truth and would deploy with en-thusiasm Page's ideas on composition and color theory, these were dreams for his future. Now he had a living to make. And it was not as a painter but as an illustrator—a draftsman for a mass audience of men, women, and children all eager for visual understanding of the rapidly evolving world in which they lived. During the pivotal election year of 1860, *Harper's Weekly* bought a further twenty-four illustrations from Homer, including eight for serialized fiction, which the editors assigned with more restrictive visual parameters. Seven others are urban genre scenes evoking a general sense of equanimity, although for these illustrations Homer did have more compo-sitional flexibility. For example, in "Skating on the Ladies' Skating-Pond in the Central Park, New York," Homer characteristically included a feature that other artists would not. A young man at lower right stops in front of a sign warning "Dangerous" to rescue a pair of gloves, perhaps belonging to the woman next to him, who stares at the bare-handed rapscallion skating at center toward the viewer.

The print is closely related to a watercolor, *Skating in Central Park*, that the jurors for the National Academy of Design selected several months later for New York's most prestigious exhibition of art, the academy's Annual. The sheet was the very first work of fine art Homer is known to have exhibited to

Figure 27: *Skating in Central Park*, 1860. Watercolor and ink on board, 16⁷⁄₁₆ × 24⁹⁄₁₆ in.

the public. In so doing, he displayed his mastery both of line (the wood en-graver's tool) and of tone (honed through his lithography at Bufford's).[35] But perhaps naively, he also ignored the public perception of watercolor as a me-dium for amateurs, favored by women and not by serious artists. He would go against the grain again, but chafed each time. Artists then needed to curate their own reputations, which at least for Homer was never easy. It would be nearly fourteen years before he again exhibited a watercolor. He learned fast that oil painting was the most prestigious medium, and if he was going to achieve commercial success in his painting, he would need to master that medium. Watercolor, at least for now, wasn't considered a serious art form.

Ironically, Homer had already proven himself adept at watercolor por-traits, including captivating depictions of Voorhees, both Howland broth-ers, and his own older brother Charlie. He translated his years of experience making lithographic and wood engraved portraits into a prescient dexterity with watercolor portraits. These small jewels, executed for his own pleasure and for the delight of his sitters, display not only his skill in capturing the physical forms of these men but also in reading and communicating their personalities and aspirations. His depiction of Henry Howland (a future admired justice of the New York Supreme Court) brims with intelligence

LEFT: Figure 28: *Alfred C. Howland*, 1860. Watercolor on paper, 8 × 6 in.

RIGHT: Figure 29: *Henry E. Howland*, 1860. Watercolor and gouache on paper, 9½ × 5¾ in.

and confidence. Homer also made a portrait of his friend Alfred Howland, Henry's brother. That one, which Winslow completed shortly before Alfred sailed to Europe, depicts him steeped in disheveled artistic ambition.

Harper's bought six portraits in 1860 from Homer, most of them based on photographs by Mathew Brady (c. 1822–1896). The subjects included Abraham Lincoln, just after his election; Congressman Jabez Lamar Monroe Curry (1825–1903) of Alabama; and a dour Roger B. Taney (1777–1864), chief justice of the Supreme Court, who wrote the infamous *Dred Scott* decision. Each portrait accompanied favorable text descriptions of the men. Late in the year, Homer also depicted the Italian nationalist general Giuseppe Garibaldi (1807–1882), whom *Harper's* described admiringly as "the Washington of Italy." The final Homer portrait of the year marked a threshold. In a tour de force entitled *The Seceding South Carolina Delegation*, Homer drew eight portraits in a single wood engraving, depicting the two sitting senators from South Carolina and their six counterparts in the House. The tone of these portraits and of the prose accompanying them was generally admiring. It reflected the fact that *Harper's* served a national market from that market's commercial center, and in this transformational year for all Americans the newspaper adopted an apolitical tone to maximize its

appeal across the entirety of its market. The editors described the eight se-
cessionists as "gallant gentlemen, with high endowments, manly attributes,
and an integrity upon which suspicion has never even dared to glance, they
carry with them kind wishes and sincere regrets, even of those who go so far
as to believe that 'secession is treason.'"[36] Homer depicted most of the seces-
sionists with a generosity that matched the text and the Brady photographs.
But one of the eight Homer portrayed dissimilarly, as a politician simmer-
ing with smug anger; he is Laurence M. Keitt, whom Homer had depicted
previously. Keitt, on the floor of the Senate, had assisted in the attack on
Senator Charles Sumner.

Bonner and his colleagues at the Harper firm recognized that Homer
possessed a distinctive talent. They offered him an opportunity to convert
from his freelance contract work to one of the few coveted positions on the
newspaper's staff. Homer declined, explaining to a friend that he "had had
a taste of freedom . . . I have had no master, and never shall have any."[37]
Homer was discovering his personal freedom just as his country was deter-
mining the meaning of freedom as an ideal—for millions of enslaved men
and women, and for the nation itself. America was ensnared in a deepening
quagmire of its own design: the "peculiar institution."

As 1860 closed, no one could deny that civil war was imminent. What
relatively few people understood then was how deep the nation's fissures ran,
or how long after the war such fissures would still throb. As the historian
James McPherson has written, "While the Revolution of 1776–1783 created
the United States, the Civil War of 1861–1865 determined what kind of
nation it would be." The Revolution had left two fundamental questions
unresolved, he noted. The first was "whether the United States was to be
a dissolvable confederation of sovereign states or an indivisible nation with a
sovereign national government." The second was "whether this nation, born
of a declaration that all men were created with an equal right to liberty,
would continue to exist as the largest slaveholding country in the world."[38]

The close election of 1860 handed Abraham Lincoln the monumental
task of resolving these two long-festering questions. Not only was his na-
tion splitting before his eyes, but from the moment of his election he was
the target of corrupt opportunists, incompetent aides, and more than a few
assassins. The journey he began in Springfield, Illinois, on February 11,
1861, stepping onto a train for his inauguration in Washington, was a cir-
cuitous 1,900-mile odyssey in which every American held a stake.[39]

When Lincoln arrived in New York on February 19, the crowd at the corner of Broadway and Vesey Street around his hotel, the Astor House, was "a jam from which egress was absolutely impossible."[40] Within that jam, a few minutes' walk from the offices of Harper Brothers at 331 Pearl Street, were the poet Walt Whitman; at least one assassin intent on murdering Lincoln that very day; and America's first female detective, Kate Warne (1833–1868), intent on foiling the assassin's plot.

Whitman described Lincoln's "perfect composure and coolness—his unusual and uncouth height, his dress of complete black, stovepipe hat push'd back on the head, dark-brown complexion, seam'd and wrinkled yet canny-looking face, black, bushy head of hair, disproportionately long neck, and his hands held behind as he stood observing the people. He look'd with curiosity upon that immense sea of faces, and the sea of faces return'd the look with similar curiosity. In both there was a dash of comedy, almost farce, such as Shakspere puts in his blackest tragedies."[41]

Homer's wood engraving of the scene has all the air of an eyewitness. It captures the sound and sight of the throng, and of the gaunt man beholding those before him and perhaps also pondering his own fate, intertwined with theirs. It also captures a woman at a nearby window, whose handkerchief may reflect a prearranged signal that Warne, Lincoln's protectress, had devised.[42] Homer chose a strained perspective, as he alluded to his own slight stature, to Lincoln's perpetual peril, and to the monumental task ahead. He accentuated the verticals of the columns, piers, and lampposts, and made his foreground figures visible only by their top hats, several aloft in salute to the sober figure astride the precipice.[43]

Homer also was witness to Lincoln's inauguration in Washington two weeks later, on March 4, 1861. It was likely his first trip south of the New York area. His depiction of the ceremony appears to be based on a photograph attributed to the Scottish-born Alexander Gardner (1821–1882), and lacks the imaginative character of the New York scene.[44]

Homer also visited George Washington's plantation home, Mount Vernon, and made a sketch of the house, viewed very unusually from the north side. Notably, his perspective is similar to the one Johnson chose for an oil painting four years earlier.[45] As in Johnson's picture, several of the panes in the house's large Palladian window are broken, and the gracious wooden structure is derelict, rotting. Four small figures, likely still enslaved, emerge from a basement door, as if in wonder at the spring light beaming

Figure 30: *View of Mount Vernon and North Colonnade*, 1861.
Watercolor and pencil on paper, 5⅜ × 8⅝ in.

through the lacy branches of the trees above—waiting, expectantly, to burst
forth. As he walked the grounds beloved by Lincoln's predecessor, Homer
grasped both the promises of the past and the frustration in the present of
those promises still unfulfilled.[46]

A few weeks later, early on the morning of April 12, Confederate forces
led by Pierre Gustave Toutant-Beauregard fired on Fort Sumter, at
Charleston, South Carolina, formally initiating the Civil War. Federal
forces surrendered the fort the next day. Homer drew a portrait of Beaure-
gard that *Harper's* published two weeks later: a slender, confident officer
whom the accompanying text described in admiring terms.[47] In another
composition in the same issue, Homer depicted the swearing-in of volun-
teer soldiers under Washington's still-leafless trees.[48] Like the New York
scene, the classical architecture of his setting invokes a sense of solemnity
appropriate to the occasion, which was far from rote. The caption and re-
lated text explained that the volunteers were committing themselves to
serve under the command of General George Cummins Thomas (1812–
1882), who was responsible for the defense of the federal capital. Washing-
ton was squarely located in the South, across the Potomac from Virginia.
Many local men who had been called up for the defense of the city refused
to swear to "bear true allegiance to the United States of America [and]

Figure 31: After Winslow Homer, "The Advance Guard of the Grand Army of the
United States Crossing the Long Bridge over the Potomac at 2 a.m. on May 24, 1861,"
from *Harper's Weekly*, June 8, 1861. Wood engraving on paper, 9¼ × 13¼ in.

serve them honestly and faithfully against all enemies or opposers whatso-
ever."[49] These men holding their rifles, their arms raised, were the excep-
tion. The order of the scene belied the disorder of the nation.

Homer drew another illustration that spring reflecting the urgency, and
the challenge, of defending the capital, and alluding to the dramatic stories of
heroism in its defense. Virginia seceded from the Union on May 23. Hours
later, just after midnight and under the light of the moon—full that night—
countless companies of men, in regiments from Michigan, New Jersey, and
New York, marched silently into Alexandria, Virginia. Their mission: to secure
this pivotal Potomac port for Federal troops, not Confederates. As *Harper's*
text explained, it was a major operation, accompanied by "our special artist"
(Homer).[50] "They came down the avenue with, as heretofore, soul-stirring,
far-sounding martial strains, but with quiet tread, more like that of hundreds
than thousands of men . . . So little noise did they cause that hardly any of
the denizens of Washington were awakened from their peaceful slumbers."[51]
Homer described the scene with geometric boldness and dramatic verve.

It would prove a momentous day.[52] Hours later, one of the soldiers who
crossed the Potomac by moonlight would lie dead—the first officer to fall

for the Union cause. Elmer E. Ellsworth, twenty-four, commander of the 11th New York Infantry Regiment, spotted a Confederate flag (sixteen by thirty feet) flying from the roof of a local boardinghouse. The proprietor had raised it the previous evening to the cheers of a large crowd of his neighbors who, like him, supported secession. Ellsworth entered the inn with five of his men, including the regiment's chaplain and the *New-York Tribune* correspondent Edward H. House, and quickly ascended to the roof. Pulling out his pocket knife, he cut the ropes from which the flag hung and draped it over his shoulder.[53] Ellsworth descended to the foot of the stairs, declaring, "I have a trophy." They were his last words. The inn's proprietor raised his double-barreled shotgun and killed Ellsworth on the spot. When Lincoln heard the news, he asked that Ellsworth's body be brought to the White House. The next day, it lay in state in the East Room, amid dozens of white lilies—symbols of the Resurrection. In death, a martyr had been born.

Even before his murder, Ellsworth had captured Homer's imagination—and the imagination of the whole country. At the age of twenty-one he had encountered a man in a Chicago gymnasium who introduced himself as Charles de Villiers, a French surgeon and fencing instructor.[54] The Frenchman regaled Ellsworth with stories of his service in the Crimean War as an officer in an elite French corps called the Zouaves, who were "named for a band of Algerian tribesmen renowned for their ferocity in battle."[55] These soldiers adopted not only an Algerian name but Algerian dress: baggy, colorful pants; a smart vest; a sash; a geometric-embroidered shell jacket; and a turban or fez. And the French Zouaves distinguished themselves in their coordinated fighting precision and their spectacularly athletic gusto.

Zouave excitement was contagious. On May 4, 1859, Ellsworth formed the United States Zouave Cadets of Chicago. He made his living as a clerk in Lincoln's law office, but he knew his real calling, and so did his boss.[56] Ellsworth was a born recruiter and drill instructor. Just over a year later, Chicago's lakefront strollers could see the results, as some forty of Ellsworth's recruits showed off their gymnastic hijinks in colorful costume. "The cadets are not large in stature, but athletes in agility and strength," one observer exulted.[57] Ellsworth's example—both in military discipline and in dress—sparked a national mania for all things Zouave, and for Ellsworth himself. Lincoln's private secretary John Hay (who four decades later would become secretary of state), wrote, "Ellsworth found himself for

his brief hour the most talked-of man in the country. His pictures sold like wildfire in every city of the land. School-girls dreamed over the graceful wave of his curls, and shop-boys tried to reproduce the *Grand Seigneur* air of his attitude. Zouave corps, brilliant in crimson and gold, sprang up, phosphorescently, in his wake, making bright the track of his journey."[58]

Homer, like Ellsworth, observed closely the volunteer fire companies then springing up in many American cities. In those companies, Ellsworth observed just the characteristics he sought: physical fitness, fearless commitment, and brotherly camaraderie. The men shared a bond transcending differences of ethnicity, age, and faith. In the spring of 1861, Ellsworth quickly organized the 11th New York Infantry Regiment (known as the First Fire Zouaves); they were more than a thousand in number as they crossed the Potomac that fateful evening.[59]

Zouave mania spread across the country as dozens of other Federal regiments and companies organized on the model Ellsworth popularized— from California to Minnesota to Maine, and even in the South, from Texas to Alabama to Georgia. While Homer would draw and paint many soldiers during his Civil War years, he would form a particular attachment to the Zouaves, and to the daring heroism Ellsworth and his followers represented.

In this first illustrated tribute to the Zouaves, Homer was characteristically oblique. The dramatic diagonal, the silent, solid line beneath the moonlit sky, told *Harper's* readers of the grim resolve guiding Ellsworth and his men, the determination, from that moment, to win back Virginian soil. Only over time would readers learn the full cost of that resolve. But into the scene with its long rhythm of silent steps, onto the bridge between free soil and that held by rebels, Homer invited his fellow citizens. Every American would soon hear the marching boots he saw that night.

Federal and Confederate forces assembled seldom in battle in 1861, and just once for a significant encounter on land: the Battle of Bull Run (First Manassas, near Washington). Some 18,000 men fought on each side. Most of those killed were Federal soldiers, who arrived on the battlefield late and poorly organized; the Confederate forces won the day.

Homer's friend from his days at *Ballou's*, Alfred R. Waud was present at Bull Run but Homer himself was not.[60] He spent much of the summer and early fall of 1861 with his parents in the modest house they had rented in Belmont, Massachusetts, and to which they had moved in 1858 from

Cambridge, a few miles away. Two of Homer's uncles, William and Eleazer Homer, had married sisters with deep roots in Belmont. The house to which Winslow's parents moved was a walk of fewer than two minutes from the grand house William occupied and another belonging to his brother James, the well-traveled sea captain. William remained engaged in business with his Mobile-based nephew, Matthias E. Homer (1819–1871), whose father had been the first of the Bostonian Homer brothers to set roots in Alabama. That summer, William sued Matthias to retrieve capital his nephew owed him.[61] The family, like the country, had long depended on a system whereby southern commodities (led by cotton) supplied northern demand (led by Massachusetts textile mills). As cotton inventories dwindled, including at the Pacific Mills employing Winslow's brother Charlie, that system's inevitable failure hardened both northern and southern wills to fight. Bull Run would be the first of many battles to come. Homer's younger brother, Arthur, enlisted in the U.S. Navy that September, weeks before his nineteenth birthday.

Northern women became engaged in the war effort, as several Homer wood engravings showed. One depicts eight well-dressed women in a well-lit room as they construct havelocks, which protect soldiers' necks from sunburn. In another, sited at the arsenal in Watertown, Massachusetts, nearly two dozen women attentively fill metal cartridges with explosive gunpowder, their delicate, systematic handiwork at odds with the deadly purposes to which these little cartridges would be put.

Probably for his own pleasure, that summer Homer executed a remarkable watercolor anticipating themes that would resonate over the coming five decades. It reflects the acuity of his perception at a moment of mortal decision. Homer places himself with his two actors—each a brook trout— just above the line of water in which they swim. He is one of two human actors who are invisible, as we the viewers are, but still present—ushered together into an intimate drama. One trout has leaped, arced, clear out of its element. The unseen fisherman has already acted. He first enraptured the fish with his bloodred fly, and then, firmly, hooked him. Now, in flying fully airborne, the trout takes center stage. It seeks to shake free of the fly and its promise of the fish's sure demise—but also, unknowing, tangles with the other fly hanging on the end of the other fisherman's line. The behavior of both aquatic actors—like the behavior of both unseen men— matters not only to themselves but to each other. Homer leaves the destiny of the other trout a matter of suspense. He conjures a narrative of

Figure 32: *Rising to the Fly*, 1861. Watercolor, 6⅜ × 9¾ in.

ambiguity, in which the viewer places himself in empathy with this living creature on the cusp. A blue fly lures this second trout, rising from the water, half-immersed. Will it, too, perish? At twenty-five, as his country-men died in battle, Homer found ways to direct his talent to tell a story without words, and even without visible human characters—and to compel his viewers to care about the outcome of his tale.

In October, Homer made his first journey to the front. During what appears to have been the sole occasion on which he operated as an official representative of *Harper's*, he began a visit to the Washington area on October 15. An adjutant to General George B. McClellan (1826–1885) signed an official press pass allowing Homer "within line of main guards" for one week.[62] Then Homer seems to have extended his southern itinerary in order to engage in a longer and unofficial visit of as long as seven weeks. His mother wrote on October 28 that he had been staying, evidently for a prolonged period, at a house at 331 F Street, North.[63] He sketched the construction of two forts near Alexandria.[64] He appears to have journeyed upriver, to Camp Benton in Maryland, along the Potomac between Pooles-ville and Edwards Ferry.[65] A large oil painting executed nearly two decades later, in 1881, *Captain W. F. Bartlett and Lieutenant-Colonel F. W. Palfrey at*

Camp Benton, Maryland, November 1861, records the visit. The portrait is based in part on a photograph, but appears also to reflect Homer's first-hand familiarity with the scene, and with Francis Winthrop Palfrey (1831–1889) and William Francis Bartlett (1840–1876).[66] Both men were Bostonians, probably knew members of Homer's family, and had attended Harvard; the regiment in which they served, the 20th Massachusetts, was known as the Harvard Regiment. The dark tones of the picture reflect the hardship yet to come. Palfrey, a military historian, would document Bartlett's heroism during the siege of Yorktown, during which he lost a leg to an eagle-eyed Confederate sharpshooter. Homer was present at that month-long siege and may well have seen Bartlett soon after he suffered those wounds. The picture is largely a memorial to the young man, who would die at just thirty-six.

A second record of this Maryland visit survives in the form of an illustration. Among the other regiments at Camp Benton was the 19th Massachusetts, including Company K under the command of Ansel Dyer Wass (1832–1889).[67] Company K was known as the Boston Tiger Fire Zouaves, organized like the 11th New York from the ranks of volunteer firemen but dressed distinctively, in "light blue baggy trousers, yellow leather leggings, with a jacket of darker blue, plentifully furnished with buttons, and a fez cap of the same color."[68] Just before Christmas, *Harper's* published a Homer wood engraving depicting among others a dozen Tiger Fire Zouaves around a campfire. At the center of the illustration, a young Black dancer entertains the troops, paying with his art for the shelter he receives within the Federal encampment. The figure is based on a drawing of a young man of indeterminate race, possibly a Tiger Fire Zouave. Camps such as these compelled cross-cultural encounters. The historian Peter H. Wood has observed that many of the Federal soldiers had likely never before seen or heard the Black culture of the South.[69] Whatever his past, in his dance the young man commands the present and imagines the future. The figure would appear repeatedly thereafter in Homer's work. The flames around him reflect the forces that were then melding his country into one, as men from starkly different Americas encountered one another in a shared and mortal mission.

A Black fiddler sets the tune. The wood engraving caricatures his face,

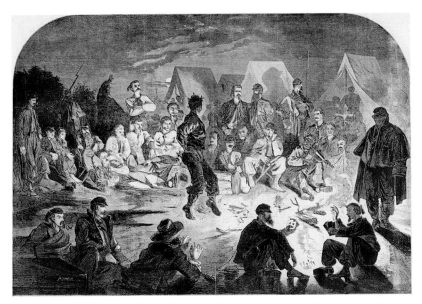

Figure 33: After Winslow Homer, "A Bivouac Fire on the Potomac," from *Harper's Weekly*, December 21, 1861. Wood engraving on paper, 13¾ × 20¼ in.

unusually for Homer. Unlike Nast, he detested caricature. If indeed it were his decision to deploy it on the fiddler, it may have been to mock the hackneyed minstrel tropes Nast and others used. It may have been instead the decision of the art editor who received Homer's drawing from the field; the wood engravers themselves typically strayed little from the drawing they were assigned to convert into a print. A Zouave plays cards with a comrade from another company of the 19th, raising his hand as if to accentuate the message on the ground: I.O.U. As Wood and his colleague Karen Dalton first suggested a generation ago, this innocuous chit implies that the immeasurable debt set at the country's founding, by which it long depended on the blood and toil of the enslaved, was coming due.[70] A soldier in the background waves as if to salute the full moon. Like the full moon on Ellsworth's last night, this moon over the Potomac portended much drama to come.[71]

Another wood engraving published that fall offers a rare glimpse into Homer's process of developing an illustration.

He composed his initial sketch on the back of a French lithograph that

was part of a series used in drawing instruction.[72] In the sheet's lower right corner he placed three nameless enslaved men as they struggle under the weight of the heavy baggage belonging to a mounted figure directing them.

Then Homer altered his design. He replaced these figures with a single one: a handsome young Black man in the same posture with which the frontispiece depicts Solomon Northup (c. 1807–c. 1863) in his 1853 memoir *Twelve Years a Slave*.[73] The winter cap Homer's model wears, with its prominent earmuffs, is distinctly different from Northup's broad-brimmed straw hat. It appears to emphasize his alertness, particularly to sounds such as the tune of "Dixie" over his head—or the groans of the man depicted on the wall behind him, as he carries a crushingly heavy sack. Homer's model carries nothing. Instead, a barrel carries him—a barrel of the kind used for gunpowder.[74] And the barrel bears a name: "Contraband," a term closely associated with a new legal concept developed by General Benjamin F. Butler (1818–1893), and promulgated through the Confiscation Act of 1861—a key precedent for the Emancipation Proclamation.[75] Butler, a wily Boston trial lawyer before the war, opined that since a) the laws of the South claimed that slaves were property, and b) the same laws prohibited the return of property to a foreign entity (as the Confederacy claimed to be), then c) by law, no person formerly enslaved could be returned to the South. Butler based his strategy on a keen observation: that within the institution of slavery lay the seeds of its own destruction.[76] Homer told this truth in a way that was empathetic and memorable.

While Homer's country reeled from the moral, political, and economic crises before it, his father focused on narrower matters: the domestic life he and Henrietta enjoyed under the protection of his nearby brothers' mercantile prosperity. Their success, by comparison with his own failures, grated on him. As the new year of 1862 opened Charles wrote, "We must have a house of our own a family nest for all hands, a *Homestead* . . . each Boy will pay for his own Room and I will pay for Mothers Room: i.e. ¼ each."[77]

Homer's mother wrote to her youngest son, Arthur, of her hope that "Win go abroad in the Spring, as he so desires to go for improvement," just as Alfred Howland had done.[78] Like Charles, Henrietta had no compunction about soliciting her two other sons for financial support despite their youth and meager means. She blithely assured Arthur of the strength of the loan he should make Winslow, that "he will be able to repay with principal & interest before many years, so write me about it."[79] At the time,

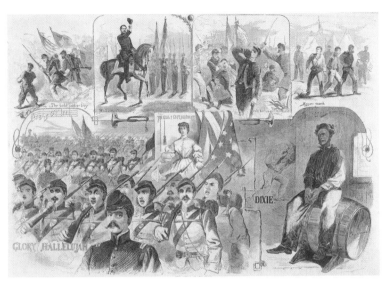

Figure 34: After Winslow Homer, "The Songs of the War," from *Harper's Weekly*,
November 23, 1861. Wood engraving on paper, 13⅞ × 20 in.

Arthur was a landsman—the lowest rank of the U.S. Navy, tasked with menial, unskilled work, and earning thirteen dollars per month—so Henrietta's request may have struck him as more than slightly unfair.

Whether or not his brothers lent Winslow funds from their own meager resources, he did not sail to Europe for nearly five years. But he did indeed travel, within his own country, to the long, narrow peninsula between the York and James rivers and their tributaries in Virginia. Just before he left, Winslow wrote to his father a letter signed "Truly Mothers Son Win" in which he said, "Bonner thinks Homer is smart and will do well if he meets no pretty girls down there, which he thinks I have a weakness for. I get $30 per week RR fare paid but no other expenses."[80] It is one of a handful of letters that survive from the first forty-five years of Winslow's life. He was not known to have ever kept a diary, and only when he was middle-aged did anyone in his family make an effort to retain any documentary evidence of the man.

Homer's description of himself through the eyes of his principal client, and told to his father, raises a question that many have asked over the years: In what ways did he develop a romantic life? The truest answer is that there is no answer—and that Homer wanted it that way. His close friends included both men and women, many of them considerably younger than

himself. In several cases, those friends never married. But it was neither Homer's manner nor the manner of his time to reveal his romantic intentions or actions. Sexual repression was the norm in that era—albeit a norm that some violated with the expectation that a record of their violations would survive. That was not the case with Homer. He left a few shreds of evidence of his romantic life, but they are not determinative.

There was little risk of Homer's distraction by pretty girls on the peninsula. It was swarming with men. The suave, diminutive General McClellan ("Little Mac"), a master organizer but cautious leader, had set the war machine in motion. He was commanding the Army of the Potomac, having briefly served as general-in-chief of all Federal forces.[81] Little Mac had set his eyes on capturing the Confederate capital, Richmond, Virginia, in a single grand move. On paper, at least, it all made sense. Fortress Monroe, the largest masonry fort in the country and a pivotal asset he controlled at the peninsula's tip, was a mere sixty-five miles from Richmond. McClellan possessed superior forces in men and munitions, and open access to major Atlantic ports from which he could access those resources. Fortress Monroe faced Chesapeake Bay and was easily accessible from even closer river ports, such as Alexandria, on the Potomac, a hundred miles north. His plan was simple on its face: assemble his large army on the peninsula safely; use the navigable York River (which he did not yet control) to supply his men from river ports; deploy his forces quickly to decapitate the Confederacy; and ensure that the war was won in decisive fashion. He set his hopes on becoming recognized as the brilliant hero, called to overshadow the gangly president who oversaw him but with whom his dialogue had grown frosty.

Homer left New York for Alexandria on March 26, anticipating eagerly his imminent departure for Fortress Monroe.[82] He had recently turned twenty-six years old. Among the regiments he would find on the peninsula were the 19th and 20th Massachusetts, with whom he had been at Camp Benton in late 1861. While he still lacked the credentials of an official *Harper's* staff artist, he now traveled with the blessing of a man his brother Charlie knew well, as his classmate both at the elite Hopkins Classical School and at Harvard: Francis Channing Barlow (1834–1896), commander of the 61st New York Infantry Regiment. Homer must have reached out to Barlow through the officer's mother, since Barlow replied to her on February 18 that "I should be glad to see Homer here + if we are farther out he must come out here."[83]

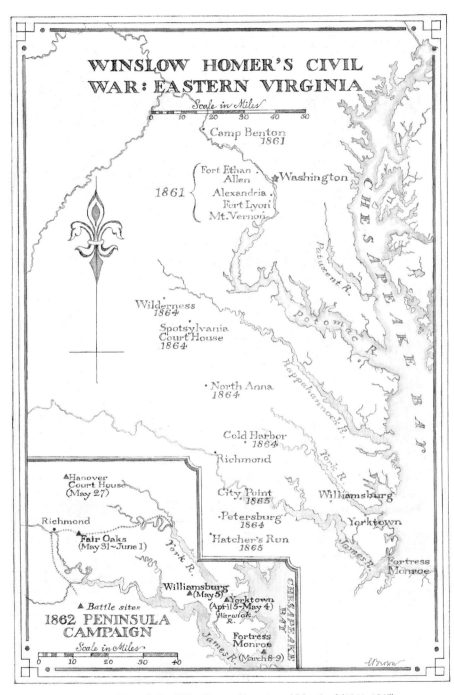

Figure 35: Homer's Civil War: Eastern Virginia and Maryland (1861–1865)

One drawing (below), likely sent to Bonner, is inscribed "April 2nd / The 6th Penn Cavalry / Embarking at Alexandria / April 2 for Old Point Comfort / This is a full Regt. All the men have / Lances which they use with great ski[ll] / this being the only Regt. Of the kind in the Serv[ice] / I thought you would like it." The cavalrymen depicted belonged to the famous 6th Pennsylvania, known as Rush's Lancers for their association with their commander, the English-born Richard H. Rush (1825–1893).

Homer's watercolor, made with calm and precision on the hectic Potomac wharf from which the lancers would board a steamship to the peninsula, conveys a sense of the excitement that he and the young men around him felt. He probably traveled with Barlow and his regiment on the steamer *Spaulding*, arriving at Fortress Monroe on April 5.[84] The spectacle awaiting him on the peninsula was even more remarkable than the crowds in Alexandria. Little Mac had assembled a force of some 58,000 men and a hundred cannons, and the previous day had begun his assault toward Richmond.[85] By the end of June, he would have 127,327 men on the peninsula. Almost overnight, McClellan had summoned a force as large as all but the eight largest cities in the country.[86]

The topography of the hostile territory before him—flat and swampy with few opportunities to gain ground—seemed to justify McClellan's assembling such an overwhelming force. So did the erroneous intelligence

Figure 36: *General McClellan's Sixth Cavalry Regiment, Embarking at Alexandria for Old Point Comfort*, 1862. Graphite, brush, and gray wash on cream paper, 8⅝ × 15⅞ in.

he received, which suggested that he faced a Confederate army far more impressive than it really was. In fact, just 11,000 rebels then defended the peninsula, under General J. Bankhead Magruder.[87] Richmond, too, was little defended. Had McClellan understood the fullness of his advantage, and suppressed his natural caution, his army would quickly have overtaken the peninsula, captured Richmond as he imagined, and the war would have been won. Not for the last time, Homer witnessed the significance of perception—truthful and false. Sight bore mortal consequences; the lives of men and nations hung upon it.

Magruder was a born conjurer. In a single day—the very day that Homer arrived—he had stopped McClellan's superior forces. He would keep them stalled for a month. Throughout a cold, rainy April in which many Federal soldiers had no better tents than what they could rig with their blankets, Magruder paraded his forces, creating the illusion that they were far more numerous than they really were. A Confederate diarist wrote, "It was a wonderful thing how he played his ten thousand before McClellan like fireflies and utterly deluded him."[88] Rather than take Yorktown quickly, as he could have, McClellan laid siege. Little Mac dreamed of a poetic prize—capturing the site of Cornwallis's surrender eighty-one years earlier—a prelude to his capture of Richmond. Instead, he won himself a quagmire.

The period allowed the Confederacy to strengthen dramatically the defense of Richmond, to bring 40,000 additional men to the peninsula under General Joseph E. Johnston and thereby to slow McClellan's inevitable advance. Rebel forces had superior maps and detailed knowledge of the local terrain; they used both for maximum havoc amid the delay. Confederate forces dammed the south-flowing Warwick River (a tributary of the James), flooded its fords, defended its western banks, and constructed a line of entrenchments over twelve miles, from the river's headwaters up to Yorktown. All that McClellan's forces could do was attempt minor skirmishes as they waited in frustration. Homer, too, could do little but wait with them and join them when they saw some opportunity to gain modest ground across the sodden fields.

Before dawn on April 26 one such opportunity arose. Company H of the 1st Massachusetts (the successor to the brigade commandeered to escort Anthony Burns back to slavery) spotted a fortification near the Warwick's headwaters. It was manned without artillery by two companies of

Figure 37: After Winslow Homer, "Charge of the First Massachusetts Regiment on a Rebel Rifle Pit Near Yorktown," from *Harper's Weekly*, May 17, 1862. Wood engraving on paper, 6⅞ × 9¼ in.

Confederate infantry, with its principal defense a six-foot ditch before the ramparts. The Federal company dashed, swiftly and silently, eight hundred yards over the soft soil, received fire at fifty yards, but did not stop to return it and instead "rushed over the ditch and parapet in the most gallant manner," as McClellan reported to Secretary of War Edwin Stanton (1814–1869).[89] Homer's illustration depicts the drama of the assault, the imperative of surprise, and the need to focus on the mission's purpose, even at the cost of a fallen rifle, and fallen men.

It was a minor melee but McClellan, grasping for evidence of his own wisdom, considered it strategic. "The object of the movement was to ascertain the nature of the ground in rear of the work, render the work untenable, teach the rebels a lesson, and catch some prisoners."[90] Fifteen Confederates were captured, three Federal soldiers died in the skirmish, and fourteen were wounded, one mortally.[91] Stanton, sure that McClellan's grand plan was working, wrote, "I hope soon to congratulate you upon a splendid victory, that shall be the finishing stroke of the war."[92]

More often, Homer saw no such action and had plenty of time on his hands, as did the soldiers around him. In a later undated painting, he recalls the effects of flickering firelight among the trees of the peninsula as he and the men around him await the assault on the historic fort, stubbornly beyond their grasp. The shivering Federal soldiers are fully dressed, huddling near one another to stay warm. They still await their tents' arrival; the best they

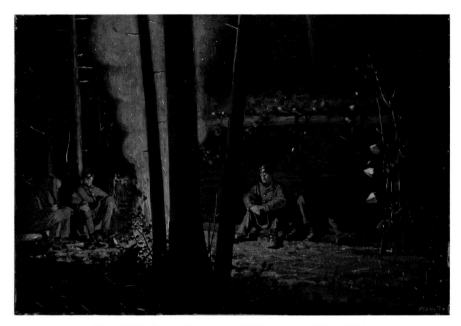

Figure 38: *In Front of Yorktown*, n.d. Oil on canvas, 13¼ × 19½ in.

can manage is to build their own lean-to for the precious heat. Characteristically, Homer places three elm trunks in the foreground; the fire his subjects fully see is, for us as Yorktown was for them, close yet out of reach.[93]

Barlow shared a sense of Homer's companionly wit when he wrote that he enjoyed "Homer's visit exceedingly. It seemed quite like home to have [him] here + I have not laughed so much since I left home. It is very tedious living so many months with men who are so little companions for me as our officers are. There is not one who I am at all intimate with or who is any companion to me."[94]

In his hours of waiting, Homer sketched a watercolor to send on to *Harper's*, depicting bored Federal forces near a modest house. The newspaper had not bought an illustration from him for nearly four months; he, too, wished to prove his worth. He wrote to Bonner that the drawing depicted a "Reconnaissance in force by Genl Gorman before Yorktown. / Rebel Battery only three hundred yards behind the woods." On the verso, arguably in Homer's hand, is written, "House was headquarters of French Commander at old siege of Yorktown."[95]

The lack of military action was not the only factor hampering Homer's ability to sell his work. In their zeal for audience-worthy reporting, the

Harper's Weekly editors had gone a step too far. Their issue of April 26 included two highly detailed illustrations based on sketches "by an officer of the Topographical Engineers," one showing Federal fortifications on the peninsula.[96] They were based on a technological breakthrough in perception just at that moment—*Harper's* had published illustrations that used aerial observations from a balloon. The deployment of men and machines to assemble aerial intelligence on the peninsula would forever transform both military inference and military action—in the United States and around the world. But in sharing that intelligence with *Harper's* readers, both the officer and the newspaper had made a tactical error.

Wild-eyed dreamers had proposed deploying balloons for aerial surveillance in both the Seminole and Mexican-American wars. Now the idea was gaining serious consideration. One trial in Alexandria depended on enthusiastic but inexperienced Zouaves from the 11th New York. It failed; the balloon quickly met an ignominious end atop a telegraph pole.[97] But an enterprising New Hampshire–born inventor and promoter named Thaddeus Sobieski Constantine Lowe (1832–1913) had more experience with balloons than the Zouaves did, and he knew how to sell. Styling himself "Professor," he won interest both from the secretary of war and from Lincoln himself, who mused that if intelligence from a Federal balloon had been possible at the recently lost Battle of Bull Run, "the result might have been different."[98]

Lowe won approval to build the first air corps in American military history, indeed, in military history anywhere. At first, the Balloon Corps he formed included just two drab brown balloons, but he arranged to have another six built in Philadelphia of delicate, expensive silk. Homer, the son of an inventor, sketched the largest of these: the *Intrepid*, with a capacity of 32,000 cubic feet, capable of carrying five men in its wicker basket.[99] A giant flying eagle decorates the balloon's side, clutching a portrait of Little Mac, who was a strong proponent of Lowe's corps. The general surely did not expect to see balloon-won intelligence published in *Harper's*.

Federal officials at Fortress Monroe confiscated issues of the newspaper lest they guide Confederate destruction of Federal defenses. *Harper's* was a victim of its own success, and its illustrators with it. Barlow wrote that the newspaper had "nothing of Homers in it but we regard his occupation as gone. He does not dare to go to the front having been an object of suspicion even before. He says he shall go home after the battle."[100] Barlow was

Figure 39: *Intrepid*, 1862. Graphite on straw paper, 8⅝ × 14¹³⁄₁₆ in.

brilliant, but in this case perfectly wrong. After their experience with the Federal censors, *Harper's* editors took a different approach, ideally suited to Homer and his scenes of life in camp. In the next issue, they presented a double-page illustration encompassing seven designs, including at least three by Homer and several by Alfred Waud. The "Reconnaissance in Force" drawing was the basis for one of these seven designs. A Homer drawing depicting six sharpshooters provided the basis for the illustration's lower left corner; these were members of an elite regiment that would inspire further Homer work.[101] Another Homer landscape drawing was used for the upper left corner, while Waud depicted the 61st New York assembled for worship, encircling a forest of felled trees. "Most of these pictures need no explanation, and the less said about our works the better," wrote the editors.[102]

As it turned out, neither the censors nor the editors need have worried. The Confederate focus was not on destroying Federal defenses but shoring up their own, in Richmond and points between. When McClellan finally overcame his caution and ordered the assault on Yorktown at daybreak on May 4, it was not the long-awaited battle that met his eyes, but a sight worthy of Magruder's most imaginative theatrics. An aide to McClellan despaired: "The confederates had vanished, and with them all chances of a

brilliant victory . . . [We] spent a whole month in constructing gigantic works now become useless, and now, after all this, the confederates fell back, satisfied with gaining time to prepare for the defense of Richmond, and henceforth relying on the season of heats and sickness for aid against the Federal army encamped among the marshes of Virginia."[103]

The failure was not one of military might or logistics. It was a failure of will. Even more, it was a failure of intelligence, comprising accurate perception, correct induction, and effective action. Intelligence mattered even more than will, or all the men and guns that McClellan had assembled.

From the air, Lowe had confirmed immediately the Confederate evacuation after the failure at Yorktown, and McClellan was now convinced that more extensive use of balloons was essential. Yet when he deployed the *Intrepid* at the Battle of Fair Oaks (May 31 and June 1), McClellan seems to have made little use of the insights it provided. Both sides claimed victory, yet like the other encounters of April and May, the battle was inconclusive. Neither side gained much more than casualties, 11,000 in all.

Homer may have remained on the peninsula as late as Fair Oaks, but he was itching to return to New York. He had witnessed men's deaths and their leader's myopia, and sorrowed for them all. His mother wrote to his brother Arthur, "Winslow went to the war front of Yorktown & camped out about two months. He suffered much, was without food 3 days at a time & all in camp either died or were carried away with typhoid fever— plug tobacco & coffee was the Staples . . . He came home so changed that his best friends did not know him, but is well & all right now will be home 4th of July . . . Win is not doing much just paying his expenses."[104]

3

THE FREEDOM OF ALL MANKIND
(1862–1866)

Such was the price of Winslow's reticence: sometimes even his own mother underestimated him. From his two months at the front he had gained far more than the ability to cover his expenses. The day Henrietta penned that letter to Arthur, *Harper's* published a Homer wood engraving that would set the course of his future career as an illustrator.[1] Like "The Songs of the War," published six months earlier, this composite encompasses seven scenes across the two-page centerfold of the newspaper. But unlike that illustration, "News from the War" hangs each scene from telegraph wires across the top, tightly integrating them thematically and visually. In so doing, Homer pays sly homage to the building into which he had just moved—where the telegraph had been invented—and to the power of that invention as recognized poetically by Abraham Lincoln. In the opening of his 1859 "Second Lecture on Discoveries and Inventions," the future president described the telegraph as "lightening" that "stands ready harnessed to take and bring . . . tidings in a trifle less than no time."[2]

Each panel of Homer's illustration tells a story in which news arrives, by letter, conversation, or even the sound of a bugle. In just one panel does it arrive on the printed page, whose speedy arrival accentuates the urgency of news-telling. As always, Homer starts with particularity: two very tall soldiers from the 1st Maine Infantry tower over a sketching "Special Artist" (Alfred Waud), seated on a barrel.[3] One of the lanky men was indeed six feet seven in height, as Homer records; John Ingalls Handley of the 1st Maine Infantry was the second-tallest man in the entire U.S. Army.[4] At

upper left, Homer imagines his younger brother, Arthur, on the deck of the *Kingfisher*, serving in the Gulf Blockading Squadron at Key West. At lower right, the New York *Herald* and the *Star* each tumble from the newspaper train, but of course it is *Harper's Weekly* itself that gets the most attention, as three soldiers at center (the middle one a Zouave) point to its centerfold. A soldier's wife, or widow, weeps at center, her darkened, ivy-shrouded New England room inviting the viewer into her sorrow.[5]

Homer remained in the North for nearly two years, mining the meaning of what he had seen, and relying, with so many others, on reports of varying quality. War limited the transfer of information between North and South. Each side eagerly sought out whatever news it could get—and depended on a wide network of unseen observers. In a deliberately ambiguous scene at upper right, Homer places three pairs of figures on a street corner in Richmond, the capital of the Confederacy, and asks: Which one is the spy? From which source might news from Richmond flow? The first pair in his cast of characters solicits our attention most obviously: two wounded Federal officers, perhaps let out for fresh air from Libby Prison, a food warehouse on the James River converted to an infamously disease-ridden jail.[6] The officers are two of 12,000 prisoners of war taken from McClellan's Peninsula Campaign; they are an emblem of sacrifice.[7] Over their heads, a poster crudely depicts a dashing Confederate cavalry officer atop a bucking horse. It taunts them: Will either man ever ride again? The second pair is the quietest: two southern gentlemen (one civilian, one in uniform) receding into the background, like their way of life.

The third and final pair is most intriguing. Homer often depicted women with his most creative imagination, and in this case he conjured up an entrancing contrast. In front, an affluent southern white woman approaches the Federal officers. A dog accompanies her. This ancient symbol of loyalty conjures up layers of irony on the streets of the rebel capital. Does the belle mock the soldiers as Homer mocks her? The Confederate diarist Mary Boykin Chesnut (1823–1886) clung to traditions of southern gentility and wrote that "decency and propriety will not be forgotten, and the prisoners will be treated as prisoners of war ought to be in a civilized country."[8] The actual treatment of Federal prisoners bore little resemblance to her expectations. Her counterpart, just behind her, is a Black woman with a towering basket on her head. While her appearance reflects her African heritage, her countenance belies the servitude associated in Rich-

Figure 40: After Winslow Homer, "News from the War," from *Harper's Weekly*, June 14, 1862. Wood engraving on paper, 13¼ × 20⅜ in.

mond with those origins. She is proud, alert, her eyes wide open, ears catching every whisper of news—a silent, powerful figure of entrepreneurial intelligence. She suggests the abundance and prosperity beyond reach in the blockaded South, an offering of hope whose realization depended on—among other factors—Federal victory. Might she be a source of news from Richmond to the North? She possesses a sense of agency, of freedom, greater than that of the white woman. Homer opens his narrative for the viewer to imagine the dialogue on Tobacco Row, to consider the outcome of the story he begins. As he observes, he invites his own observers to share in his engagement with what he sees, to interrogate and complete it.

The telling of such stories, replete with ambiguity, became Homer's specialty. Other illustrators, like Alfred Waud, showed the war's broad landscape: the strategies and tactics of the generals as they deployed their armies like figures on a chessboard, seen from afar, as if the viewer were seated on the balloon *Intrepid*. By contrast, Homer bore witness to the everyday drama of war: the life of the ordinary foot soldier, not the general. He sold a total of thirteen illustrations to *Harper's* that year, five of them double-page centerfolds. But the editors were slow to adopt Homer's view that ordinary people's lives were worthy of their pages. He was always willing to experiment; in his pursuit of excellence, and of a living, he would try

almost anything. He drew battle scenes for two centerfolds in awkward imitation of European academic painters; their stilted character evidences their distance from the truth of what Homer had seen with his own eyes. Homer's sketches of camp life on the peninsula weren't exalted, but they were real.

One example was the camp stores where soldiers used their meager pay to buy personal supplies. Entrepreneurs, known as sutlers, owned and managed these stores, in competition with one another on the packed peninsula. What one sutler lacked, another might offer. Their stores were hunting grounds of a kind, bloodless labyrinths in which young men might find evocative commodities, common at home but elusive here, from buttons to candles to dried beef to tin washbasins, and newspapers, of course.[9] At the sutler's tent, men also encountered one another, from a wide variety of regiments—and of ranks, geographies, and races. Homer synthesized a motley crew at the sutler's from a variety of field drawings, creating a small but focused sketch for his *Harper's* editors' approval. Nine figures inhabit the drawing, including two officers from the 3rd Pennsylvania Cavalry Regiment—each with a feathered cap and a long, showy sword. Under a hastily constructed canopy of twigs and tendrils cut from nearby trees and shrubs, seven other soldiers share the moment; one is well along in draining the bottle he has just procured. Among the figures is a slender man on the left, taken from his field sketch at Camp Benton. The same figure appeared in the "Bivouac" wood engraving of the previous year, dancing. Homer depicts the young Black man now still, observing the scene from its edge. He invites all viewers, of all races, into the scene to see what he sees, to watch as he watches.

When Homer drew on the block for the wood engraving, "Thanksgiving in Camp," he doubled his cast of characters and added a fire in the foreground and distant tents and horses in the background. He also inserted a seated figure at lower left, whose suspicious stare at the herring in his hand raises doubts about the quality of the sutler's goods.

That fall, 1862, Homer began work on six paintings based on ordinary life in and near camp. They were his first works in oil. Most, like one based on the scene of the sutler's tent, were small, about 12 by 16 inches, and focused on a pair of soldiers. The largest of the six compositions depicts two men from Company G, perhaps of the 61st New York Infantry Regiment, which Barlow commanded.[10] The soldiers listen as the musicians of

their regiment play the plaintive tune whose familiar opening words must have seemed powerfully ironic:

> *Mid pleasures and Palaces though we may roam,*
> *Be it ever so humble there's no place like home!*

Although executed in his studio based on the field sketches he had made during the Peninsula Campaign, he conceived this work, *Home, Sweet Home*—one of the first two oil paintings he ever exhibited—as an evocation of camp life more generally. The other picture he exhibited at the same time (slightly smaller but also vertical in format) is also set in camp. Entitled *The Last Goose at Yorktown*, it remains in private hands. Both pictures bear titles today that Homer himself chose with considerable care.[11] A man of few words, his titles were often as multivalent as his pictures. The subject of home lay behind all aspects of the Civil War for all those who had a stake in it: the enslaved (who had no home), the Confederates (who believed that only through secession could they retain their homes), and the Federal troops (who fought ultimately for a larger mission: a reimagined home, an America anointed by God for his purposes). In the closing lines of "I learned—at least—what Home could be," the poet Emily Dickinson (1830–1886) wrote of that awakening:

> *This seems a Home—*
> *And Home is not—*
> *But what that Place could be—*
> *Afflicts me—as a Setting Sun—*
> *Where Dawn—knows how to be—.*[12]

Homer's painting draws both on the sentiments in the song itself and on a specific incident that occurred just after Christmas 1862, and would have been well known to his New York audiences at the Annual Exhibition three months later at the National Academy of Design, then located at the Düsseldorf Gallery at 625 Broadway.

On the evening of December 30, 1862, 100,000 troops of the Army of the Potomac (including the 61st New York) were gathered on the north side

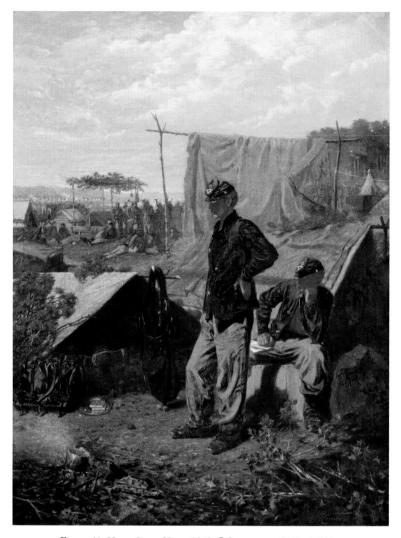

Figure 41: *Home, Sweet Home*, 1863. Oil on canvas, 21½ × 16½ in.

of the Rappahannock River not far from Fredericksburg, where they had fought an especially bloody battle little more than two weeks earlier. On the south side of the river stood 70,000 Confederate troops, one of whom (a private from South Carolina) left a vivid description of the event:

> We remained in position, ready for an attack at any moment, should [Federal troops] make an advance . . . We and the enemy were very near together, with the Rappahannock River only between us, but no

fighting going on. Just before sundown the Yankee band came down to the river bank and commenced to play. Very soon our bands were on the bank on our side. The Yankee band would play the popular airs of theirs amid much yelling and cheering; our bands would do the same with the same result. Towards the wind-up the Yankee band struck up "Yankee Doodle." Cheers were immense. When they stopped our band struck up "Dixie," and everything went wild. When they finished this, both bands, with one accord and simultaneously, struck up "Home, Sweet Home." There was not a sound from anywhere until the tune was finished and it then seemed as if everybody had gone crazy. I never saw anything to compare with it. Both sides were cheering, jumping up and throwing up hats and doing everything which tended to show enthusiasm. This lasted for at least a half hour. I do believe that had we not had the river between us that the two armies would have gone together and settled the war right there and then. I saw old weather-beaten men, naked, bare-footed, hungry, dirty and worn out, with tears streaming down their cheeks; men who were not afraid to leave their homes, their wives, their families, their *all*; but men with hearts, who could not restrain the tears when it was so vividly brought to them. Their hearts were touched then, but they were yet men who were willing to do or die.[13]

Two days later, the new year dawned, and with it the Emancipation Proclamation became effective, declaring that "all persons held as slaves within any state . . . in rebellion against the United States, shall be then, thenceforward, and forever free." The war took on a new meaning, a clarity of moral purpose. It was not only about preserving the Union. Now, at least in principle, the United States of America was committed to what Frederick Douglass had described as "the freedom of all mankind."[14] Foreign powers such as France and Britain, which had considered formal recognition of the Confederacy as a sovereign state, would never do so, in part because they recognized the moral vacuity such action would embrace. And at home, Federal soldiers—whatever their own sentiments on slavery—knew that now they fought for a principle greater than their army, and greater, even, than the Union itself.

Homer did not return to the front for nearly two years after the Peninsula Campaign. While his field sketches provided ample source material

Figure 42: *Campaign Sketches. A Pass Time. Cavalry Rest*,
1863. Lithograph, 14 × 10⅞ in.

for the oil paintings that he exhibited in 1863 and early 1864, he used them little in his production of wood engravings, of which he sold fewer and fewer over the course of the war.[15] He determined to make prints of a different kind, in partnership with a remarkable Prussian-born entrepreneur, Louis Prang (1824–1909). Homer likely met Prang during his years working for Bufford's, and they remained friends his entire adult life. Prang was many things: a lithographer, a publisher, and a bold innovator in the printing industry, including through his patronage of female artists.[16] In 1875, twelve years later, Prang would introduce Americans to a new printed product: the Christmas card. In the fall of 1863, he proposed that Homer draw on lithographic stones a series of scenes from his months on the front. Prang would sell the prints, and an illustrated title page, as a package called *Campaign Sketches*. The plan seems to have been to create a dozen plates. Homer wrote to Prang, enclosing sketches, that "if you like the style I will do twelve of them for $40," although he seems to have executed only six.[17] The sketches are similar in tone to the oil paintings Homer exhibited that year, but of course priced at a level more affordable than the roughly $60 he was then charging for his works in oil; Prang generally sold his sets of prints at 50 cents each.[18] The project provided Homer access to an emerging market of American middle-class patrons eager to own inexpensive *objets d'art*, from reproductions of European paintings to depictions of George Washington to botanical designs of the kind that Homer's mother created. Homer wrote to Prang in December that he considered the cover "very neat and the pictures look better plain than they would in color, but

why did you not get a copyright?"[19] As the Homer scholar Abigail Booth Gerdts has observed, the question was "small but telling evidence that Homer's hard-headed sense of business was operative at the earliest stages of his career."[20]

Prang and Homer must have considered the late 1863 project a success despite its modest scale; Prang launched a second set of Homer lithographs, again in a series, early in 1864. In spite of Homer's preference for monochromatic lithographs, this time they were colored, and sized similarly to playing cards. The series, in two parts of a dozen prints each, was called *Life in Camp*. The cards had a consistently more humorous character than did the *Campaign Sketches* lithographs; one is a caricatured self-portrait of Homer, as he sketched while seated on a brass cylinder (frontispiece). A telescope? A cannon? Even as he worked in a format the size of a playing card, Homer engaged his viewers with ambiguity. He titled the little print "Our Special," a term used loosely to describe the twenty or more artists on the front, most of whom were freelancers like Homer, not salaried by the illustrated newspapers publishing their work.

Four of the twelve prints in the second part of the *Life in Camp* series depict soldiers from the 5th New York Infantry Regiment, better known as the Duryee Zouaves, with whom Homer traveled during parts of his two months of 1862 attached to the vast Army of the Potomac. These Zouaves, like the Boston Tiger Fire Zouaves and many other Zouave regiments and companies, were inspired by Elmer Ellsworth's charismatic example. Ironically, Homer's link to this regiment appears to have come not via New York but Boston, and indirectly through an apologist for slavery: his family's longtime pastor, Hubbard Winslow. What Hubbard lacked in commitment to the Union, his younger brother Gordon Winslow (1805–1864) more than made up for, as the much-admired regimental chaplain to the Duryee Zouaves.[21] Gordon also served as sanitary inspector for the Army of the Potomac, within the U.S. Sanitary Commission. In this role, he was highly effective in overseeing medical care for wounded soldiers and in raising funds to purchase the countless supplies needed for their treatment.[22] Fairs organized by the U.S.S.C. were major social events and opportunities for the exhibition of a diversity of artworks from a diversity of artists, including a burgeoning group of women, and many ambitious young men—among them Homer.[23]

Gordon's son Cleveland Winslow (1836–1864) also served in the regi-

ment, as captain of its Company K. A Boston native born just three months after Homer, Cleveland had probably known him either in Boston or in New York, or both. Cleveland won his own notoriety, as a martinet and a clotheshorse. In a letter penned the following year, one of the privates in the regiment wrote, "You would think that he was some foreign count to see him rigged out for dress parade, with his big boots on up to his hams & then you see a little red of his pants, then comes a jacket (all other colonels wear long-tailed coats) then comes his red shirt, the collar turned over his coat, then his hat, a felt one, that he bought off a sutler for twenty shillings & rigged up with tassels etc. to suit himself, the last are his buckskin gloves, the cuffs reaching up to his elbows."[24]

Gordon Winslow and his son probably provided a sort of unofficial sponsorship for Homer, in parallel to Barlow, but with a variety of additional associations, from Gordon's beneficence to Cleveland's flamboyant posturing. Zouave comradeship transcended distinctions of class and even gender. A New England woman serving wounded Federal soldiers through the U.S.S.C. operations on the peninsula wrote that on her first exposure to Zouaves (likely of the 5th New York) she thought that "for an American citizen to rig himself as an Arab is demoralizing."[25] Two weeks later, she had changed her mind, finding them "kind, nimble, tender." She wrote, "I have become a convert to them after a long struggle,—their efficiency, their good sense, their gentleness are so marked. Even their dress, which I once hated, seems to take them in some sort out of the usual manners and ways of men. They have none of the dull, obstinate ways of that sex,—they are unexceptionable human beings of no sex, with the virtues of both."[26]

EXTRA RATION.

Figure 43: *Life in Camp. Part 2. Extra Ration*, 1864. Chromolithograph on off-white card, 4¹⁄₁₆ × 2⅜ in.

The four depictions of Zouaves in the *Life in Camp* series make full use of the comic possibilities their colorful

dress and gallant ambitions afforded in the midst of the drudgery and boredom of the long wait for Yorktown.

At the same time that Prang was beginning to market the series, Homer was beginning to market another work of his own: a painted, meditative depiction of a pair of Duryee's Zouaves. One soldier smokes a pipe whose bowl is carved of tough briarwood, while the other whittles a briar branch to make a bowl of his own. Such pipes were ubiquitous in camp.[27] They had even inspired a twenty-five-stanza poem published in 1861, which suggests a mysterious, romantic power that a Zouave might summon from these pipes, as he pines for his lover in the North: "*a beautiful spirit arose with the wisping smoke . . . 'I am the soul of the brier; we grew at the root of a tree / where lovers would come in the twilight, two ever, for company.'*"[28]

Another stanza reads:

> *I hear the drum and bugle, the tramp of the cow-skin boots,*
> *We are marching on our muscle, the Fire Zouave recruits!*[29]

Homer's depiction of the pair of Zouaves evokes both the possibility of an encounter with "the soul of the brier" and the long, lonely days and nights upon which such an encounter might occur. The picture also reflects a grim reality that these colorfully clad men were easy targets and paid with their lives. Some 1,100 men enlisted in the 5th New York in the spring of 1861; two years later, 250 Duryee's Zouaves remained.[30] Upon their return home, New York gave them an enthusiastic welcome; at the order of Cleveland Winslow, all wore their turbans in the parade.[31] "The attractive red breeches could be seen scattered throughout the City— everywhere the centre of attraction, the focus of ten thousand questions, the cynosure of all eyes, the envy of the men, the delight of the women. Probably no other regiment in the army is so well known."[32]

By the time that Homer exhibited the painting, in the spring of 1864, the work had a nostalgic quality to it, recalling the innocence of the war's first stage, before the regiment's colors were "worn, torn, pierced with many bullet holes."[33] He appealed to viewers' longing for such innocence and its expression in the gallant sacrifice so many men had made. While one critic lamented his "sad falling off in the study and care that went to the execution" of the picture, it was acquired by a prominent and insightful collector: the

Figure 44: *The Brierwood Pipe*, 1864. Oil on canvas, 16¾ × 14¾ in.

publisher James T. Fields (1817–1881).[34] A brilliant but short-lived writer, George Arnold (1834–1865), wrote that the picture's color ("trifle crude") ought not to distract a viewer from the more essential strengths of Homer's process. He "learned to draw with the point before he attempted color . . . Mr. Homer studies his figures from realities, in the sunshine. If you wish to see him work you must go out upon the roof, and find him painting what he sees. Not dusky, characterless, dreamy, impossible *muchachos*, but real things, instinct with life and warm with the glory of God's sunshine."[35]

Homer's connections to Boston, and to the publishing industry, probably assisted in the picture's sale. He showed it only once (at an artists' reception on the evening of March 24, 1864) and won a spot for it at the big Annual Exhibition of the National Academy of Design, which opened three weeks later.[36] Fields probably saw the picture there and acquired it

Figure 45: After unidentified artist, "Interior of Messrs. Leavitt and Delisser's Salesroom,
Broadway, New York," from *Frank Leslie's Illustrated Newspaper*,
April 5, 1856. Wood engraving on paper, 6¼ × 9¼ in.

promptly. That was not the norm. Much more often, Homer found no
buyers at such exhibitions. *Home, Sweet Home*, for example, also appeared
at the Academy's Annual and won a rave review on the front page of the
Evening Post. The unsigned critic called it "tender in its humanity to the
last degree," and wrote, "The delicacy and strength of emotion which reign
throughout this little picture are not surpassed in the whole exhibition."[37]
Nevertheless, it didn't sell. Only four years later, after Homer consigned it
to Samuel Putnam Avery (1822–1904), an influential collector and dealer,
did he make money on the picture. The process through which he sold it
was very common then: he used an auction house. The process was labori-
ous and often disappointing, and it exacted significant frictional cost. That
said, only in the 1870s did a robust gallery system begin to develop that
served contemporary artists and the collectors who wished to acquire their
work. Until then, Homer had no choice but to use the big exhibitions and
auction houses to sell his pictures.

In late February 1864, at a Brooklyn fundraising fair convened by the
U.S. Sanitary Commission so prominently associated with Gordon
Winslow, Homer exhibited a picture that, unusually for him, depicted mil-
itary action. He had already exhibited a number of other oil paintings, but

correctly or not this picture is often described as his first. That perception is attributable simply to the caption for a wood engraving *Harper's* had published in November 1862, including a phrase not printed previously in the newspaper: "From a Painting by W. Homer, Esq." However early Homer had begun his picture, it was fifteen months more before he was ready to exhibit it.

In both the illustration and the oil painting, the composition features a solitary soldier from the famed 1st Regiment, United States Sharpshooters, under the command of Colonel Hiram Berdan (1824–1893). The colonel was an expert rifle shot and successful inventor who had recruited an elite force of carefully selected, rigorously trained marksmen, and equipped them with new, rapid-action breechloading rifles. He promised them superior compensation and a distinct identity.[38] They operated as stealthy agents outside the line of battle, arousing in equal parts contempt, suspicion, and admiration. When Homer submitted the picture to the fair for its first exhibition, he purposefully titled it *Berdan Sharp-Shooter*.[39] Homer displays his usual obsessive attention to authentic detail in rendering the soldier's blue uniform, complete with leggings to keep chiggers out of his boots.[40] He also introduced an intentionally ahistorical detail. In addition

Figure 46: After Winslow Homer, "The Army of the Potomac—A Sharpshooter on Picket Duty," from *Harper's Weekly*, November 15, 1862. Wood engraving on paper, 10¹¹⁄₁₆ × 16⅛ in.

to painting denser foliage than in the illustration (and removing the hanging canteen), he removed the company designation ("A") on the soldier's forage cap. In its place (well after the illustration was published) Homer painted the bloodred diamond badge of the III Corps, 1st Division, within which Berdan's regiment was housed.[41] In the spring of 1863, soon after General Joseph Hooker (1814–1879) assumed command of the Army of the Potomac, he had instituted the system of corps badges. Hooker did so to address a military challenge of optics. To control his troops, he and his commanders needed to identify their affiliation easily. A badge contributed to a soldier's order within a complex organization. Homer would invoke the badge system repeatedly through the rest of the war.

Sharpshooters engaged in a depersonalized form of warfare; they delivered death coolly and without warning. Thirty-two years later, Homer himself wrote of the queasiness he felt about the departure from military tradition, of a fair fight on equal footing, that these soldiers represented. He wrote to a collector in Michigan (where Berdan recruited many marksmen), "I looked through one of their rifles once when they were in a peach orchard in front of Yorktown in April 1862. [Pen-and-ink drawing] This is

Figure 47: *The Sharpshooter* (*Berdan Sharp-Shooter*), 1863. Oil on canvas, 12¼ × 16½ in.

Figure 48: *Letter to George G. Briggs* (excerpt), February 19, 1896. Ink on paper, 8½ × 5⅞ in.

what I saw—I was not a soldier—but a camp follower & artist, the above impression struck me as being as near murder as anything I ever could think of in connection with the army & always had a horror of that branch of the service."[42] Homer's original title, naming Berdan's regiment, distanced himself and his own act of close and clinical observation from the marksman, and from the bloodier artistry in which he engaged. So did the letter. And yet, as the artist and critic Alexi Worth has observed, an uncomfortable commonality remains between the work of both men.[43]

Despite unprecedented bloodshed by both Rebel and Federal forces over the nearly two years since the Peninsula Campaign, the war had turned into a grinding stalemate. McClellan never did take Richmond, despite how close he got that spring. He defended the North at Antietam, Maryland, from the first of two southern invasions, and won a narrow Federal victory at high cost, with 22,717 casualties on a single day, September 17, 1862. Little Mac lost Lincoln's confidence, and his command. By the spring of 1864, McClellan was running for president, as a Democrat, on a muddled platform promising peace and compromise with the South.

In May 1863, Robert E. Lee (1807–1870), commander of the Confederate Army, won the Battle of Chancellorsville amid the dense forest north of Richmond, and then invaded the North a second and final time. His

goal was to sap northern morale, draw out southern sympathy in a region where it was plentiful, tempt French and perhaps British diplomatic recognition despite the moral force of the Emancipation Proclamation (which had become effective on January 1, 1863), and force some kind of negotiated settlement allowing southern independence. His army of some 72,000 men met nearly 94,000 Federal soldiers (now under the command of George G. Meade) at Gettysburg, Pennsylvania, on July 1–3, 1863. It proved the bloodiest battle of the entire war, with more than 51,000 casualties, but Federal forces won, due in part to the chilling aim of Berdan's Sharpshooters. Gordon Winslow won further admiration for his selfless service to the dead and dying at Gettysburg. Among the men lying on the battlefield was Homer's friend Barlow, badly wounded at Antietam and nearly dead at Gettysburg. The Confederacy entered into an almost two-year struggle to survive on its own soil.

Impressed by a series of successful battles in the western theater, on March 9, 1864, Lincoln chose as general-in-chief of all his armies a man whom he had never met: Ulysses S. Grant (1822–1885). Fewer than two months later, on May 4, the unassuming Grant began the Overland Campaign, marching his army of 102,000 men into the same tangled Wilderness of Spotsylvania where Lee had won the Battle of Chancellorsville a year earlier. Despite Grant's numerical advantage over Lee's 61,000 men, the bloody encounter that followed, concluding on May 7, was a draw. But under Grant, the Federal commanders proved their mettle. One was Barlow, now recovered and in command of the 1st Division of the II Corps as a brigadier general. Grant showed a determination his predecessors had lacked, and nearly 30,000 casualties (more than half of them Federal) did not dampen his resolve. Homer probably returned to the front in late April and witnessed both that bloody battle in the woods and two others fought just afterward on scarred fields closer to Richmond.[44]

As the smoke of gunfire lingered over the blood-sprinkled brambles, Grant ordered his troops ten miles south and east, to the small town of Spotsylvania Court House. He sought to draw Lee's army into open terrain where the sheer magnitude of Federal forces would provide an advantage he had not mustered in the forest. His overall goal was "to hammer continuously against the armed force of the enemy and his resources until by mere attrition, if in no other way, there should be nothing left to him but an equal submission with the loyal section of our common country to

the constitution and laws of the land."[45] There, over thirteen days, from May 8 to 21, he waged the first battle of modern trench warfare.

Grant then moved south of Richmond, to the strategic terminus of Petersburg, where six major wagon roads converged and five railroad lines met.[46] Confederate forces, fearful of the Federal advance up the peninsula and keen to ensure Richmond's defense, had initiated a series of fortifications of Petersburg in the summer of 1862. Although not completed until the spring of 1864, they were elaborate, including the ten-mile Dimmock Line, with fifty-five batteries separated by parapets twenty feet thick at the base and six feet wide at the top.[47] The fortifications included bomb proofs: holes within which soldiers could live (albeit miserably) in the midst of battle, protected by the piles of earth around them. At no other location Homer visited during the war did fortifications quite like this exist; a bomb proof is visible at center toward the top of his drawing *Studies of a Battlefield*. For half a mile in front of the line, the Confederate troops had felled thousands upon thousands of trees, creating clear lines of sight but a landscape of desolation.

Petersburg, like Spotsylvania, became a killing field, a place of horror. The First Battle of Petersburg, often called the Battle of Old Men and

Figure 49: *Studies of a Battlefield with Tree Stumps and Blasted Tree Trunks, Petersburg, Virginia,* c. 1864. Graphite, black crayon with touches of white chalk on tan paper, 9¼ × 13⅛ in.

Young Boys, was a failed Federal assault against the Dimmock Line, fought on a single day, June 9, 1864. The much larger Second Battle of Petersburg, fought June 15–18, resulted in more than 11,000 Federal casualties (more than five times the Rebel losses) but was inconclusive. Despite a valiant effort by Barlow, among other Federal commanders, the stalemate only deepened.

From the fragments of his scarred memory of Petersburg, and his imagination, Homer created a pregnant narrative set within the worn, ragged ranks of Confederate troops on the far side of the Dimmock Line. As with the "From Richmond" scene in "News from the War," the story in *Defiance* looks simple at first. In 1919, more than a half-century after its creation and as Civil War memories were fading, the picture acquired an apt subtitle: *Inviting a Shot at Petersburg in 1864*.[48] Homer appears to focus on a single protagonist: a Confederate ruffian who taunts Federal fire, dancing atop an earthen breastwork. The temporary parapet is similar to those that Federal forces would blow up in a powerful explosion under Rebel troops, leaving a vast crater.[49] The daring strategy to tunnel under Rebel troops failed, as it led to a horrendous counterattack on Federal troops unable to exit the crater they themselves had formed. The siege of Petersburg over the following year proved a bloody stalemate infamous in both North and South. While the picture has the quality of an eyewitness account, Homer had left Petersburg six weeks before the Battle of the Crater. He likely composed it in his studio in the fall of 1864 based on field drawings he had made in the spring, and with the full knowledge of the tragic, useless carnage for which the crater became an emblem. The plentiful smoke at right seems a harbinger of the explosion to come.

The daredevil is the most visible figure, but he is hardly alone; dozens of rebel soldiers in ratty uniforms hide in the trench. Among those hidden is another figure, not a soldier but a Black musician similar in age to the taunting rebel.[50] As with the strong, silent Black fruit vendor on the Richmond street, this man possesses multiple identities. Homer's placement gives him multiple purposes. Inviting the viewer's inquiry, the man keeps time for the soldier's dance, accompanying him with words and music on a banjo. Homer has caricatured this figure baldly enough to suggest he is ridiculing such then-common racist devices. As one scholar has observed, the ostensibly "witless entertainer" in fact "serves to cement the painting's topicality rather than its slander."[51] After all, the longer the Black man

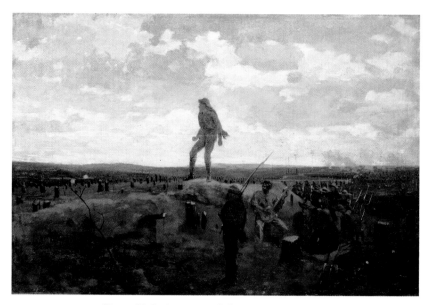

Figure 50: *Defiance*, 1864. Oil on canvas, 12 × 18 in.

sings, the more likely it is that, in the midst of his dance, the white man will die. The Black man commands the rhythm and sets the melody and lyrics to which the white man dances—inverting their prescribed roles. Yet again, Homer begins a story and invites his viewers to complete it. Will the dance end in death? Will the banjo player, like other troubadours, use his role to undermine those with power over him? What words will he choose for his own declaration?

The war continued for some nine months after the Crater, as each side tried to grind down the other, day after day. Homer returned to New York from this third stay at the front by late June 1864, probably stopping on the way at Philadelphia's Great Central Fair for the benefit of the U.S. Sanitary Commission. He had contributed a picture to the exhibition; a better reason to see the fair would have been to view the work of other artists he admired, including two pictures by George Inness (1825–1894), whose meditational landscapes he had seen at the Brooklyn fair mounted four months earlier for the U.S.S.C.[52] Homer was in Belmont by the nation's birthday on July 4 and began to make oil paintings depicting children on the home front, usually boys. The subject was a favorite of genre painters and provided a respite—for painter and viewers alike—from the

LEFT: Figure 51: *On Guard*, 1864. Oil on canvas, 12¼ × 9⅜ in.

RIGHT: Figure 52: *The Birch Swing* or *Children Playing in a Tree*, 1864.
Oil on canvas, 16⅜ × 12⅜ in.

horror of war. But the boys Homer depicts carry a more heightened sense of mortality than do those that other painters depicted. These sons are at play but bonded to the memories of their distant fathers—many of whom would never return. In one of these pictures, the boys tempt danger as they scurry out on a flimsy birch branch. Homer purposefully evades description of the ground to which one or both may fall. The viewer hangs, too: on the ambiguity the painter offers.

That summer both the saintly Gordon Winslow and his flamboyant son Cleveland, now a colonel, died. After the mustering out of Duryee's Zouaves, the zealous martinet recruited a second Zouave regiment under his command. During the Overland Campaign, he suffered a severe wound to his left shoulder. His father accompanied the colonel onto a steamship bound for a hospital in Alexandria where he would die weeks later. Tragically, Gordon never made it to the hospital; he fell overboard on the Potomac. His body was never found.

Barlow's wife, Arabella, could have remained in the safety of New York.

She did not, choosing instead to labor on behalf of Federal soldiers laid up in U.S. Sanitary Commission hospitals near the front lines, for which Gordon Winslow had worked so hard. At one of them she contracted typhus and died in July while her husband commanded his troops in the siege of Petersburg. He took a convalescent leave to mourn her death and recover from his own wounds, of body and spirit. In France he found new life; after the war he married the sister of another Bostonian war hero, Robert Gould Shaw (1837–1863), whom Augustus Saint-Gaudens (1848–1907) would later memorialize on Boston Common.

As the siege dragged on, the Alabamian waters Homer's family knew so well became the scene of a dramatic inflection in the war. In the summer of 1864, Rear Admiral David G. Farragut (1801–1870) of the United States Navy set his sights on control of Mobile Bay, the last major port in the Gulf of Mexico serving the states east of the Mississippi River. Over three weeks of overpowering force against Confederate mines and gunboats, Farragut won that control, and with it the muscle to blockade the principal rebellious states. His victory mattered in another way: it strengthened Lincoln's case for a second term in the presidential election of November 8, 1864— against General George McClellan, now running as the Democratic candidate. His party (although not Little Mac himself) advocated cessation of the war and a negotiated peace with the Confederacy. The success in Mobile Bay turned the tide in favor of Lincoln, who won the election handily; the electoral college votes of just three states went to Little Mac.

In March 1865 it became clear that at last the siege of Petersburg had succeeded; Richmond would soon be in Federal hands. Homer made a journey to see with his own eyes the place at which the war was to be won. On March 28 he sketched a pair of scouts sent by General Philip Sheridan (1831–1888), disguised as Confederate soldiers. He must have had some sort of special clearance, although no evidence of it has survived. That week, he was at a railroad station in City Point, Virginia, a small port at the confluence of the James and Appomattox rivers. There Homer witnessed a meeting between Grant and Lincoln. Homer made a hurried sketch of the tall, top-hatted president as he held the hand of his young son, Tad, and stood next to Grant, who was chomping on a cigar.[53]

Fewer than two weeks later, on April 9, Lee surrendered at Appomattox. He refused Grant's request that he influence other Confederate commanders to follow his lead; the president of the Confederacy, Jefferson Davis, would not surrender until captured, on the run in Georgia, a full month later. Lincoln was assassinated on April 14 and was succeeded by Andrew Johnson, who was both inept and opposed to granting equal rights to Black people. The nation went into a deep economic depression as families sought to make sense of the ordeal in which no one was untouched.

As his production for *Harper's* declined, Homer sold illustrations to other newspapers, too. In one, for *Harper's* competitor *Frank Leslie's Illustrated Newspaper*, he depicted a young Civil War veteran hanging up his musket. The young man and his wife startled to see middle-aged faces staring back at them in the mirror. They are the veteran's parents, present yet unseen by us—except in reflection.[54] In a daring gesture, Homer al-

Figure 53: After Winslow Homer, "Thanksgiving Day—Hanging Up the Musket," from *Frank Leslie's Illustrated Newspaper*, December 23, 1865. Wood engraving, 16 × 11 in.

ludes to the laceration of this war and the recognition it engendered that former generations had suffered, too, the weight of death and loss.

On the strength of the paintings he had begun to show in 1863, Homer was elected in 1865 both to full academician status at the National Academy of Design and as a member of the Century Association, an elite New York club including many artists and art collectors.[55] These new communities offered companionship, encouragement, and the beginnings of the recognition he long had sought.

In the spring of 1866, a year after the war was won, Homer completed another picture set in the same brutalized landscape at Petersburg that he had depicted in *Defiance*. Unlike that picture with its deceptively sketch-like appearance, *Prisoners from the Front* is large, obviously complex with multiple carefully developed figures, including a sober Federal officer and three Confederate prisoners. Although Homer created the painting in his studio out of his imagination, he included several details from his field drawings as if to suggest that this is an eyewitness account of a specific incident. They include the cap of the soldier guarding the Rebels (revealing him as from the 61st New York), the red trefoil on the white flag of the 1st Division of the II Corps, and the features of the officer himself (similar to those of Frank Barlow). Homer probably used models in his New York

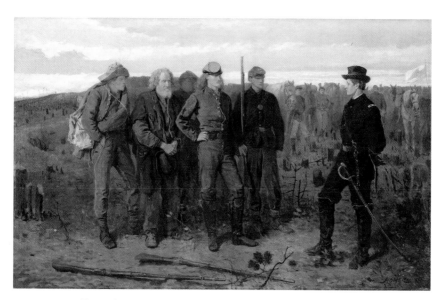

Figure 54: *Prisoners from the Front*, 1866. Oil on canvas, 24 × 38 in.

studio (and possibly manikins) for all three Confederate figures and for the stiff Federal officer. He also deployed a precise compositional structure for the picture of six columns and four rows. The system forms twenty-four squares; as a whole, the picture is based almost exactly on the golden ratio beloved by all sorts of artists since the days of Euclid.[56] The 24-by-38-inch format would become his standard. It expressed just the kind of underlying order he had learned in his first months in New York—from Cummings at the National Academy drawing classes and from Page at the Athenaeum Club. It also expressed an order promising peace amid the carnage he had witnessed.

Some 620,000 of his countrymen had died in the war, and Homer and many others were seeking to make sense of it. He centers this acclaimed picture not on the quiet commander in blue but on the dashing Confederate cavalier—in fact on his groin, where his trousers, like his jacket, are slightly unbuttoned. As in a Shakespearean tragedy, well-aimed humor deepens the meaning. Homer seconds Sumner's 1856 accusation: southern character embodies not chivalry but racial and sexual domination enacted by violence and swagger. Homer also updates that accusation, referencing the Protestant revival then sweeping across the Confederate armies.[57] The black cross on the cavalier's arm reflects Homer's deep skepticism about

Figure 55: *Prisoners from the Front*, 1866. Oil on canvas, 24 × 38 in. (scored)

the false faith that condoned such a poisonously misbegotten machismo.[58] The two rifles laid down in the foreground, amid the underbrush now growing back along the Dimmock Line, may suggest reconciliation, but each of the three prisoners appears resentful to the point of disrespect, simmering with suspicion. And the ruffian from *Defiance* appears again, at left, dressed identically. This time, four bullet holes appear in his hat, again a characteristically wry note. At least in Homer's imagination, he has survived his dance with death. But the viewer must ask: What awaits him now? What awaits any of these men?

Critics and collectors alike loved the painting, in part because they could read it as a resolution of the conflict; one writer called it "by far the best painting of its class yet given us by any American artist."[59] His friend, the artist and critic Eugene Benson, wrote, "Mr. Homer shows us the North and South confronting each other; and looking at *his* facts, it is very easy to know why the South gave way. The basis of its resistance was ignorance, typified in the 'poor white,' its front was audacity and bluster, represented by the young Virginian—two very poor things to confront the quiet, reserved, intelligent, slow, sure North, represented by the prosaic face and firm figure and unmoved look of the Federal officer."[60] For nearly a decade, Homer's new work would be compared to this picture and found deficient.

Homer exhibited the picture with its pair: a work of exactly the same size, provoking the same questions in its own way. His setting is another field, but without evidence of its history, or indeed its location. He includes two figures, boys too young to have fought in the war. The boys, perhaps brothers, labor in the field, because their father, dead or injured, cannot. Their horse is battle worn, surplus from the U.S. Army, with a brand "U.S." once visible on its flank. The improvised device it drags, made mostly of brush, is called a harrow. The word, uncommon today, was then rich in agricultural, theological, and philosophical meaning. Harrowing is an act of promise, almost—but not yet—fulfilled. Only after the soil is plowed can it be harrowed. Then, only after it is harrowed, can it be seeded—just as Christ's resurrection awaited first his harrowing of Hell. The barefoot boys anticipate a future they cannot see, but for which they prepare. *The Brush Harrow* received little of the admiration that *Prisoners* received; its subtlety denied the possibility of jingoistic interpretation. Yet it speaks powerfully of the charged, layered emotions of the country: sorrow, hope, longing, and lingering doubt.

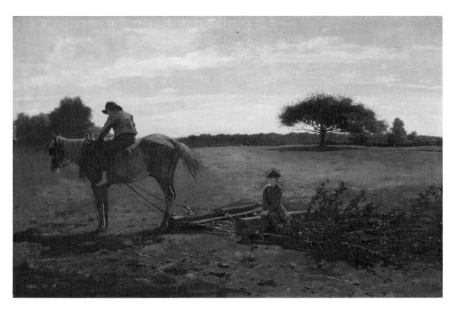

Figure 56: *The Brush Harrow*, 1865. Oil on canvas, 24⅛ × 38⅛ in.

The day after the National Academy of Design Annual opened, Homer used its prominence to market three other paintings he had developed—each smaller than the pair on the walls of the academy's grand new Venetian neo-Gothic confection on Madison Square. One of these focused on a thoughtful young woman in late July 1864, at the threshold of a simple shack.[61] The painting's title—*Near Andersonville*—locates the shack. That title, which the art historian Marc Simpson recovered only in the 1980s, also reflects the infamy associated with the Confederate prison of that name in Sumter County, Georgia, within which many Federal soldiers had died in horrific, disease-ridden conditions. One of them was another painter, John S. Jameson (1842–1864), whom Homer may have known; they shared musical and artistic interests and a common social network including several strands in Hartford, Jameson's native city.[62] Another prisoner of war at Andersonville, Warren Lee Goss (1835–1925), may also have known Homer, as they subsequently collaborated on a pair of Civil War articles. He published an exposé of Andersonville in 1867, the year after Homer exhibited his painting. In some ways the picture is another chapter in the story hinted at in the "From Richmond" panel in "News from the War." Again, Homer depicts a strong, proud young Black woman, well dressed and standing in silent witness within a geography Homer had not seen, but vividly imagined. In this case, however,

her crossroads is also that of the country within which she is now a citizen, albeit one unacknowledged by her fellow white citizens. Her sorrow suggests the death awaiting the Federal prisoners she glimpses at upper left, under the Confederate flag to which they have surrendered. The open question, as Wood has observed, is what fate awaits her? In his understated way, Homer blazes a new path. Never before had an American painter placed an appealing Black woman at center, alone, the vessel of hope for her country. The scarf tied and knotted to resemble a Phrygian cap reflects the power of that hope in the wake of the American carnage. Homer also makes a sly reference to the mudsill theory, invented in 1858 by South Carolina's senator James Hammond (1807–1864), positing that slavery conformed to natural law.[63] Lincoln opposed it vehemently; the two layers of boardwalk at her feet proclaim her as a living witness to its falsehood.

Figure 57: *Near Andersonville*, 1866. Oil on canvas, 23 × 18 in.

Homer also renewed his work as an illustrator. In the summer of 1865, he journeyed to the seaside resort of Newport, Rhode Island, where he stayed with his friend John La Farge (1835–1910). Among those in La Farge's circle were two brothers originally from Albany, who, like La Farge, had lived extensively in Europe. Both were gifted and ambitious artists, though their dexterity with the pen exceeded that with the brush. Their names were William (1842–1910) and Henry James (1843–1916). Homer saw Henry, not William, that summer. William was then in Brazil, or, as he put it in a letter to Henry, the "Original Seat of the Garden of Eden."[64] Both brothers would remain in Homer's orbit, however, and Henry, who was among other things an art critic, would later write a penetrating analysis of Homer's work.

Homer may also have visited a writer who had lived near him during his childhood in Cambridge and then served as a Unitarian minister in Newburyport and Worcester. He was Thomas Wentworth Higginson, a distant cousin of Charlie Homer's classmate Henry Lee Higginson. In May 1854, the minister had led a group of ardent abolitionists into the Boston courthouse where Anthony Burns awaited trial, with the intent of rescuing him. The cost of the attempt was still visible on Higginson's face—as it was on that of his cousin—despite the rescue's failure. "A sabre cut across the chin, and other marks, attested the rough reception he had encountered within the walls."[65] Asa O. Butman, who had entrapped Burns, rode out to Worcester later in the year to kidnap the minister—and was run out of town. Thomas Higginson served as a colonel in the Civil War, commanding a Federal regiment composed of formerly enslaved men from South Carolina and Florida. Now, with the Civil War ended, he was vindicated. Higginson would go on to an illustrious career, not least as co-editor of the first two collections of poetry by another Massachusetts native, Emily Dickinson.

The illustrations that resulted from Homer's time in Newport are evocative, one especially so. It depicts a Federal officer who has mustered out. Now, other than his forage cap, he wears civilian dress. He has lost an arm and depends on the ability of the woman beside him—whether his wife, sister, or fiancée—to direct the carriage. The man's frozen stare may suggest that he is suffering from post-traumatic stress disorder, a malady that physicians were struggling to address.[66] The accompanying short story in

Harper's Weekly recounts that the veteran "did not even wish to live," but it ends (perhaps too neatly assuaging its readers' empathies) by describing a marriage in which his wife "is only his left hand, and he, the husband, drives."[67] Homer's tight composition and his location of the scene at a place known as a destination for the wealthy to find their summer pleasures lends it particular pathos.

Figure 58: After Winslow Homer, "Our Watering Places—The Empty Sleeve at Newport," from *Harper's Weekly*, August 26, 1865. Wood engraving on paper, 9⅛ × 13¾ in.

Through war, Homer had begun to address the core questions of the American story and how that story was shaping each of his countrymen. To pursue these questions further, the James brothers and La Farge assured him that, paradoxically, he had to leave his native soil. Only by going abroad would he gain the perspective he needed on his own country. The acclaim that greeted *Prisoners* gave him the opportunity for which he had been waiting so long. The Exposition Universelle would open in Paris in April 1867, and it would include his acclaimed work.

An auctioneer contracted to sell "the entire collection of our distinguished artists Winslow Homer and Eugene Benson, who are about leaving for Europe."[68] The two friends, Benson and Homer, appeared to be heading down

a well-worn path: to Paris, where dozens, if not hundreds, of other Americans had studied painting, sculpture, and architecture under the watchful eyes of French academic practitioners. Now millions of others would be in Paris, too, among the dazzled throngs at the Exposition Universelle.

As a child, Homer had gazed from Boston wharves at ships from around the world. Early on the morning of December 5, 1866, aged thirty, he stepped onto another Boston wharf and for the first time boarded one of those ships, the Royal Mail steamship *Africa*.[69] He had set his sights on another continent: Europe.

4

THE PROOF OF A POET
(1866–1867)

THE *AFRICA*'S ITINERARY did not include any ports on the Continent. The ship sailed first to Halifax, Nova Scotia, picking up cargo and a few passengers. Then she sailed on across the Atlantic, to Liverpool, in the heart of a region of England more industrialized than any other on earth, with mills producing vast quantities of manufactured goods—and vast new entrepreneurial wealth. The bustling country must have made a startling contrast for Homer with the United States, then mired in a deep depression. This region of England provided the model for Lawrence, Massachusetts, and other mill cities around Boston. In fact, the design of Lawrence's Pacific Mills (employer of Homer's brother Charlie) closely copied blueprints from English textile mills. So did the designs of many other American textile mills. Few intellectual property laws existed then, and entrepreneurs of the era observed them loosely.

Liverpool was not on the way to France; Homer could have sailed to France directly from New York.[1] Most observers—such as Albert Warren Kelsey (1840–1921), whom Homer had known in Belmont—might think he cared principally about getting to Paris, the art capital of the world.[2] But Homer shunned many a well-worn path. He remained in England for what may have been nearly two months.[3]

There was an abundance of art, architecture, and invention of all kinds to be examined in England, starting in Liverpool itself. The William Brown Library and Museum had opened six years earlier, and exhibited a small but diverse collection of plaster casts of antique sculpture, Old Master

paintings, and work by living English artists such as John Everett Millais (1829–1896), and by those of recent memory, such as Joseph Mallord William Turner (1775–1851) and John Constable (1776–1837). But of course London was where Homer would find Britain's greatest concentration of population, political and economic power, antiquities, and art.[4] Among the most essential destinations for any visitor to London was the South Kensington Museum (now the Victoria and Albert). To the entire breadth of humanity—"the young and the adult, the humble and the lofty"—the museum offered a riveting array of objects.[5] Its purpose was to diffuse "a greater knowledge of and love for Art," and therefore widespread practical application of the arts in industry and in the daily life of as many men, women, and children as might beat a path to its doors.[6] The museum's first director called it "a refuge for destitute collections" and declared his intention that "the evening opening of public museums may furnish a powerful antidote to the gin palace."[7] The panoply of treasures ranged from a Donatello marble relief, to contemporary photography (first collected in 1856), to Constable oil sketches, to watercolors by living artists such as the visionary Samuel Palmer (1805–1881), to stained glass, ceramic objects, and other works of contemporary British decorative art.

Just a year earlier, the rarest treasure of all had arrived at the museum from Hampton Court Palace. In her husband's memory, Queen Victoria lent the South Kensington the cartoons Pope Leo X had commissioned for tapestries depicting the lives of Saints Peter and Paul, by the great Italian Renaissance artist Raphael (1483–1520). Enormous in scale, delicate in color, inventive in composition, and compelling in narrative, these seven drawings alone justified an artist's three-thousand-mile journey. Within them Homer saw the stories of the lives of Saint Peter and Saint Paul, from *The Miraculous Draught of Fishes* to *Paul Preaching at Athens*. His attention to these monumental drawings would bear fruit in his art and illustrations over the following two decades.

By the 1860s, the National Gallery's collection had long since outgrown its galleries, so its British paintings were hanging in the South Kensington Museum as well. It was an extended "temporary" arrangement that foreshadowed the 1897 creation of the Tate Gallery.[8] There, Homer surely would have admired Constable's *The Valley Farm* (1835).[9] But most of all, he would have stood in awe before some of the thousands of works that, ten years earlier, Turner had given his country in a massive bequest.

Among the greatest of these paintings were *Calais Pier* (1803), *The Fighting Temeraire* (1839), *Rain, Steam and Speed—The Great Western Railway* (1844), and a homage to a Greek inspiration for both painters: *Ulysses Deriding Polyphemus—Homer's Odyssey* (1829). These pictures would prove essential touchstones for the young American over the next five decades.

Constable and Turner were both Romantic painters in a way the blunt American, pragmatist to his core, was not. But in their work they achieved two things Homer envied—and sought to emulate. First, they set a standard for the sheer monumentality of their accomplishments: definitive statements of each man's artistic ambitions and their power in executing those ambitions. Second, they had created work that their countrymen agreed was definitive of their national identity. This was most obvious in the archetypal English landscapes of Constable, who never left his native land. But the well-traveled Turner was no less pivotal to English culture—born as he was on April 23, 1775, the patronal feast day of St. George and the celebrated date of William Shakespeare's birth. In his prodigious, searing, eccentric accomplishments and his brash salesmanship, Turner claimed kinship to his nation's greatest forebears. And he claimed, too, a principle close to Homer's heart: art, as well as words, can be central to England's patrimony.

Homer had seen Turner's landscapes in New York and knew his pictures to be utterly unlike the work of Lane, Bradford, and other American marine painters. By then only one Turner oil painting had crossed the Atlantic to the United States; it belonged to Marshall Owen Roberts (1813–1880), who had lent it to the 1864 Artists' Fund Society exhibition.[10] A few Turner watercolors had made the transatlantic journey, too. The landscapist John Kensett had acquired one from a foresighted Baptist minister from Albany, Elias Lyman Magoon (1810–1886), who had been an early, avid, and generous collector of Turner's work. Kensett lent the sheet to the same 1866 Artists' Fund Society exhibition at which Whistler had exhibited. The author, critic, and teacher Charles Eliot Norton (1827–1908) also exhibited a Turner watercolor from his collection.[11] Homer may also have seen three Turner watercolors at Philadelphia's June 1864 fair in support of the U.S. Sanitary Commission.[12] Seeing more of Turner's work on Turner's turf must have been a high priority for Winslow, and one he had recognized prior to leaving the United States.

Two miles east of the South Kensington Museum, the National Gal-

Figure 59: J. M. W. Turner, *Rain, Steam, and Speed—The Great Western Railway*, 1844.
Oil on canvas, 36 × 48 in.

lery's eight-columned portico beckoned visitors into spacious rooms filled with Renaissance and Baroque masterpieces. Many of the gallery's greatest attractions today were already hanging then on the warm, damask-lined walls, from the gracious, colossal Paolo Veronese painting *The Family of Darius Before Alexander* (1565–1567), to Caravaggio's startling *Supper at Emmaus* (1601), to Rembrandt's testamentary *Self-Portrait at the Age of 63* (1669). Rubens's late, great *An Autumn Landscape with a View of Het Steen in the Early Morning* (c. 1636) would have commanded Homer's special attention, as it reflects the painter's deep, grateful observation of the verdant landscape around his home as expressions of a flourishing life on the edge of twilight.

Likewise, Homer probably visited the British Museum, with its broad and deep collections, from Renaissance drawings to Egyptian granite heads to masterpieces of Greek classical sculpture. His boundless curiosity would have found plentiful outlets in the galleries hosting such diverse bounty across time and space.

London was awash in watercolor exhibitions. Homer did not need to

walk far to find inspiration in the medium. At 53 Pall Mall, the Institute of Painters in Water-Colours hosted a major show of its sixty-five members, one of whom, Aaron Edwin Penley (1806–1870), was a particularly eloquent spokesman for watercolor and its applicability to plein-air practice.[13]

At his Haymarket gallery, Thomas McLean hosted a smaller but "exceedingly choice collection" of watercolors, an annual event for which he was known.[14] The exhibitors included the marine specialist Edward Duncan (1803–1882) and his contemporary John Frederick Tayler (1802–1889), who was not only a versatile watercolorist but also a living link to greatness, since he had shared a studio as a young man with the legendary Richard Parkes Bonington (1802–1828).[15]

Another McLean's artist was well represented at the nearby Fifth Winter Exhibition of the Society of Painters in Water-Colours: George Arthur Fripp (1813–1896), a master of dramatic landscapes in Britain and the Continent. One reviewer praised his technique as "drawings transparent in colour, clear in atmosphere, simple and pleasing in composition. Specially happy is this artist in the hayfield, and fortunate would be the farmer who could command the weather Mr. Fripp paints—hay then would without fail be made while the sun shines."[16]

Four hundred eighteen sheets crammed into the show, from a wide range of painters including Palmer, the short-lived prodigy Frederick Walker (1840–1875), and the Pre-Raphaelite George Price Boyce (1826–1897). The history painter John Gilbert (1817–1891) and the Romantic landscapist Paul Jacob Naftel (1817–1891) won particular praise. One reviewer wrote that Gilbert's "facility of hand and fertility of pencil are exhaustless. Want of completeness in individual figures is covered under a crowd, and delicacy finds a substitute in grandiose swell of proportion."[17] The same critic wrote, "The fire which glows in Mr. Naftel's drawings has been kindled by the sun of autumn, and no moon, or other chaste goddess, mitigates the furnace heat. Yet is the artist vivacious and brilliant."[18]

Homer had been making watercolors since childhood and chose the medium for his first exhibited work at the National Academy of Design in 1859. But in London he saw the vivid embrace of the medium by serious artists who won serious patronage and attention from critics. These two impressive exhibitions, running concurrently, validated the sentiments of Winslow's few countrymen who believed that watercolor had a bright future in the United States as well.

Oil paintings' vitality in Britain was in full evidence as well. That winter, the French Gallery at 120 Pall Mall mounted its Fourteenth Annual Winter Exhibition. Thirty or more painters were represented, almost all British, among them George Frederic Watts (1817–1904); John Linnell (1792–1882), who had been an indispensable friend and patron to William Blake (1757–1827); and Ford Madox Brown (1821–1893).[19]

The star of the exhibition, however, was not British, and his picture was a late addition to the exhibition.[20] He was another American—in fact, born just twenty months before Homer, and in Lowell, a mill town fewer than thirty miles from Boston. Homer had seen one of his oil paintings, *Wapping*, at the Artists' Fund Society exhibition just as he was packing up his life in New York; it may have sparked his curiosity to see more.[21] Despite their similar age and roots, James McNeill Whistler (1834–1903) and Homer were remarkably different men. Whistler was a publicity hound; Homer intensely private. Whistler was profligate; Homer frugal. Whistler was sophisticated, returning to London, where he'd lived previously, after spending most of 1866 in Valparaiso, Chile; Homer in many ways was provincial, now on his first trip outside the United States. Characteristically, over the final three days of Whistler's voyage back to England, on three separate occasions he initiated a fistfight, including one in which he peppered his slugs with racist slurs against a fellow passenger, probably from Haiti.[22] By contrast, Homer was both an unlikely pugilist and unusually empathetic to Blacks. Moreover, Whistler was unabashed in expressing his prodigious sexuality, as was his mistress Joanna Hiffernan. While Whistler was in Chile, Gustave Courbet (1819–1877) was painting Joanna, nude and in graphic detail in his *Origin of the World*.

Dante Gabriel Rossetti (1828–1882) described Whistler by limerick:

There's a combative Artist named Whistler
Who is, like his own hog-hairs, a bristler:
A tube of white lead
And a punch on the head
Offer varied attractions to Whistler.[23]

However contemptible a man Whistler was, he could paint like a demon. One reviewer who attended the French Gallery's exhibition wrote that in Whistler's gray seascapes depicting Valparaiso at dusk he "has

Figure 60: James McNeill Whistler, *Crepuscule in Flesh Colour and Green: Valparaiso*, 1866. Oil on canvas, 23 × 29¾ in.

succeeded to admiration in giving an aspect of sleepy motion to the vessels, and, by what are apparently the simplest but really the subtlest means of execution, conveyed to the spectator the rolling, seemingly breathing, surface of the sea with a power that is magical."[24]

The moral call of art rang out from another native of Massachusetts at 13–14 Pall Mall East, where Colnaghi's hosted work by the sculptress Harriet Hosmer (1830–1908). She had received a commission from the Western Sanitary Commission to design a memorial to Abraham Lincoln. The original intention was that women and emancipated slaves entirely fund the memorial, so the design was known as the Freedmen's Memorial. However, the project's scope expanded at a rapid pace; the presentation watercolor she exhibited in London was for a sixty-foot-high granite-and-bronze monument to be placed on the grounds of the U.S. Capitol, intended to incorporate nine colossal figures. The ambitious plan was "decidedly and emphatically" a tribute both to Lincoln and to America's Black men, women, and children: a glorious salute to freedom.[25] The commissioner ultimately scuttled Hosmer's work; a sculptor named Thomas

Ball completed a smaller, sanitized bronze standing figure of Lincoln instead.[26]

Homer left no trail revealing details of his itinerary in England, although there were plenty of Anglo-American friends who could guide him, from the Waud brothers to Damoreau to Hennessy. He seems to have timed his migration across the Channel to coincide with Benson's arrival in Paris.[27] By the end of February—and possibly the end of January—both men were in the city.[28]

A vast crowd was on its way to Paris, a cloud of glitter above and around it. "Paris is not impressive, like London; it is exhilarating," Benson wrote.[29] "The fever of luxury and the thirst for pleasure are breathed in the very air."[30] Homer left no letters reflecting his impressions, but Benson more than made up for him in his distinctively pungent and disparaging published remarks. Benson was a fierce champion of the American ideal; his brilliant essays are also a window into the views of his friend Homer. "Abraham Lincoln and Henry Ward Beecher are the two men representative of America, of democracy, of the human as distinguished from the mere intellectual of the modern spirit. But Lincoln was not, and Beecher is not, corrective; they are expressive of ourselves. Lincoln represented the patience and kindliness (the one a great, the other a sympathetic quality), Beecher, the energy and hope, of democracy and the people."[31] By contrast, in Paris, "voluptuousness and death embrace each other to destroy life."[32]

The imperial government of France intended its Exposition Universelle not only as a statement to the other countries of the world of its greatness.[33] The Expo was a statement to the people of France of the power of the state, whose history was undeniably tumultuous. The government then banned the singing of "La Marseillaise" lest the anthem remind the French people of their ability to overthrow their rulers—which they would do four years later in the Paris Commune of 1871. "The Empire says: Be licentious and make a grace of immorality, but do not discuss, and do not ask questions of the State," Benson wrote. "The world of amusements in Paris is a substitute for political freedom. Here the passions are unbridled and vice has perfect liberty, for both prevent too much reflection."[34]

The fourth-ever world's exposition opened on the Champs de Mars on April 1, 1867.[35] Five years in the planning, the Exposition was by far the largest yet, with an estimated 15 million visitors, three times that of the previous French fair in 1855. The Expo included exhibits from forty-two

countries; some, such as Japan and Siam, were considered particularly exotic to Western visitors. Exhibits featured all kinds of things: folk costumes, archaeological artifacts, plant material, and animals. Many came to gawk at the technological marvels on display, several of them invented that very year. A French blacksmith, Pierre Michaux, was marketing one of these, which he preferred to call the Michauline. Others called it the Boneshaker; despite that moniker, it sparked a craze in Paris and around the world: it was the first modern bicycle. Homer, son and brother of inventors, must have been impressed. He would later depict the bicycle several times, albeit with diffidence, as a symbol of both progress and its downside: risk. His friend Benson counseled him, and his readers, toward caution about Paris and the innovations it displayed. The city, he wrote, is "for the desperate who wish to sit once at the festival of life, drink once and die. In Paris, if you would escape defilement, you should shut your eyes on the present and open them only on the past in museums, in galleries, in cathedrals, where the best part of the great world of art admonishes you and elevates your soul."[36]

Homer visited the museums, galleries, and churches of Paris, but left few documents memorializing those visits. One is a wood engraving prominently depicting three women painting in the Grande Galerie of the Louvre. A large number of other painters and lookers-on (mostly male)

Figure 61: After Winslow Homer, "Art-Students and Copyists in the Louvre Gallery, Paris," from *Harper's Weekly*, January 11, 1868. Wood engraving on paper, 9¹⁄₁₆ × 13¾ in.

litter the gallery. Over his dozen years in Paris, the Bostonian painter William Morris Hunt had formed close ties with Millet, Thomas Couture (1815–1879), and Édouard Manet (1832–1883), among others. Cole and other Bostonians in Homer's circle probably did as well. But Homer himself leaves no evidence of his interacting directly with the most advanced painters then living in the city or on its outskirts.[37]

The Expo itself, of course, had much art on display, from twenty-nine countries. Each country organized its own contributions, from those living artists considered most exemplary of its artistic excellence. The French works were the most numerous, with 625 paintings and more than 400 sculptures, prints, and architectural models. The committee for the United States focused its seventy-five principal entries primarily on landscape painting. Although Boston's Hunt had the most pictures of any (six), most of the artists represented were New York–based. They included six men close to Homer: Sanford Robinson Gifford (1823–1880), Eastman Johnson, John Frederick Kensett, John La Farge, Jervis McEntee (1828–1891), and John Ferguson Weir (1841–1926). Weir would go on to become the founding dean of the Yale School of Art. The best-known painters in the American pavilion were Albert Bierstadt (1830–1902), Frederic Edwin Church (1826–1900), Asher B. Durand (1796–1886), and, of course, Hunt (perhaps the most admired painter in the United States). In general, the entries conformed to the norms of the Hudson River School. These pictures were polished, uncontroversial, and designed to impress viewers with the majesty of American vistas. An example was Church's *Niagara* (1857), which won great admiration.

There were exceptions to the rule. Homer's own entries did not conform to the landscape norm. One was *Prisoners from the Front* (1866); the other was *The Bright Side* (1865), a depiction of five Black men in a Civil War camp. As in *Prisoners*, *The Bright Side* is based on a careful geometric composition; here Homer also includes on the side of a tent a rectangle with the approximate dimensions of the golden ratio, and hints further at the power of geometry by drawing a cross at its center. In a wood engraving Aldrich described as "copied by the artist from the original painting," Homer accentuated that cross—and omitted both the barrel at lower right and the most conspicuous figure, who observes the viewer from within the tent. Homer based the general composition of the painting on a wood

engraving for which the French painter Millet had supplied the design. He had admired Millet's work in Boston and New York, and it would prove even more important to him over the period of his residence in France. But Homer makes his nod to contemporary French painting within the context of his scrutiny of the nation at the moment the war was forging it anew. Benson had written that the painting "should be placed with 'Prisoners from the Front' and the two would make a comprehensive epitome of the leading facts of our war."[38] The longtime *New-York Tribune* art critic Clarence C. Cook (1828–1900) later wrote that *The Bright Side* reflected the important and unresolved matter of how Black troops might serve in the war. "Its punning title, with the good-natured presentation of the subject, played its part in putting the question in the right light."[39]

Despite his youth and extensive time outside the United States, Whistler managed to get four pictures into the American pavilion. They included two that Homer may just have seen: *Wapping* (at the Artists' Fund Society exhibition he attended just before he left the United States) and the Valparaiso *Crepuscule* picture. The other two pictures were Whistler's now-

Figure 62: *The Bright Side*, 1865. Oil on canvas, 12¾ × 17 in.

famous *Symphony in White, #1: The White Girl* (1862) and the gloomy *Brown and Silver: Old Battersea Bridge* (1859–1863).[40]

Like Whistler, George Inness contributed startling work to the American pavilion: two powerful landscapes replete with mystery. One, then titled *Sunset in America*, is likely the same picture now known as *Peace and Plenty* (1865).[41] Inness's entries were landscape paintings thoroughly unlike those by Durand and his followers, who sang with the power of a fervent prayer, rang with thankful adoration in celebration of a verdant homeland, and in hope for its future. There was no denying their emotional power. Homer had seen two of Inness's paintings at the Artists' Fund Society exhibition in New York just before he crossed the Atlantic, as well as at two previous AFS shows, and two 1864 fairs for the U.S. Sanitary Commission in 1864, where Henry Ward Beecher's support for the unconventional painter contributed heavily to his renown.[42]

Now Homer saw Inness in the context of the many works on display by the Barbizon painters who had so influenced Inness, and in the context of the ideas behind these works. In the fall of 1867, Inness would send a letter to the editor of the *New Jerusalem Messenger*, the newspaper of the Swe-

Figure 63: George Inness, *Peace and Plenty*, 1865. Oil on canvas, 77⅝ × 112⅜ in.

denborgian church to which he belonged.[43] In it, he noted the importance of color complementarities, and then explained his association of specific colors with specific emotional and spiritual values. "Faith which blue represents must be warmed by love to God and love to man. These are bound in one by love to the Lord, in whom is equally of heaven and earth."[44] Inness's witness to the spiritual power embodied in nature, and in man's response to it, would resonate with Homer over the years ahead.

Homer's friend Johnson contributed four genre scenes to the Expo. One of these established his prominent position in the American art scene. It remains his best-known work. Although Johnson called the picture *Negro Life at the South*, it is set in the backyard of his father's house in Washington, D.C.; the woman at the right edge is white, not Black; Johnson's sister served as his model for the figure. He acknowledges the dilapidation of the house in which the Blacks live, and the comparative comfort of the house next door, but conveys the dignity of the Blacks in his picture. His subjects are engaged in romance, learning, music, and play to which any

Figure 64: Eastman Johnson, *Negro Life at the South* (*Old Kentucky Home*), 1859. Oil on linen, 37 × 46 in.

viewer could relate. Like others of Johnson's pictures, it is a subtle case for empathetic understanding of American Blacks, made especially plaintive by the recognition that this moment was immediately prior to the outbreak of the Civil War. Homer would follow in his footsteps within a few years, addressing the same subjects in the same manner.

Within the Expo's enormous French pavilion, Millet was well represented, with nine paintings, more than Corot or Rousseau exhibited. An English critic considered him "the Whitman of art," at least in a French context, and Benson greatly praised him.[45] Among Millet's pictures shown was a work that Homer must have observed with special attention. The canvas is entitled *The Gleaners*, and today is among Millet's most admired paintings. It was ill-received when first exhibited a decade earlier, however, and won little interest at the fair. Viewers took offense at the picture's reminder of the poverty so many French experienced during their revolution and its aftermath. Three women hunch over in the foreground, collecting food left behind in the fields. They follow the guidance of the Hebrew Bible, in the books of Deuteronomy and Leviticus, which commended

Figure 65: Jean-François Millet, *The Gleaners*, 1857. Oil on canvas, 33 × 44 in.

providing for the poor by intentionally not harvesting all the food in a field, orchard, or vineyard. Gleaning is the act of collecting these remnant foodstuffs that all may live. It is an act of resilience, community, and faith, best exemplified by the biblical heroine Ruth, in her eponymous book.[46] In Millet's depiction, the women show no joy, and little hope, but the French painter nevertheless intended them, and his many other peasant subjects, as archetypes of French dignity and integrity. Homer would echo Millet repeatedly in the years ahead.

Among the four pictures by Gustave Courbet that the Exposition's French jury selected was one he then entitled *Le lièvre forcé* (*The Forced Hare*). It is almost certainly the same picture now known as *Hunting Dogs with Dead Hare*, which combines a twilight forest scene with a veiled narrative of two predators and their quarry. Although painted the same year as Millet's *Gleaners*, it contrasts sharply. Courbet's hare, like his sun, has fled the mortal realm. His sniffing dogs seem more perplexed than portentous. What now shall they do?[47] The tension visible is one that Homer would recall in a painting he would create more than a quarter-century later: *Fox Hunt* (1893). Courbet often painted at such a grand scale, but Homer's *Fox Hunt* is his only one remotely comparable in size. It reflects the long period within

Figure 66: Gustave Courbet, *Hunting Dogs with Dead Hare*, 1857.
Oil on canvas, 36½ × 58½ in.

which he marinated in the culture of the world around him—often while concealing the significance of what he was observing.

Courbet was not only a masterful painter but a salesman with flair. He wagered that the four pictures in the exposition itself were insufficient expression of his genius and conceived a major one-man retrospective to capitalize on the crowds coming to the fair. Courbet erected a special pavilion at his own expense at the Pont d'Alma, outside the fair but near its grounds. Courbet exhibited in that show one he painted during a visit from Whistler in the fall of 1865, a highly productive period: in the course of three months, he completed some thirty-five paintings. The palette of *The Fishing Boat* reflects the influence of the young American, while the eerie sky and the haunting, spectral anatomy of the skeleton-like sailboat are characteristic of Courbet's idiosyncratic manner.[48] Homer had yet to create a marine painting, but it is reasonable to expect that he visited Courbet's exhibition—perhaps repeatedly—and developed a deeper understanding of how the older painter had maintained his identity while benefiting from the fresh ideas of Homer's countryman.

Figure 67: Gustave Courbet, *The Fishing Boat*, 1865. Oil on canvas, 25½ × 32 in.

A week before Courbet opened his pavilion, Manet opened his own, also by the Pont d'Alma. It was also a one-man show, with fifty of his oil paintings and three etchings. Two of the canvases depicted a significant moment in American history. They were Manet's first seascapes and his first portrayals of a current event. The subject was a Civil War battle fought near Cherbourg, France, on June 19, 1864, between a pair of three-masted sloops-of-war. The 201-foot U.S.S. *Kearsarge*, built at the Portsmouth Navy Yard on the Maine–New Hampshire border, defeated and sank the 220-foot Confederate *Alabama*, which a British shipbuilding firm had constructed in secret near Liverpool fewer than two years earlier. It was a dramatic and ignominious end to the *Alabama*'s short but far-reaching history. She had captured or burned sixty-five American ships (primarily merchant), taken more than 2,000 prisoners, and traveled from the South Pacific to Brazil to South Africa and the North Atlantic—all without losing the life of a single crewman. Manet depicted the victorious *Kearsarge* flying the American flag as a French fishing vessel sails under a stiff wind into the foreground, directly toward the viewer. Homer left no record of

Figure 68: Édouard Manet, *The* Kearsarge *at Boulogne*, 1864.
Oil on canvas, 32⅛ × 39⅜ in.

Figure 69: *View of Paris*, 1867. Pen and brown ink, graphite on brown paper, 7³⁄₁₆ × 11⅛ in.

visiting Manet's pavilion but one cannot imagine that he would have missed it. Even without its connection to the American war, the picture's loosely described waves, high horizon, tightly framed composition, and dramatic coloring were utterly arresting.[49]

Few drawings survive from Homer's time in France, and none from the weeks in England. Homer had a wry sense of humor; one sheet depicts a Frenchman of a bygone era, determined to coax his cat back from its perilous perch atop a gargoyle. Even in a sketch that is little more than a doodle, Homer pulls the viewer into a narrative of uncertain outcome. Will trust and hope save the cat's life? Or will his own fear drive him to a plummeting death?

Albert Kelsey, an eccentric entrepreneur whom Homer had known since his Belmont days, had planned to join Homer for his time in Paris. But Kelsey did not arrive until late July or early August 1867, after an unsuccessful foray into a Nevada mine venture. When he finally got there, the two men commissioned an unusual double portrait in photographic form.

Kelsey was some eight inches taller than Homer, which helps explain the seating arrangement. An inscription, in Kelsey's hand, reads "Damon and Pythias," a reference to heroes of Greek mythology who exemplified brotherly affection. Some have inferred that it suggests a romantic rela-

Figure 70: Unidentified photographer,
Winslow Homer and Albert Kelsey in Paris,
1867. Photograph, 3¾ × 2⁵⁄₁₆ in.

tionship between the two men, for which there is no evidence. In any event, Kelsey's delayed arrival did nothing to address a mounting practical problem Homer faced. In a tone of inventive desperation, he wrote to Charles Voorhees in New York, urgently requesting more funds. Whatever Voorhees's response, Homer was so impoverished by the end of his residence in France that he was unable to pay for his ship passage home. Kelsey paid for his crossing, but notably in a lower class of service than Kelsey's class on the same ship.

Homer gave Kelsey a painting, possibly in remuneration for his payment of Homer's passage. It is a portrait of a young delicate-featured woman in a brown dress, wearing a long black veil and holding a fan. A note on the reverse (not written by Homer) suggests that the woman's name is Pauline and that "she sold perfumes and soap at the Exhibition."[50] Homer bought the stretcher for the canvas at a shop in Montmartre, very near where many of the Impressionist and Post-Impressionist painters would live and work over the coming years.[51] The shop was a block south of Place Pigalle and a couple of blocks from the home and studio of the Symbolist painter Gustave Moreau (1826–1898). It is probable that Homer himself lived in this same neighborhood.

Homer also had a long-standing interest in music, for which Paris was renowned. Among the works Homer painted while in Paris was a depiction of a pair of bearded chamber musicians: one playing a violin and the other a cello, each with a deep concentration on his music and on the sound of the other player. In the delicacy of his contrasts of light and

Figure 71: *The Cellist*, 1867. Oil on canvas, 19⅛ × 12⅞ in.

shadow, and his disciplined palette, Homer invokes the sense of a tall-ceilinged Paris studio. The music on the floor bears the composer's name on its cover: W. A. Mozart. Another canvas of similar size is even more compelling. The same cellist is alone in a high-ceilinged space atop a Gothic tower. He gazes with rapt attention at a music sheet we cannot see and creates sounds we can only imagine. The picture belonged to Charles de Kay (1848–1935), a poet, critic, and Renaissance man, who was particularly notable for his early and unflagging support for the mystical painter Albert Pinkham Ryder (1847–1917); Homer probably sold *The Cellist* to de Kay.[52]

Homer depicted another kind of music in a pair of wood engravings he drew immediately upon his return home. Both depict a dance scene, one in summer and the other in winter. *Harper's Weekly* editors described the archetypal Frenchman as "a dancing animal, and, no longer in fear of a too inquisitive police, takes the full benefit of the imperial license, and indulges

in a freedom of agility that must be seen to be appreciated. Such a vision is granted by our artist, who has caught Paris in the supreme crisis of its dancing frenzy, to every eye that may look upon his pictures, which are as faithful as truth."

Most of the oil paintings Homer made during his months in France are not urban at all, but pastoral scenes. They suggest that, perhaps accompanied by Benson, he heeded his friend's advice: "Forget Paris and the Parisians; see the vision-beauty of nature, eternal, fresh, uncorrupted, mother of peace and healer of sorrows."[53] Benson published a semi-fictional magazine article about his pursuit of that "vision-beauty of nature," in a "little French village . . . free from the haste and grasp of our mechanical and business life."[54] He explains that the village, about forty miles north of Paris, "was a place sacred to French landscape-painters." Although Benson does not name the "artist-friend" whom he describes meeting in this village, the descriptions of the locale tie tightly to the pictures Homer painted. Of all the works he created in France, Homer gave a place-name to just one: *Picardie, France*, a historic region whose southern area around the Oise River fits closely to Benson's description. Homer may well have spent time, for example, in the agricultural area around the villages of Senlis,

Figure 72: *Picardie, France* (*Cernay la Ville—French Farm*), 1867.
Oil on panel, 16¹³⁄₁₆ × 18¹⁄₁₆ in.

Creil, and Clermont, east of Beauvais. Oddly, the painting to which he gave this name later acquired an erroneous association with a village south-west of Paris named Cernay-la-Ville, which Homer is unlikely to have ever seen.[55] The panel's foreground is a rough blend of browns and greens, and its upper half is a cloud study worthy of Constable. Between the two broad horizontal bands, in a narrow strip, Homer painted a gray geometric com-position of farm buildings similar to those his French contemporary Odilon Redon (1840–1916) would go on to paint.[56] The structures almost seem to comprise a still life of the kind Jean-Baptiste-Siméon Chardin (1699–1779) painted, and which Homer would have seen at the Louvre. Its puz-zle pieces include the simple outlines of nine triangularly roofed barns and, weaving them all together, a conical-roofed grain tower just below dead center, an emblem of agricultural prosperity.

Homer echoed Millet in depicting women in the fields, and probably in calling them gleaners. But in contrast to Millet's gleaners, Homer's

Figure 73: *Return of the Gleaner*, 1867. Oil on canvas, 24 × 18 in.

stands proudly erect: an emblem of determination. His subject's attractive face has a stubborn, angry cast; she could not be more different from Millet's downtrodden curvilinear lumps. Homer addresses his gleaners as archetypes with moral significance. They anticipate a number of strong female figures he would portray in the coming years.

In 1855, Whitman had written, "The proof of a poet is that his country absorbs him as affectionately as he has absorbed it."[57] It took Homer's leaving "the long, long anchorage" of his American home for him to grasp more fully the profound truth of Whitman's insight. Through his witness of how completely, and how affectionately, visual poets such as Constable, Turner, and Millet had absorbed their countries, Homer had grown far more than the brevity of his ten months abroad might suggest. Now, in Whitman's words, his ship was "clear at last—she leaps! She swiftly courses from the shore."[58] Homer sailed back to the United States in October 1867, renewed in his distinctive calling. The illustration he drew depicting his fellow passengers is full of vigor, with strong diagonals and a stiff breeze. Homer knew now more than ever that another land awaited his absorption: that land was his own.

5

LINES OF HAND AND HEART
(1867–1872)

HOMER RETURNED TO America penniless. He'd forgone illustration for almost all of 1866, focusing his time and energy on painting—but not selling much. For ten months of 1867 he was in Europe, spending what meager capital he had generated through the sale Benson and he had staged in November 1866. Homer now needed to restabilize his precarious financial position and pay back Kelsey and others who had lent him funds. His financial supporters and he believed that ultimately his career would pay off, but the tangible evidence was paltry. All his looking and learning in England and France had produced no breakthrough comparable to *Prisoners*. He needed to prove himself still worthy of the confidence his friends and family had placed in him. First and foremost, he needed to make a living.

Where and how would he do it? Perhaps as a stopgap measure, he took up studio space with Alfred Howland, now also returned from Europe. The men subleased a part of the top floor of Clinton Hall, between Astor Place and Eighth Street, not far from the University Building, where Homer continued to live. The studio, subleased from a choral society, had skylights offering plentiful sunlight, and Howland must have made good company. But Homer just couldn't make the numbers work, and a year later was still behind in his rent by $52—the equivalent of more than $1,000 today. He offered to make his payment in kind: "It is impossible for me to pay the money immediately. If you would like a picture I will paint any subject you like, or what would be more interesting, I would make a

crayon sketch of all the members together in the Club room, with their mouths open or shut . . . Of course I mean the sketch to be finished and a good picture."[1]

In fact, not many of Homer's illustrations depict New York or its residents, and almost none of his paintings. New York is where he lived for the fall, winter, and spring months, where he found his principal markets—both for paintings and wood engravings—and where he created most of his work, in his studio. He served two markets: wealthy collectors looking for oils, and editors for newspapers and books (and, of course, the rising middle-class readers they served). Both audiences were hungry for relief from urban life and urban tension—and wanted pictures offering that relief. Homer had seen his fellow American painters make a living (some of them a good living) doing just that. While in Europe, he had seen how Turner, Courbet, Manet, and other English and French painters had done it, too. They'd gone to the Alps, to Cherbourg and elsewhere on the French seashore, to the stormy coast of Northumberland. They'd delivered what their patrons wanted and not only made great art but also in the process made a living. And some of these painters had figured out how to live well indeed: Whistler, for one, in February 1867 on Cheyne Walk, in London's Chelsea, overlooking the Thames, living in luxury.[2]

Homer had seen the work of Old Masters at the Louvre, the National Gallery, and the British Museum. He had seen the work of new masters on the walls of the South Kensington Museum, London's galleries, and at the Expo, and at the shows of Courbet and Manet. Many of these masters, old and new, had invested in their work through long voyages of the kind Homer just had taken. They'd also invested in the marketing of that work—and in the management of their reputations. With characteristic and systematic determination, Homer developed both a system for selling his oil paintings and a distinctive identity, curating his own reputation, whereby he sought to differentiate himself from those around him. Homer took up scenes of mountains, then of shores, utterly unlike those other painters had made. He mused on the meaning of labor—of many kinds—as he struggled to overcome the condemnation of his critics, and as he witnessed the tribulations of his father and the professional advances of both his brothers. Then, at the Tenth Street Studio Building, he found a better place than Clinton Hall and the University Building to live and work in—and an extraordinary community of artists who bolstered his resolve and gave him the compan-

ionship he so needed. With deepening confidence he explored new territory, considering more deeply what it means to see, and to oversee. And so, inevitably, he focused on American women, particularly those women whose ambitions—like his own—meant they failed to conform to expectations. In one case he fell in love, was rejected, and rather than suffering defeat, left a distinctive tribute to his would-be partner and to her work. And in those meditations on the fleeting character of time, and of love, he set the stage for a breakthrough, just as his country careened into another crisis.

Homer, the son of an entrepreneur, became one himself. He adopted a method by which he curated the first viewing of his new oil paintings, of which he exhibited normally five or six each year. Homer showed about half of his new pictures first at the Century Association, which mounted exhibitions of new work by its members on the first Saturday of each month from October through June. Alfred Howland had joined the club in May 1866, five months after Homer; they were just two of around thirty-five practicing artists who exhibited regularly there. On a typical Saturday night, twenty to twenty-five members would each show one or two works, for twenty-five to thirty works in each exhibition; the roster of exhibiting members was fairly consistent, with Homer and Howland often among them. Most of the works the members exhibited were paintings, but the group shows generally also included a couple of sculptures. Although Homer

Figure 74: Unidentified photographer, *National Academy of Design, New York*, 1880.
Gelatin silver print, 11⅞ × 14 in.

very rarely sold any of his new paintings directly off the walls of the Century, he and the other members certainly intended that collectors would consider the works for private purchase from the artists. These group exhibitions were open to the press, often attracting influential reviews ahead of wider public showings.[3] Homer and his fellow Centurions prized these evenings as intimate settings within which talented young men might share their latest accomplishments with an audience likely to approve of them—and to speak well of them to others who might influence opinions in their favor.

The National Academy of Design (to which he was elected a full academician about the same time he was elected to the Century) was commercially even more important to Homer. There he could be more direct in marketing his pictures, for about $100 each—and for a larger work maybe a little more.[4] At this time the academy had two major exhibitions each year, running several months in duration: the Annual, opening in April, and the less significant Winter Exhibition, which opened in November or December. In addition to these two shows, Homer exhibited occasionally at the Brooklyn Art Association and at the Union League Club, which presented group shows chosen by members (often from their own collections). He also began to market his work in Boston through an outlet that would become his most important outside New York.[5]

But in the late 1860s and early 1870s, he could not make a steady living as a painter—try as he might. In illustration he might most quickly generate income—if and only if he had the right idea for a new wood engraving. And with a few tweaks, that right idea might work for an oil painting, too. So for thirteen summers, beginning in 1868, Homer deserted the hot, smelly, crowded city each June, and sought out destinations contrasting with it. His studio, and those who might purchase pictures he painted in it, would still be there in October. In the seasonal rhythms of his life, Homer found ways to embed projects, people, and places both familiar and new. He took to heart wise words of counsel published in 1869, the year Homer—after years of journeying to the coast—first exhibited a marine painting. Samuel Clemens (Mark Twain) had written that advice, tucked into the closing sentences of his first novel: "Travel is fatal to prejudice, bigotry, and narrow-mindedness, and many of our people need it sorely on these accounts. Broad, wholesome, charitable views of men and things can not be acquired by vegetating in one little corner of the earth all one's lifetime."[6]

The right idea, whether for a new illustration or a new oil painting, always

Figure 75: *Summit of Mount Washington*, 1869.
Graphite drawing on off-white wove paper, 5⅛ × 9¾ in.

first took shape in the same form. Homer would pull out of his knapsack a block (or perhaps a sketchbook) composed of moderately thick, cream-colored wove English paper. The sheets were made from cotton or linen rags, beaten into a pulp, and shaped through a mesh into a strong, smooth, evenly surfaced material. Then he would turn to one of several instruments—usually a pencil but sometimes chalk, ink, or crayon. His standard practice was to identify an outdoor scene, to frame it carefully, and to work up a sheet on the spot that memorialized what he had seen, posing his models as needed.

Such drawings served Homer both as memory devices for his own use and as marketing devices for pitching his ideas to editors. What he'd make selling a new illustration to an editor was about the same amount—$100—as he would make selling an oil painting to a collector. The key was getting a good-enough idea to sell quickly to the editor, and then to work it up quickly with one of the wood engravers he knew well.

In pursuit of that good idea, Homer set off early in the summer of 1868 for the Presidential Range in the White Mountains of New Hampshire. It was his first summer since returning to the United States. Many other painters had preceded him, including Rondel and Kensett. Two other friends, the landscape painters John Fitch (1836–1895) and Homer Dodge Martin (1836–1897), joined Homer on the trip; his depiction of three painters at work in the mountains displays Martin's initials on a knapsack.[7]

But Homer's paintings of the White Mountains are unlike the paintings

any of his friends produced. In fact, Homer's paintings are unlike those of any of the countless painters who preceded him there, or to other mountains. Those painters, from Church, who first painted the Andes in 1853, to Bierstadt, depicting the Rockies in 1859, conceived of these majestic peaks as symbols of a grand, raw New World. As the art historians Katherine Manthorne and John Coffey have written, "The mountain sublime became the dominant typology of landscape painting."[8] These other painters' pictures stirred emotional passion, but their perspective was distant, as the Waud brothers' perspective had been as they drew from the edge of Civil War battlefields. Homer, by contrast, does not behold the mountains from afar; he conveys the sensory experience of being in and on them.

In one daring example, Homer deploys a dramatic perspective in mid-air, placing his model on a ledge with his walking stick. As in *Prisoners*, Homer's geometry is carefully composed to maximize the impact of his painting. He drew the horizontal centerline just below the horizon, and with the stark diagonal line of the rock face, accentuated the vertiginous drop. Recognizing the appeal to Boston collectors of a New England mountain scene, he forwent his usual New York channels and, to sell it,

Figure 76: *Mountain Climber Resting*, c. 1869. Oil on canvas, 10¾ × 14¾ in.

chose a Boston gallery, Doll & Richards.[9] His sketchy technique, fresh color, and dynamic composition made no sense to the provincial critic who called it "a dull affair . . . which is quite unworthy of his genius—vast flats of a peculiar green are odd enough if the artist aims at oddity, but nature cannot be respectfully represented without an indication, at least, of detail. No paint was ever laid on a barn door with a flatter or broader surface than in this . . . neither great, beautiful or pleasing."[10] Despite the inauspicious start, the gallery would become Homer's most important channel outside New York, and Boston a major market for his work. And he would keep painting mountains—whatever the critics might think.

But it took Homer a full year to sell any illustrations based on his White Mountains excursion. These, too, place the viewer in the mountains, not beholding them from afar. In one, he sets his scene just below the summit of Mount Washington, which *Harper's Weekly* explained is "the highest mountain in New England, rising 6285 feet above the level of the sea . . . As one ascends the mountain vegetation gradually disappears. Soon only dwarf pines are visible; at length even these disappear, and the only indication of vegetable life is the lichen; upon the top of the mountain the rocks lay absolutely naked to the sky, as shown in our picture." He places

Figure 77: After Winslow Homer, "The Summit of Mount Washington," from *Harper's Weekly*, July 10, 1869. Wood engraving on paper, 9⅛ × 13¾ in.

two attractive young women in the foreground, riding side-saddle on their horses but in commanding positions. As is his habit, Homer injects narrative ambiguity. One of the women thrusts a long riding crop held in her left hand toward a couple facing her, possibly to dispense directions. Homer has bestowed upon her the possibility of more authority—and more confidence—than has the society in which she lived. He had a soft spot for those whom others underestimated. He knew what it felt like to be ignored. Where he could, he wished to turn that invisibility to his advantage.

It took him another few months to complete the oil painting related to the illustration. He exhibited it at the Century at its monthly exhibition on November 6, 1869; Fitch and Benson, who both showed work that night, too, surely attended, and another of Homer's traveling companions, Martin, likely did, too. While the composition of the landscape is similar to that of the illustration, Homer accentuates the rough granite in the foreground and diminishes the dialogue between the figures, placing them behind and to the left of the horses. Like the clouds blocking the otherwise "absolutely naked" summit, the women now have adhered to protocol. Still seated on their horses above two standing men, nevertheless they demurely follow

Figure 78: *Mount Washington*, 1869. Oil on canvas, 16¼ × 24⁵⁄₁₆ in.

the direction of the walking stick. It is held by neither of them, but by a man. The Century listed the work as *Party of Ladies and Gentlemen on Horseback Ascending White Mountain*. Homer knew the collectors of his work, and their taste, well enough to be more cautious with his oil paintings than with his illustrations. Both the painting and the title ascribed to it downplayed his focus on the women. Rich men didn't wish their libraries to be hung with reminders of pesky ladies—no matter how well they might ride their horses up Mount Washington. Homer never showed it in New York again, and promptly sold it to a dealer in Boston.[11]

Three days before the *Harper's Weekly* illustration appeared, Homer checked into the Metropolitan Hotel in Long Branch, New Jersey.[12] As he explored not only American mountains but American shorelines, he had visited two contrasting beach destinations the previous summer: Long Branch and Manchester, Massachusetts. And just as he returned to Mount Washington in the summer of 1869, so he also returned to both of these seaside resorts.

Long Branch was by far the larger and better known of the two. Close enough to both Philadelphia and New York that visitors might arrive within three hours by train and ferry, hotels like the Metropolitan crowded the resort. The local newspaper's owner boasted that in Long Branch "at every point the eye is greeted with forms of active life and enterprise. Fashion, wealth, and taste combine to crowd the magnificent distances with homes, hotels, flitting forms of beauty and grace, or with dashing equipages of either aristocratic or unassuming worth. Music fills the air from instruments and voices . . ."

The setting of a beach invited informality then, just as it does today. The beach can prompt flirtation, too, although sexual signals, like dress codes, were different in 1869. In one illustration, for example, Homer depicted five young women atop a bluff, their dresses buffeted by the wind. Each has her hair dressed fashionably and integrated tightly with her tidy bonnet. As one holds onto her ribboned hat, she reveals her ankles—an act Homer's contemporaries regarded as especially lascivious.

By contrast, in another wood engraving, Homer depicted three women on the beach as a top-hatted man in a frock coat strolls toward them. Each of these women wears her hair long, on her shoulders. None displays her ankles. We can deduce that all three are ineligible just yet for marriage, or

Figure 79: After Winslow Homer, "The Beach at Long Branch," from *Appleton's Journal of Literature, Science, and Art*, August 21, 1869. Wood engraving on paper, 13 × 20 in.

even for its anticipatory coquettish rituals. The conspicuous display of Homer's initials, inscribed in the sand by the young woman on the right, is one of countless clever ways in which Homer planted his identity—his brand—in his illustrations. Whether painted onto a door frame, written on a blackboard, or carved into a fence, his name—or at least his initials—was at the heart of the narratives Homer created. Just as he managed his reputation with collectors and critics in New York, he did his best to ensure that the readers of the newspapers to which he had sold his drawings would remember who he was. And he would make light of those who forgot, as indeed they often did. On a label for a painting exhibited that year he had inscribed a humorous lament: "Not Horner or Hosmer or Homer Winslow—but Winslow Homer."[13]

Homer's other beach destination was less easily accessible from New York. Where Long Branch boasted numerous hotels, the village of Manchester, Massachusetts, twenty-five miles northeast of Boston, had none. The beauty of the seaside drew just a dozen families for the summers of 1868 and 1869, but they were people of influence, well connected with creative endeavors. They and others would construct hundreds of summer cottages in the town over the years ahead. Homer may have stayed with one of those pioneers, Benjamin W. Thayer. He had leveraged his lithographic

business into a publishing and theatrical enterprise and was a noted host for artistic figures of all kinds, including his sister's husband (and Homer's one-time boss), John Henry Bufford.

In Manchester, Homer began work on a major new picture. He had never before exhibited a seascape; this would be the first, but far from the last. Like the marine pictures of Courbet, the painting Homer called *Manchester Coast* relies on the power of the ocean itself to hold the viewer's attention. With a tightly framed composition and a high horizon line indebted to Japanese ukiyo-e woodblock prints, the picture was completely unlike the cartographic seascapes he had seen at the Boston Athenaeum in the 1850s, from painters such as Fitz Henry Lane and William Bradford.[14]

Homer must have considered *Manchester Coast* a strong achievement. He chose to show it first at the prestigious Annual at the National Academy of Design. Critics hated the painting. The wave at upper right, so reminiscent of the works of Hiroshige and other Japanese printmakers, attracted particular disdain.[15] One reviewer wrote, "We cannot refrain from calling to attention the lamentable example hanging in the East Room, painted by Winslow Homer, entitled 'Manchester Coast.' Mr. Homer has at times produced works of great merit, but of late, the inspiration which formerly guided his pencil appears to have left him, and only the indications of his former strength appear. In the present work, the most noticeable point ap-

Figure 80: *Rocky Coast and Gulls* (*Manchester Coast*), 1869. Oil on canvas, 16¼ × 28⅛ in.

Figure 81: *Eagle Head, Manchester, Massachusetts*, 1870. Oil on canvas, 26 × 38 in.

pears to be the dashing of the ocean spray above the rocks, but as indicated by Mr. Homer, it resembles the work of a boy who has dashed a 'spitball' upon a newly-papered wall."[16] The picture found no buyers; Homer retrieved it from the Annual and never showed it anywhere again.

The following year, at the next Annual, Homer tried another approach to marine painting, this time drawing on his considerable experience creating paintings and illustrations of young people at leisure. But he displayed the ankles of two women, and the wet hair of another, and thus scandalized the critics. One wrote that behind the figures "is a leaden-colored bank, and near by is a pool of ice-cream from which they have evidently just emerged. They are exceedingly red-legged and ungainly, as though the solid nature of their bathing material had abraded their calves. One of them exhibits a bewildered countenance half averted, as though the mystery of Eagle Head troubled her as it is supposed to trouble the spectator. It is a well-drawn and atrociously colored bathing scene."[17]

Rebuke and frustration were nothing new in the Homer family. They were the reward that his father's hard work had almost always earned. From his earliest days, Homer had heard the loud laments, Charles's penchant for slamming doors in moral indignation, heaping blame on others. Winslow

had heard Henrietta's soothing voice, which never really healed his father's wounds, but assuaged them that he might go on, and try again. The pattern charged and shaped the failed merchant's daily existence, and the expectations of all three Homer boys. Now Charles's long history of lofty dreams and ugly disappointment took an especially bitter turn. As the Civil War broke out, Charles's older brother William had hired and paid him to collect on the accounts receivable owed to William by their Alabamian nephew Matthias.[18] Not only had Matthias never paid, but Charles took no responsibility for the mess. He had failed again, now for his brother and closest neighbor in Belmont. William had had enough and took Charles to court. He believed Charles had defrauded him. It took a decade to work through the mess, but in the end a Boston court agreed with William and held Charles liable. After six decades in Boston, Charles's life there had met an ignominious end, at least for now. He would return to Boston for visits but never lived there again. When he returned, it would be to stay in hotel rooms. By 1872, Henrietta and Charles left Belmont and all its bad memories. It was an agonizing departure. They were both sixty-three years old, past an easy age for moving, but move they did, to Brooklyn, where Henrietta's brother Arthur, a highly successful businessman, would yet again bail the couple out.

Despite his negative reviews, Homer continued to exhibit, doubling his 1869 output to a banner crop of eleven new pictures in 1870. The next year, his meditations on work led him briefly to the unconventional subject of industrial work sites. In one case, he created a scene of tensile vitality and optimism, suggesting that the labors of this team of men may both produce sustenance and create an object of beauty. He began the painting in August 1871 while on a visit to Gloucester, the most productive American fishing port, just east of Manchester.

At the David A. Story shipyard on Vincent's Cove, just east of downtown Gloucester, he came across the 90-ton clipper fishing schooner *Dictator* under construction.[19] As with so many of his works, Homer carefully deployed a grid within which he fitted a series of four equally sized contrasting horizontal bands. Massive oak flitches—timber slabs—dominate the lowest band. As if charting the course of ship construction, planks milled from the flitches crowd the second band. Homer places a shipwright with a bright red shirt precisely at the center of this band, on its left edge. He compresses the schooner hull itself into the third band, through which he slashes a striking diagonal to mark the ship's deck. Homer posi-

Figure 82: *Ship-Building* (*Shipyard at Gloucester*), 1871. Oil on canvas, 13½ × 19¾ in.

tions silhouettes of shipwrights around the hull and offers a preview of their completed work beneath one of those shipwrights: the sails of another ship, which has entered Gloucester Harbor. Then he leaves the top band for sky and sky alone. Homer waited more than two years, until February 1874, to exhibit the radical composition, and showed it only at the Century.[20] He had learned enough about his markets to expect parochial disdain for such a work were he to show it at a National Academy exhibition.

Homer's illustrations of this period often focused on labor. In one case, a middle-aged clerk serves well-dressed women in a country store. In another, a young farmer atop a ladder carefully grafts seedlings onto tree branches. In a third, Homer drew 2,500 employees of Washington Mills, a massive complex in Lawrence, Massachusetts, that he visited with his brother Charlie not long after he got back from France. Homer gives a keen sense of the broad range of workers—men, women, and children—employed both at Charlie's nearby Pacific Mills and in countless other such industrial complexes. The *Harper's* text for the illustration is unfailingly self-congratulatory. It cited no less an authority than Charles Dickens in approval of the working conditions the newspaper commended as benign. As usual Homer leaves room for ambiguity. Making their way

Figure 83: Homer's Palenville and Hurley (1871–1876)

Figure 84: John Jacob Loeffler (1833–1901), "Foot Bridge, Near Griffin's Store, Palenville,"
from his *Fourth Series, Catskill Mountain Scenery*, c. 1870. Burnished albumen
stereograph from wet collodion negative (detail).

home at the end of the working day, the mill workers themselves seem less
consistently convinced of their well-being than are Homer's editors in dis-
tant New York.

Another painting Homer made in 1871 depicts a very different worksite
from the shipyard in Gloucester. He paints a dilapidated and now-closed
mill, in front of which a wooden footbridge rises to cross the creek beside
which it stands.[21] The old mill was just north of Spruce Creek in the hamlet
of Palenville, New York, in the southwest corner of the town of Catskill.
Palenville was a long-established destination for New York artists due to
the nearby Kaaterskill Falls, the subject of a Homer wood engraving the
following year.[22] The painter begins, as usual, with the particularity of his
site, which as recently as four years earlier had been the site of a chair man-
ufacturing business owned by Giles Griffin (1808–1886). Giles's brother
Samuel (1812–1897) operated a bluestone-dressing business just south of
the creek.[23]

The particularity of the site is preserved in a stereograph from about
1870 by John Jacob Loeffler (1834–1901).[24] The similarity between the pho-
tographer's vantage point and that of the painter suggests that Homer relied

Figure 85: *The Old Mill* (*The Morning Bell*), 1871. Oil on canvas, 24 × 38⅛ in.

not only on his field sketches but also on the stereograph, as he executed the picture in his studio. Homer stayed at the home and studio of his friend and fellow painter George Henry Hall (1825–1913) at a picturesque bend in the creek about a mile northwest of Griffin's chair shop. He memorialized his time staying with Hall in a vertiginous oil sketch of the deeply wooded valley called Kaaterskill Clove in which the studio was set.[25]

From the mid-1850s, Homer had depended on photographic portraits in executing lithographs, and he also used photography as a part of his process for making wood engravings.[26] At least two of his oil portraits are based on photographs, and Homer's familial connection to inventors would have primed him to embrace photography.[27] And of course, Homer and all his neighbors knew well that Draper had pioneered the art and science of photography at the University Building, just as they knew that Samuel F. B. Morse developed his famous code there.

Homer has not been known previously to have deployed photography as a part of his process of composing landscape paintings. The fact that he clearly did so in the instance of the Loeffler stereograph suggests the possibility of his broader application of the rapidly developing new art and science of photography. It also justifies the confidence of some art historians that the connections between Homer and photography do indeed matter and warrant their further investigation. Homer's engagement with

photography deepened over the following years. At least by 1882, and possibly earlier, he owned and used multiple cameras himself.[28]

Homer's process of creating this painting began as it always did, with his close observation of the site and his determination of his frame. He set it more tightly than Loeffler did, closing off his left edge at the mill's chimney and placing the viewer two steps from the ramp up the footbridge. Then he developed a characteristically ambiguous narrative, including four women. Three of them at right mutter to one another, in their distinctive matching hats; his horizontal centerline skates across their heads. The fourth woman captures his attention and ours—and perhaps theirs, in envy. She is brightly lit as she walks up the ramp past the rotting mill and an indolent dog.[29] Homer leaves it to the viewer to speculate on her destination—outside his picture frame—and on her identity. But he offers clues, including her more sophisticated dress and fashionable sunbonnet, a contrast with the gossip girls. Loeffler shows a bell just over the gable of the mill; Homer illuminates it in a golden glow. It tolls, just at this moment, evoking a timeliness to the labor calling her, to which she responds with enthusiasm greater than that shown by the laggards behind her.[30]

Homer took his time selling the concept of the painting to the editors at *Harper's*. When he did, he incorporated several telling changes that reduced both the primacy of his lead character and the ambiguity of the composition. Now he was addressing a national market of readers of all ages and classes. He needed to appeal broadly. He extended the composition to the left and altered the dress and demeanor of his four women, so that none wears an upbeat sunbonnet, and one of them is now stooped. He also included a fifth and sixth figure: a dejected man and a young boy. All six figures carry their own lunch buckets and are evidently going to the same place of work, with the same sense of servitude. Homer also accentuated the prominence of the bell barely visible in the Loeffler stereograph, and still small in the painting. He features it in the print's title. Homer also has repaired the windows of Giles Griffin's chair shop. In so doing, he has converted the wooden structure from an outmoded shop floor to one that is operating again. He removes a layer of ambiguity that would have appealed to a collector in New York. *The Old Mill* offered the possibility that his central figure was traveling to a different destination than that of the other three women with whom she struck a contrast. In the print, that possibility no longer exists; each of his characters is bound to the same drudgery.

Figure 86: After Winslow Homer, "The Morning Bell," from *Harper's Weekly*,
December 13, 1873. Wood engraving on paper, 9⅛ × 13½ in.

But women did have more choices by the early 1870s. They were work-ing in jobs that in previous years only men had performed. They weren't working on ships, or building them, but they were working in factories in Lawrence and other cities, including New York, where Homer found a ready new publishing patron in Mary Louise Booth (1831–1889). She was gifted with prodigious energy and writing skill. She could translate from French with the ease of any Parisian, and in her Fifty-ninth Street brown-stone (shared with her longtime companion Mrs. Anne W. Wright) she hosted New York's cultural elite.[31] Just ten days after the *Ville de Paris* docked in New York harbor, Booth launched a new publication, *Harper's Bazar*. It was a sister publication to *Harper's Weekly*, but a different sort of periodical, with Booth as editor-in-chief and a conscious focus on serving women. Booth promised fashion tips, advice for everything from embroi-dery to etiquette, serialized fiction, and of course illustrations, all geared to them. Like Homer, she had a wry sense of humor and delighted in polite subversion. Homer soon sold the new weekly a double-page spread that its editors described as "a birds-eye view of the great fashion carnival" in which its readers found themselves entrapped. "The bright and eager faces of the beautiful girls in the picture attract our attention from the bewildering maze of bonnets, cloaks, parasols, and flowers through which they are

threading their way," the accompanying text explained. In sardonic tribute to his mother's detailed floral studies, Homer depicts the heads and torsos of some twenty of the women as "artificial flowers" emerging with solemn perplexity from the six-petaled blossoms in which they are encased. With humor, Booth and Homer together ask an impertinent question: Might the same country in which a woman can edit a newspaper also offer women in general roles more significant than that of a live manikin?

And so Homer addressed more deeply the subject of vision: what we see and what we don't see. In a full-page article illustrated by Homer, *Harper's Bazar* explained the workings of a *tableau vivant*: a stationary, silent costumed scene. In one wood engraving, seven young women appear as the audience would see them: beheaded, their skulls hanging from a

Figure 87: After Winslow Homer, "Blue Beard Tableau," from *Harper's Bazar*, September 5, 1868. Wood engravings on paper, from sheet 15 × 10¼ in.

rope to which their long tresses are attached. Then, in another illustration, Homer illuminates the tableau's secret: a well-designed sheet with seven holes through which the women (still, but very much alive) have stuck their heads. Booth and Homer, proto-feminists both, attested to the shallowness of the roles to which most women were confined. With humor—and horror—they invite the readers of *Harper's Bazar* to consider more deeply the truth—and falsehood—of what they see.

Another wood engraving calls upon the authority of Holy Scripture to instill readers' understanding that sight has consequences. "Thou shalt not covet" is the tenth and longest of the Ten Commandments. Homer examines closely each component of the command, from Exodus 20:17. Praying men and women must not covet spouses, houses, cattle, servants, or anything else belonging to their neighbors—whether in the Middle East or in New York.

In a children's newspaper, Homer showed not the moral but the physical consequences of sight. *Every Saturday* described lumbermen "of Maine

Figure 88: After Winslow Homer, "Lumbering in Winter," from *Every Saturday*, January 28, 1871. Wood engraving on paper, 11^{11}/$_{16}$ × 8^{11}/$_{16}$ in.

and of Michigan" as long "noted for their stalwart forms and their great courage" and enlisted Homer in depicting two of them. He does not show what the newspaper explains awaits the men each spring: "piled-up masses of logs and ice which come crashing about . . . these brawny sons of the wood conveying their winter's work on the floods of the Penobscot."[32] Rather, Homer depicts a subtler danger: the danger of failing to see an incipient disaster. The figure in the background—already faceless, nearly a shroud—seems perilously unaware that the foreground figure is about to fell a tree—which may fall upon the other man's head.[33] Homer cautions: pay attention. Your peripheral vision may save your life.

In early 1872, Homer left both his studio at Clinton Hall and his apartment in the University Building, and moved into the three-story Tenth Street Studio Building, at 51 West Tenth Street, between Fifth and Sixth Avenues. James Boorman Johnston (1822–1887) had commissioned the complex of twenty-five studios fifteen years earlier from Richard Morris Hunt (brother of the painter William Morris Hunt). Johnston, the younger brother of John Taylor Johnston (1820–1893), who had bought *Prisoners from the Front*, was a visionary. The three-story structure was the first American facility designed expressly for the needs of artists. Johnston's first tenants included not only Hunt himself but the landscape painters Frederic Edwin Church, Martin Johnson Heade, and Homer's friends John La Farge and Sanford Robinson Gifford. Homer's White Mountains traveling friends Homer Dodge Martin and John L. Fitch were there, too; Martin moved into the building first, in 1865, and Fitch about the same time as Homer. Albert Bierstadt came soon after the building opened. It was well suited to artists like Bierstadt and Church, whose skills in showmanship measured up to their skills in painting. They made thorough use of the building's exhibition space, its on-site dining, and other facilities.

Homer's marketing savvy paled beside Bierstadt's, but he knew well the benefits of being at the Tenth Street Studio Building. Half or more of the tenants were fellow Centurions, so he must have visited friends in the building dozens of times before moving there. He made compromises to be with them. Although his two-room suite was the largest on his floor (the second), he did not face north, with its optimal light and quiet. Instead, his exposure was western, toward Sixth Avenue and the Hudson River beyond.[34] For Homer, the prestige of the building, and the social interactions it afforded, made up for the inferior light.

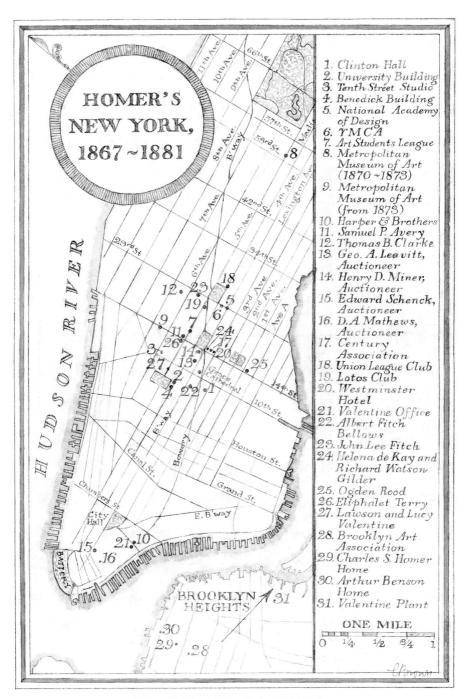

Figure 89: Homer's New York (1867–1881)

Among his friends there was a painter named Enoch Wood Perry, Jr. (1831–1915), who had moved into the building in 1867. Perry was an

extraordinarily well-traveled man who was born in Boston as a member of the well-connected Wigglesworth family. He showed artistic promise at a young age and trained with renowned painters in Düsseldorf, Paris, and Rome, even serving as U.S. consul to Venice at the age of twenty-five.[35] Despite his Yankee roots Perry spent the Civil War years primarily in New Orleans, where his family had moved when he was a teenager. Nevertheless, he also made his way during these years to the remote destinations of Hawaii, Nevada, and California, where

Figure 90: Unidentified photographer, *Tenth Street Studio Building*, 1870. Albumen print, 15⅞ × 12⅝ in.

he painted with Bierstadt in scenic locations such as Yosemite Valley. Perry even spent about ten months in Utah executing twenty-one portraits of Mormon church leaders and their wives, despite receiving a dispiriting letter from the church's head, Brigham Young.[36] Perry's peripatetic life story and keen commercial instincts led him to muse on American identity and to express his understanding of his country and its meaning primarily neither in landscapes nor portraits—in spite of the skill he displayed in those categories of painting. He focused instead on the same specialty as had another Homer friend, Eastman Johnson: genre painting. These works depicted figures in settings steeped in symbolic purpose. One reviewer wrote that Perry "occupies a position very nearly at the head of our *genre* painters. He was one of the first of them to paint American subjects, and the most lowly are invested with a poetry of feeling and delicacy of expression which are not exceeded by any of his contemporaries. That he is a close student, the wide range of his domestic subjects gives ample evidence. His style is broad, but

Figure 91: Enoch Wood Perry, Jr., *The True American*, c. 1874.
Oil on canvas, 11⅞ × 16⅛ in.

in connection with it there are an apparent mellowness of execution and unity of sentiment which are so noticeable in the best works of the modern French school."[37]

Perry's works often employed sly humor to engage viewers' interest. In *The True American*, for example, he depicted five men and a boy on a hotel porch, as two men read a newspaper. None of the six faces is visible, but the corresponding rear ends are on prominent display. Perry alludes to the entitled lassitude his fellow citizens often exhibited in the years after the Civil War.[38]

Homer did not fit neatly into artistic categories but learned much from Perry and other genre painters. In the summer of 1872, his first at Tenth Street, he traveled with Perry on the first of several summer sojourns they would share. He was thirty-six, and Perry forty-one. Unlike his trip to Palenville the previous summer or his travels with Fitch and Martin to the much-visited Presidential Range, however, he and Perry went to Hurley, New York, a farming community on mostly flat land through which the meandering Esopus Creek flows toward the Hudson. A newspaper reporter wrote that they were "sketching the quaint old Dutch interiors which abound

in that neighborhood."[39] The decision to visit there (and again on as many as three additional occasions, in 1874, 1875, and 1876) had much to do with Homer's well-traveled companion.[40] Hurley is renowned to this day for its picturesque Dutch stone architecture, and Perry had built a reputation for documenting in his art the "customs that are now nearly obsolete . . . of the oldest New-York and New-England life that still exists."[41]

The brief comment also reflected the growing awareness of collectors, critics, and painters (including Homer) about the contemporaries of New York's seventeenth-century Dutch settlers who had remained in the Netherlands.[42] Perry was an especially skilled interpreter of the work of such Dutch and Flemish Golden Age genre painters as Adriaen van Ostade (1610–1684), David Teniers the Younger (1610–1690), and Adriaen Brouwer (c. 1605–1638). Their evocative pictures were often set in dark taverns whose denizens offered abundant evidence of the ribald vulnerability of men and women everywhere. Homer understood the artistic and commercial merit of following their example and told a friend, "The great compositions of the old masters were almost all interiors. You can't control the thing out-doors."[43] His *Country Store* painting of 1872 (at the Hirshhorn Museum, Washington, D.C.) is a richly detailed expression of his ambition to weave an ambiguous narrative grounded in the work of Dutch and Flemish genre painters—but with just four characters, all male, and just one sleepy dog.[44]

In a series of pictures he again evoked Dutch precedent, depicting attractive young women in meditative poses, occasionally in pairs but more often alone. In four of these works the female figure appears in a black dress, enlivened only by a white lace shawl. Homer places his model next to a window, with flowers, as Dutch masters did.

The figures Homer painted or drew in illustrations were rarely portraits of individuals. They were archetypes who represented certain classifications of people: wistful young women, salty middle-aged men from the country, or dapper city folk transported to a beach. But on occasion his subject was a friend, such as Helena de Kay (1846–1916), then studying painting at Cooper Union.[45] As with the four women by the window, this figure is alone, in black. But in contrast to those paintings, the setting of the de Kay portrait is a stark, uncarpeted interior, without a window to relieve the

scene, or a lace shawl to lighten his subject's appearance. Homer has dis-
tilled his floral still life to a single blossom, discarded on the floor. De Kay
is in silhouette, her eyes focused not on her viewers but on her closed book.
Like a sphinx, she is hunched, purposefully inscrutable. Her pose might
seem indebted to another interior portrait completed the previous year
(Whistler's *Arrangement in Grey and Black, No. 1*, usually called *Whistler's
Mother*), but Homer probably hadn't seen either that picture or prints de-
rived from it.[46] Homer's palette, on the other hand, is indebted to Old
Masters of Dutch and Spanish painting, such as Rembrandt and Velázquez,
and to contemporary French painters like Manet. But in his syncretistic
adaptation of these precedents, he created a portrait uniquely his own, of
which he was clearly proud, and considered a tribute to his sitter.

While in most other respects his correspondence with de Kay is char-
acteristically formal, he addressed her as "My dear Miss Helena." He sent
her photographs on June 19, 1872, just before leaving for Hurley with
Perry, but described them as "a failure."[47] Photographs, then and now, do
little justice to the portrait. "Go and see your *Clever* picture," he wrote her,
presumably making arrangements for her to visit his studio on Tenth
Street while he was away. "It was painted for you to look at."[48] He knew the
portrait was unconventional but was proud of it nevertheless. "You may
think it will be dull music with so faint a resemblance and so dolorous but
it's like a Beethoven symphony to me as any resemblance of you will always
be." He included in the letter a whimsical sketch of a standing woman,
probably de Kay, holding a fan and reaching up to touch enormous blos-
soms on a tree beset by a gargantuan butterfly. Next to her, a signboard
reads, in all capital letters: THIS IS A FORGET ME NOT.

The letters suggest the two painters were close friends, even confidants,
but not lovers. She considered Homer, ten years her senior, an important
mentor. Homer called her "my runaway apprentice." Few if any other women
had dared to enter the all-male labyrinth of editors, wood engravers, and
other collaborators any artist needed to know to sell new work. Homer was
a rarity: kind and scrupulous, deeply knowledgeable, and eager to guide de
Kay through the channels he knew so well. But like John La Farge, he was
a unique personality and therefore difficult to emulate. Helena's friend Mary
Hallock Foote wrote that La Farge's work "is the result of a temperament
which even his genius can hardly convert into a boon. To draw like him, one
must be like him, I suppose—and one would hardly dare to wish that."[49]

Figure 92: *Portrait of Helena de Kay*, 1872. Oil on canvas, 12³⁄₁₆ × 18½ in.

In another letter Homer wrote:

My Helena,

If you would like to see a large drawing on wood, and will come to my studio on Monday or Tuesday, I shall have a chance to see you.

Why can't you make some designs and let me send them to *Harper's* for you, they will gladly take anything fresh, and I will see that you draw them on the block all right.

Only think how nice it would be for you to make enough for an extra spree next summer—say *Manchester*.

Think of this, and your sincere friend, Winslow Homer. I shall sail next week, but only to Boston.

Early in the year Homer painted Helena's portrait, de Kay met the prominent editor and poet Richard Watson Gilder (1844–1909).[50] They married two years later, and Homer presented the picture to the couple as a wedding present, to hang in their new home, hidden behind a large front garden at 103 East Fifteenth Street. The small brick house, the Studio, was filled with art, books, and spirited conversation. Their many guests included La Farge, Augustus Saint-Gaudens, Stanford White, Henry James, and of

course Homer.[51] Walt Whitman described the couple's prodigious hospitality: "At a time when most everybody else in their set was throwing me down they were nobly and unhesitatingly hospitable . . . The Gilders were without pride and without shame."[52] The couple's countercultural liberality stemmed from the Gilders' gratitude and passion for each other. Watson Gilder composed a sonnet, "Love Grown Bold," in honor of Homer's painting, and in honor of his wife:

This is her picture painted ere mine eyes
 Her ever holy face had looked upon.
 She sitteth in a silence of her own;
 Behind her, on the ground, a red rose lies:
Her thinking brow is bent, nor doth arise
 Her gaze from that shut book whose word unknown
 Her firm hands hide from her;—there all alone
 She sitteth in thought-trouble, maidenwise.
And now her lover waiting wondereth
 Whether the joy of joys is drawing near:
 Shall his brave fingers like a tender breath
That shut book open for her, wide and clear?
 From him who her sweet shadow worshippeth
 Now will she take the rose, and hold it dear?

Courtship was a familiar theme for Homer, but he chose an unlikely medium to explore the theme. He had grown up with at least nine silhouettes cut in around 1825 by an English-born prodigy named William James Hubard (1807–1862). One of them was the sole known depiction of Homer's maternal grandmother, Sally Buck Benson.[53] The others were portraits of eight members of his father's family; Homer inscribed and hung these silhouettes in his studio. They include carefully cut images of three of Homer's uncles and five women; while the women's silhouettes are not inscribed, they are probably their mother, Mary Bartlett Homer, and her four married daughters.[54]

In 1871 he made a series of ink drawings reproduced as silhouette-like prints (Homer called them "Shadow Pictures") to illustrate *The Courtin'*, a book-length poem by James Russell Lowell (1819–1891).[55] His designs not only evoked traditional silhouettes of the kind he had known all his life

LEFT: Figure 93: Paul Konewka, "Margarete," from Blätter zu Goethe, *Faust*,
1865. Lithograph on paper, 7½ × 4 ¼ in.

RIGHT: Figure 94: After Winslow Homer, "An'. . . . Wal, he up an' kist her,"
from James Russell Lowell, *The Courtin'*, 1874.
Heliotype on paper, 4¹³⁄₁₆ × 4½ in.

but also innovative ones made by another prodigy, the short-lived German-
Polish silhouettist, Paul Konewka (1841–1871). Konewka's big break-
through was an 1865 series of lithographs depicting characters and scenes
from Goethe's *Faust*. He went on to illustrate Shakespeare's *A Midsummer
Night's Dream* and a variety of other subjects, including children's rhymes
published on both sides of the Atlantic.[56]

In a demonstration of the degree to which Homer worked in separa-
tion from the poet—and at odds with his taste—Lowell evidently did not
see the book until well after it was published. He described Homer's
drawings as "simply disgusting" and said he intended to tear them all
out.[57] The correspondence gives us no indication of why Lowell found
them so offensive, or how Homer responded to this scorn from his one-
time collaborator. But a comparison of his drawings with those of Ko-
newka suggests he had trouble creating work that measured up to the
sophisticated standard of his European counterpart, and Homer knew
it.[58] Konewka's work is far more subtle and layered than is Homer's. *The
Courtin'* was one of Homer's numerous experiments with reproductive
technology, some of which panned out better than others—both com-
mercially and artistically.

Homer also evoked the theme of courtship for a Valentine's Day illustration just after his return from France. But as with the Lowell drawings, the depiction is distant, not personal. Couples across the centuries and across the globe romance each other, from ancient Rome to Japanese theater to eighteenth-century European courts. But their relationships hardly seem torrid; they reflect a view of romance highly removed from the actual experience of love.

Three years later, Homer experienced courtship firsthand. On his 1871 visit to Palenville, he had met a twenty-two-year-old schoolteacher named Eugenia Renne.[59] Hers was a profession that suddenly opened up to women in the 1860s with male teachers away at war. When Homer returned the

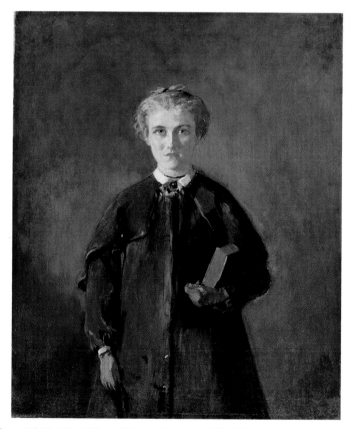

Figure 95: *The School Mistress (Eugenia Renne)*, c. 1870. Oil on canvas, 18⅝ × 15⅝ in.

following summer for his second and final visit to the riverfront studio of his friend Hall, Renne's situation had changed. She had married the inn-keeper next door to the studio. In a rare case of Homer ever illuminating any crevice of his romantic life, he lamented to de Kay that with "the School Ma'am" now unavailable to him, "I expect my heart line will shrink." He painted another portrait at the same time he painted de Kay—and it seems to be of Renne. Where his portrait of de Kay is oblique, that of Renne is frontal, suggesting a wakeful kindness and an intelligent confidence. This is no archetype but a woman of flesh and blood with a personality all her own, just as de Kay had. The portrait speaks to the respect and affection Homer felt for her. No other documents survive, however, to tell us to what extent Renne, unlike de Kay, had reciprocated his feelings for her.

Love depends on a willingness to be vulnerable, to accept the possibility of rejection. Homer's work shows a firsthand understanding of the fact. That summer he created an illustration in which he posed a different triad. It is not Renne, her new husband, and himself in the mountains, but two women and a man on a beach he had painted in Gloucester the previous year.[60] A woman carrying a parasol climbs to the top of a dune, to leave the romantic pair behind her. The title says it all: "On the Beach: Two Are Company, Three Are None." The foreground figure knows when she is out of place as, we may infer, did Homer. The accompanying unsigned poem reads:

> Out on the sands we walked, and watched
> > The sea-gulls dipping white wings low,
> > While gently murmuring at our feet the waters rippled to and fro.
> > > And merrily
> > > And happily
> > We watched the wavelets come and go.
> And one of us was very fair—
> > Alas! I knew it was not I;
> > But ah! Ah me! My heart was quick
> > To note his face when she was by,
> > > Where all too well,
> > > With tender spell,
> > Love wrote his own tale silently.
> And so at last I left them there,
> > And all unheeded went away,

Lest e'en the birds should read my heart,
As I had read myself that day.
 My dream was o'er:
 With them no more
I watched the rippling waters play.

However stretched Homer's "heart lines" with Renne may have been, it is unsurprising that, once the relationship had ended, he immediately memorialized in paint both Renne and her profession. As an illustrator, he had long depicted children and how they learn. The work he did now was different. He created a series of works set in and near a one-room red schoolhouse, of which many hundreds once stood in the Catskills, and which were already fast becoming obsolete. The first of these pictures may relate to the classroom of Eugenia Renne in Palenville.[61] He exhibited the picture as a companion for *The Old Mill*. It is of similar width and presents an interior that is the opposite of what a viewer imagines embedded within the decrepit industrial building. This structure is high-ceilinged, washed with sun, and filled with young, bright minds. His model appears to be the same as the central figure in *The Old Mill*. Her sunbonnet is identical to the one worn by that figure. In this picture, she holds a book in her hand and is an exemplar of kind intelligence.

Figure 96: *The Country School*, 1871. Oil on canvas, 21¼ × 38¼ in.

Figure 97: *School Time*, c. 1872. Oil on canvas, 12½ × 19¼ in.

A second picture, exhibited just three months later on February 3, 1872, depicts the exterior of a school.[62] Inasmuch as the model at the center of the picture is the same as that in *The Old Mill* and *The Country School*, and the topography is similar to that of Palenville, logic locates this school building somewhere near there.[63] A long-standing oral tradition in Hurley suggests the inspiration for the picture is a building still standing at the foot of the town's Eagle's Nest Road. However, there is no documentary evidence for Homer's coming to Hurley prior to the summer 1872 visit with Perry. Judging from the topography alone, the best candidate is Schoolhouse #19, long since vanished but once a landmark in a tiny hamlet in the southwest corner of Renne's native Cairo, about an hour's walk north of Hall's Palenville home and studio.[64]

The most acclaimed of these works, *Snap the Whip*, depicts a group of boys outside their school engaging in a game called Crack the Whip. Homer located this picture at the same school where he had sited *School Time*. The boys appear all a similar age, about seven years, so born just as the Civil War was ending. The game they play was a simple and common one in which a chosen leader pulled a group of boys holding each other's hands; the dizzying effect of twisting the "whip" would create enough confusion that over time some boys would fall to the ground. The painting suggests layers of tension, between play and danger, leisure and education, youth and

hardship yet to come. It is also a dazzling depiction of both motion and the stoppage of time. Just then, three thousand miles away in California, Eadweard Muybridge (1830–1904) had been hired by Leland Stanford (1824–1893) to make photographs of animals in motion, achieving a similar effect to Homer's painting.[65] Muybridge, a born promoter, could not prove or distribute his animal locomotion photographs until 1878, so Homer's *Snap the Whip* of 1872 certainly preceded the painter's seeing any of them.[66] Although today the picture is considered an American classic, at the time not everyone liked it. One critic complained of *Snap*'s "crudities and apparent carelessness of execution," but nevertheless praised it as "good in composition, drawing and expression, and pleasing." Homer understood how to capture an essential American moment with a deceptive directness. The story he conjured up was calculated to usher in his viewers, so that they, too, might experience what Homer had: innocence and danger, beauty and wonder, hope and vulnerability. He painted as Whitman and Twain wrote: from his own heart and his own experience; for Homer, beauty lay in the truth of what he himself had known. And the truth was one of time's evanescence.

Enough collectors liked the picture that one asked him to do it again. John Hinman Sherwood (1816–1887) was a wealthy New York real estate investor who prided himself in commissioning pictures directly from artists.[67] *The Country School* was one of those, and he had commissioned a version of *The Bright Side* (1865) called *Army Teamsters* (1866). In each case, Sherwood's practice was to request a larger and more complex version of a preceding work. The same pattern emerged with *Snap the Whip*. The picture he commissioned is nearly twice the size of the first version. Sherwood's grander painting also includes a ninth boy to the left (missing in the original) and darker tones. In the later version, and in the related illustration, a mountainous terrain and a brewing storm heighten the sense of suspense.[68]

After completing his enlarged version of *Snap the Whip*, Homer reworked the original picture to differentiate it. Infrared analysis shows that Homer painted over the mountains that were once visible.[69] He probably made other changes to the smaller picture for the same purpose, such as adding a church steeple and bystanders to the left. These changes have the effect of connecting his scene not to the dramatic hills and valleys of Palenville but to the flatter farmland of Hurley.

Figure 98: *Snap the Whip*, 1872. Oil on canvas, 22 × 36 in.

Both pictures adhere closely to the golden ratio dimensions and position the tallest boy at the center. The horizontal centerline of the original picture runs precisely through his waistline and those of four other boys, with a color contrast heightened by their bright white shirts. In the darker, enlarged version, Homer runs that line through six of the boys' hats, and neatly across the central boy's neck, subtly decapitating him. In both pictures, the vertical centerline connects that boy to the left edge of the schoolhouse, where the corner of a window is just visible over his shoulder. It draws our attention to the left pocket of the central boy's jacket, from which a chain dangles. To what does the chain connect? Homer invites the viewer to speculate. A fishing line and sinker? A slingshot? A watch? Homer gives no answers, only tantalizing clues. He invites our wonder of what the decades to come will bring to this first generation after a war they neither saw nor heard, but which shaped them nevertheless.

Homer had been thinking a lot about time and its fleeting nature. John Spencer Clark (1835–1920), a partner with the Boston lithographer Louis Prang in publishing manuals to teach children drawing, asked Homer to create a drawing to accompany a poem by Lucy Larcom (1824–1893). Clark evidently didn't respond to the drawing promptly enough. "My Dear Mr. Clark," Homer wrote, "I have not heard from you since I sent the 'Clock Doctor.' Did you get it? And would you like to have me make you

Figure 99: *Snap the Whip*, 1872. Oil on canvas, 12 × 20 in.

that Sea Shore drawing. If so, send me a [wood] block. I shall go out of town the first of May. Yours truly, Winslow Homer."[70] Larcom ultimately did publish a poem called "The Clock-Tinker" but no illustration from Homer accompanied it.[71]

Other time-related works include a series of paintings, and a print, related to sounding a horn at dinner, to call in unseen farmworkers to a house kept by a young woman. His print for *Harper's Weekly* as 1869 dawned included a toddler riding the recently invented bicycle as Father Time, a scythe over his shoulder, drives away a wheelbarrow marked "1868."

Homer, a keen student of history, turned to reflect on the entire decade of time marked by the Civil War. In one of his most complex wood engravings, "1860–1870," he placed the center of his "Wheel of Time" not at its chronological midpoint—1865—but on its pivot.[72] At the top of the illustration, Abraham Lincoln, bathed in the rising sun on the first day of 1863, holds the Emancipation Proclamation at the moment it became effective.[73] Around that pivot, three of Homer's four scenes are battles, including Fort Sumter at lower left and the ironclad U.S.S. *Monitor*, an observation balloon above it, at upper left. Homer quotes a stanza from Tennyson's "In Memoriam," dedicated to a friend who died at twenty-two years:

Ring out a slowly dying cause,
And ancient forms of party strife;
Ring in the nobler modes of life,
With sweeter manners, purer laws.[74]

At the center of the print's base, a bicyclist tumbles over his handlebars, as if capricious Father Time has tripped him. In the final quadrant at the lower right corner, Homer turned from war to peace, with a background view of the surrender at Appomattox in the distance. In the middle ground, two veterans of the war, still wearing their forage caps, swing scythes more purposefully than does Father Time beneath them. They beat their swords into plowshares. They are farmers now, coaxing food from soil upon which, and for which, they may themselves have fought. In the foreground, Homer turned in hope to children. He depicts another schoolteacher, leading a multiracial class including one student who has written Homer's name lightly and below the alphabet. More conspicuously, a child has written on the blackboard the names of the recently elected president and vice-president, "Grant & Colfax."[75] Homer inscribed behind Father Time another hopeful stanza from Tennyson's tribute to his dead friend:

Ring out false pride in place and blood,
The civic slander and the spite;
Ring in the love of truth and right,
Ring in the common love of good.[76]

Figure 100: After Winslow Homer, "1860–1870," from *Harper's Weekly*, January 8, 1870.
Wood engraving on paper, 13⅜ × 20⅜ in.

CENTENNIAL TRUTHS
(1873–1877)

HOMER WAS THIRTY-SEVEN IN 1873, precisely at the middle of his life. The year invited him to look both backward and forward. As John Wilmerding has observed, "even the numbers . . . form a rare conjunction of mirrored figures looking in opposite directions."[1] He entered new territories in his media, his subject matter, and his range of friendships—as he wrestled with the demons of his own childhood, of his country's history, and of the injustices persisting around him.

"Erect, slim, well groomed, military looking," he appeared that year to the budding sculptor and illustrator James E. Kelly.[2] "Slightly bald, dark, close-cropped hair, fine well-molded forehead, sparkling black eyes; very straight, prominent nose; full, mobile nostrils; dark mustache, brushed abruptly aside with a slight twist, like a cavalry officer; clean-cut, sensitive mouth and chin, and a fine, full throat. His hands were slim, brown and shapely. He had the movements and graceful bearing of a thoroughbred; was dressed to perfection—markedly so; his black cutaway coat and steel-gray trousers had the set and precision of a uniform."[3]

Despite his dapper appearance, most New Yorkers would have considered Homer a mere illustrator, albeit a talented one who once had made a single great painting—*Prisoners*. An eighteen-year-old Kelly accosted Homer at a drawing class and told him admiringly, "I saw your *Prisoners from the Front*." Homer replied, "I am sick of hearing about that picture."[4] He got no credit—yet—for making anything else comparably important to that meditation on the Civil War. Just a few men—Fitch, Martin, Hall,

Sherwood, and the young Kelly among them—understood that in Homer's evocations of fleeting time in children's play, he had already created several American classics comparable in significance to *Prisoners*—and would soon create several more. But in the small world of New York's art cognoscenti, those few observers were sufficient. Just twelve days into 1873, Homer was chosen to join the Art Committee of the Century.[5] He was one of only three members. The committee's chairman was his friend Fitch. The other member was Thomas Waterman Wood (1823–1903), who would soon join Homer at the Tenth Street Studio.[6]

Wood had already achieved fame for *A Bit of War History*, a series of three paintings. In the first, *The Contraband* (1865), Wood depicted a smiling young Black man as he arrives at a Union Army provost marshal's office. The second, *The Recruit* (1866), portrays the same man striding out of the office in uniform, a rifle over his shoulder. In the conclusion of the series, *The Veteran* (1866), the man returns to the office on crutches. Raising his right hand, he salutes in pride and in sorrow. He has sacrificed half his left leg. Wood's empathy for Americans once enslaved was powerful—and for Homer a pivotal influence, albeit one that, like so many other influences, he never discussed.

Homer also served on the Hanging Committee for the National Academy of Design. While its most prestigious exhibition each year was in the spring (its Annual), the academy had begun to host winter exhibitions as well. As Kathleen A. Foster has demonstrated, a revolution had begun.[7] For years, watercolor painters had won little respect for their work. Among them were many people close to Homer, including his mother, his teacher Frederic Rondel, and two Dutch-born Tenth Street Studio neighbors, the marine painter Maurits de Haas (1832–1895) and the landscape specialist Hendrik Dirk Kruseman van Elten (1829–1904). But change was coming. As winter winds cooled the streets of New York in late 1867, the fervor of the watercolorists heated up the stale air of the academy's galleries. The National Academy hosted the Winter Exhibitions, but another organization dominated them: the American Society of Painters in Water-Colors.

Samuel Colman (whom Homer had known from his earliest days in New York, studying in the Life School) and ten other artists had founded the society on December 5, 1866, the very day Homer boarded the *Africa* and set sail from Boston for Liverpool. Soon to be renamed the American Watercolor Society (hereafter AWS), it was born in the studio of the painter Gilbert Burling, Homer's neighbor in the University Building in New

York—one of the society's first three officers. Colman was president. The forty-two members listed at the first exhibition included Wood, Rondel, and the Columbia physicist Rood. Two English-born brothers were also active at the inception: Thomas Charles Farrer (1838–1891) and Henry Farrer (1844–1903). Thomas, a devotee of John Ruskin, had served in the 22nd New York Infantry Regiment and married the daughter of a North Carolina–born Yale graduate who became a prominent evangelical Presbyterian minister in Brooklyn. Thomas had already founded a brotherhood of American Pre-Raphaelites under the banner of the Society for the Advancement of Truth in Art. Remarkably for that moment, the members also included two women, each unusually well traveled: the English-born Elizabeth Heaphy Murray (1815–1882), then living with her British diplomat husband in Portland, Maine, and the well-connected South Carolinian poet and artist Caroline Petigru Carson (1820–1892).[8] Watercolor was a medium in which women had been active for years. These and other imaginative women were pioneers in emulating the work of Turner and his fellow British and Continental painters who had demonstrated the breadth of watercolor's possibilities. The founding members shared a common goal: to persuade collectors that the art of watercolor was as worthy of admiration—and of economic value—as was oil painting.[9]

Bostonians, including Ellen Robbins and the architect of the Boston Athenaeum, Edward Clarke Cabot (1818–1901), were well represented from the start. One of them, Albert Fitch Bellows (1829–1883), was another Centurion. Like Perry and Wood, he was a well-traveled genre painter; he had visited the Rijksmuseum in Amsterdam in 1855—one of the first Americans to do so.[10] Like Fitch, he also made landscapes. He had worked in two Boston architectural practices as a young man, and then as the principal of the newly opened New England School of Design for Women.[11] He was a passionate advocate for watercolor painting, and the author of a pamphlet the society published in 1868 just after its first exhibition. The manifesto, *Water-Color Painting: Some Facts and Authorities in Relation to Its Durability*, was unabashed in its enthusiasm. "For certain luminous qualities, for purity of tint and tone, for delicate gradations, especially in skies and distances, [watercolorists'] favorite style of painting has decided advantages over oil," he wrote.[12] The pamphlet quoted extensively from the English watercolorist Aaron Penley, whose work Homer may have seen in London, and who commended "the granular surface of

the paper" used in watercolor. "From this peculiar grain, this alternation of hill and dale, as it were, of the surface . . . the eye rather looks *into* than *upon* it, and carries the *impression* of space more than of definite distance" (italics added).[13] Penley was a figure of great influence at the time.[14]

When Homer attended the opening of the watercolor society's Sixth Annual Exhibition in the winter of 1873, it had grown to a stunning 558 watercolors. The show reflected the degree to which American painters were indebted to British precedent; works by Turner and by the art theorist John Ruskin appeared in the society's section, and another 204 works from English, French, and artists of other nationalities appeared in a special loan display, "The English Collection of Water Colors and Sketches."[15] The work of the irrepressible Elizabeth Murray appeared in both the AWS and loan sections. Bellows was again well represented, as was an artist winning new renown: the young entrepreneur and designer Louis Comfort Tiffany.[16] Albert Pinkham Ryder, a brilliant and eccentric New England painter and a contemporary of the prodigy, lent two Tiffany watercolors, each titled *Moorish Figure*.

Fewer than two weeks after the monthlong AWS show closed on Wednesday evening, March 5, 1873, another exhibition opened at the Brooklyn Art Association.[17] Artists who exhibited at a major Manhattan show such as the Winter Exhibition would often then exhibit those works again at the Brooklyn venue. But in 1873, the Brooklyn show included an artist whose watercolors had not appeared in the Winter Exhibition: Homer's mother, Henrietta, newly arrived in Brooklyn. She had come to the right place for several reasons; at the Brooklyn Art Association, female artists were especially welcome.[18] It was the first known occasion on which she exhibited her work in New York, but it would not be the last.

As spring weather warmed the streets of New York, Homer and many other artists began making their plans to depart the city for more pleasant surroundings. The *New York Herald* chronicled the summer destinations of 115 artists, including Bellows, the great exponent of watercolor.[19] He had exhibited a watercolor called *Gloucester Harbor, Cape Ann* in the AWS show. The newspaper reported that Bellows was returning to Cape Ann and was the only artist to choose that as his destination.

Homer told the *Herald* he was heading to the White Mountains of New Hampshire. But that wasn't true. We cannot know with certainty just why he lied about his whereabouts that summer—but we can guess. At the

Figure 101: Homer's Cape Ann (1868–1885)

time, Homer was in Gloucester. Just one other prominent artist was also there: Bellows. In Gloucester, Homer, like Bellows, made a series of watercolors with the intention of exhibiting them. Never before had he done so. One can infer that by the summer of 1873, the influence of others had won Homer over. Just as his mother, Bellows, Wood, and Fitch surely urged, Homer would become a watercolorist, and proud of it. But that didn't mean that he would ever admit anyone's persuasion—or their presence with him at the turning point.

But a turning point it was—in his career, and in his life. Over the course of about two months, he created some twenty-seven watercolors—about one every other day. He must have finished many of them in the long summer evenings in his room at the Atlantic Hotel at the west end of Gloucester's Main Street. His room might easily have faced the sun setting behind Norman's Woe and the Gloucester hamlet of Magnolia, where, several years later, the much-admired William Morris Hunt would set up a studio and teaching practice.

Attentive as Homer may have been at finishing them indoors, these watercolors nevertheless have a sparkling quality that suggests he conjured them up instantaneously, *en plein air*. They are simple in a sense: just colored drawings. He began each watercolor as he would a drawing from which to develop a wood engraving. First, he scouted out a promising location. Then he found his figures at play—a single child, or a group of children. If the children had failed to find the right spot to play, Homer would produce a nickel's honorarium for each. Many were poor; some were orphans. Their fathers' life expectancy averaged forty-two years, and their mothers' little more.[20] For that scarce nickel, these boys were happy to sit or to stand wherever and however the self-assured painter directed them in his Boston twang.

Then Homer reached into his knapsack. Each of the rag sheets on his block of paper (or in his sketchbook) was about ten by fourteen inches. He was loyal to paper made by Whatman, the firm established in Kent in 1740 and which had supplied Turner and countless other skilled watercolorists on both sides of the Atlantic. Doubtless Bellows encouraged this loyalty and extolled the paper's naturally reflective quality, perfect for a bright

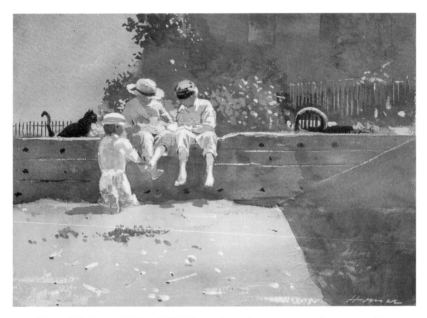

Figure 102: *Boys and Kitten*, 1873. Watercolor and opaque watercolor over graphite on moderately thick, textured cream wove paper, 9⅝ × 13⅝ in.

summer day. Homer drew his lines quickly in graphite pencil, with bold geometric patterns reflecting both his history as an illustrator and his study of Japanese ukiyo-e woodblock prints. Last, he took out his paint, more opaque in this period than transparent. He applied it thickly, coloring between his lines and reinforcing the deceptively simple shapes of his design. Usually he worked in a horizontal format composed of three or four bands stacked one on top of another.

Homer located one such drawing, *Boys and Kitten*, at the edge of a beach. Two Gloucester children (one with a white kitten in his lap) sit on a wooden retaining wall. Another boy kneels in front of them on the sand. Behind them, a silhouetted older cat oversees the play protectively, ready to leap in should the boys get out of hand. Homer devotes fully half the sheet to the shadow at lower right and the contrasting sand sparkling at left—bisecting the sheet's lower half with a bold diagonal. He crowds his narrative action into the left side of a narrow middle band—and uses that diagonal to guide our eyes to it. He characteristically leaves the top band, with the sky, shrubs, and house, "sketchy," as his critics would complain. He knows what most critics didn't: any incremental finish to the setting would

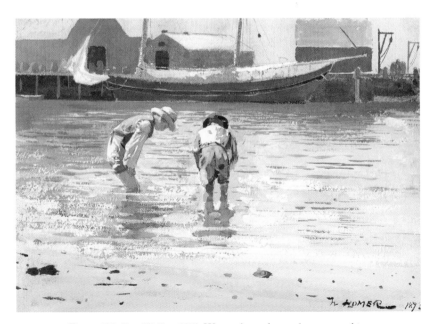

Figure 103: *Boys Wading*, 1873. Watercolor and gouache over graphite
on wove paper, 9¾ × 13¾ in.

detract, not add, to the charm of the composition. He delights in the evidence of his art-making, the visible drag of his gouache on the paper, the crooked tideline of the watercolor running down the wall. Homer created just enough narrative to draw the viewer in. But not too much; he rarely provided more than a hint of the expressions on the faces of his principal characters, the sun-washed boys. One viewer wrote that *Boys and Kitten* "is as good an artistic tonic as the fresh salt air in which the scene is laid."[21]

Another sheet, *Boys Wading*, is a meditation on the experience of looking. Here the broad middle band fully captures the boys—as the glittering water fully captures their gazes. We can't see what they can—but we want to. Homer contrasts the adult world of work in the upper band—warehouses, a sturdy fishing schooner, pulleys for baskets of fish yet to arrive—with the boys' world of play.[22] They, and the painter, invite us into a private vision. It awaits, just beneath the surface. All we need to step into that vision is observant eyes, and a childlike willingness to use them.

Homer's nostalgia for childhood, in all its quotidian ordinariness, was unabashedly sentimental. But it was also honest. His embedded stories needed to be true, to acknowledge both danger and the injury that might follow. The five boys in *See-Saw* are all barefoot, but one sports a bandage on his left foot. The largest boy, at center, controls the balance for all five, and can easily threaten his smaller playmates. Homer, having been a delicate, sensitive boy himself, surely suffered many a bully growing up in Boston and Cambridge. He also suffered a mercurial father, lurching from one entrepreneurial scheme to another, his wife and sons hostage to the fulcrum of his inventive imagination. Homer's watercolor includes a shadow behind the lowest boy, allusively threatening the evanescent moment of delight.

At thirty-seven, with two decades of experience in illustration, Homer knew well the ways in which these colored drawings might serve as winning designs for wood engravings. He sold *Harper's* seven new illustrations, at about $100 apiece, based on the watercolors he made over the long Gloucester summer. Some of these wood engravings combine ideas from multiple watercolors. In *See-Saw*, for example, three girls demurely play Cat's Cradle in the foreground; in the watercolor from which the girls sprang, instead they examine a cooked lobster with wary eyes. Homer knew how to appeal to his markets. The broad *Harper's* audience favored

busy designs and implicit assertions about the disparate interests of boys and girls. Discerning collectors for a watercolor might appreciate a bit more subtlety and humor.

The allusion to menace was not unique to *See-Saw*—or unique to threats from boys and men. Nature carried her own threats, too. Homer was in Gloucester on August 24 when a catastrophic gale swept up the Atlantic. The tempest assaulted the town and its people with unsparing, merciless force, decimating the commercial fishing fleet upon which the town depended for more than 90 percent of its economy. Then, as now, the livelihood of fishermen depended on their taking grievously high mortal risk.

> Houses were blown down, trees torn up from their roots, and the tidal wave which accompanied the storm, carried the wrecked vessels far above high-water mark, and left them stranded on the shore. Wharves were destroyed, and desolation and ruin followed in the track of the storm. Day by day the sad news came, and there is mourning throughout the town as we pen this article. Wives are weeping for their husbands, who will never again bless them with their earthly presence; sisters are mourning for brothers, and little children ask, in plaintive voices, "Why does not father come home?" It is, indeed, terrible, this news from the fishing-fleet; and the loss of life, before which all other losses sink into utter insignificance, is greater than by any other one gale since the fishing business commenced.[23]

Homer wrote not a word about the gale—at least not one that has survived. But in paint, he sketched a memorial to the dead—and a tribute to the women and children abandoned in the wake of the storm. He painted the memorial again, not in watercolor, but in oil. He drew it again, on the woodblock, for the hundreds of thousands of Americans who would see and understand the grief he, too, felt that terrible day. He sold each work: a single powerful idea, filled with empathy and earning him a threefold return.

The colored drawing includes just one figure, a boy looking out to sea, seated atop a beached dory.[24] Homer characteristically omits any description of the boy's emotional state. Into the picture he invites us, and our imaginations.

When Homer transformed the design into an oil painting on panel,

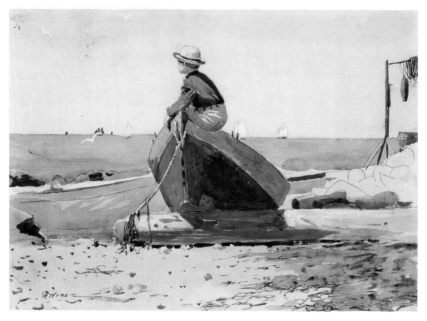

Figure 104: *Waiting for Dad* (*Longing*), 1873. Transparent and opaque watercolor
on wove paper, 9¾ × 13⅝ in.

slightly squatter than the watercolor, he added a columnar figure of a young
woman, holding a toddler. She brings a solemn air of worldly knowledge
about the uncertain fate of the unseen man at sea—on whom both she and
the children depended. Homer would have sold the oil for about $100,
twice the value of the watercolor. He carefully articulated the shape of the
patched dory, the fabric of the clothes, and the nets hanging at right. Sig-
nificantly, he recalculated the geometry of his composition. The watercolor
is centered on the dory's dark underside, with a horizontal centerline above
the horizon and a vertical centerline running through the boy's seat. The
oil, by contrast, puts the horizontal centerline exactly on the horizon. Ho-
mer sets the vertical centerline on the right thole pin, silhouetted against
the white sail of a distant schooner. The diagonal running from upper left
to lower right kisses the dory's gunwale. The diagonal running from lower
left to upper right severs from their bodies the heads of both the young
woman and the toddler. The geometry leads us unconsciously to absorb the
unsettling possibility of a tragic outcome. The nets hanging at right vaguely
suggest a hangman's noose. Homer sold the painting to Joseph W. Harper,
Jr. (1830–1896), a younger member of the family that controlled *Harper's*

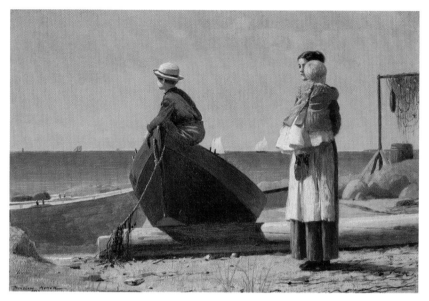

Figure 105: *Dad's Coming!*, 1873. Oil on panel, 9 × 13¾ in.

Weekly, *Harper's Bazar*, and other publications.[25] Harper was a collector who could appreciate the subtle drama to which Homer alluded. At the heart of this memorial in paint, an empathetic pun awaits discovery. While *thole* is a noun for a pin set in the gunwale of a boat to keep an oar in place, *thole* is also something else: a verb. To *thole* means to survive, to tolerate, to suffer, or to endure without complaint.[26] "A boy-child" in *Beowulf* "knew what they had tholed, the long times and troubles they'd come through without a leader."[27] Homer's "boy-child" likewise represents all those who, longing, have endured, as indeed from Middle English has the word *thole* itself.

The final step—the wood engraving for Joseph Harper's newspaper—stuck closely to the oil painting's design. But Homer introduced small differences, appealing to the newspaper's broad market. *Harper's Weekly* had hundreds of thousands of readers across a wide spectrum of classes, ages, and geographies. In this market, there was little patience for delicate artistry or a hint of gloom. The breeze on the nets, and the shorter stature of the young woman, each alleviate the oil's sense of foreboding. And *Harper's* supplied a poem to accompany the illustration, whose hopeful lines assure, "Nearer and nearer the light breeze is wafting / The wanderer back to the home of his love."[28]

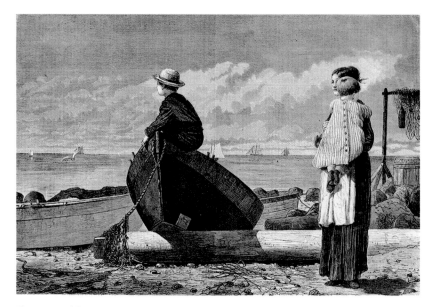

Figure 106: After Winslow Homer, "Dad's Coming!" from *Harper's Weekly*, November 1, 1873.
Wood engraving on paper, 9¼ × 13½ in.

Most of the watercolors Homer made that summer, like *Boys and Kit-ten*, didn't form the basis for illustrations, or for other works of art. The watercolors Homer brought back to New York in the fall were works of art in themselves. Homer knew it, Bellows knew it, and perhaps best of all, Clarence C. Cook of the *New-York Daily Tribune*, the country's most in-fluential critic, knew it. When, on January 28, 1874, the Seventh Annual Exhibition of the American Society of Painters in Water Colors opened, it included five entries from Homer.[29] Each carried the same title: *Leaves from a Sketch-Book*, and each included two watercolors. Perhaps reflecting the tentative nature of Homer's foray into exhibiting work in this medium, none was for sale. The exhibition received varying attention in those early days of the watercolor movement; *The New York Times* gave the opening just two paragraphs.[30] But Cook wrote:

> The "Leaves" from Mr. Winslow Homer's sketch-book, are very strik-ing leaves indeed, and we could be content to see more of them. There is an original vein in this artist, and in working it, his love for truth and directness keeps him well clear of affectation—into which vice we have never once known him to fall. Nor, though we believe he got much of

his art-education in Paris, does he in the least recall the manner of any famous artist there. It is true he has a manner of his own, mannerisms, if the reader choose to call them such, but the manner has sprung from the artist's individual way of looking at Nature, not from his way of looking at some other man's pictures. Mr. Homer plainly enjoys his art. His pictures have nothing shoppy [*sic*] about them, as if they were only made to sell. We imagine the artist painting for pure pleasure, and being rather surprised at any one's thinking of buying his work. These ten sketches—mere memorandum blots and exclamation points as they are—are sure to arrest every passer; no one can fail to see that they have been made by a clever, observing, truth-loving man. They are so pleasant to look at, we are almost content not to ask Mr. Homer for a finished piece.[31]

Homer could read another critic's verdict: "in life, vigor and individuality the leaves from the sketch-book of Winslow Homer are surpassed by nothing in the exhibition."[32] It was the fulfillment not only of his own dreams but of those of Bellows and many other evangelists for the medium. Watercolor had won an imprimatur of approval previously lacking. While some critics found them eccentric and "sketchy," the five leaves from the hand of this quiet son of Boston had opened up a new path for his own economic prosperity. Just then the country was descending into a deep six-year recession, and many other artists struggled. But with his emerging reputation as an extraordinarily gifted watercolorist, Homer began to flourish.[33]

The summer of 1873 was a breakthrough moment as the catalyst for Homer to create his first suite of watercolors for exhibition. But it was a breakthrough moment in another way as well. Just as Homer was conjuring up gossamer glimpses of summer sun, he was also grappling with the weightiest matter his country faced: race.

More than a decade had passed since the Emancipation Proclamation brought what Frederick Douglass hoped would be "the freedom of all mankind." The war's end did not deliver on that lofty promise. Congress passed a bill in early 1866 to strengthen the Bureau of Refugees, Freedmen & Abandoned Lands (known generally as the Freedmen's Bureau), which was tasked with protecting the rights of those once enslaved, most of whom remained economically dependent on white planters. The Bureau sought to provide every opportunity for these men, women, and children

to advance, despite their significant disadvantages in literacy, wealth, and other factors. On March 2, 1867, fewer than two years after the end of the Civil War, the Reconstruction Act of 1867 became law, overcoming a presidential veto. The legislation provided terms for the readmission to the Union of the eleven states that had voted for secession. The act required each of the eleven states to write a new constitution on behalf of their 9 million citizens. Through these foundational documents, approved by a vote of the majority of its citizens, each state would assure the rights of all people—regardless of skin color. The act also required each state to affirm the Constitution's Thirteenth Amendment abolishing slavery nationwide, through state-by-state ratification. The following year, on July 9, 1868, the Fourteenth Amendment was ratified. Building on the Civil Rights Act of early 1866 (also enacted over a veto by Lincoln's successor, Andrew Johnson), the amendment granted citizenship and "equal protection under the laws" to all people "born or naturalized in the United States," including, of course, those 3.5 million formerly enslaved. Each of the eleven states was also required to ratify this amendment prior to recognition and readmission in the Union. Radical (or congressional) Reconstruction governments across the South, controlled by Republicans and backed by primarily Black voters, set about transforming the region.

Building on the foundations laid through the new federal laws, these governors and legislators sought to enact in state law other essential protections: effective bargaining power for plantation laborers, state-funded public schools (which the South had never previously had), and an end to racial discrimination. These efforts failed, as white supremacist organizations such as the Ku Klux Klan undermined the Republican leaders and those who supported them—both white and Black. In its notorious decision on the Slaughter-House Cases (April 14, 1873), the Supreme Court ruled 5–4 that U.S. citizenship did not grant state citizens equal protection under the law. Specifically, the butchers of New Orleans, white and Black, whose lawyer argued that they sought to "sustain their lives through labor," had no choice. They were obligated to purchase from the city's sole slaughterhouse, a monopoly.

Homer was keenly aware of these pivotal steps in rebuilding his country. Many in the North—particularly those like him who were raised in mercantile families—followed these current events closely. But Homer had another, much more personal reason to watch the progress of Recon-

struction. His brother Arthur was instrumental in its implementation in Texas. A selfless lawyer, James Prentice Richardson (1821–1901), who had known the Homer brothers as boys in Cambridge, hired Arthur in 1867 to work under his supervision as an agent for the Freedmen's Bureau.[34] He directed Arthur to Columbia, a tiny town south of Houston and west of Galveston that had served in 1836 as the site of the first Congress of the Republic of Texas and of the inauguration of Sam Houston as the fledgling nation's president. Fewer than eight thousand people, predominantly Black, lived in Columbia's entire county, Brazoria. Ranching and growing corn, cotton, and potatoes from the flat clay soil comprised Columbia's modest economy, which operated primarily on a barter system; little currency circulated in the county. Arthur's title, subassistant commissioner, gives no hint of the breadth or complexity of his responsibilities, which would have challenged anyone, let alone a man with limited managerial experience and just twenty-five years of age. All manner of complex matters fell to him, from the education of Black children to the enforcement of fair labor contracts between white planters and the men and women they formerly enslaved, to the removal of a young woman from the clutches of a would-be bigamist.[35] Arthur served in a highly visible role that was more than unpopular; anyone in it risked being killed. One planter in response to a summons to appear in court sent Arthur "word that the Bureau might go to Hell. I then ordered him to appear and said I should send a military force and arrest him if he did not come. This brought him."[36] He enforced the rights of Black parents to obtain custody of their children from landowners, white and Black, who retained them forcibly. Arthur wrote to one such landowner, "Should you refuse to obey this order I shall send the sheriff to arrest you and you will have to pay the costs."[37]

Arthur must have kept Winslow and Charlie well informed about his tribulations, although no letters of this period between the brothers survive. The county had a history of racial violence, and he was in constant danger, as were many of his Black neighbors. While murder was rare, "white Texans more frequently resorted to other acts of non-lethal violence (e.g., beatings, assaults, castrations, whippings, arson) against newly freed blacks for a wide variety of perceived 'misdeeds,' offenses, or personal slights."[38] In the two years before he arrived on the job, one white planter, complaining of the slow pace with which a freed Black man was eating his breakfast, had struck and seriously injured him with an iron bar. Another

planter considered a remark of a freed Black woman, Lucinda Pilot, inadequately respectful of his wife. As a consequence, he beat Pilot severely with a whip on her head, face, and shoulders and threatened to kill her if she remained.[39]

Assaults, by whites or Blacks, easily escalated. Four months after Arthur arrived in Columbia a white planter named Nathaniel Williams beat a freedman on the plantation he ran in Caney, Texas, in Matagorda County, just west of Brazoria County. Some three hundred other freedmen from the surrounding community, many of them armed, gathered rapidly in support of the freedman. Similar incidents on the same plantation had occurred twice before, and this time the freedmen were determined that justice would prevail, even if by force. Arthur attempted to defuse the situation as Williams took refuge in a cabin on the plantation. The freedmen "repeatedly aimed their guns at him and demanded him to surrender, and said they wanted to hang him. This was continued all night at his house, where all the neighbors who could be summoned had collected." Arthur lamented, "There is no law in Matagorda County, no jail, and the nearest magistrate is 45 miles away." Prospects were bleak. "In the present condition of this community, it would take but a little spark to spread a conflagration that would lay waste the whole land."[40]

Arthur believed the long-term solution was in the education of all children, Black and white. The Bureau had established no schools, but upon his arrival, he noted that "the freed people have just started one under a freedwoman that can read and write but is by no means qualified for a teacher." Arthur wrote, "I have loaned them the benches in my charge and could assist them materially by furnishing a suitable building for this purpose. I think if a competent teacher could be found there could be a large school started in this town."[41] Six months later, he wrote, "I have built a schoolhouse and established a school at Chauncey Prairie. The work was all done by the freedmen. They want lumber to make flooring and benches."[42] At the end of his ten months as a subassistant commissioner, he could write proudly that there were "five freedmen's schools in my district—two in charge of the Bureau and three supported by the freedmen."[43] He continued his work for the Reconstruction government as a county commissioner and voter registrar.[44] By the fall of 1869, he was working in more benign circumstances, as customs inspector at San Luis Pass, Galveston.[45]

As an evocation of the promise and disappointment of Reconstruction,

Homer created a jewel-like painting he called *The Dove Cote*. It depicts five figures: a Black man in his fifties, a Black boy of about ten, and two girls and a boy (four to six years old), evidently white and seen from behind. The proper right leg of the man, as he lugs a heavy bucket, forms the vertical axis of the picture. But it is the boy who is at the foreground. He crouches over another bucket, which sits atop a barrel, and wrestles with a third vessel at his feet. He is alert to something we can't see or hear, and he observes it closely. The three young children also observe what we cannot see—at least, not fully: they peer into a pigsty. Through the slats, the curvature of a pig's back appears.

The structure encompassing the pigsty is no ordinary one. It is a dovecote of uniquely arklike design, including three rectangular aviaries on its roof, and a fourth whose shape vaguely evokes the pyramid on the Great Seal of the United States. Homer painted in delicate detail the faces of the boy at foreground and the Black man at center, as they stand at their work on well-lit, solid ground. By contrast, he places the heads of the three young children in shadow. Unlike the two Blacks, the children are idle, perched precariously on a board atop a sawhorse. When Homer exhibited the painting for the first time, on January 10, 1874, at the Century, the

Figure 107: *Uncle Ned at Home* (*The Dove Cote*), 1873. Oil on canvas, 14 × 22 in.

works around it included an Arctic marine painting by William Bradford (1823–1892), Bierstadt's *Winter in Yosemite*, and Tiffany's *A Ruined and a New Mosque in a Street in Cairo*. No other member had brought a work remotely like *The Dove Cote*. But Homer struck a chord; one critic wrote that the picture "fairly sparkles in its effect of sunlight and color."[46] He exhibited it again the following year at the Annual Exhibition of the National Academy of Design, renaming it *Uncle Ned at Home*. The title refers to "Uncle Ned," a nostalgic 1848 song by Stephen Foster (1826–1864) recalling a beloved dead slave; while the lyrics may appear condescending to twenty-first-century ears, no less a figure than Frederick Douglass praised the song as expressing "the finest feelings of human nature."[47] He wrote that both this song and another by Foster "awaken the sympathies for the slave, in which anti-slavery principles take root, grow, and flourish."[48] In choosing Foster's song for his title and adding the qualification "at home," Homer casts his setting and his characters in a distinct light. His central figure is neither enslaved nor dead but at home—*his* home, rudimentary yet functional.

Within four years, Homer had sold the painting to Thomas Benedict Clarke (1848–1931), his first work to enter Clarke's collection. The picture was also his first painting to address the ways in which Black and white Americans were finding their way in the years of Reconstruction. Most critics disliked it, with one calling it "slovenly" and another that it "should have been left at the cabin where it was painted."[49] Apparently only one review noted the picture's significance in the history of American art, through its maker's empathetic depiction of his fellow citizens: "As a delineator of negro character and physiognomy, Mr. Homer may at once take the foremost place among American artists. His gentlemen of color are unique."[50]

Although the closely framed picture might appear at first to be sited anywhere, it does not derive from any southern sojourn. Homer completed it in his studio in New York in the fall of 1873, ironically based on field sketches he had made in the North. Homer's itinerary and the date of the picture's first exhibition narrow sharply the range of possible locations that may have inspired the picture.[51] There are two, and only two. One is on one of several small farms on Eagle's Nest Road in Hurley, New York, where he visited in 1872.[52] The other is a farm in Essex, Massachusetts, the town next to Gloucester. The selection of which of these locations is correct is inherently speculative, but individuals living in Essex appear to correspond

most closely to his models. The young Black boy may have been based on John Jerritt (born 1863), whose father, Rodger (born 1820), may have served as the central figure. The white children seen from the rear may have been modeled on Helen and Elizabeth Crafts and Arthur Low, white neighbors of the Jerritts at the well-traveled intersection of Story and Belcher Streets. Essex was long known for its shipbuilding industry, which helps explain the rickety boatlike structure. Traveling from Gloucester, next to Essex, Homer would easily have encountered the Jerritt family. His inscription on a related watercolor of a schooner under construction at the edge of a tidal marsh suggests he traveled very near (and possibly directly in front of) the Jerritt house.[53] He didn't need to go south to depict an already multiracial country, trembling on the absurd structures of racial inequity. In his subtle, multivalent allusions—perhaps even through the pig to the New Orleans butchers whose aspirations the Supreme Court had frustrated in its April 1873 decision—Homer created a masterpiece, and one the perspicacious Clarke recognized. He would ultimately become Homer's single most important patron.

On several other occasions, Homer focused his observant eye on other citizens who, like Jerritt, lived near him, yet were generally ignored. In one wood engraving, set in a clubhouse within a Confucian temple at 12 Baxter Street, in the heart of New York's Chinatown, a mile and a half due south of his home at the Tenth Street Studio, Homer depicted domino players and opium smokers.[54] A vivid description of the building's "squalid haunts of misery," "within five minutes' walk of the City Hall," was published about two weeks before Homer completed his illustration and may have inspired it. "The walls had evidently not been brought recently in contact with the whitewash brush," wrote *The New York Times*. "They were consequently of that murky brown color so characteristic of the apartments of the lower class of tenements."[55]

He created another illustration, of fifty-one homeless men, piled atop one another on the floor of a dark hall within New York's 17th Precinct police station.[56] The unsigned *Harper's* editorial provides a powerful verbal description of the scene Homer witnessed and drew:

> There is a Babel-like confusion of snoring, and now and then a young
> man at the edge of the throng starts nervously and sighs, and an old
> man near the centre moves his hands tremulously about his face and

groans in his sleep. Between this man so near us, and, as it were, just entering upon a career with which prison life and prison scenes will have more and more to do as he advances, and the poor wreck going to pieces over there, we see the shadow of New York—the shadow of a city where misrule and riotous influences have done their work; where one hundred thousand human beings, men, women, and children, are sent to the penitentiary, the asylums, the almshouse, the hospitals, and the prisons in a single year![57]

Behind the trim policeman, his right arm raised, warm light bathes the corridor just past midnight. Homer is not with the officer. He is with the homeless men, stacked like matchsticks, their legs and arms akimbo as they try to sleep. Many of these men fought in the Civil War—and ever since, wrestled each night with demons. Like Homer himself, they had witnessed a national trauma and could never forget it. Unlike Homer, they were themselves actors in the nightmare; it lived on in them. One middle-aged man, at left, has given up his quest for sleep. He stares warily at the artist, and at us, as if to ask, with *Harper's*, how he might find some way out

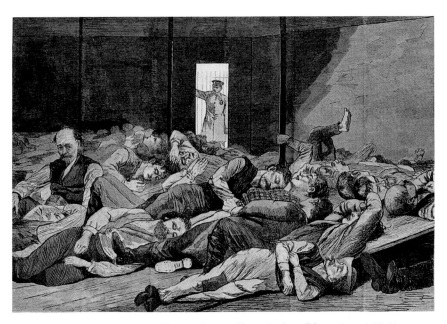

Figure 108: After Winslow Homer, "Station-House Lodgers," from *Harper's Weekly*,
February 7, 1874. Wood engraving on paper, 9⅛ × 13½ in.

of what awaits him the next morning, when he and the lodgers around him will be "wandering in the streets, with no roof, however humble, to shelter them from the drenching rain, the biting frost, or the falling snow."[58]

In a drawing he made four months later, in July 1874, Homer depicted a Sachem of the Montaukett people who farmed the windswept pastures at the southeastern tip of Long Island and fished in the waters offshore, as their ancestors had for centuries. David Pharaoh, born in 1838, was elected chief four years earlier, in 1870, after the death of his uncle Sylvester Pharaoh.[59] Just thirty-six that summer, Pharaoh was known for his attentiveness to the spiritual life of his people, particularly their June meetings. These religious ceremonies marked the summer solstice. They also celebrated the growth—and promise—of the crops planted by the Montaukett on their ancestral lands.[60] Shortly after his election, Pharaoh initiated a lawsuit in defense of the Montauketts' rights to timber and firewood from their ancestral lands.[61] The few white settlers of the area had an uneasy and contemptuous view of the native peoples and probably did not expect them to use the court system to defend their rights. Local whites described the Montaukett as "idle and worthless, except their king and queen, who are industrious, quiet citizens."[62] Pharaoh, the father of a large number of children himself, was especially zealous in his solicitation of support for the education of children in his tribe and petitioned the state for a school in Montauk—over the objections of the white settlers.[63] Homer depicted him with an air of dignity, contemplation, and sorrow. It is one of the artist's most empathetic portraits.

Homer and his traveling companion Enoch Wood Perry went back to Hurley that summer, but first journeyed to the pristine pastures and dunes where the Montaukett had farmed and fished for so many centuries. They were two of very few visitors who made it then to the east end of Long Island, although a great many artists and nonartists would follow them there. Three years earlier, Charles Parsons, art editor for *Harper's Weekly*, confessed he had been told this was a "wild, desolate country, infested by mosquitos and snakes."[64] Nevertheless, Parsons had seen this location with his own eyes and admired it as "a region comparatively unknown, except to a few sportsmen, attracted thither by its very wildness, and to such tourists as find especial charms in its seclusion, and in the bold and picturesque scenery of its defiant promontory, upon which the wild Atlantic incessantly beats, and sometimes with tremendous violence."[65]

Figure 109: *David Pharaoh, The Last of the Montauks*, 1874.
Watercolor, gouache, and charcoal on paper, 11½ × 10 in.

Homer and Perry arrived in East Hampton and its hamlet of Montauk (a dozen miles to the east) midway through Pharaoh's tenure as leader of his people. Apart from Homer's sighting of the Sachem, none of the work Homer made that summer reflected the tensions between humanity and nature, or between native peoples and white settlers, to which Parsons referred. But Perry and Homer were students of history, and as one critic remarked, Perry "has brought to his work the most conscientious and thoughtful research. He has sought through the country on remote farms, and, in town, in obscure streets and courts, from which the life of the present has ebbed."[66] Homer's drawings of children relaxing against old wooden fences and paintings of elegantly dressed young women basking on the beach invoke the sense of a nostalgic, pastoral destination for the well-to-do, within which the lost innocence of a bygone America might still exist.

That just may have been his intention. Pharaoh died four years later, in July 1878. The following year, Homer's uncle Arthur Benson acquired 11,000 acres from the Trustees of Montauk, agreeing that his purchase was

"subject to the rights and privileges" of the Montaukett tribe.[67] But neither Benson nor his heirs, nor those to whom his widow, son, and daughter sold their land, observed these rights and privileges. In fact, they enforced their ownership in ways that today would be regarded as abhorrently abusive. Benson "offered me so much money and told such sweet lies," Pharaoh's widow recalled.[68] "Our property was taken from us by shameful bribery and fraud," another Montauk leader explained.[69] The drawing itself bears one mild mark of this abuse: an erroneous inscription, probably in Homer's hand: "The Last of the Montauks." Montaukett people still live in the area, as they did long before Columbus and his successors arrived on the continent. But to this day, they lack legal recognition, declared extinct through racist arguments intended to justify the actions of Benson, his son Frank Sherman Benson (1854–1907), and their assignees, who wished to control the land unilaterally.[70] To what extent was Homer's thorough exploration of the area in 1874 an errand for his uncle in reconnaissance? As is so often the case with Homer, we can only wonder. Likewise, he tells us nothing of how he felt about the events that ensued on those "wild, desolate" dunes.

A few months after purchasing the hamlet in its entirety, Benson declared his "intention to build a place of Summer resort at or near the extreme point of the island."[71] The following year, the famed landscape architect Frederick Law Olmsted (1822–1903) completed a sensitive plan for Benson to fit seven houses into the landscape, maximizing their views while minimizing the visual effect of the houses on their delicate sites. Benson then hired a newly founded architectural firm, McKim, Mead & White, to design those seven houses. The firm would go on to create grand libraries and railway stations, palatial clubhouses, and entertainment venues such as Madison Square Garden. For Benson, the firm created a quieter design, but one no less significant: a group of houses famed to this day as masterpieces of the Shingle Style, then at its apogee.[72] They are known as the Seven Sisters. Homer was deeply connected to his uncle and to the men who joined Benson in creating this unique community set in the brush, dunes, and wildlife of Montauk. Five of Benson's partners in commissioning these cottages were members of the Century Association, the center of Homer's commercial and social life (Benson himself was not a member). They included the art collectors Robert Weeks DeForest (1848–1931) and William Loring Andrews (1837–1920). Another in the Seven Sisters was DeForest's brother Henry (1855–1938), famed at the

Century, as was Homer, for the skill and passion he possessed for fishing. Yet another Centurion ensconced in Benson's dream colony was Cornelius R. Agnew (1830–1888), a distinguished eye surgeon—one of several scientists of the eye that Homer knew well.[73] Agnew's daughter owned the portrait of the Sachem; it might easily have been a gift of Homer's to her father. A decade later, Homer and his fellow Centurions moved into a splendid new clubhouse on Forty-third Street, designed by the same firm: McKim, Mead & White. Over the last twenty years of his life, Homer spent many evenings in the elegant, high-ceilinged rooms there.

Two days after Homer's death in 1910, a few of his fellow members may have been jubilant—not for his death, but for another death, of a different kind. On that date, Judge Abel E. Blackmar (1852–1931) of the New York Supreme Court issued a landmark decision in favor of Homer's aunt, cousins, and several Centurions and their friends who sought undisputed control of Montauk. Blackmar's judgment depended most of all on a simple declaration, "There is now no tribe of Montauk Indians. It has disintegrated and been . . . dying for many years. The separation and scattering of the members, due to the purchase by Mr. Benson, gave it the final death blow."[74]

A few months before Homer journeyed to the Montauketts' oceanfront homeland, the Columbia University physicist Ogden Rood (1831–1902) electrified the National Academy of Design through a pair of speeches entitled "Modern Optics and Painting."[75] He spoke like a charismatic mystic, not a dry, narrow academic. "We are immersed," he explained, "in a sea whose very substance is constantly pulsating under the influence of systems and counter-systems of waves." All of humanity is swept up in the phenomenon, he said. "Even our very sensations are largely dependent on the action of these undulations on ourselves."[76] Rood demonstrated the ways the human eye perceives color, and therefore how artists such as those in his audience could create works whose colors might resonate more powerfully with their viewers.

Homer was almost certainly in the audience on both those evenings, listening intently. Rood had joined the Century the year before him and had then sponsored Homer's close friend John Lee Fitch for membership. Unusually, Rood was both a widely admired scientist and a passionate advocate for the watercolor medium. He was also an adept practitioner of watercolor, as evidenced by his participating in numerous exhibitions in-

cluding the very first one mounted by the American Watercolor Society. Homer had repeatedly witnessed Rood's dexterity with both brush and pen.

Moreover, Homer had long been interested in Rood's subject matter. In 1860 his brother Charles, then an industrial chemist specializing in textile dyes, had given him a book by another industrial chemist—also a specialist in dyes. The author was a long-lived French polymath, Michel-Eugène Chevreul (1786–1889), since 1824 the director of the dye works for the Paris factory producing Gobelins tapestries. His book carried a title worthy of a tapestry all to itself: *The Laws of Contrast of Colour: and their application to the arts of painting, decoration of buildings, mosaic work, tapestry and carpet weaving, calico printing, dress, paper staining, printing, military clothing, illumination, landscape, and flower gardening, etc.* Chevreul wrote, "Those painters who will study the mixed and simultaneous contrasts of colours, in order to employ rationally the coloured elements of their palette, will perfect themselves in *absolute colouring* as by studying the principles of geometry they perfect themselves in linear perspective" (italics those of Chevreul).[77] As Judith Walsh has noted, Chevreul's conviction "that an artist could learn to transcribe and use color was a novel idea; conventional wisdom held that draftsmen could be taught, but colorists were born."[78]

Rood built on Chevreul's work and went further. Both men championed the importance of contrast and harmonization of both color and tone. They believed that if painters understood the science of color complementarity, they could create pictures whose colors would be more vivid and effective in achieving painters' objectives. But Chevreul was a chemist whose first instinct was to solve practical problems in industry. Rood, by contrast, was a physicist and an artist—with an attentiveness to the mechanics of vision worthy of any ophthalmologist friend of Homer's. Rood explained how the nerves of the retina absorb colors, and how the human eye perceives something different from the underlying chemical construct. When a watercolorist deploys the white of his paper effectively—as both Rood and Homer did—he maximizes the effect of the light waves that generate the experience of these colors in the eyes of the viewer.

Similarly, when a painter lets the viewer's eye blend the pigments— rather than the painter doing so on his palette—that painter creates a more exciting work. "Every mixture of pigments on the painter's palette is a stride toward blackness," Rood cautioned.[79] The French Impressionist painter Camille Pissarro (1830–1903) credited Rood and Chevreul for his

adopting "the modern synthesis by methods based upon science . . . to sub-
stitute the optical mingling for the mingling of pigments . . . because the
optical mingling excites much more intense luminosity than the mingling
of pigments."[80] His Post-Impressionist compatriot Georges Seurat (1859–
1891) also attributed to Rood many of the breakthroughs that led to his
Pointillist masterpieces.[81] Seurat's works such as *A Sunday on La Grande
Jatte* (1884) and *Models* (1886–1888) are tributes to the truth of Rood's
observations—monuments in the movement ultimately known as Divi-
sionism. "The surface seems to flicker or glimmer," Rood wrote in 1879, "an
effect that no doubt arises from a faint perception from time to time of its
constituents. This communicates a soft and peculiar brilliancy to the sur-
face, and gives it a certain appearance of transparency; we seem to see into
it and below it."[82]

 Homer put it in a characteristically homespun way: "You simply have
to get the truth of it, as you see it; but the knowledge of the influence of
one color upon another is necessary anyhow. You can't do it unless you
know when you put down one positive color what influence that color is
going to have on the color next to it."[83] Despite essentially quoting Rood,
he never gave him credit, while saying of Chevreul's book, "It is my Bi-
ble."[84] Homer's homage to Rood is in his work, and there alone.

 As Homer developed further watercolors for exhibition, he frequently
focused on solitary female figures, with color contrasts and light effects that
display Rood's influence. Homer also constructed with care the geometry
of the settings in which he placed the women. In *Fresh Eggs*, for example,
the eggs themselves are precisely at the horizontal centerline, with the
woman's neck and waistline ribbons at the vertical centerline. The light
through the door, the tilted rake, and the half-wall behind her create a se-
ries of orthogonal lines acting as foils for the curves of the two barrels and
the basket, and of course of the woman's form, that of the rooster, and of the
eggs themselves. Homer followed Rood's counsel in complementing the
principal ocher, brown, and yellow colors of the composition with pale gray-
blue brushstrokes on the haystack, barrel straps, basket, and rooster tail.

 In another case, Homer places his model in silhouette before a black-
board with geometric shapes marked on it in chalk. The pointer in her
hand is positioned pointing down precisely to the center point of the
drawing just below the model's right elbow. As in so many other cases, he
deploys the golden ratio in the composition, here for the blackboard itself,

Figure 110: *Fresh Eggs*, 1874. Watercolor, gouache, and graphite
on wove paper, 9⁵⁄₁₆ ×7⅝ in.

which he signs and dates.[85] The watercolor is a sly homage to Vitruvius, Alberti, and his other forebears. And the gray-green colors dominating the watercolor are a perfect complement to the flesh tones of the schoolteacher serving as his model. Her impenetrable demeanor, like her headband with its moonlike bow, gently evokes the elusive Diana, goddess of boundaries.

In June 1875, Homer attended the wedding of his younger brother, Arthur, in the mill city of Lowell, Massachusetts, where his new wife, Alice Patch (1848–1904), had grown up. Lowell lies ten miles upriver from another mill city, Lawrence, which is of similar size. Their older brother

Figure 111: *Blackboard*, 1877. Watercolor on wove paper, 19¾ × 12¾ in.

Charlie knew the area well, as he had worked for a decade in Lawrence. Arthur and his bride spent their honeymoon in a hotel located a dozen miles south of Portland, Maine, in the town of Scarborough. The hotel and another half-dozen boarding houses of various sizes were perched on a rocky promontory facing south. The hamlet including that promontory, contiguous beach, and marshland had long been called Libby's Neck after the family—still in evidence—that farmed it and would soon subdivide it.[86] But by the summer of 1875, many preferred to name the hamlet after the long-lived Boston merchant Timothy Prout (1679–1768). For £500 Prout had acquired it—and another three thousand acres—in 1728, sixty years before a Libby bought a teaspoon of its rocky soil.[87] Homer visited the couple at the Neck but seems to have stayed only briefly. Still, this first

Figure 112: *The Honeymoon*, 1875. Graphite and watercolor on paper, 8¾ × 11¾ in.

visit to Maine since his boyhood proved propitious. Over the following years, he and his family made plans that would eventually lead to his spending a majority of his time on the Neck during each of the last twenty-seven years of his life.

Homer lived for a month that summer in York, Maine, just north of the border with New Hampshire. It is far south of Prouts Neck and Portland. Nevertheless, while he was there Homer corresponded several times with Philip Henry Brown (1831–1893), a pillar of the Portland establishment and the son of one of Maine's wealthiest men, John Bundy Brown (1805–1881). Philip was an early admirer of Homer's and bought his 1873 school-room painting *The Noon Recess* that August, just two years after it was completed.[88] He would prove an important figure in Homer's journey. While in York, Homer focused assiduously on the particularities of the Maine landscape. In one case, in this last summer before the nation's Centennial, he painted a portrait at dusk of a mid-seventeenth-century garrison house. It was one of Maine's most ancient structures. In another, *Winding Line*, he depicted a "double-ender" whose design is especially well suited to the Maine coast. As the name implies, these vessels were pointed at both ends and designed for navigation in either direction, and from either stand-

ing or sitting positions. Boat builders often constructed them with lapstrake hulls in which planks overlap (as was the case with this vessel) or sometimes carvel (with planks meeting flush at the seams). Homer depicts his model in a solitary, contemplative activity, seated on the boat's gunwale. Inasmuch as the light is midday, he plants our questions: Why is this fisherman not fishing? Where are the fish he caught this morning? What is he thinking as he winds his line? With Homer, every picture contains an invitation to delve into a narrative he begins and only his viewer can complete.[89]

It was ten years now since the summer Homer had spent in Newport with Henry James and the rest of the circle around La Farge. James himself may have aspired to painting then. Over the years since, James had concluded his greatest strength lay in his pen, not his brush. In January 1875, he published *A Passionate Pilgrim*—stories of Americans in Europe—and saw his novel *Roderick Hudson* begin serialized publication in *The Atlantic Monthly*. But then he retreated from fiction, and instead over the year composed some seventy reviews of books, plays, and other subjects; among these are five art reviews, one of which addresses Homer's work. James's title, "On Some Pictures Recently Exhibited," is misleading, as it is based primarily not on a specific exhibition but on his long knowledge of La Farge, Johnson, Homer, and others as painters and as men.

> Mr. Homer goes in, as the phrase is, for perfect realism, and cares not a jot for such fantastic hair-splitting as the distinction between beauty and ugliness. He is a genuine painter; that is, to see, and to reproduce what he sees, is his only care; to think, to imagine, to select, to refine, to compose, to drop into any of the intellectual tricks with which other people sometimes try to eke out the dull pictorial vision—all this Mr. Homer triumphantly avoids. He not only has no imagination, but he contrives to elevate this rather blighting negative into a blooming and honorable positive. He is almost barbarously simple, and, to our eye, he is horribly ugly; but there is nevertheless something one likes about him . . . he naturally sees every thing at one with its envelope of light and air. He sees not in lines, but in masses, in gross, broad masses. Things come already modeled to his eye.[90]

For nearly twenty years, Homer had made his living primarily from the illustrations he sold to newspapers, from *Ballou's* to *Appleton's* to *Harper's*.

Figure 113: *Winding Line*, 1875. Oil on canvas, 15¾ × 22 in.

Now, with his oil paintings beginning to sell more readily and his water-colors selling well, he resolved to give up illustration work. He would make a few wood engravings as later book illustrations, but after this summer, he was an illustrator no longer. In line with the nostalgic character of this period as he and his countrymen prepared for the Centennial, his last two newspaper illustrations both suggest the personal relevance of American history. In one case, for the female readership of Mary Louise Booth's *Harper's Bazar*, he depicted a young man, fresh off the fields, who inscribes in a family Bible as his wife looks on and their infant child rocks in a cradle at their feet. The proud father, with his typically Dutch beard, is seated at a chair and writes on a table, each constructed in a distinctive style such as was practiced by furniture makers in nearby Kingston.[91] A youthful eighteenth-century ancestor peers down from a family portrait, over which hangs a cavalryman's sword.

A closer look at the illustration reveals the significance of the time Homer and Perry spent in Hurley both the summer of 1875 and on their other two or three sojourns there. Homer sets "The Family Record" within the walls of the Dutch stone farmhouse that the descendants of Cornelius Wynkoop (d. 1676) built in the early eighteenth century on land their

progenitor acquired in 1663.[92] The 1743 portrait on the wall by Pieter Vanderlyn (1687–1778), which Homer enhanced in his print with a Dutch windmill, depicts a nine-year-old boy.[93] He is Cornelius D. Wynkoop (1734–1792), who would grow up to be the colonel who led local troops during the American Revolution. The sword is one he carried in those stormy days.[94] George Washington visited Hurley in November 1782 from his nearby headquarters in Newburgh during the still-restive eighteen months between the British surrender at Yorktown and the ratification of the Treaty of Paris; Wynkoop was probably with him.[95] The colonel was also the grandfather of Homer's host, George Wynkoop (1814–1881).[96] The sly, multivalent title of the illustration reflects the fact that a family's record encompasses more than its births, deaths, and marriages. It also encompasses how that family influences its community, for good and for ill. Cornelius not only fought for the freedom of his country but suppressed the freedom of men, women, and children of whom he claimed ownership as chattel slaves working on his farm. One of these enslaved men murdered him in the house Homer depicted.[97]

George's son James Davis Wynkoop (1843–1904) was a successful grain trader on the New York Produce Exchange and a devoted local historian.[98] He and his father not only understood their family's history, but shared it with others, as they sought for the Wynkoop family to be remembered for a different and more positive legacy.[99] Prior to Perry's and Homer's visits to Hurley, the Wynkoops appear to have already hosted at least one painter friend of theirs, and probably two: William Henry Snyder (1829–1910) and Platt Powell Ryder (1821–1896).[100] Ryder was probably at the farmhouse with Perry and Homer the month *Harper's Bazar* published "The Family Record."[101] Thirteen years later, after George's death, James Wynkoop would host a third and much younger painter, Henry Ossawa Tanner (1859–1937), then on the brink of moving from Philadelphia to Atlanta.[102] Tanner was Black and would ultimately achieve recognition as one of America's greatest painters, particularly of biblical scenes. He was elected a member of the National Academy of Design in 1910, the year of Homer's death. Ryder and Snyder are more obscure today but were recognized then as successful painters, in part for their empathetic and then-unusual depictions of Black women, men, and children. Perry sponsored Ryder as a member of the Century; another friend of Homer's, John Lee Fitch, seconded the nomination.[103] It is probable that James Davis

Figure 114: After Winslow Homer, "The Family Record," from *Harper's Bazar*,
August 28, 1875. Wood engraving on paper, 12 × 8⅛ in.

Wynkoop invited all these painters to depict his historic and capacious farmhouse; they probably stayed there during their visits to Hurley. Homer, immersed in the Wynkoop family's hospitality, expressed in his illustration more than the pride of new parents. He also shared and communicated his Wynkoop hosts' recognition that they, like those young parents and their newborn child, are but motley threads in the web of a history still in the making, and extending well beyond this house.

In his second newspaper illustration, Homer commemorated the Battle of Bunker Hill on its hundredth anniversary. But he did not do so by depicting the battle. Instead, he showed the ways the citizens of Boston responded to it. Those residents included his own grandfather Eleazer Homer, aged fourteen at the time and living in the North End neighborhood within which Homer conjures up his scene. From rooftops, men and women look in helpless alarm as billows of fire rise from the hills of

Figure 115: After Winslow Homer, "The Battle of Bunker Hill—Watching the Fight from Copp's Hill, in Boston," from *Harper's Weekly*, June 26, 1875. Wood engraving on paper, 9³⁄₁₆ × 13¾ in.

Charlestown. Homer strengthens his design by suggesting that the military action is more distant than it really was. He keeps his focus where he wants it: on the anxiety, and the vision, of ordinary people. As a student of history born a stone's throw from his scene, he alludes to his grandfather twice: by inscribing the year of his birth in the roof shingles just below Homer's initials, and by depicting a boy nearly old enough to fight—but not quite—gazing alone at the chimney.[104] On the streets below, one man throws up his arms in despair, a cow runs unfettered through the streets, and an antiquated carriage sits empty. A conventional illustrator would focus on the battle itself, and even suggest that the patriots won it. The double-page wood engraving in the same issue of *Harper's Bazar*, taken from John Trumbull's famous painting, depicts the climactic moment of the battle: as *Harper's* editors noted, a moment of retreat "instead of the repulse of the British troops on the first and second assaults."[105] Homer's story is one he heard at his grandfather's knee. It is of a battle seen from afar, whose significance grew with perspective. He invites the viewer to determine whether or not this defeat—and the response to it—signals an auspicious start, in the cradle of democracy, for his country's birth.

All Americans hoped the following year would signal the country's

coming of age at its Centennial. They also hoped the year would reflect, and even stimulate, a sense of resolution. The guns of the Civil War had lain silent for eleven years, but amid a deep recession and Reconstruction's evident failure, the country was restive. Was the seismic spark that had detonated such destruction now and truly extinguished forever?

Homer answered this question as he answered every question: with entrancing, layered ambiguity embedded in pictures whose outward appearance is matter-of-fact and direct. One example, on which he had been working for the previous several years, he named *A Fair Wind*. What began as a watercolor, then evolved into a small oil on panel, became a major oil painting, known today as *Breezing Up*. It is now sufficiently familiar to invite oversight. Three boys enjoy a brisk breeze atop the deck of a catboat, in whose cabin sits a grandfatherly figure. He holds one sheet taut, as the boy at the stern pulls the rudder with another rope, held in his right hand. A fishing schooner sails in the distance. It is an emblem of the gritty men of the sea among whom soon these boys will number. For now, they inhabit an evanescent prelude.

Homer meant more and delivered more. In the silhouetted profiles of the four figures, he tells us just enough to draw us in, and not enough to quench our questions. The heeling catboat, water lapping at her side, evokes

Figure 116: *A Fair Wind* (*Breezing Up*), 1873–1876. Oil on canvas, 24³⁄₁₆ × 38³⁄₁₆ in.

a sense of danger. The boy in the bow confirms it. Will he slide off? Homer paints the shadows on the sail with impeccable precision, and the motion of the water with perfect spontaneity, creating a sense of narrative tension. His color choices reflect Rood's wise counsel; the dark red of the man's shirt is the exact complement to the muted blue of the sky seen through the clouds. And the picture's geometry reflects his lessons from Page and others, with a strong vertical centerline running through the right knee of the boy in the stern, and the rope on the boat's rudder. The horizontal centerline neatly decapitates the second boy from the left, a favorite Homer device to invoke danger, to which the lighthouse alludes—both comfort and warning—and to which the catboat sails, dead ahead.

Homer commemorated the Centennial with a series of pictures shedding light on Americans whose lives intersected little—if at all—with those who collected his work. Homer had begun this journey with *Uncle Ned at Home*. Now Homer would go beyond the confines of jewel-like genre pictures like that, and like those of his friend Eastman Johnson. He intended to appeal not only to collectors' curiosity but to their sense of mystery, as he opened up windows to a world about which they wondered but dared not enter. Homer ushered them into stories whose endings were, and are, uncertain, laden with suspense. As a critic for *The Nation* observed at the time, "His pictures are the only figure-paintings by an American exhibitor which are grasped with the real dramatic force. Each one is perfect in telling its story: character of hero, pertinence of surroundings, degree of expression, type, age, atmosphere, time of day, strength or reticence of color—every study is a rounded sonnet sufficient to itself. But each is shouted out of breath so hastily and rawly that the prevailing impression perhaps is a sense that we are defrauded of a suggested delight."[106] Critics were accustomed to highly finished pictures of Asian and Middle Eastern exoticism. Homer both delighted and frustrated them. "It is such a beautiful thing to tell these healthful stories with all the simplicity, all that confinement to the idea, which we find in Japanese artists, that we can only mourn the loss of the fine painter Mr. Homer would be if he could give us the developed painting instead of the sketchy impression. Mr. Eakins, whose studies of American sports seemed to complete what Mr. Homer aimed at, is regretfully missed this year."[107]

The central character in several of these pictures is a Black boy slightly younger than the one he depicted in *Uncle Ned*. Where that boy was deter-

mined and resourceful, this one is tentative and tender. In his ragged clothes, he elicits empathy and care. Homer probably met his model in the foothills above the Wynkoops' historic farmhouse, where most of Hurley's Black citizens lived.[108] One legacy of the town's historic practice of chattel slavery was that Hurley now benefited from a diversity of racial back-grounds. Many of its Black citizens carried Dutch names, such as Maria DeWitt, who was born about 1812, just thirteen years after New York State began to outlaw slavery.[109] She housed her four grandchildren and her daughter Maria Davis in her log cabin on Eagle's Nest Road.

One of the children was Homer's probable model, James H. Davis (1863–1939), then eleven years old, whom Homer made the central char-acter in three major oil paintings and at least three evocative watercolors.[110] Each of these was a studio production Homer executed in New York based on field studies he had sketched in Hurley. In one watercolor, Homer cast the boy with a Zouave, still clad, a decade after war's end, in his regiment's colorful jacket, sash, and cap. The man is aging now, his cheeks hollowing, as he offers the refreshment of his canteen to the boy into whose innocent eyes he gazes. Homer accentuates their intimacy in this carefully constructed studio production by placing his two figures' knees tightly together, exactly at the vertical centerline. The boy's small hand is placed exactly at the horizon-tal centerline, atop the round vessel. As the two sit atop an ancient wooden beam, the boy's left big toe touches the toe of the soldier's left boot, a silent and grateful assent. Homer called the drawing *Contraband*, as Thomas Wood had called his own painting in his famous three-picture cycle, *A Bit of War History*. In so doing, Homer recalled the explosive legal tactic Ben Butler had originated in the first months of the war, and through which Federal troops protected those formerly enslaved who made their way to freedom. Within ten days of his first showing of this sheet at the exhibition of the American Watercolor Society, Homer sold it to Edward Delano (1818–1881), a na-tive of Fairhaven, Massachusetts, long resident in New York after making his fortune as a young man in China during and immediately after the Opium War. Delano was a lifelong bachelor who devoted himself to travel, immersion in culture, and philanthropy, and had taken an especial interest in the U.S. Sanitary Corps, which had been so important to Homer.[111]

Homer addressed America's racial challenges with honesty and empa-thy, and collectors responded well. At the Centennial Exposition, he presented "only his most finished and popular work, sentimental and hu-

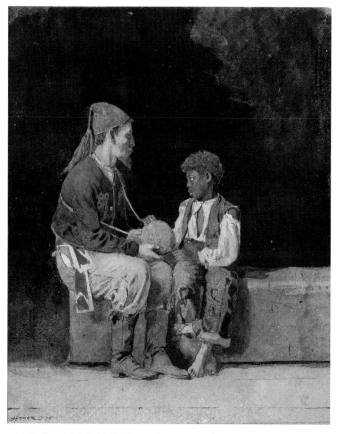

Figure 117: *Contraband*, 1875. Watercolor over graphite on wove paper, 9½ × 8½ in.

morous," writes the art historian Kathleen A. Foster. But Homer was addressing these issues in a difficult economic environment. The deep recession beginning in 1873 had not abated in the Centennial year, and in fact would drag on for the rest of the decade. Homer openly lamented, "There was not only a dull market for pictures, but what was of still more consequence, people seemed to have lost interest in the progress of artists in New-York."[112] Homer's Tenth Street Studio neighbor the eccentric painter William Holbrook Beard (1824–1900) sought out commissions, despite their disadvantage of carrying with them capricious and often overly directive patrons. Moreover, Beard looked beyond the confines of Manhattan and Brooklyn—way beyond—to San Francisco, from which one commission arrived with a handsome price of $1,800.[113]

Homer had already taken a page out of Beard's book, but not to accept

commissions. He had agreed to them from Sherwood (such as *Snap the Whip*) only grudgingly—and swore he would never do so again. Upon the presumed advice not only of Beard but also of his art collecting San Francisco uncle John Benson, Homer lent three pictures to an 1876 San Francisco exhibition opening just a few days after his public lament on the state of the New York art market. The critic for the *Daily Alta California* especially admired an oil in which Homer depicted a tussle between a calf and a Black boy (likely Davis). The reviewer described it as "a painting of a Contraband leading a Calf, the two objects being in shadow in the foreground, while the distance is in strong sunlight. The action of the figures is superb, and the modeling of the boy is remarkable. Taking it altogether, it is one of the best pictures in the exhibition and does credit to American art."[114]

Emboldened, Homer took another step, even more unprecedented for him. On March 9, 1877, he wrote to Samuel Putnam Avery, who was also a Centurion:

> Dear Sir,
>
> I have a picture which I would like to place in your hands for exhibition in the Royal Academy. It is not an ordinary work & will be a great credit to you for having discovered its extraordinary merits. The sale of it will bring you a large commission & the orders for other work by the same gifted artist will make quite a brisk business between here & England, all of which you will have under your control.
>
> The picture will be at the Century on Sat. & you can give me an answer after having seen it.
>
> Respectfully
> Winslow Homer
> P.S. I shall not go to England[115]

The picture, *The Cotton Pickers*, depicting two young women harvesting cotton in a field abundant with the crop, was indeed "not an ordinary work." It is a masterful portrayal of two strong American women of mixed race as archetypes of virtue, evoking a sense of national pride rooted in the particularities of place. Although the two women contrast with each other in posture and temperament, each is an emblem of an American identity as powerful and as memorable as any heroic female figure ever painted by Millet or others who molded archetypes for France. The picture's spirit of

unabashed admiration anticipates depictions of twenty-first-century Black women by painters such as Kehinde Wiley. Homer depicts these women with a respect opposite the caricatures then common in portrayals of Blacks. He depicts them in a matter-of-fact manner far less simple than it appears.

Homer was most specific about identifying his scene as North Carolina, whose cotton harvest in the coastal plains occurs in the early fall. He had certainly seen Virginian cotton fields in the spring months of 1862, 1864, and 1865, but it is improbable that he returned to any cotton-growing region any time before the early summer of 1876—and certainly not at harvest time. Furthermore, he was not in the habit of using drawings from that period for pictures he was making more than ten years later. It is probable, however, that Homer made a trip to Virginia and North Carolina between June 3 and July 20, 1876.[116] The picture may well be the product of a skillful grafting between a distinctly southern crop and a landscape, or models, or both, from the North.[117] Nevertheless, Homer memorializes their beauty, and the beauty of their setting, with such verisimilitude that one is led to believe he must have been there at the peak of the harvest.

As a broad range of scholars have recognized, cotton—like its gathering and processing—evoked a profound sense of meaning, and not only in this Centennial year. To some viewers, the crop signified the economic potential of land. To others it signified the tyranny of an economic system that was inextricably intertwined with slavery. Even after Emancipation, that system's intractable power wedded Southerners to the land some worked and others owned. For many Black citizens, it was the commodity that kept their dreams forever distant.

For Homer, cotton's meaning was doubly laden. By this time, his brother Arthur had moved far from his service to Brazoria County's men, women, and children once enslaved, and from his work as a customs inspector in the port of Galveston. Now he was working as a cotton buyer, employed by George Wigg (1827–1883), a New Orleans–based cotton factor. Arthur's decision to work for Wigg suggests that he possessed a degree of moral dexterity inconsistent with the rectitude one might surmise from his service to the Texas Freedmen's Bureau. Wigg was born and raised in Liverpool but had lived in New Orleans for at least ten years before the Civil War. As war broke out, he returned to his native city and fronted for the Confederate government in purchasing ships intended to elude the blockade the federal government had constructed around south-

ern ports. They included both sailing vessels and seven speedy, shallow-draft steamships. He then operated these ships on the Confederacy's behalf as a foreign agent to facilitate supply shipment between such essential Confederate ports as Charleston, South Carolina, and nearby foreign ports such as Havana and Nassau. The duration of Arthur's association with Wigg is unclear, but it was only in 1890, well after Wigg's death, that Arthur listed himself as a "cotton broker" rather than a cotton buyer. At about the same time, he sought success downstream, through establishing a manufacturing business converting cotton to finished products (rope and twine). Although it quickly failed, the company briefly employed some seventy-five laborers at its Galveston plant. Arthur's entire business career focused on cotton and on the fortune he hoped to make in the crop, but never did.

Winslow's career was entrepreneurial, too—the stuff of conversion. What he converted into products for visual consumption were also commodities of everyday life. He understood the plangent power of cotton, a crop both ubiquitous and rich in meaning. And he was canny enough to leave the finishing of his products to the eyes and minds of his viewers, an act of seduction into a narrative of purposeful dissemblance. Raised in illustration, yet now weaned from it, he would have agreed with Pablo Picasso (1881–1973): "Art is a lie that makes us realize truth, at least the truth that is given us to understand. The artist must know the manner whereby to convince others of the truthfulness of his lies."

His dissemblance—at least in time, and possibly in space—won enthusiastic praise. "Altogether the strongest and freshest piece of figure-painting that Mr. Winslow Homer has put his name to," wrote the *New York Evening Post*.[118] The critic took it to be a history painting fully capturing a southern context: "Two slave women . . . in a Carolina cotton field." The picture possessed a moral force. "The story is one not only worth telling, but one that can be told better by the artist than by the historian," the critic wrote. "Its deep meaning stares you in the face, as it should do to be worth anything. The composition is simple, unpretentious, natural, and the technical execution is brilliant and complete. The scene was painted outdoors, and it looks outdoors."

In fact, like *Contraband*, the picture was created principally in Homer's New York studio, based on his field drawings of the models and a landscape that may well have been in Hurley, New York, not North Carolina.[119] His attention to the process of creating a major breakthrough in his art is evident in the picture's intricate geometric composition, with a horizontal

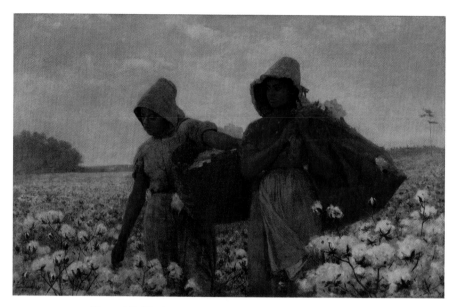

Figure 118: *The Cotton Pickers*, 1876. Oil on canvas, 24 × 38⅛ in.

centerline anchored by the foot of the tall tree at right and carrying across to the midpoint of the trees at left. The vertical centerline precisely divides the two women at the peak of the cotton in the basket. Homer accentuates the differences between them. The figure on the right stands proud, gazing directly, "erect, defiant, and full of hatred for her enemies." The other looks down, stooping to her right, "unhappy and disheartened."[120]

As the critic noted, the "immense gunny-bag" and "large bushel-basket already almost full of cotton" express vividly the "ripe, white harvest" of this field. Like Raphael's cartoon *The Miraculous Draught of Fishes*, this is a scene of plenty—and despite the tension, one of resolution. Homer inventively deployed color harmonies of rose and teal, achieving a complementarity just as Rood had suggested.

His marketing strategy was similarly inventive. Homer prearranged for the exhibition of *The Cotton Pickers* at the prestigious Royal Academy in London, and facilitated its sale to an English buyer. In so doing, he orchestrated a sensation in New York, cleverly distinguishing himself not only by the painting, but by its pending London viewing. He created a perception that the sequence of events was simply a response to his genius—not the consequence of his shrewd planning. Fifteen years later, Francis Hopkinson Smith (1838–1915) sifted through blurred poetic memories to recall

that the picture "was sent direct from his studio, with the paint still wet, to the Century Club for a Saturday night exhibition. A stray Englishman who was a guest bought it, and on the following Wednesday it was aboard a steamer to England. This, to me, was the first clear note Homer had sounded . . . I saw it this one night, but I have never forgotten it . . . In the foreground walked two young negro girls, the foremost a dark mulatto. It haunted me for days. The whole story of southern slavery was written in every line of her patient, uncomplaining face . . . This picture of Homer's was a departure from his former work, it is true, and in it he lost much, if not all, of his earlier 'paintiness' [sic]. But then, is he not always having departures and always improving?"[121]

The strategy worked. Although Avery didn't sell the painting for him, Homer made sure it did sell, and quickly—for astronomically above what any other Homer picture had ever commanded. He won a price of $1,500—more than three times what *A Fair Wind* achieved earlier the same month, albeit still a bit less than Beard had won by accepting the burden of a commission.[122] His admiring reviewer in the *Evening Post* wrote that "the picture is finely original and alluring, and when across the seas will do honor to the land that made it."[123]

No wordsmith, Homer later remarked that "the rare thing is to find a painter who knows a good thing when he sees it!"[124] To which he added, "It is a gift to be able to see the beauties of nature."[125] Homer witnessed the aesthetic value he had achieved with *The Cotton Pickers*, its moral force, and its commercial value. He had focused his eye and his hand on a very good thing—the dignity and power of his countrymen now freed from slavery. Whatever eloquence his speech and letter lacked, his brush made up for it. He wanted to go further.

The month following his triumph with the sale of *The Cotton Pickers*, Homer boarded a ship for Norfolk, Virginia, probably returning to locations he had visited in June and July 1876.[126] Two critics reported years later that he had visited Smithtown, Virginia, which is probably a reference to Smithfield, a small town fifteen miles northwest of Norfolk.[127] Homer had a habit of going back to places that he had found fruitful in his work. That said, no documentation survives charting Homer's route once he arrived in Norfolk. He could have taken a second vessel north to Fortress Monroe and then journeyed overland up the peninsula as he had fifteen years earlier, in the spring of 1862. He could have headed west to Peters-

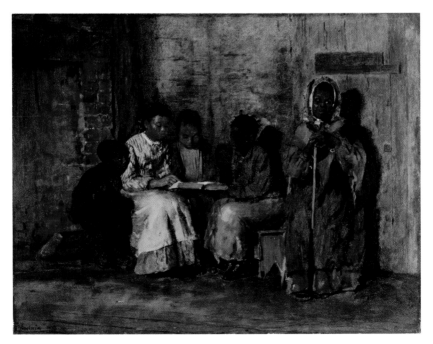

Figure 119: *Sunday Morning in Virginia*, 1877. Oil on canvas, 18¼ × 24 in.

burg, in and near where he had witnessed pivotal moments in the last year of the war. But the pictorial evidence suggests that in a smaller vessel he headed across the Virginia border some twenty-five miles south, where the coastal plains of North Carolina—the scene of his triumphal *Cotton Pickers*—beckoned to him.[128] His ship likely traveled farther down the coast, skirted Frying Pan Shoals and Bald Head Island, and then sailed up the Cape Fear River to dock at Wilmington, set amid lowland plantations. It was the state's largest city (then with a population of about 15,000).

A month later, Homer returned to New York, just in time to exhibit three new pictures at the Century. Each is a meditation on race in America. The two smallest pictures were sized similarly and set in precisely the same place, with the same perspective before the same fireplace at the heart of the same wooden shack. They comprise a diptych: *Sunday Morning in Virginia* on the left and *A Visit from the Old Mistress* on the right. Homer sent them to exhibitions as a pair six times, with a preference for their placement together as "companions," he wrote.[129] Whether based on field sketches he made in North Carolina, Virginia, or Hurley, Homer sets *Sunday Morning* in the state where the rebels' capital had been located. The picture de-

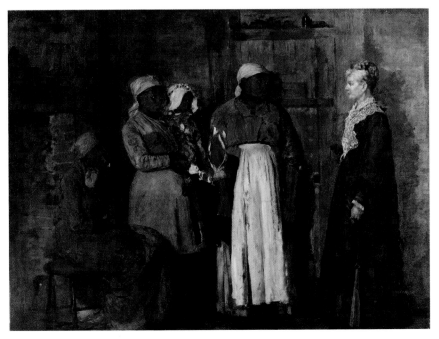

Figure 120: *A Visit from the Old Mistress*, 1876. Oil on canvas, 18 × 24⅛ in.

picts a teenage girl teaching a boy on her left to read the Bible aloud, as a younger boy and a second girl look on attentively. Glimpsed through reflection on the warm red bricks, a fire burns, just beyond the picture frame. This is a moment in which words come alive, both as the utterances of God and as the indispensable human path to freedom. The older woman on the right has endured "a lifetime of waiting."[130] Although she places her praying hands atop her red cane, she cannot read the Gospel. She listens, wistful and grateful that, with time and practice, her grandchildren will.

In *A Visit* (the pendant into which, when properly exhibited, Homer intended that the older woman would look), three young Black women, one holding an infant, confront an unwelcome visitor: the older white woman to whom they were once enslaved.[131] The fire is extinguished, the Bible missing. At first glance the former mistress appears genteel, well meaning in her sober black dress adorned with white lace. She may be a Confederate widow still in mourning and wearing her wedding ring. The three women, and even the infant, appear to question her intentions. Homer paints the interior of the fan dangling from her left hand with the same red hue of her counterpart's cane and shawl. To the eyes of some, that

color is of blood, which drenched the entirety of the "peculiar institution" upon which this white woman once built her life.[132] Homer was proud of the diptych, sending it to Paris for the Exposition Universelle of 1878. But these were not easy pictures for collectors to behold—or to purchase. One critic wrote that Homer "observed these manners with the enthusiasm of a historian and man of imagination. 'Why don't you paint our lovely girls instead of those dreadful creatures?,' asked a First-Family belle when he was in Virginia, laying up his studies for his pictures. 'Because these are the purtiest,' he said, in his gruff, final way."[133]

Of the three pictures receiving their debut at the Century, the final one was the largest, and by contrast very brightly colored. Homer probably had finished the other two works but not yet this one, which carried the title *Sketch—4th July in Virginia*.[134] It is known today as *Dressing for the Carnival*.

Each of the three pictures is composed in a frieze-like grid within which Homer fitted his figures. In *Dressing for the Carnival*, the vertical centerline runs along the left leg of the young Black man wearing a Phrygian cap of liberty, who is dressing in a harlequin costume.[135] It is no ordinary outfit, but one bedecked with strips of cloth. Once the young man begins to dance, the colorful shreds of cloth will create an exciting display. Two women of opposite characteristics (the older one smoking a pipe) attentively sew the final components onto his costume. Six children observe the process. The youngest of these stands alone, drawing our eye to a closed gate through which a path winds to five wooden structures at upper right, each marked by redbrick chimneys reminiscent of the fireplaces in the diptych.

Homer's visit to the South that spring did not correspond to the final days before Lent. But it did correspond to May Day, which has a long history of celebration both in Europe and in the Caribbean.[136] The tradition he memorializes is a very particular one: the Jonkonnu dance.[137] Originally West African, but transported to Jamaica and other parts of the Caribbean, the dance tradition recalls John Canoe, an early eighteenth-century Guinean leader celebrated for his virtue in repelling European traders.[138] To this day, the tradition survives on Caribbean islands. By contrast, on the North American mainland, Jonkonnu dance was limited almost entirely to North Carolina; the Cape Fear River was its heartland.[139] Homer's understanding of this esoteric practice, expressed in the picture, also offers an understanding of him. The Jonkonnu dance embodied a

promise of harmony across differences of race and class, particularly at Christmas, when slaves could assert themselves to enter and dance within otherwise reserved white spaces such as the front porch of a plantation house. The practice also let loose other boundaries, including those of gender definition, as Homer records; in Jonkonnu men dressed in women's clothes, with masks of the kind that Homer's masculine central figure is soon to don. When he does, he will temporarily exchange his identity for another mysterious persona that transcends sex more completely than that of any Zouave (whom a U.S. Sanitary Commission nurse had described as "unexceptionable human beings of no sex, with the virtues of both").[140]

One Jamaican writer recalled that on these occasions, "a perfect equality seemed to reign among all parties; many came and shook hands with their master and mistress."[141] The picket fence behind these figures makes clear they have already entered into the white space and left the slave quarters behind. The children beam with anticipatory excitement. The scene they witness is rooted in the past yet offers promise for the future, a promise that traditions—Black and white—can survive in pride and honor worthy of the American flags held in the boys' hands.

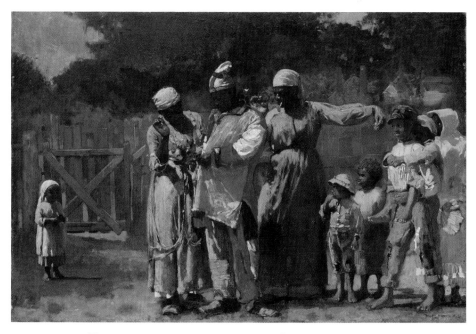

Figure 121: *Dressing for the Carnival*, 1877. Oil on canvas, 20 × 30 in.

But they hold them tentatively, for good reasons. As Homer and many of his viewers knew well, the Centennial of the nation's birth led to a massacre west of Wilmington, in Hamburg, South Carolina. A militia of freedmen on parade were quickly made victims of white supremacist "Red Shirts" who rounded up about twenty-five Black citizens, forming a "Dead Ring" around them and shooting at least five of them in cold blood. A jury indicted ninety-four white men for the murders; not one was prosecuted. The national election that followed four months later was the single most divisive one in the nation's history and led to the disbandment of Reconstruction.

The horrific event in Hamburg and the election that followed should not distract from the underlying fact that Black Americans had grown in their national pride over the decade after the war, and in their confidence to express it.[142] As historians Brian D. Page and James B. Jones, Jr., have demonstrated, Black Americans in the South had embraced the July 4 holiday with enthusiasm.[143] At a time when white Americans in the South had more diffident feelings, Black Americans could celebrate their freedom as Americans with gusto. The strong possibility that Homer was in coastal North Carolina on July 4, 1876, the moment of the nation's hundredth birthday, casts *Dressing*'s two tiny American flags in a new light. Two of the three youngest children hold these flags; the red and white stripes on the stick held by a third child, at left, reveal that it is a furled flag, awaiting her unveiling. The eyes of all six children gleam with expectant hope despite the failed Reconstruction promises. These girls and boys do not dwell on the past, or on what sort of world may confront them in their adulthood. They look to the short-lived dance of the present. In that moment, as in a canvas, strips of useless cloth may be transformed to the shimmering color of light, and the dreams of ancestors gone long before us become a dance of life.

The Centennial was a breakthrough year in several respects, from Alexander Graham Bell's patenting the telephone to Mark Twain's publishing *The Adventures of Tom Sawyer*. This picture may be regarded as comparably significant, among America's greatest achievements. But Homer's prescience exceeded that of his patrons. Only fifteen years later, and at a discount, would he sell the picture—to Thomas B. Clarke, who had bought *Uncle Ned at Home*.[144] Yet again, Homer was ahead of his time.

TELLING IT SLANT
(1877–1881)

By June 2, 1877, when Homer first exhibited both *Sunday Morning in Virginia* and its pendant *Visit from the Old Mistress*, and *Dressing for the Carnival*, his sights were already set on the Adirondack Mountains, in the opposite direction from the coastal plains of North Carolina. He did not know the Adirondacks as a whole, but was deeply familiar with one particular spot, the Baker Farm, ten miles west of the hamlet of Minerva, New York. Once a logging camp, the farm was situated on the north slope of high ground nestled among streams and ponds near a sharp turn in the upper reaches of the Hudson.

Homer had visited the farm twice before, in 1870 and 1874. It was centered on a fifty-acre clearing, and so the farm became known as the Clearing. Throughout the 1860s, Fitch and other New York artist friends had told him of the Adirondacks, but then he received an even more persuasive endorsement.[1] In November 1868, Boston's Park Street Church, the evangelical bastion where Homer's parents had married, called as its new pastor a twenty-eight-year-old prodigy.[2] William Henry Harrison Murray (1840–1904), a recent Yale graduate, was a charismatic champion of natural theology: the proposition that God calls to women and men not only through Scripture but through reason and the experience of nature. Murray spoke often about the Adirondacks; on one of Homer's visits to his parents in Belmont, he may well have heard Murray lecture on the wilderness and the powerful revelations he received there. The Boston publisher

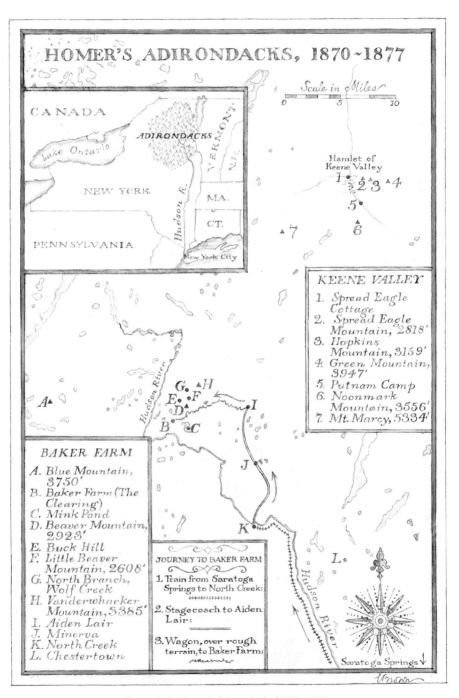

Figure 122: Homer's Adirondacks (1870–1877)

Fields, Osgood & Company issued a compilation of Murray's mountain musings in April 1869: *Adventures in the Wilderness; or, Camp-Life in the Adirondacks*.[3] The book was unabashed in its praise of the Adirondacks as a place to behold the fresh fingerprints of the Divine: "The preacher sees God in the original there, and often translates him better from his unwritten works than from his written word."[4] Murray explained that "in the mountains, which, in every literature, have been associated with the Deity, you see Him who of old time was conceived of as a 'Dweller among the hills.'"[5] To experience the Adirondacks is to open oneself to God. "The soul, when it spreads its wings for flight upward, must start from the summit of mountains. It must have the help of altitude, or no movement of wings will lift it."[6]

Despite one review describing the book as "gorgeous French, badly translated," it was an instant best seller, necessitating ten successive printings by midsummer.[7] Murray was suddenly renowned as "Adirondack" Murray, a different sort of preacher than Boston had ever seen before, who catalyzed not a conversion to the gospel but a stampede of Adirondack-bound tourists. *Harper's New Monthly Magazine* ridiculed those urban visitors that summer, such as the hapless fisherman who drowns as his hat, decorated with trout flies, floats away from him and attracts real flies. Above him, an owl, an antlered deer, and a pair of bullfrogs dutifully study Murray's commentary on their dominion, which a sharp-clawed panther holds open for their perusal.[8]

Although train service from New York to Saratoga Springs was easy, few city folks ventured past it on the sixty-mile spur to North Creek, which was not even completed until a few months after Homer's first visit in 1870, just a year after Murray's treatise appeared.[9] Homer and a few other intrepid New Yorkers took that train as far as they could, and then a stagecoach fourteen miles north, to Aiden Lair. There, someone from the Baker Farm would meet them with a wagon. They would travel together about a dozen miles over a rough 1850s logging trail, to the Clearing itself. All told, the journey required one or two days—and a heightened tolerance for discomfort. Even today, visitors arrive at the place only after driving nearly an hour from the nearest post office.

Much of the vast area was similarly difficult to penetrate. The stampede Murray sparked was concentrated in just a few hamlets on the periphery of the Adirondacks' far-reaching terrain (six million acres in what is now rec-

ognized officially as a park)—which tourists could reach easily by a combination of train and buckboard or stagecoach, and which offered comfortable beds and tolerable cuisine. The deeply forested territory's few roads were difficult to navigate in any season. Nevertheless, as the art historian David Tatham has written, the area "was, and remains, among the most scenic regions of its size in America, more varied and intimate in its charms than the grander wild country of the West."[10] To this day Adirondack Park, forged in 1892 by the New York State Legislature from a mosaic of public and private land, is the largest protected landscape east of the Mississippi and exceeds the scale of three vast national parks combined: Everglades, Grand Canyon, and Yellowstone.

Homer tended to avoid the Adirondack destinations other city dwellers reached easily and comfortably. The hardscrabble Baker Farm, well off the beaten track, appealed more to him. So did its people, including his hosts that first year, Juliette Baker Rice (1842–1931) and her girlhood sweetheart and husband, Wesley Rice (1827–1873), once her family's hired hand.[11] She married Wes at twenty-one, suffered a stillbirth at twenty-four, and may have been permanently disabled from that moment forward.[12] Homer had not met her before this trauma, but he would have appreciated

Figure 123: Unidentified photographer, *Baker Boarding House and Extensions, Western View*, c. 1889. Albumen print, 6 × 8 in.

the matter-of-fact resilience leaping from the pages of her terse diary entries.[13] He stayed in the farm's three-story log boardinghouse for about three months in the late summer and fall of 1870, and again for about a month in the late spring of 1874.[14] The mountains were of only moderate height (Beaver, the most conspicuous, is just 2,927 feet) but that was high enough for Homer. He prized quiet.

His first illustrations and art inspired by the Adirondacks reflect its isolation from civilization and its simple beauty. At first glance, they appear to be visual transcriptions of Murray's ode to the vast territory. "When you feel the presence of a friend, have his hand in yours, see him at your very side, you do not need to take up a letter and read that he is with you. So with God: in the silence of the woods the soul apprehends him instinctively. He is everywhere."[15] Murray invoked a sense of mystic harmony between humanity and nature, of still and silent wonder at the beauty and order of Eden restored. This side of heaven, God's blessing is known in full to him alone, but mortals with wide-open eyes might glimpse it for a moment. Homer followed Murray's lead in these works, as the mountains recede and quiet lakes invite his viewers to immerse themselves in "the water at your feet, which no paddle has ever vexed and no taint polluted, rivalling that which is as 'pure as crystal.'"[16]

Yet Homer had a knack for narrative more subtle, and less comfortable, than Murray's story of recovered innocence. He observes a truth and opens a tale only the viewer can complete. In *An Adirondack Lake*, a lone male figure appears silhouetted under the eastern sky on a warm afternoon in early autumn. He stands on a large tree trunk that has fallen into the shallow waters of Mink Pond, a twenty-minute walk from the Clearing, and holds his paddle as if he has just stepped out of his canoe. In the stern, he has stowed a cylindrical jacklight: an emblem of his trade and methods as a trapper.[17] It tells of his plans for the night ahead. Paddling silently in darkness, he will approach a spot just like this one, where deer drink and feed on the delicate plants that grow close to shore. Then, suddenly, the trapper will spark his jack, both to confirm the deer's location and to startle and immobilize it with the unexpected light.[18] In an instant, the trapper will make his easy shot, and the deer will die. Murray condoned the technique—and even delighted in it—but by the end of 1897, the New York State Legislature had declared it illegal.[19] Jacklighting expressed human hegemony, not stewardship. It arrogantly violated the Edenic balance

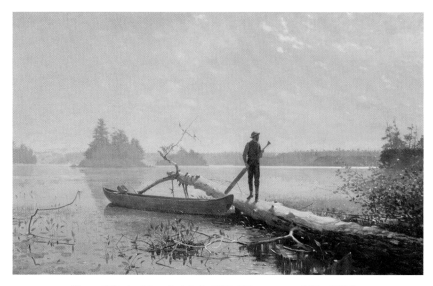

Figure 124: *An Adirondack Lake*, 1870. Oil on canvas, 24¼ × 38¼ in.

to which Homer aspired. He invokes the sacrifice of the unseen deer with a delicate cross rising to the sky from the fallen log. He positions himself, and the viewer, where the deer might be.[20]

His model is Rufus M. Wallace (1830–1913), a farmer from Chestertown, a tiny hamlet at a crossroads west of the Schroon River as it descends from Schroon Lake toward the Hudson.[21] Wallace is an archetype in the picture, just as was the Maine fisherman in *Winding Line*. But he would become much more. A lifelong bachelor then forty years old—six years Homer's senior—Wallace would appear about twenty-five times in Homer's work, as both men aged over twenty-five years.

A few months later, Homer depicted Wallace in a wood engraving paddling a canoe.[22] His other model, Charles Lancashire (1830–1904), lifts a dead mink, caught in its chained trap, to which a lily pad and its root are also attached.[23] The delicacy of Lancashire's touch and the solemnity of his expression stand in contrast to the cruelty of his act.

At that moment, Wallace, Lancashire, and other local farmers with the right mix of talents had suddenly discovered a new source of income. The stampede Murray had catalyzed meant that these men were no longer so dependent on their meager earnings from the rocky Adirondack soil. City folk—sportsmen, called "sports"—paid their guides $2.50 a day.[24] And unlike in the Catskill or White Mountains, guides were indispensable in the

Adirondacks. The peaks are taller than the Catskills, more remote than the White Mountains, and more daunting than either, particularly in the 1870s, as they were far less mapped. Only the most foolish would dare penetrate them alone.

To be a guide, Rufus Wallace needed to possess and deploy an unusual mix of talents. Murray counseled that a good guide is "quick, inventive and energetic . . . As a rule, avoid an old guide as you would an old horse."[25] A good Adirondack guide needed to be both knowledgeable about his terrain and adept as a fisherman, a paddler, and a cook. "Bronzed and hardy, fearless of danger, eager to please, uncontaminated with the vicious habits of civilized life, they are not unworthy of the magnificent surroundings amid which they dwell . . . The wilderness has unfolded to them its mysteries, and made them wise with a wisdom nowhere written in books."[26] The frequency with which Homer depicted Wallace suggests Homer's deep affinity and appreciation for him, as a friend and even alter ego.

When Homer returned to the farm in 1874, he painted not a guide but a "sport," another friend: Eliphalet Terry (1826–1896), who seems to have shared with Fitch the responsibility of introducing the Clearing to Homer.[27] Although Homer took pains to declare the watercolor a portrait, he embedded a narrative thread. The dog is a springer spaniel, bred for birding, not fishing. Given Terry's precarious position in the Adirondack guideboat, and the breed's excitable nature, the calm of this quiet fishing expedition may be short-lived. Homer called the sheet *The Painter Eliphalet Terry Fishing from a Boat*, as if to assert the artistic status of the older man, whose wealth exceeded his recognition among either collectors or critics. Terry's father, of the same name (1776–1849), had founded the Hartford Fire Insurance Company. To survive, Homer needed to sell his work; Terry did not. In a gesture of friendship, Homer gave the watercolor to the club of which they were both members. He was also sharing a private joke about Terry's ill-suited companion in the guideboat.

Homer's third visit to the Adirondacks, in 1877, was not to the Baker Farm. Instead, he joined several men gathered some twenty miles northeast, at the hamlet they called Keene Flats (now known as Keene Valley). His circle there included Fitch and two other painters he knew well, Roswell Morse Shurtleff (1838–1915) and Alexander Helwig Wyant (1836–1892).[28] William James, whom he had gotten to know through La Farge, spent six weeks that summer nearby, at Putnam Camp.[29]

Keene Valley is in the heart of the High Peaks region topped by Mount Marcy, at 5,344 feet. The dramatic scenery had attracted artists for decades and lent the small town a somewhat cosmopolitan flavor lacking at the Baker Farm. Hartford intellectuals were particularly concentrated there, led by Joseph Twitchell (1838–1918), pastor of the city's Asylum Hill Congregational Church and a close friend of Samuel L. Clemens. Fitch and Shurtleff were part of the same Hartford circle.

At the Clearing three years earlier, Homer had designed a wood engraving depicting a sport and his guide resting on a point jutting into Mink Pond, with Beaver Mountain in the background. With a full catch lined up on the sand beside them, the tired guide seems to meditate as he smokes by the fire, while the young sport toys with a coil of catgut line.

Now Homer depicted another pair, but in a dramatic nighttime scene that could be anywhere in the woods. The sport is almost audibly snoring, his left arm stretched toward the fire in one of several adept linear compositional techniques. The triangular lean-to within which he sleeps reaches up toward a fallen tree that, Homer explained, was the one exception to his creating "a general transcript of surroundings of a fire lighted one night while he was camping in the Adirondacks."[30] Even as he took a single element from another setting and combined it with his principal composition, Homer was a stickler for accuracy. He found the tree "elsewhere, built a fire in front of it, observed the effect, and transferred it to the canvas."[31]

When Homer first exhibited the picture at the Century and the Union League Club in October 1877, it was widely admired, particularly for the truthfulness of its fire effects. Shurtleff recalled the Keene Valley scene as "so real, a woodsman could tell what kind of logs were burning by the sparks that rose in long curved lines."[32] A critic wrote that Homer depicted "a peculiarity in campfires which every boy and man who has ever roved the woods much has seen in his own campfire, but perhaps never before on canvas. In stacking up branches and logs for a rousing fire, one occasionally comes across a rare chunk of moss-covered wood, which, when thrown into the fire, fills the flames above it with sparks which fly up in long, bright, waving lines and lend to the fire a most fanciful charm. Not every campfire has those comet-like sparks. It is only when mossy branches are thrown in that they appear. Mr. Homer is trying to paint a camp-fire of this sort."[33] When he showed it again several years later, another credited Homer with "a boldness which emulates Japanese draughtsmen."[34] Curi-

Figure 125: *Camp Fire*, 1877 (misdated by Homer as 1880). Oil on canvas, 23¾ × 38⅛ in.

ously, viewers paid less attention to other optical effects, such as the reflective magnifying glass hanging over the sport's body, or the gleam on the shaft of the net behind the attentive guide. The picture took thirteen years to sell.

While Homer often painted wilderness scenes, for sleeping he favored a comfortable bed. He might well have stayed at Spread Eagle Cottage, operated by a genial and lanky entrepreneur, Monroe Holt (1845–1921), in the center of Keene Valley at the southwest corner of Adirondack and Main Streets.

Holt was a pillar of the town who served at various times as constable, tax collector, assessor, inspector of elections, auditor, justice of the peace, and eventually supervisor.[35] He and his wife, Amanda (1851–1931), arranged for a variety of activities from croquet to hiking, and they were known for their hospitality to women visiting from the city.[36] Like the beach, the woods encouraged a relaxation of then-rigid barriers between the sexes. Holt offered his guests the frisson of excitement in the mountain air, and then a safe return to their snug lodgings. He knew and loved his territory, from the boardinghouse itself to the wilderness a short walk out its front door.

The subject of female tourists had worked well for Homer eight years

Figure 126: Unidentified photographer, *Spread Eagle Cottage*, 1872.
Albumen print, 9⅜ × 8⅛ in. Monroe Holt stands on the grass
in a jacket, white shirt and vest, and a light hat and pants, as he leans
against a pillar at the northeast corner of the house.

earlier. He portrayed vigorous women—modern, urban—on the trail at
Keene Valley in his canvas *In the Mountains*, just as he had depicted pro-
gressive women set amid the even taller White Mountains in *Mount Wash-
ington* (1869). He deployed dramatic tonal contrasts and stark diagonals
from upper left to lower right to convey the steepness of the grade. His
vertical centerline neatly bisects the four hikers into two groups, each a
pair, as if to convey the followers' difficulty keeping up with the leaders.
Homer describes with exactitude what the local historian Robin Pell de-
scribed as a distinctive "long shelf of rock" just below the summit of Hop-
kins Mountain, at the south end of Keene Valley.[37] Pell described the
Mossy Cascade Trail up to Hopkins's open summit as "one of the least
demanding in the Adirondacks." The trail was also the direct one most
commonly used during this period, and passed directly by the studio of
Alexander Helwig Wyant, where Shurtleff often stayed.[38] The path likely
used by Homer is seldom used today because it runs in part over private
land. By other routes, however, Hopkins (3,156 feet) remains a popular
destination for hikers, as it offers a spectacular view without exceptional
physical challenge or time commitment. It was especially convenient to

Figure 127: *In the Mountains*, 1877. Oil on canvas, 23⅞ × 38⅛ in.

guests at Monroe Holt's Spread Eagle Cottage, which was located across the street from its eponym, Spread Eagle Mountain (2,818 feet). Hopkins lies just behind that slightly lower peak. As was his custom, Homer framed his picture precisely, to include a hint of Green Mountain in the distant right.[39]

On a smaller canvas, he depicted two of the hikers, clad in the same colorful dresses. This time, however, he set his scene not in Keene Valley, but at the Baker Farm. While most artists take abundant artistic license of this kind, Homer did not. It was a startling extension of the sort of transposition he had deployed in *Camp Fire*, which was modest, but noteworthy enough for him to call out as a departure from his usual practice. Normally, Homer's dedication to close observation of the particular led him to insist that his models be posed within the landscape where he wished to depict them, but as might have been the case with *The Cotton Pickers*, exceptions were sometimes warranted. In this case, perhaps influenced by the New York artist friends around him, Homer took his exception much further. He created a pastiche based on figure drawings made in Keene Valley and landscape drawings made three years earlier at the Baker Farm. The composition of Homer's picture is set on Buck Hill (a low ridge west of Beaver Mountain), looking northeast to Vanderwhacker Mountain; on the right he painted the

northwest slope of Little Beaver Mountain.[40] In addition to the unidentified visiting women, Homer includes a third figure standing at a respectful distance from them: Orson Schofield Phelps (1816–1905), better known as "Old Mountain Phelps," an intrepid explorer deeply knowledgeable about the High Peaks. By 1877, at age sixty-one, he spent more time at home writing columns for the local newspaper than leading tourists on mountain hikes. Even so, every sophisticated visitor knew that a séance with the garrulous sage was an indispensable part of the Keene Valley experience. Phelps relished the attention he garnered as a quintessential Adirondack character who "doesn't aspire to much as a hunter, but claims to have caught more trout than any other man in the country."[41]

Figure 128: Seneca Ray Stoddard, *Orson Phelps*, 1876. Negative taken in 1962 from a glass lantern slide from 1873, 3¾ × 4¼ in.

Three years earlier, the landscape photographer and Adirondack publicist Seneca Ray Stoddard (1844–1917) described Phelps vividly:

"We found him at his home near the falls that bear his name—a little old man, about five foot six in height—muffled up in an immense crop of long hair, and a beard that seemed to boil up out of his collar band; grizzley as the granite ledges he climbs, shaggy as the rough-barked cedar, but with a pleasant twinkle in his eye and an elasticity to his step equaled by few younger men, while he delivers his communications, his sage conclusions and whimsical oddities, in a cheery, cherripy, squeaky sort of tone—away up on the mountains as it were—an octave above the ordinary voice, suggestive of the warblings of an ancient chickadee."[42]

The oil sketch is unusual for Homer in three ways: it depicts an immediately recognizable figure; it is a pastiche; and the experiment is an abject failure. The cardboard appearance of all three figures and the blandness with which Homer painted the mountains are especially notable. He appears never to have exhibited the picture publicly. Abigail Booth Gerdts, editor of the definitive catalogue of Homer's works, notes that the painting

Figure 129: *Beaver Mountain, Adirondacks, Minerva, New York*, c. 1877.
Oil on canvas, 12⅛ × 17⅛ in.

received a "postal-address style of titling" (or rather mistitling) in 1936 as *Beaver Mountain, Adirondacks, Minerva, New York*, lacking only a zip code.[43] But Homer did not destroy it either. In fact, he hung it in the New York apartment his friend Samuel Thorndyke Preston (1848–1899) rented and shared periodically with Homer beginning in 1880 (figure 137).[44] Perhaps Homer found the oil sketch an unusual form of inspiration.

He resolved to try again with a more ambitious work, the same size as *In the Mountains*. But in *Two Guides* Homer recalled the mountain landscape surrounding the Baker Farm far more effectively than he had in the oil sketch. From the same vantage point on Buck Hill, Vanderwhacker Mountain appears. It is a tall peak two miles north of Beaver Mountain. It looms taller and wilder than in the sketch, as wisps of cloud wrap around its summit and in the valley to its south. On the far left, Homer includes a stream omitted in the oil sketch: the north branch of Wolf Creek.[45] He renders the berries and turning leaves of early autumn with just the attention Rood commended to their complementarities of color, both in the foreground and on a maple sapling to the right, which Homer depicts as canting toward the middle of the picture.

There, precisely at the picture's center, Homer placed Phelps—or rather Phelps's best-known attribute: his voice box. The slovenly seer looks out from under his Whitmanesque slouch cap and gestures with his right hand, as with his left he lightly holds an axe. Phelps carries a distinctive Adirondack pack basket, examples of which he wove at home from black ash and reeds, and gladly sold to visiting tourists. In place of the two women who appeared in the oil sketch, the long-legged Holt appears, standing next to Phelps and attentively looking where the older man points. Holt is as natty as Phelps is ungainly. He wears a stylish new hat, a daypack of the modern style Homer himself favored, and a bright red flannel shirt. The shirt's curved bib, attached by nine shiny silver buttons, is embroidered in a distinctive way: with a heart.[46] Holt appears as tidy as the lunch bucket his wife has packed, while Phelps, known to dislike bathing, appears with filthy hands.[47]

Homer first exhibited this picture and *In the Mountains* at the National Academy of Design Annual Exhibition in the spring of 1878. He may have intended the two pictures as pendants. *Two Guides*, like many Homer pictures, features a pair. The contrasts are abundant: old and young; speaker and listener; scruffy and spotless. Homer preserves for himself a sly joke,

Figure 130: *Two Guides*, 1877. Oil on canvas, 24¼ × 38¼ in.

and he lets the viewer ponder what words of wisdom Phelps imparts to his young friend and what insights he might glean if only the old man stopped talking. By 1877, neither worked much as an Adirondack guide, but each represented a directional pole.

Holt wears a valentine to community, to hearth and home in Keene Valley, where he was known as the soul of hospitality. His direction is toward rootedness, the contentment of a settled life. Phelps, on the other hand, had traveled widely in his youth in the High Peaks region of the Adirondacks (although not the more southerly region where Homer posed him), and was now regarded as a seer about the territory as a whole. He embodied the American itch, forever restless in pursuit of fresh vistas to observe and explore. He was also an ardent follower of Horace Greeley (1811–1872), founding editor of the *New-York Tribune* and a catalyst in establishing the Republican Party.[48] Greeley popularized the saying for which he is best known today: "Go West, young man! Go West!"[49] The specific landmark to which Phelps points was one Murray had praised, Blue Mountain, on the horizon twelve miles distant. Homer didn't paint it, but he knew it, as did Fitch and Terry, and that was enough for him. What matters is not the mountain but the orientation: West!

Homer's Greeley allusion reflects both the painter's sense of humor and his American identity: longing for home and gazing far beyond it, a passage through a polarity. The picture also reflects his engagement with American literary culture. Despite Homer's decision to cease almost all his illustrations for magazines after 1875, he retained friendships with a wide variety of writers and editors, including Thomas Bailey Aldrich, who had interviewed Homer for his article in *Our Young Folks*; the poet, critic, and inventor Edmund C. Stedman, a collector of Homer's work; and the Civil War historian Francis W. Palfrey, whose service at Camp Benton Homer had witnessed during the opening months of the war. In Keene Valley, literary figures from Boston, Hartford, and New York gathered in a relaxed atmosphere fostering the exchange of ideas. Artists such as Fitch and Shurtleff were a part of that circle into which Homer stepped.

That year, the Boston publisher James R. Osgood & Company (successor to Murray's publisher Fields, Osgood, and to its famous predecessor Ticknor & Fields) commissioned fifteen wood engravings to illustrate a special book-length edition of an 1841 Henry Wadsworth Longfellow poem, "Excelsior."[50] Osgood paid Homer $25 for each of the four illustra-

tions he designed.[51] The poem is set in the Alps, but Homer's dramatic illustrations recall the appearance of the High Peaks around Keene Valley, and the powerful influence of his time there. Yet the evidence suggests he never again returned—and waited twelve years to come back to any part of his beloved Adirondacks.

Upon his return to New York, Homer joined an eclectic group of illustrators, architects, and artists who gathered weekly in one another's studios on Wednesday evenings, as much for camaraderie as for artistic innovation. He hosted the club's first annual dinner at his studio in the Tenth Street building. The twelve men called themselves the Tile Club.[52] In the club's earliest days, its other members were all younger than Homer, then forty-one years old. They included the illustrator Edwin Austin Abbey (1852–1911) and the painter Julian Alden Weir (1852–1919), a younger half brother to John Ferguson Weir, the founding dean of the Yale School of Art.[53] Homer's fellow New Englander the painter Robert Swain Gifford (1840–1905) was another early member. Another illustrator in the club, Charles Stanley Reinhart (1844–1896), portrayed the Tilers as they

Figure 131: After Charles Stanley Reinhart, "The Tile Club at Work,"
from *Harper's Weekly*, January 30, 1880. Wood engraving on paper, 15½ × 21⅛ in.
Homer is depicted bald at center, hunched and with a cigar in his mouth.

Figure 132: William Rudolf O'Donovan,
Bust of Winslow Homer, 1876. Plaster, 12 × 6 × 4½ in.

congregated around a common table to paint eight-inch-square ceramic tiles, aided by the liberal consumption of beer and tobacco.

The sculptor William Rudolf O'Donovan (1844–1920) also joined the club. A Virginian (and a former Confederate officer), he would move into the Tenth Street Studio in 1878. He had created a plaster bust of Homer in 1876 and given it to him. Homer's brothers and their heirs preserved it well into the twentieth century until his great-niece's son gave or sold it to a friend who was a graduate of Colby College.[54] The friend, in turn, gave it to the college's museum in 1976, unaware of its significance. While many photographs of Homer survive, he seems to have been less inclined to pose for painted or sculpted portraits; the bust is unique as a depiction of him in the prime of his life, created solely as an act of friendship.[55]

Each member chose a nickname; Homer's was "Obtuse Bard." Like the bust, the nickname is a compact and cunning description of the man. With humor, Homer recalled his ancient Greek forefather, whose works were then familiar to every schoolboy, and asserted his own poetic calling. Ever sensitive to the critics who denounced him as blunt—even a bit slow—he also adopted proudly the mantle of the obtuse. The truth he told was his truth, seen his way and told his way. Emily Dickinson understood what

Homer did, when five years earlier she wrote a subtle explanation of her own way:

Tell all the truth
but tell it slant—
Success in Circuit
lies
Too bright for our
infirm Delight
The Truth's superb
surprise
As Lightning to
the Children eased
With explanation kind
The Truth must
dazzle gradually
Or every man be
blind—[56]

Homer's humorous yet instructive nickname reflects his unique position in the club. He seems to have taken the tile-painting part of its life more seriously than his fellow members generally did. His eleven surviving ceramic works include both monochromatic and colored pieces. Five of them relate to farm life, with whimsical shepherds and shepherdesses, while four depict seaside scenes. All have a frivolous quality reflective of the circumstances in which Homer made them. His most elaborate compositions were both for multi-tile fireplace surrounds. One survives: a colorful hilltop farm scene with young figures of both sexes dressed in courtly eighteenth-century clothes and shyly looking away from one another. Winslow made the composition for his brother Charlie and may have considered producing it in commercial quantities, as he took the trouble to copyright the design. John La Farge wrote that Homer considered working in wall decoration and stained glass (two media in which La Farge was creating important work during this period).[57] Homer made a wall drawing in charcoal on the second floor of the house his parents rented in Belmont, shortly before he left for his first trip to England.[58] It is incised as if he planned a painting that would cover the drawing, but never moved be-

Figure 133: *Couple on the Shore*, 1878. Oil on ceramic tile, 8 × 8 in.

yond the initial phase of his work. No other wall paintings or drawings by Homer are known. His Tile Club works remain the principal evidence of his interest in the decorative arts.

The imperative to form the Tile Club came in part from a revelation to many Americans during the Centennial Exhibition in Philadelphia: British artists were clearly ahead of American artists in both commercial and artisanal advances in the decorative arts. The Americans were more than envious of the fine British work; they were worried that their livelihood depended on altering their tone. An early Tiler told the story of two members, the first of whom declared, "This is a decorative age . . . We should do something decorative, if we would not be behind the times." The other replied in a similarly jocular tone, "It is only a temporary craze, a phase of popular insanity . . . [although] of course it has interfered with the sale of our pictures."[59]

As the long depression that began in 1873 wore on, the Philadelphia-born Abbey became convinced that a brighter future beckoned for him in Britain. He resolved to pull up stakes and abandon his native land—with encouragement from publishers to whom he sold illustrations. The farewell dinner Homer and his fellow Tilers gave him at the Westminster Hotel was a night to remember, including several special guests such as *Harper's*

Charles Parsons (1821–1910) and the editor and poet (and Helena de Kay's husband) Richard Watson Gilder.[60]

Homer's time in the Tile Club exposed him more deeply to the Aesthetic Movement, which had begun in England and which he had glimpsed there in late 1866 and early 1867. From the Grosvenor Gallery on Bond Street, which opened in 1877, the cry of "Art for Art's Sake" rang out. On its wings that cry carried both Whistler's career and the publicity following it—including an infamous review that year from John Ruskin leading Whistler to launch (and lose) a suit against the English critic. The gallery, and the movement, included many other artists working across a range of media, including George Frederic Watts, Ford Madox Brown, John Everett Millais, Edward Burne-Jones (1833–1898), and Homer's exact contemporary James Joseph Tissot (1836–1902).[61]

LEFT: Figure 134: James Joseph Tissot, *October*, 1877.
Oil on canvas, 85¼ × 42¹³⁄₁₆ in.

RIGHT: Figure 135: *Autumn*, 1877. Oil on canvas, 38¼ × 23³⁄₁₆ in.

The Cult of Beauty became a phenomenon touching many corners of the globe.[62] Homer's responses to the movement include his 1877 watercolor *The New Novel*, his 1877 oil *Autumn* (probably based on studies of a sophisticated urban denizen visiting Keene Valley), and his 1880 painting *Promenade on the Beach*. Homer's women are formidable and intelligent. His unidentified model in *Autumn*, for example, though generic, is brimming with confidence. Tissot's model Kate Newton (1854–1882) appears by contrast not only flirtatious but frivolous. In *Promenade*, two women walk on the beach under a strangely lit indigo-ultramarine sky. They, too, wear highly fashionable clothes, but one also holds a Japanese fan. It is a tribute to the passion for all things Japanese then sweeping America, which affected Homer and many other artists engulfed in the Aesthetic Movement. As he made these works, Homer explored horizons far from his roots in narrative illustration. They embed meanings that are intrinsically mysterious and undiscoverable.

Homer spent much of the summers of 1878 and 1879 in Mountainville, New York, with the family of Lawson Valentine (1828–1891) and his wife, Lucy Houghton (1830–1911). The Valentines had just recently acquired Houghton Farm (as the Valentines called their country home), located in gently rolling countryside about six miles due west of the U.S. Military Academy at West Point, and about forty miles south of Hurley.[63] Over these months, Homer produced a series of works depicting children and beautiful young women, often solitary or in bucolic settings with cows, oxen, sheep, and red-combed roosters as their only companions. The trees and other natural surroundings seem perfectly suited to maximize the attractiveness of their idealized inhabitants. His figures appeared increasingly in pairs in 1879, in gentle play that embodied perpetually childlike innocence. Homer created a narrative void, inviting viewers to immerse themselves in a lingering presexual moment they would otherwise consider evanescent.

His hosts Lawson and Lucy Valentine were, like Homer, native Bostonians who had moved to New York. In 1852, when he was just twenty-four years old, Lawson had completed a five-year apprenticeship for a Boston paint dealer and founded a specialized varnish manufacturing company. The firm, focused on coach varnish, included Lawson's younger brother Henry C. Valentine (1830–1912) from 1860 forward.[64] Beginning in 1867, the business was known as Valentine & Co.; it moved its headquarters to

New York in late 1870 when, as Lawson reported, he had succeeded in creating an American varnish superior to the English products that "were then used exclusively for first-class work."[65] Lawson had a simple ambition: "to make a better article, sell it cheaper, and drive the imported article out of the markets."[66] About that time, the firm built a factory in Williamsburgh, Brooklyn, at the corner of Ewen and Jackson Streets.[67] Lawson had grown up in Cambridge near the Homer family's first residence on Dana Hill; it is reasonable to conclude that he knew Homer and his brothers from childhood. To run the factory he recruited Winslow's older brother, Charlie, who had operated Pacific Mills' dye works in Lawrence for more than ten years.[68]

Charlie's first decade with the varnish company was spent primarily in Brooklyn, but over time he migrated into a leadership position based in the company's offices on Pearl Street, close to the *Harper's* offices. He soon became a partner in the firm, and ultimately its president and chairman. From about 1871 until around 1879, he lived at 36 Washington Square West, close to Winslow. Then he moved to the Westminster Hotel at Sixteenth Street and Irving Place, a favorite New York haven for Samuel Clemens and the site of Abbey's farewell dinner given by Homer and his fellow Tilers. Charlie and his wife, Mattie, made it their New York nest for the following thirty years, in the heart of the literary and artistic community Winslow knew so well.

Valentine & Co. commissioned a series of advertisements, published in 1876 and 1877 and signed by Frederick Stuart Church (1842–1924).[69] One appeared in the catalogue of the Annual Exhibition for the National Academy of Design. They were silhouettes highly similar to the work Homer made in the early 1870s as illustrations for Lowell's poem *The Courtin'*— to the displeasure and ingratitude of the poet. The advertisements' gentle, romantic tone, including allusions to the company's focus on coach varnish, is similar to the mood of the watercolors Homer made during this period, many of them on the Valentines' farm. It is difficult to imagine that Homer was uninvolved with their commissioning or design. Homer's and their work of this period speak to the close relationships Homer enjoyed with both his brother and his brother's employer, and with a broad circle of artists and collectors. It is notable that in 1878, the year Homer first spent

a summer at Houghton Farm, the Valentine firm added color to its line of products, diversifying beyond varnish into paints.[70] Other technical developments at the company would follow, benefiting both the Valentine company and the community of which Homer was a part.

Lucy Valentine, like her husband, Lawson, was known for her generosity and hospitality. Her family's publishing company suffered a disastrous fire in 1880, which precipitated Lawson's investment of the then-massive amount of $250,000 (and the assumption of considerable debt).[71] Houghton Mifflin was saved, but Lawson and Lucy seem never to have returned to their previous standard of living. The editor, critic, and author William Dean Howells knew Lawson well; his novel *The Rise of Silas Lapham* (1885) appears based in part on his knowledge of Lucy and Lawson's struggle to cleave to a high standard of personal ethics amid volatile business conditions.

The Valentines considered artistic patronage a part of their mission, just as Henry Ward Beecher (from whom they acquired a controlling interest in the journal *The Christian Union*) had demonstrated years earlier in sup-

Figure 136: *Apple Picking*, 1878. Watercolor and gouache on paper,
laid down on board, 7 × 8⅜ in.

porting the work of the watercolorist Ellen Robbins.[72] Among the works they acquired by 1878 was a somewhat smaller version of *An Adirondack Lake*, which Homer probably executed for the Valentines at their request, with a few alterations reflecting their preferences.[73] The smaller picture has, for example, a more prominent placement for the jacklight and a cooler blue-gray tone.

At Houghton Farm, Homer shifted both from his penchant for embedded narrative and his watercolor style, which previously had made heavy use of thicker paint deployed in blocks within graphite outlines of stark geometric shapes. Now, while continuing to use opaque paint in certain cases such as *Apple Picking*, he more frequently adopted an English style of watercolor using transparent washes. He engaged in a technique that let his viewer's eye blend complementary colors applied in small brushstrokes. The practice certainly follows Rood's teaching and that of Chevreul. The practice coincides with two of Homer's practices: his use of glazes on tile and his adoption of compositions reflecting the Aesthetic Movement, sparked at the Grosvenor Gallery and currently aflame around the world.

By early 1880, Homer's life had reached a turning point. After eight years of living at the Tenth Street Studio Building—the artistic epicenter of New York—he developed plans for "relinquishing his studio at a date not far distant, and continuing his work in private."[74]

First, he decided not to participate in the increasingly large exhibition of the American Watercolor Society early that year. Instead, over the five weeks following the opening of that exhibition, he placed six oil paintings and seventy-one watercolors and other drawings up for auction, all through the same firm, D. A. Mathews.[75] It was a house-clearing similar to that which he and his friend Eugene Benson had launched in November 1866, just before his ten months in England and France. Although the individual prices Mathews achieved for him were exceptionally low (at less than $15 for each work), the volume meant that he cleared $1,037—the equivalent to $27,945 today.[76]

Second, he moved into elegant living quarters completed the previous year to the designs of Charles Follen McKim, the same architect Homer's uncle would hire in 1881 for his Seven Sisters project in Montauk.[77] The apartment into which Homer moved was that of Samuel Thorndyke Preston, a dealer in animal hides a dozen years younger than Homer and a

Figure 137: Pach Brothers, *Principal Room in Apartment
Leased by Samuel Thorndyke Preston and Shared with Winslow Homer*, c. 1883.
Gelatin silver print on stiff archival paper, 13 × 22 in.

childhood friend of Charlie Homer's wife, Mattie.[78] The lifelong bachelors shared a passion for fish and game. They chose a well-lit corner flat in the spanking new, six-story building at 80 Washington Square East.[79] The professional photographs the flatmates commissioned shed rich light on the material culture of the two men's everyday lives. Among the intriguing and enigmatic aspects of the prints, however, is an addition to one of them: a large fern, painted on the print in opaque watercolor. It purposefully obscures the identity of the flat's sole visible resident.

The building's developer named it the Benedick, after a character in Shakespeare's *Much Ado About Nothing*, because he wished to identify it as an address perfectly suited to affluent single young men. He was confident they would appreciate a range of on-site services from bootblacking to breakfast, given that their "hours are naturally somewhat irregular."[80] While Homer left behind his neighbors at the Tenth Street Studio, he was hardly lacking artistic company at the Benedick. His friends J. Alden Weir and John La Farge also lived there, as did Albert Pinkham Ryder, another influence on Homer. Within a few years, the building's reputation deepened and darkened. In 1888, the architect Stanford White (1853–1906), the sculptor Augustus Saint-Gaudens, and the painter Thomas Wilmer Dewing (1851–1938), among others, founded the Sewer Club in the building.[81] Although

Figure 138: Pach Brothers, *View of Corner in Principal Room of Apartment
Leased by Samuel Thorndyke Preston and Shared with Winslow Homer*, c. 1883.
Gelatin silver print on stiff archival paper, with opaque watercolor paint, 13 × 22 in.

that secret society moved to another location within a couple of years, its impact on the Benedick endured. The Sewer Club was a hothouse for men's sexual dalliances—with both women and other men.[82] Despite his knowing many of the members, the repressed Homer was unlikely to have participated in the club's activities. There is also no evidence of a sexual dimension in his friendship with his flatmate, Preston.

Third, Homer began plans for an extended period away from New York. The photographs of Preston's apartment show an abundance of Homer's art, but from this moment, Homer knew it would be a pied-à-terre for him as a guest of his friend. New York would never again be his permanent home.

His first destination was not far: the town of Greenwich, Connecticut, just thirty-five miles northeast of the apartment at the Benedick. Despite its proximity to New York, Greenwich retained the flavor of a sleepy New England town with a traditional inn at its center called the Lenox House, where Homer and his father both stayed.[83] Homer may well have visited the town at the suggestion of Robert W. Weir (1803–1889), longtime West Point drawing instructor, and of Weir's sons John Ferguson Weir and J. Alden Weir. But Homer's eleven extant watercolors from Greenwich— each horizontal in format and about nine by twelve inches—suggest that

he explored the town little. They adhere to a highly consistent program, anchored to the same location: Field Point, two miles southwest of Homer's hotel. Development was coming to Greenwich, but the point was still rural then and a popular destination for a stroll in the fresh air of Long Island Sound.

Most of the sheets Homer made depict an attractive young woman (one of several similar models, probably visiting for the day from New York) posed alone, in contemplation. These are no portraits. The figure is in each case an archetype of a sophisticated, intelligent woman. For an evanescent moment she is lost in her thoughts, and in the beauty of her setting, with which she harmonizes perfectly. All parts of the watercolors contribute to the sense of peace, from the color complementarity to the balanced geometric composition. The dresses the models wear contribute too, in a black or dark gray color suitable for travel from the city for a day in the country. The previous summer, *Harper's Bazar* had noted, "There was a time—our mothers will remember it—when the sole fact of wearing a

Figure 139: *The Rendezvous*, 1880. Watercolor, 8½ × 11⅜ in.

black dress when one was not in mourning was sufficient to call forth a kind of reprobation, and to cause the wearer to be classed among the dangerously eccentric women." Now, however, "black is more than ever the favorite color of fashion."[84] The skirts Homer likely prescribed for his models have symmetrical draping and a fashionable train. Like the tree trunks between which the models walk, the dresses accentuate their slender physiques. As at Houghton Farm and at Keene Valley, with dogged determination, Homer followed his intentions for his Greenwich sojourn. And once his work was done, he moved on and did not look back.

Homer settled his father back in Brooklyn and spent several days, including the annual commemoration of the nation's independence on July 4, 1880, in and near New York. He made his most daring watercolor of the year there. Homer conjured up the light from fireworks by blotting his sheet, rinsing his washes as they bled across the paper, and then scraping to create the discrete shape of a waxing crescent moon. The moon was indeed a slender crescent that night, but it was waning, not waxing; Homer preferred the shape that promised a larger moon to come. In this case, as in so

Figure 140: *Sailboat and Fourth of July Fireworks (Bergen Point, N.J.)*, 1880.
Watercolor and white gouache on white wove paper, 9⅝ × 13¹¹⁄₁₆ in.

many others, he composed his title with care. It was unusually specific: *Bergen Point, N.J.*[85] That location, a section of the New Jersey city of Bayonne, is two miles southwest of Bedloe's Island, which had been identified nine years earlier, in 1871, as the future site of the French government's gift to the United States of *Liberty Enlightening the World*. The monumental sculpture by Frédéric-August Bartholdi (1834–1904) would not be completed until 1886, but it had already captured the imagination of the country, particularly as a symbol of the freedom of Americans once enslaved. By placing himself so close to Bedloe's Island that night and by titling his daring watercolor as he did, Homer made subtle reference to the national landmark that would be unveiled at the same location six years later.

Soon after the national holiday, Homer set off to another destination for about three months. Despite the success of the watercolors he had painted in Gloucester in 1873, Homer had not returned to the port. Now he did. Over the seven years since that pivotal summer, much had changed in Homer's life. No longer could one describe him as a talented illustrator with just one memorable oil painting (*Prisoners*). Now he created illustrations only exceptionally, and no longer for newspapers such as *Harper's Weekly*. He had created a series of widely admired oil paintings, like *A Fair Wind* and *Camp Fire*. In his watercolors, Homer had identified a medium that paid him as well as his illustrations ever did, but with better commercial and artistic control. That said, he was never quite content, always considering a

Figure 141: *Sunset at Gloucester*, 1880. Watercolor and graphite on wove paper, 13 × 23¾ in.

fresh experiment, as he showed with his dexterous deployment of transparent watercolor paint, especially from his summer of 1878 at Houghton Farm, and with remarkable effect in *Bergen Point, N.J.* In the postscript to a letter he wrote to his Chicago dealer, he put it simply: "I will paint for money at any time. Any subject, any size."[86]

He returned to Gloucester with a commitment to go further—both in a commercial sense and artistically. Other peregrinations lay ahead. He arranged to stay with the mother- and father-in-law of a distant cousin, Captain Hatsel Emery Crosby (1842–1893).[87] Homer's host was Octavius Augustus Merrill (1820–1893), a colorful former Gloucester postmaster who manned the lighthouse set on Ten Pound Island (less than four acres in size) amid Gloucester Harbor. There, in Merrill's house, Homer executed about one hundred watercolors, averaging more than one per day, more than he ever produced at any other time. They included a series of daring sunset scenes, about which opinions have differed over the years. A contemporary critic wrote of their "demoniac splendor of stormy sunset skies and waters."[88] But as the art historian Marc Simpson has observed, citing the age-old phrase "Red sky at night, sailor's delight," one may conclude instead that they are expressions of awestruck gratitude in the face of such beauty, and genuinely ebullient joy.[89]

Figure 142: *Children Wading at Gloucester*, 1880. Watercolor, 9⅞ × 13¼ in.

Figure 143: *Five Boys at the Shore*, 1880. Watercolor, 9¾ × 14 in.

On a large sheet he contrasted two schooners in the harbor. One is a sturdy commercial vessel returning at sunset after a day of mackerel fishing. The other is a recognizable yacht, *Ambassadress*, which the *New York Sun* described as "the Finest in the World," and the largest schooner yacht on earth.[90] She was impractically grandiose even for her very rich owner, William Backhouse Astor, Jr. (1829–1892); Homer engaged in a touch of gentle ridicule at Astor's expense as he painted the yacht's tender rowing past the mackerel fishermen to return to the overscaled *Ambassadress*.

In another watercolor, Homer deployed a narrow range of colors in a way that anticipates the work of Milton Avery and other much later painters. In this case (and in few others in Gloucester), the site can be identified with precision. It is Half Moon Beach at Stage Fort Park, a secluded destination beloved to this day by wading children.[91]

Another presents five boys seen from behind, drying on a pink granite outcropping just after a swim. Without ever showing the boys' faces, Homer invites us into imagining their individual personalities. He also engages with a topic of controversy at the time; two wear bathing suits, and the others do not. As tourism grew in economic importance to Gloucester and other coastal destinations, so did the importunity of those seeking to pro-

Figure 144: *Gloucester Harbor Fishing Fleet*, 1880. Watercolor, 12¼ × 19¼ in.

tect tourists from sights that might offend them—such as the longstanding practice of boys swimming in the nude. Many at the time lamented the arrival of such strictures, which placed Homer's models at risk of being arrested by the local constabulary. One Gloucester newspaper article noted that "as our city ordinances read to-day, it is a crime for anyone to attempt to be clean or to enjoy a bath in the natural state."[92]

The triangular sails of clipper fishing schooners took on greater importance this summer, as scenes of children at play became less frequent, and Homer engaged with the primal drama set before him in the middle of the harbor, at the mysterious meeting of land, sea, and sky. While commercial fishing was then, and is now, among the most dangerous of all industries, most of the schooners Homer painted were outfitted for mackerel fishing. Their voyages were shorter and safer than those of, for example, halibut, cod, or haddock fishermen. Homer's scenes this summer are generally hopeful, not reckoning with tragedy.

By mid-September, he had accumulated enough watercolors to be convinced he had completed his work in Gloucester. A Boston newspaper wrote, "Winslow Homer, the eminent New York figure painter, who has

been passing the summer down this way studying his favorite New England types of seaside urchins and country maidens, was in town yesterday, on his way home, with a portfolio bursting with sketches."[93]

In December, Homer exhibited 112 watercolors and other drawings at a new dealer, pricing them to sell—mostly in the range of $50 apiece.[94] After years of staging auctions of his oil paintings and watercolors and curating his submissions to group shows at the National Academy of Design, the Brooklyn Art Association, and other venues, another option was emerging. Boston's Doll & Richards was one of many well-organized dealers springing up in major American cities; it became Homer's primary channel for his watercolors. The dealer system meant Homer could control his time more completely. Even if he were on an extended trip away from his lead markets of New York and Boston, dealers would keep selling his work and his reputation. In about ten days, Doll & Richards sold most of the works Homer consigned them. One critic, in a review that Homer himself squirreled away as a memento of his triumph, called the show "the most remarkable works of this class ever shown in Boston." Saying that Homer "has given a new interpretation to the ordinary and dignified the commonplace," the critic went on to caution:

> Simple as these subjects are, they must not be attempted by an ordinary painter. Without showing the individuality of talent they must always be flat stale and unprofitable, without intention or value and only worthy of study as sign-posts against future failure, but when genuine skill and a certain artistic insight address themselves to describing them, they have an importance which cannot be overestimated. An artist's greatest success is often found in the judicious use of his materials, in a certain economy of his resources and the husbanding of means which at first sight seems ordinary. A single thought in a painting, as well as in an essay or poem, is sufficient to satisfy when the best possible use is made of it, and when its motive is presented gracefully, yet concisely, in a few strokes of the brush or the pen, but with those strokes so put in that it is at once made evident that not one of those could have been spared. Mr. Homer's work gains its greatest strengths from these qualities.[95]

His summer on Ten Pound Island had won Homer a freedom he had never before experienced. He could plan a future guided not so much by economic need as by his artistic longings. A dealer and friend to Homer, J. Eastman Chase (1841–1923), later recalled this summer as a turning point in Homer's life:

> The freedom from intrusion which he found in this little spot was precisely to his liking, and here he painted a large number of watercolors of uniform size, but of a wide range of boldly conceived and vigorously executed subjects. No experiment, however fraught with risk of failure, had any terrors for him. He painted absolutely as he saw, entirely unafraid, caring for nothing so much as his freedom to express himself with unfettered independence . . . That serene and undisturbed summer on "Ten Pound" Island—it is little larger than a city lot—had given him his *clou*, and thereafter, for most of his life, it was the sea and the humble folk who live on and get their living out of it that chiefly interested him.[96]

Fewer than three months after the Doll & Richards exhibition, on the afternoon of March 15, 1881, Homer packed his bags at the Benedick flat he shared with Samuel Preston and boarded the *Parthia*, a steamship set for Liverpool. He had not been in England for almost fifteen years and was eager to return—eager enough to get onboard with plenty of time for an early supper.

ON THE EDGE
(1881–1884)

NEW YORK HARBOR was still gray at 6:23 on the morning of March 16, 1881, as the *Parthia* sounded her foghorn and slipped from her pier.[1] Few were on deck; an eastbound passage late in winter was never crowded. Cunard had commissioned the ship primarily to serve the demand of Irish emigrants for passage to America; while Liverpool was her home port, Queenstown (now Cobh), County Cork, was a close second. She could accommodate more than 1,000 in steerage, and 150 cabin passengers. That morning, though, just twelve cabins were occupied, and the steerage berths were nearly empty. The *Parthia* paid for her voyage principally with her cargo of U.S. commodities and manufactured goods bound for British markets.

In a watercolor, Homer captured the 360-foot ship's keeling deck, a lifeboat, and an intrepid traveler buttressed against the wind. Homer described that small vessel and the railing under it with particular care. He relished the circular geometry of the funnels; the large one at right is set precisely on the horizontal centerline, and receives an echo beneath the sheet's brightest spot, just right of center. He played with a series of triangles, created by the diagonals of cables and a ladder up the mast (one of three on the steamship, whose sails, common then on steamships, were rigged as a barque).

The crossing gave the crew plenty of time to tell tales, many of which the Cunard line wished they wouldn't.[2] Whether they did or not—and whether Homer listened—cannot be known with any certainty. But one

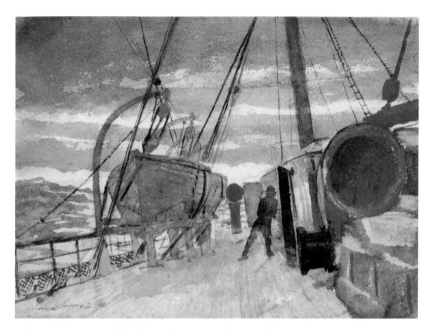

Figure 145: *Marine*, 1881. Watercolor over graphite on off-white wove paper, 9¾ × 13½ in.

may speculate that the extraordinary history of the ship, the paucity of passengers, and the especially observant eye and ear of one of them—Homer—led to his learning much over the eleven days at sea. On five of her ninety-four voyages over a dozen years since her launch, a curse had fallen on the *Parthia*—or so the superstitious might believe. Before her first birthday, the *Parthia* had already collided with a Bombay-bound steamship (she would collide with another ship in 1882). Then, fewer than two years later, she suffered a major fire.[3] More to her credit, she had also launched two dramatic rescues, in the year preceding Homer's voyage. In both cases, her men saved the crews of the vessels in distress, though the ships themselves were lost.[4]

The first was in March 1880, exactly a year earlier, when the *Parthia* was in the midst of the Atlantic, two days out of New York, blown by a stiff south wind. A *Parthia* crewman had spotted a signal of distress from another ship in deep danger amid heavy waves. The *Mary A. Myrshall*, a 153-foot, 693-ton cargo ship carrying 182 tons of British pig iron, was bound for Baltimore but had sprung a leak and now carried more than six feet of water. Despite her exhausted crewmen's bailing, the hold contin-ued to fill. In short order, the *Parthia*'s fifteen-man prize crew relieved

the *Myrshall* of her crew and did their best to stabilize the foundering ship.

Five hours later the rescue seemed to have worked. The wind and sea settled and the prize crew set a heavy cable to tow the *Myrshall* to the nearest port, on the south coast of Ireland, four days away. The two vessels traveled chained for thirty-six hours, more than 250 miles, until suddenly, in a heavy swell, the cable snapped. All members of both the prize crew and the *Myrshall*'s crew were saved, but not long after dawn, the *Myrshall* herself, and all her cargo, sank to the ocean's bottom, never to be seen again.[5]

Just over eight months later, on November 28, 1880, the *Parthia* rescued the crew of another cargo ship, the *James Edwards*, whose rudder had broken loose in high seas. Without direction or momentum, her deck was quickly swamped before the eyes of her hapless crew of twenty-two men. Their ship sank minutes after their salvation at the providential arrival of the *Parthia*.[6]

Until Homer was out on the open sea, well beyond the safety of New York Harbor, the *Parthia*'s eventful history may have been unknown to him. But once the crewmen began to speak, he was primed to hear. From his earliest childhood, stories of shipwrecks were in the warp and weft of his daily life. Not the least of these was that of his uncle James, precisely a year before Winslow's birth.[7] Homer's empathy, his native instinct for narrative, his decades of experience as an illustrator, and his ambition to create art to stir souls—and make his reputation—suggest that these eleven days onboard the *Parthia* were catalytic. For two decades, he turned again and again to the drawings he made on deck. Not in letter or in diary entry, but in art and art alone, Homer retrieved memory and meaning. He made it his testament. From this moment forth, the particularities of mid-ocean wreck and rescue became seeds from which mighty trees would grow. The drama of men at risk, and men whose acts can save them, would resonate with him for the rest of his life. In the endless ocean, and the finitude of creatures upon its surface and at its edge, Homer discovered a depth of truth and purpose.

His nature was to prepare. London held fewer surprises than the *Parthia*, but countless avenues he anticipated eagerly. It had been fifteen years since his last visit, when he stood in wonder at the city's museums and galleries. But now there was so much more to see—both places and people.

Abbey had lived there for more than two years and was not shy with introductions. From Liverpool, Homer went straight to a boardinghouse at 80 Newman Street, in Fitzrovia, on the corner of Eastcastle Street, a mile southwest of London's Euston Station.[8] Abbey had lived in the same house, and must have known well its owners, both of whom were artists. The illustrator and genre painter William Rimer (1825–1892) was better known than his wife, Louisa Serena (b. 1827), although she was the better painter. She specialized in closely observed flower painting, just as Homer's mother did, but Louisa worked in oil.[9] The Rimers were ideal hosts, and their house was in an ideal location. The neighborhood was then, as one scholar describes it, "an artists' quarter, though one much reduced in reputation."[10] No internationally renowned artists inhabited the block. That said, the art teacher Thomas Heatherley (1824–1914) lived and worked next door at 79 Newman Street; his Heatherley School of Art thrives to this day. The painter and illustrator T. Gordon Stowers (1854–1938) and the Italian-born dealer Federico Sacchi (1835–1902), longtime adviser to the National Gallery's director William Boxall (1800–1879), lived at 76 Newman Street. Another Italian, Augusto Lorenzini (1852–1921), lived at 74 Newman Street and would move to Australia two years later, where he would become a leading figure in the decorative arts. Several cabinetmakers, an upholsterer, and an "eboniste" also lived around Homer.[11]

Moreover, the boardinghouse to which Abbey directed him was very near the public collections Homer had visited in 1866 and 1867. The British Museum, ten minutes' walk away, was again an obvious destination, for many reasons. Homer was the first to sign the Visitors' Book of the museum's Print and Drawing Room on the morning of Thursday, April 14, 1881, shortly before the painter and etcher Alphonse Legros (1837–1911) appeared with five other viewers.[12] Legros collaborated closely with Whistler, among others; one cannot help but wonder who his five companions were. Homer surely also viewed the sculptures from the Parthenon, and other parts of the museum's broad and deep collection.

He must also have returned to the South Kensington Museum. Among the seven Raphael cartoons drawing his special attention was *The Miraculous Draught of Fishes*, particularly the figures at right, straining over their net, which is weighed down by a plentiful catch. Four years later, the theme would reappear in a picture set on the Maine coast.

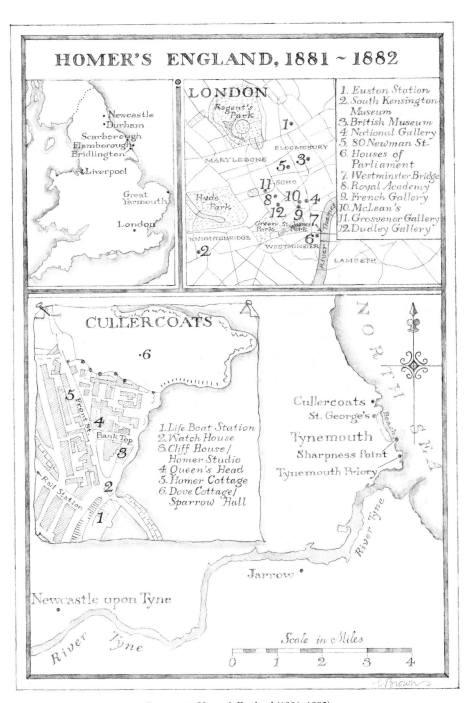

Figure 146: Homer's England (1881–1882)

Even more than the South Kensington Museum, however, the National Gallery on Trafalgar Square must have drawn him. When Homer had first come to England in 1866, the enormous bequest Turner had left to the British nation was split between two locations. His nearly 300 finished pictures were exhibited at the gallery, but most of the Turner bequest (his 300 sketchbooks and 30,000 sketches) was two miles northeast at the "refuge for destitute collections." Now, in rooms completed just five years earlier, the entire bequest was on view in Trafalgar Square. In comfort Homer could get a sense of Turner's pictorial process, how his mind developed visual concepts to completion, and what ideas remained uncompleted at his death.[13]

Homer seems to have paid a backhanded homage to Turner's famous depictions of the burning of the Palace of Westminster when he made his own watercolor of the newly rebuilt complex. Although as a young man, Homer made many illustrations of urban scenes, this is one of his very rare painted depictions of a city. He chose an unusual vantage point downriver

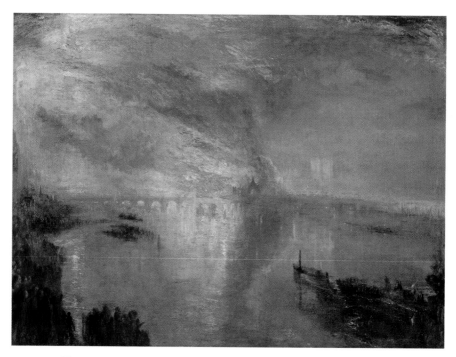

Figure 147: J. M. W. Turner, *The Burning of the Houses of Lords and Commons, 16 October 1834*, 1835. Oil on canvas, 36¼ × 48½ in.

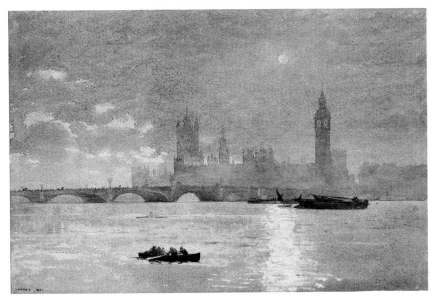

Figure 148: *The Houses of Parliament*, 1881. Watercolor on paper, 12¾ × 19¾ in.

from the south bank of the Thames—as did Turner.[14] The rhythmic arches of Westminster Bridge and the reflections on the river each play an essential role, both on Turner's canvas and on Homer's sheet. Each picture is set in the early evening. From there, the differences outnumber the similarities. Turner's work is wildly colorful; Homer's is nearly monochromatic—excepting the setting sun, colored in a Turneresque orange. Homer invokes discipline and calm; Turner conjures disorder and destruction. Turner leaves no doubt that a crowd of many thousands surrounded him that day. Homer is detached. He observes serenely the rowers' beaten trace and the trail of walkers on the distant bridge. He is content alone—something one never deduces from all the work of Turner.

Homer wrote little, but read a lot: novels and short stories, history books and lots and lots of periodicals. In about 1878, he began keeping a scrapbook with American newspaper clippings, mostly about exhibitions in which his own art appeared. He may have hired a clipping service to help him as a form of surveillance, just at the moment he was beginning to rely primarily on dealers. The book's 121 pages, built over about twenty years, suggest how deeply Homer cared about critics' and the public's perception of him and his work.[15] A few of the articles relate to European artists and critics, including a lengthy *New York Times* review of contem-

porary British painting: "The British School Again: Where English Art-
ists Are Peculiar."[16] Homer may or may not have agreed with the reviewer's
verdict on Whistler's pictures ("thrice-to-be-detested"), or that "the two
giants" of English painting were Frederic Leighton (1830–1896) and
Lawrence Alma-Tadema (1836–1912). But the fact that he kept the article
and a few others relating to his contemporaries in France indicate the
breadth of Homer's reading—of publications both American and British.
One, *The Graphic*, was a weekly illustrated newspaper, started in London in
1869 as a competitor to the *Illustrated London News* and priced at a penny
higher than its competition, reflecting the richness of its visual offerings.[17]
From its founding, *The Graphic* was a highly successful vehicle for the wide
distribution of English novels in serialized form, such as the fourth Palliser
novel by Anthony Trollope (1815–1882), *Phineas Redux*.[18] George Eliot
(pen name of Mary Ann Evans, 1819–1880) and Thomas Hardy (1840–
1928) also contributed. But it was better known for the prints in its pages,
including work from a broad range of artists including Millais, the por-
traitist Frank Holl (1845–1888), and the cartoonist and novelist George
du Maurier (1834–1896), among many others. Homer owned a copy of du
Maurier's Gothic horror classic *Trilby* (1894), which introduced to the
world the character Svengali and inspired, among other derivative works,
The Phantom of the Opera (1910).[19] *The Graphic* developed a passionate read-
ership, including Vincent van Gogh (1853–1890), who by mid-1882 had
already collected more than a thousand prints from *The Graphic* and other
publications.[20] He loved the newspaper.[21] He wrote to a friend that, in
1873, living in London at twenty years of age, he "used to go every week to
the display case" to stare wide-eyed into the shop window of *The Graphic's*
office at 190 Strand, a block from the National Gallery.[22] He considered
newspapers salutary to one's health: "looking at them could revive and
strengthen you."[23]

Homer read *The Graphic* avidly, too, and surely hastened to the same
display window through which Van Gogh had stared. It is reasonable to
assume that he also read *The Art Journal* and *The Magazine of Art*, and other
periodicals that informed him of the breadth and depth of activity in the
British art market. Since his last visit, the number of commercial galleries
in London had tripled to nearly twenty. The six pioneers, such as the
French Gallery and McLean's, were still going strong. McLean's opened its
"Seventeenth Annual Exhibition of Paintings by Artists of the British and

Foreign Schools" at its 7 Haymarket premises a few days after Homer arrived in London.[24] On Pall Mall, the French Gallery hosted its "Twenty-ninth Annual Exhibition of Paintings by Continental Artists" that spring.[25]

At the Grosvenor Gallery—the most exciting upstart anywhere in the city—he surely viewed the Third Winter Exhibition, composed of watercolors and other drawings by Homer's peers in Britain and on the Continent. The show was an eloquent case for the watercolor medium, as the British publisher and critic Wilfrid Meynell (1852–1948) observed. "Water-colour, as properly conceived and practiced, is an art of impulses," although, he lamented, more rarely practiced properly in Turner's native land than by French painters who "have exercised and perfected the art of choosing from the Nature before them precisely that which will serve their purpose."[26] The Dudley Gallery, located on Piccadilly in the Egyptian Hall and much under the influence of the art theorist John Ruskin, also hosted an enormous watercolor exhibition that ran throughout Homer's time in London, including 679 sheets.[27]

Homer left no evidence for the date of his departure from London but would certainly have stayed well into May.[28] On the second day of that month, both the Grosvenor and the Royal Academy opened their principal exhibitions of the entire year. The Grosvenor was proud of its record for hosting oil and watercolor work by living painters (primarily British), "some of whom had previously been imperfectly known to the public."[29] Its focus for the exhibition that spring was portraits, including strong new work by Whistler, Millais, and Holl.[30] The Royal Academy's exhibition at its spacious quarters in Burlington House was the venerable institution's 113th Annual and its trademark event.[31] It encompassed landscapes, portraits, history paintings, and marine pictures, as seen in the depiction of Gallery III (the academy's largest) by the English painter William Powell Frith (1819–1909). Moreover, Frith showed the wide spectrum of English society into which Homer had stepped, from politicians to literary figures.

Although the Royal Academy exhibition was the single best way to observe the state of contemporary painting in Britain, Homer had other reasons to attend. Among the painters whose works were in the show were Robert Swain Gifford (a fellow Tiler) and Thomas Charles Farrer (founder of New York's Society for the Advancement of Truth in Art). Farrer had returned to Britain in 1869 with his American wife and made their home

Figure 149: William Powell Frith, *A Private View at the Royal Academy, 1881*, 1883. Oil on canvas, 23¾ × 44¾ in. Select figures include, from left to right: a) the novelist Anthony Trollope (1815–1882), inscribing in a notebook; b) Prime Minister William Gladstone (1809–1898), standing behind a woman in a peach dress and a girl in pale red; c) George du Maurier (1834–1896), to the right of the woman in the peach dress; d) the poet Robert Browning (1812–1889), well lit, standing to the right of a woman in a bright green dress with a sunflower, and speaking to another woman in a darker green dress; e) the painted Prime Minister Benjamin Disraeli (1804–1881), whose death two weeks before the exhibition opened led Queen Victoria to request his portrait be prominently located; f) Frederic Leighton (1830–1896), president of the Royal Academy, in a brown frock coat, standing to the right of the Disraeli portrait (below and in front of which Frith depicts himself); g) Lillie Langtry (1853–1929), in a white dress, mistress to the Prince of Wales until the previous summer, when she conceived a child born in March 1881; h) the novelist Oscar Wilde (1854–1900), with a large lily in his buttonhole; and i) John Edward Millais (1829–1896), at right with a patron in a brown frock coat who carefully examines *Sappho and Alcaeus*, a painting by Homer's contemporary Lawrence Alma-Tadema (1836–1912), now in the collection of the Walters Art Museum in Baltimore.

in London, where they may have welcomed Homer. Farrer's younger brother Henry had remained in the United States and become a prominent advocate for the art of etching—a medium Homer himself would soon adopt.[32] Two other Americans were also much-discussed participants in the exhibition: Frederick A. Bridgman (1847–1928) and George Henry Boughton (1833–1905). Homer lamented the comparisons that critics and collectors drew between his work and that of Bridgman.[33] The Alabama-born painter was a Paris-domiciled Orientalist in the manner of Gérôme and enormously popular in the United States; he was elected an academi-

cian of the National Academy within days of the Royal Academy opening. The English-born Boughton had more commonalities with Homer. He was self-taught and had grown up in Albany, but since 1861 he had been based in London, where he painted genre paintings in historic settings. He was acclaimed for pictures like the one in the show: *Hester Prynne*, his tribute to Nathaniel Hawthorne's heroine in *The Scarlet Letter*, and other depictions of seventeenth-century New England Puritans and Pilgrims.

The exhibition also included work by French painters then resident in London, including Tissot and Henri Fantin-Latour (1836–1904). These men's commercial successes, like that of Bridgman, in establishing themselves in a foreign context would certainly have impressed Homer. He also would have noted that the exhibition included several depictions of the picturesque place 280 miles north of London where the River Tyne flowed into the North Sea, ten miles downstream from the substantial industrial city of Newcastle-on-Tyne. Most of these were by successful London painters, including Charles Napier Hemy (1841–1917). His work in the exhibition, and that of lesser-known painters such as John Charlton (1849–1917) and Charles Richardson (1829–1908), demonstrated vividly the compelling character of the coastline in the northeast of England.[34]

Homer had probably already set his sights on that coast before leaving the United States. By midsummer, he had decamped to Cullercoats, a village of 1,365 people who made their living primarily from fishing, just as did the population of Gloucester.[35] Slightly north of the Tyne, Cullercoats was ten miles from Newcastle, had a train station, and was adjacent to the better-known town of Tynemouth (at 25,713, slightly larger than Gloucester).[36]

The proximity of Cullercoats to nearby patrons was a major advantage of the village. Many wealthy industrialists made their homes not in bustling Newcastle but along the scenic coast, near the mouth of the Tyne. Like Liverpool and Manchester, Newcastle and its 163,668 inhabitants were benefiting from the wide and deep markets the British Empire had opened to their products. Although only about half the size of Boston at the time, Newcastle was booming in a way that Boston was not. The newly wealthy merchants of the city formed a culture of unusual ambition. A contemporary described them as

> all men of enterprise, and actively engaged in business, but men who had time and taste for something beyond mere money-making. In fact,

they were men with artistic and scientific tastes; and the collections of pictures that were centred in that little colony of Tyneside merchants and manufacturers were such as could not probably be matched in any equal plot of ground so far as the works of the best painters of the day were concerned, in England or out of it. Music had also its devotees, while social and political matters were not overlooked, but in some instances ardently followed. Of course, business matters held an every-day place with them, and their interests were of a world-wide nature, as their dealings were with every nation on the face of the earth.[37]

A second advantage of Cullercoats was that, despite its small size, the village and its larger neighbor Tynemouth had won a degree of fame for its association—like that of the *Parthia*—with danger. *The Illustrated London News*, which Homer read on occasion, had written as early as 1865 of the "perils of shipwreck on the rocks which fringe the north shore of the estuary of the Tyne."[38] Both Cullercoats and Tynemouth had established Volunteer Life Brigades in December 1864, immediately following the loss of the steamship *Stanley*, of a schooner called *Constance*, and of thirty-four passengers, crew, and life brigade men.[39] Painters such as Hemy and Henry Perlee Parker (1795–1873) had capitalized in their art on the coast's reputation for danger, and for the bravery of the men who responded to it.

Illustrators had capitalized on it, too, through newspapers fostering the distribution of dramatic words and images on both sides of the Atlantic. English writers such as George Eliot and Charles Dickens found ready outlets in both British and American publishers, and so did British illustrators. But given the intrinsically collaborative nature of making wood engravings, these illustrators had a greater need than writers did to travel both to the art editors to whom they were selling and to the wood engravers who would complete their work. One of these illustrators was John Dawson Watson (1832–1892), an English artist who had visited the United States and had sold his designs to the same editors at *Harper's Weekly* and *Every Saturday* to whom Homer was selling; he was one of the illustrators whose work Van Gogh admired in *The Graphic*.[40] In 1870, Watson had contributed to that new journal an illustration entitled *The Life Brigade Man*.[41] The following year, Watson sold both *The Graphic* and *Harper's Weekly* a wood engraving based on a large oil painting inspired by

the rescue of a woman and child from an 1866 wreck.[42] He called both the painting and the British print *Saved*. The print became an archetypal image of the heroic Tyneside life brigade men—so much so that another local painter, Henry Hetherington Emmerson (1831–1905), included it in a picture he painted, set over the shoulder of a grieving young widow.[43] A lifelong admirer of Millet, Emmerson had attended Heatherley's academy, just down the street from Homer's London residence, and may have had previous contact with Homer. His blessing was no small matter; by the time of Homer's visit in 1881, Emmerson had already been for some fifteen years the artistic *eminence grise* of Cullercoats.[44]

Newcastle's bustling business community included several men who sought to strengthen the visual arts in the region, including one to whom Homer might have had an introduction. Beginning in 1869, a merchant named Alexander Shannan Stevenson (1826–1900) had invited Watson and several other artists to come stay at his home in Tynemouth. The house was near the chemical works that he and his brother James Cochran Stevenson owned and managed in Jarrow, halfway between Newcastle and the mouth of the Tyne. Stevenson may have known Homer's brother Charlie through the chemical industry, as the Jarrow Chemical Company was the second-largest chemical firm in the United Kingdom, employing some 1,400 men.[45] By this time, Charlie was also well known in the chemical industry on both sides of the Atlantic. Stevenson, like Watson and Emmerson, was an advocate for Cullercoats and its dramatic coast, and was well positioned to educate Homer about the locale long before he actually went there—and possibly as early as the late 1860s.

Stevenson, a prominent art collector and antiquarian, had commissioned a major painting, *Lady Lilith*, from Dante Gabriel Rossetti, and was a leader in establishing the Newcastle Arts Association three years earlier, in 1878.[46] He daringly collected work by the Pre-Raphaelite painter Simeon Solomon (1840–1905), who had illustrated the erotic novel *Lesbia Brandon*, by Algernon Charles Swinburne (1837–1909), and who had won a reputation for painting scenes from Greek mythology and the Hebrew Bible replete with uniformly gorgeous young models of both sexes.[47] A critic described the abundant Solomon artwork in Stevenson's house as "imperfect in its very effeminacy."[48] Stevenson also owned *Lilies*, a much-admired depiction by Albert Moore (1841–1893) of a reclining seminude young woman.[49] The architect and critic Edward William

Godwin (1833–1886) lauded that 1866 picture as "the nearest approach to the spirit of the true wall-painter."[50]

Although Stevenson's patronage had begun to draw a community of regional artists to Cullercoats for parts of the year, when Homer arrived, just one full-time resident was listed as a participant in major exhibitions in London and elsewhere in the United Kingdom. This was John Conrad Wassermann (1845–1882). He had exhibited the previous year at the Royal Academy (but not in 1881) and had showed the year of Homer's arrival at both the Dudley Gallery and the Royal Scottish Academy. Despite a background as a businessman, including as a ship broker, he had natural talent as a painter, and was a passionate naturalist.[51] Wassermann had used his impressive collection of local Lepidoptera to develop a distinctively detailed painted description of butterflies, *Autumn Beauties*, which had appeared in the Royal Academy exhibition of 1880.[52] Wassermann was struggling with cancer and died a year after Homer's arrival. Nevertheless, as the only artist domiciled in Cullercoats who had achieved national recognition, it seems reasonable to infer that he and his wife, Lillias Robson Wassermann (1846–1932), a prolific writer, extended their hospitality to Homer.[53]

The cottage Homer rented was about 700 feet north of the Wassermanns, in a cottage on Front Street across from the Queen's Head pub.[54] He also rented a larger north-facing studio in a part of a historic building called Cliff House, overlooking the bay. The origins of the fortified edifice date to 1768, when a corrupt local customs officer constructed it with a series of subterranean cells to imprison smugglers who had failed to pay him adequate bribes.[55] Perhaps the most recognizable structure in the village is the Watch House, completed just two years earlier. It stands directly south of Cliff House and immediately north of the Lifeboat Station. In Homer's time, the latter building, dating to 1852, housed the Cullercoats lifeboats at a lower elevation than the Watch House and just south of it. The current building, on the same foundation, replaced it in 1897.

Cullercoats is a compact place; its rail station is about 600 feet west of the Watch House. In 1882, while Homer was living in his tiny rented residence, the village fathers laid the cornerstone just a half-mile south for the village's spiritual heart, St. George's Church. The Wassermanns' house was halfway between Homer's cottage and the church steeple. The steeple anchors the north end of Tynemouth Beach, a mile-long stretch of wide

sand, ending at Sharpness Point. South of that point, the ruins of the medieval Tynemouth Priory loom, guarding the mouth of the Tyne. Henry VIII took possession of the priory in 1539 and converted it into a fortress that retained military status until 1956.

When the Newcastle Arts Association opened its annual exhibition on August 26, one of the 800 works contributed was Wasserman's *Autumn Beauties*.[56] Surprisingly, Homer exhibited, too, although the local newspaper credited him as "Winslow Heron, an American artist."[57] The catalogue listed his address as "Cullercoats. [and] 449, Strand, London."[58] That was the address of the American Exchange in Europe, where travelers could have mail delivered, exchange currency, and procure steamship, rail, and other travel tickets.[59] Homer's inclusion of a London address might suggest a degree of uncertainty about just how long he would stay in Cullercoats, or simply his providing a reliable mail drop address. The fact that he participated in the exhibition at all, however, indicates his conviction that, at least for the near term, Cullercoats was the right place for him.

His picture, like half of the sixteen reviewed in the most detailed description of the exhibition, was a marine painting, which the anonymous critic identified as *Two Cullercoats Fisher Girls*.[60] The reviewer recognized the influence on Homer of Jules Breton (1827–1906), a Naturalist painter who had developed a series of emotionally laden depictions of the people and landscape of his native French countryside. The critic went on to attribute to Homer a spirit in his work that seeks "to catch the noble forms and attitudes so frequently to be found in the toilers of the earth and sea, who are unfettered by modern conventionalities of costume. The aim is an admirable one, for on our English coasts and fields are to be found types of simple and noble beauty equal to those which inspired the old Greek masters when they gave to the world treasures of hewn marble that stand out clear and unrivaled in all succeeding ages."

Although one cannot determine with certainty today which specific picture he exhibited at the show, the evidence of the exhibition suggests that Homer had already determined a principal subject for the work he would make during his stay in Cullercoats: the village's women and their spirit of resilience in the face of daunting economic and climatic conditions. Like the boys of Gloucester, these women serve as archetypes. Homer often sets the women in recognizable locations such as near the Watch House; its sheltering porch appears in his large watercolor *Perils of the Sea*.

Among the works Homer made on the North Sea is one that can be dated with great certainty as it memorializes an event consistent with the coast's dangerous reputation. *The Wreck of the* Iron Crown is an unusually large watercolor depicting a dramatic rescue Homer witnessed. Just after midnight on October 21, 1881, a 995-ton cargo ship, arriving from Hamburg, was caught in a strong wind near the rocks north of her entrance to the Tyne. She immediately began sending out flares to signal her distress. Before daybreak, the brave men of the Tynemouth Volunteer Life Brigade made their way to the Brigade House, to row out to the vessel on the lifeboat *Charles Dibdin*.[61]

It took "the most strenuous efforts" to launch the boat. "Whenever the craft was pushed afloat the waves caught her and threw her broadside on the sand. From twenty-five to thirty men struggled there for upwards of an hour to get the boat afloat. They waded in waist deep, they risked being carried off their legs by the incoming seas or sucked into deep water by the receding wave. The foam-covered water, lighted up by their lanterns, looked like a great sheet of snow in which dark figures dressed like Esquimaux [*sic*] plunged about amid shoutings heard far above the noise of the storm."[62]

Figure 150: *The Wreck of the* Iron Crown, 1881. Transparent and opaque watercolor, with graphite, with touches of charcoal on cream wove paper, 20¼ × 29⅜ in.

The courage and dedication of the men saved the lives of the entire crew of eighteen, plus the captain's wife, who was onboard at the time. The brigade performed an unexpected second rescue after completing its first, since in the confusion of the storm two crew members had been left stranded on the *Iron Crown*.

Homer sent the watercolor to a newly launched Boston dealer, J. Eastman Chase, who was formerly employed at Doll & Richards and had done so well at selling the freshly made Gloucester watercolors in December 1880. Homer explained that "it was taken from a high bluff & that makes the horizon high," and priced it at a lofty $250. Perhaps in jest, he added, "If you like you may cut off the life-boat."[63] Chase sold the watercolor swiftly to Edward Hooper, his biggest customer at Doll & Richards.

By the time of the wreck, Homer had probably already gotten to know Robert Jobling (1841–1923), an illustrator whose work was familiar to readers of *The Graphic*. Jobling was a Newcastle native, but by 1881 had made plans to move to the village of Whitley Bay, just north of Cullercoats. He executed a second watercolor depiction of the wreck, strikingly similar to that which Homer made.[64] From the date of Homer's arrival at Cullercoats, Jobling's work reflected his considerable influence.

The influence seems to have gone the other way as well. In 1880, the

Figure 151: Robert Jobling, *The Wreck of the* Iron Crown, 1881.
Watercolor on paper, 23 × 35 in.

year before Homer arrived, Jobling had created a painting called *Fisher Life at Cullercoats*. It depicts a group of figures on and around the steps of Dove Cottage, a once-grand Jacobean manor house built by Thomas Dove, a Quaker coal merchant, in 1682.[65] The subject of a watercolor by a renowned

earlier painter, Thomas Miles Richardson (1784–1848), it was situated at a conspicuous location on Brown Point facing south over Cullercoats Bay.[66] Jobling's picture is composed vertically, with an idle mariner surveying a group of seven women hard at work. Five doves, a cat, and a gaggle of children complement the busy fishwives (as they would have called themselves, married or not) set in front of the decaying building.

Figure 152: Robert Jobling, *Fisher Life at Cullercoats*, 1880. Oil on canvas, 29½ × 21½ in.

From the same vantage point and at the same location, but with some essential differences, Homer created his own genre painting. His picture is in a horizontal format and more tightly framed, giving no hint of the rest of the building or of the commanding view his models would have enjoyed from its steps. His cast of characters has narrowed to the pink-and-white-clad toddler and the five young female figures. No doves tempt the cat from sleeping on its barrel in the corner, and no male figure dominates the scene. Homer's composition enlarges the scale of the three darkened doors, invoking a touch of narrative mystery in the bright sunlight visible as it begins to penetrate the highest, central entry. Homer constructed the geometry of his composition with great care. For example, a diagonal line begins at upper left and carries just past the right elbow of the standing woman knitting left of center, then descends to the left edge of the skirt of the other knitting woman across the landing, then continues to the lower right corner, just touching the rubbish bin. This technique subtly connects the picture's parts and creates

Figure 153: *Sparrow Hall*, c. 1881. Oil on canvas, 15½ × 22½ in.

a sense of harmony across them. Despite the differences between the two pictures, their similarities suggest that he knew Jobling's earlier work. Homer called his version *Sparrow Hall*, derived from the local name for Dove Cottage, which was Sparra Haall.[67] Like Jobling, Homer invoked a timeless quality in which these women find purpose and solace in their community—despite the rapid change in the world around them, driven partly by the industrial technology just up the Tyne at Newcastle.

Homer stayed in Cullercoats through the winter and for nearly all the following year—about sixteen months in all after his first three months in London. His work, primarily in watercolor, focused on two primary themes.

The first and principal one was the strong, sturdy women of Cullercoats in their distinctive dress: steadfast partners and witnesses to fishermen whom Homer placed in the background, not the foreground (perhaps in part because the men were out fishing when he needed models). Like the shepherdesses of Houghton Farm, these women are not portraits but archetypes. The watercolors are generally denser and more solemn than those he made at Houghton Farm and lack the decorative frivolity of most other watercolors he made during his Tile Club period.

Homer's portrayal of his models in a less hopeful, darker key recognizes

the mortal risks he witnessed the Cullercoats life brigade men take regularly. Despite its color harmonies, his *Mending the Nets*, for example, may be read to possess a funereal tone, as if the two women are weaving shrouds for the dead. "The effect of the leaden atmosphere of England has had a slightly depressing influence upon the artist," one review said. "The coloring is heavy and obscure."[68]

The sheet today also shows the effect of one of Homer's many reworkings.[69] The first exhibition of *Mending the Nets* occurred in New York at the AWS Annual while Homer was still in England; he priced it at $500 and called it *Far Away from Billingsgate*. The title reflects the fact that while Homer was a laconic writer, he was a voracious reader. The noun *billingsgate* is rich in meaning—a sort of inside joke he intended to appeal to sophisticated collectors. Billingsgate is the name of a fish market that operated near the Tower of London for two thousand years, until the 1980s. The language of its fishmongers of both sexes was so foul that by the middle of the seventeenth century the place name Billingsgate had become a label for unusually vulgar expression: a "billingsgate."[70] Homer was drawing a distinction between the coarse "oyster-wives" of London and the young women of Cullercoats, to whom he paid tribute for their dignity and grace as they labored at humble but honorable work.

Both the title and Homer's intentions probably eluded collectors and critics, one of whom wrote that "the most characteristic power of the painter will be seen in the wonderful action he has given the hurrying figures along the sands."[71] The sheet didn't sell, then or in Brooklyn at a follow-on venue (and despite a much reduced price), or at either of two venues in Boston the following fall. So Homer changed both the title and the picture. Before he showed it again at the New York gallery Reichard's in January 1891, he scraped away the "hurrying figures along the sands," which the critic had so admired. His effect, as an insightful observer wrote, was to create "a white wall of space that finally resolves itself into mist and sea" as if to accentuate the women's calm. "The composition is almost bald in its simplicity, but the harmony and novelty of colour and arrangement, the sense of air and void make this painting a most distinguished work." He showed it again on February 2 when the AWS Annual opened three weeks later. The catalogue illustrated the sheet prominently, and Homer gave it a higher price ($800). He also bestowed a new title on the sheet: *Mending Nets*. It sold promptly.[72]

The women's forms reflect his close observation—and likely vivid sketches, now lost—of the sculptures from the Parthenon installed at the British Museum. In their silent meditation, the pair seem a world apart from the vulgar fishmongers of London. Homer composed his color harmonies with great care, and included a wall at right to accentuate his vertical centerline, which runs straight through the neck of the stooped woman at center. Although the sheet itself is exactly six centimeters narrower than the golden ratio dimensions Homer often adopted, the geometric composition within the picture is thoroughly constructed to achieve a sense of resolution for this grave, contemplative moment. The horizontal centerline runs from the underside of the raised right wrist of his model on

Figure 154: *Mending the Nets* (*Far Away from Billingsgate*), 1882.
Watercolor and gouache over graphite, 27⅜ × 19¼ in.

the left, under her nose, atop the right ear of the model at center, to rest on a knot of the net as it hangs on the wall to the right. His design is subtler and even more powerful than that of *Blackboard*, whose Diana-like school-teacher had appeared four years earlier. And his reworking, by subtracting, magnified the power of his multivalent allusions.

Homer's careful geometry may have benefited from his continuing interest in the art and science of photography—then more advanced in Britain than in the United States. His early use of portrait daguerreotypes and other professionally produced photographs, such as Loeffler's stereograph of the Palenville mill, must have encouraged him to purchase a camera for his own use as a "serious amateur."[73] But until the 1880s, even in the country's largest and most advanced city, it was somewhat challenging to acquire a truly easy-to-use camera suitable for the nonprofessional. By contrast, Homer had come to the place where, months after his arrival, the Photographic Society of Great Britain held its 26th Annual Exhibition.[74] In short order, he had purchased not one but two cameras specially designed for serious amateurs like him.

Each was a plate glass camera that anyone today would consider cumbersome at best. One, which its manufacturer, Marion & Company, claimed could be "carried in the pocket with ease," was the smallest of its seven "Academy" models. At 5 inches wide, 5½ inches tall, and 2⅝ inches wide, it made "acceptable little" 1¼-inch square plates. Marion promoted it none too modestly as "the most useful article ever invented for artists and tourists."[75]

Stevenson may have helped introduce Homer to his other, larger camera, whose origins were surprising. Its maker, Mawson & Swan, was one of many entrepreneurial industrial firms in the small city of Newcastle serving the wide expanse of the British Empire. The company was another chemical manufacturer, but unlike Stevenson's Jarrow works, it was small enough to be quite agile and had identified a growth market: chemicals for photography. The firm was now just thirty years old but had become a world leader.[76] In March 1881, the same month Homer arrived in England, Mawson & Swan acquired the Leeds chemical plant of a recently deceased competitor and continued to diversify its offerings to include more photographic equipment. Rather than buy another camera from a better-known maker such as Marion, the ever curious and inventive Homer bought a larger camera from Mawson & Swan. On August 15, 1882,

Homer inscribed his initials and the date on one of the company's first new products, sold from its store in the heart of Newcastle, amid the neo-Palladian buildings of Grainger Town. This camera was more complex than the Marion "Academy" model, but could make images of about 3 by 4 inches. The date appears to be the one on which Homer purchased the camera. Only one photograph survives from Homer's first pair of cameras, and it is from the larger one. It suggests that Homer was finding it technically challenging to work with the technology—and also that he was intrigued with its possibilities, and with the flat geometric shapes a camera could capture.

By the time he acquired his Mawson & Swan camera, he had traveled well beyond greater Newcastle and its scenic Tyneside neighbors. He left a drawing demonstrating his knowledge of the dramatic white cliffs of Flamborough Head in Bridlington, some eighty miles southeast of Cullercoats. He may also have visited Scarborough, about twenty miles north of Bridlington but still quite far from Cullercoats, and possibly journeyed even to Great Yarmouth, in distant Norfolk.[77] These were well-known tourist destinations, but Homer appears not to have recorded, for example, Scarborough's St. Martin's Church (a pre-Raphaelite landmark) or Flamborough's chalk tower, the oldest extant complete lighthouse in England. The county seat of Durham, with its Norman cathedral and picturesque eleventh-century castle, is fewer than twenty miles south of Newcastle and would have been an easy ride on the train. But characteristically, no Homer sketches of that historic city survive.

He did make at least one trip from Cullercoats to London, however: to the Royal Academy Annual Exhibition in the spring and summer of 1882. He had only one picture accepted, and it hung in a terrible position: at a neck-craning height atop three other pictures, in the last painting gallery.[78] He completed very few oil paintings during his sojourn in England and would describe the one that appeared at the Royal Academy as "the most important picture I ever painted, and the very best one."[79] He titled it then *Hark, Hark, the Lark!*, which was a familiar quotation from one of Shakespeare's final plays, *Cymbeline* (1610). By its second exhibition, eight years later, the picture's title had lost its second "hark."[80] The play's cast includes a loutish villain named Cloten, who requests from a troupe of musicians "a wonderful sweet air, with admirable rich words to it," in order to persuade his stepsister to accept his unwelcome sexual advances.[81] The song he commands begins "Hark, hark! The lark at heaven's gate sings." Homer created

a canvas featuring neither a menacing thug, nor hapless troubadours, nor a beautiful woman caught in an impossible situation. He cast three characters—all fisherfolk women—on the edge of a seaside cliff, enraptured by the sight and sound of a bird that we, the viewers, cannot see. With their heavy nets and baskets awaiting their catch, the women reflect both a practical hope and an inner light. To British audiences then, they also evoked an authentic faith, a visual expression of another familiar quotation: "We look not at the things which are seen, but at the things which are not seen: for the things which are seen are temporal; but the things which are not seen are eternal."[82]

Figure 155: *Hark! The Lark*, 1882. Oil on canvas, 36⅜ × 31⅜ in.

Not all the work Homer made in Cullercoats focused on the women of the village. Another subject was the North Sea storms and their attendant havoc—and his neighbors' heroic response to them. One of these pictures, *Watching the Tempest*, invites the viewer into the heart of the storm, joining the villagers Homer represents through a series of tiny dots at upper left as they watch from a higher and safer elevation. His focus, which he makes ours, is where he stands: in the midst of a scene of coordinated action on the sand, as some twenty life brigade men launch a lifeboat to save fishermen who would otherwise be lost offshore. Jobling would make several later pictures closely relating to this Homer watercolor, one of which, *The Lifeboat Off* (1884), seems almost a sequel to the American's narrative.[83]

Sparrow Hall and *Hark! The Lark* hint at the freedom he felt in England to experiment. He began four or five other oils there, one of which is composed so boldly that one almost suspects it of being a Rothko canvas turned ninety degrees.[84] Homer included figures, but as props in a raw, purposefully asymmetrical geometry. The canvas is divided in three vertical columns: a dark one to the left of exactly one quarter of the composition;

Figure 156: *Watching the Tempest*, 1881. Watercolor over graphite
on off-white wove paper, 14 × 19¹³⁄₁₆ in.

another dark one to the right, purposefully somewhat more slender; and the stormy sea at center, occupying more than half the composition. In that seascape column, too, Homer creates a mysterious place. The sea itself is just a loosely sketched band of waves precisely at the horizontal centerline. Below that band, four men in foul-weather gear stand in a pink, warm, indeterminate space that they share only with a missing boot. Like the viewers on the embankment, in *Watching the Tempest*, these figures watch the drama of the storm. But unlike those viewers, these four men wait until the moment they must enter into the drama themselves. They seem paralyzed. Above the thin band of the sea, the gray clouds weigh oppressively, like a vise.

Homer's confidence in his more somber manner remained with him when, on November 23, 1882, he returned to New York and moved back to the Benedick apartment he had left early the previous year.[85] His flatmate, Samuel Thorndyke Preston, had kept the home fires burning for him. The living room was still hung with a portrait of his brother Charlie, centered over the mantel, and at least three small Gloucester watercolors remained from his summer on Ten Pound Island. Homer brought back few

Figure 157: *The Life Brigade*, c. 1883. Oil on canvas, 12¼ × 17¼ in.

oils from England, but had made about 140 watercolors there, so there was plenty of new art from which he could choose to decorate the place—and Preston gave him free rein. Three swords, a shield, a tiger skin by the fireplace, a banjo, a Chinese urn, and a doll hanging from the chandelier completed the sunny, eclectic space. But Winslow knew this homey setting was no longer for him.

Over the following few months he continued to paint scenes based on his memories of the North Sea, in a more transparent, fluid technique than he had deployed in England. Just two months after returning to the city, at the annual exhibition of the American Watercolor Society, he exhibited four highly finished large watercolors, each portraying the fisherwomen of Cullercoats. He priced these sheets at levels far above the typical $50 at which he had offered his Gloucester watercolors two years earlier. The cover of the exhibition's catalogue featured a wood-engraved illustration of a detail from one watercolor that Homer had priced at $500. It is a close view of the three women from *Hark! The Lark*. But now he has placed them in front of the distinctive white chalk escarpment of Flamborough Head.[86] As in the original composition, his title referred to sound from an unseen source: *A Voice from the Cliffs*. The *Tribune* raved about the picture: "There is something of the same quality in Mr. Homer which belongs to Walt Whitman. There is the same rude virility and independence, with the same disregard of conventional forms. In 'The Voice from the Cliff' [*sic*] three fisher girls, bronzed, stalwart, with a likeness which tells that they are sisters, stand with eyes dilated and lips apart looking upward and listening. Each of the two foremost has her left arm stretched straight out over her basket. Another artist might have considered these two rigid arms a fault, but to us they seem to emphasize in a way the attitude of strained attention which characterizes the group."[87] Despite its $500 price, far above that of any other watercolor Homer had ever sold, the poet Edmund Clarence Stedman, a longtime Homer friend, purchased it immediately.[88]

The other three watercolors were each priced at $300. One, *The Incoming Tide*, depicts an isolated young woman walking across Tynemouth Beach. As in *Snap the Whip*, Homer arrested motion in such a natural way that we accept it unknowingly. The left boot of his model is raised in her step; we see the reflection of its sole in the wet sand. His geometric construction is exquisite, with the vertical centerline running from his model's brow down to her left wrist just as it meets her hip, and then continuing to

Figure 158: *A Voice from the Cliffs*, 1883. Watercolor on wove paper, 20⅞ × 29¾ in.

the edge of her left boot toe. Homer achieves a perfect resolution amid the swirl of the elements around her. Interestingly, the same *Tribune* review was disdainful about this picture, and referred directly to Muybridge's recently circulated photographs commissioned by Leland Stanford. "It is curious to see the utter disregard with which Mr. Homer follows out his own ideas," the critic wrote. "The woman on the beach stands with one foot awkwardly raised in air after the style of photographs of the horse in motion."[89] The watercolor was a favorite of Homer's, so when it didn't sell, he brought it back to the flat so that he and Preston could enjoy it on the wall of the living room they shared (figure 138). He also made a sketch of a detail from the sheet and gave it to Frederick Stuart Church, the maker of the silhouette advertisements for the Valentines, who was composing the images for the exhibition catalogue, to ensure it was reproduced there faithfully.[90]

The small number of works Homer showed, their size and their pricing, all suggested that he intended to achieve a decided pivot from his historic commercial practice. It's not clear that he actually sold any of the three watercolors beyond the large one that Stedman bought, but he did achieve critical acclaim for them (although not for the single oil painting—also of

Cullercoats—that he chose to exhibit a month later at the National Academy's Annual).[91] One critic wrote that Homer had returned to New York "with flying colors, and makes the sensation" of the exhibition, which included 605 watercolors from more than 250 painters. A clear indication of how much he cared about the success of his commercial pivot is that he retained the clippings in his scrapbook for nine of these reviewers' responses to it—far more than the one or two he normally tucked away.[92]

Homer's usual focus in his scrapbook was the published critiques of the major tastemakers in New York, such as those at the *Tribune*, the *Herald*, and the *Times*, whose opinions mattered to the collectors of Homer's work. In this case—and only in this case—he also cut out a review from a publication he knew well that catered to readers of all ages and all classes across America, not just New Yorkers: *Harper's Weekly*.[93] The unsigned columnist utterly ignored the fact that Homer, nearly two years overseas, had focused his attention on Englishwomen. What mattered to this critic was what Homer had done for the medium he had chosen and for the country of his birth. Homer demonstrated "more ably than any other American the virility" of the watercolor medium, the critic wrote. "In his hands it is pre-eminently a man's art," he declaimed, as if to banish the memory of watercolor's historic association with women. The exhibition established emphatically "the American aptitude" for the watercolor medium.

The same critic also let slip a connection between Homer's art and his life that the more sophisticated reviewers had missed: "The painter who, two or three years ago, introduced us to the American shepherdess as she can be seen any day in the uplands of New York State, now invites us into the society of the American fisherwoman as she can be seen any day on the coast of Maine." It seems reasonable to conclude that before Homer went to England, he and his family had decided on a major change in all their lives—and especially in his.

In August 1882, three months before Homer returned from Cullercoats, his father paid $175 to purchase a plot of land on a rocky promontory in Scarborough, Maine: Prouts Neck. It was where Charles Sr., Henrietta, and Winslow had visited briefly in 1875 just after Arthur's wedding.[94] It is about the same distance south of Portland (a dozen miles) as Cullercoats is east of Newcastle.

Eight days before that land purchase, Charles S. Homer, Sr., also signed a complex agreement with a local builder and his wife.[95] Hannah Libby

Figure 159: Homer's Prouts Neck (1882–1910)

Googins (1843–1910) agreed to sell Charles a total of fifty-eight lots she had inherited from her family who had farmed the land for generations.[96] In four other transactions with Hannah and her husband—and twelve other transactions with eight other counterparties—the Homer family would ultimately purchase about seventy acres on the Neck, most of which then had limited access to fresh drinking water.[97] Sewage disposal, similarly, depended on the best efforts Prouts Neck landowners made by creating cesspools on their properties and constructing pipes to the nearby Atlantic Ocean—not far from their bathing beach. Sanitary expectations then were different than they are today.

The agreement commissioned Hannah's husband, Alonzo Googins (1859–1919), to construct a residence for the Homers on the windswept cliffs of Prouts. They would call it The Ark. The blueprints for the house, signed by the Portland firm of Fassett and Stevens, had been completed prior to Charles's signing the agreement to purchase the land.[98] They are quite sophisticated and reflect considerable thought to many details, including locating a north-facing studio on the second floor of the house.[99] It seems that the Homer family chose Googins, an inexperienced contractor, in recognition of his marriage to the woman who was simultaneously selling them a considerable amount of land. Hannah was nearly sixteen years older than twenty-three-year-old Alonzo, and they had been married

Figure 160: Unidentified photographer, *The Ark and W. H.'s Studio at Prouts Neck*, c. 1884. Gelatin silver print, 6⅝ × 9¹⁄₁₆ in.

fewer than two years. The Homers were likewise casting their lot with a second young man. John Calvin Stevens (1855–1940) was the junior architect in the firm, but clearly had impressed the Homers, who may have met him previously. He had spent two years working on a major project for Fassett and Stevens at their satellite office at 5 Pemberton Square in Boston. While Homer was painting up a storm on Ten Pound Island, Stevens was sweltering at his desk in the heart of Boston's artistic community—and soaking up the influence of those around him. Directly across the hall from his office was the great (if now nearly forgotten) architect, William Ralph Emerson (1833–1917), a remote relation of Ralph Waldo Emerson. Stevens was probably the lead designer of The Ark, and the family's designated eyes and ears on Hannah's husband. The many houses and other structures Stevens would design over the following six decades would reflect the Emersonian touch and represent an apogee in Maine's distinctive interpretation of the Shingle Style.

The plan, formally documented beginning in August 1882, may have evolved over the previous several years, but took hold when the land became available on which the Homers would build The Ark. Winslow appears to have been an essential part of the intrafamilial decision-making both before he left for England and by letter and telegraph while he was there.

The Homer family as a whole had developed an affection for the place where Winslow's younger brother, Arthur, and his wife, Alice, had honeymooned in the summer of 1875. Their first cousin and Winslow's contemporary, Maria Mead Homer (1835–1917), daughter of William Flagg Homer, may have shared that affection.[100] Her father had found it necessary to sue Winslow's father after his poor performance collecting debts owed by the Alabamian branch of the family, but Maria herself probably was untainted by that experience.

An additional factor may have been Winslow's relationship with Philip Henry Brown, who had acquired Homer's painting *The Noon Recess* in 1875. His father, John Bundy Brown, owned Glen Cove Cottage, of 1853, one of Maine's first coastal summer houses, located on Cape Elizabeth, near Scarborough.[101] Over the summer that he acquired that picture, Brown was staying at Oak Hill, in central Scarborough, and corresponded with Homer from there. Although he is not known to have owned land at Prouts, he would correspond often with Homer over the years to come;

letters suggest he was an essential link between Homer and Portland's Cumberland Club, the most prestigious men's club in the state.[102] He may have influenced Arthur and Alice's decision to come there for their honeymoon that same summer. He may also have influenced other decisions the Homer family made to gather over the following years in the state where he and other Brown family members cast a long shadow.

Prouts was not large (about 150 acres, including wetlands in the middle) but it accommodated abundant visiting family members and friends. With a half dozen boardinghouses and hotels serving several hundred guests at a time, it was lively in the summer and offered both great ocean views and a mile-long sandy beach with sea breezes.[103] It was an ideal gathering spot for a New England clan—and the Homers and Bensons were two very large ones.

The Homer brothers and their parents were also executing this complex plan in a coordinated way. The source of the capital was not the imperious and impoverished Charles S. Homer, Sr., but his eldest son, Charlie,[104] both a gifted chemist and an agile businessman, who recognized the unusual opportunity that Hannah and her young husband offered, and was eager to capitalize on it. Charlie and his wife had been unable to have children, and Winslow was a bachelor who some time ago had concluded he, too, would never have offspring. The brothers' two nephews, Arthur Patch Homer (1876–1940) and Charles Lowell Homer (1881–1955), six years old and one year old in 1882, were then living in Galveston for most of the year, two thousand miles away from their grandparents and aunts and uncles. Charlie led the shared project on behalf of all three generations. It required Winslow's singular engagement and Charles Sr.'s peculiar role as the family's honored—but only titular—leader. As the Homers executed the plan over the ensuing years, it would involve a dizzying array of purchases, leases, and other trades among Charles and his three sons, and among the sons after their father's death.

The plan and its execution also solved multiple problems for multiple Homer family members. Most important of all, it got Henrietta back to her native state and fulfilled the dream Charles Sr. had recorded twenty years earlier for "a family nest for all hands, a *Homestead*."[105] For a few weeks each summer, Henrietta would gather her far-flung progeny in one place—within practical traveling distance of the Thurstons and other Maine-domiciled Benson and Buck relations. And she would give her

Figure 161: Simon Towle (1834–1910), *West Point, Prouts Neck,*
with West Point House, Barn and Stable and Cammock House, Barn and Stable
to right, and Mattie *on shore of Western Cove*, 1890. Gelatin silver print, 6¹⁄₁₆ × 9⁷⁄₁₆ in.

difficult husband a commercial purpose: to create value through the accu-
mulation of Prouts Neck real estate. Charles Sr. had experienced another
decade of frustration, this time in Brooklyn, in the shadow of his wife's
accomplished relatives. In transitioning to Prouts, he could reside in a place
where if only by dint of his land ownership he would matter—and his wife
must surely have hoped, where he might quiet his restive soul. Prouts Neck
real estate—buying, managing, and never selling—represented a contained
activity for him, an entrepreneur blessed with boundless and imaginative
energy but little to show for those gifts.

The plan addressed differing needs for Homer's two brothers. Lawson
Valentine's exit from his firm meant that Charlie was now a full partner,
receiving regular ample distributions that he needed to invest. Prouts Neck
land was inexpensive and close to the ocean but had limited access to clean,
reliable fresh water.[106] It was a good place for someone willing to invest
capital with a long horizon. Arthur, by contrast, probably possessed modest
capital. But his wife, Alice, was likely a factor in the decision-making. Her
twice-widowed father, the Lowell auctioneer Ephraim Bennett Patch
(1806–1889), was too old to visit Galveston; he would have been grateful
for an assured regular northern rendezvous with his daughter and her
family and for that annual event to be located in southern Maine. Alice's
brother bought land nearby to further cement the family bond.[107] By the

summer of 1884 Arthur had scraped together enough funds to build a tiny wooden cottage on a small inland site near the hotel where he and his wife had stayed on their honeymoon. They called their summer house "El Rancho" in celebration of their principal residency in the South. Other than The Ark, there were only about four houses on Prouts built purely for the summer pleasure of their owners. One, the home of the physician Benjamin Eddy Cotting (1812–1897), was next door to El Rancho. It must have been a lively place; for more than fifty years Cotting led the Lowell Institute, one of Boston's leading cultural institutions.[108]

Winslow was also a significant beneficiary of the plan. Over the twenty-three years between his move to New York in 1859 and his family's commitment to Prouts Neck, the world had changed in many ways. He was ready for a shift in his life, which was now practical and prudent. The process of industrialization—which began in British textile mills and then transformed the Western world, especially his native Massachusetts—had accelerated. This revolution spurred changes of all kinds: breakthroughs in engineering to allow mass production and distribution of products large and small; reform movements dedicated to temperance (his father's favorite cause) and other ideals; and rising inequality of wealth and income.

New York was a different place than it had been a quarter-century earlier. It had nearly two million in population (including Brooklyn, which it would annex fifteen years later, in 1898). It was also more diverse and sophisticated. Homer and all New Yorkers were benefiting from more frequent travel but that did not stop some from complaining about immigrants crowding New York's narrow streets. Technology had developed at a fast pace in ways that made it more practical to live elsewhere. Bell's 1876 invention of the telephone and by that same year the New York Central's speedy and frequent trains between Boston and Albany were just two examples. Winslow could get to Boston easily, for a day trip or a single overnight stay from Prouts.

Many of Homer's friends, married or not, had moved on to the next stages of their lives. Homer, forty-six in 1882, had not. Preston and Homer's Tile Club companions, all younger than he, could still enjoy life in Greenwich Village. Homer could not. He, too, was different now—still a bachelor, but an aging one who had likely given up hope of marrying. He was always intensely private and prized his independence—despite the inevitable price he paid for it in periodic loneliness. With Doll & Richards and

other dealers beginning to represent him well, he no longer needed to live principally in New York. More than ever, he would now set the terms of his encounters. As Emily Dickinson had written twenty years earlier:

The Soul selects her own Society—
Then—shuts the Door—
To her divine Majority—
Present no more—

Unmoved—she notes the Chariots—pausing—
At her low Gate—
Unmoved—an Emperor be kneeling
Upon her Mat—

I've known her—from an ample nation—
Choose One—
Then—close the Valves of her attention—
Like Stone—[109]

In an odd way, Homer had discovered an advantage—both to his commerce and to his convenience—in cultivating a reputation as a recluse. He is *"posé* in the extreme, and affects eccentricities of manner that border on gross rudeness," one critic wrote weeks before Homer's 1880 summer on Ten Pound Island.[110] "To visit him in his studio," another wrote, "is literally bearding a lion in his den; for Mr. Homer's strength as an artist is only equaled by his roughness when he does not happen to be just in the humor of being approached."[111] He chose a head of Medusa (the terrifying snake-haired Gorgon) as the door knocker of his Prouts Neck home. The message was as direct as it was humorous: those who dared to stare into his eyes— and life—risked being turned into stone. He painted a sign promising neighborhood children SNAKES! SNAKES! MICE! In so doing he was not only fending off unwanted interruptions but also fostering a memorable—if misleading—notoriety. Pictures that a misanthrope made were intrinsically intriguing—to collectors and critics alike, especially when their subject was the maker's hermitage. The distinction between Homer's reserve, which was real, and his misanthropy, which was false, quickly vanished.

Prouts offered surprising flexibility. He could live there for a substantial

part of the year, with focused time for painting, and leave whenever he wanted to meet with dealers and friends in New York, where Preston still lived. He could go easily by train to his native Boston, where he and his father became regular visitors at the American House hotel. While in residence at The Ark, Winslow could also address on-site matters relating to the three brothers' houses; Maine's oceanfront weather necessitates frequent attention from contractors. And when Prouts got too crowded or his father got too difficult—which happened almost every summer, in his opinion—he could go away for a few weeks, to a destination of his own choosing.

A small notice appeared in the *New York Herald* on February 25, 1883: "Winslow Homer will settle on the Maine coast, near Portland. He will leave this summer for that locality, and only abandon his studio on the barren coast when he has something to show or for an occasional visit."[112] His earliest depictions of the Neck suggest that as at Cullercoats, he found drama and meaning in the rhythms of day and night, of the seasons, and of the tides—and in the less predictable patterns of storm and sun. He wrote to Charlie's wife, Mattie, that his mother had been ill but was now "better,

Figure 162: *Prout's Neck, Breakers*, 1883. Watercolor, with blotting and sanding, over charcoal, on moderately thick, moderately textured, ivory wove paper, 15 × 21½ in.

so am I (in behavior). I am delighted with this place."[113] Homer stood transfixed at the edges of the promontory, where naked rock kissed ever-changing sea and sky.[114]

He returned that fall to the Benedick apartment and gave a Christmas party jointly with Preston.[115] But not all in New York was merriment. His mother's health continued to be weak enough that she could no longer remain in the Brooklyn home she and Charles had created. She lived now in a recuperative facility. Homer wrote to his sister-in-law Mattie an upbeat letter, and brought Henrietta his copy of *The Graphic*, the British illustrated newspaper to which Jobling had sold many illustrations. Henrietta told her son "that the Queen of England could not be better cared for, that her bed was the best that Father or she had ever had—that the food and attendance [*sic*] she considered unequaled, & she has all the company that she wishes—she wishes it understood that when she get[s] *old* her greatest comfort will be to do as she likes—and when she gets *sick* it will be time enough for her to have a companion."[116]

When the AWS annual exhibition opened on February 4, 1884, Homer exhibited just two watercolors. One, *Scotch Mist*, depicted three groups of figures standing on a dreamlike beach. In the background, six men stare at the sea. An empty, mastless Cullercoats fishing boat awash on the beach separates them from five women in the foreground. Three of those women tremble, anxious in the cold. But two of the fisherfolk are different. Homer

Figure 163: *From the Retina of a Drowned Man*, n.d. Graphite on paper, 3⅜ × 4⅞ in.

Figure 164: *Cliff at Prout's Neck*, 1883–1887. Albumen silver print, 3⅝ × 4½ in.

describes them most closely. These two women stand apart, supporting each other amid the wind. In the warmth of each other they find confidence to face the mist that engulfs them.

The other, *The Ship's Boat*, is similarly large, and even more mysterious. Its origins are in a tiny drawing of a desperate scene in a stormy sea near a rocky coast much like that of Prouts. Homer inscribed the drawing with the evocative phrase "from the retina of a drowned man." Although the sheet is barely a doodle, it is haunting, as a single hand emerges helpless from the briny deep. The hand resembles one in a 1654 etching by Rembrandt van

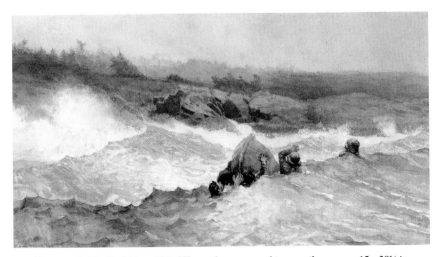

Figure 165: *The Ship's Boat*, 1883. Watercolor over graphite pencil on paper, 15 × 28¼ in.

Rijn (1606–1669), *The Descent from the Cross: A Night Scene*, and several hands of enslaved figures whom Turner depicted drowning in chains when in 1840 he painted *The Slave Ship*. Out of reach, several other figures cling to a lifeboat. They are close to land, but not close enough. Homer keeps any viewer—even himself—on the edge.

The inscription reflects Homer's contacts with ophthalmologists such as Henry Clay Angell (1829–1911). Homer was one of a number of artists in whom Angell took an inordinate interest; he published the records of William Morris Hunt in 1881, two years after that painter's untimely death. Angell was also an internationally renowned expert on diseases of the eye—just as Rood was an internationally renowned expert on optical physics. Homer's technical and scientific interest in the eye probably nudged him toward photography—and photography may have nudged these interests, too. He appears to have begun making photographs at Prouts Neck not long after moving into The Ark. Very few of his photographic prints survive, but those that do communicate a sense of the raw power he perceived in the elements before his ever-observant eye.

The completed watercolor retains the raised hand—but it is now connected to a live body, and to the lifeboat's prospect of safety. Homer has domesticated his scene a bit for public consumption. Four men, each swimming for land, ride the crest of the wave. Although the boat is now capsized, Homer guides the viewer to hope.

Two months later, on April 7, 1884, and in the same galleries at the National Academy of Design, the academy's own Annual Exhibition opened. Homer had given his trusted fellow members at the Century the first look at the picture that he hoped would be his big breakthrough at the academy show. He titled it *The Life Line* and took pains to characterize the origins of the picture in an American context: a rescue he had witnessed the previous year, or so he said, in Atlantic City, New Jersey. Whether or not he really did witness a brave life brigade man saving a young woman using a New Jersey breeches buoy, there is no question that he had had many opportunities in Cullercoats to see exactly that kind of device in action. The rescue Homer depicted in 1884 is also remarkably similar to that memorialized by John Dawson Watson in 1871, thirteen years earlier, in the pages of *Harper's Weekly* and *The Graphic*.[117]

The close connections between what Homer had seen in Cullercoats and what and how he now painted were of secondary interest to the many

viewers who flocked to see his dazzling new picture. They regarded *The Life Line* as an American masterpiece, surpassing even *Prisoners from the Front*, first seen eighteen years earlier. One of the wealthiest women in America and a renowned collector of European art, Catharine Lorillard Wolfe (1828–1887), acquired it two days before the exhibition opened, and paid $2,500 for it—far above the $1,500 set in 1877 for *The Cotton Pickers*, which was Homer's previous record. The *New York Herald* wrote that her "purchase shows that the tide is turning, and that our richer collectors are beginning to patronize American as well as foreign art."[118] Mariana Griswold Van Rensselaer (1851–1934), one of Homer's most insightful critics, wrote that the picture showed Homer to be "at once a realist in aim and an idealist in feeling, a painter with a personal style and an artist with an individual message to deliver." She connected the compelling painting to Homer's compelling life story: "No one could have painted a scene like this with such convincing strength who had not lived among the breakers and the tragedies they work; but no one, on the other hand, who lacked that constructive imagination which the thorough-going realist professes to despise. The theme, in its essentials, was the saving of a

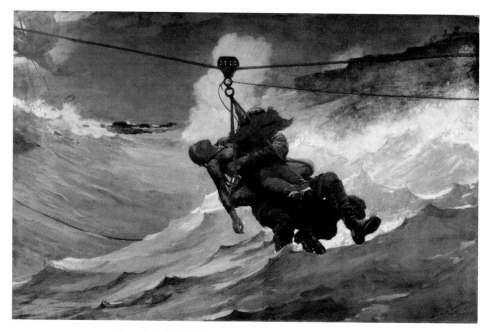

Figure 166: *The Life Line*, 1884. Oil on canvas, 28⅝ × 44¾ in.

woman's life. To express it the painter gave prominence to her blanched face and half-clothed form; and he clearly showed, in contrast, the vigor of the sinews which upheld her and the tremendous rage of the sea. These he had shown, and all else he had omitted . . . How many would have known what Homer knew—that among the things to omit was the sailor's face?"[119] Homer had found a way to depict in his own country the same depth of dramatic truth he had explored in Cullercoats.

His exploration of mortal themes in both *The Ship's Boat* and *The Life Line* may have reflected his witness to his mother's declining health. The recovery for which Winslow hoped a few months earlier was short-lived. In Brooklyn on April 27, 1884, just three weeks after his big sale at the academy, his mother breathed her last.

The three brothers and their father laid Henrietta's remains to rest four days later, in Cambridge, at Mount Auburn Cemetery, past which Homer had walked and ridden innumerable times as a boy and a young man. She had returned to New England in a final way, and at an earlier age—seventy-five—than she had expected. Homer arrived at the Prouts homestead on May 6. He wrote to Mattie that he found The Ark "in good order" despite Henrietta's absence. "Thought of mother with a certain amount of pleasure. Thank the Lord I knew that if possible she was with me. I feel quite well for the first time in two weeks."[120] Winslow was determined to affirm his decision—and hers—to make Prouts the Homers' home. He contemplated the constancy of her encouragement as he grieved her loss.

The process of doing so was complicated by the fact that he had inherited from his mother the challenging responsibility of caring for her headstrong husband. The following month, Winslow wrote that Charles Sr. was "too well if anything. He looks about for a chip on his neighbors shoulders. I think he will have a pleasant summer."[121] Winslow quickly determined that he could no longer live under the same roof as his father. He hired his friend Stevens to transport to an adjacent property a small stable then sitting on a corner of The Ark's lot. Together, he and the architect designed an expansion of the stable to make it a home and studio for him—and only him. It would be next door to his father's house, but Winslow would be out of earshot of his father's frequently voiced opinions. The most distinctive characteristic of the design was the large balcony on its second floor, overlooking the sea. Homer wrote that "the piazza is braced so as to hold a complete Sunday school picnic. Charlie will be very much pleased with

Figure 167: Unidentified photographer, *Winslow Homer on the Gallery of His Studio at Prouts Neck, Maine*, c. 1884. Gelatin silver print, 4⁷⁄₁₆ × 6¹¹⁄₁₆ in.

it."[122] Winslow could write to his older brother on September 1, 1884, "We are all well at The Old Ladies Home . . . Arthur leaves here tomorrow. I shall try & keep Father interested here as long as possible. I shall stay until Dec. 1st if not longer. I like my home more than ever as people thin out."[123]

That was a busy fall. On November 19, Homer signed his will in New York, with Preston as his witness. A week later, the Homer family acquired even more lots at Prouts. And three days after that, Winslow was in Boston for the opening of an exhibition of his drawings at Doll & Richards. Of the seventy-eight sheets, thirty-four sold, netting Homer $1,280, or just under $38 per drawing.[124] Although he would exhibit many watercolors over the years to come, this would prove the last occasion on which he exhibited such modestly priced work. The major exhibition watercolors such as *A Voice from the Cliffs* had shown that there was a market for truly ambitious works on paper.

Homer didn't stay in Boston long. Five days later, he and his father boarded a steamship in New York called the *Cienfuegos*. For the first time in his life, Winslow was headed to the tropics.

9

COUNTING THE COST
(1884–1889)

The weather was balmy—most unlikely—the first Thursday of December as the little tugboat guided the *Cienfuegos* down the East River and she began to steam out of New York Harbor on her four-day voyage to Nassau.[1] The two men watching from the deck were also an unlikely pair. Charles Homer was seventy-five, obese and self-important. He cast his eye, and pronounced his judgment, on all around him, sharing his opinions liberally with anyone who would listen. Winslow was nearing fifty, wiry, quiet, and easily embarrassed—especially by his father. His eye, too, was sharp, but he had learned long ago to keep his opinions to himself. Never-

Figure 168: Simon Towle, *Winslow Homer, Charles S. Homer, Sr., and a Dog, at Prouts Neck, October 1884*. Gelatin silver print, 3½ × 6½ in.

theless, the two men were obviously father and son. Their determination, like their powers of observation, was in their blood. A photographer who grew up near Prouts, but was now based in Lowell, captured an image of the two men a few weeks earlier, together on the cliffs, facing a blustery autumnal wind.[2] Not only kinship bound the two. So did a sense of responsibility each felt for the other—in grief, loneliness, and vulnerability. But neither could speak such a thing directly. Charles remained the master of self-protective bromides: "Money makes the man!"

He approved of this journey, since in it Winslow was seeking a new way to make money and taking him along for the ride. Their destination, Nassau, was the capital of the Bahama Islands, a British colony but one of dozens spanning the globe. Sir Henry Arthur Blake (1840–1918), governor of the Bahamas, had solicited New York opinion leaders on how he might create a more favorable American impression of the islands as a winter resort. Among those he consulted was Helena de Kay's husband, Richard Watson Gilder, editor of *The Century Magazine* for the previous three years. He commissioned the renowned journalist and *Galaxy* founder William Conant Church (1836–1917) to write a story about the Bahamas and asked Homer to illustrate it.

The idea of visiting the Bahamas was not unheard of. Just four years earlier, an enterprising New Haven attorney, Charles Ives (1815–1880), published a detailed memoir recounting the pleasures he and his wife enjoyed in the winter of 1879–1880.[3] He entitled the book *The Isles of Summer: or, Nassau and the Bahamas* and seems to have arranged for the entire project himself, including fourteen wood engravings and twelve lithographs.[4] It is the sort of book Homer would have loved reading, crammed with "the results of his study of the climate, soil, inhabitants, plants, insects, and history of the islands."[5] Ives was a gifted writer and loved the islands and their people, whom he described as good-natured, generous, and simple. "They freely gave to each other from their little stores, and never seemed to either fret, fume, worry or hurry. Truly blessed are these destitute children of the sun, for theirs is the kingdom of heaven," he wrote.[6]

The idea of an advertorial product designed to attract tourists was not particularly original either. Respected journalists, artists, and editors often bent their editorial standards then for commercial purposes. Six months before Homer went to the Bahamas, *The New York Times* began running a series of weekly columns by William Drysdale (1852–1901), who was both

Figure 169: Homer's Tropics (1884–1910)

a venturesome reporter and an entrepreneur.[7] After two trips to the Caribbean, he planned both a much longer third one and the establishment of a new hotel there in partnership with the nationally recognized hotelier Warren F. Leland (1845–1899).[8] Drysdale cut a striking figure, standing six feet three inches and "accompanied by a huge yellow mastiff." His Bahamian servant, Theophilus Sweeting (1863–1906), enhanced the package. The two men had sailed to New York in March 1884 and now returned for this extended journey.[9] Drysdale had first achieved renown covering the trial of Henry Ward Beecher, and ultimately would be best known for his boys' adventure novels. He published *In Sunny Lands: Out-Door Life in Nassau and Cuba* (a compilation of his *New York Times* Caribbean columns) through Harper's Franklin Square Library. These were intended to be inexpensive books for reading on the go.[10] Homer's cousin Virginia Wales Johnson (1847–1916), with whom he had collaborated on *The Christmas Stocking* in 1869, had published her novel *Two Old Cats* in 1882 as part of the same Franklin Square series, at the price of 15 cents.[11] Harper's priced Drysdale's book at 25 cents and got a bonus: an underwriting by James E. Ward & Company, the operators of the steamship line running the *Cienfuegos*, on which both Homer and Drysdale sailed, possibly together. Drysdale returned to New York a month after Homer—on the same ship Homer took—and stayed in the same hotel at the same time. He also addressed many of the same subjects that Homer did. Blake, the colonial governor, might well have commissioned the expeditions of both men.[12]

Blake had considerable clout and arranged for his honored guests to stay at the best available quarters in town, the Royal Victoria Hotel, where Ives also had stayed. He also invited Homer to attend a "Fancy Dress Ball" that Blake hosted for Nassau's children—including his own (aged seven, eight, and ten years, and dressed improbably as two princes and a princess from *The Arabian Nights*).[13] Drysdale wrote enthusiastically and in a generally positive tone, just as Blake wished, telling his readers that Nassau "is a dream to most people, for they do not realize how quickly and easily such a land may be reached."[14]

By contrast, Gilder's hand-plucked journalist, Church, repaid Blake's hospitality in a way the governor could never have imagined. Church reported that in Nassau, "the monotony speedily becomes tedious," and lamented that even at the season's height, there were only 150 visitors to

Nassau. For good reason, he wrote: "Few Americans can long endure exis-
tence in a land without scenery except such as the ocean affords; without a
mountain, or a stream of running water; without a railroad, bank, or tele-
graph line; with no Wall Street or stock indicator; without so much as a
single sheet that can be dignified by the name of *news*paper."[15] Church
viewed the Bahamians (of whom 80 percent were Black) through a pa-
tently racist lens, describing their life as generally one of grim poverty,
ever-threatening disease, and rank dishonesty. He called them "toilers of
the sea" but then qualified his use of this honorable title. Bahamians con-
sider the shipwrecks "strewn along the coast" as "among the sea's most lu-
crative products," he wrote, and an invitation to engage in a legalized form
of "organized robbery."[16]

The journalist's physical comfort in his hotel could not overcome his
association of the place with Lewis Frederick Cleveland (1841–1872), the
young American who had run it more than a dozen years earlier—until his
gruesome death. He and his brother Richard Cecil Cleveland (1835–1872)
were burned alive on the steamship *Missouri* off the Bahamian island
Grand Abaco, just north of Nassau.[17] (A month before Church and Ho-
mer sailed to Nassau, the United States elected as president a third brother,
Grover Cleveland.) Church's story implied that future American steam-
ship passengers should venture to the colony only with the understanding
that they might suffer their own demise on the same treacherous Bahamian
shoals where the Cleveland brothers had perished.

Homer saw the same people in the same places Church did and re-
sponded very differently—with empathy and admiration. While Church
viewed the island people's ease on land and water with amused condescen-
sion, calling the archetypal Bahamian "an amphibious animal," Homer ex-
pressed an affinity for the Bahamians and their way of life.[18] As he had
with the women of Cullercoats, Homer portrayed the Bahamians as peo-
ple of practical, curious intelligence—a quality he valued and about which
he wanted to learn more. In December 1885, he exhibited twenty-five fin-
ished Bahamian watercolors, nine of which formed the basis for the illus-
trations in the *Century* article.[19]

Where Church could find words of passing praise only for the natural
beauty of the Bahamas, it was the people who drew Homer. On most of
these sheets, his focus was the women and children he posed as models,
often next to distinctively high garden walls or the wooden gates punctur-

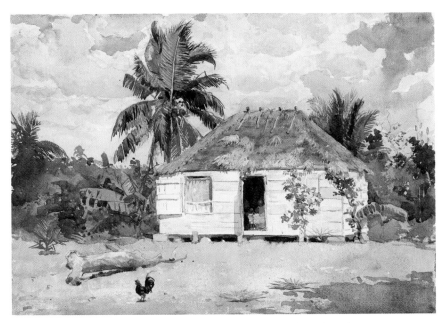

Figure 170: *Native Hut at Nassau*, 1885. Watercolor and graphite
with scraping and blotting on wove paper, 14½ × 20¹⁵⁄₁₆ in.

ing them. In six cases, the thatched single-room cottages of the native
Bahamians drew his eye; he was eager to understand the lives they lived
within these houses. An open doorway into a clapboard shack is an invita-
tion into a community with layers of meaning that await his discovery.
Only one of these watercolors featured a natural landmark, and it was no-
tably not on Nassau but on another island, Eleuthera. That was the very
place where his uncle James Bartlett Homer had been shipwrecked one
year before Winslow's birth. Father and son went there together; each
signed an autograph book kept by another American tourist.[20]

Six of the works Homer exhibited were set not on land but on sea. Four
of these are hopeful evocations of the life of local fishermen: teenage boys
who harvest their waters for the bounty waiting to be shared with those
willing to work for it. Homer was a lifelong fisherman and surely hired
boatmen recommended by the concierge at the Royal Victoria Hotel. Ives
had remarked that in Nassau "good sailing and good fishing can be calcu-
lated upon with confidence, as it is very rare indeed that there is any failure
of a favorable wind, or of an abundance of piscatory game."[21] On one sheet,
the basis for an illustration in *The Century*, he depicts a boy emerging from

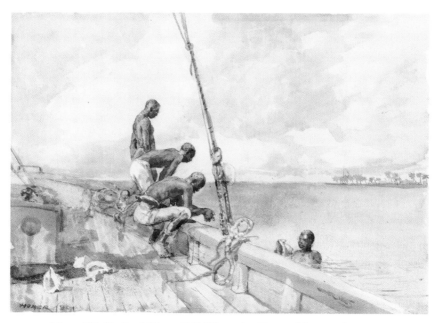

Figure 171: *The Conch Divers*, 1885. Watercolor, blotting, lifting, and scraping,
over graphite on ivory paper, 13¹³⁄₁₆ × 20 in.

the deep with his prize, a large pink conch shell. From the deck of the
aging sailboat next to him, three men watch, each in a different posture:
kneeling youth, crouching midlife, and bemused, bespectacled old age.

Two sheets suggest a darker side of the fishermen's lives. Ives had re-
marked that at Nassau, "sharks abound, and come near enough to the sur-
face to be soothed and quieted by the Bahama air. As the tempting bait
floats near the top of the water about three rods from the boat, it is very
interesting to watch, in the clear water, the movements of the sharks as
they reconnoiter and cautiously approach the savory but deceitful prize."[22]
In one Homer watercolor, *Shark Fishing*, two young men in a worn vessel—
no larger than their prey—haul in their fish with grim determination. The
shark is no longer so menacing, despite its open jaw and fierce teeth. It is
already dead, fallen to the peg hammered in its side.[23]

In the other watercolor, *The Derelict*, the sharks have triumphed. The
fishermen are absent, their boat empty and minutes from sinking. Four
sharks circle in pursuit of fresh flesh. Homer gives one of them credit for
terrifying intelligence; the fish seems to lean purposefully into the vessel,
accelerating its rapid submersion. Both in the New York exhibition and in

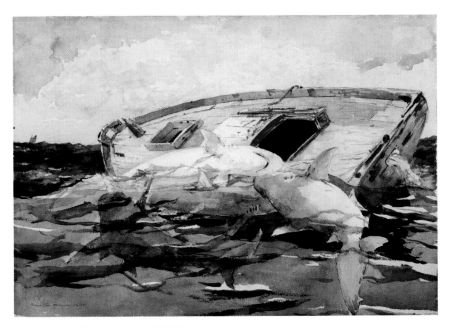

Figure 172: *The Derelict*, 1885. Watercolor over graphite on cream, moderately thick, moderately textured wove paper, 14½ × 20¹⁵⁄₁₆ in.

a similar one in Boston, this sheet was the climax. But Homer and his gallerists misread their market. Nothing else in either show was nearly so foreboding as this watercolor. It did not sell for another twenty years.[24]

A dozen weeks after father and son arrived together in Nassau, Winslow embarked on another adventure—alone. He left Charles at the Royal Victoria Hotel and boarded a steamship for Santiago de Cuba, at the southeastern tip of the 777-mile island.[25] Founded in 1515, Santiago is among the oldest European settlements in the New World. It was the Spanish colony's second-largest city. Homer's onetime boss, Maturin M. Ballou, visited the "quaint, rambling old city" about the same time.[26] The decaying port of 45,000 "has been the seat of modern rebellion against the arbitrary and bitterly oppressive rule" of Madrid, he wrote.[27] For good reason Santiago's citizens sought to rise up against their Spanish overlords. Santiago's "thoroughfares were once paved with cobblestones, but are now characterized by dirt and neglect, a stream of offensive water constantly percolating through them, in which little naked children play. No wonder that the city is annually decimated by yellow fever; the surprise is that it does not prevail there every month of the year."[28] Ballou described Santiago as "dead

Figure 173: *Spanish Club, Santiago de Cuba*, 1885. Watercolor on wove paper, 14 × 20 in.

and void of all activity." He lamented that there was not a single bookstore. Instead, he noted "three or four spacious two-story club-houses, with some pretension to neatness and social accommodations . . . where the male population may congregate for evening entertainment."[29]

When Homer unveiled the watercolors inspired by his Bahamian sojourn, he also included fifteen watercolors based on his time in Cuba. Ten of these are architectural studies, primarily of the streets around which he was living.[30] He had chosen a French inn distinguished by its cuisine: the Hotel Lassus (1830), named for its founder, Antoine Lassus.[31] The hotel's location was convenient, too. It was three blocks from the harbor, near the foot of the central Calle baja de las Enramadas, and immediately next to the city's principal theater.[32] Within a couple of days of settling into his room, Winslow pulled from his bag a single sheet of creased paper and sat down to write to Charlie:

"Here I am fixed for a month—having taken tickets for NY on 8th, leaving 27th of March. This is a red hot place full of soldiers they have just condemned six men to be shot for landing with arms, & from all accounts they deserve it. The first day sketching I was ordered to move on until the crowds dispersed—now I have a pass from the Mayor 'forbidding all agents

Figure 174: *Spanish Flag, Santiago de Cuba*, 1885. Transparent and opaque watercolor over traces of graphite with scraping on heavy wove paper, 12¼ × 16½ in.

to interfere with me when following my profession.' I expect some fine things—it is certainly the richest field for an artist that I have seen . . . Lucky Father did not go with me. No breakfast until 11, very bad smells, no drains, brick tiles & scorpions for floor & so hot that you must change your clothes every afternoon. I will be very glad to get home. You are very lucky to be able to secure a cool place for the winter."

The work that emerged from his six weeks in Santiago de Cuba is similar to the Bahamian work in its intense colors and luminosity. But it is different in almost every other respect. He seemed struck, as Ballou was, by the distinctive particularity of what his fellow Bostonian called "the many-colored, one-story houses of Santiago . . . Moorish in architecture, ranged in narrow streets . . . in an almost impassable condition."[33] Drysdale described the street to the house of the American consul as "the perfection of everything bad . . . the rains have washed gullies in it in some places three or four feet deep."[34] Although Cuba had a large Black population, the few figures who do appear on the streets Homer memorialized were Caucasian. Most of them were shy, beguilingly attractive young women,

Figure 175: *Spanish Girl with a Fan*, 1885. Watercolor on paper, 8½ × 11⅛ in.

elaborately dressed in characteristically Spanish veils, fans, and frills, some-
times behind equally frilly balconies. His only male figures are the occa-
sional driver of a horse-drawn open carriage or a cowboy lugging a donkey
up a hill. But they barely register in the nearly empty landscape.

Homer also seemed far more interested in the city around him than in
the harbor visible a minute's walk from his hotel's front door. To enter the
city, however, he and all visitors needed to pass through the harbor, and
thereby receive its initiation into the tension otherwise concealed on San-
tiago's quiet streets. Homer's steamship navigated a narrow passage as she
entered the port. On the eastern edge of that passage an imposing Spanish
fort stands to this day: Morro Castle. Where Drysdale noted only its sce-
nic characteristics, Ballou understood the fort as a powerful expression of
tyranny. The colonial government had chosen it for the placement of its
political prisoners, that their torment should be seen by all. "As we steamed
past it that sunny afternoon, stimulated by the novelty of everything about
us, a crowd of pallid, sorrowful faces appeared at the grated windows,
watching us listlessly," Ballou wrote.[35] "Spain extends no mercy to those
who dare to raise their hands or voices in favor of freedom; her political

existence is sustained only in an atmosphere of oppression and cruelty. Every page of her history is a tableau of bloodshed and torture."[36]

Cuba was a powder keg waiting to explode. Its economy depended primarily on a single commodity—sugar—shipped to a single market, the United States. A new industry, iron mining, was just beginning on the island, backed by capital and know-how from Pennsylvania. This industry had its origins less than four miles northeast of Santiago, in the mines of the Juraguá Iron Company.[37] The economics of both businesses worked the same way, however. Over time, the wealth of the colony was exported to Spain and the United States, and what remained became concentrated among a very few Cuban families. The vast majority of Cubans meanwhile languished in poverty with little hope to ever flourish. Ten years after Homer's visit, the Cuban War of Independence would begin, as Cuban patriots led by José Martí (1853–1895) struck the chains of the Spanish Empire. Homer observed closely the world around him—above and below the bubbling surface of the Cuban cauldron—as the men and women of the island began planting the seeds of their struggle for their freedom. Although the circling sharks of *Derelict* are Bahamian, not Cuban, they reflect the tension he absorbed in Santiago that would soon flare on those once-quiet streets.

The two Homers, father and son, returned to New York on April 3, 1885.[38] Winslow left Santiago on March 27 and caught up with his father before their voyage home on another Ward ship, the S.S. *Santiago*—which Drysdale took back to New York a month later. As the old man and his now middle-aged son stepped back on U.S. soil, Winslow carried more than his three pieces of luggage. He brought a resolve to further change the ways in which he sold his work. Beginning in 1880 and continuing over the following four years he had had good experience with his principal Boston dealer, Doll & Richards, and with his friend J. Eastman Chase, who had spun his own dealership out of Doll & Richards. Both of them had proven effective in selling Homer's watercolors. But New York was a much larger market. With the right dealer, he could find an outlet there comparable to what he had in Boston and be done with the hassle of arranging auctions of his own work. Over time, he might even dispense with marketing his pictures at the big exhibitions mounted by the National Academy of Design, the American Watercolor Society, and other similar organizations.

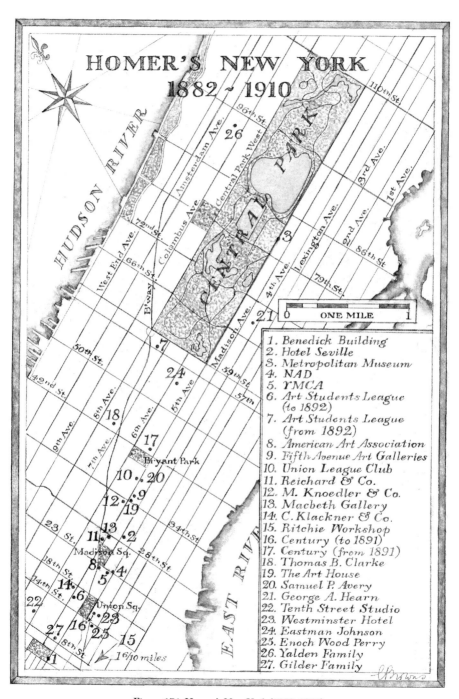

The map contains the following text:

HOMER'S NEW YORK
1882 ~ 1910

HUDSON RIVER

CENTRAL PARK

EAST RIVER

110th St.
96th St.
86th St.
79th St.
72nd St.
66th St.
59th St.
57th
50th St.
42nd St.
34th St.
28th St.
23 St.
18th St.
14th St.
8th St.

Amsterdam Ave.
Central Park West
Columbus Ave.
West End Ave.
B'way
Madison Ave.
5th Ave.
4th Ave.
Lexington Ave.
2nd Ave.
3rd Ave.
1st Ave.
9th Ave.
8th Ave.
7th Ave.
6th Ave.

ONE MILE
0 1

Bryant Park
Madison Sq.
Union Sq.
1 6/10 miles

1. Benedick Building
2. Hotel Seville
3. Metropolitan Museum
4. NAD
5. YMCA
6. Art Students League (to 1892)
7. Art Students League (from 1892)
8. American Art Association
9. Fifth Avenue Art Galleries
10. Union League Club
11. Reichard & Co.
12. M. Knoedler & Co.
13. Macbeth Gallery
14. C. Klackner & Co.
15. Ritchie Workshop
16. Century (to 1891)
17. Century (from 1891)
18. Thomas B. Clarke
19. The Art House
20. Samuel P. Avery
21. George A. Hearn
22. Tenth Street Studio
23. Westminster Hotel
24. Eastman Johnson
25. Enoch Wood Perry
26. Yalden Family
27. Gilder Family

Figure 176: Homer's New York (1882–1910)

But what New Yorker would fit the bill? The ranks of gallerists in New York were thin, and most had only passing interest in American art, when what sold was European paintings—both Old Masters and increasingly the work of the French and English painters Homer had studied so closely. The Prussian-born Gustave Reichard (1842–1917) was an exception. His bread and butter was selling the work of Millet, Barbizon painters, and European academic artists. They included figures now obscure but then admired for their realism, biblical sentiment, and innovative compositions, such as the Spanish Emilio Sánchez-Perrier (1855–1907), the Germans Fritz von Uhde (1848–1911) and Johann Friedrich Voltz (1817–1886), and the Finnish Albert Edelfelt (1854–1905).[39] But Reichard also wanted to sell contemporary American art. He had immigrated to the United States in 1861 at nineteen years of age and served in a Civil War artillery unit that fought at the Battles of the Wilderness and Spotsylvania.[40] He became a naturalized U.S. citizen in April 1867 and had established a dealership specializing in prints by 1872.[41] It was located right in the heart of Homer's neighborhood around Grace Church and the Dodworth Building, so it's reasonable to conclude that Homer met him around that time, which coincides with Homer's moving to the Tenth Street Studio. The year before Homer moved to the Benedick in 1880, Reichard moved his gallery to the premises where he stayed, at 226 Fifth Avenue, on the west side of the avenue just south of Twenty-seventh Street.

Homer settled his father into their hotel and probably met Reichard in the gallery shortly after getting off the ship. He recognized that the choice before him was an important one. Homer's nature was to be loyal, to make and keep a commitment, and to take his relationships seriously. When he stepped through Reichard's door, it was with the forty watercolors he had made in the Bahamas and in Santiago, and an idea for a pair of oil paintings he wanted to exhibit by the end of that year. Reichard listened well and gave him a prime slot on his calendar: a one-man exhibition opening a week before Christmas, on December 18, just eight months away. That slot was also just after the Autumn Exhibition of the National Academy of Design, which ran from November 23 to December 19. They discussed pricing, watercolor matting, the display—perhaps including the placement of *Derelict*—and the possibility that one or both of the two new oil paintings would be ready in time for the show.

He returned to Prouts a few days later and set up a second, much simpler studio—just a one-room shack at Ferry Landing. It was well out of view from his father and the summer guests at the neck's hotels. Facing southwest toward Old Orchard Beach, its orientation, with its changing light, was worse than his north-lit principal studio. But he could store his props there with a minimum of fuss and, if necessary, drench a model in nearby salt water to achieve the effect he intended.

Boyer Gonzales (1864–1934), the son of a partner of Arthur's in a Galveston cotton press, and an aspiring marine painter himself, visited Homer in about 1887 and described the "annex studio."[42] In particular, he recalled "a regular stockade, that surrounded [the] rough, one room, shack. The stockade was built strongly enough to withstand the assault of Indians, too high to climb, and absolutely sight proof. A stout doubly locked door admitted us to the interior, where I saw with a thrill a dory, well protected from the sun."[43]

Gonzales deduced several personality traits from Homer's construction. "He detested the curious. When he painted, he wanted to be alone. Any stranger looking over his shoulder disconcerted him. So, to obviate this, he built the stockade, and I can vouch for the fact that it accomplished its purpose, because even an ex ray [sic] could not have got through."[44]

The Ferry Landing shack wasn't the only new thing Homer had going for him. He probably began about this time to adapt to his own purposes an invention of his father's. Henrietta and Charles had spent enough time in the 1870s at Prouts Neck and other New England shore destinations for Charles's imaginative mind to concoct a novel idea. On September 20, 1878, he applied for a patent to recognize the improvements he intended to existing "Movable Huts or Compartments for the Use of Bathers, which I call a 'Surf-Hut.'"[45] He envisioned "a convenient, safe and comfortable compartment, easily movable from place to place, and adapted to be pushed by an attendant into the water." His invention was not completely coherent as, for example, he envisaged "the structure to be moved into a suitable depth of water without subjecting the hut to a wetting from the surf." He also intended that the hood would project outward and downward sufficiently "to screen the occupant as he descends the steps to go into the water," and conceal the bather as he or she "casts off" wet garments to dress in the hut's dry interior. He also explained that the interior, containing a seat, "may be fitted up with such conveniences as hooks for suspending the

clothing, *pockets to contain brushes and other necessary articles*, and the like" (italics added).[46] He is not known to have ever marketed the Surf-Hut, or to have been especially solicitous of the bathing appearance of his sons, himself, or his wife. One may speculate that at least one factor in Charles's invention was his interest in ad-dressing Winslow's practical needs as a painter regularly exposed to stormy weather—who wished to capture that weather as authenti-cally as possible. In any event, the U.S. Patent Office agreed that his design warranted recognition and issued him Patent 220,147 on September 30, 1879, just over a year after his filing, and a few months after his seventieth birthday.

Figure 177: Charles S. Homer, Sr., *Patent Model—Improvement in Surf-Huts for Bathing Purposes*, 1879. Wood, fabric, and brass, 17¼ × 18 × 12 in.

Homer worked for most of 1885 on the two big new paint-ings. One of them depended on the little Ferry Landing shack, and perhaps on the Surf-Hut. He called it *The Fog-Warning*. It de-picts a craggy fisherman, alone in his dory far from shore as the sky darkens and his home schooner begins to slip from his sight. With two heavy halibut in his stern and his survival dependent on his returning to the mother ship, it is a startling evocation of the mortal risks appearing in the lives of all men—and especially in some. The picture took longer to complete than he'd expected, but he got it to New York just in time to show it briefly at the monthly Century exhibition in early December, and then for Reichard to include it with the watercolors in the show he opened two weeks later, on December 18.[47]

Homer completed the other picture, of the exact same size, a little ear-lier. A deliberate contrast, it depicts a plentiful harvest of herring, a small coastal fish caught with little risk and in close sight of land. Homer was able to include it both in the Century's monthly show on November 7 and

Figure 178: *The Herring Net*, 1885. Oil on canvas, 30⅛ × 48⅜ in.

in the National Academy's Autumn Exhibition. It is based on field sketches that survive, as do the recollections of the boy, Roswell Googins (1871–1966), who rowed Homer out from the Prouts Neck beach to the herring fishermen a mile offshore to make those drawings. *The Herring Net* gleams with sunlight on the skins of the fish and the oilskins of the two fishermen, each hunched to conceal his face. The crossed oars recall Christian iconography from Old Master pictures Homer had seen in London, and the fully laden net is reminiscent of the Raphael cartoon *The Miraculous Draught of Fishes*. The assurance of a safe, fruitful harvest is the exact counterpoint to the gaping uncertainty in the picture Reichard showed. Although the timing of the Autumn Exhibition meant that the two paintings' first showings were not side-by-side, Homer clearly conceived them as a pair, just as he had *Sunday Morning* and *A Visit from the Old Mistress*. He would exhibit them as pendants the following February at Doll & Richards, and then three more times: in Cincinnati the fall of 1886, and again in 1893 at both Reichard's gallery and at the World's Columbian Exposition in Chicago.[48]

The two paintings, taken together, are a major monument in American culture. But in creating *The Fog Warning*, Homer was departing from his almost obsessive dedication to the faithful observation of the particular. His "annex studio" gave him the freedom to create an entirely fictive scene. An actual halibut fisherman would have been working on the Grand Banks

Figure 179: *The Fog Warning*, 1885. Oil on canvas, 30¼ × 48½ in.

two hundred miles offshore. He would never have fished without a dory mate, and would have worked from a Banks dory better suited to fishing in that dangerous region than the Maine coastal dory Homer depicts. Homer never went to the Grand Banks. In creating *The Fog Warning*, he relied on the model and the dory to which he had access on dry land at Prouts Neck.

To our eye today, the incorrect details detract little from the picture's overall effect, but they may have bothered Homer. As he had shown in many other cases, Homer kept working on a subject until he felt he had gotten it right. In June 1885, he left Prouts Neck and rented a house in the Gloucester hamlet of Annisquam.[49] It was near the home of his friend George J. Marsh (1835–1896), recently completed to a design including a second-story piazza strikingly similar to that on Homer's own home and studio. Homer situated himself also near another friend, Andrew Craigie Spring, Jr. (1845–1914), whom he sketched at the tiller of a sailboat. Perhaps most important, however, Homer made sure that he was not far from a Gloucester fisherman named Howard Blackburn (1859–1932).

Homer might never before have met Blackburn but he had surely heard of him. In January 1883, the dory from which Blackburn's mate Thomas Welch (c. 1860–1883) and he were fishing on the Grand Banks had lost sight of the schooner to which the two men returned at dusk each day. A winter storm besieged them, surrounded them with fog, and tossed their

little dory like a twig. Welch died of cold. Blackburn wrapped his big hands around the grips at the end of the dory's rough wooden oars, iced his fingers purposefully in place, and rowed himself and the body of his dead companion some fifty miles, to Newfoundland. A Canadian family found him, fed him, and nursed him back to enough health that a few months later, he could return to Gloucester—having lost his fingers and toes, but not his indomitable spirit. He was welcomed home a hero and a symbol of human resilience, as he remains to this day.[50]

Homer created a third picture set on the open sea: *Lost on the Grand Banks*. Like *The Fog Warning*, it asks more questions than it answers. Unlike *The Fog Warning* it reflects as close observation as was practical of the particulars of the scene Homer depicts. It is not taken wholly from his imagination, but from his meditation on Blackburn's ordeal, and on the broader meaning that may be mined from those particulars. Every aspect of the painting is based on a detailed factual understanding of the life of a Grand Banks fisherman, from the dory's gear, to the men's clothes, to the design of the vessel. While it is speculative to conclude that the unerring accuracy of Homer's picture reflects one or more meetings with Blackburn in the summer of 1885, such an inference seems reasonable.

The picture is about the same width as *The Herring Net* and *The Fog Warning*, but somewhat less tall, accentuating the horizontality of the scene. The exhibition history of *Lost on the Grand Banks* suggests that Homer considered it a standalone picture—his final word on this subject—and not a companion to the pair. It would not hang together with the pair until 1893, the year of the World's Columbian Exhibition in Chicago, where fifteen major oil paintings represented Homer—these being three of them. When he returned to New York in the spring of 1886, it was with this painting, to hang only briefly at the Century. He then sent it on a national tour for the year: the Saint Botolph Club in Boston, the Inter-State Industrial Exposition in Chicago, and then back to New York for the National Academy's Autumn Exhibition.[51] He knew it was one of the most important paintings of his life but got no takers at any of these venues. Frustrated by Reichard's failure to produce collectors for either *The Herring Net* or *The Fog Warning*, he would not let Reichard touch *Lost on the Grand Banks* for another seven years, until he was assembling Homer's works to send to Chicago. Even after that, the picture didn't sell. It took fifteen years before a buyer arrived, and long evenings hanging over a fire-

Figure 180: *Lost on the Grand Banks*, 1885. Oil on canvas, 28¼ × 48¼ in.

place in Portland's Cumberland Club, where Homer knew many a well-heeled local collector would see it.

Like *Lost*, the pair, too, languished unsold for years, until finally in 1893 at the World's Columbian Exposition in Chicago the pictures attracted more attention. Even then, they sold to two different buyers—one of whom was Homer's cousin and financial adviser, Grenville Norcross (1854–1937). He bought with a purpose: to get it on the wall of Boston's Museum of Fine Arts as his gift, both to his city and for the recognition of his relative. A New York collector then bought the other one, *The Herring Net*, which ultimately made its way back to Chicago to hang at the Art Institute. With the exception of the occasional exhibition, the pair has been split ever since. In this case, as in so many other instances, Winslow discovered, and rediscovered, that it wasn't easy to be ahead of one's time, or to craft the legacy for which he longed.

Homer had high hopes for the new relationship with Reichard and made a special effort to work with him closely at the end of that year. He went to New York in November, probably stayed at the Benedick with Preston, and had dinner at the Century on the sixteenth, three days before the National Academy's Autumn Exhibition opened. Enoch Wood Perry and Jervis McEntee (who had arranged for the sale of *The Cotton Pickers*) were both at the club that night. McEntee was also a diarist, often jotting

down the details of the friends and acquaintances he observed around him and what they were doing.[52] Since no evidence has emerged of Homer keeping a diary himself—and few letters survive from the first forty-five years of his life—the diary entries and letters of McEntee, Stedman, and others are among the few practical ways today to chart Homer's journey.

As it turned out, Reichard aided little in the sale of Homer's forty tropical watercolors. The critic and architect Russell Sturgis (1836–1909) bought *The Conch Divers* and another sheet.[53] John La Farge bought one or two sheets as well. Both Sturgis and La Farge might easily have acquired them directly from Homer, or through the Century, where all three were very active. Homer needed to wait for the Doll & Richards sale early in 1886 in order to realize much from his months in the winter sun.

Once the Reichard show opened, on about December 19, Homer left New York again for warmer climes. He and his father boarded a steamship for the four-day voyage to Jacksonville, in northeastern Florida. After celebrating Christmas in a hotel there, they took a newly built luxury train to the port city of Tampa, on the state's west coast.[54] Winslow was there just long enough to inscribe "Tampa" on two watercolors, before sailing on to the southwestern tip of Florida: Key West.[55]

His watercolors from this second trip to the tropics reflect his close attention to certain specific characteristics of the Florida landscape that he did not observe in either the Bahamas or Cuba. In *A Norther, Key West*, for example, he accentuated the isolation of Key West and its exposure to the powerful winds waiting to attack the tiny island from any point on the compass. He framed his composition to omit the first floors of two cottages and to engage with the geometric forms of their triangular rooflines silhouetted against a low horizon as palms wave wildly above these squat shelters erected in defense from the forces of nature casting them under siege.

Other watercolors portray the lush, dense foliage of more protected Florida landscapes. Homer executed at least one of these sheets near Brock House, a hotel built in 1856 on Lake Monroe in Enterprise. Alexander Helwig Wyant had depicted the lake and the hotel in a canvas executed fifteen years earlier.[56] It was a favorite destination of many American luminaries, including two U.S. presidents (Ulysses S. Grant and Grover Cleveland) and Henrietta's brother Arthur Benson, who had just turned seventy-three then and remained an enthusiastic fisherman. In fact, he was

Figure 181: *In a Florida Jungle*, 1886. Watercolor over graphite on moderately thick, smooth off-white wove paper, 14⅛ × 20⅟₁₆ in.

such an avid angler that fewer than four years later he would drop dead on Lake Monroe, having cast his line seconds before he met his maker.[57] A swamp known today as Thornhill Lake lies three miles southeast of the mouth of Lake Monroe, as it feeds the St. John's River on a meandering two-hundred-mile journey north to its basin near Jacksonville. In that lake, a serpentine bar of low land provides ideal nooks and crannies within which fish may hide. Homer undoubtedly set his eye on those rich crevasses and named a watercolor after the spot.[58] In another sheet, an alligator emerges from the river to approach an indifferent pink heron. Vultures circle over the lush vegetation, and a strange skeletal form—like vertebrae from a mastodon—lies in the lower left corner, awaiting our investigation.

After two weeks at the Brock House, Winslow and his father took the overnight steamship up the St. John's River in time to celebrate Homer's fiftieth birthday in Jacksonville on February 24, 1886, in the company of his generous supporter Lawson Valentine. He was back in New York in March, but declined to exhibit at the National Academy's largest exhibition, the Annual—even though he was on the Exhibition Committee.[59] He may have lingered in New York and Boston before arriving in Prouts

Neck by early May, as he was hoping for two pieces of commercial success. The first was his showings of *Lost on the Grand Banks*.

The second was his progress on a continuing experiment: the creation of etchings based closely on his oil paintings and watercolors. He had developed the first of these etchings in tandem with *The Life Line* and altered his composition little to harness the power of the alternate medium. Homer left few words to reveal what art he saw and what he thought of it, but the art itself (such as *The Country Store* of 1872) suggests that he had admired the Old Master pictures he had seen both in the United States and on his two trips to Europe. He would have had more opportunity to see Old Master prints than paintings during the period of his formation in New York in the 1860s and 1870s, but only in the work Homer made did he leave evidence for what he saw. And even there, the evidence is scant. But his attentiveness to learning the art of etching suggests that he had looked closely at etchings created by virtuosos who had preceded him.

At first, his experiment in this form of printmaking seemed purely commercial. When he exhibited *The Life Line* at the Century, for example, he valued the oil at $2,000—and priced his etched version (also called *The Life Line*) at $25 for each impression. He chose as his tutor the young George W. H. Ritchie (1857–1929), Brooklyn-bred son of the Scottish-born mezzotint engraver Alexander Hay Ritchie (1822–1895); father and son shared space at 109 Liberty Street. Homer's etching publisher was Christian Klackner (1850–1916), who had joined the gallery M. Knoedler & Co. as a boy and set up his own shop just the year before Homer began working with him and Ritchie. Ultimately, with Ritchie's and Klackner's assistance Homer created five additional etchings that, like *The Life Line*, are based on his oil paintings or watercolors—with an increasing freedom of expression over the five years of his making them. All six etchings are figural, not landscapes.

Intriguingly, he also authorized other, even more prosaically imitative prints. They include etchings credited to Homer but worked on the plate by James David Smillie (1833–1909), Hamilton Hamilton (1847–1928), or Pierre Salvy Frédéric Teyssonnières (1834–1912), or photogravures based on pallid photographs of his paintings. While in most (and perhaps all) of these cases, Homer had authorized these lifeless prints, he had nothing else to do with them. His willingness to engage with this process suggests both a decline in his economic circumstances and his willingness to experiment—albeit through processes that in hindsight appear intemper-

ate. He behaved similarly in providing utterly wooden ink-and-crayon drawings to the *Century Illustrated Monthly Magazine* based on his lively Civil War field sketches. The *Century* undertook a series of illustrated stories about the war, using photographs of these ink-and-crayon drawings. The articles were published both in the magazine and in volumes entitled *The Battles and Leaders of the Civil War*. Homer probably agreed to do these illustrations out of affection for the *Century's* editor, Richard Watson Gilder, but he must have had some sense of the mistake he made in associating his name with something so completely banal.

Despite his disappointment with collectors' responses to the pendants *The Herring Net* and *The Fog Warning*, and to his Blackburn meditation, Homer carried on. He was nothing if not tenacious. He had achieved his greatest commercial success with *The Life Line*, acquired by such a prominent collector as Catherine Lorillard Wolfe. Now he dialed up the essence of that picture: its intertwined allusions to sex, death, and salvation. He spent most of 1886 working on a picture he called *Undertow*, which he delivered to Doll & Richards on the last day of the year. Like *The Life Line* it reflects his eyewitness observation of brave life brigade men risking their lives to save the lives of others at risk in the North Sea and the North Atlantic.

But Homer made *The Life Line* in New York, based on field sketches he had made in England and possibly on the American coast. For this picture, as with *The Fog Warning*, he could use his "annex studio" away from prying eyes at Ferry Landing. He may have used his Surf-Hut as well. Homer hired Hannah Louise Googins's nephew and niece John (1865–1940) and Isa May Libby (1867–1931) to serve as models. John was twenty-one and boasted an impressive physique reflecting his hard work farming the rocky Scarborough soil.[60] Isa May was nineteen, and two years from her forthcoming marriage to an aspiring Portland photographer.[61] Homer also employed his models' younger brother Leonard (1871–1962), then fifteen. Isa May's daughter wrote, "Mother posed on a couch and he (Uncle Len) poured water over her head and he said he poured extra quantities just for the fun of it and to give my mother a good 'wetting.'"[62]

The picture also benefited from Homer's close attention to geometry. *Undertow's* lines converge precisely at the central point of Isa May's left elbow, glistening with salt water. Extensive surviving studies suggest that Homer originally conceived of the picture to depict only the three figures in the triangular mass at left, and that Isa May's pose was once more sexu-

ally provocative. The male figure to right was a late addition, with his face shaded to mitigate offense of collectors' elevated sensibilities. At left, John similarly averts his gaze. There is no denying the picture's power, or the physical appeal of each of its four figures, male and female. The horizontal centerline, which runs through Isa May's elbow, also connects precisely to John's waistline below his chiseled abdomen, and to the developed pectoral muscles of the male figure on the right. Homer deploys all his gifts to draw his viewers into a scene charged with excitement of all kinds. The process worked, and he knew it had, pricing the picture at $3,000, even higher than the then-colossal price of *The Life Line*.[63] He delivered *Undertow* to Doll & Richards on New Year's Eve, and less than four months later he could read this in the *New York Evening Post*, reviewing the National Academy's Annual: "Sincere, honest searcher after truth as Mr. Homer is; poet, painter, and sturdy realist, at the same time, like Millet; distanced as he might be by a man of the same temperament but better equipped; faulty as his work is in some respects, we cannot but accord to Mr. Homer a very high homage. His *Undertow*, by its virility, its truth, its sincerity of intention, outranks every picture in the Academy exhibition."[64] It sold within two years—which for Homer in those days was rapid.

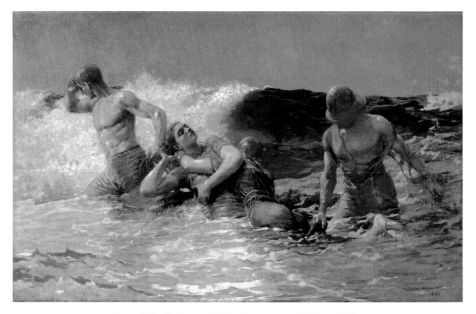

Figure 182: *Undertow*, 1886. Oil on canvas, 29¹³⁄₁₆ × 47⅝ in.

John Libby's deliberately turned head—expressing his will *not* to see—
was an ironic statement from the Obtuse Bard.[65] Homer never turned his
own head away. He looked directly, and then looked again. He was fasci-
nated with seeing, in art, in life, and in science. An autodidact dependent
on his own wits, he took full advantage of whatever he might soak up from
whomever he might encounter. He read Chevreul and Rood to learn the
chemistry and physics of color, and surely engaged in conversations in New
York and Boston with Rood himself, and with ophthalmologists such as
Angell. And as the son and brother of inventors, he was ever poised to
detect the practical application of technology to enhance how one sees. He
thought deeply, too, about the next step: what one does with the intelli-
gence gathered by the eye.

In 1884, Winslow had painted three panels for a Prouts Neck sloop, the
Mattie, which was named for Charlie's wife. It is reasonable to conclude
that Charlie commissioned and paid for the vessel, too, but that Arthur
and his two sons took her out for the day more often than did either
Winslow or their generous older brother. The panels, surprisingly, relate
not to Maine but to Gloucester and the mid-Atlantic. The largest two
panels are another pair of identical size and complementary subject: a fleet
of schooners outfitted for mackerel fishing. One panel depicts the fleet
heading out of Gloucester Harbor at dawn, about to pass Eastern Point.
The other depicts the fleet returning at dusk, silhouetted against the hills
of West Gloucester.

The smallest of the three panels is based on Homer's studies from the
empty deck of the star-crossed *Parthia*. It is in grisaille, as if from a photo-
graph, and set far from the sight of land. Homer made it toward the end of
a ten-year period in which he often created finished drawings in a French
tradition, in a black-and-white format on toned paper. "I have never tried
to do anything but get the proper relationship of values," Homer is re-
corded to have said. "That is, the values of dark and light and the values of
color. It is wonderful how much depends upon the relationship of black
and white. Why, do you know, a black and white, if properly balanced,
suggests color."[66] A solitary middle-aged officer in his Cunard uniform is
taking an observation of the moon, which was full the first night of Ho-
mer's voyage. The octant in the officer's hand was a tool deployed in the
ancient process of celestial navigation. By then, navigators used sextants
more often, but Homer had an affection for octants, which were more

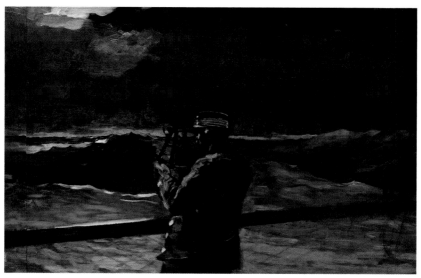

Figure 183: *Taking an Observation*, 1884. Oil on panel, 15¼ × 24 in.

compact than sextants and less dependent on the stability of the ship's deck. In the midst of an ocean crossing, as the clouds parted and afforded a sighting, an officer such as Homer depicts would pull out his instrument to determine a line of position on the surface of the earth. To do so, he also needed a second instrument, a sophisticated chronometer that Homer omits, to know exactly when he took that observation. For every four seconds of error on the ship's clock, the calculation of the vessel's position will also be in error—by one nautical mile, or enough error in a storm to risk its very existence. As with observations from Civil War balloons, this actionable intelligence bore mortal consequence.

In *Eight Bells* two men take another set of observations. The picture is a meditation on the process of seeing, the indispensability of that process and the imperative to engage in it collaboratively. Homer made *Eight Bells* about the same time as he did *Undertow* and probably delivered both pictures to Doll & Richards on that New Year's Eve.[67] This picture is more complex than it appears, smaller than *Undertow*, untainted by sex and brushed gently with death. Homer limited his mortal allusions to the shrouds at right, flying in the wind from their spectral spars.

Characteristically, he omits components of the scene that were in fact indispensable. The moment Homer depicts is exactly noon, since a precise sighting of the sun at local noon was the one and only way in this period

to determine both latitude and longitude. To ascertain a ship's position accurately in this process, three observers—not two—must together perform a navigational feat. He shows us two of the three at work under the mottled sky. The man at center stands on the rolling deck while taking his observation with his octant, much as did the officer on the *Parthia*. The man on the right holds a second octant, which he has turned to measure the exact angle of a separate observation he just has made. The third man is unseen, but essential. Homer is that man, and he commands his viewer to stand in his shoes and complete the assignment with the readings his partners have made from their instruments, for his assembly on paper. As they shout out over the roaring waves their observations of the height and angle of the sun, Homer—the third man—watches for the pivotal, particular moment. That is when the sun is at its highest above the horizon. The third man not only inscribes these numbers but draws them, in linear form, on graph paper. It is he, the unseen draftsman, who makes comprehensive sense of the visual evidence. By head and hand he leads his partners in

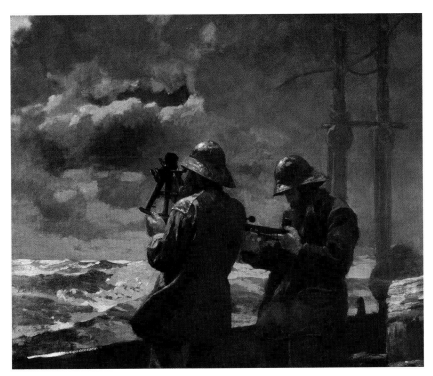

Figure 184: *Eight Bells*, 1886. Oil on canvas, 25⅛ × 31 in.

order that, together, the three may ascertain the single answer to a fundamental question: Where are we?[68]

These cold-weather scenes that occupied him for most of 1886 seem to have exhausted Winslow. Although he wrote to Mattie at Thanksgiving that "my affairs are very encouraging," his life at Prouts was arduous.[69] Although Charles Sr. extolled a Spartan existence, even he had concluded that he preferred the American House in Boston as his winter home. Winslow had visited him at the hotel for Thanksgiving, and ten days later wrote to him on stained, cheap paper, ending with a reference to Sir John Franklin (1786–1847), an Arctic explorer who froze to death:

> I have just put coal on the fire, which accounts for this smut. I made a mistake in not getting a larger stove. It is very comfortable within ten feet of it. It heats the room within two feet of the floor, & water freezes anywhere within that space. I wear rubber boots & two pairs of drawers—I know very well what a mistake I am making. I should "simply irritate my skin and take a cold bath."
>
> But water is scarce. I take a sponge & pick out certain portions of my body which I do at any time of tide, & always.
>
> I break four inches of ice to get my water. I thank the Lord for this opportunity for reflection. & I am grateful for the advantage I enjoy over Sir John Franklyn.
>
> Affectionately,
> Winslow[70]

Another Englishman observed more than a century previously that when a man faces a deadline—like delivering *Undertow* by the end of 1886—"it concentrates his mind wonderfully."[71] Winslow stuck to his work and let his father travel without him to spend Christmas with Charlie and Mattie. He joked about his father's "most hazardous journey . . . no friendly hand at his coat-tail to keep him from the seductive railroad pie— confidential conversation with the brakeman, at forty miles an hour, will be in order."[72] Winslow resolved that once *Undertow* was delivered he would spend the first months of 1887 in New York, working on etching new plates—reworkings with young Ritchie of old ideas Homer had already put on canvas.

He would not sleep at the Benedick. Although Preston remained listed in the New York directory, the hide merchant had decided to move to Mount Eden, a section of Hayward, California. He wished to give up his trading business and become a full-time rancher, although he wouldn't stay there long and instead settled in Argentina.[73] Another friend was dropping out of Homer's once-vibrant bachelor life. He made the best of it, proclaiming cheerfully to Mattie that he "shall live *up town*"[74] (italics his).

The response to *Undertow* from critics was gratifying; McEntee called it "an altogether manly work."[75] *Eight Bells* sold to Homer's most enthusiastic patron, Thomas B. Clarke, before the painter could get it on the walls at Reichard's, Doll & Richards, or the National Academy. But the flurry of activity leading up to 1887 had drained him. He would date not a single oil painting that year, or either of the two following years. He did execute about fifteen watercolors for exhibition in 1887, but they generally lack energy. The title of one made at Prouts late one afternoon speaks to his entropy: *Bringing in the Nets*. Clarke acquired the sheet. Homer wrote to Charlie, "I am very busy painting in watercolor, which means something that I can sell for what people will give."[76] His watercolors were indeed selling, but Homer seems to have been dissembling for his brother. The evidence suggests he was far from busy painting in watercolor, and was having trouble sustaining even this low level of production.[77] Not a single watercolor from the following year survives.

He also withdrew from the big group exhibitions, beginning with his refusal after 1888 to submit work to the annual exhibitions of the National Academy of Design. He continued to refuse for eighteen years. Similarly, for seventeen years after the annual exhibition of the American Watercolor Society closed in the winter of 1888, he sent no new work. His tribute to the dignity of working women, *Mending the Nets*, was a decade old when he showed it at the 1891 annual, singly, and undoubtedly at Reichard's provocation. While Homer's detachment reflects a degree of confidence in his dealers, it probably also reflects his sense that he had nothing new to offer—and his understanding that those exhibitions needed something new.

Winslow started the new year of 1888 in New York. He had more ambitious etchings to make and a commercial instinct to satisfy. He sent a joking letter to J. Eastman Chase, citing the glazed cases he detested, in which dealers then often enfolded grand canvases. Nevertheless, his face-

tious idea speaks to his blunt economic imperative, recommending that Chase "exhibit an oil painting in a robbery box with an etching from it in the end of your Gallery with a pretty girl at the desk to sell and possibly some other etchings enough to make that end of your place attractive enough for your approval. I think from the first of December to Christmas the right time."[78] As it turned out, his entire artistic production for the year would consist of just three etchings, each derived from his depictions of women at Cullercoats. His confidence in the new medium had risen, as he displayed in an etching based on his watercolor *A Voice from the Cliffs*. While that sheet and the *Hark! The Lark* oil painting both are hopeful, and even faithful, the tone of the etching that relates to these works is grim—masterful but alarming. The women look to the sea in inexplicable dread, their faces as darkened by terror as the cliffs over their shoulders are whitened by the unseen sun. He appears to have printed just six impressions and did not market even those six.[79]

McEntee bumped into Homer at the Century on January 3 and wrote in his diary, "Homer says he has not painted much for a year and wont paint when he dont feel like it. From what he said he is like all the rest of us. Has no encouragement."[80]

Later that month, however, Homer did get a lift from an unexpected quarter. A syndicate of New York sportsmen had acquired Baker Farm,

Figure 185: *A Voice from the Cliffs*, 1888. Etching, 19⅜ × 30¼ in.

where Homer had spent such happy months in 1870 and 1874. The group had formed a club, initially called the Adirondack Preserve Association, which was renamed in 1895 as the North Woods Club. The minutes record that on January 28, 1888, at the meeting of the association's trustees at 178 Broadway, "the name of Mr. Winslow Homer, address Century Club 109 E 15th St New York, was presented for membership by Mr. Adams seconded by Mr. Case."[81] Homer's friend Eliphalet Terry, with whom he'd visited the Clearing in the early 1870s, already had joined the North Woods Club and had given his address as Homer did—at the Century's Union Square clubhouse. Surprisingly, Terry doesn't appear in the minutes even as supporting the nomination.[82] Adams was Edwin W. Adams (1846–1924), a lawyer and lumber merchant who was a good friend of Homer's. He was business partner to a young Cuban-born entrepreneur, José Oswald Jimenis (1858–1941), whom Homer also knew and who would become active at the North Woods Club.[83] Jeremy G. Case (1845–1926) was a coal dealer and the organization's secretary. Homer's election may have come during a period not only of discouragement but of illness. He wrote to Mattie three weeks later "that this incomparable fisherman has been restored to health."[84] He would not return to the Clearing until May 1889. But once he did, a restoration was indeed on its way, of the angler and the man. For twenty-one years, the pure streams and brisk air of the Adirondacks would prove as essential to Winslow's vigor and purpose as breath itself.

Figure 186: Unidentified photographer, *The Clearing, including former Baker Boarding House and Extensions, Southern View*, c. 1889. Albumen print, 6 × 8 in.

10

A FLOURISHING CONDITION
(1889–1893)

As the final year of the 1880s opened, Homer may have lamented what an empty year 1888 had been—at least artistically for him. He had just the three etchings to show for all his labors. As he opened the *Portland Daily Press* on the morning of January 1, 1889, he may have agreed with the editorial, that "when one undertakes a retrospect of a twelvemonth that is gone, how few events come to his recollection."[1]

The anonymous Mainer continued, however, by noting that 1888 was not quite the nonevent it might appear to be. An Indiana Republican, Benjamin Harrison (1833–1901), had defeated the first Democratic president elected in twenty-eight years: the former New York governor Grover Cleveland (1837–1908). Although Cleveland would return to the White House four years later, he would be the sole Democrat to occupy the office from 1861 until the election of Woodrow Wilson in 1912, two years after Homer's death. The salty editorial observed that with hindsight other events of 1888 had mattered, too: the abolition of slavery in Brazil (the last Western nation to do so), "terrific storms of wind and snow . . . stranding vessels by the score," and "the bursting of the greatest financial bubble in modern times, in the failure of the Panama Canal enterprise."

For Homer, too, the year mattered, in that it set the ground for a new phase of his life, as he completed the etching experiment begun in 1884 with *The Life Line*. He had developed that print cautiously, in parallel with his oil of the same name, at the beginning of a period of remarkable productivity. Now at the end of his etching career, and with mixed endorse-

ment from collectors, he was bold. One scholar described his five-year journey: "As would be expected from a creative talent of Homer's dimension, he became deeply absorbed in exercising the intrinsic artistic qualities of the etching medium, and made a series of independent compositions."[2] Of the six etchings he completed, none illuminates that trajectory better than the largest: *Saved*.

With perfect symmetry he returned to the subject with which he started: two figures on a breeches buoy, of which one is a prostrate woman destined for certain death were it not for the other, a brave man of the life brigade. In *The Life Line*, Homer set his sights on the delicate young woman, but the muscular man in whose lap she sits gets nearly equal treatment. Despite her scarf, blown across his face, he is visible enough for one to recognize him in gratitude as a figure of rescue and comfort. In *Saved*, almost nothing of him is visible but two sculpted hands grasping her shoulder and breast. He is a force of mystery, like the winds and waves from which those enormous hands appeared. *Saved* is a complete tour de force, in the figures themselves, the pounding foam beneath the timeless rocks, the serpentine cord whipping in the surf, and the tensile suspense of the fraying cable overhead. Few if any prints of any kind ever made by any other American surpass it. Homer knew that he had hit a high point, and concluded the opposite of what other printmakers would have deduced

Figure 187: *Saved*, 1889. Etching on imitation parchment, 22⅞ × 32¾ in.

from such an achievement. For Homer, his mastery of the medium meant that now his labors were complete and it was time to move on.

He knew the value of scarcity. As he headed south from Prouts on the last day of February 1889, he probably wrapped the finished plate in a soft cloth and placed it gently in his bags. His first stop that day was surely his father's hotel, the American House in Boston.[3] Then he was on to New York, where he could barely suppress his eagerness to show his plate to George Ritchie.[4] Ritchie may have administered a few finishing touches himself, but in this case—and only in this case—Homer kept the plate. He wouldn't leave it with Ritchie, lest he or someone else make restrikes.[5] But first he made his next stop, near Ritchie, to his publisher, Christian Klackner. Under Homer's watchful eye, Klackner's press printed twenty-five crisp, clean impressions.[6] For a masterpiece, it was a deliberately and remarkably short run.

The fallow year of 1888—or so it might have seemed—also readied him for another kind of breakthrough in early 1889. He was eager to reengage with the Adirondacks in a way that none of his visits in the 1870s had allowed. Then he was an admired illustrator and an aspiring painter, with few traveling companions, each male and an artist. He was looking for scenic ideas to convert to salable wood engravings and noteworthy oils— and the affirmation of his peers along the way. Now he had plenty of good ideas. He had achieved an eminence that led him away from other artists, not toward them. He did not need the Adirondacks for distraction from the city. He was already living outside New York and showed no inclination for Prouts to become home to any important artist but one: him. So also at the North Woods Club his companions were generally commercial in their vocations. His old friend Eliphalet Terry—who never needed to make a living from his art and didn't—was the exception to the rule. Two of the other members with whom he spent time at the Clearing were also members of the Century, but neither was an artist.[7] He and Terry overlapped their stays at the club just twice: once that spring when he returned to the Clearing, and for a return visit in the fall of 1889.

What Homer sought at the North Woods Club was, most of all, a quiet place where he could practice his favorite pastime: fly fishing. There he could share that experience with others who valued it, and with their families. When he came in the '70s with Terry and Fitch, all three were bachelors. The arduous route to Baker Farm, and the conveniences it offered,

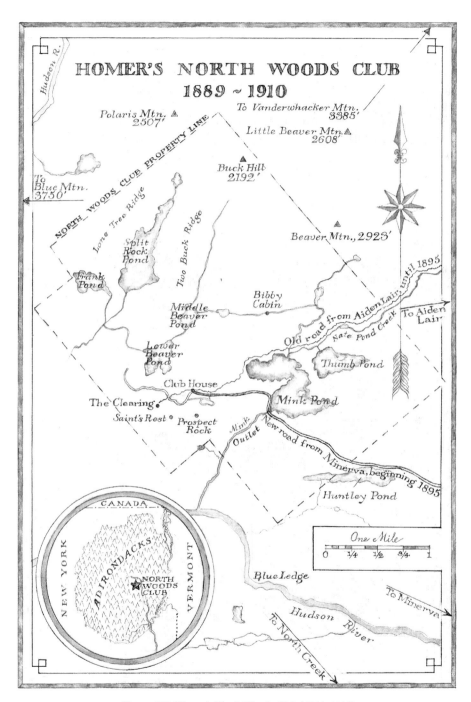

Figure 188: Homer's North Woods Club (1889–1910)

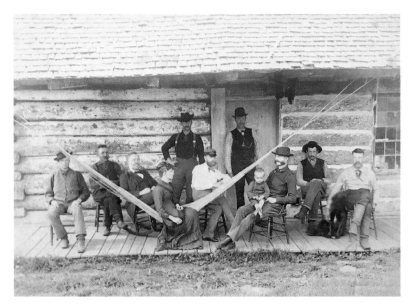

Figure 189: Unidentified photographer, *Members, Guests, Superintendent, and Guides on Porch at The Clearing*, c. 1889. Albumen print, 6 × 8 in.

were unfit for women—at least by the standards of the time. Now the journey to Aiden Lair and over to the Clearing was moderately more comfortable, and the club welcomed women and children adventurous enough to make the trip. The club accommodations were simple but perfectly acceptable, as were the few houses the members built—all within the Clearing and near its clubhouse. Homer's eighteen visits to the club, over twenty-one years, were far from solitary.

They brought him together with a discrete group of about eighteen fellow members and their families. Most were not men of great wealth but entrepreneurs and professionals, generally from New York, New Jersey, and Pennsylvania.[8] There were a few who were then on the cusp of success, such as an ambitious Wilmington, Delaware, civil engineer named Henry Grant Morse (1850–1903), who later became a successful shipbuilder before his early death, and the English-born James Yalden (1842–1905), who effectively founded the American public accounting profession at the same moment that he and a few others were founding the North Woods Club.[9] But these were the exceptions; lawyers, doctors, and moderately successful merchants in everything from commodities to wallpaper were more the

norm. A few other members who came during Homer's first stay would return with regularity during his future visits; one good example is Frank W. Kitching (1839–1917), a wool merchant. Like Adams and Jimenis, he was an officer of the New York Bicycle Club and an advocate for that new mode of transportation.[10] The club's small size and modest number of member-owned cabins meant that when Homer visited, he would have seen these other members and their families every day. There were few members there at any one time—no more than about six. When Homer came in the fall, it was usually with just one other member.

Both Case and Adams, the two members who proposed him, overlapped with Homer during the stay he began on May 6. May is black fly season, which some members considered incommodious. Homer did not; he recognized that the flies were as attractive to fish as they were annoying to humans. He stayed more than two months, until July 13.[11] His friend Yalden left after a week, on May 25. But between running his own accounting business and laying the foundations for his profession in his adopted country, Yalden had excuses beyond the flies. His son James Ernest Grant Yalden (1870–1937), then entering New York University as a freshman, stayed almost a month, leaving the same day as Homer, and likely with him. Homer had already evidenced a liking for the young man.

Homer's first watercolors at the North Woods Club are unlike anything he had ever made. They display a loose brush, a confident line, and daring color harmonies. To create *Casting in the Falls*, he walked thirty minutes from the Clearing to the outlet from Mink Pond. The stream slices inexorably to the Hudson, slenderly slipping past brawny boulders and through them. Homer depicts a single fisherman casting with a muscular pose. Half-sitting, half-standing, he courts more danger than he knows; the confused mass of squared boulders is more slippery than it looks. A massive stone, its edge lit in red like the man's belt, hides all his left leg but his thigh, as if it has already broken his bone. The stone at dead center is like a pink-tinged glistening anvil, hanging over the puddles of red in the basin below.

From that anvil, Mink Pond Outlet descends quickly to the Hudson. The mighty river is but one hundred feet wide here, and shallow enough to tempt the foolish to wade across. In the spring, when the snow melts and swells its edges, the Hudson runs fast, foaming and furious. For decades

Figure 190: *Casting in the Falls*, 1889. Watercolor on paper, 14⅛ × 20⅛ in.

the river had served as a corridor for the dominant industry of the Adiron-
dack region: logging.[12] Just as Homer's illustration had documented, every
winter daring young men would risk life and limb to snowshoe across icy
hills and steep valleys to fell giant trees amid the dense forest. They cut the
trunks and their largest branches to thirteen-foot saw logs, then turned them
over to teamsters who built the sleds, drawn by oxen, that would drag those
logs over the slippery ice.[13] It was hazardous work, but with practice the
slopes and ice were the teamsters' allies as the logs rolled down toward
the frozen water. Come spring, the river would run, the logs would roll,
and the agents of the money men would pay these country boys for the
work they'd done all winter.

Not far from Mink Pond Outlet Falls, the Hudson hits a wall, or seems
to. Blue Ledge is a sheer cliff at a sharp turn in the river's course. Homer
painted the stone a purple hue, and chose its perfect color complement, a
muddy green, for the triangle of foliage to the right. There are men here,
but they are like ants to the left, clambering across a landscape of a kind,
made by humans. The thirteen-foot logs are like limbless corpses, intima-
tions of the mortal risk with which these men lived all year long. Each of
them had seen a pair of logs twist in the river unexpectedly, sever a man's

Figure 191: *The Hudson River at Blue Ledge, Essex County* (*The Log Jam*), 1889.
Watercolor on paper, 14½ × 21 in.

leg, or take him under. Each had put on his Sunday best, cried at the grave-side of a friend or cousin, and called, red-eyed, on his widow.[14]

Not all was grim for Homer the first spring and summer at the North Woods Club. In the choreography of angling itself, he found a rhythm of reassurance and peace—and communicated that rhythm in his watercolors. One critic wrote that he "never hesitates to express the full intensity of light, as we may see in his picture of a much occupied angler who is endeavoring to rescue his fish from the fallen trees and other entangling rubbish along the shore. The angler's back is white in the sunlight, and his curiously curving rod gleams like a line of silver."[15]

For that long stay at the Clearing—his first since it became the North Woods Club—Homer may have taken with him a book to which he had paid much attention. It was a gift from an unusually extroverted friend, the stockbroker John H. Gourlie (1807–1891).[16] Written by an Anglo-Scots physician, George Chaplin Child-Chaplin (1812–1883), its title was not short: *The Great Architect: Benedicite, Illustrations of the Power, Wisdom, and Goodness of God, as Manifested in His Works.* The book was inspired by the song that the three companions of Daniel sang in the furnace whose fire

the Babylonian King Nebuchadnezzar II (c. 642–562 BCE) had set to burn them alive, and within which they demonstrated the greater power of God. The song, as a canticle (the Benedicite) sung in the Episcopal service of Morning Prayer, would have been familiar to Homer, a music lover. For his last twenty summers he must have heard it sung often in the church across the street from his house.[17]

A best seller in its day on both sides of the Atlantic, the book proposed a simple but startling idea: "every thing bears the mark of order impressed upon it by the Almighty hand."[18] Homer's copy bears marks itself—many of them subtle and soft but clear. They are open windows into his well-sealed heart. As the art historian Elizabeth Johns first observed, "with his brush he could depict the integration of humanity in the great forest, celebrating . . . the participation of trees and plants in nature's designs. He moved beyond his personal pleasure in fishing to focus on the forests as a natural system."[19] One of his annotations marks the chapter "Sun and Moon" right at its start as the author observes, "There are not a few in this world who habitually receive God's blessings so much as a matter of course that they are scarcely conscious of any active feeling of gratitude in regard to them."[20]

Child-Chaplin explained as a scientist how effectively for him "natural objects serve as aids to adoration." He meditated in print on why and how God's book of Nature, "crowded with emblems of His Greatness and Mercy," provides such abundant reason to believe in God and give thanks to him.[21] He also demonstrated why advances in science, from Darwin's evolutionary biology to astronomy to botany, further strengthen his conviction of God's loving purposes. For example, in the chapter "Winter and Summer," he wrote, "In any of these ways the length of the earth's natural year might have been different from what it now is . . . [and so] the working of the botanical world would be thrown into utter disorder, the function of plants would be entirely deranged, and the whole vegetable kingdom involved in instant decay and rapid extinction."[22] But, he explained, "nothing in Nature has been established without benevolent design, and even the difficulties arising from the proverbial uncertainties of climate, as well as the impediments encountered in the cultivation of the soil, are not without their use."[23]

Homer was highly observant in all walks of life but one: organized religion. The son of two devout Christians, he absorbed certain essential

elements of the Christian faith, including a deep conviction of God's love for him, and for all of humanity—and a conviction that salvation, wrought by God, is the highest expression of that love. That said, he studiously avoided regular church attendance. Now, as he entered the last chapter of his life and emerged from the dark period following his mother's death, he found in Nature the same abundant reasons for gratitude that Child-Chaplin had found. The watercolors flowing out of his idiosyncratic faith and sense of wonder produced not only commercial success but spiritual relief, and even joy. They are his testimony to the inspired order, the working out of natural processes he witnessed at the North Woods Club, and relished that summer, and for the rest of his life, as an angler and man.

Homer observed especially closely one particular species of fish. As the critic in the *New-York Tribune* noted, "The fish which he paints are the Adirondack trout, which we fear would be considered unworthy game by fishermen on Canadian rivers. But Mr. Homer teaches us again that 'it is not all of fishing to fish,' and the artist's trout are not to be estimated according to their weight."[24] The critic from the *Times* noted with delight "two trout leaping together from the flat disks of the lily at the same dragonfly—and missing it . . . They belong to the most brilliant variety of that game fish, and sweep through the air like tropical birds, with their brilliant spots and ruddy fins fully displayed. The surface of the lake is wrought with a rare sense of color. Lily leaves overturned by the wind show their pink and violet undersides, and one feels, rather than distinctly sees, the background of somber forest."[25]

In fact, Homer knew more about the life of the brook trout than did the art critic of *The New York Times*. He studied the fish's world so thoroughly that he caught a remarkably brief and pivotal moment in the fish's life. The leaping trout are indeed exuberant young "troutlings with the bars still on their sides," but their prey is no dragonfly.[26] It is a mayfly, part of a group of three thousand winged aquatic insect species with a brief but dramatic life cycle (Ephemeroptera).[27] This one, at the upper left of his sheet, has just hatched from the exoskeleton in which it's lived as a nymph, submerged in the water for the past year. Now, suddenly, at this moment it is a dun, ready to fly. Within hours, it becomes a spinner, to realize, with equal speed, its essential purpose: to mate. Once it does, its work is done, and the mayfly falls down and dies. Somehow, in the benevolent design of the pond, the trout know, too, that time is short, their dinner is evanescent.

Figure 192: *Leaping Trout*, n.d. Watercolor over graphite pencil on paper, 14 × 20 in.

They have sprung from the rippled, nurturing shallows for a brief moment, just as has the dun. Homer sees all of it, in mysteriously ordered balance: the fish, the bug, the lily pads, and the air he, too, shares. He relishes the suspense of the moment, and its extreme brevity for the three characters in his drama. Homer's greatest patron, Thomas Benedict Clarke, long the master of the Union League Club's art exhibitions, acquired the watercolor as soon as he saw it on Reichard's walls. He wanted the best, nothing less, and he knew it when he saw it.[28]

The Clearing was quiet on October 1, 1889, when Homer returned. Terry arrived a week later, and the two bachelors stayed at the club, alone, through the entire hunting season. Homer remained almost two months, to Sunday, November 24, in time to celebrate Thanksgiving with his family four days later. Terry left on the seventeenth. Winslow discovered fresh delight in the changing colors of the fall. Perhaps remembering, with a chuckle, his depiction of Terry seated in his guideboat fifteen years earlier, Homer depicted him again.[29] Then, Terry's companion was a single small, hyperactive spaniel. Now, five hounds crowd him so completely as to make him nearly invisible. Homer was taking on a controversial topic; hounding,

Figure 193: *Waiting for the Start*, 1889. Watercolor with sponging and scraping
over graphite on paper, 14 × 20 in.

like jacklighting, set an arguably unfair advantage for humans over the deer
they came to hunt.[30] The awe-struck *Tribune* art critic had eyes only for the
art, not the conservation politics, and wrote: "More pictorial still is the
study of a pack of hounds in a scow, a quiet comparatively low-toned and
very beautiful symphony . . . Such are a true artist's notes of Adirondack
life. They are impressions, it may be said, but they now serve all that we care
to know. They are the results of an observation entirely personal, expressed
in a manner so fresh, individual and vigorous that the commonplace in our
art seems doubly wearisome after this."[31] This watercolor, too, quickly
found a buyer, and within four years, it had changed hands twice again. The
last of these transactions was the most important. In 1894, this became the
very first Homer watercolor to enter a public collection: one dedicated,
appropriately, to the education of young artists.[32]

Suddenly, after years of discouragement, Homer could read that "there
is a directness and simplicity, an individuality and character in the water-
colors that is inexpressibly refreshing. The painter seems to have been
pleased or interested in this or that effect in nature, to have noted it, and to
have at once set to work to realize it in pictorial form. The effect is seized

in its largest sense, and the salient points are emphasized. Detail is not much insisted upon. Mr. Homer's water-colors, in fact, are impressions. But Mr. Homer has not found it necessary to copy Manet or Monet, or Renoir or Degaz [*sic*]; he has means of his own, very simple means, artistic rather than scientific, and he uses them frankly. Truth is his first principle; to give the main facts with the least trouble the next."[33]

By the time the reviewer penned those glowing words, Homer was already in Florida at the Brock House, where his uncle, Arthur Benson, had died fewer than two months earlier, as he fished on Lake Monroe. Winslow wrote to Clarke on February 16, the day before Reichard opened the show. "This is the most beautiful place in Florida. I commence work & play tomorrow—& expect to show you something when I return."[34] One can only speculate exactly what he had in mind to show Clarke when Homer returned to New York, but the few sheets he did produce are exceptionally fluid in their brushwork. One example depicts two coordinated rowers, their oars reflected in the still water, as they navigate through the fog. Their client, in the stern, untangles his line at the tip of his rod and seems unaware of the lucid blue wake his craft creates. Homer gave or sold the sheet to the architect Stanford White.[35]

His delight in the fishing and tropical scenery did not keep him at the

Figure 194: *Three Men in a Boat*, 1890. Watercolor on paper, 12⅛ × 19⅞ in.

Brock House long, however. He was itching to realize fresh ideas on canvas, too. By the time he wrote to Charlie at the end of May, he was well underway. "My factory after being shut down for two years, is to be opened for the month of June—*every day*. Superintendent engaged, & hands. Pay rate $3 per day." His mocking postscript reflected his awareness that his family worried he drank too much: "I have not had anything to drink for two weeks. I am writing this on cider & this pen."[36] Winslow never did get to the North Woods Club in 1890. He was flat-out working on four major oil paintings at once, each intended for delivery to Reichard at the end of the year.[37] Not since *Undertow*, in January 1887, three and a half years earlier, had he shown a fresh oil painting. The four he would exhibit now were all marine paintings, but each was quite different, reflecting his willingness to experiment in disparate ways. The one that proved commercially most significant was his first oil seascape without figures. The longtime critic Clarence Cook realized its importance, and described it as "painting of the finest, a noble sweep of hand, and color, as if a mine of emerald, sapphire and beryl had been torn up by the roots and hurled into the air . . . The sense of mighty movement in the water, the sense of weight, of force above all human resistance, make themselves felt in this picture."[38] The prominent Philadelphia lawyer and art collector John G. Johnson acquired

Figure 195: *Sunlight on the Coast*, 1890. Oil on canvas, 30¼ × 48½ in.

it immediately, and then returned the following month and acquired another of the quad. Johnson's zeal for great art, like Clarke's, matched well the ambition of this painter. Although neither Johnson nor any other collector would ever match the importance Clarke had in Homer's commercial life, nevertheless, the year 1891 had begun with a bang.

Despite the admiration Cook, Johnson, and others displayed for the seascapes, Homer returned the following summer and fall to the North Woods Club, and to the figure. Just as he had worked on four major marine paintings through most of 1890, now he worked at once on two major Adirondack paintings. Of all the work he made based on his eighteen visits to the North Woods Club from 1889 to 1910, these are his only oil paintings. In each a single figure appears in the landscape: a young man named Michael Francis Flynn (1872–1944). Unlike Rufus Wallace, this model was not a guide but a laborer on the Minerva farm of his parents, Patrick and Sarah, both native-born children of Irish immigrants. Homer painted him some seventeen times in the summers of 1891 and 1892, as an archetype of this place, just as boys in Gloucester and girls at Houghton Farm became in his hand archetypal expressions of their own settings.

Flynn is the young invincible who exploits the forest and the creatures who dwell in it. Homer had placed the entire carcass of a yearling deer on Flynn's nineteen-year-old shoulders in the watercolor that is the basis of the painting. In the final version, he converts that carcass to a skin. With callous indifference, Flynn carries the skull of a full-grown buck by one of its antlers—antlers that Homer studied closely and that survive to this day.[39] The red linings of his shirtsleeve and trouser waistline match the red in the skin of the slain deer. Neither hound is placid; the one at right compares in menace to a Bahamian shark.

Homer leaves little doubt about his own empathy—for the deer. The American frontier was closing in the West, but Homer found his own slice of wilderness. He showed it as he wished it to be, and always to have been: an idyllic harmony between humanity and nature. But he also showed it as it was: altered and ugly, the mountains transformed by man. He dared to paint the wounded land: the clear-cut old-growth forests, the merciless killing of graceful animals, the unknowing truculence that young men often show to those they encounter. About this time, Homer may have met one young man at the Century with whom he shared common friends and common interests.[40] His outward appearance might have suggested a

bluster, even a crudeness of the kind Homer evokes in Flynn. But this man, like Homer, loved the land with a tender heart. A generation younger than Winslow, his name like his father's was Theodore Roosevelt (1858–1919). The young man and future president shared Homer's passion for Adirondack beauty, and his interest in preserving it. Homer's picture, *A Huntsman and Dogs*, is visual testimony to the goals of the conservation movement Roosevelt had founded four years earlier, in 1887, when he was not yet thirty years old. That movement would lead to the passage of the Adirondack Deer Law ten years later, in 1897, and limit hunters' use of hounds.[41] No letters survive between the two men, but their common interests, friends, and acquaintances suggest their paths intersected multiple times over the two decades that followed.

As with the stump-laden landscape of *Prisoners at the Front*, Homer embeds ambiguity about the future of the central character in his picture. Will the sullen Flynn awaken to the moral consequences of his deadly acts? Will he fall before he wakes? The critics, even those who admired Homer, had no time for such questions. They found the picture "cold and unsympathetic" and believed Homer was glorifying a "low and brutal . . . scoundrel . . . who hounds deer to death up in the Adirondacks for the couple of dollars the hide and horns bring in, and leaves the carcass to feed the carrion birds."[42] Nevertheless, Reichard sold the picture quickly, and to an out-of-town buyer whom he might have presumed to be squeamish. Edward W. Hooper was a Bostonian father of five young daughters—but he had also served in the Civil War and therefore may have grasped the moral complexity of the picture in a way that the principal critics did not. Hooper was the single most avid collector of Homer watercolors, but this was the first Homer oil he would acquire. Perhaps he, too, saw the value of scarcity.[43]

On his way to the Adirondacks, Homer had stopped in New York, at least in part to bid farewell to Charlie and Mattie as they prepared to sail to Europe. Writing to Arthur after he had returned from the dock, Winslow compared their ship ("the best Steamer in The World") to "the old tubs that I have been over the ocean in." He mused, "I have never seen any one off before that I cared anything about & I found it hard. & I was glad when the steamer was off but NY seems empty to me. They had lots of friends to say good bye. I bet you everything will be just as it should be in the end since Charlie has to do with it."[44] He arrived two days later at the North Woods

Club after an overnight train from Manhattan, and was in residence until July 31, as usual staying longer than most of his fellow members.[45] They had begun recording the number of trout they caught during their time at the Clearing; Homer's count is just five fish over six weeks, far fewer than the catch of other members staying for shorter periods.

Much as he liked to fish, he had work to do. He may have painted only a half-dozen watercolors over six weeks that summer of 1891. But he kept mulling over the two pictures of Flynn. He returned on October 1 with easel and canvas—almost certainly the only time he lugged them to the Clearing. He wrote to Charlie two weeks later: "I am working very hard & will without doubt finish the two oil paintings that I commenced Oct 2nd & great works they are. Your eye being fresh from European pictures, great care is required to make you proud of your brother."[46] He may have wanted Charlie's eye, but not the prying eyes of his fellow members. His only company for the five weeks he spent at the club that fall was his friend Edwin Adams and his wife—for a weekend at the start. Otherwise, he was on his own, with a sense of purpose. Upon his return to Prouts he wrote to his cousin that "everything is quiet here, but Father, & he is like Wall Street on a 'Black Friday' with his business."[47] He got *A Huntsman and Dogs* done in record time, writing to Mattie with relief on December 29 that he was "thinking of the painting that I had just finished, & singing with a very

Figure 196: *A Huntsman and Dogs*, 1891. Oil on canvas, 28⅛ × 48 in.

loud voice See! The Conquering Hero Come. & I sung it, 'Sound the Parsnip, Beat the Drum!' I have just sent the picture off. When I go to N.Y. in Feb'y I will show you these things."[48]

Hound and Hunter was more difficult to complete. He had begun the two similarly sized pictures, with related subject matter, at the same time. He seems to have thought of them as loose complements to each other, rather than true pendants like *The Fog Warning* and *The Herring Net*. But the speed with which he had completed *A Huntsman and Dogs* meant that the criticism of it echoed through his head as he struggled with *Hound and Hunter*, a tightly framed autumnal scene depicting land, reflective water, and two animals—one alive and one dead. His model Flynn's task is difficult, too: to fasten the heavy corpse of a dead deer to his guideboat while keeping his lively hound from upsetting his plan.

When he did show the picture, a year after *A Huntsman and Dogs*, viewers didn't understand it. Even his biggest patron, Clarke, thought Flynn was drowning the deer. Homer was astounded. "The critics may think that that deer is alive but he is not—otherwise the boat & man would be knocked high & dry. I can shut the deer's eyes & put pennies on them if that will make it better understood. They will say that the head is the first to sink. That is so. This head has been under water & from the tail up has been

Figure 197: *The Fallen Deer*, 1892. Watercolor over graphite pencil on paper, 13⅞ × 19¹³⁄₁₆ in.

carefully recovered in order to tie the head to the end of the boat. It is a simple thing to make a man out an Ass & fool by starting from a mistaken idea. So anyone [who] thinks this deer is alive is *wrong*."

He made a tender watercolor, *The Fallen Deer*, even more tightly framed, and in which his disdain for unsportsmanlike behavior is palpable. A wounded deer descends to the stream in desperate thirst for his last drink. Homer inscribed on the reverse: "A miserable Pot hunter; just shot." His empathy is for the victim, not the victor.

Unlike *A Huntsman and Dogs*, it took time to sell *Hound and Hunter*. He was able to show the two together as a pair several times, but he kept getting the same complaint: the deer is still alive. Finally, ten years after its first exhibition, and a few years after New York State legislators had passed a law against such acts as Flynn's alleged drowning, Homer "reworked" the picture. He submerged the deer's head more completely, and just like that, the picture sold. Thereafter he could respond graciously to compliments about it by saying in one case, "I am glad you like that picture; it's a good picture. Did you notice the boy's hands—all sunburnt; the wrists some-what sunburnt, but not as brown as his hands; and the bit of forearm where the sleeve is pulled back not sunburnt at all? That was hard to paint. I spent more than a week painting those hands."[49]

Figure 198: *Hound and Hunter*, 1892. Oil on canvas, 28¼ × 48¼ in.

Figure 199: *Camp-Fire, Adirondacks*, c. 1892. Transparent and opaque watercolor, with blotting and scraping, on thick, moderately textured, ivory wove paper, 15⅛ × 21½ in.

Homer created a wide range of watercolors that summer, many of them prominently featuring Wallace. On one luminous sheet, the old guide seeks shelter in a kind of cave: a tangled mass of dead tree roots. The tree's skein, shaped like Wallace's torso, seems almost to reach out behind and grab him. Homer's narrative instincts provide the framework for a story only the viewer may complete. Might this man, in pursuit of rest and refreshment, instead succumb like the fallen deer to a mortal moment that has swept upon him?

In another case, Wallace and Flynn look warily from Prospect Rock. Are they hunting bears, or are bears hunting them? Homer presents his two characters each responding in different ways to a threat the viewer cannot see—but must imagine. Flynn is excited, and hints at a smile, but Wallace is wary, worn, weary. Homer seats them just where the tension is most palpable—on the edge.

When he returned on September 17, 1892, the club was nearly empty. Adams and his wife were there and stayed another twelve days. The day after Homer arrived, so did another companion: J. Ernest Grant Yalden, the twenty-two-year-old son of Homer's accountant friend. He and a

Figure 200: *Bear Hunting, Prospect Rock*, 1892.
Watercolor and pencil on paper, 13⅞ × 20 in.

young man who had studied at Columbia, Arthur Evans Dornin (1870–1904), had ridden up from New York with Homer for the six-week stay he took from mid-June to the end of July. Yalden had already shown signs of becoming a remarkable young man, now entering his senior year as a civil engineering student at New York University.[50] But he was in no hurry to get to class; he stayed until September 27. He, Homer, and the Adamses witnessed an amazing event the afternoon before he left. One of them termed it an "equinoctial storm"—a cyclone that blew down an enormous number of trees, blocking the road out of the Clearing. It took five hours for the resourceful young man to get to the Kellogg house, just seven miles away. Before Yalden departed, Homer presented him with a gift he had carefully inscribed at Prouts the previous month. It is a watercolor portrait of Yalden paddling the lightweight canoe he had built himself. With the same fluid brushstrokes Homer had applied to Stanford White's Florida watercolor, he captured the reflections of the light on Yalden's wake and his glistening paddle. It is also another example of Homer's composing with more precise geometric intentionality than a rapid glance suggests. The vertical centerline precisely kisses the right edge of the paddle, and the

diagonal running from upper right to lower left precisely bisects Yalden's neck. Homer knew him to be tender, open to his calling even if it led to waters beyond others' sight.

The young man was a true polymath, just the kind of person with whom Homer liked spending time. He graduated a year later with flying colors and then worked in Pittsburgh briefly for, among others, the Pittsburgh Bridge Company. The trustees of a fund established by an Austrian nobleman and philanthropist for the aid of Jewish immigrants recruited him to lead a new trade school in New York City.[51] His example of vocational education for the young ("learning by doing," he called it) became a model followed widely in the United States, and he led it for more than thirty years. One of his graduates, born in Russia, wrote, "This school is to me the most holy spot in New York, for to it I owe all that I have in America."[52] Yalden's work, impressive though it was, did not prevent him from flourishing through another interest he shared with Homer: celestial navigation. Yalden studied graduate-level physics at New York University part-time and built an astronomical observatory both in his backyard and at the Marine Biological Laboratory in Woods Hole, Massachusetts. He led the

Figure 201: *Paddling at Dusk*, 1892. Watercolor with graphite on wove paper, 15⅛ × 21⁷⁄₁₆ in.

training of all navigators in the American Merchant Marine during World War I and by his death in 1937 at the age of sixty-seven was widely regarded as the foremost lay astronomer in the country. Homer's early affection for him reflects the multidimensional character of both men, as does the watercolor Homer gave Yalden.

His visit to the club was short that fall. Two weeks after Yalden left, Homer did, too, to complete another major painting at Prouts Neck. He'd probably sold it before the paint was dry. Homer wrote to his brother Arthur's wife, Alice, that "the days are so short & I have so much to do."[53] His greatest patron, Clarke, had notched up his appetite for Homer's work, and for good reason. He had exited the dry goods business in 1890 and opened the doors in October 1891 of what he called Art House, located at 4 East Thirty-fourth Street, just off Fifth Avenue.[54] It wasn't a professionally run gallery like Reichard's, but rather an idiosyncratic attempt to commercialize Clarke's exuberant, attic-bursting passion for American art. He was at heart a collector and didn't want to offend the dealers upon whom he depended, so he refused to sell directly any works at all but the oil paintings of George Inness. Although he showed an early interest in the works of Eastman Johnson and Platt Powell Ryder, among others, by now he favored Homer and Inness most of all.[55] Clarke prized bigness of quality, subject, and size in the work that he collected, so the grand rooms of the Union League Club suited him well. He had been lending to those exhibitions, and often organizing them, since 1884. Now he was organizing exhibitions of his own collection in a quasi-commercial New York space and could look forward to an internationally significant exhibition one thousand miles west.

By 1890 Chicago had risen from the Great Fire of October 1871 to become the nation's unquestioned Second City.[56] The City of Broad Shoulders did not hesitate to share the good news of its resilience. It set its sights on hosting an international exposition comparable to—but better than, of course—those hosted in London in 1851 and 1862 and in Paris in 1855 and 1867, when Homer exhibited *Prisoners* and *The Bright Side*. The United States had ever hosted just one such exposition previously, in Philadelphia, commemorating the Centennial in 1876. This event would now mark the four-hundredth anniversary of Christopher Columbus's landing in the New World. The fair's leaders intended that the White City they built at Jackson Park also pronounce the superiority of the New World, of the

United States, and of Chicago.[57] Although the fair's opening missed the anniversary by a year, it was an enormously popular event, drawing more than 27 million people and nearly surpassing the record set in Paris of some 32 million people for the Exposition Universelle in 1889.

An important part of the plan was art—and Clarke knew just what to do. Of the many Homer masterpieces he already owned, he resolved to send to Chicago three pictures of 1877 (*Camp Fire, Dressing for the Carnival*, and *Two Guides*), *Eight Bells* (1886), and the now thoroughly reworked picture on which Homer had labored immediately after his return from Cullercoats, then called *The Coming Away of the Gale*. When he completed it in 1893, Homer renamed it *The Gale*. Clarke claimed it as his own in the catalogue of the fair, although he hadn't yet gotten around to buying it; he sent his check for the bargain price of $750 in January 1894, after the picture had returned from Chicago.[58] He had also purchased a major new Prouts Neck landscape, *The West Wind* (1891), as soon as Homer premiered it at Reichard's in January 1892. His timing allowed Clarke to send *The West Wind* to a major art exhibition in Munich in the summer, ahead of its showing at the Exposition in Chicago. In a restrained palette of browns, Homer depicted a young woman as she surveyed the roaring waves, her tam-o'-shanter pressed to her head in defense against the blustery blast. Homer's model was Florence Lord (1872–1958), a rising Smith College freshman the summer of 1891; her family had been longtime summer visitors to Prouts.[59]

Clarke wanted one more masterpiece, to send a total of seven to Chicago with his name attached. On November 5, 1892, he dispatched a check to Homer for *Dressing for the Carnival* and a second picture also addressing the lives of Black Americans during Reconstruction: *A Visit from the Old Mistress* (1876). His letter promised payment the following month for the picture Clarke wanted: *Coast in Winter*. Homer must have believed him; the picture showed up in New York five days after Clarke sent the letter. The venue was the Union League Club, with Reichard as the lender since Clarke hadn't yet bought the picture. It presents a majestic winter seascape as waves roll onto the snowcapped rocks of Prouts Neck. Even Homer's "pure" seascapes often include some hint of human life (such as a ship passing in the upper right corner of *Sunlight on the Coast*). So does this one. The footprints at lower left lead the viewer's eye into the painting and to the top of the cliff at upper left, where a single matchstick figure stands.

Figure 202: *Coast in Winter*, 1892. Oil on canvas, 28½ × 48¼ in.

The contrast between the nearly transparent foreground water as the roiling wave creates a sense of dramatic suspense as the wave prepares to pound the cliff. It was just the kind of painting Clarke loved, and he knew that the visitors to the World's Columbian Exposition would love it, too.

In addition to Clarke's six paintings (and the seventh for which he took credit), John G. Johnson lent two 1890 pictures, *Sunlight on the Coast* and *Winter Coast*, a vertical-format Prouts Neck winter landscape. Hooper lent *A Huntsman and Dogs*. Homer himself lent five pictures, all of them previously exhibited, and several of them many times. He was adamant about defending his pricing. They included the 1885 pendants of *The Herring Net* and *The Fog Warning*, his recently completed and controversial *Hound and Hunter*, and the tribute to Blackburn, *Lost on the Grand Banks* (1885). His fifth was an even older oil painting, begun at Cullercoats and called then *Sailors Take Warning (Sunset)*.[60] He reworked the picture after its return from Chicago, and it is now known as *Early Evening* (1907).[61] Only Inness, with fifteen oil paintings (all but one from Clarke), matched the number in Chicago from Homer's hand.[62] Several other painters came close, though. Eakins, Elihu Vedder (1836–1923), and the recently deceased Wyant each had ten, and Homer's friends Kenyon Cox (1856–1919) and Robert Swain Gifford each had eleven. An increasingly visible

London-based portraitist, John Singer Sargent (1856–1925), had nine; he claimed American affiliation when it was advantageous.[63]

Any painters who came to Chicago hoping to view their own work in a favorable light were disappointed. One insightful critic wrote that "the motives which governed the hanging of American pictures at the Fair are unfathomable . . . almost all of Winslow Homer's paintings—an ad-mirable collection, includ-ing the best work he has done . . . seem to be ob-scured in this collection."[64] However, she wrote, "after diligent search," one can appreciate in American landscape painters such as Homer and Inness "their originality, their variety and dignity . . . In the pictures of today, there is a fresh-ness in the atmosphere, a vitality in the landscape, of which the older painters knew nothing. Color has

Figure 203: Unidentified photographer, *Gallery 8, North and West Walls, Fine Arts Department, Palace of Fine Arts, World's Columbian Exposition, Chicago*, 1893. Cyanotype print, 8 × 10 in.

become a science, and the study of light is the essential now, where for-merly it was the study of lines. But in spite of the influence of France in producing this change, the work of the present time is no less distinctively American than when the Catskills and the Hudson were the universal subjects."[65] The symmetrical if inane placement of *Eight Bells* beneath the insipid behemoth *Mlle. De Sombreuil (Episode of the French Revolution)* by Julian Story (1857–1919) validates the reviewer's perspective.[66]

Homer did travel to Chicago for the fair (likely about the end of April), but he was no egotist and had seen many a jumbled exhibition previously. He memorialized his visit with an unusual painting that is one of the few urban scenes he ever painted. Like his meditation on celestial navigation for the family sloop, *Mattie*, it is a moonlit picture in grisaille, reflecting his knowledge of photography but nevertheless probably not based on a pho-tograph. Homer depicts a sliver of the circular fountain that Frederick

MacMonnies (1863–1937) created for the central focus of the long east-west basin toward the south end of the fair's premises. As visitors exited the railway station and passed the administration building, it was the first of the glorious features they would see.

But Homer provides no sense of the fountain as a whole, or the fair as a whole. His focus is on the suddenly animated cast seahorses and their glistening, well-armed rider at least as much as on the two gondoliers and their craft's embracing lovers. An alchemical mixture of moonlight, gaslight, and Chicagoan moxie have cast this spell. Homer absorbs it as a scientist, an artist, and a man. As Margaretta Lovell has observed, Homer "acknowledged the artificial, constructed aspect of the illusion and the contributions of the watery medium on which it floated to the overall effect. That he was able to translate the fair's potentially bathetic elements into understated mystery is an index of his power as an artist."[67]

The picture is one of several vivid expressions of his appetite for experimentation, particularly with light, as he continued to press new frontiers—but rarely now geographic. This trip was the one and only time he ever went west of Pittsburgh.[68] While many other prominent New York and

Figure 204: *The Fountain at Night, World's Columbian Exposition*, 1893.
Oil on canvas, 16⅜ × 25⅛ in.

Boston artists spent years exploring the Rockies, California, and even Hawaii (like his friend Perry), he did not.

As he planned for the big fair in Chicago, Homer made a surprising decision. He had just completed the single largest picture he would ever paint, *Fox Hunt* (1893), nearly seven feet wide and more than three feet high. The picture is mesmerizing, with a gripping, subtle narrative of an emaciated fox beset by fearsome crows—all hungry in the midst of a Prouts Neck winter. Any other painter in his shoes would have sent the picture to Chicago. He did not. As the art historian Abigail Booth Gerdts has written, "In all logic *Fox Hunt* should not only have been one of the group chosen by Homer for the most prestigious art event held in America in the later nineteenth century, but its star. It was conventional for artists to create a large painting, with an arresting subject, specifically to attract attention on the occasion of an important exhibition."[69]

He showed the picture for the first time in April 1893, first briefly at the Century and then within about a week at Reichard's. The gallery had probably not yet shipped out Homer's pictures to Chicago before *Fox Hunt* arrived. But Homer kept it in New York through the spring, and then sent it to Doll & Richards so that Bostonians could see it, too. The response was enthusiastic in both cities. An unabashed fan, the Bostonian William Howe Downes (1854–1941) wrote, "There is something very impressive and very solemn about this stark and frigid landscape, and it is a fit scene for the impending tragedy that threatens the fox."[70]

His decision to keep the picture on the East Coast is curious but consistent with the pattern he set of sending the exposition only major pictures that he had thoroughly marketed already—and hadn't sold. In a letter to Reichard of March 17, 1893, he described it as "quite an unusual and *very beautiful picture*" (italics his).[71] He clearly considered *Fox Hunt* worthy of a full price, asking $2,500 for it at Doll & Richards.[72] And he encouraged that gallery to act as his intermediary in sending it to Philadelphia for the 63rd Annual Exhibition that the Pennsylvania Academy of the Fine Arts opened a week before Christmas. What happened there validated his strategy. The secretary and managing director of the academy, Hamilton S. Morris (1856–1948), asked to acquire the picture for the academy's prestigious permanent collection. It would be the first of his oil paintings to enter a public institution. The picture would also memorialize his empathy

Figure 205: *Fox Hunt*, 1893. Oil on canvas, 38 × 68½ in.

for the animals he observed so closely; in *Fox Hunt*, his own signature sinks into the snow in emulation of the tired old fox chased by menacing crows. A pentimento from the grid that he evidently laid down on the canvas is now visible to the naked eye: the horizontal centerline neatly decapitates the fox. He retained a sly sense of humor and an understanding of his own vulnerability. He sold the picture for $1,200, less than half of what he had asked, but knew this sale was a threshold moment. When Morris's check arrived in his mailbox, he wrote back to thank him, adding, "My honors are beyond my deserts."[73] For years afterward, he would regard *Fox Hunt* in a league of its own, and not only because of its size. A friend recalled, "It is the only one of his paintings that he suggested my going to see in a gallery. 'It's so true to nature,' he repeated."[74]

At the start of the banner year of 1893, he was working on a peculiar new project. His lifelong friend Hubbard Winslow Bryant (1839–1917) had asked him to design a bookplate for his burgeoning collection. Bryant, like Homer, was named after the pastor of the Bowdoin Street Church so beloved by Winslow's father. The Latin motto at the top of the plate is one with which Homer would agree: *Omne Bonum De Super*, or "Every Good Is from Above."[75] As the year ended, he wrote a letter to his young Galveston friend Boyer Gonzales: "Now about myself, I like this life here, so long as my father is alive & I wish him to live long, I am handy to him & near

enough. He is in Boston. I have painted one or two very good thing[s] this year & that is saying much. I shall not bring them out until times get better. They would only pave the way for others to do better & not benefit me. This sounds very selfish but I simply must take advantage of my experience. I have improved my place & have more room & better books & I am in what is known as a flourishing condition."[76]

Figure 206: *Book Plate for Hubbard Winslow Bryant*, 1893.
Ink on paper, 3⅞ × 2¾ in.

11

THE LIFE THAT I HAVE CHOSEN
(1894–1898)

IN SOME WAYS, Homer's life was different now. The affirmation from Morris—even if at half price—had a value beyond any payment a patron like Clarke might ever make, or any words from the pens of Clarence Cook and Mariana Van Rensselaer. Homer was always worried about running out of money, even when he claimed not to be. In a letter to Mattie (in this case thanking her for the gift of a new pair of shoes), he alluded to his brother's riches won in the varnish business, his own commercial success, and his own self-styled hermitage at Prouts. Charlie's "foot may have become smaller since he has grown prosperous with less to kick at. (You will be glad to know that I also have had great luck the past year and as Father tells me, I am rich.) But no money will buy shoes like these in Scarboro or Portland & I am very glad to get them."[1]

The affirmation from Philadelphia may have encouraged another institutional imprimatur closer to home. Among Homer's many cousins to whom he was close were two who had married each other: the long-lived Lucy Ann Lane (1816–1916) and the Boston merchant and onetime mayor Otis C. Norcross (1811–1882).[2] Boston was a small world in those days; the technically incestuous marriage did not prevent their having eight children. Two of those eight, Homer's financial adviser, Grenville Norcross, and his older sister Laura Norcross Marss (1845–1926), resolved to honor both their father and their cousin by arranging for the anonymous gift of *The Fog Warning* to the Boston Museum of Fine Arts. Homer

was a donor, too, as he again agreed to a discounted price. The picture is much smaller than is *Fox Hunt* but its sale price was higher: $1,500.[3]

Winslow's family members celebrated their pride in him not only in direct generosity of word and deed but by applying their irrepressible spirit of invention to Homer's practical needs. Nine years after his father, then seventy, patented his surf hut, Winslow's brother Charlie patented another invention clearly developed with Winslow in mind. The packaging design permitted a thin, compressible bladder to contain in a single tube both pigments and "the oils, spirits, and driers, which are as essential to the artist as his colors." It was a simple but significant advance, which is taken for granted today. Charlie's patent explained that without his invention, each time a painter pulled out the pigments (already in tubes) he needed to mix them with his conditioners, which were then supplied in glass bottles. Charlie had heard Winslow complain about the nuisance both in his studio and *en plein air* and wished "to do away with this inconvenience" to his younger brother and to other painters near and far. Although the bladder was not particularly relevant to Valentine's principal lines of business, Charlie assigned his invention to the company anyway. Both brothers prized loyalty no less than imagination.[4]

Charlie's simple invention was also a physical manifestation of a precept of natural theology to which Child-Chaplin alluded—and which Winslow annotated in his well-thumbed copy. "It has been finely observed that chemistry confers a kind of creative power upon man, by which he produces many substances which have no independent existence, and decrees at will unions and separations among the passive operations around him. There is scarcely a domestic operation or a manufacture in which the energies of chemistry are not turned to account."[5] Child-Chaplin noted that "the most worthless substances, under the magic touch of chemistry, cast off their commonness and become things of value and beauty . . . What feat can be conceived more wonderful than from a substance so dingy, dirty, and unpromising as coal-tar, to create the beautiful series of aniline colors which we admire as mauve, Magenta, Solferino, and Bleu de Paris."[6] He summarized by quoting the father of modern science (and a devout Christian), Isaac Newton (1643–1727): "To man himself Providence has vouchsafed to impart a certain knowledge of this Power, which he wields to his infinite profit and advantage. But, in the vast domain of

chemistry, when the known is contrasted with the unknown, man will for long ages to come continue to resemble the little child wandering on the sea-shore and 'picking up now and then a pretty pebble, while the great ocean of truth lies undiscovered before it.'"[7]

Winslow had kept in touch with another inventive business mind he had known for years. Both Homer and his old friend Louis Prang retained warm feelings about their Civil War collaboration on the *Campaign Sketches* and *Life in Camp* lithographs. In April 1893, three decades after those projects, Prang sent Homer a note. Evidently the Boston publisher included a magazine article he wanted Homer to see. There is no way to be absolutely sure which article it was, but given the date of the letter one may deduce that it was "The Progress of Art in New York," by George Parsons Lathrop (1851–1898).[8] Homer clipped a pivotal section of the article for his scrapbook. Lathrop wrote, "There have been other painters besides Inness who have failed to grow old, and have unfailingly kept themselves open to new light, new ways of looking at things. Such a one is Winslow Homer, in some sense the most racy [*sic*], most American, of our painters. One marvels at the self-reliance with which he long ago set out to jot down unreservedly, with cheerful disregard of tradition, exactly what he perceived in American scenes or persons, on the farm, the lake, the river, along the sea-shore. Half a generation before the watchword of 'impressionism' was uttered, he had struck its note over and over again—crudely, perhaps, and with sometimes harsh color, but always with truth and power and a singular fascination." Homer's reputation had risen to the lofty height at which his elder, Inness, formerly stood alone.

"My amiable and dear old friend," Homer replied warmly. "I think the writer in his way is much the better artist. I am glad that you suggest that you would like to see Scarboro. It will give me pleasure to invite you at some time this Spring or Summer. Just now I have arranged to leave for some time. I have been here all winter. This is really a beautiful place, as you will say when you see it. Only think of our outliving all these other people. Yours very truly, Winslow Homer."[9]

Prang had more in mind than sightseeing. Whether or not he visited that spring or summer, he must have suggested to Homer a fresh collaboration. Winslow liked the idea, but had been busy, to say the least. At the end of 1893 he sent Prang another letter with a motto at its top: "But's what's your hurry, said the King of Prussia." He went on to write:

Dear Friend Prang,

As I wrote you I am interested in that lithograph & when I get ready will let you know and send for a stone. This picture that I have in view is not quite finished & requires another look from Nature after the Snow is off the ground.

Now as this proposed Lith will take me (should I do it), at least one month to put on stone it would as you say [be] a labor of love. & If this print above mentioned should appear it will *be fine*, otherwise I should destroy it.

This being the case, the "labor of love" would end with me and I should get comparatively nothing for my month's work & copyright.

After setting forth his pricing for the lithograph, at $5 per impression, he acknowledged that Prang and other friends worried about him, especially during the long winter months.

I deny that I am a recluse as is generally understood by that term.

Neither am I an unsociable hog. I wrote you its [*sic*] time that it was not convenient to receive a visitor, that was to save you as well as myself.

Since you must know it I have never yet had a bed in my house. I do my own work. No other man women [*sic*] within half a mile & four miles from railroad & P.O. This is [the] only life in which I am permitted to mind my own business.

I suppose I am today the only man in New England who can do it. I am perfectly happy & contented. Happy New Year.

Winslow Homer[10]

The picture he had in mind requiring "another look from Nature after the Snow is off the ground" is a watercolor depicting the surf pounding the cliffs at Prouts Neck, beheld by a small group of figures in the upper right. With stunning dexterity Homer evokes the power of the ocean, the resilience of the rocks, and the evanescence of the effects that humans observe, and of humanity itself.

Once Homer completed that watercolor in the spring of 1894, he quickly turned to a closely related new work. It was not the lithograph he had discussed with Prang but a larger, grander version of the watercolor's

Figure 207: *Sea and Rocks During a Storm*, 1894. Watercolor on paper, 14½ × 21¼ in.

subject, in oil. The original canvas seems to have been about ten inches wider than the picture in its surviving form, which he reworked over the next few years, including a trim to the right edge. Homer framed out much of the sky he depicted in the watercolor, squeezing the viewers into a tiny wedge at upper right. And he dialed up the intensity of the waves and the cragginess of his rocks. He knew the canvas was good and set a high price—$2,400 gross and $2,000 net to him. It didn't sell, for all his efforts and those of his dealers. For almost nine years, the oil traveled the country for repeated showings in New York, Pittsburgh, Des Moines, and Chicago. Homer considered his vagabond a market indicator: "If it will not sell there is little use in my putting out any more things."[11] He wrote in 1903, "The fact that good picture *High Cliff* is unsold has been most discouraging to me."

It took him a couple of years to complete the project with Prang, and grudgingly. He wanted to develop fresh ways to commercialize his work, but had no interest in letting "Friend Prang" set his schedule or his priorities. Four and a half months after his defensive letter to Prang, he put him off again, and characterized Prouts Neck rather differently than what he had extolled two years earlier as "really a beautiful place." "I leave this cold miserable hole for one or two weeks of fishing in the Adirondacks. When

Figure 208: *High Cliff, Coast of Maine*, 1894. Oil on canvas, 30¼ × 38¼ in.

I return here I may have better luck in painting weather and make some advance on that picture that I have in mind for a lithograph." He added a postscript: "You lose nothing by waiting, as the subject is a fine one much too good to hurry."[12]

When he finally finished his work on the lithograph, many months after he and Prang began their dialogue, it was quite different than either the watercolor or the oil. The waves pouring over the rocks in the lithograph relate more closely to his great etching *Saved* than they do to either the watercolor or the oil painting. The print is naturally reversed, but more than that, it is softened. Homer reduced the watching figures to just two—one with his arm raised—and inserted some seaweed on the rocks. He had domesticated his scene to meet his market, just as decades earlier he had simplified the subjects of his oil paintings to create wood engravings for illustrated newspapers. He addressed a variety of markets, as he said he wished to make "something that I can sell for what people will give."[13] He may not have been entirely satisfied with either the commercial or artistic results of this late-in-life "Labor of Love." The print is extraordinarily

Figure 209: *Sea and Rocks During a Storm*, 1896. Lithograph on paper, 4 × 7 in.

rare today, suggesting that he made just a handful of impressions.[14] And Homer never made another lithograph again.

Ever the dissembler, Homer had presented to Prang one of several truths about his life. He did spend portions of the year apart from others— "no other man women within half a mile & four miles from railroad & P.O." But that was only one truth, and not by any means the whole truth. He traveled regularly to Boston during the winter months, both to check in on his father at his hotel and for other reasons. He wrote to Charlie one February, "I am going to Boston to have my hair cut and I shall be there from Wednesday to Saturday morning. My house here is *very pleasant. I do not wish a better place.* & what I wrote in my last about a dog—was only that I did not wish to be bothered in providing a boarding place for any more than my birds leaving me free to go, & come. Thanks, Winslow."[15]

All Homer's life he valued music, but he had to find it beyond his "cold, miserable hole." Alone in Prouts Neck in the middle of winter, Homer's musical choices were limited to what the sea and a few birds provided. But nearby Portland had concerts, and Boston was home to some of the world's most gifted musicians, just as it is today. Among the leading musical lights of the era was Homer's contemporary Benjamin Johnson Lang (1837–1909), of whom Charlie's wife, Mattie, like Boston's arts patroness Isabella Stewart Gardner (1840–1924), was a particular admirer. Homer made a delicate sketch of Lang in his embroidered smoking jacket, evidently at the

Figure 210: *Benjamin Johnson Lang*, 1895. Graphite on wove paper, 16 × 13⅜ in.

organ console at Boston's historic King's Chapel, a few doors down from Tremont Temple (site of Frederick Douglass's impassioned 1860 speech). He wrote to Mattie the next day (April 20, 1895) that Lang "was very prompt in giving me permission and opportunity & he likes the sketch. The light was bad & he was a hard subject."[16]

Imagined music and unseen light had been two of the inspirations for *A Summer Night*. That picture had several titles in the first years after he completed it in 1890, among them *Buffalo Girls*, which is what the Chicago real estate developer and collector Potter Palmer (1826–1902) called it. The name related to a song including the line "Buffalo Gals, won't you come out tonight / And dance by the light of the moon?" Whatever name they called the picture, however, neither Palmer (to whom Homer sent the picture in hopes of a sale) nor anyone else in New York or Boston bought it. Homer dispatched *A Summer Night* to the safe walls of the Cumberland Club in downtown Portland, where *Lost on the Grand Banks* had been hanging for years, and where friends such as John Calvin Stevens and a collector such as Philip Henry Brown would see it often.

Figure 211: *A Summer Night*, 1890. Oil on canvas, 30³⁄₁₆ × 40 in.

The picture was ambitious. Clarence Cook, among other critics, quickly recognized that Homer was accepting a time-honored and robust challenge: "to reconcile two lights—one natural, the other artificial; moonlight and lamplight—in the illumination of the same scene."[17] He cited the best-known example of the period, which was *The Light of the World*, painted nearly four decades earlier by the English Pre-Raphaelite William Holman Hunt (1827–1910). The reviews of Homer's picture focused more on the light than on the theatrical construction of the scene with its unexplained extension of the stage toward the ocean, forward from the viewer's space. They did not much consider the otherworldly dance of the two women in their innocence, a world apart from the silhouetted figures behind them, as the sea in its conical foam echoes and embraces their single, enraptured form. After ten years of languishing unloved in the United States, Homer sent *A Summer Night* to Paris for the Exposition Universelle of 1900. The French government not only awarded him a gold medal but acquired the picture for its national collection.

As figures receded from his Prouts Neck seascapes, Homer took on

further complexities of moonlight. In *Moonlight, Wood Island Light*, as with *Summer Night*, the moon itself is hidden. But Homer shows us other lights, the warmth of human presence, such as the red light from the lighthouse on distant Wood Island, and the white spots of gaslight visible on the peninsula of Biddeford Pool to the right. Homer loved layers and invitations to look deeper. The art critic Ernest Knaufft (1864–1942), whose insights Homer liked well enough to clip for his scrapbook, wrote, "Winslow Homer is the Walt Whitman among our painters. He is a self-taught painter, and though his black and whites, published in *Harper's Weekly* and *Appleton's Home Journal*, in the seventies, brought him prominently before the public, his early paintings were crude in color; but of recent years his work has so improved as to bring him in the very forefront rank of American artists. His poetic appreciation for the beauties of nature in every form, moonlight or sunlight, sea or rock, has the intense beauty of truth. He is astoundingly, startlingly truthful."[18]

Among his experiments in tonalism was a picture he probably made for his own pleasure, but liked well enough to exhibit through a dealer, William O'Brien of Chicago, whom he had gotten to know better in 1893 when he attended the World's Columbian Exposition. Chicago remained a secondary market for him, well behind New York and Boston, but the Second City had no shortage of major collectors such as Palmer, whose walls still lacked Homer's work. Homer sent O'Brien a few watercolors and two Prouts Neck oils, one of them *The Artist's Studio in an Afternoon Fog*. The critic in the *Chicago Herald* liked the picture more than he understood it, describing a "silvery moon" that "has burst through the cloud mass and shines forth from a disk of pale blue. The middle distance reveals a charming bit of the sea, its crested waves are touched by the sun's rays."[19] More broadly, he wrote, "Homer is a painter of simple incident and pictorial effect; he is rarely a teller of dramatic stories. His performances are either despised or enthusiastically admired. Homer's pictures are never viewed with indifference."[20]

His picture pays homage to Homer's chief rival in American landscape painting, George Inness, who was renowned from his tonalist pictures, often with disciplined palettes. But it is best known as a different kind of homage. Homer gave the picture to his friend Stevens in 1901, upon receipt of a bill for the architect's services designing a cottage Homer had commissioned in the hope of generating rental income. Stevens's invoice

contained no numbers, and just five words: "Any production of Winslow Homer." The painter sent Stevens this oil sketch, and a letter in which he wrote, "The interest that you have shown in this cottage of mine & the valuable time that you have given to it in your busy season & your success in producing it, shows me that I can greet you as a brother artist."[21] The architect, a gifted painter himself, treasured the oil and the letter for the rest of his life. When he sat in 1935 for a formal portrait by Claude Montgomery (1912–1990), Stevens made sure that Homer's painting was prominently featured. It is a fitting tribute to the structures Stevens designed for the Homer family, the beauty of their setting, and the strength of the bond between the two artists.[22]

By the time he sent the *Afternoon Fog* painting to Chicago, Homer must have known that he was nearing a change in a different sort of climate: that of his commercial life. Not only was Inness now dead, but Homer's lead dealer for the previous decade, Gustave Reichard, would close his doors the following month, January 1895. Weeks later, Reichard would auction off the paintings, drawings, prints, and sculptures he owned out-

Figure 212: *The Artist's Studio in an Afternoon Fog*, 1894. Oil on canvas, 24 × 30¼ in.

right. Inasmuch as Homer always consigned work to Reichard, rather than sold it to him, the auction contained no Homer pictures, but nevertheless it was a pivotal moment.

Clarke leapt at what he thought was his golden opportunity to become Homer's New York dealer, but Winslow had a different idea. Remarkably, he remained loyal to Reichard for another five years despite the closure of his gallery. He wrote to Clarke, "I must thank [you] for your continued interest in my work, and for your suggestion which I consider a great Comp[limen]t. I can see that it would be greatly to my advantage to ask you to take charge of all my work now that Mr. Reichard has given up his gallery on Fifth Ave. But two years ago and without any reason beyond my being grateful to them for their success in selling my work, (They sold the most of it to you & your friends), and my appreciation *of them all* as gentlemen, I wrote to them that '*I appointed them my New York agents, for life.*' Since that has been said, it must stand. Mr. Reichard has already written me that he is not to give up the picture business. I may be in New York in April."[23]

Eleven months later, Clarke was still after him, and Homer maintained a careful balance between sustaining Clarke's interest as a collector and insulating himself from Clarke's advances. "I think I can assure you that my best work is *yet to come*, whenever I think it is needed. I am engaged now in depressing things and making a 'corner.' I shall no longer put out anything unless it is carefully considered & made the *most* of . . . I have not been in New York since last March or April & *then* I forgot all about you."[24] Less than two months later, Clarke evidently sought again to differentiate his position in Homer's commercial life, apparently by claiming that he had awarded Homer a commission. Homer wrote him back immediately. "Yours of March 11th at hand. You must not call that a commission—it is not. I refused your commission, but told you that the only picture I had that was of that size and general appearance *you should have*—and I have considered it your picture ever since. I have never taken a commission since the days of Mr. Sherwood—& I never will."[25] Skeletal as Reichard's operation had become, Homer still preferred keeping him as his "New York agent for life" to allowing Clarke to become anything more than what he already was: Homer's greatest patron. Only in 1900 did Homer finally decide to make the long-established firm of Knoedler his new lead gallery in New York.

In each of 1889, 1891, and 1892 Homer went to the North Woods

Club twice: once in the spring, extending into the midsummer, and again during hunting season in the fall, when he went alone or with just one friend such as Yalden. His characterization of Prouts as a "cold miserable hole" was calculated for his audience, but an underlying truth was embedded in the comparison: he loved the North Woods Club. Two weeks after writing that letter, he was off to the Adirondacks for five weeks, from June 3 to July 8, 1894. His principal companion was a dry-goods merchant with broad and deep intellectual interests, Edward Day Page (1856–1918), father of the eminent physicist Leigh Page (1884–1952).[26] Oddly, Page came as the guest of J. Ernest Grant Yalden, who did not join him, but the

Figure 213: *Old Friends*, 1894. Watercolor and opaque watercolor over graphite, with scraping, on wove paper, 21½ × 15⅛ in.

timing of his two-week stay to overlap with Homer and their shared inter-ests suggest that Page and Homer planned their schedules together. Page was an art collector, a spirited conversationalist, the president of the New York Merchants' Association, and a vocal advocate for sound currency and clean government. Homer seems not to have depicted Page that summer but did depict his old friend Rufus Wallace, who continued to serve as a guide to members of the North Woods Club and their guests, just as he had for the guests of Baker Farm going back to Homer's first visit in 1870.

The previous year, 1893, he had enjoyed a different kind of fishing ex-perience than he could ever have in the Adirondacks. It was in Canada, and planned with Charlie, who hadn't yet come to the North Woods Club. When he eventually did, it was just for two visits of five days each, in 1902 and 1904. Canada—specifically Quebec—was a place where the two brothers could be together without other family members, offering an ex-perience unlike that of either Prouts Neck or the North Woods Club.[27] In the spring of 1895, he wrote to Charlie in sympathy for a recent sprain he had suffered and lampooned the family sailboat, the *Mattie*, informing him, "Now that that crazy old tub of a yacht is out of commission I see no reason why this place [i.e., Prouts] should not be a healthy one. I shall be all through with my work by July, & shall loaf about in different places, Canada preferred."[28]

He and Charlie took the train to Quebec City and then traveled farther north, where they visited two destinations. The first was the Tourilli Club, considerably more rustic than even the North Woods Club. It was only about thirty miles north of Quebec City but offered an experience of the wilderness in all its primitive beauty. Their guides were two of the three men who had created the club in 1890: John Uriah Gregory (1830–1913) and his irrepressible nephew George Van Felson (1865–c. 1940).[29] A dis-tinguished New York physician and commentator on the Hebrew Bible, William Hanna Thomson (1833–1918), whom Homer knew from the Cen-tury, probably introduced them to the Tourilli Club; Thomson was one of its fifteen founding members. Gregory, the club's president, was an agent of the Marine and Fisheries Department of the government of Quebec and an expert on shipwrecks. He had published extensively on the subject and advocated for lighthouses and other publicly funded solutions to mitigate risk to Canadian shipping. Tourilli members fished for the same species found in the Adirondacks: the brook trout, albeit generally larger

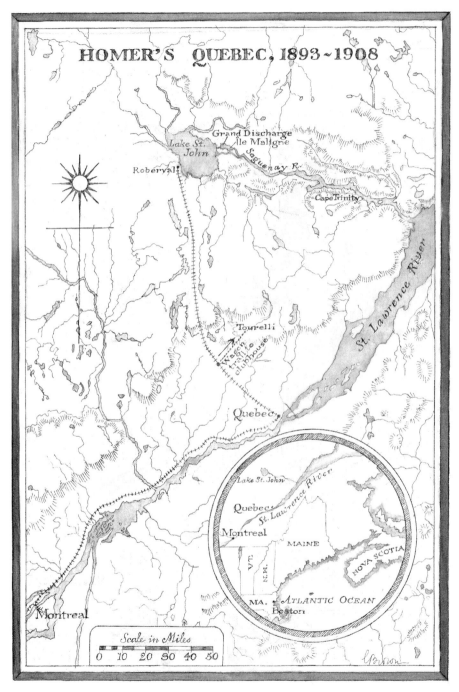

Figure 214: Homer's Quebec (1893–1908)

than Homer had caught at the North Woods Club. The club ultimately attracted a wealthy membership whose tastes were more demanding, but in those first years of the Tourilli Club's existence its appeal was Spartan. Inasmuch as almost no art survives depicting it from any of Homer's likely three visits, one may deduce that he generally considered it mostly a place for fishing and time with his brother, not for painting. Homer felt comfortable taking his Kodak #1 camera there, however. Eastman Kodak introduced the camera in 1888; Homer appears to have been using a model by 1890.[30] That said, Charlie's supposed gift of the camera to Winslow is not documented, and the instrument Homer may have used has not survived. What have survived are a dozen period prints from a Kodak #1 that appear to have been in Homer's studio. His authorship of them seems reasonable, if slightly speculative.

The camera's lightweight, easy-to-use design seems to have facilitated Homer's taking it on trips, such as his visits to the Laurentides. Eastman Kodak's slogan ("You Press the Button, We Do the Rest") reflected the simplicity for which it strived, enabling the amateur to focus primarily on the composition of the shot and its lighting, rather than on complicated matters of chemical processing and printing. Probably on his second visit in 1895, Homer captured the "boys' getaway" informal character of the Tourilli Club.

Figure 215: *Homer's Cabin, Tourilli Club, Province of Quebec*, c. 1895.
Pinhole print from Kodak #1 camera, 2⁹⁄₁₆ in.

Quebec also offered a spectacular landscape with spectacular fish, but not at Tourilli.[31] From St. Raymond, near the club, a rail line ran 154 miles north to Roberval, on the edge of Lake St. John. William Henry Harrison Murray, who was not prone to understatement and had popularized the Adirondacks more than two decades earlier, wrote of Lake St. John that it is "a reservoir of water so wide and shallow that its creation changed the climatic conditions of its locality." It is, he opined, "a curiosity and a marvel, and as such well worth the seeing on the part of those who love knowledge and are intelligent enough to appreciate the extraordinary in nature."[32] In 1891, an American entrepreneur, Horace J. Beemer (1845–1912), had completed a luxurious 257-room hotel at the terminus of the rail line on the southwest shore of the lake.[33] He also built a smaller, 36-room hotel, Island House, on a seventeen-acre granite isle he named immodestly: Beemer Island. He also ran the steamship connecting the two establishments.

The brothers clearly loved Lake St. John. Two distinctive fish lived there, both unusually large. The better-known one gave Winslow's well-thumbed guidebook by Eugene McCarthy its title: "The Leaping Ouananiche."[34] The land-locked salmon "is a beautiful fish to look upon, the strongest and hardest fighter that I have ever met with, one that tests the tackle and skill of the angler to the fullest extent; in total, the king of fresh-water fish."[35] The

Figure 216: *A Good Pool, Saguenay River*, 1895. Watercolor over graphite, with scraping, on cream wove paper, 9¾ × 18⅞ in.

second and lesser-known fish abounding in the lake also attracted Homer's attention. It was known locally as a *brochet*; he called it a pike or a pickerel. McCarthy described the pike as the ouananiche's "one mortal enemy," and wrote that he had "frequently caught ouananiche bearing large scars, both recent and old, showing narrow escapes from the enemy. Perhaps feeling the wound when hooked, and attributing it to their natural enemy, may have something to do with causing them to fight as they will."[36]

Homer's many watercolors depicting the act of fishing on the lake are vivid testimony to his affection both for the time he spent there with his brother and his enthusiasm as an angler. Several also allude to the distinctive, mysterious character of the place. In one especially powerful sheet, Homer depicted a scene at the edge of the lake. A reviewer noted the landscape's "gray rocks surmounted by gnarled trees, beyond which is a wet, stormy sky," but ignored the large cross hanging on the tree at center. Although the stones, roots, and tree trunks are all akimbo, the cross is perfectly straight, an emblem of calm amid chaos. Like the canoe at lower left, the cross also reflects the presence of human life hidden and flourishing amid the wildness.

The most dramatic scenery was at the east end of the lake, where the Grand Discharge flowed into the Saguenay River. Murray described it as "by

Figure 217: *Lake St. John, Canada*, 1895. Watercolor on paper, 14¼ × 20 in.

Figure 218: *Under the Falls, the Grand Discharge*, 1895. Transparent watercolor over graphite
with touches of opaque watercolor and gold leaf, and possibly brown ink, on cream,
moderately thick, slightly textured wove paper, 12⅞ × 19⅞ in.

common assent . . . the most extraordinary river in the world . . . a monstrous
cleft opened by earthquake violence for sixty miles through a landscape of
mountains formed of primeval rock."[37] Very unusually, Homer deployed
gold leaf in a few of his evocations of this remarkable passage.

But it was not only the fish and the beauty of the place drawing Homer.
It was the native peoples of Lake St. John. Few indigenous peoples now re-
mained in the Adirondacks.[38] But fewer than four miles north of his hotel in
Roberval was Pointe Bleue, a vibrant community of the Pekuakamiulnuatsh
First Nation. This reserve of the Ilnu, whom Homer called Montagnais
Indians, is known today as the home of the Mashteuiatsh. Founded in 1856,
it is one of the oldest reserves in the country for First Nation peoples.

Homer had a particular affection for the Ilnu. He wrote on August 9,
1895, "I shall want two Guides from the 17th or whatever date my brother
has arranged with you. I prefer Indians to any others, & they must be in
perfect health."[39]

On the banks of the lake, he portrayed indigenous children and women
with the same empathy he had shown to African Americans. He was
deeply attentive to how Québécois native peoples lived, what games they

TOP: Figure 219: *The Portage*, 1897. Watercolor, 14 × 21 in.

BOTTOM: Figure 220: *Indians Making Canoes (Montagnais Indians)*, 1895.
Watercolor on paper, 13½ × 19¾ in.

played, how they interacted with nature. Homer never went to the American West, but nevertheless grappled with how those who had treasured the land and waters on which for millennia they lived and worked—and for which they acted as stewards for future generations—now encountered the descendants of European settlers, whose values and expectations contrasted so greatly.

Figure 221: *Bear and Canoe*, 1895. Watercolor with touches of gum varnish over graphite
on cream, moderately thick, moderately textured wove paper, 14 × 20 in.

The companions he depicted on his Grand Discharge canoe trips are often identifiably Ilnu, with red sashes at their waists and sometimes distinctive headgear—or both, as in *A Good Pool, Saguenay River*. Homer's watercolors suggest his delight in the canoes themselves, as works of art crafted by both these men and their children, one a little girl Homer depicts hard at work in front of an open tent, whose interior invites in the viewer just as did his 1885 watercolor *Native Hut at Nassau* (figure 170). Homer liked his watercolor *Bear and Canoe* so much that in 1906, eleven years after painting and selling it in 1895, he bought it back for his own pleasure. It hadn't been a good investment for the collector who had bought it; Homer got $300 for it then, and bought it back for $150.[40]

As his father grew frailer and needier in his mid-eighties, Winslow became more reflective. He was growing older himself. He shortened his trips away—when he took them at all—so that he could focus on his father, and on his work at Prouts. On Christmas evening 1895, he sat down at the desk in his Boston hotel room and wrote to Mattie, "Father and self have had a very pleasant Christmas. I shall go home tomorrow." He continued:

I find that living with Father for three days, I grow to be so much like him that I am frightened. We get as much alike as two peas—in age and manners. He is very well—only he will starve himself. I shall go to Boston once in two weeks this next month to give him a dinner.

Yours very truly,

Winslow Homer[41]

As early as 1884, Homer had returned to his memories of the eleven days onboard the *Parthia* and of the stories he heard on deck. He liked a small but evocative drawing he called *Passing a Wreck—Mid-Ocean* enough to sign, date, and exhibit it in Boston cheek by jowl with larger, more obviously ambitious Cullercoats watercolors. The greatest collector of his watercolors, Edward W. Hooper, acquired it as soon as he saw it. The sheet depicts six figures (four in sou'westers) staring out to sea, as a seventh turns toward the others—and the viewer—as if to speak.

Homer's first biographer, William Howe Downes, saw the drawing at Doll & Richards and wrote that Homer possessed

the faculty of crowding into indistinct figures all the expressiveness and meaning which his faces are strangely vacant of, being correct in type and noble in execution, yet like the faces of Vedder, quite passionless. The huddled cluster of cowering figures is in this sketch wonderfully impressive, giving, it may be, the human expression which is wanting in so much of this painter's work. And this is but another evidence of that

Figure 222: *Tense Moments* (*Passing a Wreck—Mid-Ocean*), 1884.
Charcoal and white chalk on paper, 4½ × 11½ in.

same power noted before—the power of giving broad, strong generali-
ties, powerful and impressive, yet quite without delicacy of detail or
subtlety of expression. His faces are as devoid of mental detail as his
pictures of physical detail. He never paints a scene as he sees it, nor
even as he feels it personally, but only as he finds it to be intrinsically.

Downes found "no detail, no facial expression, and yet the varying
emotions of the sailors and the general effect of the incident are perfectly
rendered, and to all appearances quite naturally and unconsciously. What
another would have done with careful and studied faces, Homer has done
with a few firm, vigorous strokes of his brush."[42]

The sight that draws the attention of Homer's "huddled cluster of cow-
ering figures" is that of another ship, under full sail, and in grave danger.
Like *Lost on the Grand Banks*, the sight of that flailing ship was one he
imagined from stories he heard, rather than saw with his own eyes. He
resolved to make a major oil painting inspired by that imagined sight, which
this drawing, an early photogravure, and another more obviously prepara-
tory drawing tie tightly to the *Parthia*.[43]

The oil was sufficiently advanced by December 10, 1890, for Homer to
describe it confidently to his brother Charlie as "*The Distress Signal*, a scene
in mid-ocean. I expect to do well."[44] He exhibited it at least once in 1891
in New York, and again in 1892 in Springfield. Then Homer showed the
painting again, at an exhibition hosted by the Portland Society of the Arts
at the end of 1893. He probably lent the picture at the suggestion of his
friend Stevens, who exhibited a watercolor of his own in the show, and was
on the cusp of leading the society.[45] At least at the first of these venues, and
possibly at each of them, the ship flew a noticeably inverted American flag,
as a widely understood indication that she was in trouble.

But by the time Homer sold the picture in 1896 to a Grand Rapids,
Michigan, collector, George Briggs, that signal was barely visible. In the
intervening period, Homer had "reworked" the painting in several ways. The
first and most obvious is that he thoroughly transformed the distressed ship.
In the earlier version she was upright, sailing toward the viewer. As re-
worked, she is demasted, a slender, vulnerable stack of sticks. The once-proud
schooner's flag is inverted but so tattered and wan that it is now not a call
but a whimper. No signs of life are visible on her deck. Homer seems to have
recast the picture in the mid-1890s when he made another watercolor (prob-

Figure 223: *The Signal of Distress*, 1890–1896. Oil on canvas, 24⁷⁄₁₆ × 38⁹⁄₁₆ in.

ably at Prouts), depicting a schooner pounded in a storm, with one lone crew member still at the wheel, and others emerging on deck to cry for help.[46]

Homer made other important changes as well. The officer standing on the right in his Cunard uniform, buttressed against the wind, is the same man who appeared in *Taking an Observation* (1884) and in the same uniform on the same deck. But Homer made a subtle change to the figure closest to the viewer. In Winslow's reworking, this figure acquired a bright red bandanna whose style is similar to the sashes Homer observed on his Ilnu guides on Lake St. John. Another figure, climbing about the lifeboat, had a dangling leg, noticeable in the painting as exhibited initially. He now has lost that leg (or at least Homer has hidden it). Last but not least, the *Parthia*'s railing, once so protective, has all but vanished. Homer reduced the separation between the waves afflicting the two vessels (which his previous design accentuated with the conical wave between the *Parthia* and the ship in distress). His reworkings suggest that distress, and the need for salvation, is a broader human condition, also affecting each of the passengers and crew of the star-crossed *Parthia*.

Homer completed another somber canvas in 1896, the year he sold *The Signal of Distress*. This one, *The Wreck*, is six inches taller and ten inches wider. It, too, draws on his memories and particularly his memories of

Cullercoats and its lifeboats. But the spectral, dystopian vista and the tall, gloomy man with his raised right arm suggest doom more than hope. Homer allows little relief from his bleak, disciplined palette: the six-sided yellow star on the lifeboat's stern, a yellow sou'wester and the red scarves of two women on the bluff. In its unremittingly apocalyptic character, it seems to anticipate the poetry of Wilfred Owen (1893–1918) and the World War I paintings of John Singer Sargent.

Homer effectively offered the picture, *To the Rescue*, first to Thomas B. Clarke, reminding him of its connections to another canvas that he had made about ten years earlier. Homer named that picture as a "companion" to *Eight Bells*, which Clarke already owned; it is almost identical in size, but there is no evidence that Homer intended to exhibit the two together. Clarke bought *To the Rescue*, and not *The Wreck*.[47] Homer evidently had been working on *The Wreck* intermittently for years. When John Beatty (1851–1924), the director of the Carnegie Institute in Pittsburgh, announced its First Annual Exhibition, to be held from November 5, 1896, to January 3, 1897, Homer agreed to participate. He wrote to Beatty that he would send "but one picture to your exhibition, but that is the best one I have painted this year."[48] Once the exhibition opened, the institute made the painting its first acquisition, awarding Homer a medal and a $5,000

Figure 224: *The Wreck*, 1896. Oil on canvas, 30⅜ × 48⁵⁄₁₆ in.

prize for the single best American painting in the show. It was an enormous honor and a high price. Homer would chew up many hours responding politely to congratulatory correspondence.

Honored though the painting was, Homer couldn't quite control his itch to keep improving it. When he took the train to Pittsburgh on October 13, 1897, to participate in the jury assigned to determine the winners among the pictures in the Second Annual, he had another objective. He wanted "to have time to look about in my own way & particularly to overlook & put in order (as it must need it by this time) the picture of *The Wreck*." Homer's luggage contained what he described as "the proper varnish & a brush & sponge." He would make no trouble for the staff, he wrote, as he was coming a day early to do his work. "That is all I need but clean water," he wrote. What he seems most to have sought to do was increase the ambiguity and universality of his canvas. A drawing with cursory inscription, coupled with the letter, suggests that once, behind the white clouds on the horizon at center, a three-masted schooner was visible. On it hung an inverted American flag: another signal of distress. Homer was intent on quietly scraping that out. He had done enough already to draw viewers into the picture, that they might make their own meanings within its mysteries.[49]

For the Second Annual, he submitted a painting of similarly impressive size and of markedly dissimilar character: *A Light on the Sea*. His model was a married Prouts Neck woman, Ida Frances Meserve Harding (1878–1947), and her setting was the rocks at Prouts Neck. But she is dressed in a strange pink skirt with a fishnet twisted over her shoulders, dancing to a mysterious music audible to her ear alone. Homer considered the picture a masterpiece, but opinions were uneven then, and have been since. It took ten years to find a buyer. When it happened, the moment was another commercial breakthrough for Homer, as the picture's new home became a prestigious public institution: the Corcoran Gallery in Washington.

The jurors for the Pittsburgh exhibition were drawn from its own participants. Homer disliked such service, but given the honor and prize money he had received a year earlier, he could hardly turn down Beatty's invitation. It was a prestigious group of painters called to Pittsburgh to choose the winners. It included his old friend John La Farge and six younger painters: Cecilia Beaux (1855–1942), Frank Benson (1862–1951), William Merritt Chase (1849–1916), Frank Duveneck (1848–1919), Will Hickok Low (1853–1932), and Edmund C. Tarbell (1862–1938). Beaux,

Figure 225: *A Light on the Sea*, 1897. Oil on canvas, 28³⁄₁₆ × 48⅛ in.

the sole woman on the jury, recorded a lively story about the experience of meeting Homer for the first time:

> The weather being fine, it was proposed, on our arrival, that we should drive about and see the town, which none of us had visited before. Four barouches [open horse-drawn carriages] were drawn up at the door of our hotel, and into the first of these Mr. La Farge, Mr. Caldwell, the President of the Institute, a mysterious stranger, and I were invited to ascend. I sat in the Queen's place, Mr. La Farge beside me. Opposite rode Mr. Caldwell, full of explanation and courtesy, the ambiguous person beside him. This personage I took to be a high official in the world of the Institute or of coal or steel. He was a spare, oldish man, with a short, dark, almost unnaturally dark, moustache. Everything he wore, and even his cane, was new; gloves, necktie, hat, suit, never had been worn before, and seemed to oppress the wearer a little. He remained absolutely silent during the drive, in which the chief object to be pointed out to our attention—and it was a worthy one—was the jail . . . It is indeed a masterpiece. No ambiguous character has the mighty structure. It has a soul, just and terrible; it is the very epic of jails. But I was still wondering about the unknown man who had driven with us. He looked, I whispered to myself, as a diamond expert might, if I had

ever seen one. There was something intense, observant, in his quiet. His new clothes seemed like a disguise. I inquired of Mr. Beatty, who was the operating angel of our destiny. Mr. Beatty looked at me in wonder— "Why, Winslow Homer, of course." He was amazed that I did not know, had not met him. Until nearly the end of our labors, which, with the entertainment so generously provided, filled every moment of the day and a good deal of the night, Winslow Homer maintained his silent attention to duty. He came and went, voted and endured, until nearly the end, when he became restless, and finally confided to one of the men that he grudged every minute now passing.[50]

He did Beatty another favor that fall, sending twenty-seven watercolors to Pittsburgh, all based on his time on Lake St. John and the Grand Discharge to the Saguenay River. These were not for sale, and he considered them a group that would show well as an ensemble. His letter to Beatty is a good example of his attention to detail: "As you have plenty of room I think if it is convenient for you, that the best place in your Galleries for a small show is on the Wall that was behind us when the committee met & passed on pictures. That is the best light that I remember & would be just about large enough for two deep of my water colors. You know you can always get light by taking the soot off the glass on your roof. P.S. No insurance. I take the chances. You will find that the men of Pittsburgh will like these things & the women will be curious to know what the men are liking & first thing you know you will have an audience."[51] Three days after the show opened, an explosion of unknown origin blew up the U.S. battleship *Maine* in Havana Harbor. Of the 364 crew, 266 died as the ship sank. Within three months, the nation was at war.

Homer's increasingly lofty reputation was winning him attention he found flattering but distracting from the work of painting. As an example, J. Alden Weir, a fellow Tiler whom he had known for many years, asked Homer in January 1898 to be a part of a new artists' group that they would call the Ten American Painters. Others in the group included Benson, Dewing, Tarbell, Childe Hassam (1859–1935), and John Henry Twachtman (1853–1902). For years, many of Homer's friends (and likely Homer himself) had grown frustrated with the arthritic leadership of the National Academy of Design. In 1878, some of these friends had formed an alternative organization, the Society of American Artists, and Homer finally

Figure 226: *Wild Geese in Flight*, 1897. Oil on canvas, 34 × 50 in.

exhibited with that association in 1897. But he turned down Weir's invitation to join this group of ten American Impressionists.

His principal work now was caring for his father. He made another picture with a disciplined palette of browns and blacks. It depicts five geese; two are dead or dying and three fly squawking overhead. One cannot help but think that Homer reads himself and his two brothers in the living birds, aching for the other two but unable to alter the trajectories on which each of the five is embarked.

Winslow's father's deteriorating health seems to have made Homer more keenly aware of his own mortality. On the eve of his fifty-ninth birthday in 1895, Winslow had written to Charlie:

I am very well with a birth day tomorrow. I suppose I may have 14 more (That was Mother's age 73 years) and what is 14 years when you look back.

The life that I have chosen gives me my full hours of enjoyment for the balance of my life. The Sun will not rise, or set, without my notice, and thanks.[52]

Three years later, on February 24, 1898, Winslow wrote from Prouts Neck to his father at his Boston hotel: "This is my birthday Feb 24—St.

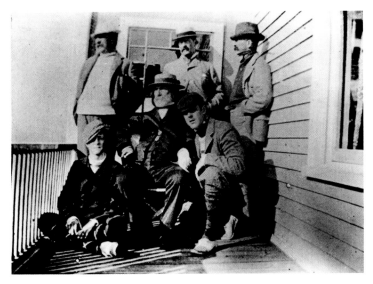

Figure 227: Unidentified photographer, *Homer Family Members on the Deck of The Ark*, c. 1898. Photographic print. Standing at rear (*left to right*): Arthur Benson Homer, Charles S. Homer, Jr., Winslow Homer; seated at front (*left to right*): Charles Lowell Homer, Charles S. Homer, Sr., Arthur Patch Homer

Matthias. Sun shine. Clear sky. Clear conscience, empty stomach." He was snowed in the day he turned sixty-two, but he was in a good mood and wasted no time kidding his judgmental father. "Storm bound & telegraph down. But today *I shall get everything* [doodles of a flying goose, a raised glass and three bottles of liquor] HOW! Many happy returns. I pray you give up your intemperate habits: Red Pepper & Long Hair."[53]

That was the last of Winslow's birthdays that his father could celebrate, albeit alone and away from his son. Six months later, in his ninetieth year, Charles died. It had been a tough last period of his life. Winslow turned increasingly to hired manservants in order to care for the old man. Among them was a Black man named Lewis Wright (born 1866), whom Winslow continued to employ after his father's death as he himself now needed help keeping his household running.[54]

Four days after the death of their father, Winslow wrote a painful note to his younger brother, Arthur. Evidently Arthur had felt that Charlie and Winslow had excluded him in the immediate aftermath of their father's death. Winslow wrote, "As for your being left out *you* are the one who now lead with your large family, & we are out in the cold, melancholy &

lonesome. I join you in thinking that things might in general be better than they are & let us all make the best of it."[55]

Winslow did make the best of it. He sent *Wild Geese* as his entry to the Carnegie's Third Annual Exhibition. He explained to Clarke and others that he would be away from Prouts Neck for six months and not answering his mail. On December 8, 1898, he stepped onto the steamship *Seneca*, bound for Nassau, where he not been since his visit with his father fourteen years earlier, just after his mother's death. This time, he went alone.

12

ALIVE WITH A REPUTATION
(1898–1902)

THE *SENECA* DOCKED in Nassau four days later, on December 12, 1898.[1] He saw the island and its people differently now than he had on his first trip. Then, he was on commission from the *Century*—and from the colonial governor. For Winslow's father, and for him, it was an expedient expedition, a distraction from grief in a voyage of discovery meant to be easy on the eyes. Now he had arrived with a purpose of his own. Homer grieved the loss of his father, but it was his way to mourn in work, not words.

For fourteen years, a restive memory had tugged him to return. It had seared him, compelling his creation then of a watercolor distinguished by its empty, terrifying beauty: *The Derelict* (figure 172). He had exhibited it at Reichard's promptly upon his return in 1885, and again at Doll & Richards the following year. Each show found its climax in the sheet, whose terror outweighed its beauty; the watercolor never sold. He tucked it away in his inventory, where it joined so many other sheets for which there were no takers. He knew they were good, and he would wait—and watch for ways in which some might turn into the seeds of fresh achievements. In those new things, perhaps he might satisfy his itch and find a collector bold enough to buy.[2]

Most of his watercolors from his first Bahamian trip were set on land, often with an eye on the islands' women. Boys then he portrayed most often singly or with one other figure, as archetypes of encounter, reflecting in their curiosity Winslow's own. But in his watercolors now no women appear. The sheets set on land are almost entirely bereft of figures.[3] On and in the water his Bahamians—all boys and young men—gain personality,

Figure 228: *West Indian Divers*, 1899. Transparent watercolor, with scraping,
over chalk, on wove paper, 15 × 21⅜ in.

archetypes no longer. With intensity and focus, they engage with their surroundings, which Homer painted in colors electrifying in their vitality. His models harmonize enviably with their kaleidoscopic setting, but for them this aquatic paradise exists not for pleasure, but for work. Whether conch, sponge, or sea turtle, it is the bounty of the sea for which they search, and which, merciless and despite their youth, they harvest.[4]

The sea, too, is unforgiving. In one watercolor, Homer depicted a young Bahamian washed ashore like the remains of his blasted vessel, whose splintered keel seems almost to rupture his pelvis. The sun sparkles, the waves have lessened, the wind blows gently now, but the remnants tell that the storm, just passed, had been brutal. Is the man alive or dead? Homer delivers the question, then lets it linger.[5]

Homer had himself experienced a brutal storm just before leaving Maine. On November 26 and 27, 1898, a pair of low-pressure air masses converged off the Virginia coast and proceeded north toward New England. With little warning, the weather system hit the Massachusetts coast with such power that it reversed the course of a river south of Boston. Among the many ships the storm assaulted was the S.S. *Portland*, a ferry running regularly between Boston and Portland. All 192 passengers and

Figure 229: *After the Hurricane, Bahamas*, 1899. Transparent watercolor, with touches of opaque watercolor, rewetting, blotting, and scraping, over graphite, on moderately thick, moderately textured (twill texture on verso), ivory wove paper, 15 × 21⅜ in.

crew perished in the storm, known since as the Portland Gale.[6] Notably, the gale struck the Black community of Portland with special fury, inasmuch as the crew of the ship included many of the leaders of that community. Several factors beyond Homer's proximity to Portland and his empathy with Blacks would have caused him to consider this event with particular gravitas. These factors included his close observation of weather systems and his ties to local business leaders such as Brown family members and others in the Cumberland Club. His family's long employment of a Black servant, Lewis Wright, may also have meant that he had at least second-hand knowledge of some of the local Black leaders who died in the tragedy.[7]

On another sheet Homer depicted a solitary young man holding fast to the gunwale of a worn sailboat. The vessel's mast is so neatly clipped that not even a stub remains. The cabin is black as night in the bright light of day, but overhead, thunderclouds converge, darkening the sky. A shark nearly the length of the vessel slips by her gunwale on the other side, more intent than able to flip the boat and devour her sole crewman. In his yellow hat, with nothing but three canes of sugar to sustain him, he is determined to survive.[8]

Homer took the kernel contained in the watercolor *The Gulf Stream*.

Figure 230: *The Gulf Stream*, 1898–1899. Transparent watercolor, with touches of opaque watercolor and traces of blotting, over graphite, on moderately thick, moderately textured, ivory wove paper (lower edge trimmed), 11⅜ × 20¹⁄₁₆ in.

Three sharks now swim in the foreground, and the jaw of the one closest to the viewer is wide open, visibly threatening. Shreds of red—not seaweed, blood?—float on the sea's surface. The storm clouds in the watercolor have merged into a single waterspout at upper right, more exotic than thunder-clouds and even more threatening. Homer's model, as the Black critic Alain Locke noted in 1936, "is half nude, modeled with a musculature and physical power that was revealing and in a situation of common human appeal."[9] The picture "broke the cotton-patch and back-porch tradition," Locke wrote, "not all at once, but inevitably." The young man on the deck of the demasted sailboat stares not with terror but penetrating discernment—and not at the sharks but at other, smaller fish to the right of the canvas. As Peter H. Wood demonstrated in *Weathering the Storm*, his exegesis of the painting, these are no ordinary fish, but flying fish, *Exocoetidae*. "Mariners viewed this aquatic species as the epitome of all those obliged to live constantly between the devil and the deep blue sea," Wood writes.[10] Homer is linking flying fish to Blacks in the South, "who found themselves caught perpetually in that situation, not knowing where to turn for support or succor during troubled times."[11] Locke wrote that the picture "began the artistic emancipation of the Negro subject in American art."[12]

The title of the picture stems from the writings of Matthew Fontaine

Figure 231: *The Gulf Stream*, 1899. Oil on canvas, 28⅛ × 49⅛ in.

Maury (1806–1873), astronomer and founding superintendent of the U.S. Naval Observatory. His seminal book *The Physical Geography of the Sea* (first published in 1855) opens with a vivid description of the Gulf Stream: "There is a river in the ocean. In the severest droughts it never fails, and in the mightiest floods it never overflows. Its banks and its bottom are of cold water, while its current is of warm. The Gulf of Mexico is its fountain, and its mouth is in the Arctic Seas. It is the Gulf Stream. There is in the world no other such majestic flow of waters. Its current is more rapid than the Mississippi or the Amazon."[13]

Maury was closely associated with the phrase "the great architect" as an expression of God's sovereign will in and over the universe. The concept long predates him, however, and originates in the Bible's Letter to the Hebrews (11:10).[14] St. Thomas Aquinas, perhaps the foremost proponent of natural theology prior to the Renaissance, also embraced the idea.[15] The very title of Child-Chaplin's book, *The Great Architect*, which Homer owned and annotated, quotes Maury. The Anglo-Scots doctor considered the astronomer and oceanographer comparable to Charles Darwin (1809–1882), William Herschel (1738–1822), and few others as a true luminary of modern science, and awarded this approbation to only one American: Maury.[16] For this son of Virginia the Gulf Stream stood as an especially compelling example of the intricate balance God strikes in creating and

sustaining the natural world. To the observer who studies the sea's phe-
nomena closely, with its physical geography, he wrote, it may be seen as

> the main spring of a watch; its waters, and its currents, and its salts, and
> its inhabitants, with their adaptations, as balance-wheels, cogs and
> pinions, and jewels. Thus he perceives that they, too, are according to
> design; that they are the expression of One Thought, a unity with har-
> monies which One Intelligence, and One Intelligence alone, could
> utter. And when he has arrived at this point, then he feels that the study
> of the sea, in its physical aspect, is truly sublime. It elevates the mind
> and ennobles the man. The Gulf Stream is now no longer, therefore, to
> be regarded by such a one merely as an immense current of warm water
> running across the ocean, but as a balance-wheel—a part of that grand
> machinery by which air and water are adapted to each other, and by
> which this earth itself is adapted to the well-being of its inhabitants—
> of the flora which deck, and the fauna which enliven its surface.[17]

Today Maury's legacy is replete with irony. Despite his pioneering work
as an astronomer, oceanographer, meteorologist, and cartographer, he had a
darker side. In April 1861, after nineteen years leading the U.S. Naval Ob-
servatory, he resigned to become a commander in the Confederate States
Navy. He led its Coast, Harbor, and River Defense, which included his de-
velopment of electrically charged floating mines that were highly effective at
sinking vessels both in the merchant marine fleet and in the U.S. Navy he
once served.[18] The Confederacy also dispatched him as its emissary to Brit-
ain and France to win diplomatic recognition and ships and weapons for the
Confederacy. Among his most important destinations was Liverpool, where
George Wigg (future boss to Homer's brother Arthur) operated during the
war as a Confederate foreign agent. Maury was not a slave owner himself but
advocated for an "Amazonian Republic . . . to be the safety valve for our
Southern states," a vast empire uniting both Americas, North and South, in
shared commitment to the peculiar institution.[19] It is difficult to understand
today how he reconciled his profound Christian faith with his advocacy for
the physical and structural extension of race-based slavery. Nevertheless,
Homer admired Maury. He pasted a wood-engraved portrait of him in the
inside cover of his volume of Child-Chaplin's book.

The image of the young Black man that Homer created in *The Gulf*

Stream is highly countercultural in its empathy—and in its disturbing ambiguity about the man's fate. A staffer at his gallery wrote to Homer to report the anxious questions his viewers asked. Homer replied,

> You ask me for a full description of my picture of the *Gulf Stream*. I regret very much that I have painted a picture that requires any description. The subject of this picture is comprised in *its title* & I will refer these inquisitive schoolmarms to Lieut. Maury. I have crossed the Gulf Stream ten times & should know something about it. The boat & sharks are outside matters of little consequence. *They have been blown out to sea by a hurricane.* You can tell these ladies that the unfortunate negro who now is so dazed and parboiled, will be rescued & returned to his friends and home & ever after live happily[20] (italics his).

Homer's attachment to the title reflects his agreement with Maury on the significance of the Gulf Stream as a balance wheel. His model is an Everyman in the heart of "the exquisite machinery by which the harmonies of nature are preserved." As a part of God's creation, he and all humans are subject to God's "laws, and agents in his economy." Man and woman are the only ones of all God's creations made in God's image: *imago Dei*. Humans are therefore uniquely able to "perceive the developments of order and the evidences of design which make it a most beautiful and interesting subject for contemplation."[21] All viewers, of all races, who look with open eyes will care about the fate of the man in *The Gulf Stream*, as Locke observed. His fate is that of us all. Each of us lives within the balance wheel of God's exquisite machinery—whether we know it or not.

Homer's pride in the work is evident in a photograph for which he posed with his easel as if caught midstroke, probably at his request, on or about November 25, 1899. This is the only photograph known that depicts Homer engaged in his work, and is therefore notable for that reason alone. He had promised the painting to Hamilton Morris, managing director of the Pennsylvania Academy of the Fine Arts, who had pleaded with him that "the greatest American Art Exhibition can not open without an example from the greatest American artist."[22] That exhibition, the academy's 69th Annual, would not open until January 15, 1900, but on Tuesday, November 28, Homer left Prouts Neck for eight days in New York, having dispatched the painting to Morris. He wrote, "At any rate I am out of

business, unless I see some money in it. I think this is the last picture I shall ever paint for fun. This picture is called *The Gulf Stream*. Please [*do*] *not change this title*." He went on to say that Morris "may remember 'Turner's *Slave Ship*' with the chain cables floating on the water & the impossible arms & legs that have been admired by the public. These figures [*sic*, plural] of mine [are of] about the same value to the picture."[23]

The photograph is also notable for another reason: it memorializes the picture as unveiled in Philadelphia to the public who saw it first. *The Gulf Stream* kept changing as Homer reworked it. In its final form, another contrasting vessel sails on the horizon. She is a three-masted square-rigged ship of the kind that had largely vanished in these waters by this period; Homer painted her as a gray phantom. At lower left he made a strange inscription, probably relating to this nearly invisible clipper ship: "At 12 feet from this picture you can see it."[24] Homer had strong opinions about the optics of seeing, and specifically the appropriate distance from which to view his pictures. He wrote to Knoedler about a picture he had sent them for exhibition, that "it can be seen properly from the opposite side of 5th Ave. The old Stewart building corner—as it is painted at the distance of 60 feet from the artist. That is the rule for the nearest figure on the base of a picture." He then scribbled into the corner of the page a caricature of a man with his nose right up against a canvas, and wrote, "This man cannot see it."[25]

After the picture's first viewing, Homer changed the demasted central vessel, too. He reworked the starboard gunwale to be broken and placed a sail, wrapped like a shroud, at the gunwale's edge. Perhaps most important, he gave the worn vessel a name, *Annie*, and a home port, Key West. Homer's viewers grew more numerous as *The Gulf Stream* became another unsold vagabond, traveling to Pittsburgh, New York, Venice, Chicago, and Des Moines.[26] The model from whom he made his field sketches was surely Bahamian, but in his reworking he bestowed on the vessel and her crewman a narrative particularity. Everyman has become an American, and he is Black. The Saint Lucian poet Derek Walcott found the picture so inspiring that it plays a pivotal role in his epic book-length poem, *Omeros*, in which he identifies Homer's figure with Walcott's protagonist Achille. One passage reads:

> *circled by chain-sawing sharks; the ropes in his neck*
> *turned his head towards Africa in The Gulf Stream,*
> *which luffed him there, forever, between our island*

and the coast of Guinea, fixed in the tribal dream,
in the light that entered another Homer's hand,
its breeze lifting the canvas from the museum.

But those leprous columns thudding against the hull
where Achille rests on one elbow always circle
his craft and mine, it needs no redemptive white sail

from a sea whose rhythm swells like Herman Melville.[27]

Upon *The Gulf Stream*'s return from its showing in Philadelphia, Homer wrote to his New York dealer that he wished he had coordinated the painting's exhibitions better, as he "had rather have a picture in your show window than any place." While his letter referred specifically to *The Gulf Stream* it was also a more general statement about a change in his commercial life. He had adopted a new "show window," at a new dealer, M. Knoedler & Co. It had taken Homer five years from the date on which Gustave Reichard closed his gallery to finally lose his loyalty to the Prussian-

Figure 232: Unidentified photographer, *Winslow Homer with* The Gulf Stream *in His Studio at Prouts Neck*, 1899. Gelatin silver print, 4¹¹/₁₆ × 6¾ in.

born dealer with whom he had collaborated for some fifteen years and whom he had named his "*New York agents for life.*"[28]

Reichard had said that he would not "give up the picture business," and didn't, then or ever. When he closed his gallery, he shifted to a more modest space and stayed open until his death in 1917, long after Homer's own demise.[29] For five years Reichard performed the basic functions Homer needed done in New York, including packing and unpacking his pictures for exhibition at venues there and elsewhere, and showing them by appointment to discerning private collectors. But then in 1900 Homer finally concluded that he needed more services in New York than Reichard could provide him. He chose Knoedler as his principal dealer while retaining Doll & Richards in Boston, O'Brien in Chicago, and other venues for representation beyond Knoedler's reach.[30] Homer must have had some acquaintance with Knoedler as early as the mid-1860s, inasmuch as the gallery's founder had joined the Century fewer than two years before he did, and the firm had begun making a market in Homer's work by 1874.[31]

Michael Knoedler (1823–1878) was born in a village about thirty-five miles east and a little north of Stuttgart, Germany. He arrived in New York in 1852 to establish the American branch of Goupil, a French dealer in engravings for whom he had worked in Paris for eight years.[32] In 1857 he had bought out Goupil's ownership and upon his death left the business to his three sons, Roland (1856–1932), Edmond (1862–1933), and Charles (1864–1944).[33] Under Roland's leadership, the firm expanded to include branches in London and Paris and to sell a broad range of Old Master pictures and the work of internationally renowned living painters on both sides of the Atlantic, prime among them John Singer Sargent. In April 1898, the gallery had served as the New York venue for the exhibition of twenty-seven watercolors (plus two oil paintings) Homer assembled for the Carnegie Institute and entitled as a group *Life and Scenes in the Province of Quebec.* With the art market booming and a broad and deep base of wealthy industrialists seeking to acquire pictures for the large houses they were building, Homer was wise to seek out a new gallery. Knoedler offered him representation as effective as any in America.

The price Homer put on *The Gulf Stream* was a robust $4,000, which reflected his view of the picture's importance. It also reflected an event that happened while Homer was in the tropics: Thomas B. Clarke's sale on

February 14–17, 1899, of his outstanding collection of 372 American paintings, including thirty-one works by Homer. While the landscapes of George Inness won the highest prices at the Clarke auction, that landscapist had been dead for five years, creating an obvious scarcity value. Several of Clarke's fifteen oils by Homer sold for what were then astonishingly high prices. *Eight Bells* sold for $4,700, the auction's highest price for the work of any living artist. *The Life Line*, which Clarke had acquired from Catherine Lorillard Wolfe's nephew as few as three years earlier, sold for $4,500, and *Moonlight, Wood Island Light* won $3,650.

Homer recognized the effect of the sale on the market value of his work. For twenty years, from Clarke's first purchase in 1879 of *Uncle Ned at Home*, the onetime linen merchant had been his most important patron. Their relationship was often testy, but Clarke had set an example of the passionate collector and inspired many other collectors to follow him, with a transformative influence on the perception of Homer, and of other American artists. Homer congratulated Clarke while noting with humility his own advancing age, and including a subtle sales pitch—even though Clarke had turned his collecting interests away from contemporary art and toward early American portraits:[34]

> Owing to the delay in the mails I have only just received the news of the great success of your sale. I owe it to you to express to you my sincere thanks for the great benefit that I have received from your encouragement of my work & to congratulate you. I have had a most successful winter at Nassau, N.P. Bahamas I found what I wanted & have many things to work up into two paintings that I have in mind. I shall not go North until it is warmer but I am through work for the winter & desire to report myself very well. Only think of my being alive with a reputation (that you have made for me).[35]

Doll & Richards wasted no time in harnessing the commercial benefit of the Clarke sale. The Boston gallery sold *Wild Geese* for $2,500 on March 7, 1899, less than a month later. As Homer began planning life without Reichard, he laid plans to ship two major canvases to Knoedler, *Hound and Hunter* (1892) and *Lost on the Grand Banks* (1885), which had slumbered for years in Maine. When Knoedler showed them in March 1900, both canvases were still unsold despite the passage of eight years from their first

exhibitions. *Lost on the Grand Banks* sold immediately, and Homer's faith in his new dealer was vindicated.

Homer was not in Philadelphia when the public first laid eyes on *The Gulf Stream*. He had gone to work on another project. With that magnum opus packed up and dispatched to the City of Brotherly Love, Winslow made haste to New York for eight days of catching up, then boarded a steamship for the two-day trip to Hamilton, Bermuda. He seems to have gone with a particular purpose in mind: to create a suite of watercolors for the Pan-American Exposition scheduled to open in Buffalo on May 1, 1901. It was the final occasion on which he assembled an exhibition of his own work; after this moment he would leave that job to his gallerists. In preparation for the exposition, he remained in Bermuda for six weeks, from December 8, 1899, to January 22, 1900.[36]

The Bermuda sheets differ in several ways from those he painted in the Bahamas just a year earlier. One obvious aspect is that the local particularities, where Homer's process always began, in this case include the island's distinctive architecture, with coral walls and rain-gathering stepped roofs. The red-coated Black soldiers of the West India Regiment represent a subtler particularity. These Jamaican men arrived the month before Homer

Figure 233: *Natural Bridge*, 1901. Watercolor on wove paper, 14⁷⁄₁₆ × 21 in.

did; Britain was at war in South Africa, and the effects of that conflict had reached this island in the middle of the Atlantic.[37] Homer depicted from afar the uniformed men and the empire's bristling armaments in the harbor. He could get no closer; the colonial government prohibited sketching or photography except from a distance.[38]

The watercolors differed in other ways, too, from what he had created in the Bahamas. Where his Bahamian models were fully engaged with their environs, boys immersed in their work of commercial discovery, these figures are furtive. Their stealthy character suggests that they fear being discovered themselves amid the spectacular scenery. The bright Bermudian sunlight falls on luridly red seaweed in *Opposite Ireland Island* and on aggressive boars in *Bermuda Settlers*. Homer titled one sheet *Gallows Island*, in recognition of the place (now called Gibbet Island) where slaves had suffered public execution from the seventeenth century. Oral history recalled one horrific case of 1754 in which a slave was condemned to die suspended in tight chains, lingering for days to await his death. In starvation and despair, he ate the flesh of his own arms until finally expiring. In 1898, the year before Homer's arrival, the chain was still visible.

In pursuit of a complete suite to show in Buffalo, Homer produced a

Figure 234: *Opposite Ireland Island*, 1899–1900. Watercolor on wove paper, 14½ × 28⅛ in.

Figure 235: *Inland Water, Bermuda*, 1901. Watercolor on wove paper, 14 × 21 in.

further seven watercolors in 1901, based on field sketches, now lost, of his singular visit to the island.[39] The incremental sheets reflect his intention to create a sufficiently balanced and large enough offering that he could be justified in the unusual marketing strategy he had chosen. He placed a price of $4,000 on the entire suite of twenty-one watercolors and forbade the sale of any sheet individually. In a single act, he differentiated himself memorably, further established the scarcity value of his work, and created a sense of excitement about the American hemisphere the exposition celebrated.

With the imprimaturs of gold medals from the Carnegie and then the French government, and the Clarke sale in February 1899, Homer had every reason to become less anxious and more confident in his economic and professional outlook. He did not. He wrote Knoedler a letter in advance of another trip to Pittsburgh to serve on a Carnegie jury: "I wish to know if you are still overloaded with my pictures. I am waiting until some of them get settled for good before *I paint any more*. I have not painted *anything this summer*"[40] (italics his). In a letter to Clarke responding to his inquiry about the possibility of Homer sending a painting to the Union League Club, he seemed especially eager to deflect blame on others for his own unpredictable behavior. He first wrote that he "would Paint some-

thing & thought of a fine subject & immediately commenced it. I have to-day ordered a frame for it & if I finish it by Jan 3rd I will ship it." And he then added, "I may not send it, & have nothing but that, not having painted anything since March. Do not take any old Pictures of mine *that Knoedler may want to unload on you* for the League. I am very well, & I sincerely hope that you are. Do not think that *I have stopped painting*. At any moment I am liable to paint a good picture."

His trips to the North Woods Club grew shorter. He came for just five days in midsummer 1899 and then for three weeks in the late spring of 1900, and again in 1901 and 1902. Charlie came to the club for the first time in 1902, but left after five days. After 1894, Homer seems to have made just six watercolors in the Adirondacks, three of them in 1900. One of those depicts a solitary man walking across Rye Field Ridge, a recently cleared landscape a twenty-minute walk from the Clearing.[41]

Another, *Burnt Mountain*, depicts Beaver Mountain after a recent fire that exposed the underlying topography, previously hidden and softened by the mature trees. Homer conveyed the tangibility of the clouds with layer upon layer of transparent wash.

Figure 236: *Burnt Mountain*, 1902. Watercolor, 14⁷⁄₁₆ × 21¹⁄₁₆ in.

Figure 237: *Triple Fish Skin*, 1896. Cedar and taxidermic brook trout, 29½ × 19 in.

He also made a group of unusual fish portraits in the last years of his life. They include several taxidermic fish, which he called "fish skins" and mounted on cedar boards. Homer painted the wood carefully in a monochromatic blue, inscribing in the paint the specific length, girth, and weight of each fish, and the pond where each was caught. In the case of one trio of brook trout, he mounted the topmost fish in the act of catching a fly. The sculptures are a way in which Homer honored the unique characteristics of each creature inhabiting the world around him.

A small number of undated and surrealistic works Homer made about the same time come to life in a fresh way with the understanding of his fish skins. One, in crayon on composition board, depicts a bottom-dwelling fish called a tautog; it, too, is dated with length, girth, and weight inscribed. Another is a vivid watercolor in which a black bass is strangely suspended in the air above Mink Pond, with Beaver Mountain silhouetted against the horizon at sunset. Homer sent a letter to Mattie on the summer solstice, June 21, 1900, in which he wrote that "the fishing is over here & I am sketching in watercolors . . . Tell Charlie I have a fine sketch of a black bass taken in the boat five minutes after he was caught. I present it to him for his fish room at W.T. [West Townsend, Charlie and Mattie's farmhouse northwest of Groton, Massachusetts]."[42] That fine sketch was probably this watercolor.

Figure 238: *Bass*, c. 1890. Watercolor, 13¾ × 21 in.

Homer did not seem especially sure of his destination when in the summer of 1902 he wrote to his guide George Van Felson: "I shall leave here very soon—that is in ten days & start for Cape Breton & Gaspe Coast . . . Ile Malin or any other old place—I shall keep moving until I find a good working place."[43] He returned to Quebec, to Lake St. John and the Saguenay River, in 1902 for what would turn out to be his final visit to the Ilnu homeland. The watercolors he painted there have a similarly dream-like quality to the black bass caught on the close of the year's longest day, as if Homer is savoring every minute.

One of them is a depiction of an osprey's nest on the shore of the lake, with a pair of raptors circling around it protectively as a pair of men approach with their canoe. Just one of the two birds in flight (the closer, lower one) is an osprey. In his powers of observation, his penchant for particularity, and his wit, Homer bestowed on the sheet another subtly ironic title, *The Eagle's Nest*. The scene he depicted is not a benign one, but one of narrative tension between two species of birds—and between birds and men. The more distant, higher bird—an eagle—appears to be preparing an attack on the osprey nest, which houses a helpless chick. The men's defensive posture speaks to the tension and suggests that they know that the territory on which they stand does not belong to them. Of course, it

Figure 239: *The Eagle's Nest*, 1902. Watercolor over graphite on
cream wove paper, 21⁹⁄₁₆ × 13⁷⁄₁₆ in.

doesn't belong to the eagle either—but the eagle's aggression suggests the
possibility of its victory. Homer leaves dangling the outcome of this
attack—and how one might consider the role of men as invaders.[44]

It is a measure of Homer's close observation of the entirety of the world
around him—natural and commercial—that he drew special attention to
this watercolor five years after making it, and commended its fit with one
particular collector. In a brief letter to Knoedler, he wrote, "If Mr. H.C.
Frick calls at your store please call his attention to the watercolor No. 4
[Eagle's Nest]. I think he would like it."[45] Henry Clay Frick (1849–1919)

had been a fellow member of the North Woods Club for more than ten years at the time Homer wrote the letter; he was a ruthless and highly successful industrialist. He was also a prodigiously ambitious art collector. The letter suggests Homer knew Frick well enough to appeal to his appetite for art and to his personality, as Homer perceived it. As it turned out, a Maine inventor and businessman, Jacob Robinson Andrews (1861–1915), bought the sheet instead, as well as several other Homer works.[46] Frick seems never to have acquired any work by Homer.

In all of this, Homer glories in the sheer beauty of the forces of nature playing out before his eyes. He had annotated the opening sentences from Child-Chaplin's chapter "Fowls of the Air: O ye Fowls of the Air, bless ye the Lord: praise Him and magnify Him for ever." The author wrote, "It may be truly affirmed that Birds are not surpassed by any class of animals in the illustrations they afford of the Power, Wisdom, and Goodness of the Creator. Their shape and plumage attract our admiration. Their voices fill our woods in spring with sounds of cheerfulness and life."[47]

Murray called the Saguenay a Stygian river, reporting that its waters "are unlike those of any other river known. They are a purple-brown, and, looked at en masse, are, to the eye, almost black. This peculiar color gives it

Figure 240: *Grand Discharge, Lake St. John, Province of Quebec*, c. 1902.
Watercolor over graphite pencil on paper, 14 × 21 in.

a most gloomy and gruesome look, and serves to vastly deepen the pro-
found impression its other peculiar characteristics make upon the mind."[48]
Homer invoked the mystery of the river as the waters of the lake erupted
and thrust into the narrow channel of the Grand Discharge. He depicts
deep blue breaks in the clouds as if the roiling waves of the river reached
up to pierce the dome above them.

While the new century brought acclaim to Winslow, it brought disas-
ter to his younger brother, Arthur. On September 8 and 9, 1900, a powerful
hurricane hit Galveston. Arthur had already encountered a series of set-
backs prior to the hurricane, particularly the failure of Galveston Rope &
Twine, which he led as president. The company's factory, completed in
1890, when bigger was better, boasted the city's tallest smokestack at 162
feet. Within five years, however, the business had failed and was sold at
public auction, a prominent humiliation for the proud entrepreneur.[49] Al-
though Winslow was never as close to Arthur as to Charlie, these events
must have affected him, just as their father's business struggles molded the
three Homer sons in their boyhood. The hurricane, like the Portland Gale,
was a tangible expression of the risks that unleashed nature posed to man.
Arthur's large wooden house and his wife and two sons survived both the
bankruptcy and the hurricane, but he resolved to return to New England
by the end of 1900. He gave up his remaining entrepreneurial hopes and
relocated in reduced circumstances to Quincy, Massachusetts, near Boston.
Both Arthur's sons, Charles Lowell Homer (eighteen years old) and Ar-
thur Patch Homer (twenty-four), moved with him and took jobs in the
Boston area.

The Homer family's purchases of land on Prouts Neck had begun in 1882
when fewer than six other families had built houses for their own summer
use. But many other families, including those running Prouts Neck's hotels
and boardinghouses, were year-round residents. They did not live on the "hard
neck" (the southwestern tip of Scarborough) where Winslow's home and stu-
dio was located, but east of there, along the beach, and north, on Black Point
Road past Homer's annex studio at Ferry Landing. These other families who
lived within two miles of his house were generally farmers, such as James
Frank Coolbroth (1828–1915). Many of those neighbors owned parcels of
developable land and interests in the local hostelries. Coolbroth, as an exam-
ple, married successively two of Hannah Louise Libby Googins's aunts. His
daughter Elmira (1855–1941) married John M. Kaler (1852–1935), who

Figure 241: Unidentified photographer, *Winslow Homer and Mr. Coolbroth,*
Scarborough, October 5, 1899. Gelatin silver print, 6⅝ × 9¹¹⁄₁₆ in.

built the Southgate Hotel in 1878. In considerably altered form, it survives today as the sole hotel on the neck, known as the Black Point Inn.

But no neighbor mattered more to the formation of Prouts Neck as a summer resort than did an entrepreneur named Ira C. Foss (1856–1919). Twenty years after Winslow's birth, Foss was born to a farmer and his wife living in Saco, several miles from the Neck. Foss, like Winslow, encountered tough challenges in his childhood; he was one of six children, and the only son, whose father died when he was twelve years old. Three of his five sisters died when Foss was a teenager, but his redoubtable mother, Tryphena Burnham Seavey (1823–1889), put her wits together and came up with a plan. In 1876, when Foss was twenty, he married Anna Maria Libby (1854–1876), daughter to Silas J. Libby (1811–1878), who owned much of Prouts Neck. Hannah Louise Libby, Alonzo Googins's future wife, was Anna Maria's much older half sister. The day following the wedding, Anna Maria died, possibly to a chronic illness. The documentary evidence has not survived to explain the circumstances. But one thing is clear: by the end of that year, Foss, still a minor, had acquired substantial land and buildings from Silas. The following year, 1877, he began construction of what would become Prouts Neck's largest hotel, the Checkley House. His mother acted on his behalf. Foss operated the hotel for the rest of his life, dutifully supporting his mother and two sisters, Ida and Tryphena.[50] He was also active in Maine politics, serving as a state representative and a state senator.

In 1898, he and two other forward-thinking men attempted to install a comprehensive sewer system for Prouts Neck. They were the summer residents Charles A. Burditt (1836–1926), a Boston hardware merchant, and Howard A. Carson (1842–1931), chief engineer of the Boston subway and streetcar system. Burditt had tried to connect his 1888 house to Foss's freshwater system but was unable to do so because it would require crossing private property.[51] The men, like the Homer brothers, probably recognized that the then-current systems for sewage disposal—such as the iron pipe running from the Jocelyn Hotel toward the bathing beach—were "detrimental to the health of the place or people."[52] But many others did not agree, and New Englanders pride themselves for their frugality. The initiative failed; not until 1961 would Scarborough form a sanitary district.

Nevertheless, Foss had another initiative underway to create value for himself, his family, and his neighbors. In 1896 he acquired a site for the construction of a water tower and began plans for a deliberately oversized freshwater system.[53] It enabled him to provide fresh water not only for his hotel but for home owners on the neck who otherwise depended on rain-gathering cisterns and unreliable wells. With his two sisters he formed a private company, the Prouts Neck Water Company, and on March 22, 1901, won passage in the state legislature for a bill authorizing its establishment.[54]

The Foss water system was immediately transformative to the prospects for Prouts Neck as a whole, and the Homer brothers recognized that fact. For two decades they had purchased land but not sold a single lot. Seven months after the water company was formed, they sold a parcel for the first time. The buyers were a Philadelphia physician, James W. Holland (1849–1922), and his wife, Mary (1851–1933). A year later, the brothers sold a second parcel, to a wealthy divorced New Yorker, Catherine Cheyney Bartol (1849–1938). The Homers were not only seeking to maximize their profit on their low-basis land, but also cultivating a community. In addition to the hostelries of Prouts Neck, there were now more than forty houses, owned generally by the same sorts of people who stayed at the hotels: affluent professionals and entrepreneurs. Burditt and Carson were two examples; the Vermont inventor, educator, Congregational minister, mountaineer, and numismatic collector Henry Fairbanks (1830–1918), the Philadelphia industrialist J. Vaughan Merrick (1828–1906), the Cincinnati lawyer John Wesley Warrington (1844–1921), and the New Jersey Presbyterian pastor Stanley

Figure 242: Unidentified photographer, *Houses at Prouts Neck, Maine,*
with Water Tower and Hotels, c. 1900. Cyanotype postcard, 3⅓ × 5½ in.

White (1862–1930) were others. These residents who built cottages on land
they acquired from the Libby family and other owners prior to the Homers
beginning their land sales had profiles similar to the members of the North
Woods Club, but they originated from a wider geographic area. The sum-
mer cottages they built were also, like the North Woods Club houses, mod-
est relative to the primary residences of their owners; their servants' quarters
(if any) allowed room for just one or two retainers.

Two of the earliest owners of summer cottages on Prouts Neck pur-
chased their nearly adjacent lots on the same day, September 1, 1883, from
a pair of local sisters, Ella and Mary Libby.[55] Both purchasers were single
New Yorkers born the same year: Mary T. Agnew (1833–1901) and Charles
E. Thomas (1833–1898). Thomas was originally from Albany but settled
ultimately in Manhattan. He made a modest living as a music teacher and
was an enthusiastic amateur painter. Upon his death, he arranged for two
neighbors to deploy proceeds from his estate to establish a free library for
Prouts Neck; the library survives to this day in the house Thomas inhab-
ited. "Taciturn in habit, he possessed a fund of humor, and a keen artistic
sense," his friends recalled at the library's opening. His will contained sev-
eral demonstrations of his interest in the visual arts, including the bequest
of "my easel and all my painting materials to Stephen Carlton Clark
[1882–1960] of New York City."[56] Clark was then sixteen years of age and
a student at Phillips Academy in Andover, Massachusetts. Like his older

brother Robert Sterling Clark (1877–1956), he would grow up to become one of America's most perceptive art collectors.

Three years later, in 1886, the same two sisters sold a parcel of land directly across the street from Thomas. The wife and husband who purchased it were Annie Bathurst Harrison (1852–1938) and her husband, Frank Moss (1838–1924), a moderately successful painter and illustrator.[57] Moss had studied in Paris at the studio of Léon Bonnat (1833–1922), had exhibited at the National Academy of Design in New York, and a year after his 1885 marriage moved his studio from Philadelphia to New York.[58] Although born Jewish, he converted to Christianity and specialized in scenes of Christian narrative.

Another notable single woman soon followed these early builders of Prouts Neck summer cottages. Elizabeth G. May (1850–1925) acquired land in 1888 near Thomas, the Mosses, and Agnew, but closer to the shore.[59] She was from Leicester, Massachusetts, and was the daughter of a prominent Unitarian minister who had been an outspoken advocate for abolition. She and another summer resident, Philadelphia's Eliza L. Austin (a teacher serving Black students at Hampton Normal School in Virginia), expressed with particular power in their words and deeds their commitment to the equality of all Americans—regardless of race.

Figure 243: *The Ghosts of Departed Prouts*, 1901. Crayon on paper, 4⅞ × 7⅞ in.

Women and children were more than welcome at Prouts Neck, in fact generally more visible than the men, who stayed for shorter periods than did their wives. Women appeared more often than men in the deeds for Neck properties, perhaps in recognition that their sex would be the predominant one living there.

A couple of Winslow's drawings reflect this inflection point in the life of the place he called home. He inscribed one, "The Ghosts of departed Prouts / at the house-raising," and even put the time of the sheet: "6.30 AM Dec 1 1901." He was probably memorializing the very beginning of construction on the Holland house.[60]

The two decades of buying property and never selling it had ended, and he would have more neighbors and more noise. Homer didn't like either change but he made his peace with it, as a doodle on the back of an envelope shows. While he acknowledged that Foss's water project supported his real estate values, it also had catalyzed five pressing questions—at least half in jest:

"Where will I get the water to clean this house?"

"Who knows enough to flush my pipes in the swamp?"

"How long am I to go to the neck with one yeast-cake?"

"How long are all my horse blankets to be out covering my water pipes?" and, last but far from least,

Figure 244: *Water Pipes, Prouts Neck*, 1903. Ink on paper envelope, 3½ × 6 in.

Figure 245: *Eastern Point*, 1900. Oil on canvas, 30¼ × 48½ in.

"When will I get a chance to go out and do some work?"

His art also seemed to deepen his sense of the drama intrinsic to living by the sea. One example is a rapidly executed sketch he made in anticipation of a possible new oil painting. In a letter to his Chicago dealer O'Brien he titled it *(On the Banks)—Hard-a-Port!—Fog*. The term "hard-a-port" is a command in response to changed circumstances that necessitate steering a vessel sharply to port (left). He places the viewer on the deck of a Grand Banks schooner as a large steamship emerges, menacingly, out of the fog.[61] Homer seems never to have pursued the idea of a canvas based on the sketch, but it hints at his increasing interest at the end of his life in creating pictures whose narrative power stirs viewers' souls as effectively as his illustrations once had captured their eyes.

The sea possesses an endless drama of its own, in the rhythm of the tides, the motion of sun and moon, and the passage of storm and season. The privilege of living within that drama—or at least gazing upon it in comfort and from a ringside seat—was part of what the Homer brothers were offering when they sold Prouts Neck land. Child-Chaplin wrote, "The ocean enhances beauty where beauty already exists; and it often creates beauty where, but for the charm which it bestows, there would be nothing to admire."[62] Is it surprising that Homer made several of his most

Figure 246: *West Point, Prout's Neck*, 1900. Oil on canvas, 30¹⁄₁₆ × 48⅛ in.

monumental seascapes at the moment that he and his brothers were selling land from which the new owners might witness their own such vistas?

Just then, he developed two canvases of identical size, hanging them near each other as he had with several other pairs such as *The Fog Warning* and *The Herring Net*. But now, at the century's end, the contrast he created was less narrative and more atmospheric. *Eastern Point* is the less surprising of the two, depicting a stormy scene from a protrusion into the sea.

The other, *West Point, Prout's Neck*, elicited more scorn than admiration when Homer first showed it. Today, some regard the painting as his greatest work; its plume of ocean spray left of center has become a Rorschach test all on its own. Homer kidded Clarke that his brother had called the aquatic tower a "piller [*sic*] of salt (Formerly Lot's Wife)."[63] He recognized that the picture was unconventional and that he needed to explain "the peculiarity of the light. The picture is painted *fifteen minutes* after sunset— not one minute before—as up to that minute the clouds over the sun would have their edges lighted with a brilliant glow of color—but now (in this picture) the sun has got beyond their immediate range & *they are in shadow*. The light is from the sky in this picture. You can see that it took many days of careful observation to get this—(with a high sea & tide just right)."[64] The picture is a tribute to the fleeting quality of both time and

Figure 247: Unidentified photographer, *Charles Savage Homer, Jr., and Winslow Homer at the Driveway to "The Ark,"* 1900. Gelatin silver print, 4¾ × 6¾ in.

beauty—and the urgency of observing the balance the "Great Architect" has struck.

It is also an expression of his engagement with this place where he and his brothers gathered with one another. A photograph of Winslow and Charlie returning from a fishing trip captures the fraternal affection undergirding their investment of capital and labor on Prouts Neck.

Charlie received an unexpected note from Winslow one winter day:

I am so very thankful for all "His mercies"—that I now write to you.

There is certainly some strange power that has some overlook on me, & [is] directing my life.

That I am in the right place at present there is no doubt about—as I have found something interesting to work at—in my own field—& time & place & material, in which to do it.

So much better than loafing about with nothing to do—I am very well.

At the end of 1902, Winslow wrote to his young friend Boyer Gonzales:

I think some of going to Florida, Homossat [*sic*] or some such name on the West Coast where there is good fishing *& no painting*. If I go, I will let you know.[65]

13

TIDE TAKEN AT THE FLOOD
(1903–1910)

HOMER DID GO FISHING in Florida, but not with Gonzales, and not, as he implied he would, in the cold first months of 1903. He stayed at Prouts, alone on his sixty-seventh birthday, February 24, and increasingly sick. Ever reserved, he didn't tell his friends and family what was wrong with him. Finally, in early March, he became so ill that he had to leave in search of a cure. Within three weeks he was back, resolute and jaw shut. He wrote to Knoedler: "I wish to thank you sincerely for the fine showing that you have given me while I have been away sick. I am all right now in health."[1] He was recovered enough to get to the North Woods Club in time for Adirondack fishing (and black flies) on May 23.

By the end of that year, he was also well enough to go to Florida, eyeing on his map Homosassa, the small angling destination on the west coast of the state, upon whose spelling he had stumbled. First he returned to the familiar destination of Key West, an easy passage from New York. He wrote Arthur: "I decided to go direct to Key West. I have Stateroom 20 upper deck *Sabine* go on board to-night leave early Sunday morning. I know the place quite well & it's near the points in Florida that I wish to visit. I have an idea at present of doing some work but do not know how long that will last. At any rate I will once more have a good feed of goat flesh & smoke some good cigars & catch some red snappers. I shall return through Florida & by May may be at Scarboro."[2]

The eight surviving watercolors present strikingly open vistas, as if to suggest that Key West is not an island at all but an experience of submer-

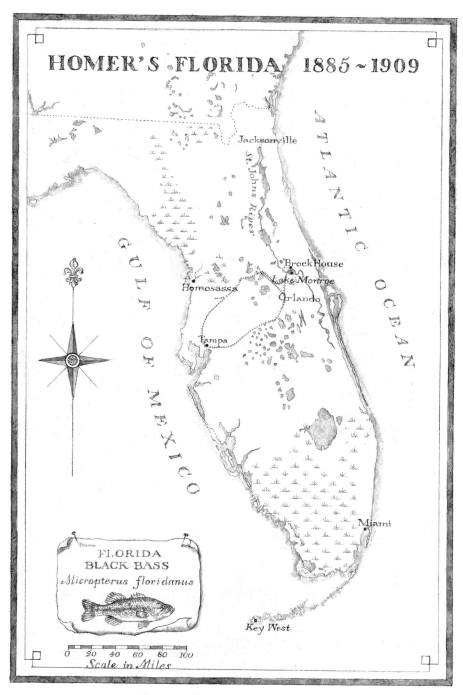

Figure 248: Homer's Florida (1885–1909)

Figure 249: *Taking on Wet Provisions*, 1903. Watercolor and graphite
on off-white wove paper, 13⅞ × 21¾ in.

sion in glistening salt water. Among the sheets he painted immediately
after his arrival was *Taking on Wet Provisions*, which appears a spontaneous
sketch. A closer look reveals that it is a highly rigorous geometric compo-
sition with carefully constructed component parts hanging in balance. The
two red-jacketed figures on the vessel precisely touch the diagonal lines
running from the upper corners across the page to their opposite lower
corners. Those upper corners and the sheet's center in the dark cabin form
a triangle balanced on the center. In it, Homer painted a series of bold,
straight lines: the two masts of the boat and her myriad sheets. The oppo-
site triangle (from the lower corners to that same center point) is also op-
posite in content. The red stripes on the hull are the only straight lines, foils
for the fluttering movement of the waves lapping the sides of the vessel.
Homer's diagonal line to lower left just kisses the dinghy delivering a bar-
rel of provisions to the sailboat. Whatever illness Homer had suffered, his
ability to paint in watercolor was unimpaired.

Another sheet is similarly constructed with geometric precision but
conveys a sense of the quiet of Key West. There are no figures visible at all,
just the sparkle of these sailboats moored at noon on an oppressively hot
day. The red adorning two pennants, a buoy, and a tiny stripe at the water-

Figure 250: *Key West*, 1903–1904. Watercolor and graphite
on off-white wove paper, 13¹⁵⁄₁₆ × 21¹³⁄₁₆ in.

line of the sailboat at left are the only sources of relief from the uniformly
blue and white tropical palette.

By January 7, 1904, he had taken a northbound ship from Key West to
Tampa, and journeyed on another forty miles farther north to register at
the Homosassa Inn.[3] As he had suggested, his main purpose was fishing,
not painting, but paint he did. The jungle he depicted was dense with ani-
mal life—and not as free of the human stamp as his watercolors suggested.
He brought his Kodak #1 camera on at least some of these Florida jaunts.
One of the prints is an essay on the encounter between the tropical foliage
of the jungle and the buildings plunked down in its midst. Crisp orthogo-
nal lines collide with the curvilinear organic forms that preceded them
and will remain after these structures, now gleaming, wear away like all the
marks of man.

Homer's affinity with the animals and fish he observed on his expedi-
tions only deepened as he aged. In *Life-Size Black Bass* he positions the
viewer inches from a fish already hooked, as we witness the last seconds of
its life. Homer reveled in the freedom he now possessed, to make a market
with works reflecting all he was—head, heart, and hand—and the truth of his
own mortality. His letters express both a wry recognition of life's brevity

Figure 251: *Life-Size Black Bass*, 1904. Transparent watercolor, with touches of opaque watercolor, rewetting, blotting, and scraping, over graphite, on thick, moderately textured (twill texture on verso), ivory wove paper (left, right, and lower edges trimmed), 13¾ × 21 in.

and an incredulous astonishment that he need worry about money no lon-ger. He wrote his cousin, "The money that I have just drawn I have left in the bank until now as being near Mt. Auburn [Cemetery] to be handy in case I wanted to be buried—but I have postponed it for the present. I am very well & now I have three sets of teeth, all perfect, so if I break any one I always have another handy."[4]

A day or so after checking into the inn, he wrote to Arthur that Homo-sassa suited him well. "Delightful climate here about as cool as our Sep-tember. Fishing the best in America." He quickly sketched five local fish in profile—a shorthand paper counterpart to his fish skins. He exulted in the unique character of each species, describing a channel bass as "like a new $20 Gold piece." He explained, "I shall fish until the 20th then my guide has another engagement & I shall take my own boat & work half the time & fish on my own hook. I have not done any business this fall so far—& I shall only paint to see if I am in up it [*sic*]—& with a chance of paying expenses. I have not heard a word from Charlie yet. I suppose you are all well. *Do not send me* any kind of *newspapers*. I have all I want."[5]

Homer stayed at the inn for six weeks and then a further several weeks

Figure 252: *Homosassa Jungle*, 1904. Watercolor on off-white wove paper, 13⅞ × 21¾ in.

at and near the Brock House. He was in Jacksonville for his birthday on February 24, 1904. The affection he felt for the place is visible in the watercolors he made. He held aside for Charlie a sheet depicting a middle-aged bearded man, with his companion half-hidden in his little boat. The fisherman is as engaged as Homer, his curving line taut as he reels in a fish he feels, but cannot yet see. The watercolor is a tribute to his love of fishing, and his love of the older brother with whom he spent so many happy hours with rods in hand. Charlie wasn't with him then, but he was rarely out of Homer's thoughts.

Like the skeletal trunk of the palm tree in *Homosassa Jungle*, the menacing mountain lion at the center of another sheet, *In the Jungle, Florida*, conveys a frisson of danger in the swamp, of death waiting in the wings.

The very last watercolor Homer is recorded ever to have exhibited, *Diamond Shoal*, is even more allusive of death. Homer may have based the sheet in part on his earlier drawing *Hard-a-Port*.[6] The sheet depicts two vessels in a notoriously hazardous place that Homer himself had seen on his voyages to Florida: the Diamond Shoals, a shifting formation of shallow sandbars extending eight miles off the coast of Cape Hatteras, North Carolina. The shoals are often called the "Graveyard of the Atlantic"; more than five thousand shipwrecks have occurred there.[7] Homer would have

Figure 253: *Diamond Shoal*, 1905. Watercolor on wove paper, 13⅞ × 21¾ in.

been especially attentive to the geological phenomenon of these shoals because they are formed at the confluence of the Gulf Stream and the colder Labrador Current.[8] In an effort to protect shipping from the danger of the shoals, the United States Lightship Service commissioned a 122-foot, 590-ton ship to be stationed there. Built in 1897, she had three electric lens lanterns atop each of her two masts and a 1,000-pound fog bell, among other devices.[9] Her ungainly profile contrasts in his hand with the lines of the sailboat in the foreground, which seems to be called *Commander*. Neither of the two vessels appears in command of its fate. The two figures in their yellow and red oilskins pulling hard on the sheets of the sailboat seem far weaker than the force of the winds against which they battle. And the lightship herself, intended to warn and save, appears at risk of her own submersion amid overwhelming waves. With vigor, passion, and precision as he neared the end of his life, Homer observed and expressed the power of natural forces and the vulnerability of all mankind.

Although he had predicted staying south far into the spring, he returned to Prouts by the end of March 1904.[10] He had serious work to do and needed time alone in his studio to do it. Mud season in Maine kept him indoors and frustrated, quite a contrast to Florida sunshine. Homer wrote Knoedler, "It has been so cold and wet here that paint would not dry

and I had all I could do to keep alive."[11] But the hardest work was in his head and heart, not his hand. He was mining his memory, and his imagination, in a way that would shape the remaining years of his life.

His few weeks in Santiago de Cuba nearly two decades earlier had resonated with him for years. The images were ever-present: the empty, rutted streets, the tyranny of the Spanish, the beauty of the worn colonial buildings, and the shy, veiled women. Homer had never painted the "pallid, sorrowful faces" of the political prisoners Ballou had described staring from the grated windows of Morro Castle, but he had never forgotten them either. From the sorrows of those malnourished men had sprung the hopes of a generation of Cubans. Disappointment had sprung quickly, too: their independence did not follow the war fought in the name of their liberation. Santiago was closely associated with a lightning political advance beginning on the hills overlooking the city. Theodore Roosevelt had commanded American troops called Rough Riders on San Juan Hill above Santiago de Cuba in the summer of 1898. Soon after, on the momentum of the Rough Riders' victory, the United States, in the name of freedom, ended Spanish rule in Cuba. But when the Spanish flag descended Cuban flagpoles, it was not the flag of a truly independent Cuba rising to take its place. The United States had defeated both the Spanish Empire and the hopes of Cuban patriots. America had raised fundamental questions of what it means for the people of one country to overturn the government of another—and to take responsibility for the aftermath.

Roosevelt seized his opportunity and was elected New York's governor in the fall of 1898, and two years later he was elected vice president. Less than a year later, William McKinley (1843–1901), his running mate, was assassinated; Roosevelt became president of the United States. It was a meteoric rise, driven in important part by the story of Roosevelt's vigorous imposition of American will on the hills overlooking the fort and prison of Morro Castle.

In painting *Searchlight on Harbor Entrance, Santiago de Cuba* within weeks of Roosevelt's inauguration, Homer delved not only into the meaning of the place he had seen but what happened there, and what it meant. Other artists would offer their viewers those pallid faces sealed within the castle's walls, but not Homer. He completed the picture right at the end of 1901, as a court of inquiry was completing its investigation into the events of the war, and into whether certain officers warranted commendation or

blame for its outcome.[12] "This is just the time to show that picture as the subject is now before the people," he wrote.[13] Homer sent a description of the painting to Clarke, as detailed as a journalist's account, although by then Homer ought to have known that his longtime patron wasn't buying new work from him or anyone else. His letter includes specific reference to the fact that, in the words of one critic, "the quiet scene is painted beneath the conflicting rays of a cold moon and a colder electric light."[14] Homer felt an obligation to demonstrate, if only to Clarke and himself, his "factual structure," as Abigail Booth Gerdts has written, "that his subject—created in imagination—was securely grounded in a three-dimensional under-standing of the site."[15]

One critic wrote, "Beauty is hardly the word to describe the rude force that is in this silent old fort about which the searchlight sweeps." He ad-mired primarily Homer's technical feat in combining the two light sources, saying that Homer "has come as near as possible to achieving the impossi-ble."[16] Three days later, Homer wrote to his dealers that he was aspiring to more than they understood, as the picture "*is not intended to be 'beautiful.'* There are certain things (unfortunately for critics) that are stern facts but are worth recording as a matter of history as in this case. This is a small part of Morro Castle & immediately over the Harbor entrance which is only

Figure 254: *Searchlight on Harbor Entrance, Santiago de Cuba*, 1901. Oil on canvas, 30½ × 50½ in.

about 400 feet wide & from this point were seen all the stirring sights of June & July 1898. *I find it interesting*."[17] Homer's commercial instincts were right in this case. The picture sold three weeks after its first exhibition, to the man who would become Homer's most important collector for the last decade of his life: the New York dry goods merchant George A. Hearn (1835–1913).[18] *Searchlight*, like so many other Homer pictures, is composed with geometric precision; the canvas's dimensions approximate the golden ratio. The painting captures Homer's memories of the past and his meditations on the present, and distills them into a form both final and mysterious. The armaments and architecture of the Spanish crown, built over centuries, rest upon an unseen rock, whose age is far greater. And above it all, a waxing moon sheds a natural light as another light—mechanical and searching—appears on the horizon. Other than *The Gulf Stream* it is his sole Caribbean canvas.

Three years later, the monument bug had bitten him again—twice. He worked on two major paintings at once, each delving deep in his memory, each deliberately inconclusive. *Kissing the Moon* of 1904, like *Searchlight*, invokes a strange stillness by the meditational light of a visible moon, now

Figure 255: *Kissing the Moon*, 1904. Oil on canvas, 30¼ × 40 in.

full and kissed by the peak of a wave. The sea nearly swallows the tiny fishing boat in which three men ride, evidently with neither oars nor sail. There is no denying a sense of vague but looming danger, yet the men seem utterly unalarmed. Only one of the three, an Ilnu transported to Saco Bay, offers any legible expression. He is grimly impassive. The picture is a dreamlike integration, a mosaic containing memories of the past, observations of the present, and dreams of the future. Homer felt free to imagine, construct, and reconstruct until he had made a work reflecting the melodies half heard in his subconscious, beating rhythms from the hot forge of his own experience.

Homer was determined, too. He needed a deadline. He promised Knoedler on November 8, 1904, "I shall send you within three weeks two paintings & I will ask you to show them one at a time in your show window. That will prevent their being shown at any of the New York Exhibitions. Keep them away from critics & insure their being well hung. Your window is the only place where a picture can be seen in a proper manner. That is, at a point of view from which an artist paints his picture—to look at & not smell of."[19] He attached a sketch of the painting with several inscriptions including "this is one picture I send you." It is instructive to see how attentive he is to the geometry of the picture, measuring the moon at three and one-half inches and comparing it to the sou'wester on the figure

Figure 256: *Letter to M. Knoedler & Co.* (excerpt), November 8, 1904. Ink and graphite on paper, 5 × 8 in.

(five inches wide). Homer's visual record of his picture's bare essentials is summary but includes the ultimate Homeric fashion accessory for the taciturn young man: a mask.

The other picture he sent Knoedler is also a moonlit picture—but the moon is almost hidden, like the painter. He wrote to Charlie, "My picture *Cape Trinite* will take the Christmas cake."[20] It was a dramatic enough advance in his work that he wanted to distance it from what was already in inventory at Knoedler. "Please put out [i.e., return to him] the watercolors belonging to me & notify me & I will tell you where I wish them sent. I consider that you have had them in your hands long enough. My things are too common & cheap. & what I am now painting is of quite another order & I propose to have something to say about the disposition of my things— so as to keep them out of public exhibitions when I wish them kept out."[21]

When he did send the two big oil paintings to Knoedler two weeks later, he didn't attach a sketch accompanying *Cape Trinity* the way he did with *Kissing the Moon*. But he wrote a letter anticipating the dealer's objections. He acknowledged that the painting "appears a very slight performance but at the same time it is a most truthful rendering of this most beautiful & impressive cape & from a point of view impossible to take by photograph. This should be in your window about Christmas time." Homer rarely referred in his letters to photography, and in so doing he was admitting that his subject was a celebrated one. Thousands of tourists clambered onto steamships at Chicoutimi to stare with awe as the Saguenay River becomes a fjord sixty miles downstream from the Grand Discharge. The fjord's most impressive feature, Cape Trinity, is a sheer rock formation rising 1,350 feet from the river's edge, broken only by a feature Homer omits. That is the thirty-foot white pine sculpture of the Virgin Mary of Saguenay carved in 1881, covered in lead and painted in white and blue with a crown of stars. Homer's sketch of the cape includes the sculpture, which local authorities lit at night with bright electric torches for the benefit of the tourists. Homer desired neither the conclusive religiosity of Mary's presence nor her competition with the mysterious light of the moon.

The sketch also includes evidence of Homer's use of a grid, which one may deduce he deployed in many other works as well, from watercolors to oil paintings. This is the only scored Homer drawing yet discovered. Yet the pentimento in *Fox Hunt* and the careful geometric compositions of *Prisoners*, *Snap the Whip*, and countless other oils and watercolors suggest

TOP LEFT: Figure 257: *Study for Cape Trinity, Saguenay River*, c. 1904. Graphite on paper, 4⅞ × 7³⁄₁₆ in.

TOP RIGHT: Figure 258: Albert Pinkham Ryder, *Moonlit Cove*, 1880s. Oil on canvas, 14⅛ × 17⅛ in.

BOTTOM: Figure 259: *Cape Trinity, Saguenay River, Moonlight*, c. 1904. Oil on canvas, 28¾ × 48¾ in.

that it was something he learned early in his practice and retained to the end of his life.[22]

Homer left no documentation to demonstrate that he knew two other pictures relating to *Cape Trinity*. One is an 1880 canvas by the Canadian landscapist Lucius R. O'Brien (1832–1899) entitled *Sunrise on the Saguenay*, which had already become a symbol of the country's pride in its magnificent scenery.[23] The second is Albert Pinkham Ryder's picture, painted in the 1880s and bearing sufficient resemblance to Homer's painting that one cannot help but wonder whether Homer had seen it. He would have encountered many of Ryder's strange, dreamlike symbolist pictures in New York exhibitions.[24]

Neither of the two pictures attracted buyers with much speed. *Kissing the Moon* sold three years later, after showings in New York, Philadelphia, and Buffalo. *Cape Trinity* sold in 1909, five years after Homer signed it, and after showings in Portland, Oregon; New York; and Cincinnati. He was tired by the time he shipped off the two pictures to Knoedler in November 1904 and ready for a long fishing trip. He may have gone to the Century to arrange the hanging of *Kissing the Moon* for its first viewing, on December 3, 1904, but four days later was at the Windsor Hotel in Jacksonville, sending Knoedler instructions: "My address will be Homosassa, Florida until further notice."[25]

He returned to New York in time to attend the Century's dinner and exhibition opening on March 4, 1905, where he showed *A Light on the Sea*. He and Charlie concluded that spring that they would sever their ties to Tourilli. Charlie wrote to George Van Felson, "If my camp needs any repairs I wish you would tell the proper man to have them done and send me the bill. Then I want you to accept it [the cabin] with my blessing. My brother Winslow joins me in this request."[26] Homer's appetite for roughing it was diminishing.

The Foss water system continued to benefit all those owning land at Prouts Neck, including the Homer brothers. Charlie had commissioned the first of the brothers' rental cottages in 1890, from a local housewright, Francis X. Jannelle (1870–1949).[27] They called it "Black Rock." By about 1900, Charlie was prepared to build three more rental cottages. Now he upgraded his design standards by hiring the family's trusted architect John Calvin Stevens. These three rental cottages were the elegantly named

Figure 260: Unidentified photographer, "A Residence at Prouts Neck, Maine,"
Scientific American Building Monthly 38, no. 1 (July 1904): 6. 10½ × 5½ in.

"Fearn-y-Breeze," "The Coop," and "Briarwood." About the same time, Winslow also hired Stevens to design a house he called "Kettle Cove."[28]

These houses were designed in the same general mode as other cottages on the neck. They were relatively simple structures with room for children and a bit of servant assistance. They had good views and would prove fine investments for the moment when the Homers decided to sell them. In the first ten years of the twentieth century Charlie sold three of the four cottages he built: Black Rock to the career military officer Henry Clay Merriam (1837–1912); Fearn-y-Breeze to Lilla W. Warren (1858–1925), the widow of a prominent New York Episcopal priest; and the Coop to Eva Fraser (1857–1948) and her husband, Abner Kingman (1856–1930), a Montreal-based banker.

George Hearn donated a large collection of pictures to the Metropolitan Museum of Art on January 11, 1906, including two major Homer oils, *Searchlight* and *Cannon Rock*. In October, Knoedler offered *The Gulf Stream* to the museum, which turned down the acquisition. On December 14, a surprising letter arrived at the museum. It was a petition, signed by the entire Hanging Committee for the National Academy of Design, and by seventeen of the twenty-seven members of the jury choosing works for the Winter Exhibition the academy would open eight days later. The petition recommended strongly that the trustees of the museum approve the purchase. With such unprecedented and enthusiastic support, the trustees reversed their decision and acquired the picture.[29] At the end of that year, likely encouraged by this remarkable groundswell of support for him, Homer participated in the National Academy exhibition, showing both *The Gulf Stream* and *A Light on the Sea*. It was the first National Academy exhibition in eighteen years (since 1888) at which Homer had shown his work.

As 1907 began, Homer's sense of finitude seemed to weigh on him, but

Figure 261: *Early Evening*, 1881, reworked 1907. Oil on canvas, 33 × 38¾ in.

he had spurts of energy belying his age of seventy. He wrote his younger brother, "I have no time to write. The days are short & there is now a tide in my affairs that I am taking at the flood."[30] He assured another New York dealer that he expected "to live about fifteen years longer, as both of my grandfathers & my own Father lived to 88 years, but I am taking things in time."[31] He also disclosed that he was "destroying everything that I think unworthy of being left behind me."[32] Homer's skills in construction happily exceeded his skills in destruction. About this time, Joseph Rokowski (1886–1962), an Austrian-born farmer, acquired at least seven Homer drawings. They provide invaluable insight into his process of developing his Civil War illustrations; one double-sided sheet is clearly a Roberval field drawing. Deft, spontaneously conceived sheets like these leave one wondering what else he may have considered "unworthy of being left behind," and what else from his hand may yet appear.

He took up a major painting that he had begun as a meditation on his time in Cullercoats. What he called now *Early Evening* he had called then *Sailors Take Warning*. He had thought enough of the picture to send it to Chicago for the World's Columbian Exposition, but then put it into his deep-freeze inventory for more than a dozen years. At the end of 1907 he wrote to John Beatty, who led the Carnegie Institute, that he was "painting again—I work hard every afternoon from 4.30 to 4.40, that being the limit

Figure 262: *Right and Left*, 1909. Oil on canvas, 28¼ × 48⅜ in.

Figure 263: *Driftwood*, 1909. Oil on canvas, 24½ × 28½ in.

of the light that I represent, the title of my picture being 'early evening.' I am alone here & very well."[33] The picture contrasts a craggy fisherman, seated on rocks similar to those at Prouts Neck, with two young women who are knitting improbably as they stand on the rocks. Knoedler showed it in January 1908, as soon as Homer had completed his rather extensive reworking, and it sold immediately.[34]

The year 1908 was tough for Homer. While he was fishing in Florida in the first months of the year, his studio was robbed. The thieves stole what he described as "my greatest treasure, a watch given to my mother on the day I was born."[35] Then in mid-May he suffered a mild stroke. He recovered rapidly enough to paint *Right and Left*, an ocean scene dominated by two ducks in midflight, one of them startled, struck, seconds away from losing its life, and the other already plummeting to its death. The picture is a startlingly direct statement of the struggle of competing forces that shaped him: between life and death, man and nature, free flight and its sudden end. He wrote to Charlie that he was "painting when it is light

enough—on a most surprising picture but the days are short and some-
times very dark."[36]

In the fall of 1909 Homer painted a nearly square seascape called
Driftwood. A solitary figure, hunched in cold-weather garb, surveys a
stormy sea. The tempest, now passing, has cast a great tree trunk upon the
rocks. As the waves spurt before him, the swirling sea casts a hypnotic spell
upon the man. The canvas is often considered Homer's final one.[37] "It is
now well recognized that Homer was one of the most autobiographical of
American painters," wrote the art historian Theodore E. Stebbins, Jr. *Drift-
wood* "itself provides persuasive evidence that Homer conceived it as a
valedictory effort. It comes as close to being a self-portrait as anything
Homer painted."[38] Many today perceive the picture in ways consistent
with the mythology Homer wove of himself as a protean figure living a
hermetic existence on the rocky shoreline, contemplating the forces of na-
ture besieging him.

But *Driftwood* may not be Homer's last picture. He may still have been
working on another canvas in that last year of his life, after he sent *Drift-
wood* to New York, as his health worsened in the weeks and months lead-
ing up to his last day, September 29, 1910. He was getting no good answers
from his doctor in New York. He stayed at the Hotel Seville on Twenty-
seventh Street and Madison for one of these clinical visits. Once the doc-
tor released him he went back to the hotel and sat down to write to Arthur
that "there has been no particular change in my case. But now that I know
all about it I will tell you I find that much to my surprise there is nothing
unusual the matter with me that after all it is only an acid stomach, all the
other machines are in perfect order. I have had two thorough examinations
& have been punched without finding a tender place. The pain is owing to
eight per cent acid rather than six."[39]

Homer summoned the strength to go to the North Woods Club for
one final visit in early summer 1910. But he returned to Prouts Neck after
only ten days. He hoped, perhaps, to complete one last picture. Its origins
are in a watercolor of 1902 depicting two men in a canoe on the rushing
waters of the Grand Discharge, and two other watercolors he created in
Canada at the same time. Six years earlier, he had been excited enough
about the possibility of an oil based on the ideas in these watercolors that
he requested that Doll & Richards return the sheets to him for use in his
development of the oil.[40] One of the three watercolors was *Grand Dis-*

charge, Lake St. John, Province of Quebec (figure 240), a spectacular depic-
tion of the lake's rushing waters as they pound with power into the narrow
channel. A second sheet focused on the human experience of the place,
with two determined guides paddling a birchbark canoe in fierce waves,
overseen by a steep, dark forest.

In the fall of 1905, he mentioned in a letter to his "Old Friend" Louis
Prang, "I retire from business every now & then & then take it up again . . .
I have been waiting for the summer people to leave here thinking I would
do more work although I am the one interested in the matter . . . Just now
I have commenced a picture the first since last October. I find one a year is
enough to fill the market." The picture was *Shooting the Rapids, Saguenay
River.*

The oil depicts a muscular Ilnu bowman with the red sash Homer often
gave his Québécois guides, and a distinctive peaked hat. Homer was work-
ing on the articulation of this figure's body and had not yet added the
paddle itself. He had just begun to paint the outline of the paddle held by
the guide at the stern, whose eyes Homer had developed more extensively
than the rest of his face and torso. The figure at center bears a startling re-
semblance to Charlie, but not as he was then: sagging, slowing, shrinking.

Figure 264: *Shooting the Rapids at Grand Discharge*, 1902. Watercolor over graphite on off-white,
thick, moderately textured wove paper with watermark, 13¹⁵⁄₁₆ × 21¹³⁄₁₆ in.

This Charlie is a sport in the prime of life, confident and engaged with the beauty and drama around him. The picture is Homer's last journey into his past as he looked to his future. It is also a visual evocation of what he had written to Arthur: "Everything will be just as it should be in the end since Charlie has to do with it."[41] It expresses the exultation Winslow felt as witness to the powerful forces of nature. But in this picture his witness is incomplete. In its unfinished state, it makes room for the viewer, the listener, to possess the tale and allow it to become her own, his own. Homer left the viewer to imagine the ending.

Both brothers were with him at his bedside at Prouts on September 29, 1910. Homer had gone to see a local doctor, Benjamin F. Wentworth (1871–1936), on the twenty-seventh, complaining of chronic indigestion. Wentworth came to Winslow's home early on the twenty-ninth to discover he had ruptured a blood vessel in his stomach and suffered "profuse hemorrhaging." He could see the waves no longer, but heard them as they crashed on the rocks below. The doctor stayed with him, but there was nothing he could do. Around low tide, as the grandfather clock struck the chime of 1:30 that afternoon, the rhythm of Winslow's heart failed him. It beat no more.[42]

Figure 265: *Shooting the Rapids, Saguenay River*, n.d. Oil on canvas, 30 × 48¼ in.

EPILOGUE:
MYTH AND MEMORY

AT 2:45 ON THE AFTERNOON of October 3, 1910, Homer's brothers and their wives, and about twenty others, gathered at Mount Auburn Cemetery in Cambridge.[1] The graveyard's majestic trees were turning crimson that cool day, ushering in autumn as they shaded the hills beyond the small stone chapel. Almost everyone who came was a relative, such as Homer's cousin and financial adviser Grenville Norcross; Grenville's sister Laura Marss and her husband; and Maria Mead Homer, three months older than Winslow but still spry. They had all been at Mount Auburn many times. It was where they arrived to bury the remains of their fathers and mothers, their sisters, brothers, nieces, and nephews, in dignity, sorrow, and resignation. There, under the tall trees and within sight of once-familiar names, family and friends recalled those who had come before them and had molded them into the men and women they became.

One mourner arrived for a different reason than all the others. William Howe Downes (1854–1941), longtime art critic for the *Boston Evening Transcript*, had now failed in a long-standing endeavor. For years he had been sending Homer letters, all for a single purpose: to arrange a meeting whenever and wherever the old man might allow it, so that Downes might write his biography. Homer answered one on August 1, 1908:

"It may seem ungrateful to you that after your twenty-five years of hard work in booming my pictures that I should not agree with you in regard to that proposed sketch of my life. But I think that it would probably kill me to have such a thing appear, and as the most interesting part of my life is

of no concern to the public I must decline to give you any particulars in regard to it."[2]

Just what "the most interesting part" of Homer's life might be remained unsaid. Downes telephoned, too, and wrote again in early August 1910, just seven weeks before Homer's death. Homer was consistently and adamantly unavailable. His last-known letter was to Downes:

"No doubt as you say a man is known by his works. That as you say I have heard at many a funeral & no doubt in your thoughts occurred to you in thinking of me. Others are thinking the same thing. One is the Mutual Life insurance Co in which I have an annuity. But I will beat you both. I have all your letters & will answer all your questions in time, if you *live long enough*. In reply to your recent letter, I will say that I was in Tynemouth in 1881 & two yrs *worked there*."[3]

Despite all the praise Downes heaped on Homer's work, he had never met the man. The critic's 1900 book *Twelve Great Artists* presented Homer (and other living artists such as Sargent and La Farge) as a peer of Rubens, Rembrandt, and Frans Hals: America's answer to the Old Masters. Homer's work, Downes wrote, "has in it not the least scintilla or hint of Europe or of Asia." He continued that Homer's

> style comports with his subjects: out-of-doors Americans, big, rough, sturdy, and true-hearted men, sailors, soldiers, pioneers, fishermen, farmers, "in their habits as they live,"—the stuff out of which the nation is made. He understands them as thoroughly as if he had made them. He presents them in their integrity. He shows them conquering the elements, heroic, modest, grand, unconscious. In a setting as vast and imposing as the ocean itself, or the primeval forest, he places, with nobility and simplicity, the continental American type of manliness. The style with which he draws this virile, rude, and clean-cut historical type is directness itself. So straight does it go to the mark, one is not aware there is any such thing as style. Art conceals art. It is as easy as lying,—only, it never lies.[4]

Now it was too late for Downes to meet Homer, or even to attend his funeral as an acquaintance. He came to work, to write the story of a man who was "the first exponent in pictorial art of the New World."[5] He had little appetite for research into Homer's life. Downes had already determined the true identity of his subject. "Like the men of Viking blood, he

rises to his best estate in the stress of the hurricane," he wrote.[6] Homer was a picturesque hermit. "The isolation of Winslow Homer is entire."[7] He "relishes wildness with a fierce gusto. He is a solitary."[8] Downes found so intoxicating the myth of an "absolutely original and national artist" that he sifted few facts of Homer's life, such as his prolonged periods living and working in New York City, or his empathy with Blacks and Native Americans. He ignored the depth, breadth, and significance of Homer's relationships with scientists, farmers, poets, and many others. Arthur and Charlie, whom he met at the funeral, provided amusing stories of their brother's life. For the tale Downes wished to tell, that was evidence enough. Like Knoedler, Doll & Richards, and like Homer himself, the brothers understood the commercial advantage of perpetuating a story built on narrowly selective memory, and Downes was happy to advance that process. The book he published a year after the funeral may be called a biography, but it is primarily a tribute to Homer's art—albeit garnished with stories from the brothers, and from Arthur's sons, Arthur Patch Homer and Charles Lowell Homer, then thirty-four and twenty-eight years old. They, too, basked in the bright light of their uncle cast as a protean figure whose greatness placed him beyond time and—but for his American character—beyond place.

La Farge, too sick himself to attend the funeral, agreed with Downes, calling Homer's work "the only record of absolutely American Yankee expression." He admired the fact that "its very defects indicate a hardness" that exemplified its maker's New England origins.[9] Those origins were real, of course, as was Homer's choice to depict and live upon Maine's rocky cliffs and breaking waves. But to claim that Homer found his true identity only when "his subjects became more serious and masculine" (as did Lloyd Goodrich in 1944) is to discount both the making of the man and most of what made him.[10] Goodrich continued that Homer's "paintings of sailors, fishermen and hunters showed aspects of primitive American life never before represented with such power,"[11] and concluded that Homer "loved the wildest, most solitary aspects of nature—sea, forest and mountains— and the hardy men who inhabited them. These themes he painted with extraordinary strength, largeness and truth. His art was uniquely close to nature, the primordial source of all art. It seemed a part of nature, having the salt breath of the sea and the smell of pines. Above all it possessed that fundamental vitality that is an essential element of all enduring art."[12]

This is the truth, but not the whole truth, of what Homer made—and

not of who Homer was. His onetime dealer Eastman Chase offered another view that touched, perhaps, on what Homer himself called "the most interesting part" of his life. A few days after Homer's death, Chase acknowledged the tension ever present in the man—and how he responded to it. "Beneath what often might be mistaken for brusqueness of manner dwelt a most kindly nature. He was a charming companion, not effusive, witty and racy in his conversation. The wrinkles around the eyes in this somewhat austere face recorded the rare humor that had helped as a solvent to the difficult things in life which I feel that he must have known. He was a grave humorist—a reticent poet."[13]

Unlike Downes, Chase knew the man behind Homer's work—not only his hand, but his heart and head. With Walt Whitman, Chase knew that how and what we remember will determine what we see.

> *Something it swings on more than the earth I swing on,*
> *To it the creation is the friend whose embracing awakes me.*

> *Perhaps I might tell more. Outlines! I plead for my brothers and sisters.*

> *Do you see, O my brothers and sisters?*
> *It is not chaos or death—it is form, union, plan—it is eternal life—it is*
> *HAPPINESS.*

> *The past and present wilt—I have filled them, emptied them, and proceed to*
> *fill my next fold of the future.*

> *Listener up there! Here you! What have you to confide in me?*
> *Look in my face, while I snuff the sidle of evening,*
> *Talk honestly—no one else hears you, and I stay only a minute longer.*

> *Do I contradict myself?*
> *Very well, then, I contradict myself,*
> *I am large—I contain multitudes.*[14]

More than 110 years after Homer's death, can we now see him in the context of his time and place? Can we take inspiration from Homer to find meaning and truth in the rhythms of daily life, which he, too, yearned to

discover? Homer's journey was a search for balance, order, and beauty amid the conflicts he confronted. Beyond Homer's acute observation and agile movement, beyond his empathy, lay a longing for resolution, for a place where his restless spirit might find the peace long eluding him. Into that quest he invites all people, that they might find that for which he, too, searched: a land of harmony and promise fulfilled, just beyond the line at which he gazed, a horizon both real and imagined.

Figure 266: Lillian Baynes Griffin (1871–1916), *Winslow Homer at the Door of His Studio, Prout's Neck, Maine*, between 1906 and 1910. Silver halide print, 6½ × 4⁹⁄₁₆ in.

NOTES

To preserve original voices, quotations are included in both text and endnotes in as close a form to the original as is practicable. In some cases that includes nonstandard grammar and spelling, for which this author begs the reader's forgiveness.

PROLOGUE

1. Thomas H. O'Connor, *The Lords of the Loom: The Cotton Whigs and the Coming of the Civil War* (New York: Charles Scribner's Sons, 1968). See also J. V. Matthews, "'Whig History': The New England Whigs and a Usable Past," *New England Quarterly* 51, no. 2 (June 1978): 193–208.
2. Unidentified editor, *The Boston Slave Riot, and Trial of Anthony Burns* (Boston: Fetridge & Co., 1854), p. 68.
3. Charles Emery Stevens, *Anthony Burns: A History* (Boston: John P. Jewett, 1856), p. 108.
4. "The Abolition Riot in Boston," from St. Louis Pilot, *The Missouri Courier*, June 8, 1854, p. 1.
5. The Burns trial is heavily documented. Stevens, 1856, op. cit., and more recent books such as Anthony J. von Frank's *The Trials of Anthony Burns: Freedom and Slavery in Emerson's Boston* (Cambridge, MA: Harvard University Press, 1998) are especially valuable resources. For the quotation about the overnight epiphany of Amos A. Lawrence (1814–1886), see his letter to his uncle Giles Richards, June 1, 1854, Massachusetts Historical Society, Box 38 of 44, Amos A. Lawrence Papers, MS. N-1559, Volume 4. For Whitman, see "A Boston Ballad" in *Leaves of Grass* (Boston: Thayer and Eldridge, 1860), pp. 337–40. For Douglass's sarcastic response to the trial, see *Frederick Douglass's Paper* (also known as the *Rochester North Star*), June 9, 1854. For the responses of Higginson and Forten, see his sermon of June 4, 1854, *Massachusetts in Mourning* (Boston: James Munroe & Co., 1854), p. 5, and her diary entry of May 25, 1854, in *The Journal of Charlotte L. Forten: Free Negro in the Slave Era*, ed. Ray Allen Billington (New York: Dryden Press, 1953), pp. 34–63. For the resolutions of the crowd at Tremont Temple in 1860, see *Harper's Weekly*, December 15, 1860, p. 787, and for a detailed transcription of the meeting, including Douglass's speech, see *The Liberator*, December 7, 1860, p. 195.

1. MIDDLE SON (1836–1859)

1. U.S. Bureau of the Census, 1830 and 1840 rankings by population (respectively of the 90 Urban Places and of the 100 Largest Urban Places).
2. "Correspondence of the Courier, February 17, 1836," and "Slavery," *Boston Courier*, February 25, 1836, p. 1; "A Man Buried in the Snow," "Marine Journal," and "Correspondence of the Courier,

February 20, 1836," *Boston Courier*, February 25, 1836, p. 2; and "Mr. Calhoun's Report," *Boston Courier*, February 25, 1836, p. 4.

3. Although no birth certificate or baptismal record has been found, the pages of the Homer family Bible (Archives of American Art, Smithsonian Institution) list Friend Street as Homer's birthplace, with the date of February 24, 1836. The Bible records, in the same nineteenth-century hand (probably that of Winslow's father), "The birthplace of Winslow has been removed and a store is now erected upon the ground = on the north side—Gould Estate-#24 Friend Street." The sole Boston City Directory associating the Homer family with any Friend Street location is that of 1836, and names #25 Friend Street; the family Bible seems a more reliable source, but either could be correct. In any event, urban renewal razed that entire block of Friend Street and much else around it. Whether #24 or #25, the house was located on what is today Congress Street, near the middle of the Boston Holocaust Memorial. That location is directly in front of a historic building that still stands: 33 Union Street, the onetime location of a crockeryware store operated by Winslow's uncle William Flagg Homer, and in more recent times the headquarters of the Yankee Publishing Company.

4. Listed in the Boston city directories in this capacity for twenty-three years, from 1806 to 1829.

5. Ship Registers and Enrollments of Boston and Charlestown, compiled by the Survey of Federal Archives, Division of Professional and Service Projects, Works Progress Administration, Vol. I, 1789–1795 (Boston: National Archives Project, 1942), lists seven vessels partially owned by Eleazer, as follows: *Greenhill*, a 64-ton sloop built in 1790 (#411); *Hannah*, a 104-ton schooner built in 1784 (#421); *Hope*, a 54-ton schooner built in 1787 (#489); *Industry*, a 94-ton sloop built in 1783 (#519); *Maria*, a 94-ton brig built in 1785 (#649); *Mary*, a 161-ton ship built in 1794 (#674); and *Rambler*, a 101-ton brigantine built in 1785 (#897).

6. Boston city directories.

7. Almira Homer cross-stitch sampler, 1826, gives many vital record dates, some erroneously. Once owned by Winslow's cousin and financial adviser Grenville Howland Norcross, its current location is unidentified. The sampler is included in *American Samplers* by Ethel Stanwood Bolton and Eva Johnston Coe (Massachusetts Society of the Colonial Dames of America, 1921), p. 174. The fourteen children of Eleazer and Mary were:

 1. Jacob (1787–1829), who in 1815 married Ann Barber (born c. 1790) in Boston;

 2. Eleazer (1789–1795);

 3. Mary Cunningham Homer (1790–1869), who in 1809 married Otis Norcross (1785–1827) in Boston;

 4. Sarah Merritt Homer (1792–1862), who in 1814 married George Lane (1788–1849) in Boston;

 5. Harriet Homer (1794–1846), who in 1816 married John Mellen (1790–1851) in Boston;

 6. Eleazer Bartlett Homer (1796–1869), who in 1828 married Louisa Agnes Wellington (1806–1863) in West Cambridge;

 7. Eliza Bonner Homer (1798–1875), who in 1821 married Charles Lane (1787–1833) in Boston (NB: he was a brother of George Lane, husband of Sarah Merritt Homer);

 8. Abraham Bartlett Homer (1800–1873), who in 1821 married Phebe Elkins (1803–1875) in Nantucket;

 9. William Flagg Homer (1802–1883), who in 1831 married Adeline Matilda Wellington (1809–1889) in West Cambridge (NB: she was a sister of Louisa, wife of Eleazer Bartlett Homer);

 10. James Bartlett Homer (1804–1885), who in 1832 married Adeline Nichols (1805–1885) in Mobile, Alabama;

11. Henry Homer (1807–1878), who in 1876 married Mary Boyd (1836–1921) in New York;

12. Charles Savage Homer (1809–1898), who in 1833 married Henrietta Maria Benson (1808–1884) in Boston;

13. Almira Homer (1811–1811); and

14. Almira Homer (1812–1893), who in 1846 married William F. Clark (1817–1849) in Boston.

In addition to the twenty-one children born to Homer's four aunts at the time of his birth, Harriet would bear one more daughter, and Almira would bear a son and a daughter. Homer's six uncles (five of them married at his birth) had eight children at the time of his birth, and would have thirteen more. Florence Tryon Homer, the last of these forty-five first cousins on his father's side, was born in 1878, five months after the death of her father, Henry; she died in 1955 in Australia.

8. Abraham Bartlett (c. 1731–c. 1782) captained the privateers *Starkes, Fame*, and *Commerce* during the War of Independence. Mary Bartlett was a daughter to his second of three wives, Thankful Brown (1744–c. 1780). The eminent physician and patriot Josiah Bartlett (1729–1795) served as guardian for Mary's brother Abraham (1774–1847) after the elder Abraham's death, but it's not clear what family relationship Abraham shared with Josiah. See Old North Church records, military records, and the probate file for Abraham, who may well have died at sea.

9. When at last she did marry, she was an unusually old bride of thirty-three years, and her husband, William F. Clark, was twenty-nine years old. Both of their two children died young, and Clark died three and a half years into their marriage.

10. The son, Matthias E. Homer (1819–1871), married the Maine native Frances Emeline Small in Boston in 1852, and had a business relationship with William Flagg Homer (a brother of Charles S. Homer). William sued him in Boston in 1861 in connection with that business, and then his wife sued him in Portland for desertion in 1864 (*Portland Daily Press*, February 12, 1864). He died in Point Clear, Alabama, in 1871.

11. Advertisements in Boston and Mobile newspapers.

12. Ibid.

13. *Le Courrier de la Louisiane*, New Orleans, March 9, 1835, p. 2.

14. *Mobile Daily Commercial Register and Patriot*, October 22, 1833.

15. *Southern Patriot*, February 25, 1835, stranded on Eleuthera on return trip from Rio.

16. City directories.

17. Ibid.

18. His estate was the largest of these brothers. See his probate records: Middlesex County probate files, 1878.

19. *Boston Courier*, June 2, 1836.

20. One example of manufactured goods sold by A. B. Homer into southern ports is tarpaulins (*Mobile Daily Commercial Register and Patriot*, November 26, 1841). Two examples of commodities he sold into New Orleans are a distinctly northern one (cranberries) (*New-Orleans Commercial Bulletin*, February 3, 1836) and molasses from Cuba (*New-Orleans Commercial Bulletin*, March 26, 1836). William Flagg Homer depended heavily on British goods for his crockery-ware store, and advertised widely (*Vermont Watchman*, May 20, 1847).

21. Bowdoin Street Church archives, Series III (B), Examining Committee Membership Records, Box I, Folder 12.

22. *Sermons Delivered on Various Occasions by Rev. Lyman Beecher, D.D.* (Boston: T. R. Marvin, 1828), pp. 76–77.

23. Bowdoin Street Church archives, Series III (B), Examining Committee Membership Records, Box I, Folder 12.

24. Charles's landlord, John C. Proctor (1786–1860), would have known the man for whom Charles served as junior partner, James Butler (b. 1805). See Boston city directories.

25. Charles's partner William Gray (1809–1876) was the son of Sylvanus (1765–1818) and his second wife, Abigail Hinckley Lee (1788–1818). He is not to be confused with his contemporary and cousin, the better-known William Rufus Gray (1810–1892). He and his brother and sisters were raised primarily by his mother's unmarried sister, Martha Lee, daughter of a prominent Marblehead Revolutionary War captain. Although both sides of his family were wealthy, his childhood was challenging, including his being orphaned at nine after the death of his mother (likely at her own hand) and the death of his father by consumption four weeks later. See obituary of Martha Lee, *Cambridge Chronicle* 14, no. 28 (July 9, 1859).

26. Boston newspaper advertisements, such as *Boston Courier*, October 3, 1833, p. 3.

27. See *Boston Atlas*, April 9, 1838, for notice of the dissolution of the partnership with William Gray, selling his inventory to his former boss James Butler, and taking on a new partner, also from their church, Malthus A. Johnson. Johnson married Henrietta's sister Sarah in 1841. See *Boston Atlas*, August 20, 1841, noting that Malthus is from "Cleaveland, Ohio" (*sic*). They were married at a Baptist church in Stonington, Connecticut.

28. Patent for Garden Hoe, 1840, Engraving, U.S. Patent and Trademark Office, No. 1,593.

29. Daniel Buck (1757–1826), father to Henrietta's mother, Sally, had been among those who had founded (and named) the village in 1792. His wife was Mary Sewall (1762–1841). Bucksport was known as Buckstown until 1817. Henrietta's birth month and year are recorded in the pages of the Homer family Bible, Archives of American Art, Smithsonian Institution.

30. He was from Pembroke, in central New Hampshire, on the Merrimack River southeast of Concord.

31. H. H. Price and Gerald E. Talbot, *Maine's Visible Black History: The First Chronicle of Its People* (Gardiner, ME: Tilbury House, 2006), pp. 113–16. See also W. Jeffrey Bolster, *Black Jacks: African American Seamen in the Age of Sail* (Cambridge, MA: Harvard University Press, 1997), especially his tables on pp. 235–39. Solid documentary evidence for Maine's earliest Black mariners is scarce, but it is noteworthy that the Maine 1850 census showed that more than 50 percent of the state's Black population worked in maritime industries (Price and Talbot, p. 113). But as Bolster shows, the important role Black seamen played during the period in which Benson was most active had diminished by the middle of the century (see pp. 220–24).

32. Bolster, op. cit., pp. 122–26.

33. See September 5, 1814, letter by Sally Buck Benson to her husband, John Benson, belonging to Mr. and Mrs. W. Bradford Willauer. The letter, written from Bucksport under British occupation to Benson while he was defending Machias, is a riveting expression of one woman's experience of the War of 1812. A leading citizen of Bucksport, Benson had helped found the Penobscot Bank there in 1806. See *Bangor Historical Magazine* 3, no. 6 (December 1887): 110.

34. *Portland Herald*, January 29, 1821, p. 3, aboard the schooner *Olive*, bound for New Brunswick.

35. The Boston city directory includes John Benson for the first time in 1822, with a home on Green Street, which is consistent with the membership rolls of Park Street Church, which show him and his three eldest children joining in December 1821. The directories for 1825–1829 cite Benson's home as being in Kingston (immediately north of Plymouth, Massachusetts), while Henrietta's spiritual autobiography (Bowdoin Street Church archives, Series III [B], Examining Committee Membership Records, Box I, Folder 21, July 7, 1836) cites her school in Bradford (formerly an independent town but annexed as of 1897 to be a part of Haverhill, Massachusetts). She was formally admitted in September 1836. Interestingly, the Park Street Church rec-

ords in the Congregational Church Archives, Boston, include a letter dated May 8, 1835, from John Benson and others in the parish announcing their intention to depart the church in order to found a new Evangelical Congregational church. This church was first located in the building at the corner of Federal and Franklin Streets, "heretofore known as the Federal Street Theatre" and as the Odeon or Boston Theatre. The parish built a new church in 1841 on the north side of Winter Street, just off Boston Common. Initially known as the Franklin Street Church, at the time of its new building the parish changed its name to Central Congregational Church. Henry J. Benson appears as a Bucksport resident in August 1821 in the *Catalogue of the Officers and Students of Bradford Academy* (American Antiquarian Society, Worcester, MA). No members of the family appear in 1822, but in July 1823, the second member of the family (Homer's mother, Henrietta) appears, as a Boston resident. She and her brother Alfred G. Benson appear again in the roster, as Boston residents, in November 1823 and July 1825.

36. This younger John Benson, born in Boston on November 3, 1824, died on February 10, 1910, at his ranch in Oakville, Napa County, California.

37. The youngest, John, was the only one born in Boston; all the other siblings, like Henrietta, were born in Bucksport. The nine children of John and Sally Benson were:

 1. Clara Matilda Benson (1803–1886), who in 1827 married Rev. Stephen Thurston (1797–1884) in Boston;
 2. Henry John Benson (1804–1889), who married first Julia J. Todd (1816–1866) and second Amanda Melvina Webb (1830–1902);
 3. Alfred Granville Benson (1806–1878), who married Philomela Rollo (1804–1875);
 4. Henrietta Maria Benson (1808–1884) who in 1833 married Charles Savage Homer (1809–1898) in Boston;
 5. Frederick Augustus Benson (1811–1879), who in 1836 married first Lucy B. Churchill (c. 1819–1870) and in 1873 married Mary Jane Greenwood (1828–c. 1910), widow of Reuben Ramsey Homer (1826–1871);
 6. Arthur W. Benson (1812–1889), who in 1850 married Jane Ann Marks (1829–1913) in St. Louis;
 7. Sarah Elizabeth Benson (1815–c. 1895), who in 1841 married Malthus Augustus Johnson (1815–1847) in Stonington, Connecticut;
 8. Maria Swazey Benson (1819–1868); and
 9. John Benson (1824–1910).

 After Sally's death, John in 1833 married Lucy Adams (1792–1867) in Pembroke, New Hampshire. They had one child, George Frederick Benson (1834–1928), who married first Cornelia Elizabeth Whiting (1843–1867) in 1861 in Reading, Massachusetts, and second Emma Florence Barnard (c. 1847–1936) in 1868 in Wayne, Indiana.

 Two of Henrietta's sisters had children (Clara had six daughters and four sons [of whom all daughters survived to adulthood, but only one son], and Sarah had two daughters, Josephine and Virginia, both of whom were important to Homer in their adult lives). Henry, Alfred, Frederick, and Arthur all had children (totaling at least eighteen, and possibly as many as twenty-three). And John's last child, George, had two daughters. These Benson first cousins therefore total at least twenty-seven who reached adulthood, and as many as thirty-two in all.

38. Stephen Thurston was a Congregational minister and an ardent advocate for the abolitionist cause. See *Liberator*, September 13, 1834, p. 146, and May 29, 1840, p. 18, and *The Congregationalist*, June 13, 1877, and Thurston's letter of December 30, 1834, to Rev. Amos Augustus Phelps, Agent for the American Anti-Slavery Society, Wrentham, MA (Boston Public Library, MS A.21.4 [79]). He received his theological training at Bangor Theological Seminary (from which he graduated in 1825) and an honorary degree from Bowdoin College (1846).

39. Bowdoin Street Church archives, Series III (B), Examining Committee Membership Records, Box I, Folder 21, July 7, 1836.

40. See Garth M. Rosell, *Boston's Historic Park Street Church: The Story of an Evangelical Landmark* (Grand Rapids, MI: Kregel Publications, 2009), p. 87, and H. Crosby Englizian, *Brimstone Corner: Park Street Church, Boston* (Chicago: Moody Press, 1968), pp. 97–112. Edward Beecher was called away from Park Street in 1830. His successor, Joel H. Linsley, who officiated at the 1833 wedding of Henrietta M. Benson and Charles S. Homer, remained at the church from 1832 to 1835. Linsley's successor, Silas Aiken, served for eight years, from 1837 to 1845.

41. See *Sixth Annual Report of the Board of Managers of the Massachusetts Anti-Slavery Society* (Boston: Isaac Knapp, 1838), p. 50.

42. *The Liberator* VIII, July 13, 1838, p. 111. See also *The Liberator* V, June 27, 1835, p. 103, and *Right and Wrong in Massachusetts*, by Maria Weston Chapman (Boston: Henry L. Devereux, 1840), p. 175, where Winslow is described as "the well-known pro-slavery divine."

43. Gordon Hendricks, *The Life and Work of Winslow Homer* (New York: Harry N. Abrams, 1979), p. 13. Hendricks often makes wild leaps of illogical inference, but in this case he appears correct. And as he observes, Winslow Homer's longtime friend and fellow history buff Hubbard Winslow Bryant (1839–1917) was named after Winslow, too. The unusual first name of the future painter strongly appears to reflect the connection to his pastor, and not one to Edward Winslow (1595–1655), a governor of the Plymouth Colony, or to some other Bostonian Winslow.

44. Birth date from Homer family Bible, Archives of American Art, Smithsonian Institution. Note that A. B. Homer's gravestone and many other records state his birth year as 1841, which the Bible suggests is erroneous.

45. Alfred G. Benson (1806–1878) and Arthur W. Benson (1812–1889) both settled in New York (as sometime partners) and were highly successful in multiple fields, from shipping to real estate to fertilizers to natural gas distribution; see their *New York Times* obituaries on April 20, 1878, and December 29, 1889, respectively. The eldest son, Lieutenant Henry John Benson (1804–1889), worked as a merchant, a mariner, and a farmer in Ohio, with little economic success; Frederick Augustus Benson (1811–1879) remained in the Boston area, working with their father as a coal and wood dealer. The youngest, John, noted above, participated successfully in the Gold Rush, settling in San Francisco and becoming active in that city's cultural life.

46. Letter of President John Tyler, Wednesday, February 26, 1845, included in Documents of the 28th Congress of the House of Representatives of the United States, 2nd Session, No. 161, p. 21. A House investigation of the contract led to Tyler's explanation very shortly before his leaving office. It is noteworthy that three days later, on March 1, a joint resolution of the House and Senate approved the annexation of Texas. See also Will Bagley, "'Everything Is Favourable! And God Is on Our Side': Samuel Brannan and the Conquest of California," *Journal of Mormon History* 23, no. 2 (1997): 185–209, in which Arthur's role in settling Oregon, with federal subsidies, is described in vivid detail; Bagley's book *So Rugged and Mountainous: Blazing the Trails to Oregon and California, 1812–1848* (Norman: University of Oklahoma Press, 2010) addresses the same subject in a broader context.

47. See *Public Statutes at Large of the United States of America* VIII (Boston: Little, Brown, 1867), pp. 248–50, particularly Article 3 on p. 249. While the treaty included a ten-year sunset provision, the two countries renewed its essential terms several times, until signing the Treaty of Oregon.

48. Also referred to as the Buchanan-Pakenham Treaty, or the Treaty with Great Britain, in Regard to Limits Westward of the Rocky Mountains, signed June 15, 1846.

49. Signed February 15 and passed by the Senate on March 10, 1848.

50. See *Memorial of Alfred G. Benson to the Senate and House of Representatives of the United States*, January 8, 1855, for Benson's explanation of his efforts to effectuate an American empire in the South Pacific based on guano.

51. *New York Herald*, January 18, 1849, p. 1, traveling on the *Harriet T. Bartlett* via Chagres, an Atlantic port on the Isthmus of Panama.

52. The vessel was the *George Emery*, departing New York by the longer route around Cape Horn.

53. *Yankee Trader in the Gold Rush: The Letters of Franklin A. Buck* (Boston and New York: Houghton Mifflin, 1930). See particularly the letters of December 17, 1848, January 17 and October 25, 1849, and April 4, 1851. The pair were traveling with at least three other friends: Benjamin Franklin Pond (1819–1895), Charles Battell Loomis (1812–1877), and Joshua Sands Henshaw (1829–1883).

54. *Boston Atlas*, November 13, 1849.

55. 1850 Federal Census, Butte County, California. NARA Roll M432_33, p. 31A, image 67. Two of Benson's fellow passengers on the *Harriet T. Bartlett* (B. F. Cheeseman and Edward M. Burrows) were living with Benson at the time.

56. Arriving on the steamship *Isthmus* as one of 285 passengers, according to the *Daily Alta California* I, July 13, 1850, p. 167.

57. Nathaniel Currier (1813–1888), "The Way They Go to California," 1849. Lithograph on paper, 33.4 × 49.2 cm. Library of Congress, 91481165.

58. Charles is listed as among the passengers on the *Empire City* in the *North American & United States Gazette*, December 9, 1850. He is also listed in the *Newark Daily Advertiser*, May 15, 1852, arriving on the *Baltic* in New York with his fellow Bostonians R. Kendall and W. P. Barnard, so it is possible that there were multiple trips, or that he stayed for a longer period and that the *Empire City* passenger is another person. The short stay in California appears the most probable.

59. Ellen Robbins, "Reminiscences of a Flower Painter," *New England Magazine* XIV, 1896, pp. 440–51 and 532–45.

60. These events, typically held just before Christmas, grew in size through the 1840s and 1850s. A detailed advertisement for the 1845 bazaar, including floral work, was published in the *Boston Atlas* on December 23, 1845.

61. As Kathleen A. Foster has demonstrated vividly (Foster, 2017, op. cit., p. 9), a popularizing movement was underway. At the same moment, long-standing traditions of folk art, such as Shaker drawings and furniture, and elaborately illuminated German American Fraktur drawings and furniture, were also becoming better known outside those communities.

62. Boston city directories list the business address for Charles annually for most of the 1830s and 1840s. The directories also but more sporadically list the family's home address; 7 Bulfinch Street is listed in five directories (1839–1843), and then no home address is listed for the following three years. The directory for 1847–1848 lists a residence only as "Cambridge."

63. Cambridge directories were first published in 1847, initially with a listing only for businesses. The 1848 Cambridge directory (the first with residential listings) includes a listing for both Charles and his father-in-law. Even though in each case the location reflects the men's home addresses, they indicate them as business addresses ("Main Street, Dana Hill" for Charles and "Mason Street" for John Benson).

64. The church was then located on Mount Auburn Street at Holyoke Street, close to Harvard Yard. Only in 1872 did the church build its current complex, at the corner of Garden and Mason Streets. The church is a stone's throw from the 8 Garden Street house (long since razed) at which the Homer family lived in the late 1840s and early 1850s.

65. *The Works of Daniel Webster*, ed. Edward Everett II, p. 393 (Dinner of the Charleston Bar, May 10, 1847).

66. Charles is listed in *Boston Atlas*, November 14, 1842, and Henry in a leadership role, *Boston Atlas*, September 1, 1842. *The Constitution and By-Laws of the Harrison Club of Boston* (1840) lists the leading Whigs of Charles S. Homer's generation, including his sometime business partner George Leighton and his cousin George F. Homer.

67. See *Cambridge Chronicle* 4, no. 32 (August 9, 1849). While Barlow (1834–1896) was far more prominent in the Civil War, the detailed letters of Noyes (1838–1908) provide much insight (Houghton Library, Harvard).

68. Cambridge Historical Society, Auburn Grammar School records, September 1850; Daniel Mansfield, master, shows Winslow as a student with a good attendance record, but the graduation records for Cambridge high schools do not include either boy.

69. "Depos'd October 3. 1853 / See Vol. 28 Page 422 / Oliver Ditson propr." Inscribed on the Library of Congress impression of "Katy Darling" (*Record of Works by Winslow Homer*, Goodrich/Gerdts [hereafter *RWWH*], vol. I, p. 92) in script that Abigail Booth Gerdts considers mid-nineteenth-century.

70. George W. Sheldon, "American Painters: Winslow Homer and F. A. Bridgman," *Art Journal* 4 (1878): 225–29.

71. Homer's earliest Bufford work of 1853 might have preceded a formal apprenticeship, but Abigail Booth Gerdts's illuminating discussion of Homer's lithograph for the cover of "Katy Darling, a favorite song" appears to pin the start of his illustration career to 1853. See *RWWH*, I, p. 92, including a photograph of the Library of Congress's impression of "Katy Darling," with an inscription suggesting that the impression entered the library on October 3, 1853.

72. Elizabeth Hodermarsky, "The Role of Prints in the Cultivation of an Image-Hungry America: Teaching from Yale's American Print Collections," *Yale University Art Gallery Bulletin*, The Original Work of Art: What It Has to Teach (2003), p. 48.

73. See *Philadelphia on Stone: Commercial Lithography in Philadelphia, 1828–1878*, ed. Erika Piola (State College: Pennsylvania State University Press, 2012), p. 233, n. 164.

74. Ibid.

75. Sheldon, 1878, op. cit., p. 226.

76. The others, as per *RWWH*, I, pp. 93–101, are *O Whistle and I'll Come to You My Lad* (1854); *Annie Lawrie* (1855); *The Ratcatcher's Daughter* (1855); *The Wreath* (1855); *National Songs of America* (1855); *The Queen's Waltzes* (1856); *Polka Mazurkas* (1856–1857); *Roger's Quickstep* (1856); and *The Wheelbarrow Polka* (1856). In David F. Tatham's definitive study of the subject, "Some Apprentice Lithographs of Winslow Homer: Ten Pictorial Title Pages for Sheet Music," *Old Time New England* 59 (Spring 1969): 87–104, he questions Homer's authorship of *Polka Mazurkas*. Nine of the eleven were developed for Oliver Ditson & Co., whose music store was at 115 Washington Street, close to the Bufford shop.

77. The author is indebted to Kathleen A. Foster, who pointed out that the dome Homer depicts on the left is that of St. Paul's Cathedral. The woman described in the title falls off a bridge into the Thames to drown on the right, leaving to their own devices the oily forage baitfish she peddled (sprats, genus *Sprattus*, family *Clupeidae*).

78. William F. Hunter, Jr., *Ottawa Scenery*, 1855. Hunter was a well-traveled spokesman for the natural beauty of his native Quebec and other parts of eastern Canada.

79. Advertisement in *Liberator*, January 3, 1851. This print, priced at 25 cents, was published prior to Homer's association with the shop.

80. Abner Morse (1793–1865) published a series of genealogical books and pamphlets for which Homer prepared portraits. David F. Tatham's *Winslow Homer and the Illustrated Book* (Syracuse, NY: Syracuse University Press, 1992) discusses these as well as other examples of Homer's early illustrations.

81. Massachusetts Senate, 1856, *RWWH*, I, p. 103.

82. William L. Champney (c. 1833–1880) is best known for this work. Revere's engraving is entitled *The Bloody Massacre perpetrated in King Street Boston on March 5th 1770, by a party of the 29th Regt.*, 1770. It is based closely on another engraving by his friend Henry Pelham (1749–1806), entitled *The Fruits of Arbitrary Power, or The Bloody Massacre*. It includes an utterly plaintive quotation from the depths of Psalms 94:4–7: "How long shall they utter and speak hard things? And all the workers of iniquity boast themselves? They break in pieces thy people, O Lord, and afflict thine heritage. They slay the widow and the stranger, and murder the fatherless. Yet they say, I Lord shall not see, neither shall the God of Jacob regard it." Pelham completed his engraving before Revere completed his, but Revere published his engraving first; his fame has overshadowed his ethical behavior in the case. Champney's design for Bufford (and for his picture framer customers Henry Q. Smith and Thomas A. Arms) is entitled, more simply, *The Boston Massacre, March 5th, 1770*. Crispus Attucks (c. 1723–1770) is often described today as the first casualty of the American Revolution. See American Antiquarian Society and Clarence S. Brigham, *Paul Revere's Engravings* (New York: Atheneum, 1969), pp. 52–78. The enterprising picture framers commissioned Bufford to make this print.

83. William C. Nell, *The Colored Patriots of the American Revolution* (Boston: Robert F. Wallcut, 1855). The book's frontispiece depicts the same scene as Champney's print.

84. From a speech Beecher gave in New York, honoring Sumner, at the Tabernacle, May 30, 1856.

85. *The Crime Against Kansas; The Apologies for the Crime; The True Remedy. Speech of Hon. Charles Sumner, in the Senate of the United States, 19th and 20th May, 1856* (Boston: John P. Jewett, 1856). Much of Sumner's speech speaks to sexual predation through coded language to comply with Senate rules and makes ample use of parallels with Roman history and mythology. See Michael D. Pierson, "'All Southern Society Is Assailed by the Foulest Charges': Charles Sumner's 'The Crime Against Kansas' and the Escalation of Republican Anti-Slavery Rhetoric," in *The New England Quarterly* 68, no. 4 (December 1995): 531–57.

86. Thomas Bailey Aldrich, "Among the Studios," *Our Young Folks*, July 1866, p. 396.

87. Barrett Wendell, "The Influence of the Athenaeum on Literature in America," in *The Influence and History of the Boston Athenaeum, 1807–1907* (Boston: Boston Athenaeum, 1907), pp. 11–12.

88. *The Bulletin of the New England Art Union*, 1852, as quoted in Robert F. Perkins, Jr., and William J. Gavin III, *The Boston Athenaeum Art Exhibition Index 1827–1874* (Boston: Library of the Boston Athenaeum, 1980), p. xiii.

89. Ibid.

90. Ibid. The lender of the Millet was the young Martin Brimmer (1829–1896), who would become the first chairman of the board of the Museum of Fine Arts; a roofer named Thomas J. Herring (1825–1895) lent the Lane and the Rondel; and the great promoter of music and visual arts in Boston, Charles Callahan Perkins (1823–1886), lent the marine by Thomas Birch.

91. Oath of Citizenship, April 4, 1855, Boston.

92. See Thomas Butler Gunn Diary, Missouri History Museum, February 3, 1860, vol. 12, pp. 37–38.

93. Ibid., p. 38.

94. Lent by Quincy Adams Shaw; see Perkins and Gavin, op. cit., p. 60.

95. See William Henry Downes, *The Life and Works of Winslow Homer* (Boston: Houghton Mifflin, 1911), p. 29. Downes places the incident in "Dobson's picture gallery," which appears not to have existed. But the Frere painting's subject matter and its history of being lent to the Athenaeum exhibition in 1858 lends the story a credibility often lacking in Downes's source material. Downes places Cole, Baker, and the portraitist Moses Wight (1827–1895) at the scene of Homer's declamation.

96. Sheldon, 1878, op. cit., p. 226.

97. See *Cambridge Chronicle*, February 12 and 19, 1853, sending British newspapers and magazines (including *Punch*) from London; and *The Boston Atlas*, February 15, 1855, as he sails on the *Africa* from Boston for Liverpool.

98. Letter in private collection, February 13, 1857, quoted in Hendricks, op. cit., pp. 29–31.

99. Hendricks quotes a letter dated March 19, 1857, from Alfred C. Howland that can be read as suggesting that on that date, Homer was still at Bufford's. See p. 28, citing a letter that appears to be in the Charles Prentice Howland Family Papers, MS 292, Yale University Library Manuscripts and Archives, Box 1, Folders 25, 27, and 28.

100. *Illustrated London News*, May 14, 1842, p. 1.

101. See Mason Jackson, *The Pictorial Press: Its Origin and Progress* (London: Hurst and Blackett, 1885), p. 315.

102. Sarah E. Fuller, *A Manual of Instruction in the Art of Wood Engraving* (Boston: Joseph Watson, 1867), pp. 16–18.

103. A specific example from December 15, 1876, provides details of the economics involving two gifted artists Homer knew well. Mary Hallock Foote (1847–1938) as illustrator and Andrew Varick Stout Anthony (1835–1906) as wood engraver developed eighteen designs for the Houghton & Company production of Longfellow's *Skeleton in Armor*. Hallock was paid $730 and Anthony $2,066. See the Ticknor firm cost books, Houghton Library, Harvard University (Ms. Am 2030.2 [21]), p. 182, and the discussion of the topic in April F. Masten's *Art Work: Women Artists and Democracy in Mid-Nineteenth-Century New York* (Philadelphia: University of Pennsylvania Press, 2008), pp. 155–60.

104. See "Maturin M. Ballou and the Editor Function," in *Hemispheric Regionalism: Romance and the Geography of Genre*, by Gretchen J. Woertendyke (Oxford: Oxford University Press, 2016), p. 105. A prolific writer of fiction and travel books himself, he had wide influence as an editor of a variety of periodicals, from *Flag of Our Union* to *The Boston Globe*. Writers whose work he published included Louisa May Alcott, Horatio Alger, and Edgar Allan Poe.

105. The issue of June 27, 1857. *Ballou's* generally avoided subjects that might irritate its Whig readers; nowhere in the profile of Mobile is slavery mentioned. The conclusion of that article includes the statement that a visitor to Mobile "sees the elements of prosperity quietly and effectively worked out; he is surrounded by evidences of wealth and of business transactions resting on a solid basis" (p. 408). However, the same issue includes an excerpt from a letter an anonymous reader had sent from Havana: "The slave trade continues, and I am sorry to see that American vessels are engaged in it to an extent never before known. Several vessels have left this port quite recently, against which strong suspicions existed of their being intended for the slave trade" (p. 415).

106. See *Winslow Homer and the Pictorial Press*, by David Tatham (Syracuse, NY: Syracuse University Press, 2003), pp. 207–16. Tatham's meticulous observation of these wood engravings illuminates the fact that Fred. E. Fox, George H. Hayes, and Edmund N. Tarbell also engraved a few of Homer's designs.

107. Lay is listed at the same 24½ Winter Street location in 1858 and 1859. He is also listed in 1857 as a "photographist" working with the better-known John B. Heywood. See the draft record of June 27, 1863, for the Fourth Congressional District of Massachusetts, p. 199, listing him as living at 155 Pleasant Street, which was the address of Pfaff's Hotel. The state census taken on May 1, 1865, for Boston's Ninth Ward shows him in the same location. The proprietor is identified as "C. Pfaff," born in about 1809 in Germany. He was presumably the Charles Pfaff who was operating the German Coffee House at that location by 1836. This author has been unable to trace Lay after 1865, or to ascertain whether his landlord was related to the New York publican Charles Ignatius Pfaff (1813–1890), who knew many women and men in Homer's circle. See

https://pfaffs.web.lehigh.edu for the treasure trove the Lehigh University professor Edward Whitley has curated about the Bohemian hothouse that the younger Pfaff operated. See also Stephanie M. Blalock, *Go to Pfaff's!: The History of a Restaurant and Lager Beer Saloon* (Bethlehem, PA: Lehigh University Press, 2014), for a detailed analysis of that catalytic New York establishment.

108. The issue of August 1, 1857, just seven months after the newspaper's first issue. The Quebec-born John Bonner joined as managing editor the following year.

109. Forbes was a very prominent figure in Boston, engaged in everything from the China trade (including opium) to ship design, construction, and financing, to charitable aid during the Irish Famine. The text that accompanied Homer's wood engraving names a photograph by Silsbee, Case & Co. as Homer's source material, rather than a life sitting.

110. See Tatham, 1992, op. cit.

2. A TASTE OF FREEDOM (1859–1862)

1. 1860 Federal Census; Census Place, *New York Ward 18 District 2, New York, New York*, p. 290, Family History Library Film: 803814. New York's 1861 street renumbering project converted the house, then known as 52 East Sixteenth Street, to 128 East Sixteenth Street. The house is still standing, just east of Irving Place. The census keeper made his record on June 15, 1860, including an erroneous first name (James) for Homer.

2. Born in Edinburgh on May 3, 1798, Jane Ramsey Cushman grew up in Baltimore until the age of twenty, when she moved to Richmond, where she married Alexander Cushman on November 11, 1822. A son of Elkanah Cushman of Boston, he was born on April 27, 1797, and died in Richmond in October 1841, according to the *New York Evening Post*, October 25, 1841, which describes him as from Richmond. See Henry Wyles Cushman, *A Historical and Biographical Genealogy of the Cushmans* (Boston: Little, Brown, 1855), pp. 495–96 and 595–96 for details of their children.

3. One of the six bachelors is assumed to have replaced Alfred C. Howland, who according to his diary, quoted in Lloyd Goodrich, *Winslow Homer* (New York: Macmillan, 1944), p. 11, departed early in June for Europe. The diary belonged to Howland's daughter Alice Howland Montgomery (1879–1961) at the time of the publication of Goodrich's book. It can no longer be located, at least by this author.

4. The letters from April 11, 1858, and January 29, 1860, in the Charles Prentice Howland Family Papers, Yale University Library Manuscripts and Archives, MS 292, b. 1, f. 27, provide further insight into Alfred's artistic development and the brothers' life at the Cushman residence.

5. See "Obituary Record of Yale Graduates, 1913–1914," *Bulletin of Yale University* 19, no. 8 (June 1914): 545–47.

6. Howland family papers, op. cit.

7. Ibid.

8. Thomas Butler Gunn diaries, Missouri History Museum, vol. 12, p. 24.

9. Ibid., vol. 12, p. 37.

10. Sheldon, 1878, op. cit., p. 227.

11. Ibid. See also Thomas Butler Gunn diaries, Missouri History Museum, vol. 14, p. 82.

12. *Harper's Weekly*, March 19, 1859, p. 180.

13. Homer's friend Alfred R. Waud disliked Nast personally, writing in a letter of July 5, 1862, "I heard Nast was with you. Between you and I, I detest him . . ." (Library of Congress, to "Friend Paul" from Camp Lincoln, James River).

14. October 3, 1859, National Academy of Design records, 1817–2012. Archives of American Art, Smithsonian Institution, Reel 5051. See also Sheldon, 1878, op. cit.

15. Benson was elected a member of the Century on March 5, 1864, at age twenty-three, on the nomination of Jervis McEntee and Sanford Robinson Gifford (1823–1880). The available evidence suggests that he was unrelated to Homer's mother's family. His father, Benjamin P. Benson (1794–1868), was from an old New York family, according to his obituary in the March 12, 1868, issue of the *Christian Intelligencer of the Dutch Reformed Church.*

16. Elliot Bostwick Davis, "American Drawing Books and Their Impact on Winslow Homer," *Winterthur Portfolio* 31, nos. 2/3 (Summer–Autumn 1996): 141–63. See also Lisa Fellows Andrus, *Measure and Design in American Painting, 1760–1860* (New York: Garland, 1977).

17. Rembrandt Peale, *Graphics: A Manual of Drawing and Writing for the Use of Schools and Families* (New York: J. P. Peaslee, 1835).

18. Ibid., p. 84 ("Study of the Egg").

19. Letter of January 5, 1863, by Eugene Benson, sold on June 26, 2020, by Cowan's Auctions as part of Lot 319 in its American Historical Ephemera and Photography Auction. A man identified only as Gifford also attended these dinners. He was likely Sanford Robinson Gifford but possibly Robert Swain Gifford (1840–1905); each was a friend of Homer's.

20. "Walt Whitman and American Art," *New York Saturday Press* 3, no. 26 (June 30, 1860): 2.

21. John W. Beatty, quoting Homer in the introductory note to William Howe Downes, *The Life and Works of Winslow Homer* (Boston: Houghton Mifflin, 1911), p. xxvii.

22. Ibid.

23. Edward Verrall Lucas, *Edward Austin Abbey, Royal Academician: The Record of His Life and Work* (New York: Charles Scribner & Sons, 1921), vol. I, p. 38.

24. The daguerreotype of Draper's sister, Dorothy, was displayed at the World's Columbian Exhibition, where, lamentably, it was damaged. Given the work's significance, Draper's son Daniel made a copy that year (1893), which the family gave to the Smithsonian's National Museum of American History, accession #304826.

25. Ibid., pp. 38–39.

26. Homer may have met Morse through mutual friends; the inventor-artist was briefly a member of the Century Association prior to Homer's election to the club.

27. Thomas Bailey Aldrich, "Among the Studios, III," *Our Young Folks,* July 1866, p. 394.

28. Ibid., p. 395.

29. New York City directories.

30. Sheldon, 1878, op. cit., p. 226.

31. Ibid.

32. Thomas Butler Gunn diaries, Missouri History Museum, vol. 14, p. 82.

33. *New York Times,* November 3, 1860, p. 4 ("General City News").

34. That same year, Page delivered his lecture "A New Geometrical Method of Measuring the Human Figure," which was published in somewhat different form in *Scribner's Monthly* XVII, April 1879, pp. 984–88. It is highly consistent with the ideas in Homer's drawing.

35. In fact, Bufford's would replicate the watercolor in a lithograph the following year. It appears not to be set to stone by Homer.

36. *Harper's Weekly,* December 22, 1860, p. 802.

37. Sheldon, 1878, op. cit., p. 226.

38. James McPherson, "A Brief Overview of the American Civil War: A Defining Time in Our Nation's History," civilwar.org, www.civilwar.org/education/history/civil-war-overview/overview.html.

39. See Ted Widmer, *Lincoln on the Verge: Thirteen Days to Washington* (New York: Simon & Schuster, 2020), a superb evocation of every moment and every mile of this journey.

40. *New York Herald*, February 20, 1861, as cited in Widmer, op. cit., p. 332.

41. Walt Whitman, *Complete Prose Works* (Philadelphia: David McKay, 1892), p. 308.

42. Widmer, op. cit., p. 333.

43. *Harper's Weekly*, March 2, 1861.

44. Frank H. Goodyear III, "A Good Thing When He Sees It," in *Winslow Homer and the Camera: Photography and the Art of Painting* (Brunswick, ME: Bowdoin College Museum of Art, 2018), p. 8.

45. In August 1857, Johnson's father, Philip, married Mary Washington James, a collateral relation of George Washington, which afforded Johnson plentiful access to the house. He painted as many as six pictures of the Mount Vernon kitchen and just one exterior view. That picture, *The Old Mount Vernon*, 1857 (oil on board, M-4863, Mount Vernon Ladies' Association), was purchased in 2009 with funds courtesy of an anonymous donor and the Mount Vernon Licensing Fund. The author is indebted to Peter H. Wood for drawing my attention to this important precedent for Homer's drawing. He also makes the point that during the four years between the Johnson picture and the Homer drawing, a national campaign had succeeded in buying the house to restore it, in recognition that its neglected condition epitomized the disrepair of the country. Homer's eyewitness account suggests that such restoration had not yet begun.

46. Peter H. Wood and Karen C. C. Dalton, *Winslow Homer's Images of Blacks: The Civil War and Reconstruction Years* (Austin: University of Texas Press for the Menil Collection, 1988), pp. 22–23. Wood and Dalton deftly discuss "the fact that a small trickle of enslaved persons was beginning to emerge from beneath the large and darkened structure of plantation society." This trickle would turn into a mighty stream of profound meaning to Homer.

47. *Harper's Weekly*, April 27, 1861, p. 269. David Tatham includes the print in his *Winslow Homer and the Pictorial Press* (2003), and notes the "H" characteristic signature at lower left.

48. In his *Winslow Homer and the Pictorial Press*, David Tatham includes neither this print of April 27, 1861, nor the Ellsworth-related print of June 8, 1861. But in an email to the author dated July 17, 2020, he confirmed that he now considers both of them to have been executed after Homer's designs. Given the lack of foliage on the trees Homer depicts in the print, it seems likely that he made the drawing while in Washington for the Inauguration, and that the caption, and the speed of action in the war, led the editors to associate it with General Thomas's swearing in the volunteers the following month.

49. *Harper's Weekly*, April 27, 1861.

50. *Harper's Weekly*, June 8, 1861. Note that the text, on page 359, misidentifies the month as March and, citing the *Herald*, suggests that the 5th New York was present; neither is true. The caption is correct.

51. Ibid.

52. See Adam Goodheart, *1861: The Civil War Awakening* (New York: Vintage Books, 2011), pp. 269–92. See also Marc Leepson, "The First Union Civil War Martyr: Elmer Ellsworth, Alexandria, and the American Flag," in *Alexandria Chronicle*, Alexandria Historical Society, Fall 2011.

53. House (1836–1901) was a Bostonian who would go on to found the *Tokio Times*, with financial backing from the Japanese government.

54. Goodheart, op. cit., p. 193. De Villiers's arrest in Baltimore in 1866 raises the possibility that for many years he was a huckster and a fraud, not French, known as De Villiers only when he wished to be, and never in the French Zouaves at all. See *Chicago Tribune*, August 3, 1866, "The City." Note that the correct pronunciation of the word *Zouave* is "Zoo-Have," with an emphasis on the first syllable.

55. Ibid., p. 193.

56. John Hay, "Ellsworth," in *Atlantic Monthly* VIII, July 1861.

57. Newspaper clipping, undated, in *History of U.S. Zouave Cadets, G.G. Military Champions of America, 1859–60*, Library of Congress General Collections, UA178.Z8.H6, as cited in Goodheart, op. cit., p. 194.

58. Hay, op. cit.

59. The regiment crossed by steamship, rather than by bridge.

60. Frederic E. Ray, *Alfred R. Waud: Civil War Artist* (New York: Viking Press, 1974), p. 18.

61. *Boston Daily Advertiser*, September 14, 1861, p. 4, and "Charles S. Homer vs. William F. Homer," in *Massachusetts Reports 107: Cases Argued and Determined in the Supreme Judicial Court of Massachusetts, March-October 1871*, Albert G. Browne, Jr., Reporter (Boston: H. O. Houghton, 1873), pp. 82–87 and 663–64.

62. The pass, dated October 15, 1861, has been identified as being in the collection of the Strong Museum, Rochester, New York. A letter from *Harper's* dated October 8, 1861, requesting this pass is in the collection of Mount Vernon. *RWWH*, I, pp. 119 and 127. As Abigail Booth Gerdts notes, *Harper's* provided official credentials to its staff artists, naming six of them (and notably not Homer) in the June 3, 1865, issue (p. 339), including Theodore R. Davis (1840–1894), Andrew McCallum (1821–1902), Andrew W. Warren (1828–1873), Alfred R. Waud (1828–1891), his brother William Waud (1831–1878), and the West Point drawing instructor Robert W. Weir (1803–1889), father to two friends of Homer's who were accomplished artists themselves. The list is interesting as A. R. Waud and Davis appeared to contribute more than half of the total Civil War illustrations *Harper's* published, and Weir and McCallum contributed very little; and the list omits not only Homer as a freelancer but also three others (John R. Hamilton, 1825–1901; Henry Mosler, 1841–1920; and Alexander Simplot, 1837–1914), each of whom contributed three dozen or more illustrations over the course of the war. See William P. Campbell, *The Civil War: A Centennial Exhibition of Eyewitness Drawings* (Washington, DC: National Gallery of Art, 1961), p. 107 (Appendix I).

63. Hendricks, op. cit., p. 45, quotes the privately held letter. Homer's landlady, the former Sarah Jane Burch (1827–1929), was the Maryland-born widow of a Bostonian who fought in the War of 1812, Adams Foster (1794–1860), and the mother then of four-year-old twin sons, Romulus and Remus.

64. They were Fort Lyon and Fort Ethan Allen, each of which began construction in September 1861; see *RWWH*, #64 and #65. He seems to have been unable to sell these drawings to *Harper's* and the inscriptions on them suggest that he was not present to make the pitch to the editors on their behalf, or to draw the illustrations on the block himself. This is consistent with the idea that his fall 1861 visit to the Potomac was a few weeks long. If it had been shorter, he would not have sent drawings to New York by mail and instead would have kept them for his own in-person presentation to the editors.

65. Hendricks, op. cit., pp. 44–45, suggests based on a privately held letter that Homer arrived in Belmont for Thanksgiving on October 21, 1861, and left shortly thereafter. It appears more likely that the Homer family celebrated Thanksgiving on the official state holiday of November 21 (the celebration occurred a week later in most states that year).

66. Palfrey married Louisa C. Bartlett (1839–1897) just as the war was ending, on March 29, 1865, at the Unitarian King's Chapel in Boston, a stone's throw from one of his favorite haunts, the Boston Athenaeum.

67. See James L. Bowen, *Massachusetts in War, 1861–1865* (Springfield, MA: Clark W. Bryan, 1889), pp. 293–95 and 1003–1004. On p. 312, in the description of the 20th Regiment, he explains that Camp Benton then housed the 19th Massachusetts, the 20th Massachusetts, the 7th Michigan, and the First Company of Andrew Sharpshooters, which together formed General

Lander's Brigade of General Stone's Corps of Observation. See also Ernst Linden Waitt for the History Committee, *History of the Nineteenth Regiment, Massachusetts Volunteer Infantry, 1861–1865* (Salem, MA: Salem Press, 1906).

68. Waitt, op. cit., pp. 2–3.

69. Wood and Dalton, op. cit., p. 31., and private email from Peter H. Wood to the author, July 7, 2021.

70. Wood and Dalton, op. cit., p. 31., and private email from Peter H. Wood to the author, July 7, 2021.

71. Wood and Dalton, op. cit., pp. 29–32.

72. The lithograph was a page from a series for drawing instruction; the subject on this page was the head, neck, and left hand of a female figure resting on an urn. The series was drawn by the French academic painter and teacher Leon Cogniet (1794–1880), with lithography by Bernard Romain Julien (1802–1871), and published about 1846 by Lemercier.

73. Solomon Northup, *Twelve Years a Slave* (Auburn, NY: Derby and Miller, 1853).

74. Wood and Dalton, op. cit., pp. 23–29.

75. Signed into law August 6, 1861, the act declared that enslaved persons being used to support the Rebellion were property subject to confiscation—a step, albeit only a first step, toward declaring such persons free.

76. Wood and Dalton, op. cit., p. 27.

77. Ibid., p. 46, a privately held letter of January 1, 1862.

78. Hendricks, op. cit., p. 45, a privately held letter of December 17, 1861.

79. Ibid. Arthur was commissioned on September 13, 1861, on the 197-foot *Ohio* (a three-masted ship of the line built in 1820, then operating as a receiving ship). He was transferred to the newly commissioned *Kingfisher*, a 121-foot barque, for service as part of the Gulf Blockading Squadron, initially near Key West. The *Kingfisher* saw very active duty over the next year, capturing Confederate and foreign vessels in the Gulf of Mexico, including several on the same trade routes that Homer's Mobile- and Boston-based uncles had traveled for years. By the fall of 1862, scurvy and other hardships, and the need to repair the vessel, prompted her return to Boston, where Arthur was discharged on November 12, 1862. He then reenlisted on February 17, 1863, again on the receiving ship *Ohio*, this time as an acting master's mate. His service continued under appointment on February 24, 1864, as an acting ensign on the *Argosy*, a newly commissioned 156-foot stern-wheeled river steamship serving as a gunboat and supply ship in the Western Theater of the war, on the Ohio, Cumberland, Tennessee, and Mississippi rivers. That ship saw considerably less activity. He was discharged on November 18, 1865, as an acting ensign. See his application for naval pension at www.fold3.com/image/60865859 and James L. Mooney, *The Dictionary of Naval Fighting Ships* (Navy Dept., Office of the Chief of Naval Operations, Naval History Division, 1959–1981).

80. Letter in a private collection, location unknown, and reproduced in Hendricks, op. cit., pp. 46–47.

81. James M. McPherson in *Tried by War: Abraham Lincoln as Commander in Chief* (New York: Penguin Press, 2008), p. 66, quotes Lincoln as exclaiming on January 10, 1862, "If General McClellan does not want to use the army, I would like to borrow it for a time."

82. The postscript of the letter cited in Hendricks, op. cit., pp. 46–47, gives the date of Homer's departure at "Wednesday afternoon," that is, March 26, 1862. The Army of the Potomac was organized into three corps and other units. Each corps was divided into typically two or more divisions, each of which was composed of two or more brigades. Within each brigade were found two or more regiments, each of which comprised roughly ten companies, each initially composed of one hundred men, but more typically about thirty as casualties mounted. These companies were themselves subdivided into platoons and squads.

Homer's work of April and May 1862 is replete with inscriptions, most of which appear to

be contemporaneous. Many refer to specific individuals and battle units. For the sake of clarity, the following paragraphs identify the leaders of the forces he depicted, many of whose names appear inscribed on these drawings or published in text associated with Homer-designed wood engravings of the period.

Brigadier General Edwin Vose Sumner (1797–1863), the oldest of the generals in the Army of the Potomac, was then in command of the II Corps, including the First Division, led by Israel B. Richardson (1815–1862), and the Second Division, led by John Sedgwick (1813–1864). The First Brigade, led by Oliver O. Howard (1830–1909) under Richardson, included four regiments, one of which, the 61st New York, was led by Francis Channing Barlow. Within Sedgwick's division, the First Brigade, led by Willis A. Gorman (1816–1876), included three regiments, and the Third Brigade, led by Napoleon J. T. Dana (1822–1905), was composed of the 19th and 20th Massachusetts regiments, and the 7th Michigan and 42nd New York.

In another corps, III Corps (led by Samuel Heintzelman, 1805–1880), the Third Brigade (led by Daniel Butterfield, 1831–1901) of the First Division (led by Fitz John Porter, 1822–1901), included Berdan's Sharpshooters, also known as the 1st U.S. Sharpshooters. That corps included in its Second Division, under Joseph Hooker (1814–1879), two other regiments Homer drew: the 1st Massachusetts, in the First Brigade, led by Henry Morris Naglee (1815–1886), and the 70th New York, within the Second Brigade, led, respectively, by William Dwight, Jr. (1831–1888), and Daniel Sickles (1819–1914). The 3rd Pennsylvania Cavalry, also depicted by Homer, was an unbrigaded unit within this corps.

In addition to the three corps under his command, McClellan's Army of the Potomac included a force of Reserve Infantry under Brigadier General George Sykes (1822–1880), composed of nine U.S. infantry regiments not associated with any state, and the 5th New York (Duryee's Zouaves) under the command of Gouverneur K. Warren (1830–1882). The reserves also included Rush's Lancers (the 6th Pennsylvania Cavalry).

83. Barlow letter at the Massachusetts Historical Society, cited in *"Fear Was Not in Him": The Civil War Letters of Major General Francis C. Barlow, U.S.A.*, ed. Christian G. Samito (New York: Fordham University Press, 2004), p. 48.

84. Several drawings document Homer's placement in Alexandria and on the Potomac. Dates, likely some in Homer's hand, suggest a departure date from Alexandria after April 2, 1862 (CR 91-R, inscribed *"From Alexandria to Ship Point,"* National Gallery of Art), but before April 5 (CR 88, inscribed *"The Ocean Queen,"* private collection). Another drawing (CR 77, private collection), is inscribed "Soldiers leaving Alexandria for Fortress Monroe / April 1st." On the verso, Homer inscribed "J. Bonner Esq / D__-for I make this sketch from life—troops have been leaving here for fortress Monroe for two weeks past. I am off tomorrow for Gen'l Sumners Division / Departure of troops for Fortress Monroe on the reverse." The Barlow letters (op. cit., p. 56) agree with the idea of a departure from Alexandria on April 4 and an April 5 arrival date on the peninsula, with Barlow's regiment.

85. *The War of the Rebellion: A Compilation of the Official Records of the Union and Confederate Armies* (hereafter, *Official Records*) (Washington, DC: Government Printing Office, 1884), Series I, Vol. XI, Part I, p. 7. For an overview of the Peninsula Campaign, see Stephen Sears, *To the Gates of Richmond* (New York: Ticknor & Fields, 1992).

86. William J. Miller, ed., *The Peninsula Campaign of 1862: Yorktown to the Seven Days*, Vol. 2 (Campbell, CA: Savas Publishing, 1997). Miller notes that while the population of Chicago was then larger than the army McClellan had assembled, few other cities could claim that distinction. St. Louis was smaller than the Federal forces gathered on the peninsula.

87. *Official Records*, Vol. XI, Part I, p. 405, letter from Confederate Major-General J. Bankhead Magruder, May 3, 1862, to General Samuel Cooper, to whom he reported.

88. Mary Boykin Chesnut, *A Diary from Dixie* (New York: D. Appleton, 1905), p. 196 (entry for June 28, 1862).

89. *Official Records*, Vol. XI, Part I, p. 382, letter from McClellan to Edwin M. Stanton, 11 a.m., April 26, 1862. The author is indebted to Edward G. Longacre, distinguished historian of the Civil War and other conflicts, for illuminating this verbal counterpart to Homer's illustration.

90. Ibid., p. 383.

91. Ibid., p. 384, report from Brigadier General Cuvier Grover to Assistant Adjutant-General, Headquarters, First Brigade, General Hooker's Division, April 26, 1862. McClellan's letter states the distance of the run over the field as 600 yards, while Grover writes that it was 800 feet.

92. Ibid., p. 383.

93. As Marc Simpson has observed, the neat stripping of the largest tree's bark is a subtle suggestion of the despoiling of the land around the men, which was an inevitable consequence of war. The men are likely gnawing on elm bark as they gaze at the fire. See Marc Simpson, ed., *Winslow Homer Paintings of the Civil War* (San Francisco: Bedford Arts, Publishers, for the Fine Arts Museums of San Francisco, 1988), citing the letter of Alfred Davenport, April 21, 1862, who wrote, "On the banks above the ravine there was a thick wood of pine, with its ever-green foliage; elm-trees, which were soon robbed of their bark to satisfy the chewing propensities of the men; sassafras bushes, the roots of which are pleasant to eat, and are therefore pulled up without regard to quantity; but the wood is getting thinner every day, falling a sacrifice to our axes, and used by the cooks to keep up their fires, and by us as a means to warm ourselves when it is necessary." See Davenport's regimental history of the Duryee's Zouaves, *Camp and Field Life of the Fifth New York Volunteer Infantry* (New York: Dick and Fitzgerald, 1879), p. 162.

94. Samito, op. cit., p. 58.

95. *RWWH*, I, p. 210, CR 170.

96. On p. 262. Note that the April 26 edition was available about a week ahead, so Barlow's letter, dated April 23, refers to this issue.

97. Charles M. Evans, *War of the Aeronauts: A History of Ballooning in the Civil War* (Mechanicsburg, PA: Stackpole Books, 2002), p. 67.

98. Ibid., p. 84, citing Thaddeus Lowe's own memoir, *My Balloons in Peace and War*, p. 65.

99. Ibid., p. 122.

100. Barlow letter of April 23, as transcribed by Samito, op. cit., pp. 59–60. Note that the letter is transcribed differently in David Tatham, "Winslow Homer at the Front in 1862," in *American Art Journal* 11, no. 3 (July 1979): 86–87, and by Christopher Kent Wilson in Simpson, 1988, op cit., "Marks of Honor and Death: *Sharpshooter* and the Peninsular Campaign of 1862," p. 27, with Barlow writing, "We were much amused to read that *Harper's* of last week had been suppressed."

101. See Lucretia H. Giese and Roy F. Perkinson, "A Newly Discovered Drawing of Sharpshooters by Winslow Homer: Experience, Image, and Memory," in *Winterthur Portfolio* 45, no. 1 (Spring 2011): 61–90. The privately owned drawing (p. 63, fig. 2) bears the following inscription, possibly in Homer's hand: "Berdan sharpshooters in Peach orchard in front of a Rebel battery at Yorktown."

102. *Harper's Weekly*, May 3, 1862, p. 283.

103. Prince de Joinville, *The Army of the Potomac: Its Organization, Its Commander and Its Campaign* (New York: Anson D. F. Randolph, 1862), pp. 47–48.

104. A June 7, 1862, privately owned letter from his mother to his brother Arthur, cited by Hendricks, op. cit., p. 50.

3. THE FREEDOM OF ALL MANKIND (1862–1866)

1. The ship date for *Harper's Weekly* preceded the stated publication date by seven days.

2. Abraham Lincoln, *Collected Works*, ed. Roy P. Basler, asst. eds. Marion Dolores Pratt and Lloyd A. Dunlap, on behalf of the Abraham Lincoln Association, Springfield, Illinois (New Brunswick, NJ: Rutgers University Press, 1953), vol. 3, p. 358. The lecture is dated February 11, 1859, and is an extended critique of the seductive ideology that Stephen Douglas personified in the figure of "Young America," who might consider himself "the inventor and owner of the *present, and sole hope of the future.*" Lincoln further describes Young America by saying, "He owns a large part of the world, by right of possessing it; and all the rest by right of *wanting* it, and *intending* to have it" (italics his). See also Diana Schaub, "The Invention of Slavery: Lincoln on Whether Technology Makes Us Free," *New Atlantis* (Fall 2021): 74–96.

3. Waud was photographed heavily during this period; Homer depicts Waud fully in his element, wearing one of his characteristically floppy felt hats.

4. Handley (or Handly) was from Franklin County, Maine, where he was born in 1839 and died in 1891, and served in Company F, Lewiston Light Infantry. See John M. Gould, *History of the First-Tenth-Twenty-ninth Maine Regiment* (Portland, ME: Stephen Berry, 1871), p. 74. "E. Farrin," standing next to Handley in Homer's illustration, is more difficult to identify.

5. As Peter H. Wood has observed (email to the author, August 28, 2020), ivy is a regular device Homer uses to indicate a New England location.

6. Libby was one of two prisons on Tobacco Row, along the James River. The other was Castle Thunder, two blocks away.

7. Chesnut, op. cit., p. 196.

8. Ibid., p. 105. The author is indebted to Peter H. Wood for his elucidation of "From Richmond," and much else in Homer's Civil War work.

9. John E. Tobey and Nicholas H. Ellis, *U.S. Army Sutler, 1861–1865* (Wellsboro, PA: Milatus Publishing, 2012). The drawing discussed in this paragraph is *Sutler's Tent, 3rd Pennsylvania Cavalry*, National Gallery of Art (CR 182). It is preparatory for Homer's wood engraving "Thanksgiving in Camp," published in the November 29, 1862, issue of *Harper's Weekly*.

10. The emblem on the soldiers' forage caps is likely the bugle horn associated with infantry. Another, less likely, reading is that it is an Irish harp. Homer sketched the Irish Brigade on at least one occasion. If this is the case, the regiment is the 63rd New York, known as the Third Irish Regiment of Irish Volunteers. Patrick J. Condon commanded Company G; Homer would have asked his permission to depict men in his company. Condon was heroic in battle but also used his position to recruit for the Fenian Brotherhood, dedicated to the overthrow of the British government and the establishment of an Irish republic. He later returned to his native Ireland to fight for Irish independence; he was imprisoned in Mountjoy Prison, Dublin, and photographed there. See Michael H. Kane, "American Soldiers in Ireland, 1865–67," in *The Irish Sword: The Journal of the Military History Society of Ireland* 23, no. 91 (2002): 118.

11. Lamentably, gallery owners, curators, and collectors have very frequently developed their own titles that are now affixed to Homer's works, and obscure his intended, often ironic, meanings. A systematic campaign to restore his original titles would be an excellent contribution to the deeper understanding of American culture.

12. *The Poems of Emily Dickinson: Reading Edition* (Cambridge, MA: Belknap Press of Harvard University Press, 1998), F891 A. The poem is Amherst Manuscript #set91 (1864). A digital image of the manuscript is available at www.edickinson.org/editions/1/image_sets/12176135.

13. Frank M. Mixson, *Reminiscences of a Private* (Columbia, SC: State Company, 1910), pp. 37–38.

14. Maryland, a border state, was especially slow to emancipate its enslaved people. See Miranda S.

Spivack, "The Not-Quite-Free State: Maryland Dragged Its Feet During Civil War," *Washington Post*, September 13, 2013.

15. Homer seems to have designed just eight wood engravings published in 1863, compared with thirteen in 1862, in both cases entirely for *Harper's Weekly*. This author has depended on David Tatham's two volumes on Homer's illustrations for his count, with the notable addition of the wood engravings that *Harper's Weekly* published on April 27, 1861, and June 8, 1861, both of which Tatham has now reattributed to Homer as noted above, contrary to his statements about these prints on p. 232 of *Winslow Homer and the Pictorial Press* (2003).

16. See April F. Masten, *Art Work: Women Artists and Democracy in Mid-Nineteenth Century New York* (Philadelphia: University of Pennsylvania Press, 2008), pp. 155–57. In 1870, Prang initiated an art contest in *Revolution*, a women's rights journal. "My object in starting the project has been principally to give an impetus to female art," he wrote (p. 156).

17. Smithsonian Institution, Archives of American Art, letter from New York to Louis Prang, November 28, 1863. The cover of the series clearly says "Part I," but there never seems to have been a Part II. Prang's workshop was located at 159 Washington Street.

18. *Boston Daily Advertiser*, November 21, 1865, listing the *Life in Camp* series as two parts, each priced at 50 cents.

19. Goodrich / Gerdts Homer Archives, National Gallery of Art, Box 19, correspondence folder.

20. *RWWH*, I, p. 242.

21. See Michael J. McAfee, "The Reverend Doctor Gordon Winslow: '. . . this noble and useful man,'" in *Military Images* 29, no. 1, Civil War Medical Issue (July/August 2007): 45–46.

22. Ibid. The commission's arguably murky mandate gave Winslow a wide platform from which to oversee the physical and spiritual health of men across the Army of the Potomac.

23. *New-York Daily Tribune* in its review of the Fourth Artists' Reception at the Dodworth Building lamented "the fact that the artists have been very busy of late in getting ready their contributions to the Sanitary Fair, and that the Reception had to suffer that the Fair may be enriched" (March 26, 1864, p. 6).

24. Alfred Davenport in a letter to his parents, November 16, 1862, as cited in Brian Pohanka, "Profile: Cleveland Winslow," in *Military Images* 1, no. 3 (November–December 1979): 14. Davenport wrote the definitive regimental history, *Camp and Field Life of the Fifth New York Volunteer Infantry* (New York: Dick and Fitzgerald, 1879).

25. Katherine Prescott Wormeley, *The Other Side of War, with the Army of the Potomac: Letters from the Headquarters of the United States Sanitary Commission During the Peninsular Campaign in Virginia in 1862* (Boston: Ticknor, 1889), p. 84 (letter of May 27, 1862).

26. Ibid., p. 126 (letter of June 10, 1862).

27. Charles A. Fuller recounts one morning on which his affection for his briar pipe nearly set him on fire. See *Personal Recollections of the War of 1861* (Sherburne, NY: News Job Printing House, 1906), p. 76.

28. Charles Dawson Shanly, "The Brier-Wood Pipe," *Vanity Fair* 4 (July 5, 1861): 5.

29. Ibid.

30. *New York Times*, May 9, 1863, p. 8.

31. *New York Times*, May 10, 1863, p. 8.

32. *New York Times*, May 9, 1863, p. 8.

33. Ibid.

34. *New-York Daily Tribune*, March 26, 1864, p. 6.

35. *New York Leader*, April 30, 1864, p. 1, "The Academy Exhibition. Second Article."

36. "The Artists' Reception," *Evening Post*, March 25, 1864, p. 2.

37. "The National Academy of Design—Its Thirty-Eighth Annual Exhibition," *Evening Post*, June 12, 1863, p. 1.

38. See Charles A. Stevens, *Berdan's United States Sharpshooters in the Army of the Potomac 1861– 1865* (St. Paul: Price-McGill, 1892). *Harper's Weekly* introduced its readers to Berdan and his Sharpshooters on August 24, 1861 (p. 540), and covered the regiment extensively for the balance of the war. See also Sebastian Smee, "Death from Above," *Washington Post*, July 14, 2021, for a brief but insightful discussion of Homer's painting. Berdan was already a distinguished inventor by the early 1850s; see, for example, his patent for an Ore Amalgamator (#9,741, May 24, 1853) and the discussion in *Scientific American*, January 16, 1858, of his patented machinery for large-scale commercial baking operations.

39. See *History of the Brooklyn and Long Island Fair, February 22, 1864* (Brooklyn: "The Union" Steam Presses, 1864), p. 58, #85.

40. Berdan's men had green dress uniforms, intended to represent their ability to blend into foliage and remain unseen. But in practice they did not ordinarily wear them, according to the Civil War artist Don Troiani.

41. Simpson, 1988, op. cit., p. 127. The late Lucretia Hoover Giese contributed greatly to the understanding of this pivotal picture, and of Homer's Civil War pictures as a whole. The Third Brigade, in which Berdan's regiment was located, included a total of six regiments.

42. Letter to George C. Briggs, February 19, 1896, Archives of American Art, Smithsonian Institution.

43. Private email from Alexi Worth to the author, September 11, 2021.

44. Few drawings survive from this period, but those that do support this chronology.

45. Grant report to Edwin Stanton, July 22, 1865, as quoted in *Official Records*, Series I, Vol. XXXVI, Part I, p. 13.

46. Earl J. Hess, *In the Trenches at Petersburg: Field Fortifications & Confederate Defeat* (Chapel Hill: University of North Carolina Press, 2009), p. 11.

47. Ibid., p. 11.

48. *RWWH*, I, p. 316. This was at the 1919 sale by the American Art Association of several collections, including that of department store magnate Thomas R. Ball (1844–1911), who had acquired *Defiance* in 1904 at a similar estate sale. Knoedler acquired the picture then for $700, according to a *New York Times* article (March 15, 1919, p. 15) that does not include the word *Petersburg* in the picture's title.

49. July 30, 1864. See A. Wilson Greene, *A Campaign of Giants: The Battle for Petersburg*, Volume I: *From the Crossing of the James to the Crater* (Chapel Hill: University of North Carolina Press, 2018).

50. Wood and Dalton, op. cit., pp. 48–51. The phrase "taunting Rebel daredevil" is that of Peter H. Wood.

51. Lucretia Hoover Giese, "Winslow Homer: Best Chronicler of the War," *Studies in the History of Art* 26, Symposium Papers XI: Winslow Homer: A Symposium (1990), p. 23.

52. *Playing Old Soldier* (1863, now in the collection of the Museum of Fine Arts, Boston). The Inness pictures were *Evening* (then likely owned by John W. Burt [1825–1910] of Orange, New Jersey) and *Landscape* (then owned by the auctioneer Ogden Haggerty [1809–1870] of New York. Haggerty had proposed Inness for the Century, to which he was elected in 1853 but in which he was inactive until the late 1870s).

53. The two drawings are *Two Scouts*, 1865 (graphite on wove paper, 13⁷⁄₁₆ × 9¹⁵⁄₁₆ in., National Gallery of Art, gift of Dr. Edmund Louis Gray Zalinski II, 1996.121.18), and *Grant and Lincoln at City Point, Virginia*, 1865 (charcoal on wove paper, 13⅞ × 9¹⁵⁄₁₆ in., National Gallery of Art, gift of Dr. Edmund Louis Gray Zalinski II, 1996.121.6.a). The latter drawing is on the recto of a sheet that contains a study for Homer's painting *Army Boots* (1865, Hirschhorn Museum) on the verso.

54. Christopher Kent Wilson, "Winslow Homer's 'Thanksgiving Day: Hanging Up the Musket,'" *American Art Journal* 18, no. 4 (Autumn 1986): 76–83.

55. He was elected a full academician at the Annual Meeting on May 10, 1865, one year after his election as associate academician on May 11, 1864 (while he was at the front in Virginia). He was elected a member of the Century on December 2, 1865, after a nomination by Johnson and the short-lived portraitist William Oliver Stone (1830–1875).

56. Approximately 1.618. The golden ratio or golden mean was much popularized by the German psychologists Adolf Zeizing (1809–1877) and Gustav Fechner (1801–1887) by the mid-1860s. The picture has been the subject of prodigious research, for which this author gives great thanks. See especially Nicolai Cikovsky, Jr., "Winslow Homer's 'Prisoners from the Front,'" *Metropolitan Museum Journal* 12 (1977): 155–72; Nicolai Cikovsky, Jr., "The School of War," in Cikovsky Jr. and Franklin Kelly, *Winslow Homer*, with contributions by Judith Walsh and Charles Brock (New Haven, CT: Yale University Press, 1995), pp. 17–60; Charles Colbert, "Winslow Homer's 'Prisoners from the Front,'" *American Art* 12, no. 2 (Summer 1998): 66–69; Lucretia H. Giese, "*Prisoners from the Front*: An American Painting," in Simpson, 1988, op. cit., pp. 65–77; Angela L. Miller et al., *American Encounters: Art, History, and Cultural Identity* (Upper Saddle River, NJ: Pearson Education, 2007), p. 275; and Natalie Spassky et al., *American Paintings in the Metropolitan Museum of Art*, Vol 2., ed. Kathleen Luhrs (New York: Metropolitan Museum of Art, 1985), pp. 437–45.

57. See William J. Jones, *Christ in the Camp, or Religion in Lee's Army* (Richmond, VA: B. F. Johnson, 1887), and William W. Bennett, *A Narrative of the Great Revival Which Prevailed in the Southern Armies During the Late Civil War Between the States of the Federal Union* (Philadelphia: Claxton, Remsen & Haffelfinger, 1877).

58. The cross recurs on a wood engraving Homer designed for the 1866 novel *Surry of Eagle's-Nest*, by John Esten Cooke (1830–1886). Cooke's novel glorifies the Confederacy, and particularly its General J. E. B. Stuart, whom he served as aide-de-camp. Homer's willingness to illustrate a novel patently dedicated to the mythology of the Lost Cause is a mystery that must be left for future biographers to decode. The fact that the book was a best seller in both the North and the South reflects the country's prodigious appetite for stories that made sense—however wrongly—of the carnage America had endured.

59. *New York Leader*, May 12 and 15, 1866.

60. *New York Evening Post*, April 28, 1866.

61. Peter H. Wood, *Near Andersonville: Winslow Homer's Civil War* (Cambridge, MA: Harvard University Press, 2010). In a private email to the author of July 7, 2021, Peter H. Wood drew attention to the Garibaldi sleeves on the central figure's dress.

62. The author is indebted to Peter H. Wood and to David Grey for drawing this connection. Wood's book, *Near Andersonville*, sparked David Grey's insights about the parallel lives of the two painters. See also Kevin J. Alery, "John S. Jameson (1842–1864)," Olana Partnership, https://www.olana.org/wp-content/uploads/2019/03/John-S-Jameson-Kevin-J-Avery.pdf.

63. Hammond speech to the U.S. Senate, March 4, 1858.

64. Letter of July 15, 1865, to Henry, whom William calls "Darling Harry." See Ignas K. Skrupskelis and Elizabeth M. Berkeley, eds., *The Correspondence of William James, Volume I: William and Henry, 1861–1864* (Charlottesville and London: University Press of Virginia, 1992), p. 9.

65. Stevens, 1856, op. cit., p. 44.

66. This subject has attracted prodigious scholarly attention. See, for example, "'The Corporeity of Heaven': Rehabilitating the Civil War Body in *The Gates Ajar*," *American Literature* 69, no. 4 (December 1997): 781–811; Eric T. Dean, Jr., "'A Scene of Surpassing Terror and Awful Grandeur': The Paradoxes of Military Service in the American Civil War," *Michigan Historical Re-*

view 21, no. 2 (Fall 1995): 37–61; and Jonathan Lewy, "The Army Disease: Drug Addiction and the Civil War," *War in History* 21, no. 1 (January 2014): 102–19.

67. *Harper's Weekly*, August 26, 1865, p. 534.

68. *New York Herald Tribune*, November 14, 1866, p. 6, placed by Leeds' Art Galleries.

69. *Boston Daily Advertiser*, December 4, 1866, p. 6. The ship departed from East Boston and stopped at Halifax, Nova Scotia, on her way to Liverpool.

4. THE PROOF OF A POET (1866–1867)

1. Boston had no direct service to France; New York did.

2. Henry Clay Warmoth Papers, 1798–1953, Southern Historical Collection at the Louis Round Wilson Special Collections Library, University of North Carolina, Series 3, Folder 8: Letter of June 25, 1866, to Henry Clay Warmoth.

3. Ibid., Series 3, Folder 10: Kelsey letter of February 13, 1867, to Henry Clay Warmoth stating that "Winslow Homer, my artist friend, waited until the last minute but is now in Paris." A privately owned watercolor in a Dallas collection is dated "Wednesday, March 29th" and depicts a canal. It belonged to Kelsey and was found with other archival material related to this period in Kelsey's life, including work that may well be by Homer. The drawing bears the additional inscription (likely in another hand) "Calais." But the watercolor seems unlikely to evidence Homer's crossing the channel on this date, particularly since in 1867 March 29 was a Friday, not a Wednesday. The attribution of the drawing to Homer is not secure.

4. See Amy Woodson-Boulton, "'Industry without Art Is Brutality': Aesthetic Ideology and Social Practice in Victorian Art Museums," *Journal of British Studies* 46, no. 1 (January 2007): 47–71.

5. Henry Cole, *American Journal of Education* 21 (1871): 62.

6. Ibid., p. 62.

7. Ibid., pp. 55–56.

8. The South Kensington Museum was a predecessor to today's Victoria and Albert Museum.

9. Two oil paintings by Constable had entered the United States by then. One belonged to the Albany entrepreneur John Finley Rathbone (1819–1901), a prominent Baptist philanthropist and brigadier general during the Civil War. Under the title *Landscape, with Cattle*, he lent it to Ransom's Iron Store (Albany) in 1858 and to Palmer's Sculpture Gallery on February 22, 1864. The other, entitled *Landscape*, belonged to the politician and author John Pendleton Kennedy (1795–1870) of Baltimore, who lent it to the Maryland Institute in 1855 and to the Maryland Historical Society in 1858. Homer is unlikely to have seen either picture, because he probably visited none of these exhibitions, and he would have known neither collector well enough to have received a private viewing at either residence.

10. Roberts was a distinguished collector and a member of the Century Association; his second wife (of three), Caroline Danforth Smith (1827–1874), was a prominent philanthropist from a well-connected Hartford family. Among the important pictures in Roberts's collection were Emmanuel Leutze's *Washington Crossing the Delaware* (1851) and *Rainy Season in the Tropics* (1866) by Frederic Edwin Church.

11. The Seventh Annual Exhibition of the Artists' Fund Society, in New York. Whistler's patron George Alfred Lathrop lent *Wapping* to the same exhibition. Note that Norton was an important influence across the United States as a whole, in part because of his extensive knowledge gained through travel. He was, for example, one of fewer than twenty-five American visitors who signed the guest register at the Rijksmuseum during the Civil War years (in his case, on September 9, 1864). See Henry Nichols Blake Clarke, *The Impact of Seventeenth-Century Dutch*

and Flemish Genre Painting on American Genre Painting, 1800–1865 (PhD dissertation, University of Delaware, 1982), appendix I, p. 433.

12. In 1858 Magoon showed the *Sketch from Nature* Kensett later acquired, and three other Turner watercolors, at the unlikely venue of a hardware shop, Ransom's Iron Store, located at 463 Broadway, Albany. Magoon had acquired the other three watercolors (and likely Kensett's) directly from John Ruskin. He gave the other three to Vassar College in 1864, where they have the accession numbers 1864.1.217, 1864.1.218, and 1864.1.221. Homer is unlikely to have been shopping for hardware in Albany in 1858. Philadelphia's Great Central Fair for the benefit of the U.S. Sanitary Commission included three Turner watercolors (two lent by the painter William Thompson Russell Smith, 1812–1896, and one lent by Francis McMurtrie, 1821–1888, both of Philadelphia). They were numbers 890 and 1006 (Smith) and 811 (McMurtrie).

13. *Art-Journal*, December 1866, p. 374.

14. Ibid., p. 376.

15. Ibid., pp. 376–77.

16. *Art-Journal*, January 1867, p. 18.

17. Ibid., p. 19.

18. Ibid., p. 19.

19. *The Athenaeum* published a comprehensive review of the exhibition at its opening, November 10, 1866, pp. 612–13.

20. *The Athenaeum*, no. 2045, January 5, 1867, pp. 22–23.

21. The painting, then called *On the Thames*, dated 1861, is now at the National Gallery of Art in Washington (1982.76.8). A private patron lent the picture to the Artists' Fund Society annual exhibition that opened on November 8, 1866 (according to the *New York Herald*, October 21, 1866, and confirmed by its November 11, 1866, issue, p. 5). Daniel E. Sutherland, *Whistler: A Life for Art's Sake* (New Haven, CT: Yale University Press, 2014), p. 86, implies that the lender was Whistler's most important early patron, Thomas Winans of Baltimore (1820–1878), but the catalogue of the exhibition lists the lender as the well-traveled physician George Alfred Lathrop (1819–1877), father of two gifted sons: the poet, editor, novelist, and critic George Parsons Lathrop (1851–1898) and Francis Augustus Lathrop (1849–1909), who is best known today as a decorative artist in both stained glass and wall painting. Among the latter's extant work are three 1877 murals in the Bowdoin College chapel. Homer likely knew both sons beginning in the 1870s, but is unlikely to have known them prior to his first trip to Europe.

22. Sutherland, 2014, op. cit., p. 98.

23. Ibid., p. 100.

24. *The Athenaeum*, no. 2045, January 5, 1867, pp. 22–23.

25. *Art-Journal*, 1867, p. 218.

26. It stood in Washington's Lincoln Park from 1876 until 2020.

27. The date of Homer's Channel crossing cannot be pinpointed, but Henry Clay Warmoth Papers, Series 3, Folder 10 (Kelsey letter of February 13, 1867), reports that Homer had arrived by that date.

28. Benson correspondence related to his articles in *Galaxy*, William Conant Church collection, New York Public Library, quoted in Lois Fink's *The Role of France in American Art, 1850–1870* (PhD dissertation, University of Chicago, 1970, p. 327).

29. "Paris and the Parisians," *Galaxy*, October 1867, p. 666.

30. Ibid., p. 674.

31. "Solitude and Democracy," *Galaxy*, June 1867, p. 169.

32. "Paris and the Parisians," p. 668.

33. This chapter is especially indebted to the scholarship of Erica Hirshler, particularly in "North

Atlantic Drift: A Meditation on Winslow Homer and French Painting," in *Weatherbeaten: Winslow Homer and Maine*, ed. Thomas Denenberg (New Haven, CT: Yale University Press, 2012), pp. 70–83. Carol Troyen's "Innocents Abroad: American Painters at the 1867 Exposition Universelle, Paris," *American Art Journal* 16, no. 4 (Autumn 1984): 2–29; Lois Fink's "American Artists in France, 1850–1870," *American Art Journal* 5, no. 2 (November 1973): 32–49; and Henry Adams's "Winslow Homer's 'Impressionism' and Its Relation to His Trip to France," ed. Nicolai Cikovsky, Jr., et al., *Studies in the History of Art* 26, Symposium Papers XI: Winslow Homer: A Symposium (Washington, DC: National Gallery of Art, 1990), pp. 60–89, were also instructive.

34. "Paris and the Parisians," p. 671.

35. London had hosted International Expositions in 1851 and 1862. The Empire had set a goal of handily exceeding the success of the fair in London five years earlier. While there are many definitions of a world's fair, this author is using that of the Bureau International des Expositions (BIE).

36. "Paris and the Parisians," p. 668.

37. The art historian David Tatham has suggested that one of the three women in Homer's print may be Philadelphia-born Mary Cassatt (1844–1926), who moved to Paris in December 1865, but was a resident in Ecouen, fifteen miles north of the Louvre, throughout Homer's time in the city (Tatham, 2003, op. cit., pp. 143–44), and Nancy Mowll Mathews, *Mary Cassatt: A Life* (New York: Villard Books, 1994), pp. 29–61. See also Ross King, *The Judgment of Paris: The Revolutionary Decade That Gave the World Impressionism* (New York: Walker, 2006).

38. Eugene Benson, signed as "Sordello," "National Academy of Design. Forty-First Annual Exhibition. First Article," *New York Evening Post*, April 28, 1866, p. 1.

39. Clarence Cook, *Art and Artists of Our Time* (New York: Selmar Hess, 1888), vol. 3, p. 258.

40. The portrait is now at the National Gallery of Art (1943.6.2) and the Battersea Bridge picture is at the Addison Gallery of American Art, Phillips Academy, Andover, MA (1928.55).

41. The picture, then owned by Inness's leading patron and agent, Marcus Spring (1810–1874), is now at the Metropolitan Museum of Art (94.27).

42. The auctioneer Ogden Hagerty lent an Inness picture to both the AFS exhibition in 1860 and the Great Central Fair in 1864. Another collector with the last name of Maynard lent a picture to the 1863 AFS exhibition. It is noteworthy that Henry Ward Beecher lent three of the five Inness pictures at the Brooklyn fair for the U.S.S.C., and that one of his parishioners, Mrs. E. T. H. Gibson, lent another. A Brooklyn merchant, Henry W. Banks (1824–1905), lent the fifth; he may have been a parishioner as well. Beecher's sponsorship of Inness's work reflects the tight connections in the period among art, faith, and patronage.

43. November 13, 1867. See Sally M. Promey, "The Ribband of Faith: George Inness, Color Theory, and the Swedenborgian Church," in *American Art Journal* 26, nos. 1/2 (1994): 44–65, which very helpfully includes a photograph of the entire letter.

44. *New Jerusalem Messenger*, November 13, 1867.

45. This description of Millet is credited to the English critic William Michael Rossetti (1829–1919) by Elbert Hubbard in his *Little Journeys to the Homes of Great Lovers* (East Aurora, NY: Roycroft Press, 1906), p. 168.

46. See Bradley Fratello, "France Embraces Millet: The Intertwined Fates of 'The Gleaners' and 'The Angelus,'" *Art Bulletin* 85, no. 4 (December 2003): 685–701.

47. Laurence des Cars, *Gustave Courbet* (New York: Metropolitan Museum of Art, 2008), p. 392.

48. Ibid., pp. 294–95.

49. Juliet Wilson-Bareau with David C. Degenet, *Manet and the American Civil War: The Battle of the U.S.S.* Kearsarge *and the C.S.S.* Alabama (New York: Metropolitan Museum of Art, 2003). See also Gary Tinterow et al., *Manet / Velasquez: The French Taste for Spanish Painting* (New York: Metropolitan Museum of Art, 2003), p. 394.

50. *RWWH*, II, CR 298.

51. A stamp on the reverse of the canvas suggests that Homer acquired the canvas at the shop of a Monsieur Vieille, located at 30 Rue Bréda. That is consistent with the details of his letter to Voorhees, which is dated August 26, but postmarked from Montmartre on July 28. Both the envelope's date stamp itself (indicating that Homer sent the letter on the earliest dispatch that day) and the diamond postal cancellation stamp indicate his use of the Montmartre post office. Homer wrote the letter in a disingenuously casual manner given its content and then misaddressed it to 6 Pine Street. It found its way eventually to Voorhees's correct address at 48 Pine Street. The author cannot explain either Homer's dating error or his misreading of his address book, but is deeply grateful to a great-great-grandson of Voorhees, Eric S. Reimer of Bedford, New York, for sharing photographs of the letter and its envelope and other aspects of his ancestor's friendship with Homer.

52. *RWWH*, II, pp. 46–47, CR 302.

53. "Paris and the Parisians," p. 674.

54. Eugene Benson, "Substance and Shadow—A Fantasy," *Putnam's Magazine*, February 1869, p. 171.

55. *RWWH*, II, pp. 52–53, CR 306.

56. See, for example, Redon's *Breton Village* (1890), collection of Mr. and Mrs. Paul Mellon, National Gallery of Art, 1994.59.11.

57. Walt Whitman, *Leaves of Grass* (self-published, 1855), p. xii. The sentence is the final one in Whitman's preface to the book.

58. From "Joy, Shipmate, Joy!," in "Songs of Parting," Walt Whitman, *Leaves of Grass* (Boston: James R. Osgood, 1881–82), p. 379. The poem seems not to appear in earlier editions.

5. LINES OF HAND AND HEART (1867–1872)

1. *RWWH*, II, p. 9, a letter to Mr. Charles H. Scott of the Mendelssohn Glee Club, dated March 3, 1869. The Glee Club (Homer omitted the "Glee" in its name) was founded in 1866 and is the oldest organization of its kind in the United States.

2. Then 2 Lindsey Row, Whistler's house is now numbered 96 Cheyne Walk. Mary Ann Evans (better known as George Eliot) lived and died ten minutes' walk east, at 4 Cheyne Walk. Eliot's novel *Middlemarch*, among others, was familiar to Homer as it was published in serialized form in *Harper's Weekly* beginning in December 1871. His illustrations published on August 17 and September 14, 1872, appeared in the same issues as segments of Book IV ("Three Love Problems") of the novel. See Sutherland, 2014, op. cit., p. 100.

3. The Century closed its exhibitions to the press beginning in early 1877, according to Abigail Booth Gerdts (*RWWH*, III, p. 48). She writes that the *New York Evening Post* was able to continue "to find ways to publish critiques of the club's exhibitions." Her source for the Century's admittance practices is not apparent.

4. While records for the pricing of Homer's oil paintings during this period are scarce, a receipt for $130 received by Homer on August 23, 1875, for *The Noon Recess* (Lunder Collection, Colby College Museum of Art, and then called *Kept In*), was offered at auction on June 4–5, 2008, as Lot 56264, in the Grand Format Books & Manuscripts Auction #683 hosted by Heritage Auctions (Dallas). The picture is dated 1873, sized at 9¼ × 14⅛ in. and is closely related to *The Country School* of 1871 (St. Louis Art Museum), and *Country School* (Addison Gallery, likely 1873), which are each larger and more detailed.

5. Although the relationship began at this date, it was only in December 1880 that Homer had a major exhibition at the gallery. Just as the gestation period for his oil paintings was often long,

so the gestation period for several of his commercial relationships stretched over an extended period of time.

6. Mark Twain, *The Innocents Abroad, or The New Pilgrims' Progress* (Hartford, CT: American Publishing, 1869), p. 650.

7. Both Fitch and Martin would be elected to the Century just after Homer. It is notable that it was the eminent color theorist and Columbia University physicist Ogden Rood who sponsored Fitch. Homer's friend Henry Howland wrote the club's tributes to each man upon his death.

8. Katherine E. Manthorne and John W. Coffey, *The Landscapes of Louis Remy Mignot: A Southern Painter Abroad* (Washington, DC: Smithsonian Institution Press, 1996), p. 72.

9. Then Hendrickson, Doll & Richards.

10. *Boston Sunday Times*, November 14, 1869, as quoted in *RWWH*, II, p. 98.

11. Williams and Everett, who showed it the following month (December 1869). See *RWWH*, III, pp. 94–96, which cites the *Boston Sunday Times* as discussing the work in the "Art Matters" columns of its issues of December 12 and 19, 1869.

12. See *Long Branch News*, July 8, 1869, p. 2; Homer inscribed in the register that he was coming from New Hampshire. Note that the transcriptions of Long Branch hotel registers into the newspaper were often imprecise; one indication is the July 20, 1869, identification of the recently inaugurated President Ulysses S. Grant and his wife as "Gen U S Grunt & 1, Wash." On his first arrival, Homer had been identified on August 17, 1868, p. 1, as "W. Hone." When he returned he was noted as "W. Home." For more on the Metropolitan Hotel, see J. H. Schenck, *A Complete Descriptive Guide of Long Branch, N.J.* (New York: Trow & Smith, 1868), pp. 33–34.

13. Label for *The Bridle Path, White Mts*, exhibited March 16, 1869, at the Brooklyn Art Association, New York Public Library, Manuscript Division, as cited in *RWWH*, II, pp. 10–11.

14. As John Wilmerding points out in his Prelude to William R. Cross, *Homer at the Beach: A Marine Painter's Journey, 1869–1880* (Gloucester, MA: Cape Ann Museum, 2019) (p. 5, referring to Homer's period working in Boston during the mid-to-late 1850s), "it is hard to imagine that the youthful aspiring artist was not aware of either Lane's art or his presence." Homer's contact with Bradford likely was far more frequent and extended over a longer period. The older painter was elected to membership in the Century on June 3, 1865, six months before Homer.

15. In a private email to the author, Kathleen A. Foster also notes possible connections to Whistler's *Coast of Brittany*, 1861 (now at the Wadsworth Athenaeum). Whistler sold it to his half brother George William Whistler (1822–1869) in 1863. Although there is no record of that picture's exhibition in the United States prior to Homer's first exhibition of *Manchester Coast*, it is possible that Homer had seen the picture privately or publicly.

16. The reviewer was Theodore Grannis (1829–1878), a fellow painter. See *New York Commercial Advertiser*, May 12, 1869, p. 1. On Grannis's work, see Margaret C. Conrads, *Winslow Homer and the Critics: Forging a National Art in the 1870s* (Princeton, NJ: Princeton University Press and Nelson-Atkins Museum of Art, 2001), pp. 16–17.

17. "National Academy of Design. Forty-fifth Annual Exhibition," *New York World*, April 24, 1870.

18. "Charles S. Homer vs. William F. Homer," in *Massachusetts Reports 107: Cases Argued and Determined in the Supreme Judicial Court of Massachusetts, March–October 1871*, Albert G. Browne, Jr., Reporter (Boston: H. O. Houghton, 1873), pp. 82–87 and 663–64.

19. Erik A. R. Ronnberg, Jr., "Vincent's Cove in the 1870s: A Pictorial Record of Gloucester Shipbuilding," *Nautical Research Journal* 41, no. 4 (December 1996): 209–18. See also *RWWH*, II, pp. 149–51, and Cross, op. cit., 55–59.

20. The picture listed as No. 18., *Ship-Building*, in the February 7, 1874, exhibition is almost certainly this one, although no critical review of it has turned up. Homer may have exhibited the

same painting again at the Century three years later, on February 3, 1877, under the title *Shipyard at Gloucester* (No. 21). In that second case, it did receive a review, in the February 5, 1877, *New-York Daily Tribune*. See *RWWH*, II, pp. 149–51 (which omits the first exhibition of the painting).

21. Homer exhibited the picture together with its pendant, *The Country School*, at the Century, on November 4, 1871. Both pictures also appeared at the 47th Annual Exhibition of the National Academy of Design on April 12, 1871, but by that date, John H. Sherwood had acquired *The Country School*. The two pictures were also exhibited at the Union League Club, but in consecutive months: *The Country School* in February 1872 and *The Old Mill* (as *The Mill*) in March.

22. "Under the Falls, Catskill Mountains," *Harper's Weekly*, September 14, 1872, p. 721.

23. Both Loeffler and Homer situated themselves at the same place, at the north end of a 1,200-foot spur that ran north from Malden Turnpike. Today that spur is the southeast end of Kaaterskill Avenue, just prior to its sharp turn to the northwest in order to run parallel to the creek. Homer and Loeffler each stood on the south side of the creek looking northeast to Giles Griffin's chair shop on the north side of the creek. The building whose corner appears with rocks around it, on the right edge of the right side of the stereograph, is Samuel Griffin's Stone Rubbing Mill, where his firm dressed recently quarried bluestone. The footbridge ran across the creek at the end of the spur. Samuel and Giles Griffin married sisters, respectively Cornelia Wynkoop (1815–1902) and Ida Carolyn Wynkoop (1815–1896). The sisters were the daughters of Evert Wynkoop (1784–1855), who was from Kaatsbaan, about four miles southeast of Palenville and about ten miles due north of Hurley. Evert was a very distant cousin of George Wynkoop of Hurley, discussed later in this chapter. *The Atlas of Greene County, New York* (New York: F. W. Beers, A. D. Ellis & G. G. Soule, 1867), Map 4, and the 1870 U.S. Federal Census for the Town of Catskill, pp. 165–69, document thoroughly not only Giles and Samuel, their families, and their businesses, but also the families and businesses around them. Mr. Jonathan Palmer, Greene County's tireless historian and the curator of the Vedder Research Library at the Greene County Historical Society, has made these identifications possible, for which this writer gives profound thanks.

24. Mr. Palmer's colleague, the local historian Crane Davis, first identified this photograph and its obvious connection to Homer's painting. See Raymond Beecher, *Kaaterskill Clove: Where Nature Met Art* (New York: Black Dome Press, 2004), p. 57. This author is deeply thankful for the insights of both Mr. Palmer and Mr. Davis. Very recently, Mr. Palmer has posted on the blog for the Vedder Research Library an article about the Loeffler photograph, entitled "A Palenville Footbridge." It may be found at vedderresearchlibrary.org/gc-historians-blog/2021/10/18/a-palenville-footbridge.

This author is deeply grateful to the costume historian Lynne Bassett for her dating of the stereograph, and of other stereographs Loeffler made in the same series.

25. *RWWH*, II, p. 190, CR 413.

26. Examples include Homer's famous lithograph of forty-two members of the Massachusetts Senate (1856) and his wood engraving in *Harper's Weekly* (March 4, 1861), "The Inauguration of Abraham Lincoln as President."

27. See Frank H. Goodyear III and Dana E. Byrd, *Winslow Homer and the Camera: Photography and the Art of Painting* (New Haven, CT: Yale University Press, 2018), pp. 14–15, for a discussion of Homer's portrait of Albert Kintzing Post (*RWWH*, I, p. 359, CR 284). This catalogue for the exhibition of the same name, which originated at the Bowdoin College Museum of Art and traveled to the Brandywine Museum, omits discussion of another Civil War portrait based on a photograph, the much larger and more complex Boston Public Library–owned 1881 tribute to William F. Bartlett and Francis W. Palfrey (*RWWH*, III, pp. 399–400, CR 1015). Doubtless

Homer used photography as part of his process of making other portraits in oil and watercolor, although this writer knows of none others that are documented. The photograph of Post has not yet been identified but the Boston Public Library owns the photograph related to its picture.

28. See Goodyear and Byrd, op. cit.

29. Another, smaller painting Homer entitled *Crossing the Bridge* is dated 1873 and depicts one of the four women walking up the ramp with a young boy. It is in the collection of the Lauren Rogers Museum of Art (Laurel, Mississippi), which calls the picture *The Fisherman's Wife*.

30. Nicolai Cikovsky, Jr., "Winslow Homer's (So-Called) 'Morning Bell,'" *American Art Journal* 29, nos. 1/2 (1998): 5–17.

31. *New York Times*, March 6, 1889, p. 5, and April 19, 1890, p. 5. They lived at 101 East Fifty-ninth Street. An example of Booth's innovative editorial leadership and design sensibility is Homer's wood engraving *Opening Day in New York* (described in the text), which *Harper's Bazar* published in its March 21, 1868, issue.

32. *Every Saturday*, January 28, 1871, p. 78.

33. Note that the pair are not adhering to the safer logging practices of today, in which the pair adheres to a practice of carefully beginning with a preliminary vertical notch. The deep wedge shown appears to be the only cut. That fact, and the evidently flailing posture of the lumberjack in the foreground, poses considerable risk to the lumberjack in the rear.

34. *RWWH*, II, p. 31, n. 27, citing an inscription on *Farmyard Scene* (CR 400). In June 1877, Homer moved to another studio in the same building, which was likely on the first floor. See *New York Evening Post*, June 19, 1877, and June 15, 1880.

35. See Linda Mary Jones Gibbs, *Enoch Wood Perry, Jr.: A Biography and Analysis of His Thematic and Stylistic Development* (University of Utah master's thesis, 1981); "Perry, Enoch Wood" in *The 20th Century Biographical Dictionary of Notable Americans*, Robert Johnson, ed. (Boston: Biographical Society, 1904), n.p.; and "E. Wood Perry," *American Art News* 14, no. 11 (December 18, 1915): 4. Perry made excellent use of the opportunities the Louvre afforded for aspiring painters to copy works in its collection, registering on three occasions in 1855 to copy five paintings, including those of de Hooch, Rubens, Titian, and Veronese. See Henry Nichols Blake Clarke, *The Impact of Seventeenth-Century Dutch and Flemish Genre Painting on American Genre Painting, 1800–1865* (PhD dissertation, University of Delaware, 1982), appendix IV, p. 444.

36. See "E. W. Perry's Portraits of Early Church Leaders Located," *Church News*, Church of Jesus Christ of Latter-day Saints, August 27, 2015, unsigned (www.churchofjesuschrist.org/church /news/e-w-perrys-portraits-of-early-church-leaders-located?lang=eng). The letter from Young is dated February 14, 1865. Perry arrived in Utah late that summer and departed shortly after his contract with the church ended in May 1866.

37. *Art Journal* 1, New Series (1875): 216 (unsigned).

38. See also Dorothy Hesselman, "*Talking It Over*: A Patriotic Genre Painting by Enoch Wood Perry," *Metropolitan Museum Journal* 33 (1998): 297–303. For the broader topic of humor in art of this period, see Jennifer A. Greenhill, *Playing It Straight: Art and Humor in the Gilded Age* (Oakland: University of California Press, 2012).

39. *New York Evening Post*, July 8, 1872, p. 1, "Art Notes," with detail on various artists' locations.

40. The possibility of Homer's visiting Hurley in 1874 is more speculative than for 1872, 1875, and 1876, and relies largely on a) his traveling companion Perry, with whom he visited East Hampton; and b) the work he produced that year and in the following year—both the nature of that work and its quantity. That said, the summer of 1874 was a busy one, with travel to East Hampton by the July 21 date on the Pharaoh portrait and a trip to the Baker Farm by early October. It is possible that he and Perry waited to return to Hurley the following year. Of course, the summer of 1875 was even more crowded, with his brother Arthur's wedding on June 22 and

Homer painting in York, Maine, for the month of July. But the report of the *New York Evening Post*, July 28, 1875, p. 1, "Art Notes," with detail on various artists' locations, is notable for its detail: ("E. Wood Perry and Paul [*sic*] P. Ryder are making studies of the old houses at Leeds, Ulster county. Mr. Winslow Homer will join them at the same place during the present week."). Leeds is in Greene County, about twenty-five miles north of Hurley, and like Hurley slightly west of the Hudson River; it seems likely that the paper had the substance right and the hamlet's name wrong, especially inasmuch as Homer published the Hurley-related illustration "The Family Record" just a month later. Two days after that illustration appeared, "Studio Notes" in the *New York World* (August 30, 1875) published that "Winslow Homer and E. W. Perry are sketching at Hurley in the Catskills" (as cited in *RWWH*, II, p. 25, n. 65, p. 33). And then the *New York Evening Post*, October 1, 1875, p. 1, "Art Notes," reports simply that Perry and Homer "are at Hurley," and *The Boston Evening Transcript* (October 5, 1875, p. 6) reports that the two men are "still at Hurley, Ulster County, and J. G. Brown is at Line Hill, near them.—Wood is in Vermont.—George Hall has a studio at Palenville, among the Catskills. He starts for Spain soon after his return to New York." John George Brown was at this point in the hamlet of Pine Hill, in the town on Shandaken, also in Ulster County but some twenty-five miles due northwest of Hurley. Wood was of course Thomas Waterman Wood. George Henry Hall's mountainous location was one of his selling factors. "Art Notes" in the *New York World* (October 25, 1875, cited in *RWWH*, II, p. 25, n. 67, p. 33) reported that at last Homer "returns with several studies" to New York. The *New York Evening Post* (July 20, 1876, p. 1, "Fine Arts") reported that Perry and Homer "are at Leeds, Ulster county," and then six weeks later (*New York Evening Post*, August 28, 1876, p. 1, "Fine Arts,") "sketching in the neighborhood of Hurley, Ulster county." The detail of that report is noteworthy. "During the summer Mr. Perry has painted a half-length life-size picture of a pretty country girl carrying a basket of corn. The girl is walking bareheaded in the open air, and was studied from life. Mr. Homer is engaged upon a picture entitled 'Watermelon Bugs [*sic*].' It represents a group of boys helping themselves to the melons in a melon patch, and is treated in that broad and vigorous style which has heretofore been so noticeable in this artist's outdoor pictures." The description is of course of his oil *The Watermelon Boys* (1876) and is especially notable inasmuch as the multiracial composition drew no attention from that critic. The final citation relating to Homer's several visits to Hurley is from the *New-York Daily Tribune* (November 25, 1876, p. 2), in which he is described as "engaged on some of his negro studies."

41. *Appleton's Journal* 10, no. 230 (August 16, 1873): 219.

42. Clarke, *The Impact of Seventeenth-Century Dutch and Flemish Genre Painting on American Genre Painting, 1800–1865*, and "A Taste for the Netherlands: The Impact of Seventeenth-Century Dutch and Flemish Genre Painting on American Art 1800–1860," *American Art Journal* 14, no. 2 (Spring 1982): 23–38.

43. George W. Sheldon, *Art Journal* 6, New Series (1880): 107.

44. See *RWWH*, II, pp. 160–62. The author is grateful to Marc Simpson for his insightful analysis of this picture and its connections to seventeenth-century Netherlandish genre painting.

45. *Letters of Richard Watson Gilder, Edited by His Daughter Rosamond Gilder* (Boston and New York: Houghton Mifflin, Riverside Press, 1916), p. 56. Through their mutual friend Helen Hunt, they met in the editorial rooms of *Scribner's Monthly*. See also Masten, op. cit., p. 198.

46. See *RWWH*, II, pp. 162–165, CR 392. The author is indebted to Marc Simpson in pointing out the timing mismatch between the portraits of Helena de Kay and of Whistler's mother.

47. Letter at Lilly Library, Indiana University, in Gilder Mss., Correspondence, Box 11. The year is omitted in the letter but the context makes clear that it is 1872.

48. Homer's handwriting is often challenging to read; Abigail Booth Gerdts believes that the operative word is "Clover" rather than "Clever" and that he is therefore urging de Kay to see one of

his pictures depicting a young woman with a four-leaf clover, such as #380, in *RWWH*, II, p. 141. This brief missive is inscribed on an undated sheet that appears to be a postscript to the letter dated June 19 [1872].

49. See Masten, op. cit., pp. 195–96, citing a letter from Mary Hallock Foote to Helena in the Mary Hallock Foote papers, Box 6 (Fall 1873 in Folders 16 or 17, or alternately c. 1870 in Folder 13; her n. 100, p. 296, is unclear), Special Collections, Stanford University Library.

50. Masten, op. cit., p. 198. Gilder published six sonnets, clearly written to Helena, in *Scribner's Monthly* VII, November 1873, pp. 42–43 (the publication within whose editorial rooms at 654 Broadway they had met). They announced their engagement three months later.

51. Masten, op. cit., p. 200.

52. Horace Traubel, *With Walt Whitman in Camden*, Vol. II (New York: D. Appleton, 1908), p. 119.

53. The portrait was owned by Homer's cousin Mary W. Blanchard (1857–1943) when Lloyd Goodrich was beginning his Homer research. Goodrich / Gerdts Homer Archives, National Gallery of Art, Box 19, includes a photograph and a negative (70–1).

54. Goodrich / Gerdts Homer Archives, National Gallery of Art, Box 19, includes a photograph, detailed transcription of Homer's inscriptions, and a negative (A 84–9). The silhouettes were still in Homer's studio in 1941, but their current whereabouts are unknown.

55. Letter to Louis Prang of May 16, 1871, quoted in *RWWH*, II, p. 148, without disclosure of its archival location. The prints were heliotypes, a form of collotype that had been introduced in England in 1871 and swiftly brought to the United States. See "Books Illustrated with Photographs: 1870s" and "Collotype," in *Encyclopedia of Nineteenth Century Photography*, ed. John Hannavy (London: Routledge/Taylor & Francis Group, 2008), vol. 1, pp. 190–92 and 313–15. For a contemporaneous account of the heliotype process see *Nature* 4, no. 83 (June 1, 1871): 85–87. Osgood was an early adopter of the technology and recruited its British inventor, Ernest Edwards (1837–1903), to move to Boston and lead a company devoted to it. See https://graphicarts .princeton.edu/2018/01/11/picture-periodical-without-letterpress for more on the topic.

56. One book of children's rhymes, by Hurd & Houghton, was called *Black Peter*; another, published by Stroefer & Kirchner, was entitled *Silhouettes*. Each was published in 1870 with the same format: a silhouette accompanying a children's poem translated from German into English. Konewka did similar designs for U.S. publications of works both by Goethe and by other European authors.

57. Letter to Mrs. S. B. Herrick, June 15, 1875, as published in *Letters of James Russell Lowell*, ed. Charles Eliot Norton II (New York: Harper & Brothers, 1894), p. 139.

58. This was one of several experiments in photomechanical reproduction that fell short of Homer's expectations artistically and commercially. See, for example, the three objects Homer submitted to the monthly art exhibition at the Century on April 3, 1880. Each was identified without title and given the price of $2.00 and the description of "Facsimile."

59. The Federal Census record for 1900 states that she was born in July 1849. The 1879 Rusk's guidebook includes on page 118 an advertisement by her husband (1839–1880) for "Palenville Hotel—Peter Burger, Proprietor. Near the First Bridge in the Cauterskill Clove—A very Pleasant Location and Favorite Resort. Comfortable Rooms. Excellent Table. Terms, $7 to $10. Watering Tank for Horses." Her death date is elusive, but she appears on the Catskill, New York, tax rolls as late as 1914, owning seven acres at "Palenville Clove." The site is typically called Kaaterskill Clove today.

60. The setting of the painting (collection of Mrs. Joyce Wolf, Houston, Texas) is Wingaersheek Beach, in West Gloucester.

61. Another picture, *Crossing the Pasture* (Amon Carter Museum, Fort Worth), is clearly set in Palenville and based on field sketches made in the summer of 1871. See *RWWH*, II, pp. 158–59,

CR 390. The picture is undated and unsigned but Homer exhibited it at the Century on January 13, 1872, at the club's Annual Exhibition under the title *Two Boys Going Fishing* and then at the 47th Annual Exhibition of the National Academy of Design on April 12, 1872, as *Crossing the Pasture*. The topography matches that of the area around the Hall studio, and the building depicted at the right of the canvas may be identifiable with further research.

62. It is entirely possible that the high-ceilinged room depicted in *The Country School* (St. Louis Art Museum) and two sister school interiors, *Country School* (Addison Gallery of American Art) and *The Noon Recess* (Colby College Museum of Art), are inspired by a room that was different from the schoolhouse depicted in *School Time* and *The Red School House* (National Gallery of Art) and the two paintings each entitled *Snap the Whip*. The roof of the schoolhouse he depicted in his paintings of the exterior does not seem especially high, and one can imagine the interior being darker than he depicts in the Addison and St. Louis pictures. But Homer's practice suggests that he drew field sketches inside and outside a single particular schoolhouse, not multiple schoolhouses, and then executed his various school pictures in his studio based on those sketches.

63. Identifying the location of the correct school building may be possible with enough time and effort, although it is likely that the building itself is long since demolished. Neither of the two candidates within easy walking distance of Hall's studio seems to fit. One is Schoolhouse #12, today the site of the Gloria Dei Episcopal Church, and the other is Schoolhouse #17, on Pennsylvania Avenue. The topography of both locations, however, discourages the possibility that Homer's schoolhouse landscapes are set at either.

64. See Nicolai Cikovsky, Jr., "Winslow Homer's *School Time*: 'A Picture Thoroughly National,'" in *Essays in Honor of Paul Mellon, Collector and Benefactor*, ed. John Wilmerding (Washington, DC: National Gallery of Art, 1986), pp. 46–69.

65. Homer's uncle John Benson knew Stanford and was a San Francisco art collector and advocate, so might have written to Homer of Muybridge's experiments, but no letters from Benson to Homer survive.

66. The peripatetic Muybridge lived and worked primarily in California beginning in 1867 but had lived in New York briefly in the 1850s, and in 1860 even registered a British patent (#2352) as "E. Muggeridge of New York." His famous photographic studies of animals in motion began (at the behest of Leland Stanford) about the same time that Homer was making *Snap the Whip*. See John Ott, "Iron Horses: Leland Stanford, Eadweard Muybridge, and the Industrialised Eye," *Oxford Art Journal* 28, no. 3 (2005): 407–28. See "Muybridge's Photographs," *Daily Alta California* XXX, no. 10,315 (July 9, 1878): 1, for the long-awaited announcement of his breakthrough.

67. See Linda J. Docherty, "A Problem of Perspective: Winslow Homer, John H. Sherwood, and *Weaning the Calf*," *North Carolina Museum of Art Bulletin* XVI (1993): 32–48.

68. It is notable that Homer chose to base the wood engraving (*Harper's Weekly*, September 20, 1873) so closely on the second and larger version of the picture. It is also notable that unusually, his drawing for that illustration survives and was owned by a Boston collector and friend to whom Homer almost certainly gave it: Francis Bartlett (1836–1913), not to be confused with the Civil War hero (and Homer's subject in his 1881 oil) William Francis Bartlett (1840–1876).

69. Cikovsky, 1986, op. cit.

70. See letter from Homer of April 18, 1871, at the Morgan Library, MA 2032.

71. *Our Young Folks* IX (October 1873): 594. See Tatham, 1992, op. cit., p. 321.

72. See Wood and Dalton, op. cit., pp. 64–65.

73. Tatham, 2003, op. cit., pp. 168–69.

74. Alfred Lord Tennyson, *In Memoriam* (London: Edward Moxon, 1850), Canto 104, p. 162. Ten-

nyson wrote the poem in memory of Arthur Henry Hallam (1811–1833). Later editions place this canto as #106.

75. Ulysses S. Grant (1822–1885) and Schuyler Colfax (1823–1885).

76. Tennyson, op. cit., Canto 104, p. 163.

6. CENTENNIAL TRUTHS

1. John Wilmerding, "Winslow Homer's Dad's Coming," *In Honor of Paul Mellon: Collector and Benefactor* (Washington, DC: National Gallery of Art, 1986), p. 401.

2. "Winslow Homer," typescript, James E. Kelly papers, Smithsonian Archives of American Art, p. 1.

3. Ibid., p. 1.

4. Ibid., p. 5.

5. *New York Evening Post*, January 13, 1873, as cited in *RWWH*, II, p. 32, n. 38.

6. Century Exhibition records, February 1, 1873. See also Annette Blaugrund, *The Tenth Street Studio Building: Artist-Entrepreneurs from the Hudson River School to the American Impressionists* (Southampton, NY: Parrish Art Museum, 1997).

7. The Academy's First Winter Exhibition opened on November 16, 1867 (Kathleen A. Foster says December 21), and closed on March 11, 1868. It was also the first exhibition of the American Society of Painters in Water Colors. It also included many of the works from the American Art Department of the Paris Exposition, which had closed on October 31, 1867.

8. Another prominent woman exhibitor in the first exhibition was Susan Clark (1821–1906), the gifted wife of the Centurion Henry Peters Gray (1819–1877), and someone who appears to have stopped exhibiting after the first show.

9. See Kathleen A. Foster, *American Watercolor in the Age of Homer and Sargent* (New Haven, CT: Yale University Press, 2017), particularly chapters 3 and 4, "The Formation of the American Watercolor Society" and "'Strenuous and Persistent Efforts': The Watercolor Movement, 1873–1877," pp. 57–89. This exhibition and its catalogue have made an indispensable contribution to the understanding of the watercolor movement and its many members, including these remarkable women.

10. See Henry Nichols Blake Clarke, *The Impact of Seventeenth-Century Dutch and Flemish Genre Painting on American Genre Painting, 1800–1865* (PhD dissertation, University of Delaware, 1982), appendix I, p. 432. The year that he came (on September 27, 1855), the only other American recorded was President Millard Fillmore (October 29, 1855). Eastman Johnson had visited three and a half years earlier (March 10, 1852).

11. Maureen Meister, "Expressions of Quiet: The Art of Albert Fitch Bellows," *Antiques*, November/December 2015, pp. 116–23.

12. *Water-Color Painting: Some Facts and Authorities in Relation to Its Durability* (New York: American Society for Painters in Water-Colors, 1868), p. 5.

13. Ibid., p. 6.

14. Aaron Edwin Penley, *The English School of Painting in Water-Colors: Its Theory and Practice* (London: A. Tarrant, 1874).

15. Foster, 2017, op. cit. The catalytic effect of the 1873 show is especially well told on pp. 79–81.

16. Ryder's loans of the Tiffany watercolors were #33 and #37. Tiffany's watercolors had not appeared in the inaugural exhibition, when he was only nineteen years old.

17. The exhibition opened on Tuesday, March 18, 1873.

18. See Masten, op. cit., p. 140, and Clark S. Marlor, *A History of the Brooklyn Art Association with an Index of Exhibitions* (New York: J. F. Carr, 1970), for details of pricing and artists represented.

19. July 30, 1873, p. 11.

20. Mary Ray, compiler, *Gloucester, Massachusetts Historical Time-line 1000–1999* (Gloucester: 2002), p. 153, referencing 1878 Gloucester Archives, Peterson File HEALTH, Massachusetts Public Health, p. 12.

21. "The Water Color Exhibition," *New York World*, February 4, 1874.

22. See Kathleen A. Foster's penetrating analysis of this watercolor in this video: www.nga.gov /audio-video/safra/safra-foster-audio.html. See also Cross, op. cit., p. 68.

23. George H. Procter, *The Fishermen's Memorial and Record Book* (Gloucester, MA: Procter Brothers, 1873), p. 67.

24. A flat-bottomed vessel averaging sixteen feet in length with a narrow, V-shaped stern, ubiquitous in Gloucester, then and now.

25. *RWWH*, II, p. 255, referencing the 49th Annual Exhibition catalogue of the National Academy of Design.

26. Both as a noun and as a verb, the word predates the twelfth century.

27. *Beowulf: A New Verse Translation*, by Seamus Heaney (New York: Farrar, Straus & Giroux, 2000), page 3, line 13.

28. *Harper's Weekly*, November 1, 1873, p. 970.

29. "The Water-Color Exhibition," *New York Times*, January 29, 1874, p. 8.

30. See the extensive bibliographic resources that Kathleen A. Foster and her colleagues at the Philadelphia Museum of Art have expertly assembled and generously shared at philamuseum .libguides.com/AmericanWatercolors. This includes an indispensable array of contemporary criticism.

31. "Fine Arts. The Water Color Exhibition," *New-York Daily Tribune*, February 14, 1874, p. 7.

32. "The Water Color Exhibition," *New York World*, February 4, 1874.

33. See Foster, 2017, op. cit., esp. pp. 135–40 and chapter 5, "Landscape in the 1870s," pp. 91–113.

34. Richardson was a neighbor of the Homers during Arthur's childhood. He went on to Civil War heroism as a commander of the 38th Massachusetts Infantry Regiment. See his obituary in *Cambridge Tribune* XXIV, no. 11, May 18, 1901, for more detail. The letter of January 10, 1868, instructing Arthur to go to Columbia under Richardson's supervision was signed by William Henry Sinclair (1838–1897), who had served as subassistant commissioner in Galveston and was then serving as the Bureau's acting inspector general for Texas. It may be found in National Archives and Records Administration: Bureau of Refugees, Freedmen, and Abandoned Lands, Columbia. Letters Received [at Bureau Headquarters in Austin], January 1866–December 1868, NARA M1912, Roll 15, Images 553–54.

35. The definitive scholarly work addressing this period is William L. Richter's *Overreached on All Sides: The Freedmen's Bureau Administrators in Texas, 1865–1868* (College Station: Texas A&M University Press, 1991). Homer is discussed only briefly, on p. 244 and in n. 12 on p. 373. See also Christopher B. Bean's PhD dissertation, *A Stranger Amongst Strangers: An Analysis of the Freedmen's Bureau Subassistant Commissioners in Texas, 1865–1868* (Denton: University of North Texas, 2008), and Evelyn L. Merz, "From Slaves to Sharecroppers," *Texas Parks & Wildlife Magazine*, June 2007. The source of the incidents mentioned in this paragraph is National Archives and Records Administration: Records of the Field Offices for the State of Texas, Bureau of Refugees, Freedmen, and Abandoned Lands, 1865–1870, Columbia. Letters Sent and Registers of Letters Received with Endorsements, V. 2 (78), April 1867–November 1868, NARA M1912, Roll 15, pp. 112–64. The order for the rescue from the would-be bigamist is on p. 116. Arthur's month-end reports throughout his tenure as subassistant commissioner offer a helpful longitudinal perspective.

36. National Archives and Records Administration: Records of the Field Offices for the State of Texas, Bureau of Refugees, Freedmen, and Abandoned Lands, 1865–1870, Columbia. Letters Sent and Registers of Letters Received with Endorsements, V. 2 (78), April 1867–November 1868, NARA M1912, Roll 15, p. 128.

37. Letter from Arthur B. Homer to Jim Wadkins ("fmc," i.e., Free Man of Color) on Jordans Plant, July 7, 1868, with respect to Addison and Marshal, two children of Jane McNele. "Texas, Freedmen's Bureau Field Office Records, 1865–1870," Columbia, Roll 16, Miscellaneous Records, October 1865–July 1868, image 134 of 223; NARA microfilm publication M1912, National Archives and Records Administration, Washington, DC.

38. Chad R. Trulson and James W. Marquardt, *First Available Cell: Desegregation of the Texas Prison System* (Austin: University of Texas Press, 2009), p. 23.

39. National Archives and Records Administration: Records of the Assistant Commissioner for the State of Texas, Bureau of Refugees, Freedmen, and Abandoned Lands, 1865–1870. Miscellaneous Records Relating to Murders and Other Criminal Offenses Committed in Texas, 1865–1868. NARA M821, Roll 32. The whip was a quirt: short-handled with a braided leather lash.

40. National Archives and Records Administration: Records of the Bureau Office for the State of Texas, Bureau of Refugees, Freedmen, and Abandoned Lands, January 1866–December 1868. Letters Received, NARA M1912, Roll 15, pp. 645–47. See also "Texas, Freedmen's Bureau Field Office Records, 1865–1870," Columbia, Miscellaneous Records, October 1865–July 1868, Roll 16, images 17, 44, 44A4, 43, 30–33, for details on these complex peacekeeping responsibilities he shouldered (NARA microfilm publication M1912, National Archives and Records Administration, Washington, DC).

41. National Archives and Records Administration: Records of the Field Offices for the State of Texas, Bureau of Refugees, Freedmen, and Abandoned Lands, 1865–1870, Columbia. Letters Sent and Registers of Letters Received with Endorsements, V. 2 (78), April 1867–November 1868. NARA M1912, Roll 15, pp. 120–21, Arthur's report of January 31, 1868.

42. Ibid., p. 155, Arthur's report of July 31, 1868.

43. Ibid., p. 168.

44. Richter, op. cit., p. 244, and n. 12, p. 373.

45. *Register of Officers and Agents, Civil, Military, and Naval, in the Service of the United States, on the Thirtieth of September, 1869* (Washington, DC: Government Printing Office, 1870), p. 143. Arthur was earning $4 per day in the job.

46. *New York Evening Post*, January 12, 1874, as cited in *RWWH*, II, p. 269.

47. Frederick Douglass, *My Bondage and My Freedom* (New York: Miller, Orton, 1857), p. 462.

48. Ibid.

49. *New York Sun*, April 21, 1875, and *Philadelphia Evening Bulletin*, April 28, 1875, each cited in *RWWH*, II, p. 267.

50. *New York Sun*, April 21, 1875.

51. The scene might be based on field sketches Homer made in 1872 in Hurley, as is proposed in the insightful analysis in *RWWH*, II, pp. 265–69. A detailed scrutiny of the documentary evidence for the residents of Hurley, of Palenville and other Catskill locations, and of Gloucester and its surrounding communities, and the peculiar nautical construction of the dovecote leads to the identification of Essex as the leading possibility, albeit one that is intrinsically speculative. Abigail Booth Gerdts deserves particular credit for her contrarian recognition that previous scholarship has erred in assuming that the subject matter necessitates an undocumented Homeric journey to the South.

52. There are several possible Hurley farms, but none of them is documented as the location for children or an adult male who are consistent with Homer's models. Given the possibility of

models residing in this section of Hurley without documentation, one cannot be certain about the identification of these models; the process is intrinsically one of gauging probability.

53. The watercolor, #480 in *RWWH*, II, p. 258, is privately owned. A sheet of paper glued to the reverse of the watercolor is inscribed "Shipbuilding, Ipswich." Ipswich is a historic town just north of Essex. Until its incorporation in 1819, Essex was a part of Ipswich. The topography of the marsh Homer depicts in the watercolor, and the schooner-building activity itself, point to Essex as his site, rather than Ipswich, but Lloyd Goodrich believed that the inscription was in Homer's hand. Whether the watercolor depicts Essex or Ipswich, it suggests that Homer explored Cape Ann more broadly during this period than is generally supposed, and therefore supports the admittedly speculative link to the Jerritt family.

54. "The Chinese New Year," *New York Times*, February 16, 1874. The temple included a banquet hall, a worship space, and the clubhouse on which Homer focused. The *Times* noted that there were about four hundred Chinese residents of New York, overwhelmingly male.

55. Ibid.

56. *Harper's Weekly*, February 7, 1874. The lengthy and powerful text extends over pp. 133–34.

57. Ibid.

58. Ibid.

59. John A. Strong, *The Montaukett Indians of Eastern Long Island* (Syracuse, NY: Syracuse University Press, 2001), p. 96, citing the *Sag Harbor Express*, July 14, 1870. The *Brooklyn Daily Eagle*, July 23, 1870, cites the date of election as July 12.

60. *San Francisco Bulletin*, August 1, 1878, obituary.

61. Strong, 2001, op. cit., pp. 98–99.

62. *Harper's New Monthly Magazine*, September 1871, p. 493.

63. Strong, 2001, op. cit., p. 100.

64. *Harper's New Monthly Magazine*, September 1871, p. 481.

65. Ibid.

66. *Appleton's Journal* 10, no. 230, August 16, 1873, p. 219.

67. *New York Times*, October 23, 1879, p. 8. See also Strong, 2001, op. cit., p. 105, citing East Hampton Public Library Collection, BG 1–6c. Benson paid $151,000, which was an excellent investment, albeit one that strikes twenty-first-century readers as unjust. See Peter Ross, *A History of Long Island from Its Earliest Settlement to the Present Time* (New York: Lewis Publishing, 1905), p. 41. His chapter "The Decadence of the Aborigines," like the detailed *Times* report of 1879, reveals that the two tribes received none of the purchase price Benson paid. In 1895, Benson's wife, son, and daughter sold 5,500 acres to Austin Corbin (1827–1896) and Charles M. Pratt (1855–1935); see *New York Times*, June 1, 1895. Corbin extended his Long Island Rail Road tracks east from Bridgehampton, beginning the day after his purchase, which had a decidedly positive impact on the value of the acreage the Bensons retained. The price the Bensons received may have been $600,000 (*New York Times*, September 23, 1900, and February 20, 1902, and Ross, op. cit.) or $200,000 (*New York Times*, June 1, 1895). In either case, the family's basis was negative, and its returns infinite.

68. Philip Rabito-Wyppensenwah, "Those Days Will Never Return: The Autobiography of Maria Pharaoh," in *The History and Archeology of the Montauk*, ed. Gaynell Stone (Stony Brook, NY: Suffolk County Archeological Association, 1995), pp. 365–67.

69. Rev. Eugene A. Johnson, a Presbyterian minister in Harrisburg, *New York Times*, September 23, 1900. See also *New York Times*, February 20, 1902, and October 12, 1910.

70. See John A. Strong, "Who Says the Montauk Tribe Is Extinct? Judge Abel Blackmar's Decision in *Wyandank v. Benson* (1909)," in *American Indian Culture and Research Journal* 16, no. 1 (1992): 1–22, reprinted in *Long Island Historical Journal* 10, no. 1 (Fall 1997): 39–55; Strong, 2001,

op. cit., pp. 123–40; and Samuel A. Rose and Richard W. Rose, "Outside the Rules: Invisible American Indians in New York State," *Wicazo Sa Review* 30, no. 2 (Fall 2015): 56–76.

71. *New York Times*, May 1, 1880, p. 8.

72. Stanford White is often credited as the houses' lead designer; their inventive massing, so perfectly suited to the site, appears indebted primarily to his partner Charles Follen McKim.

73. Another Centurion involved in the Seven Sisters was Alfred Miller Hoyt (1828–1903), a banker.

74. Judge Abel E. Blackmar, *Pharaoh v. Benson*, New York State Supreme Court, Suffolk Equity Term, 69 Misc. 241, decided October 1, 1910.

75. The two lectures were published in *Popular Science Monthly*, February 1874 (pp. 415–21) and March 1874 (pp. 572–81), with ample diagrams.

76. *Popular Science Monthly*, February 1874, p. 415.

77. Michel-Eugène Chevreul, *The Laws of Contrast of Colour: and their application to the arts of painting, decoration of buildings, mosaic work, tapestry and carpet weaving, calico printing, dress, paper staining, printing, military clothing, illumination, landscape, and flower gardening, etc.*, translated by John Spanton (London: Routledge, Warne, and Routledge, 1861), p. 102.

78. "Winslow Homer and the Color Theories of Michel-Eugène Chevreul," in Tedeschi et al., *Watercolors by Winslow Homer: The Color of Light* (Chicago: Art Institute of Chicago, 2008), p. 199.

79. Ogden N. Rood, *Modern Chromatics, with Applications to Art and Industry* (New York: D. Appleton, 1879), p. 147.

80. Camille Pissarro letter quoted in Henry G. Stephens, "Camille Pissarro, Impressionist," *Brush and Pencil, An Illustrated Magazine of the Arts of To-Day* XIII, no. 6, March 1904, p. 414.

81. See "Seurat's Painting Practice: Theory, Development and Technology," by Jo Kirby, Kate Stonor, Ashok Roy, Aviva Burnstock, Rachel Grout, and Raymond White, in *National Gallery Technical Bulletin* 23 (2003): 4–37.

82. Ogden N. Rood, *Modern Chromatics*, p. 280.

83. "Recollections by John W. Beatty," in Goodrich, op. cit., p. 223.

84. Ibid.

85. See Davis, op. cit., 141–63, for an excellent discussion of geometry in this watercolor and other Homer work.

86. The understanding of Prouts Neck and its history of this author depends to a very great extent on the many years of research by six scholars: Kenyon C. Bolton III, John Cromie, Patricia Junker, Earle G. Shettleworth, Jr., Laura Sprague, and Philip Von Stade. See as starting points Patricia Junker, "Expressions of Art and Life in the Artist's Studio in an Afternoon Fog," in *Winslow Homer in the 1890s: Prout's Neck Observed* (New York: Hudson Hills Press, 1990), pp. 34–65; and Kenyon C. Bolton III, "'The Right Place': Winslow Homer and the Development of Prouts Neck," in *Weatherbeaten: Winslow Homer and Maine*, ed. Thomas A. Denenberg (New Haven, CT: Yale University Press, 2012), pp. 28–47.

The Libby family's subdivision was documented in August 1879 as "Plan of Libby's Neck, with Divisions for Heirs of Thomas Libby," and is often called "The Stephenson Map," after its cartographer, S. L. Stephenson. A draft of this map exists in the archives of the Prouts Neck Historical Society (hereafter PNHS), which Mr. Von Stade serves tirelessly as president. The next important map is published in *Stuart's Atlas of the State of Maine* (South Paris, ME: J. H. Stuart, 1894). The Stuart map, "Prouts Neck: Scarborough and Higgins Beaches" (p. 83), is invaluable and is accessible online through www.davidrumsey.com/luna/servlet/detail/RUMSEY ~8~1~33128~1170494:Prouts-Neck—Scarborough,-Higgins-b.

Mr. Cromie has done extensive research on Prouts Neck deeds and this writer is deeply indebted to him, as he is to Mr. Von Stade. Each of them has spent countless hours with the work

products of the two sons of Arthur Benson Homer. The elder of the two, Arthur Patch Homer, created a map that exists in two forms, both dated August 1901: a draft in the archives of the PNHS and a final version at the Bowdoin College Museum of Art (BCMA). His younger brother, Charles Lowell Homer, completed a similar map that is not dated but appears to be from 1910. It survives at both the PNHS and BCMA. J. W. Holland created a larger map the same year, entitled "Sketch Map of Prouts Neck, Main and Vicinity," which was published fourteen years later in Rupert Sargent Holland, *The Story of Prouts Neck* (Scarborough, ME: Prouts Neck Association, 1924).

Those early maps became the foundation for extensive scholarship by the Maine State Historian, Mr. Shettleworth, including during his long tenure leading the Maine Historic Preservation Commission (MHPC). In that role, he commissioned Ms. Sprague's thorough 177-page analysis of the architectural history of Prouts Neck, which the MHPC published in 1988. To each of these six scholars, this author gives profound thanks.

87. See Augustus F. Moulton, *Old Prouts Neck* (Portland, ME: Marks Printing House, 1924). For the Prout purchase, see p. 79. For his death, see p. 87. For the arrival of the Libby family in 1788, see p. 93. Augustus Freedom Moulton (1848–1933) was born in Jay, Maine, but had grown up in Scarborough and was greatly respected there by all and sundry, including Homer, as an attorney and general counselor. In 1927, the state's governor appointed him as Maine's second state historian, a post he held until his death.

88. The receipt, dated August 23, 1875, was for sale at Heritage Auctions (Books & Manuscripts Sale #683), June 4–5, 2008, as Lot 56264. It carries a value of both $130 and $150 for the picture Homer called *Kept In*. Brown exhibited the picture immediately, at the State Fair in Rossini Hall. See *Portland Daily Press*, September 23, 1875, p. 5, column 4.

89. The implicit question, of course, recalls the story of Jesus meeting the Samaritan woman at Jacob's well in Sychar, recounted in John 4:7. The hour of the day is pivotal to understanding that story as well.

90. "On Some Pictures Lately Exhibited," *Galaxy* 20 (July 1875): 89–97, with sections quoted appearing on pp. 93–94. See Colm Tóibín, Marc Simpson, and Declan Kiely, eds., *Henry James and American Painting* (University Park: Pennsylvania State University Press, 2017).

91. The Elting-Beekman workshops in Kingston were especially renowned, and the great chair may be one made by those joiners. See "Ulster County" in *American Kasten: The Dutch-Style Cupboards of New York and New Jersey, 1650–1800*, ed. Peter M. Kenny, Frances Gruber Safford, and Gilbert T. Vincent (New York: Metropolitan Museum of Art, 1991), pp. 23–26.

92. Deana F. Decker, *Hurley, New York: A Brief History* (New York: History Press, 2009).

93. The author is deeply grateful to several citizens of Hurley who have researched their local history extensively and provided the foundation for an understanding of this illustration, and of Homer's time in Hurley generally. They include Gail Whistance of the Hurley Heritage Society; her husband, Bruce Whistance; and the skilled local researcher Lorna J. Smedman. They in turn have benefited from the research of Reilly Rhodes, the author of *Winslow Homer, from Poetry to Fiction: The Engraved Works* (Laguna Niguel, CA: Contemporary and Modern Print Exhibitions, 2017). Last but far from least, Viola Elizabeth Woodruff Opdahl has contributed greatly to the understanding of Homer's visits to Hurley and their context. She and her husband purchased the Wynkoop house in 1971 from the estate of James Davis Wynkoop's widow after the death of the widow's son from her first marriage. He was the last family resident over an unbroken chain extending back over three hundred years. For fifty years, Mrs. Opdahl has been a model of good stewardship and generosity in preserving and sharing the rich history of this remarkable homestead.

94. Both the picture and the sword Homer depicts above it are now in the collection of the Hun-
tington Museum and Library, Art Museum and Botanical Gardens, San Marino, California.

95. See address by Matthew Ten Eyck, November 16, 1782, and Washington's response, *Founders
Online,* National Archives, founders.archives.gov/documents/Washington/99–01–02–09960.
See also Richard Wynkoop, *Wynkoop Genealogy in the United States of America* (New York:
Knickerbocker Press, 1904), pp. 45–46, for more details on the colonel. In 1906 or later, the same
author wrote an *Addendum* to his genealogy. This addendum corrects certain errors in his 1904
genealogy. It also suggests incorrectly that Washington spent the night of November 16, 1782,
with the colonel rather than at the nearby 1767 house of Cornelius Evert Wynkoop (1746–
1795) in the hamlet of Stone Ridge, Marbletown, New York. The latter younger man is generally
agreed to have been Washington's host. See Marius Schoonmaker, *The History of Kingston, New
York, from Its Earliest Settlement to the Year 1820* (New York: Burr Printing House, 1888),
pp. 335–40, and "The Washingtons in Kingston," *Olde Ulster, An Historical and Genealogical
Magazine* 3, no. 1 (January 1907): 6–17.

96. See Jervis McEntee Diaries, August 17, 1875, Archives of American Art, Smithsonian Institu-
tion. He records that Perry "had just come from Leeds, in a waggon [*sic*] with George Wynkoop
on his way out there where Homer already is. Had a postal card from Bellows who was disap-
pointed in Hurley and could not get in at Wynkoops and has gone to Leeds." This short entry
a) corroborates other evidence that George Wynkoop hosted artists; and b) confirms that Ho-
mer traveled with other artists besides Perry, even though to the disappointment of Albert Fitch
Bellows, George Wynkoop's beds that month were already filled.

97. Wynkoop, 1904, op. cit., p. 119, for George Wynkoop (1814–1881), and his sons James Davis
Wynkoop (1843–1904) and Derrick Cornelius Wynkoop (1841–1923).

98. James Davis Wynkoop may be the same James Wynkoop who enlisted in New Paltz and then
served in the 156th New York Infantry for a week in November 1862, whereupon he deserted.
That regiment included at least five other men from Hurley. Given the military fame of his
great-grandfather, this desertion is notable if it is indeed the same man. James Davis Wynkoop
lived in the 1870s at the historic Cosmopolitan Hotel, located and still standing at the corner of
Chambers Street and West Broadway in New York City. See Christopher Gray, "The Grand-
daddy of Them All," *New York Times*, October 11, 2009. He was active in the Holland Society of
New York and in the Empire State Society of the Sons of the American Revolution. He may
have been the posthumous author of a book-length twelve-canto poem entitled *The Rebellion of
Hell* (New York: Broadway Publishing, 1908).

99. Neither Derrick Cornelius Wynkoop nor his brother James Davis Wynkoop had children. Der-
rick in 1863 married Anna Roosa Wynkoop (1839–1919), and James in 1888 married Elizabeth
Appleton (1854–1897). Elizabeth was the widow of Clement Horace Warren (1848–1884) and
had two sons by him, one of whom, William Appleton Warren (1880–1970), remained in the
house under a life estate until his death.

100. Both men depicted the Wynkoop farmhouse from the same angle, at the same distance. Snyder
may have depicted the house from a more distant position in another picture. These pictures are
all now in private collections. Snyder's principal one is now unlocated but hung in the house
until 1969. His other picture, likely of the Wynkoop house, is identified only as an oil on board
of a farmyard, dated 1871, which was offered for sale on March 22, 2014, by the Rago Arts and
Auction Center, Lambertville, N.J. Ryder's picture is undated but may derive from the 1875 visit
noted in the *New York Evening Post* (July 28, 1875, p. 2). Entitled *Feeding the Birds*, it was offered
on December 8, 2020, at Freeman's Auction House in Philadelphia.

101. *New York Evening Post*, July 28, 1875, p. 1, "Art Notes."

102. The evidence for Tanner's association is pictorial: a picture of the house signed and dated 1888 in

the collection of the New Britain Museum of American Art. It is entitled *Wynkoop House, Old Haarlem*. The painter, then twenty-nine years old and completing his study at the Pennsylvania Academy of the Fine Arts, composed his picture so identically to those of Ryder and Snyder that one can only conclude that he had seen one or both of the older painters' pictures. However, Tanner's enhanced color contrasts suggest his awareness of the work of his contemporaries in France such as Georges Seurat (1859–1891) who had moved well past the Barbizon vocabulary Ryder and Snyder deployed. Three years later, in 1891, Tanner would move to Paris after an unsuccessful stint as a photographer in Atlanta. The team at the Hurley Heritage Society and their advisor Reilly Rhodes have recognized, to their credit, that the New Britain picture depicts the Hurley house, and have shared generously the details of the Snyder picture(s) and that of Ryder.

103. He was elected in 1891, at the age of seventy.

104. The year inscribed is either 1760 or 1761. Eleazer was born in Boston's North End on March 22, 1761.

105. *Harper's Weekly*, June 26, 1875, p. 522.

106. *The Nation*, February 17, 1876, "Fine Arts—Ninth Exhibition of the Water-Color Society," p. 120.

107. Ibid.

108. See 1875 New York State Census for Hurley, Ulster County, New York.

109. Maria DeWitt, born about 1812, is noted on the census as the owner of the land on which she and her daughter Maria Davis, born about 1839, and her grandchildren lived. One of these grandchildren was James H. Davis (1863–1939). James and his mother and grandmother also appear in Hurley on the 1870 census, and the two women on the 1880 census. Both women are noted on all of these records as being unable to read or write. The state's Manumission Act declared that children born after July 4, 1799, to enslaved women would no longer be considered enslaved. A separate act passed in 1817 declared that enslaved men and women born before 1799 would be considered free as of July 4, 1827. Maria was likely born in 1813 as the mixed-race daughter of Cornelius N. DeWitt and Elizabeth Freer and baptized on July 10, 1814, at the Dutch Reformed Church of Wawarsing, New York (*New York Genealogical and Biographical Record*, Volume VII), a town along the historic D&H Canal, about twenty miles southwest of Hurley. She moved to Hurley in 1850, according to the 1855 State Census, and typically indicated her birth year as 1812. She appears in Wawarsing in the 1850 Federal Census and thereafter in Hurley. Davis appears probable as Homer's model based on his age and location, but other Black boys of similar age may have been living in Hurley and been less fully documented, so one cannot be certain about the identification of Homer's model.

110. The oil paintings are *The Unruly Calf* (private collection), *Weaning the Calf* (North Carolina Museum of Art), and *The Watermelon Boys* (Cooper Hewitt Museum, Smithsonian Institution). The watercolors are *Contraband* (Arkell Museum), *A Flower for the Teacher* (Georgia Museum of Art, University of Georgia), and *The Busy Bee* (private collection). All but *The Watermelon Boys* are dated 1875; that painting is dated from 1876. Two other drawings, both undated, likely also include Davis. One is a preparatory study in the Brooklyn Museum for *The Unruly Calf* and the last is a fourth watercolor, *Two Boys in a Wagon* (Philadelphia Museum of Art). These works are discussed in *RWWH*, II, pp. 382–96, CR 387–395.

111. *RWWH*, II, p. 383, citing *New York World*, February 11, 1876. Like Homer, Delano was a member of the Century Association, to which his brother's grandson Franklin Delano Roosevelt (1882–1945) would also belong. For the importance of comprehending the emotional impact of this watercolor and many other Homer works, see Rebecca Bailey Bedell's superlative *Moved to Tears: Rethinking the Art of the Sentimental in the United States* (Princeton, NJ: Princeton University Press, 2018).

112. *New-York Daily Tribune* (November 25, 1876, p. 2, "A Ramble Among the Studios"). Foster's description is on p. 82 of her magisterial volume on American watercolor (Foster, 2017, op. cit.).

113. Ibid. Beard, an academician, was also a fellow Centurion, joining the club six months after Homer. He was among the earliest and most durable of Tenth Street tenants, moving into the building in 1861 and remaining there until his death.

114. *Daily Alta California* XXVIII, no. 9,738, December 4, 1876, p. 1. Although the review records three Homer pictures on exhibition, it does not describe the other two, and other documentation to ascertain their identity appears unavailable.

115. Letter from Winslow Homer to Samuel Putnam Avery, dated March 9, 1877, Metropolitan Museum of Art Library, Watson Online Record b17716433, gift of Samuel P. Avery, Jr., 1914.

116. No letters, newspaper references, diary references, or other similar documentary evidence supports this first trip after the Civil War, or details where he went. But the period is one that has no evidence for Homer being in New York, and the pictorial evidence, as this chapter suggests, supports a trip south.

117. See Susanna W. Gold, "A Measured Freedom: National Unity and Racial Containment in Winslow Homer's *The Cotton Pickers, 1876*," *Mississippi Quarterly* 55, no. 2 (Spring 2002): 163–84, and Michael Quick, "Homer in Virginia," *Los Angeles County Museum of Art Bulletin* 24 (1978): 60–81. Homer's models may be two sisters in Hurley, Sarah and Catherine Newkerk, born in 1855 and 1857, according to the 1875 New York State census (Hurley, 2nd Election District, Ulster County, p. 11). They lived in the log cabin of their father, Richard Newkerk (born 1823), and mother, Margaret Newkerk (born 1825), on land their father owned, with their parents, an older brother, and two younger siblings, all of whom were literate. Evidence of Homer's intention to link the picture to North Carolina rests not only in the review in the *New York Evening Post* published the month Homer showed it at the Century (March 30, 1877, p. 2, "Winslow Homer's *Cotton Pickers*") but in a label contemporaneous with the painting. See *RWWH*, II, pp. 415–19, CR 602.

118. *New York Evening Post*, March 30, 1877, p. 2. For a broad history of cotton, see Sven Beckert, *Empire of Cotton: A Global History* (New York: Knopf, 2014), and Anna Arabindan-Kesson, *Black Bodies, White Gold: Art, Cotton, and Commerce in the Atlantic World* (Durham, NC: Duke University Press, 2021). For Arthur's first entry in the Galveston directory and his first listing as a cotton broker rather than a cotton buyer, see *Heller's Galveston City Directory, 1874* (Galveston, TX: Strickland & Clarke, 1874), p. 52, and *Morrison & Fourmy's General Directory of the City of Galveston, 1890–1891* (Galveston, TX: Morrison & Fourmy, 1890), p. 469. For a recent treatment of blockade runners such as Wigg, see Joseph McKenna, *British Blockade Runners in the American Civil War* (Jefferson, NC: McFarland & Co., 2019), with George Wigg discussed on p. 42 and his ships *Eagle/Jeanette* and *Juno/Helen* discussed respectively on pp. 111–12 and 123. For insight into Arthur's short-lived success in manufacturing, see "Story of the City. How Galveston Grows and Expands in Every Way," *The Galveston Daily News*, August 9, 1891, p. 6. The business, Galveston Rope & Twine (later Galveston Rope Co.), failed and was sold at public auction in 1895. See "Legal Notices. Trustee's Sale," *The Galveston Daily News*, July 27, 1895, p. 3. The Galveston City directories suggest that under its new ownership, Arthur remained president of the company and his son Arthur Patch Homer served as superintendent of its rope mill. The hurricane of September 8, 1900, apparently did not significantly harm the plant, which had by then converted to sisal as its principal raw material. See Tom Finty, Jr., "Manufacturing Interests," in *Galveston in Nineteen Hundred*, ed. Clarence Ousley (Atlanta: William C. Chase, 1900), pp. 174–78. For the Picasso quote, see "Picasso Speaks: A Statement by the Artist," *The Arts* 3, no. 5 (May 1923): 315. Picasso made the statement in the course of an interview with the Mexican artist and gallerist Marius de Zayas (1880–1961).

119. Like most of Homer's such field drawings, these are lost.
120. *New York Evening Post*, March 30, 1877, p. 2.
121. *RWWH*, II, p. 415, presumably citing Smith's *American Illustrators* (New York: C. Scribner's Sons, 1892), pp. 49–50.
122. Although Homer's March 1877 letter to Avery explains his commercial strategy, it was Centurion Jervis McEntee, working in tandem with yet another Centurion, Robert Gordon (1829–1918), a renowned Scottish-born collector, who actually implemented it on Homer's behalf. See McEntee's diary entry for March 23, 1877 (Smithsonian Archives of American Art), recording that he and Gordon brokered the sale for "$1,500 including copyright." The price of *A Fair Wind* was $425, as published in the *New York Herald*, March 3, 1877, "Art Sales" (p. 10).
123. *New York Evening Post*, March 30, 1877, p. 2.
124. "Recollections by John W. Beatty," in Goodrich, op. cit., p. 224.
125. Ibid.
126. Letter of April 27, 1877, to the wood engraver Andrew Anthony (1835–1906), with whom Homer would collaborate on four wood engravings to illustrate "Excelsior," a poem by Longfellow published the following year.
127. See Mary Ann Calo, "Winslow Homer's Visits to Virginia During Reconstruction," *American Art Journal* 12, no. 1 (Winter 1980): 4–27. The two critics are an unsigned one in the *New York Sun*, March 12, 1898, quoted in *RWWH*, III, pp. 50–51, and Christopher W. Knauff in "Certain Exemplars of Art in America: Winslow Homer and Elliott Daingerfield," *The Churchman*, July 23, 1898, pp. 123–25 and p. 128, which is quoted in *RWWH*, III, p. 51. Both articles describe *Dressing for the Carnival*. Knauff is insightful in general but cites clothing for "Christmas festivities" (p. 128) and ignores the role of the American flags in the picture. While Jonkonnu was associated with Boxing Day, Homer appears never to have been present anywhere near the area associated with Jonkonnu during the Christmas season.
128. The principal pictorial evidence for his location is in *Dressing for the Carnival*, discussed below. The Jonkonnu tradition was concentrated around Wilmington.
129. These six occasions were: 1) Century Association, New York, June 2, 1877 (the only case where Homer could control their hanging, as #25 and #26); 2) Exposition Universelle, Paris, May 1, 1878 (#59 and #61); 3) Boston Art Club/Boston Society of Architects/Schools at the Museum of Fine Arts Exhibition of Contemporary Art, Boston, April 22, 1879 (#308 and #404); 4) Springfield Art Association, Springfield (MA), December 9, 1879; 5) Union League Club, New York, January 8, 1880; and 6) National Academy of Design, New York, March 30, 1880 (#327 and #593). At the sixth and final of these exhibitions, William T. Evans acquired *Sunday Morning in Virginia*. About the time of the October 1892 New York Celebration of the 400th Anniversary of the Discovery of America, Clarke bought *Visit from the Old Mistress*, enabling the pair to be exhibited in the same place for one last occasion during Homer's lifetime. Homer's letter of April 23, 1892, to Thomas B. Clarke describes *A Visit from the Old Mistress* as "the companion to the one Mr. W. T. Evans has . . . I always thought that Mr. Evans should have it—it's the same size and was exhibited in Paris with his *Sunday Morning in Va*. He paid me 400 & I would sell this to him for $500." Clarke's letter to Homer of November 5, 1892, shows that he bought both *Visit from the Old Mistress* and *Dressing for the Carnival* for a total price of $1,000. See *RWWH*, III, p. 50.
130. *Art Amateur* 2, no. 6 (May 1880): 112.
131. See Jo-Ann Morgan, "Winslow Homer Visits Aunt Chloe's Old Kentucky Home," *SECAC Review* XIV, no. 5 (2005): 439–51.
132. See Wood and Dalton, op. cit., pp. 87–95. This is the definitive analysis of the subject. See also Calo, "Winslow Homer's Visits to Virginia During Reconstruction," 4–27, and Matthew Pratt

Guterl, *American Mediterranean: Southern Slaveholders in the Age of Emancipation* (Cambridge, MA: Harvard University Press, 2008).

133. *Art Amateur* 2, no. 6 (May 1880): 112.

134. The Century Association, Exhibition Records, June 2, 1877, p. 182, #2.

135. Wood and Dalton, op. cit., p. 101.

136. See David Park Curry, "Winslow Homer: Dressing for the Carnival," National Gallery of Art, *Studies in the History of Art*, vol. 26, Symposium Papers XI: Winslow Homer: A Symposium (1990), pp. 90–113, particularly p. 102.

137. See Judith Bettelheim, *The Afro-Jamaican Jonkonnu Festival: Playing the Forces and Operating the Cloth* (PhD thesis, Yale University, 1979), pp. 253–61.

138. See Elizabeth A. Fenn, "'A Perfect Equality Seemed to Reign': Slave Society and Jonkonnu," in *North Carolina Historical Review* 65, no. 2 (April 1988): 127–53.

139. Bettelheim, op. cit., p. 257.

140. Ibid., p. 258. See also Dougald MacMillan, "John Kuners," *Journal of American Folklore* 39, no. 151 (January–March 1926): 53–57.

141. Cynric Williams, *A Tour of the Island of Jamaica*, 1827, as cited in Fenn, op. cit., p. 138.

142. Questions have arisen about whether Homer was memorializing the holiday Juneteenth (June 19), which had become acknowledged in at least a few parts of the country as a holiday within fifteen years of the painting, as is evident in the *Brenham Weekly Banner*, June 25, 1891, p. 7, first column, and see Elizabeth Hayes Turner's essay, "Juneteenth: Emancipation and Memory," in *Lone Star Pasts: Memory and History in Texas*, ed. Gregg Cantrell and Elizabeth Hayes Turner (College Station: Texas A&M University Press, 2007), pp. 143–75. The celebration of Juneteenth originated in Galveston, where Homer's brother Arthur had lived since 1869, and was specific to commemorating the emancipation of enslaved Americans in Texas. That said, it seems a far less probable occasion for Homer to memorialize than Independence Day on July 4, especially given the fact that this was the centennial year.

143. Brian D. Page, "'Stand by the Flag': Nationalism and African-American Celebrations of the Fourth of July in Memphis, 1866–1887," *Tennessee Historical Quarterly* 58, no. 4 (Winter 1999): 284–301; and James B. Jones, Jr., "The 'Battle' of Franklin: A Reconstruction Narrative," *Tennessee Historical Quarterly* 64, no. 2 (Summer 2005): 110–19.

144. See Homer's letter to Clarke of April 23, 1892, stating a $750 value Homer then placed on *Dressing*, but agreeing to sell it to Clarke with *A Visit*—for a total of $1,000. The letter is quoted in *RWWH*, III, p. 50, and is in the Smithsonian Archives of American Art.

7. TELLING IT SLANT (1877–1881)

1. David F. Tatham, *Winslow Homer in the Adirondacks* (Syracuse, NY: Syracuse University Press, 1996), p. 36.

2. *Boston Daily Advertiser*, November 12, 1868.

3. *Boston Daily Advertiser*, April 10, 1869, the date of the book's release.

4. William H. H. Murray, *Adventures in the Wilderness; or, Camp-Life in the Adirondacks* (Boston: Fields, Osgood, 1869), p. 24. Murray appears to have moved from Meriden, Connecticut, to Park Street in the fall of 1868. See p. 9 of *Manual of First Congregational Church of Meriden, Conn.*, published by the church in 1906.

5. Ibid., p. 195.

6. Ibid., p. 197.

7. See Terence Young, "The Religious Roots of America's Love for Camping," October 17, 2017, www.whatitmeanstobeAmerican.org.

8. See "Satire in the Sticks: Humorous Wood Engravings of the Adirondacks," by Edward Comstock, Jr., in *Prints and Printmakers of New York State, 1825–1940*, ed. David F. Tatham (Syracuse, NY: Syracuse University Press, 1986), pp. 163–82.

9. See Michael Kudish, *Where Did the Tracks Go: Following Railroad Grades in the Adirondacks* (Saranac Lake, NY: Chauncey Press, 1985), pp. 57–58. For an excellent overview of rail service in the Adirondack region, see Jerry Jenkins with Andy Keal, *The Adirondack Atlas: A Geographic Portrait of the Adirondack Park* (Bronx, NY: Wildlife Conservation Society for Syracuse University Press and the Adirondack Museum, 2004), pp. 88–89.

10. Tatham, 1996, op. cit., p. xiii. See also Jenkins with Keal, op. cit., p. 3.

11. See 1850 Census record for Thomas Baker, farmer, in Warrensburgh, New York. Rice's gravestone suggests that he was born in 1830 but the family Bible maintained by his father, Nathaniel, a minister, gives a birthdate of October 10, 1827.

12. See the Adirondack Museum finding aid for the Juliette Baker Rice Kellogg papers, including the suggestion that Juliette's stillbirth led to an infection that paralyzed her. The author finds no evidence in the papers themselves for the idea that she suffered a disability from that moment forward.

13. Juliette Baker Rice Kellogg diary transcript, Adirondack Museum.

14. Thomas Baker (1809–1863) appears to have begun constructing the boardinghouse prior to his death, and his wife, Eunice Harris Baker (1814–1891), to have completed it. The dining room for the North Woods Club (built in approximately 1895) occupies the site today. Documentary evidence has not materialized to justify the notion that Thomas Baker also served as minister in the Darrowsville Wesleyan Methodist Church, and assisted the formerly enslaved on their passage to Canada on the Underground Railroad.

15. Murray, 1869, op. cit., p. 195.

16. Ibid. Murray is quoting Revelation 22:1, the climactic vision of Eden restored. The King James translation reads, "And he shewed me a pure river of water of life, clear as crystal, proceeding out of the throne of God and of the Lamb."

17. Tatham, 1996, op. cit., p. 27.

18. Ibid.

19. See James B. Trefethen, *An American Crusade for Wildlife* (New York: Winchester Press and the Boone and Crockett Club, 1975), pp. 110–12, and Daniel J. Philippon, *Conserving Words: How American Nature Writers Shaped the Environmental Movement* (Athens: University of Georgia Press, 2004), pp. 62–63. Philippon's chapter "The Closing of the Frontier: Theodore Roosevelt and the Boone and Crockett Club" (pp. 33–71) summarizes the role of the Boone and Crockett Club in establishing a national conservation movement that Roosevelt (1858–1919) and George Bird Grinnell (1849–1938) initiated over a New York dinner on December 8, 1887. Among the early members of the club were at least nine whom Homer knew through the Century and other circles, including Bierstadt; Heber R. Bishop (1840–1902); Grinnell himself; Arnold Hague (1840–1917); Clarence King (1842–1901); James West Roosevelt (1858–1896); Roosevelt himself; Rutherford Stuyvesant (1842–1909); and W. Austin Wadsworth (1847–1918). While Homer was not a member himself of the Boone and Crockett Club, the circumstantial evidence is strong that he knew these men's efforts and supported their objectives. See William Cary Sanger, "The Adirondack Deer Law," in *Trail and Camp-Fire: The Book of the Boone and Crockett Club*, ed. George Bird Grinnell and Theodore Roosevelt (New York: Forest and Stream Publishing, 1897), pp. 264–79. Sanger (1853–1921), a lawyer, was also a Centurion. See Doyle Leo Buhler, *Capturing the Game: The Artist-Sportsman and Early Animal Conservation in American Hunting Imagery, 1830s–1890s* (University of Iowa PhD thesis, 2011), for a thorough analysis of the ways in which this conservation movement (and its opponents) shaped the art of the Amer-

ican landscape and its inhabitants. Homer's congruence with the club's goals, and their expressions in his art, is the subject of Annie Ronan's article "Capturing Cruelty: Camera Hunting, Water Killing, and Winslow Homer's Adirondack Deer," *American Art* 31, no. 3, Smithsonian American Art Museum (Fall 2017): 52–79.

20. Homer based this painting, and a similar one at the Colby College Museum of Art, on studies he made on the shore of West Bay, at Mink Pond, the site of dozens of later Homer watercolors. The two islands he depicts in this work permit a precise identification of the spot from which he sketched. Lamentably, neither these sketches nor Homer's other studies for his Adirondack oil paintings and watercolors survive.

21. Tatham, 1996, op. cit., p. 28.

22. This illustration, like "Looking at the Eclipse" of December 16, 1865 (*Chimney Corner*), and "Lumbering in Winter" of January 28, 1871 (*Every Saturday*), was drawn by Homer and then engraved by the painter and illustrator John Parker Davis (1832–1910).

23. Letter from Eliphalet Terry to Juliette Baker Rice Kellogg, December 18, 1870, naming the two models (Juliette Baker Rice Kellogg Papers, MS 83–18, Adirondack Museum Archives). In 1879, after the 1873 death of Wesley Rice, Juliette would marry another neighboring farmer, William Kellogg (1850–1931). Juliette's sister Jennie (1855–1937) and her husband, Robert Bibby (1854–1923), whom she married in 1876, would succeed Juliette as the principal managers of the farm and boardinghouse.

24. Murray, 1869, op. cit., p. 25.

25. Ibid., p. 34.

26. Ibid., p. 38.

27. Ibid., May 14 and 19, 1874, for Homer's and Fitch's arrival on May 14 and Terry's on May 19. The Juliette Baker Rice Kellogg diary, January 9, 1874, reports that on a trip to Manhattan she had seen both Fitch and Terry, and had visited "Cousin Homer."

28. Fitch and Wyant were very active in the Century, as was another painter also in Keene Valley then: Horace Wolcott Robbins (1842–1904).

29. Logbook, Keene Valley Library archives. James was a co-founder of Putnam Camp with three prominent physicians: Henry Pickering Bowditch (1840–1911), Charles Pickering Putnam (1844–1914), and his brother James Jackson Putnam (1846–1918).

30. G. W. Sheldon, "Sketches and Studies. II. From the Portfolios of A. H. Thayer, William M. Chase, Winslow Homer, and Peter Moran," *Art Journal* 6, New Series (1880): 107.

31. Ibid.

32. R. M. Shurtleff, Letter to the Editor, *American Art News* IX, no. 3 (October 29, 1910): 4.

33. "Reopening the Studios," *New-York Tribune*, October 13, 1877, p. 2.

34. *New York Times*, April 9, 1880, after Homer submitted the painting to the National Academy's Annual Exhibition. The picture's erroneous date likely reflects the fact that it was undated until March 1905, when a Homer letter to his gallery, Knoedler, explains that he intends to "overlook it & fix it" for a new owner. See *RWWH*, III, p. 69, for a full discussion. Homer dated it to its first nonclub exhibition.

35. Obituary of Charles Monroe Holt, *Elizabethtown Post*, February 25, 1921. He also served Essex County for several years as deputy sheriff. His letter of February 20, 1917, to the *Elizabethtown Post* shows him to be a highly literate man with a deep interest both in the history of Keene Valley and Elizabethtown and in the likelihood that the United States would enter World War I.

36. Charles Holt, *Adirondack and Main*, Part Three (1874–1922), p. 22 (unpublished manuscript, Keene Valley Library Archives).

37. Letter dated June 30, 1997, from Robin Pell, Baldwin, New York, to David Tatham of Syracuse

University, found in the curatorial files at the Brooklyn Museum. Tony Goodwin, the author of the guidebook *High Peaks Trails* and the executive director of the Adirondack Trail Improvement Society, independently confirmed Pell's identification of the location that inspired this picture.

38. Ibid.

39. Tony Goodwin identified Green Mountain, for which the author gives thanks.

40. The author is deeply indebted to Peter Dean and Caroline Welsh, longtime members of the North Woods Club, for their identification of Homer's location and the locations of his models in this picture and in *Two Guides*. Their insights on the topography depicted in these pictures have been invaluable. Buck Hill, 2,192 feet in height, is at the north corner of the North Woods Club property and is often described as Round Top Hill.

41. Seneca Ray Stoddard, *The Adirondacks: Illustrated* (Albany, NY: Weed, Parsons, 1874), pp. 137–38.

42. Ibid., p. 137. Charles Dudley Warner's better-known homage to Phelps as the archetype of "The Primitive Man" appeared the year after Homer's visit, in the fifth installment of his essays in the *Atlantic Monthly* (May 1878, pp. 636–46), and concludes with the pronouncement "Here our study must cease. When the primitive man comes into literature, he is no longer primitive."

43. See *RWWH*, III, p. 61, where Abigail Booth Gerdts suggests that Knoedler created the errone-ous title in 1936.

44. Preston may have given the painting to Rev. George J. Prescott (1848–1928), an Episcopal priest in Boston whose wife, Caroline Miller, was from New Ipswich, New Hampshire (Preston's childhood home).

45. This detail of a meandering creek is cropped out of many published photographs of the picture.

46. David Tatham suggests that the shirt's heart insignia reflects a specific hose company, but no documentary evidence has emerged connecting shirts of this kind to firemen or to their hook-and-ladder organizations, either in the Adirondacks or outside the vast area. See p. 72 of his book *Winslow Homer in the Adirondacks*. The fame of the painting has led to much speculation on the shirt Homer depicts Holt wearing. A column by James P. Atkinson published in the *Lake Placid News* on April 5, 1929 (p. 6), suggests that Holt wore a red flannel shirt year-round. Holt appears in many photographs, but consistently in a white (or possibly yellow) shirt. The consult-ing costume expert Lynne Bassett and the menswear historians David Rickman and Thomas Shaw each conclude that bibbed shirts of this kind were common, as was embroidering the plastron (or bib) itself. In this case, Rickman points out, the plastron's edge is likely edged with contrasting fabric to accentuate the metallic buttons. The heart was a common embroidery motif on men's shirts during this period, but in no case has been identified on the plastrons of shirts made for firemen, whose emblems were more visible, bolder, and more heraldic. Bassett has identified a related shirt from the mid-1850s at Kansas City's Arabia Steamboat Museum. The plastron of that shirt (clearly handmade and hand-embroidered) also includes a heart motif.

47. Amanda Holt was known as an excellent cook; see Holt, op. cit., p. 22.

48. See Warner, especially pp. 638–41, for extensive discussion of Phelps and Greeley's association, including the similarities of their voices.

49. See Thomas Fuller, "'Go West, young man!'—An Elusive Slogan," in *Indiana Magazine of His-tory* 100, no. 3 (September 2004): 231–42. Fuller explains that the saying seems not to have appeared in print until August 20, 1870 (in *Punchinello*, a satirical magazine, in the first para-graph of chapter 14 of Orpheus C. Kerr's serialized *The Mystery of Mr. E. Drood*, p. 323), but that Greeley had been using it orally for many years. *Harper's Weekly* used it in a satirical article by Max Adeler (a pen name for Charles Heber Clark) in its June 29, 1872, issue. The Congrega-tionalist minister Josiah Bushnell Grinnell (1821–1891) documents very specifically Greeley's oral admonition to him on September 25, 1853, "Go West, young man! Go West!" when he

encouraged Grinnell to travel to Springfield, Illinois; see *Men and Events of Forty Years* (Boston: D. Lothrop, 1891), pp. 84–87 and 220–27.

50. The publisher was also successor to the better-known Ticknor & Fields. The book's copyright is 1877 although the title page bears the date of 1878. A second edition, entitled *Christmastide*, included not only "Excelsior" but one poem each by Aldrich, James Russell Lowell, and John Greenleaf Whittier.

51. Ticknor firm cost books, Houghton Library, Harvard University, Ms. Am 1185.6 (8): 328–29.

52. See Ann Glasscock and Ronald G. Pisano, *The Tile Club: Camaraderie and American Plein-Air Painting* (Madison, WI: Chazen Museum of Art, 2018). See also William Mackay Laffan, "The Tile Club at Work," *Scribner's Monthly* 17, no. 3 (January 1879): 401–409; F. Hopkinson Smith and Edward Strahan, *A Book of the Tile Club* (Boston: Houghton Mifflin, 1887); and Mahonri Sharp Young, "The Tile Club Revisited," *American Art Journal* 2, no. 2 (Autumn 1970): 81–91.

53. Other early members included the painters Arthur Quartley (1839–1886) and Francis Hopkinson Smith (1838–1915) and two art critics: William Mackay Laffan (1848–1909) and Earl Shinn (1837–1886), writing under the pen name Edward Strahan.

54. See Daniel Sutherland, "Virginia's Expatriate Artists: A Post-Civil War Odyssey," *Virginia Magazine of History and Biography* 91, no. 2 (April 1983): 131–60. The Colby bust appears to be the only surviving one created during Homer's lifetime. A bronze version cast in 1911 is at the Pennsylvania Academy of Fine Arts. Posthumous bronze casts from 1923 are at the Brooklyn Museum, the Metropolitan Museum of Art, and the National Gallery of Art.

55. The ungainly portrait Homer's friend Oliver Ingraham Lay (1845–1890) painted at the age of twenty is best understood as a favor Homer permitted his young comrade by complying in an unusual way with the requirements of the National Academy of Design. Ordinarily, new academicians would produce their own self-portraits; Homer chose instead to give his friend the opportunity of painting Homer. The idea allowed the ever-private Homer to avoid taking on the task himself, and gave his friend a chance to show off his skill. Lay became an associate academician in 1876.

56. *The Poems of Emily Dickinson: Reading Edition* (Cambridge, MA: Belknap Press of Harvard University Press, 1998), F1263 A. The poem is Amherst Manuscript 372 (1872). A digital image of the manuscript is available, including two variations that do not appear in print, at www .edickinson.org/editions/1/image_sets/12177283.

57. Gustav Kobbe, "John La Farge and Winslow Homer," *New York Herald*, December 4, 1910, Magazine Section, p. 11. The fireplace surround that Homer made in 1878 for the home of his friend Joseph Foxcroft Cole (1837–1892) in Winchester, Massachusetts, was installed in the Washington, D.C., home of Stanley Woodward (1899–1992) for much of the twentieth century. Although it is listed in *RWWH*, III, as CR 657 (pp. 102–103), it appears to have been destroyed during one of two house renovations in the mid-1990s.

58. Dated and signed "Winslow Homer N.A. / Oct 20. 1866," it also bears the inscription "Leave this Room." It remains in private hands and has never been exhibited. The drawing includes two figures. One is a dashing cavalry officer complete with sash and sword, his left arm bent with his hand to his hip and his right arm pointing. This figure anticipates rather precisely the officer standing next to a pile of cannonballs on the lower left of Homer's complex wood engraving (*Harper's Weekly*, January 8, 1870). The other and much smaller figure, to whom the male figure is pointing, is a maid in a long dress, standing in front of an enormously overscaled dustpan.

59. Laffan, "The Tile Club at Work," p. 401.

60. Edward Verrall Lucas, *Edward Austin Abbey, Royal Academician: The Record of His Life and Work* (New York: Charles Scribner & Sons, 1921), Vol. I, p. 59.

61. See Colleen Denney, *At the Temple of Art: Grosvenor Gallery 1877–1890* (Teaneck, NJ: Fairleigh Dickinson University Press, 2000).

62. See the exhibition catalogue *The Cult of Beauty: The Aesthetic Movement 1860–1900*, edited by Stephen Calloway and Lynn Federle Orr, for the show they curated at the Victoria and Albert Museum, which traveled from there in 2011 and 2012 to Paris and San Francisco.

63. Lyman Abbott, *Reminiscences* (Boston: Houghton Mifflin, 1915), p. 340.

64. Lawson appears to have left the business as a function of personal bankruptcy. His efforts to save Houghton Mifflin appear to have been the principal drivers of his failure. See Ellen B. Ballou, *The Building of the House: Houghton Mifflin's Formative Years* (Boston: Houghton Mifflin, 1970), pp. 275–84 and 296–302. See also *New-York Daily Tribune*, December 25, 1882, p. 2, column 3, in which he is described only as "the owner of the Houghton Farm, Orange County." His brother Henry succeeded him as president, and Homer retained good relations with both men. Despite Lawson's starting up his own smaller varnish business in the wake of his departure, there is no evidence of rancor between the two brothers. It is noteworthy that long after his summers at Houghton Farm, Homer sketched Susan E. Valentine (1875–1938) and dated the sheet August 24, 1900 (CR 1703). She was daughter to Henry C. Valentine and his wife, Grace Barrett Valentine (1846–1931). Homer also wrote a letter to Grace Barrett Valentine that is not dated but is addressed to her at Prouts Neck. Susan Valentine appears in a photograph (Bowdoin College Museum of Art, Photo Album Homer I, HomerMemorabilia 36.23) wearing the same dress and hat as she wears in the Homer drawing. That photograph locates her at Prouts Neck, evidently in the summer of 1900. The evidence is consistent with a pattern of the Homers (including Winslow) retaining a friendship with the families of both Valentine brothers, and that friendship extending to various members of the Homer family. No blood relationship between the Valentines and the Homers is known to this author, but the photograph is inscribed "Coz. Susie."

65. Obituary of Lawson Valentine, *New York Times*, May 7, 1891, p. 2.

66. Ibid.

67. The plant was at 364 Ewen Street (now 364 Manhattan Avenue), Williamsburgh.

68. Dun & Bradstreet auditor reports, Special Collections, Baker Library, Harvard Business School.

69. Frederick Stuart Church, not to be confused with the better-known landscape painter Frederic Edwin Church (1826–1900), was a prolific illustrator who lived near Homer at 788 Broadway through 1877, then moved in 1878 around the corner to 58 East Thirteenth Street. No documentation has surfaced explaining the commissioning of these advertisements or the precise relationship between Church and the Valentine family, or between Church and either Charles or Winslow Homer. Church appears to have first done work for the company in 1873 while he was also making advertisements for the Elgin Watch Company. On December 18, 1875, *Harper's Bazar* published a group of silhouettes (p. 820) Church had designed depicting quotidian scenes: Morning, Noon, and Night. His work for the Valentines first appeared the following year. The subtlety, romance, and wry humor of these advertisements' designs are highly similar to Homer's work of this period. Homer, like his older brother and Lawson Valentine, enjoyed helping his friends achieve greater recognition—particularly when they were younger than he and more in need of it. Dale Horst and Deborah Hobler, two experts on Church, have each been most helpful in discussing these unusual works.

70. *Painters Magazine and Paint & Wallpaper Dealer* 41 (January 1914): 371.

71. Obituary of Lawson Valentine, *New York Times*, May 7, 1891, p. 2.

72. Ibid. See chapter 1 for more on Ellen Robbins and Beecher's patronage.

73. See *RWWH*, II, pp. 133–36. Homer sold *An Adirondack Lake* about six months after first exhibiting it at the Century on April 1, 1871; Lawson could easily have seen it either at the Century or at Homer's studio during that spring and summer, after the exhibition had ended.

74. *Andrews' American Queen*, March 20, 1880, p. 166. The New-York Historical Society has recently received the donation of a copy of this extraordinarily rare periodical and generously provided access to it.

75. "Winslow Homer's Water-Colors," *New York Times*, March 5, 1880, p. 8, with considerable detail on the pricing of the works sold.

76. *American Art Review* 1, no. 6 (April 1880): 269. For CPI-based inflation calculations, see the website MeasuringWorth.com.

77. See Christopher Gray, "Bachelors as Artists in Residence," *New York Times*, April 27, 1997, Section 9, p. 7. McKim was still partnered on this project with William B. Bigelow; Stanford White would replace Bigelow months later. Their client on the project was the iron merchant Lucian Tuckerman (1818–1890), another Centurion New Englander.

78. Preston is often described as a cousin of Mattie, but the truth is more complicated than that. Preston's father, Thomas Preston (1813–1862), who married Sarah Woodbury (1823–1862), had an older brother, John Preston (1802–1867). John married Elizabeth Smith French (1808–1882), older sister to Mattie's father, Abram Stickney French (1809–1896). So the children of John and Elizabeth were first cousins to both Samuel and Mattie, but these two important people in Homer's life did not share common blood. The small New England towns of New Ipswich, New Hampshire, and West Townsend, Massachusetts, which birthed the extended French and Preston clans, were just a few miles apart from one another. Homer visited there periodically at the invitation of his brother and Mattie, and doubtless knew many other members of these intertwined family circles.

79. See Mosette Broderick, *Triumvirate: McKim, Mead & White: Art, Architecture, Scandal, and Class in America's Gilded Age* (New York: Alfred A. Knopf, 2010), pp. 106–12.

80. Gray, op. cit.

81. Broderick, op. cit., pp. 275–76. The death of the brilliant but underappreciated architect Joseph M. Wells (1853–1890), a very active member of the club, precipitated its move.

82. Ibid., p. 276. Broderick tells us that New York's second recorded gay bar was located near the Benedick at 157 Bleecker Street, and was called the Slide. Its proprietor, the boxing entrepreneur Francis A. Stevenson (1847–1906), employed his brother Thomas H. Stevenson to operate the bar; the work led to his serving a year in prison. Another bar Stevenson owned, the Black and Tan, was at 153 Bleecker Street and was better known, primarily for its welcoming Black patrons as readily as whites.

83. See Cross, op. cit., pp. 115–23.

84. *Harper's Bazar* XII, no. 32 (August 9, 1879): 1.

85. List of ten watercolors, and prices net to him, in Homer's hand, on Macbeth stationery, in the Goodrich / Gerdts Homer Archives, National Gallery of Art, Box 19. His list includes prices and numbers for all ten sheets in his hand, but a specific title for only one: *Bergen Point, N.J.* See Foster, 2017, op. cit., p. 85, to place Homer's advanced technique in better context, including the fresh influence of the Dutch school.

86. Letter from Homer to O'Brien and Son, generally regarded as dated October 23, 1893, microfilm copy from the collection of Stephanie Roberts and Bill Dickerson available through Reels 4180–4181 in O'Brien Galleries records, 1811–1970. Archives of American Art, Smithsonian Institution. This author has yet to see the frequently quoted letter in its original form; its date, in Homer's often challenging handwriting, may well be 1898 rather than 1893. See Kevin M. Murphy, "Painting for Money: Winslow Homer as Entrepreneur," *Winterthur Portfolio* 37, nos. 2/3 (Summer/Autumn 2002): 147–60.

87. Ibid., pp. 125–51.

88. Mariana Griswold Van Rensselaer, "An American Artist in England," *The Century*, November 1883, p. 15.

89. Marc Simpson, "Homer's Wine-Dark Seas," in Lévy et al., *Winslow Homer: Poet of the Sea*, pp. 26–39.

90. William Backhouse Astor, Jr. (1829–1892) commissioned the yacht. See *New York Sun*, July 20, 1877, p. 3, for a lengthy and detailed description. She was 146 feet long and 28 feet in breadth, weighed more than 232 tons, and required a crew of fifteen.

91. This watercolor has been exhibited in public just once since Homer sold it in December 1880 (in 1911, at the Museum of Fine Arts in Boston). It is one of a very large number of watercolors that the Bostonian Edward W. Hooper (1839–1901) acquired through Doll & Richards. Hooper collected more of Homer's watercolors than any other collector and served as a trustee and major donor to the museum. His descendants own few of the watercolors today, but this one remains in the family. The editors of the Homer catalogue raisonné tried valiantly to identify its whereabouts, but their inquiry only reached the owner after publication, so *RWWH* omits this work.

92. "Bathing and Swimming," *Cape Ann Weekly Advertiser*, June 10, 1881 (unsigned article).

93. "Art Notes," *Boston Evening Transcript*, September 14, 1880, p. 8.

94. Goodrich/Gerdts Homer Archives, National Gallery of Art, Box 19, exhibition folder, appears not to include a list of the objects or prices in the Doll & Richards exhibition, although the detail published in *RWWH*, III, suggests that such a list exists. This author has depended upon the price information available in *RWWH*, upon these archives developed in its creation, and upon other sources available at the time of this book's publication. An example of this last category is the catalogue for the AWS show that opened in New York the month after the Doll & Richards show closed.

95. "Art Gossip at Home and Abroad," *Boston Journal Supplement*, December 11, 1880, p. 1, author unnamed but likely Sidney Dickinson (1851–1919).

96. J. Eastman Chase, "Some Recollections of Winslow Homer," *Harper's Weekly* 54, no. 2809 (October 22, 1910): 13.

8. ON THE EDGE (1881–1884)

1. The sun rose at 6:09 that day.

2. The other cabin passengers traveling to Liverpool, in alphabetical order, were G. Clayton; William Court; J. L. Given; C. B. MacDonald; A. H. Silverthorne; James Shaw; Edward Taylor; L. A. Tilley; William Wilson; and a Miss Womack. W. Carmichael disembarked at Queenstown. See *New York Times*, March 17, 1881, p. 8, and *Liverpool Mercury*, March 29, 1881, p. 6. The *Mercury* spells MacDonald's name as McDonald. None of these passengers can be identified with certainty, and none appears linked to Homer. The detail on the *Parthia*'s sailing and arrival information may be found in the Cunard logbook (Entry for the *Parthia*, February 26–March 28, 1881, Ship Passage Books [D42/GM2/4], Records of the General Manager's Office, Cunard Archive, University of Liverpool Library).

3. Markus Neacey, "George Gissing's Voyage to America and the Hazardous Career of the Good Ship 'Parthia,'" *Gissing Journal* 46, no. 3 (July 2010): 23–33. These two events were only the earliest of a series of dramatic circumstances associated with the ship. *The Christian Union* 23, no. 2, p. 39, published an account of the *Parthia*'s rescue of the *James Edwards*, which appeared on January 12, 1881, two months before Homer boarded the ship. The account does not name the *Edwards*, but enough particulars in the story correspond to that rescue that it leaves no doubt as to the identity of the rescued ship. This writer is indebted to Kathleen A. Foster in pointing out this documentation of the *Edwards* rescue, which is especially intriguing given the multiple connections it has with Homer.

Whether Homer read the story (which had appeared previously in London's *Daily Telegraph*) on or near its date of publication is intrinsically uncertain. It is reasonable to speculate that he did, however, inasmuch as the same issue carried another story five pages after "A Rescue at Sea," which would have caught Homer's eye. That story, "Houghton Farm," was a profile of the Mountainville, New York, retreat where Homer had spent many happy summer days. That second story casts in expectedly favorable light the farm's owner, Lawson Valentine, who at that time had recently also become president and principal stockholder of *The Christian Union*. Valentine's son-in-law Lawrence Fraser Abbott (1859–1933) was the son of Lyman Abbott (1835–1922), the editor of the newspaper with Henry Ward Beecher, who had preceded Lyman Abbott as pastor of Brooklyn's Plymouth Church. The younger Abbott would succeed Valentine as president of *The Christian Union* in 1891.

4. Ibid., pp. 28–30. Given the *Parthia*'s checkered history and the launch of faster and more luxurious transatlantic steamers, Cunard found it prudent to take the ship out of service in December 1883, at the age of just thirteen years. See pp. 26–28 and 31.

5. Ibid., pp. 29–30.

6. Ibid., p. 30.

7. *Southern Patriot*, February 25, 1835, noted that Charles S. Homer's older brother James Bartlett Homer (1804–1885) had been stranded on Eleuthera after the ship he captained was wrecked on her return trip from Rio. This chapter is especially indebted to the remarkable scholarship of Kathleen A. Foster. Her book *Shipwreck! Winslow Homer and* The Life Line (Philadelphia: Philadelphia Museum of Art, 2012) is much more than an exhibition catalogue. It illuminates far better than this biography can the work that Homer, his predecessors, and his contemporaries created on the powerful themes of wreck and rescue. This writer is deeply grateful for Dr. Foster's insights and her tireless generosity in sharing them.

8. For Homer's time in England, see Elizabeth Athens and Brandon Ruud, with Martha Tedeschi, *Coming Away: Winslow Homer & England* (New Haven, CT: Worcester Art Museum and Milwaukee Art Museum, in association with Yale University Press, 2017). David F. Tatham's *Winslow Homer in London: A New York Artist Abroad* (Syracuse, NY: Syracuse University Press, 2010) and his *Winslow Homer and His Cullercoats Paintings: An American Artist in England's Northeast* (Syracuse, NY: Syracuse University Press, 2021) also cover these periods in detail. For details of the rescue of the crew of the *Edwards*, see Neacey, op. cit., p. 30.

9. Both are now obscure, but William's picture after Joshua Reynolds, *A Fortune-Teller*, survives at Knole (National Trust). His wife, despite her sex, had received strong reviews as early as 1858. See, for example, *Art Journal* (issues of March 1, 1858, p. 77, and May 1, 1858, p. 143).

10. Tatham, 2010, op. cit., p. 36.

11. See *Census Returns of England and Wales, 1881*. Kew, Surrey: National Archives of the UK (TNA): Public Record Office (PRO), 1881, Class: RG11; Piece: 133; Folio: 53; Pages: 32–35; GSU roll: 1341030.

12. Judith C. Walsh, "More Skillful, More Refined, More Delicate: England," in Martha Tedeschi et al., *Watercolors by Winslow Homer: The Color of Light* (New Haven, CT: Yale University Press, 2008), pp. 76–106, especially p. 85.

13. A depiction by Henry Edward Tidmarsh (1854–1939) entitled *An Interior View of the National Gallery*, c. 1885, depicts a room in which Turner's sketchbooks and other works on paper appear highly accessible—and alarmingly unguarded. Lamentably, the current location of Tidmarsh's picture is unknown.

14. Turner depicted this scene a number of times, from a number of vantage points. It is impossible to know which of these Homer may have seen, if any.

15. Judith C. Walsh is currently engaged in an in-depth study of the scrapbook, and intends to

publish her analysis within the next several years. A preliminary review of the scrapbook in advance of that study offers a few conclusions beyond those discussed in the text of this biography: a) New York papers predominate, with *The New York Times* as the leading source of the clippings, followed by the *New York Herald*, the *New York World*, the *New York Daily Tribune*, and the *New York Evening Post*; b) a wide variety of other periodicals are also represented, from *The Nation* to *The Churchman* to *Scientific American*; c) at least four of the clippings in the scrapbook were published while Homer was in England (including two from less traveled papers, the *Boston Evening Transcript* and the *Boston Daily Advertiser*), which suggests that during Homer's lifetime other family members were involved in assembling the scrapbook; and d) a single *Tribune* review from April 1, 1876, seems to be the only clipping that predates 1878, while the most recent clippings that appear to have been kept by Homer himself are from 1894 and 1895.

16. GAR, "The British School Again: Where English Artists Are Peculiar," *New York Times*, September 8, 1878, p. 5.

17. See, for example, Homer's letter to Mattie, undated but likely from December 1883 (Bowdoin College Museum of Art, 1964.69.21d), which refers to his infirm mother's delight "at the amusing pictures in *The Graphic*" that Homer had shown her.

18. *The Graphic*, July 9, 1873, to January 10, 1874.

19. The Portland Museum of Art has recently acquired most of the extant volumes from Homer's library. *Trilby* is 2020.1.5.

20. At his death Van Gogh would own dozens of English, American, and French prints by du Maurier and Homer's friend William John Hennessy, among many others, and once spent 21 guilders to buy ten years of bound volumes of *The Graphic*—the equivalent of seven weeks of his rent, according to a letter from Vincent van Gogh to Theo van Gogh, written from The Hague on June 1–2, 1882 (Letter 234, Van Gogh Letters, Amsterdam, Van Gogh Museum, inv. nos. b226 a-b V/1962 [sheet 1, 2] and b223 a-b V/1962 [sheet 3, 4], digitized by Van Gogh Museum, Amsterdam, as a co-production with Huygens ING). See vangoghletters.org/vg/letters.html.

21. Letter from Vincent van Gogh to Anthon van Rappard, written from The Hague on or about Sunday, January 18, 1883 (Letter 302, Van Gogh Letters, Amsterdam, Van Gogh Museum, inv. nos. b8356 V/2006, digitized by Van Gogh Museum, Amsterdam, as a co-production with Huygens ING). He paid 3.1 guilders for a week of rent. For the count of prints van Gogh owned at his death, see the notes to Letter 235 to Theo van Gogh and Letter 273 to Anthon van Rappard. See also the entry by Mark Bills on *The Graphic*'s founder William Luson Thomas (1830–1900), in *Oxford Dictionary of National Biography* (Oxford: Oxford University Press, 2004).

22. Letter from Vincent van Gogh to Anthon van Rappard, written from The Hague on or about Sunday, February 4, 1883 (Letter 307, Van Gogh Letters, Amsterdam, Van Gogh Museum, inv. nos. b8354 a-c V/2006, digitized by Van Gogh Museum, Amsterdam, as a co-production with Huygens ING).

23. Ibid.

24. Marcus Bourne Huish, *The Year's Art, 1882: A Concise Epitome of all matters relating to the arts of Painting, Sculpture, and Architecture which have occurred during the year 1881 in the United Kingdom, together with information respecting the events of the year 1882* (London: Sampson Low, Marston, Searle & Rivington, 1882), p. 50.

25. Ibid., p. 49.

26. "The Winter Exhibition at the Grosvenor Gallery," *Magazine of Art* IV, June 1881, pp. 177–82. These quotations are on pp. 177 and 178.

27. Ibid., pp. 342–43. Huish, op. cit., p. 41, describes the year's exhibitions at the gallery.

28. Tatham, 2021, op. cit., p. 11, cites "three weeks" as the period of Homer's stay in London, without explaining why he believes that. No documentary evidence of Homer's whereabouts that

spring or summer has emerged, to the best of this author's knowledge—from his appearance in the guest register at the British Museum on April 14 until he participated in the Newcastle Arts Association exhibition in late August. He then writes a letter from Cullercoats about six weeks later, on October 7, 1881, to Eastman Chase (Archives of American Art, Smithsonian Institution).

29. Huish, op. cit., pp. 39–40. See also Tatham, 2010, op. cit., p. 64.

30. *Art Journal*, June 1881, p. 189.

31. See *The Exhibition of the Royal Academy of Arts: The One Hundred and Thirteenth* (London: William Clowes & Sons, 1881), and *Academy Notes*, ed. Henry Blackburn (London: Chatto and Windus, 1881), with details on selected works in the exhibition and their hanging.

32. Homer wrote Farrer a brief letter on January 23, 1884, offered by Brainerd Phillipson Rare Books, Holliston, MA, Inventory #4149. It gives Homer's approval for Farrer to use an unidentified Homer illustration, "with my correct address—Scarborough, ME." See Foster, 2017, op. cit., which places both Farrer brothers in context, e.g. Henry on p. 239.

33. For example, the implicit comparison Sheldon draws (Sheldon, 1878, op. cit., pp. 225–29).

34. One of the pictures was by Newcastle's own Robinson Elliott (1814–1894).

35. 1881 Census of England and Wales, as provided in GB Historical GIS: University of Portsmouth, Cullercoats Tn/CP Through Time, Population Statistics, Total Population, *A Vision of Britain Through Time*, "Tables: Ages, Condition as to Marriage, Occupations and Birthplaces of People." Table 10: "Occupations of Males and Females in the Division and Its Registration Counties" shows that fishermen comprised 188 of the men employed in the village, by far its largest concentration.

36. Tynemouth had a population of 25,713, including 253 fishermen. See 1881 Census of England and Wales, as provided in GB Historical GIS: University of Portsmouth, Cullercoats Tn/CP Through Time, Population Statistics, Total Population, *A Vision of Britain Through Time*, "Tables: Ages, Condition as to Marriage, Occupations and Birthplaces of People," Table 10: "Occupations of Males and Females in the Division and Its Registration Counties."

37. William Hayward, *James Hall of Tynemouth*, Vol. I (London: Hazell, Watson & Viney, 1896), pp. 138–39.

38. *Illustrated London News*, December 2, 1865, p. 535.

39. See *The Life-Boat* 5, no. 55 (January 1, 1865): 544–46.

40. Letter from Vincent van Gogh to Anthon van Rappard, written from The Hague on or about Sunday, October 22, 1882 (Letter 273, Van Gogh Letters, Amsterdam, Van Gogh Museum, inv. nos. b8349 V/2006, digitized by Van Gogh Museum, Amsterdam, as a co-production with Huygens ING).

41. *The Graphic*, February 19, 1870, pp. 9–10. John Dawson Watson's work appeared frequently in *The Graphic*, and later that same year in *Every Saturday* on August 13, 1870, six weeks after his July 5 New York arrival on the *China* from Liverpool. Another illustration of his appeared in *Harper's Weekly* on March 1, 1879. Note that the illustration on p. 536 of *The Illustrated London News* of December 2, 1865, is signed by the paper's art editor, Mason Jackson, but in the related article is said to be based on "a sketch by Mr. R. Watson, of Tynemouth." This is not J. D. Watson, but rather Robert Watson (1815–1885).

42. *The Graphic* sold the engraving as a special Christmas supplement, advertised in its issues of December 2 and December 9, 1871. *Harper's* included it in the issue of December 23, 1871, as "Saved from the Wreck." Dawson Watson's son, Dawson Dawson-Watson (1864–1939), himself a gifted painter, in an unpublished memoir in his family's archives recalled the oil as four feet wide by six feet in height. The wreck was of the *Tenderden*, on April 2, 1866, and the hero saving the woman and child was named Joe Cook. See *John Dawson Watson RWS RBA RCA: A Sedbergh*

Artist and His Circle (Sedbergh, Cumbria, UK: Sedbergh and District History Society, 2012), p. 44. See Foster, 2012, op. cit., p. 51, and her important observation (p. 109, n. 184) that Watson shows the conventional resolution of the crisis—but Homer focuses on "the suspended moment" at which the outcome is uncertain.

43. The picture, *Bereaved*, 1888, is in a private collection. See Laura Newton, "Cullercoats: The Region of Poetry," in *Painting at the Edge: British Coastal Art Colonies 1880–1930*, ed. Laura Newton (Bristol, UK: Sansom, 2005), pp. 115–33, with the Emmerson picture on p. 121.

44. Ibid., p. 116.

45. Ibid., and *The Engineer*, November 27, 1874, p. 388.

46. The picture, *Lady Lilith*, depicts Rossetti's mistress Fanny Cornforth and was sold at Sotheby's on July 13, 2017. He painted a highly similar painting at the same time that is now in the collection of the Metropolitan Museum of Art. Stevenson's slightly older brother, James Cochran Stevenson (1825–1905), was a member of Parliament for South Shields from 1868 to 1895. The Scottish-born brothers expanded greatly a smaller chemicals operation that they inherited from their father. Alexander Shannan Stevenson should not be confused with a different Alexander Stevenson whom Rachel Mumba identifies in her *Class, Nation and Localism in the Northumberland Art World, 1820–1939* (Durham University PhD thesis, 2008), p. 81, as living from 1848 to 1918. Dianne Sachko Macleod in her article "Private and Public Patronage in Victorian Newcastle" (*Journal of the Warburg and Courtauld Institutes* 52 [1989]: 188–208, discusses the correct Alexander Stevenson of Tynemouth, albeit omitting his middle name. The Frederick George Stevens essay about his visit to Alexander Shannan Stevenson's house at 45 Front Street, Tynemouth, published in *The Athenaeum*, September 27, 1873, is discussed in a separate article by Dianne Sachko Macleod, "Mid-Victorian Patronage of the Arts: F. G. Stephens's 'The Private Collections of England,'" *Burlington Magazine* 128, no. 1001 (August 1986): 597–607.

47. Long-lasting sensitivity to the content of the novel suppressed its publication until 1952, long after Swinburne's and Solomon's deaths.

48. *The Athenaeum*, September 27, 1873, p. 406.

49. The picture is now at the Sterling and Francine Clark Art Institute. See *Nineteenth-Century European Paintings at the Sterling and Francine Clark Art Institute*, Vol. II (Williamstown, MA: Sterling and Francine Clark Art Institute, 2012), pp. 550–53.

50. Ibid., p. 551.

51. *Natural History Transactions of Northumberland and Durham*, Vol. V, Part I (London: Williams & Norgate, 1873), pp. 282–95.

52. See Royal Academy catalogue, #766, p. 32, Gallery VIII. Wassermann also showed it at the Royal Scottish Academy in 1878.

53. The cause of Wassermann's death at age thirty-seven is listed as "Tumour (Sarcoma/Blood Poisoning)": England, death certificate (certified copy) for John Conrad Wassermann, died July 8, 1882; registered September quarter 1882, Tynemouth District 10b/121, Tynemouth Subdistrict, Northumberland; General Registry Office, Southport.

54. Tatham, 2021, op. cit., gives great detail on Homer's whereabouts in Cullercoats. He lived at 44B Front Street (p. 19).

55. See William Weaver Tomlinson, *Historical Notes on Cullercoats, Whitley and Monkseaton, with a Descriptive Memoir of the Coast from Tynemouth to St. Mary's Island* (London: Walter Scott, 1893), p. 117; and Dr. Nick Barratt, "An Intriguing Family History," 2004, www.bbc.co.uk/history /trail/familyhistory/community/intriguing_history_01.shtml.

56. William H. Gerdts, "Winslow Homer in Cullercoats," *Yale University Art Gallery Bulletin* 36, no. 2 (Spring 1977): 18–35, describes the exhibition and refers to the Scottish painter Erskine Nicol (1825–1904), and to Léon Augustin Lhermitte (1844–1925), Tissot, and Fantin-Latour

as three French exhibitors (each having also exhibited that summer at the Royal Academy, with London addresses). On p. 32 he refers to two oil paintings by Thomas Charles Farrer in the show.

57. *Newcastle Courant*, August 26, 1881, "Arts' Association Exhibition." See also Gerdts, 1977, op. cit.

58. *RWWH*, IV.1, p. 8.

59. Run by Henry F. Gillig & Company, the office appears in *A Study in Scarlet*, 1887, by Arthur Conan Doyle, as the mail drop for two letters from the Guion Steamship Company.

60. Now unidentified, because this title could fit many of Homer's works from this period. The review is unsigned but appeared in the *Tyneside Daily Echo* on August 31, 1881, p. 3. The sixteen paintings discussed in the review were: 1) *A Thames Wharf*, by Clara Montalba (1842–1929); 2) *The Thames from Hungerford Bridge*, by John O'Conner (1830–1889); 3) Homer's painting; 4) *The Thames at Chelsea*, by James Aumonier (1832–1911); 5) *The Quay, Newcastle*, by Thomas M. M. Hemy (1852–1937); 6) *Wayfarers*; 7) *Happy Childhood*, both by Arthur Hardwick Marsh (1842–1909); 8) *Poppies*, by John George Sowerby (1849–1914); 9) *Trawlers at Rest*, by Caroline Fanny Williams (1836–1921); 10) *Noon, Llanberis, North Wales*, by James Jackson Curnock (1839–1891); 11) *The Honeymoon, Venice*, by Edward Frederick Brewtnall (1846–1902); 12) *Man Haven, Marsden*, by Lionel Hugo Hawkes (1851–c. 1925); 13) *English Cart Horses*, by Otto Weber (1832–1888); 14) *The Doctor's Horse*; 15) *He Is Coming*, both by John Charlton (1849–1917); and 16) *Friends*, by Emmerson.

61. The name is that of an English poet (1745–1814) whose naval songs were renowned. His son of the same name was a longtime manager of Sadler's Wells Theatre; he in turn had a grandson of the same name (1845–1910) who was a postal civil servant, had founded the Civil Service Life-Boat Fund in 1866, and in 1883 became secretary of the Royal National Life-Boat Institution.

62. "The Gales," *Shields Daily Gazette*, October 21, 1881, p. 3. As Kathleen A. Foster points out in her book (2012, op. cit., pp. 57–58), Homer arrived with his sketching block at eleven in the morning, so he did not see the entire rescue, but rather the second launch of the lifeboat.

63. Letter in the J. Eastman Chase papers (Images 10252–10253), Smithsonian Archives of American Art, undated, and referring to the wreck erroneously as occurring on October 28, 1881. Homer goes on to say that "I am glad to find a way of sending you sketches (by book post) that is if you would want any more—if you can raise the devil at your end I will try & do it at this [end]." His letters to Chase during this period refer repeatedly to his friend J. Foxcroft Cole, to whom he extends his greetings in a postscript of this letter. Chase had been working for Doll & Richards during Homer's successful sale of December 1880 in that gallery next to Park Street Church, and then had set up his own shop around the corner at 7 Hamilton Place, just off Tremont Street.

64. Jobling had contributed a somewhat different picture of a wreck to the first annual exhibition of the Newcastle Arts Association, in 1878. Titled *The Wreck—The Last of the Seven Sisters*, it is depicted in John Millard's *A Romance with the North-East: Robert & Isa Jobling* (Newcastle upon Tyne: Laing Art Gallery, Tyne & Wear Museums, 1992), p. 15.

65. For details of the building's history, see Lloyd G. Reed, *Cullercoats Village: 1292–1950* (Lloyd G. Reed, 2014), pp. 16–18.

66. That watercolor is in the collection of the Laing Art Gallery, Newcastle.

67. The name derives from an ancient and erroneous inference that the dove that Thomas Dove commissioned to be sculpted in relief on a finial between his initials and that of his wife, Elizabeth, was in fact a sparrow. The finial was on the house's east gable, according to William Weaver Tomlinson's *Historical Notes on Cullercoats Whitley and Monkseaton* (London: Walter Scott, 1893), p. 9. See also Reed, op. cit., p. 16.

68. "Fine Arts. The Water-Color Figure Painters," (New York) *Mail and Express*, February 1, 1882, as cited in *RWWH*, IV.1, p. 102.

69. Professor Elizabeth Athens of the University of Connecticut very helpfully pointed out Nicolai Cikovsky Jr.'s analysis in his *Winslow Homer* (New York: Harry N. Abrams, 1990), p. 81, of this reworking of the figures' background after the sheet's first exhibition. Kathleen A. Foster notes the important point that Homer's original title might also reflect his recognition that the London fish market relied on stock sent to it from a place such as Cullercoats, distant and disparate yet tied to it economically. Homer delighted in exactly such multivalent character in his work—and in his titles.

70. Shakespeare's *King Lear* (1607) does not use the word, but one of his sources does. His play is based on, among other things, the description by Raphael Holinshed of a British king prior to the Roman occupation, which was published in the latter's *Chronicles of England, Scotland and Ireland* (London: John Harrison, 1577), pp. 446–48. The story inspired Thomas Kyd (1558–1594) to write a play about Leir, first performed at Easter 1594, four months before his death. It was published eleven years later as *The True Chronicle History of King Leir, and His Three Daughters, Gonoril, Ragan and Cordella* (London: Printed by Simon Stafford for John Wright, 1605). On the play's history, see Brian Vickers's essay "Kyd's Authorship of King Leir," *Studies in Philology* 115, no. 3 (Summer 2018): 433–71. Lines 1025–1030 of the play include a messenger's description of himself to Gonoril. He proudly claims to possess "as bad a tongue if it be set on it, as any oyster-wife in Billingsgate hath: why, I have made many of my neighbors forsake their houses with railing upon them, and go dwell elsewhere; and so by my means houses have been good cheap in our parish: My tongue being well whetted with choler, is more sharp than a Razor of Palermo." See emed.folger.edu/sites/default/files/folger_encodings/pdf/EMED-TCKL -reg-3.pdf.

71. "Fine Arts. The Water-Color Figure Painters" (New York) *Mail and Express*, February 1, 1882, as cited in *RWWH*, IV.1, p. 102. The insightful review was in *Art Interchange*, January 17, 1891, p. 19, and is quoted in *RWWH*, IV.1, p. 100. Notably, the sheet was Homer's sole entry in the exhibition, affirming its scarcity value. In Brooklyn, it had been exhibited with another major watercolor (*Fishing Fleet Coming In, Newcastle, England*, which is now in the collection of Scripps College) and marked down to 100 dollars. That other sheet was also much reduced, to 175 dollars. Neither sold. Both watercolors retrieved their original prices of 500 dollars each when they were next shown, in Boston.

72. See CR 1100 in *RWWH*, IV.1, pp. 100–102. Reichard showed a selection of watercolors immediately before exhibiting four oil paintings in anticipation of the AWS show, where Homer's *Mending Nets* was his sole entry.

73. Goodyear and Byrd, op. cit., p. 33.

74. The society has been known since 1894 as the Royal Photographic Society. The exhibition was juried by a panel of seven, purposefully including two painters (Philip Hermogenes Calderon, 1833–1898, and George Dunlop Leslie, 1835–1921). Calderon was a member of the jury, acting on behalf of the German-born painter Hubert Herkomer (1849–1914), who would go on to become both a highly successful portraitist (particularly of prominent British men) and a pioneering filmmaker. See A. L. Baldry, *Hubert von Herkomer, R.A., A Study and a Biography* (London: G. Bell, 1901). The extensive scholarship of Kathleen A. Foster into Thomas Eakins has illuminated (among many other things) his prolific photographic oeuvre, including his purchase of an American-made camera in 1881. Philadelphia, she explains, was a pioneer in the emerging art of photography.

75. Goodyear and Byrd, op. cit., p. 33.

76. See Colin A. Russell, *Chemistry, Society and Environment: A New History of the British Chemical*

Industry (Cambridge: Royal Society of Chemistry, 1999), and "The Late Mr John Mawson," *British Journal of Photography* 14, no. 399 (December 27, 1867): 618. The *Leeds Mercury* published an advertisement on June 26, 1880, seeking offers for purchase of the Leeds chemical plant of the recently deceased William Huggon. Mawson & Swan did in fact purchase that plant. See Michael Pritchard, *The Development and Growth of British Photographic Manufacturing and Retailing, 1839–1914* (PhD thesis, De Montfort University, 2010), p. 80. The firm's chemical expertise and entrepreneurial instincts did not limit it to serving the photography market. See, for example, the advertisement in the July 28, 1882, *Newcastle Courant*, p. 1, which reflects Mawson & Swan's role as a retail agent for J. L. Pulvermacher's Galvanic Establishment, the British manufacturing center of a global enterprise established by the Polish-born, Vienna-associated, and London-based quack Isaac Lewis Pulvermacher (1815–1884). The over-the-counter pharmaceutical product offered "restoration of impaired vitality" and repair from "imprudent indulgence" and "deleterious medicines." The product, "Pulvermacher's World-Famed Galvano-Electric Chain Bands and Belts," possessed a "curative effect" that the advertisement described as surpassing "the wonders wrought by Electricity in Telegraphy, Light, etc." Many sought out the company's products, including Charles Dickens (in his last letter, June 3, 1870) and Homer's friend Albert Pinkham Ryder. See Zachary Ross, "Linked by Nervousness: Albert Pinkham Ryder and Dr. Albert T. Sanden," in *American Art* 17, no. 2 (Summer 2003): 86–96, and Carolyn Thomas de la Peña, "Designing the Electric Body: Sexuality, Masculinity and the Electric Belt in America, 1880–1920," in *Journal of Design History* 14, no. 4, Technology and the Body (2001): 275–89.

77. Homer left an inscription ("Flamborough Head 1882") on his vivid charcoal-and-watercolor drawing of a young woman dressed similarly to the fisherfolk of Cullercoats, but posed on the distinctive cliffs of Flamborough Head. It is in the collection of the Art Institute of Chicago, Mr. and Mrs. Martin A. Ryerson Collection, 1933.1240. See *RWWH*, IV.1, p. 145, CR 1160. The same collection includes a drawing without an identification to a place but which is even more intriguing. Dated 1882, it is #1933.1239 and currently entitled *Fishing off Scarborough*. It is the basis for a more complex watercolor Homer made in his New York studio in 1883, *Returning Fishing Boats*, now in the collection of the Harvard Art Museums/Fogg Museum (Acc. #1939.233). The name Homer drew on the boat in the Chicago drawing is difficult to read, but may be "G. Yarmouth," a reference to a seaside resort named Great Yarmouth, in Norfolk. The vessel is typical of those in the Tyneside area, however, and Great Yarmouth is much farther southeast than Bridlington, some 280 miles. Scarborough is certainly closer but the drawing's connection to that town would benefit from more research on Homer's inscription on the boat.

78. See *The Exhibition of the Royal Academy of Arts: The One Hundred and Fourteenth* (London: William Clowes & Sons, 1882), p. 57, entry 1533, in Gallery XI, and *Academy Notes*, ed. Henry Blackburn (London: Chatto and Windus, 1882), p. 73. His picture was probably a late entry, given its placement, with just eight pictures after it out of a total of 1,541.

79. Letter to O'Brien and Son, March 20, 1902, O'Brien Galleries Records, 1811–1970, Archives of American Art, Smithsonian Institution.

80. *RWWH*, IV.1, pp. 103–105, CR 1101. The second exhibition was in New York at the Union League Club in 1890.

81. Act II, Scene III. A drawing survives (*RWWH*, IV.1, p. 98, CR 1097-d) upon which Homer inscribed "Hark! Hark! The Lark at / Heavens Gate sings" with color notations.

82. 2 Corinthians 4:18, King James Version. See Brandon Ruud's essay "Hark! The Lark," in Athens and Ruud, op. cit., pp. 64–69.

83. The picture is in the Laing Art Gallery, Newcastle.

84. The other three or four oils also reflect his spirit of experimentation. They include 1) *Fishermen's Wives* (Harvard Club of New York), a little-recognized but intriguing American response to the

work of H. H. Emmerson; 2) a tribute to the tradition of British hunting pictures such as those painted by John E. Ferneley (1782–1860), called *Coursing the Hare* (Virginia Museum of Fine Arts); 3) a major meditation that he reworked at the end of his life to become *Early Evening* (1907, Freer Gallery, Smithsonian Institution, discussed in the final chapter of this book); and arguably 4) *Two Figures by the Sea* (Denver Art Museum), discussed at the end of this chapter.

85. By contrast to his voyage on the *Parthia*, the documentary evidence suggests that this trip aboard another Cunard steamship, the *Catalonia*, was less significant to Homer's development.

86. The sheet is in a private collection and is discussed in detail in *RWWH*, IV.2, pp. 220–21, CR 1170.

87. "The Water-Color Exhibition: Second Notice," *New-York Daily Tribune*, February 19, 1883, p. 3, column 3.

88. *RWWH*, IV.2, pp. 220–21, CR 1170.

89. "The Water-Color Exhibition: Second Notice."

90. The illustration on p. 20 of the catalogue followed the sketch slavishly, even to the point of reproducing what appears to be a water stain that Homer overlooked. See *RWWH*, IV.2, p. 226, CR 1174.

91. That picture, then called *The Coming Away of the Gale*, was a miserable failure memorialized in a photograph of its original appearance. Homer repainted it ten years later, and it is now known as *The Gale*, in the collection of the Worcester Art Museum. See *RWWH*, IV.2, pp. 227–29, for discussion of the original picture.

92. *New York Times*, January 27, 1883, p. 5; *New York Herald*, January 27, 1883, p. 6; *New York Sun*, January 28, 1883, p. 5; *Art Interchange*, February 1, 1883, p. 36; *Harper's Weekly*, February 3, 1883, p. 71; *New York World*, date undetermined; *New-York Tribune*, date undetermined; *New York Mail & Express*, date undetermined; and likely one additional publication, whose name and date cannot yet be determined.

93. *Harper's Weekly*, February 3, 1883, p. 71.

94. Cumberland County Recorder of Deeds (hereafter CCRD), Book 488, p. 493, contract signed August 18, 1882, with John Cloudman and J. M. Allen as sellers a week later. See CCRD, Book 491, p. 234. John Cromie, Esq., of Ballston Spa, New York, points out that on October 1, 1881, Hannah Louise Googins mortgaged the land that the Homers would acquire from her. She sold the note to a Westbrook, Maine, lawyer (and poet) named Fabius Maximus Ray (1837–1915) who then assigned it to Augustus F. Moulton, who like Ray practiced in Portland. Despite his office location, Moulton was (as Cromie puts it rightly) "everyone's local lawyer" in his native Scarborough (see chapter 6, n. 87). Moulton assigned the mortgage to Charles S. Homer, Sr., to whom the property with the Ark was transferred for $1,500 on January 22, 1883. The mortgage assignment was filed the following day. Cromie has accomplished an in-depth analysis of the nineteenth- and early-twentieth-century real estate transactions on Prouts Neck. This is one of many transactions that he and his wife, Vicki, identified despite numerous obstacles including spelling, handwriting, and transcription errors. All other Prouts Neck deed deductions in this volume (including notes below) are constructed on the foundation the Cromies have laid. Their work will benefit Homer scholars for decades to come.

95. CCRD, Book 491, p. 234, August 10, 1882, with Alonzo L. Googins and H. Louise Googins as counterparties. The family circumstances of Alonzo and his wife likely contributed significantly to this transaction and to the economic arrangements with the Homers that followed. Hannah was almost sixteen years older than her husband and had married him fewer than two years previously, on September 28, 1880. She delivered their first child, Eva Louise Libby (1880–1902), seven weeks after their wedding. The couple also had a son, Clifford Googins (1883–1952), and another daughter, Isa Mae Googins (1885–1927), who in 1910 married Har-

old Millikin. Note that Alonzo was not born in 1860, as his gravestone suggests; he was eleven months old in June 1860 when the census taker knocked on his family's door.

96. Hannah Louise Libby's father, Silas Jason Libby (1811–1878), lost his wife, Hannah Haines, on December 1, 1843, at the age of twenty-nine. She left him with two children: Hannah Louise Libby and her older brother, Thomas Jason Libby (1840–1894). He then married Phebe Libby (to whom he was distantly related, if at all) (1816–1898), who bore him a second daughter, Anna Maria Libby (1854–1876). Silas's father, Thomas Libby, Jr. (1784–1871), lived with Silas and appears to have been the cause for the subdivision of Prouts Neck, called Libby's Neck in its early days. The apostrophe in the Neck's name has vanished over the years and this writer purposefully neglects to reinsert it.

97. For the Googins transactions, see CCRD, Book 494, p. 168, January 23, 1883; Book 495, p. 118, January 22, 1883; Book 514, p. 241, November 25, 1884. For the other purchases by Charles, Charles Jr., or Winslow, see CCRD, Book 531, p. 163, October 14, 1886, with John Wiggin as seller; Book 541, p. 419, December 22, 1887, with Harriet A. Libby as seller; Book 542, p. 401, July 6, 1888, with Seth Larrabee as seller; Book 564, p. 95, September 25, 1889, with Edward Proctor as seller; Book 564, p. 97, November 26, 1889, with Edward Proctor again as seller; Book 578, p. 331, September 15, 1891, sold to him by the descendants of Robert Libby, including Louisa Libby (wife of Milton Libby of Westbrook) and Charles, Robert, and Horatio Libby of Scarboro; and Book 578, p. 340, August 1, 1891, with Seth Larrabee again as seller. Winslow himself acquired parcels as follows: CCRD, Book 567, p. 341, April 28, 1890, with Asa M. Sylvester as seller; Book 567, p. 342, May 1, 1890, with Charles C. Wiggin and Mary A. Wiggin as sellers; Book 629, p. 100, September 21, 1895, with Edward Proctor again as seller; Book 632, p. 20, November 19, 1895, with Edward Proctor again as seller; and Book 648, p. 1, September 10, 1896, with Edward Proctor again as seller.

It is notable that there were no sales outside the Homer family whatsoever until after the death of Charles S. Homer, Sr. One fascinating instance that might appear to be an exception—but isn't—is a broken sale to a notable figure. Appearances suggest that the Philadelphia art collector and painter Walter Leighton Clark (1859–1935) purchased property from Charles S. Homer, Jr., in 1891 (CCRD, Book 584, p. 319, and Book 590, p. 79, both February 27, 1892). The warranty of CCRD, Book 600, p. 226, signed on November 10, 1892, however, extinguished the deed and its associated mortgage. He was founder and president of the Grand Central Art Galleries and deeply wedded to the Berkshires; his wife, Llewella, was the daughter of Thomas Belsham Merrick (1813–1902), a leading Prouts summer resident. Although Homer had various visitors at Prouts who were or became prominent in American art, Clark appears to be the sole significant such figure to get close to purchasing property there during Homer's lifetime.

98. The specifications from the blueprints were a part of the contract. See Patricia Junker, "Expressions of Art and Life in the Artist's Studio in an Afternoon Fog," in *Winslow Homer in the 1890s: Prout's Neck Observed* (New York: Hudson Hills Press, 1990), pp. 34–65; James F. O'Gorman, "The Architecture of Homer's Studio," in *Weatherbeaten: Winslow Homer and Maine*, ed. Thomas A. Denenberg (New Haven, CT: Yale University Press, 2012), pp. 49–69; and Earle G. Shettleworth, Jr., and William David Barry, "'Brother Artists' Winslow Homer and John Calvin Stevens," *Bowdoin* 61, no. 4 (Fall 1988): 16–19.

99. Junker, 1990, op. cit., and O'Gorman, 2012, op. cit.

100. Daughter to William Flagg Homer, she appears on August 8 and 15, 1884, in the diary of David G. Haskins, Jr. (1845–1926), whose father, David Green Haskins, Sr. (1818–1896), was a well-known Episcopal priest and regular visitor to the Neck. Since she is identified only as "Miss Homer," her identity cannot be confirmed with certainty, but other threads, such as a book of her father's that ended up in Homer's library, suggest that the rift between William and Charles

Sr. did not prevent a connection between Maria and her first cousins Winslow, Charles Jr., and Arthur.

101. This author is indebted to Earle G. Shettleworth, Jr., Maine State Historian, for these insights into the Brown family's history. See also Arthur H. Norton, "In Memoriam: Nathan Clifford Brown, 1856–1941," *The Auk: A Quarterly Journal of Ornithology* 59, no. 4 (October 1942): 471–76, for one window into this important Maine family, whose connections to Homer warrant considerably more research than was possible for this biography.

102. See, for example, Homer's letter to Brown of March 28, 1904, Cumberland Club Archives, for whose identification this author is very grateful to Earle G. Shettleworth, Jr. See also Earle G. Shettleworth, Jr., "A Tale of Two Mansions: The Homes of the Cumberland Club," lecture delivered at the Cumberland Club, Portland, Maine, October 28, 2021. An unsigned analysis of the Cumberland Club's guest registers, which a club historian performed in the 1970s, suggests that Homer was a guest at least in 1884, 1886, and 1895. A number of other luminaries visited the club during this period, such as the English poet Matthew Arnold. A thorough investigation of the club's records is yet to be accomplished.

103. "Report of John S. Hodgson, Civil Engineer, to the Joint Committee on Sewerage of Prout's Neck, August 20th, 1898," *Annual Report of the Town of Scarboro, 1898–1899* (Scarborough, ME: Town of Scarborough, 1898), p. 2. No reliable evidence has surfaced to calculate the room count or average occupancy for the hotels as of the early 1880s. The 1898 figure estimating a capacity of six hundred visitors in the hotels appears the best starting point for an estimate of the average visitation level in the early 1880s. Given moderate room-count growth over the fifteen-year period and a moderate level of vacancy even in midsummer, one may deduce that the visitor count at peak levels in the early 1880s was in the range of 350. For a more qualitative description of the visitors' experience, see the diaries of David G. Haskins, Jr., to which n. 100 refers. They are in the collection of the Maine Historical Society, with transcriptions by John Cromie of portions (primarily in the 1880s) housed at the Prouts Neck Historical Society.

104. Junker, 1990, op. cit., and Bolton, 2012, op. cit.

105. Hendricks, op. cit., p. 46, a privately held letter of January 1, 1862.

106. The foremost historian on Prouts Neck real estate history during this period points out that despite the lack of a reliable supply of piped fresh water, summer residents improvised and made use of springs such as those that keep moist much of the Sanctuary in the interior of the Hard Neck today. He also points out that land values remained low on the Neck for years; this was the right place to be a patient landowner.

107. The half brother, George Porter Patch Lawrence (1836–1907), confusingly changed his name from Patch to Lawrence. He was a Cambridge lawyer and son to Ephraim through his first wife, Martha Adams (1811–1843). Alice Patch Homer (1848–1904) was a daughter to Ephraim through his second wife, Sarah Morse (1821–1860). George's wife, Belle, bought their land on November 3, 1885; see CCRD, Book 522, p. 184. See also the note at the start of the next chapter on the October 1884 Simon Towle photograph, which dates the construction of "El Rancho" to that date, not earlier as has been presumed.

108. Cotting's title at the Lowell Institute was curator, which hardly does justice to his responsibilities. He led the organization for more than fifty years and was described as "successively secretary, councillor, orator, and president of the Massachusetts Medical Society . . . [and] a gentleman of rare business instincts and calm judgment, interblended with most gracious social qualities," in Harriette Knight Smith, *The History of the Lowell Institute* (Boston: Lamson, Wolffe, 1898), p. 20. His formidable wife, Catherine Greene Sayer (1817–1881), surely was a part of the decision to purchase the land for the cottage, and may have aided in its design, but died on April 29, 1881, while on a trip to Salt Lake City. See their obituaries in the *Boston Evening Transcript* on

May 22 and 26, 1897, and April 30, 1881. Alice Patch Homer bought a small parcel from Thomas and Harriet Libby on July 18, 1882 (Book 488, p. 441), but a photograph of her with her family, dated October 1884, suggests that she and Arthur did not build their house for two years. Her half brother never built at all.

109. *The Poems of Emily Dickinson: Reading Edition* (Cambridge, MA: Belknap Press of Harvard University Press, 1998), F409 B. The poem is within Packet XIII, Mixed Fasciles (c. 1862) at Harvard's Houghton Library. A digital image of the manuscript is available at www.edickinson .org/editions/1/image_sets/235698. The author is grateful to Earle G. Shettleworth, Jr., for proposing this apt parallel.

110. "Exhibition of the Academy of Design," *Art Amateur* 2 (May 1880): 121.

111. "The Studio. Art Interchange Artists," *Art Interchange* 5 (December 22, 1880): 130.

112. Unavailable online, but cited in *RWWH*, IV.2, p. 180, and p. 202, n. 16, "Fine Arts. General Home Notes."

113. Letter, August 27, 1883, to Mattie, from Prouts, Bowdoin College Museum of Art, 1964.69.22.

114. See Arthur M. Hussey II, "Bedrock Geology of the Prouts Neck 7.5' Quadrangle, Cumberland and York Counties, Maine," Department of Conservation, Maine Geological Survey, 2003. It is notable that with a couple of minor exceptions such as *Prout's Neck: Looking Toward Old Orchard* (Addison Gallery of American Art, Phillips Academy, *RWWH*, IV.2, p. 251, CR 1197) and *Through the Rocks* (Brooklyn Museum, *RWWH*, IV.2, p. 258, CR 1204), Homer quickly arrived at a compositional and color format for describing the nexus of land, sea, and sky at his new home.

115. *RWWH*, IV.2, p. 183.

116. Letter undated but likely December 1883, to Mattie, without origin but likely New York, Bowdoin College Museum of Art, 1964.69.21.

117. See Foster, 2012, op. cit., especially pp. 63–77, including a detailed analysis of the picture's development, making use of technical photography and a highly developed preparatory drawing. Her discussion of *The Ship's Boat* and the related drawing appears on pp. 60–63 of her book and includes her insight that the raised hand in the drawing connects to Turner's famous painting *The Slave Ship*—to which Homer's letter of November 26, 1899, to Harrison Morris refers (*RWWH*, p. 286), suggesting that he knew it well. The picture also acknowledged the considerable interest among Americans in the brave men of U.S. life brigades. While Homer was in the U.K., for example, M. J. Lamb published "The American Life Saving Service" in *Harper's New Monthly* 64, no. 381 (February 1882): 357–73.

118. *New York Herald*, April 7, 1884, cited in *RWWH*, IV.2, p. 273.

119. Mrs. Schuyler Van Rensselaer, *Six Portraits* (Boston and New York: Houghton Mifflin, 1889), pp. 260–61.

120. Letter, May 6, 1884, to Mattie, from Prouts, Bowdoin College Museum of Art, 1964.69.23.

121. Letter, June 24, 1884, to Mattie, from Prouts, Bowdoin College Museum of Art, 1964.69.24.

122. Ibid.

123. Letter, September 1, 1884, to Mattie, from Prouts, Bowdoin College Museum of Art, 1964.69.25.

124. *RWWH*, IV.2, pp. 185–86.

9. COUNTING THE COST (1884–1889)

1. "Outgoing Steamships," *New York Times*, December 4, 1884, p. 8; "The Weather Indications," *New York Times*, December 5, 1884, p. 2. The ship sailed at 3 p.m. on December 4, and the temperature was recorded at 52 degrees at 3:30. An advertisement ran in *The New York Times*, November 30, 1884, p. 13, for the New-York and Cuba Mail Steamship Company, the "only weekly

line of American steamers" with service for Cuba. The ship sailed from Pier 16 on the East River. The ship docked at three ports: Nassau, Santiago de Cuba, and then Cienfuegos itself.

2. Simon Towle (1834–1910) was born in Buxton, just over the county line from Scarborough in York County, Maine, but worked for most of his adult life in Lowell with his sister Nancy's husband, George C. Gilchrest (1812–1888), the city's first professional photographer. He made frequent trips to the area around Scarborough and relocated there in 1893 after the death of his partner, specifically to Old Orchard Beach. Given the number of tourists visiting Prouts Neck and his ties to the area, it is unsurprising that several of his photographs of Prouts Neck would come into the possession of the Homer family, and ultimately into the collection the family gave to Bowdoin College. Another photograph Towle made in October 1884 depicts (left to right) a dog; Arthur Benson Homer; Charles Lowell Homer at the age of three; Charles Savage Homer, Sr.; Alice Patch Homer leaning against a seven-foot post; Arthur Patch Homer at the age of eight and a half; and Ephraim Patch, on whom his grandson is leaning.

3. The author of *The Isles of Summer* is not to be confused with any of the following: his son of the same name (1853–1883), who worked as a lawyer in his practice; the distinguished physician, evangelist, and philanthropist Charles Linnaeus Ives (1831–1879); or the composer Charles Edward Ives (1874–1954). Each of these three men was a graduate of Yale College; the author was not a Yale undergraduate but graduated from Yale Law School (Class of 1846). Among his other works is an 1843 collection of his poetry called *Chips from the Workshop*.

4. The book is published by Ives himself but printed by Hoggson & Robinson, New Haven. He dedicated it on December 13, 1880, fewer than three weeks before his death on December 31, in Iveston, a section of East Haven, not far from his downtown New Haven law office. See his Preface, p. 8.

5. *Publishers' Weekly*, no. 472 (January 29, 1881): 93.

6. Ives, op. cit., p. 50.

7. Drysdale's weekly Caribbean columns, signed W.D., began appearing in *The New York Times* on June 1, 1884, and continued until at least May 17, 1885. (His article on April 6, 1884, from Florida, is in a similar style and preceded the series.) He also wrote a story based on St. Kitts that appeared on December 6, 1885, after the completion of the series. He had been to Nassau and Cuba at least twice previously, arriving in New York from those trips on February 12, 1879, and March 8, 1884. He also is noted as returning on April 26, 1886, possibly for the first time in more than two years. A week later, on May 2, 1886, the *Times* published an article signed with his full name, and with a dateline of April 28 in his hometown of Cranford, New Jersey. His travels in 1884 and 1885 provided the research for *In Sunny Lands*, which is essentially a book-length compilation of the articles the *Times* began publishing in June 1884.

8. "Farewell to a Correspondent," *New York Times*, August 27, 1884, p. 5; and "Off for New-Providence," *New York Times*, August 29, 1884, p. 8.

9. "Off for New-Providence," *New York Times*, August 29, 1884, p. 8. Sweeting died in Monroe County, Florida, in 1906, according to the Florida Death Index, Florida Department of Health, Office of Vital Records, 1998, vol. 13, p. 748.

10. Harper's Franklin Square Library, #490, published on September 18, 1885. See also "William Drysdale Dead," *New York Times*, September 21, 1901.

11. "Current Fiction," *Literary World*, June 17, 1882, p. 201. The New York publisher Wilcox & Rockwell published *The Christmas Stocking*, which was one of Homer's illustrated books developed for children.

12. "List of Passengers," S.S. *Santiago*, District of New York, Port of New York, May 1, 1885, p. 487.

13. See *RWWH*, IV.2, pp. 312–13, CR 1257.5.

14. Drysdale, op. cit., p. 4. The columns included various references to danger, such as that of April

26, 1885, p. 6, entitled "Spiders as Big as a Hat," which did not make it into the Ward-sponsored Harper's book.

15. William Conant Church, "A Midwinter Resort," *The Century Magazine* 33, no. 4 (February 1887), 500. He disdained the process by which passengers got from the steamship, past a coral reef, and into the port itself—and depended on a repurposed New York tugboat (p. 503). The advertisement in the *Times* explained, "Nassau passengers will be landed by steam tender sent there for that special purpose."

16. Ibid., p. 505.

17. Ibid., pp. 504–505. See also "The Missouri Disaster," *New York Times*, November 9, 1872, p. 1.

18. Church, 1887, op. cit., p. 506.

19. The Church article "A Midwinter Resort" included reproductive prints based on nine Homer watercolors: *Fresh Flowers*, CR 1259 (private collection); *The Conch Divers*, 1266 (Minneapolis Institute of Art); *Shark Fishing*, 1270 (private collection); *Hemp*, 1274 (private collection); *Hurricane, Bahamas*, 1277 (Portland Museum of Art); *The Buccaneers*, 1282 (Cleveland Museum of Art); *Glass Windows, Bahamas*, 1283 (Brooklyn Museum); *Rest*, 1288 (private collection); and *Bahama*, 1289 (Museum of Fine Arts, Boston).

20. The autograph book belonged to Edith M. Ewen, identified in *RWWH*, IV.2, p. 340, CR 1285. She was likely the same woman born in New York on March 26, 1854, who arrived in New York on the steamship *Minnehaha* on June 8, 1914, but more specifics on her are elusive. Homer inscribed a place-name in the book, which is located at the northern end of Eleuthera: Dunmore Town, Harbour Island. The landmark he depicted was less than two miles south of Dunmore Town: the well-known "Glass Windows" natural bridge. The *Century* article misidentified this rock formation as being located on Grand Abaco Island.

21. Ives, op. cit., p. 150.

22. Ibid., p. 115.

23. The sheet is in a private collection. See CR 1270, *RWWH*, IV.2, pp. 326–27.

24. *RWWH*, IV.2, pp. 358–59, CR 1295. The sheet clearly relates to his Bahamian work, not that in Cuba, but his dealer placed it among the Cuban watercolors, likely with Homer's blessing. It evokes the famous Copley painting *Watson and the Shark* (1778), which is set in Havana Harbor, as does *Shark Fishing*.

25. February 17, 1885, *RWWH*, IV.2, p. 187, the Ward steamship *Santiago*.

26. Maturin M. Ballou, *Due South, or Cuba Past and Present* (Boston: Houghton Mifflin, 1885), p. 34.

27. Ibid., p. 36.

28. Ibid., pp. 34–35.

29. Ibid., p. 35.

30. Ten of the fifteen sheets focus primarily on Santiago's architectural heritage, including 1296 and 1297 (views of Santiago from its harbor), 1299 (Morro Castle), and 1300–1306 (Santiago street scenes). Three are set in the Cuban countryside with dramatic mountain backdrops, and two are closely framed meditations on cockfighting (1319 and 1320).

31. Efforts to determine whether Antoine Lassus was related to the distinguished French architect Jean-Baptiste-Antoine Lassus (1807–1857) have proven futile. The innkeeper (or more likely his son of the same name) appears as a French resident in the city, according to the *Journal Officiel de la République Française*, October 16, 1875, p. 8695. The innkeeper's birth and death dates are similarly elusive.

32. The hotel was at 32 Calle baja de las Enramadas, at the corner with Gallo. Advertisement in *El Redactor*, Santiago de Cuba, vol. 11, no. 1688 (Sunday, December 15, 1844). A three-part description of Cuba by the French journalist Ernest Duvergier de Hauranne (1843–1877) in-

cludes ample discussion of the hotel. See his "Cuba et les Antilles, III," *Revue des Deux Mondes* 65, no. 4 (October 15, 1866) (Paris: Bureau de la Revue des Deux Mondes): 852–92. Samuel Hazard's *Cuba with Pen and Pencil* (Hartford, CT: Hartford Publishing, 1871), p. 439, mentions the hotel as well, but spells the owner's name "de La Suss."

33. Ballou, 1885, op. cit., p. 34.

34. Drysdale, op. cit., p. 52.

35. Ibid., p. 33.

36. Ibid.

37. Lisandro Perez, "Iron Mining and Socio-Demographic Change in Eastern Cuba, 1884–1940," *Journal of Latin American Studies* 14, no. 2 (November 1982): 381–405. Given the increasing breadth of collectors for Homer's work, which was beginning to include Pennsylvania steel and mining barons during this period, one may speculate that his visit to Santiago included a day trip to the freshly opened mine in El Caney.

38. "List of Passengers," S.S. *Santiago*, District of New York, Port of New York, April 3, 1885, p. 368. It is notable, and inexplicable, that Charles S. Homer, Sr., does not appear on the passenger list, or on any other passenger list from Nassau that winter and spring that this writer has been able to locate.

39. *American Art News* 15, no. 14 (January 13, 1917): 4.

40. Regular Army, 1st Regiment, U.S. Artillery, Company E, Record on Microfilm M233, Roll 28, private listed as Gustav A. Richard.

41. The 1872 New York City directory lists him as selling prints from 749 Broadway, with a home on Staten Island. By 1875, he listed himself as selling "pictures" rather than prints and was living at 235 West Twenty-third Street. By 1879 he had moved from 749 Broadway to his longtime premises at 226 Fifth Avenue. By 1880 he was married to Louisa, a New York native, and appears that year with her in the federal census at their home on West Sixty-first Street. The directory lists also a home in Fort Washington, Long Island. In the 1882 directory he lists his home at 126 West Thirty-sixth Street, and beginning in 1891 he lists his home as in Lawrence, Long Island. Intriguingly, in 1886 he lists his profession as an artist.

42. "Some Reminiscences of Winslow Homer," Gonzales Family Papers, Subgroup 3, Series 4, Box 1, File 14, Rosenberg Library, Galveston, Texas, MS87.0035. The first sentence of this essay gives a hint of the date of Gonzales's first meeting with Homer, when he said that their friendship extended "over a period of fifteen years or more." The date of 1887 for Gonzales's first visit to Prouts is based on *RWWH*, IV.2, p. 188, but ill-confirmed by documentary evidence. Abigail Booth Gerdts also dates the typescript of these reminiscences to about 1916 but the fact that it is based in part on a separate manuscript dated September 1, 1933, suggests that it dates from that year. He died fewer than six months later, on February 14, 1934. Gonzales provides his explanation of the circumstances for his introduction to Homer in that manuscript, contained in the same file. See Edward Simmen, *With Bold Strokes: Boyer Gonzales, 1864–1934* (College Station: Texas A&M University Press, 1997), particularly pp. 44–85.

43. "Some Reminiscences of Winslow Homer," op. cit.

44. Ibid. The typescript converts the rustic "got through" to a more poetic "penetrated its solidity." Although the typescript is signed by Gonzales, this author has depended on the handwritten manuscript when it differs from the typescript.

45. "Surf-Hut for Bathing Purposes," Patent 220,147, granted to C. S. Homer on September 30, 1879.

46. Note, of course, that brushes could be not only paintbrushes but also clothes-brushes and hair-brushes.

47. Jervis McEntee ignored *The Fog Warning* and focused on the Nassau watercolors in his brief

notation of the Century show. See Jervis McEntee Diaries, December 7, 1885, Archives of American Art, Smithsonian Institution.

48. The Doll & Richards show was not a one-man exhibition, but shared with Walter Gay. It opened on February 19 and closed on March 3 and was successful in selling a number of the tropical watercolors—but not the pair of marine paintings. See *RWWH* IV.2, p. 191.

49. "Table Gossip," *Boston Daily Globe*, July 19, 1885, p. 13. See also *Cape Ann Weekly Advertiser*, July 3, 1885, p. 1.

50. See Joseph E. Garland's biography of Blackburn, *Lone Voyager* (Boston: Little, Brown, 1963). Another source, using interviews with Blackburn, is James B. Connolly, *The Port of Gloucester* (New York: Doubleday, Doran, 1940), pp. 196–220.

51. *RWWH* IV.2, p. 394.

52. Jervis McEntee Diaries, November 16, 1885, Archives of American Art, Smithsonian Institution. He notes that two other painters not otherwise known to have crossed paths much with Homer were there that night: William Bispham (1838–1909) and Frederick Dielman (1847–1935).

53. The other sheet was CR 1271, discussed in *RWWH*, IV.2, p. 327, Thomas Colville Fine Art.

54. See the excellent summary of this complex itinerary in *RWWH*, IV.2, pp. 189–90.

55. The two sheets are discussed in *RWWH*, IV.2, pp. 395–96, CR 1326 and 1327. The first is dated 1885 and the second 1886, suggesting that father and son celebrated the New Year facing the setting sun.

56. See *Winslow Homer: Artist and Angler*, ed. Patricia Junker with Sarah Burns (Fort Worth: Amon Carter Museum, 2002), p. 165. At the date of that publication, the Wyant picture, *Enterprise, at Lake Monroe* (1871), was owned by Samuel H. and Robbie Vickers, who appear in the meantime to have donated it to the Harn Museum of Art in Gainesville, Florida.

57. Ibid., p. 168, citing the *Brooklyn Daily Eagle* of December 30, 1889.

58. *Thornhill Bar* (1886), Museum of Fine Arts, Boston. See *RWWH*, IV.2, pp. 398–99, CR 1330.

59. See *RWWH*, IV.2, p. 191.

60. The exigencies of war had led to a more complex family life than one might expect for the Libbys. Hannah's only sibling, Thomas Jason Libby (1940–1894), was serving in the 12th Maine Infantry Regiment when he fell in love with a New Orleans native, Harriet Ann Farrar (1846–1931). They were married in her city on May 4, 1864, and John was born a bit over nine months later, on February 17, 1865. The Libby family moved to Thomas's native Scarborough at war's end, and Isa May was born there on July 15, 1867.

61. See *RWWH*, IV.2, pp. 412–16, and federal census records for Isa May Libby and her husband, Edward Clifford Plummer (1860–1941), who also worked as a vulcanizer, that is, a skilled worker who improves the strength and resilience of rubber, in his case in the context of shoe manufacturing.

62. *RWWH*, IV.2, p. 412.

63. Ibid., p. 413, a May 14, 1887, letter to Reichard, location undisclosed.

64. "The Academy Exhibition," *New York Evening Post*, April 14, 1887, p. 4.

65. See Alan Hirsch's brilliant *American Genre Painting and the Art of Oversight* (unpublished manuscript, 2018), for discussion of this fascinating subject with respect to Homer and other painters around him.

66. As quoted by John W. Beatty in Goodrich, op. cit., p. 159.

67. See *RWWH*, IV.2, p. 424. A note made by William Howe Downes, based on a conversation he had with two members of the Doll & Richards staff, suggests that *Eight Bells* was exhibited in Boston very shortly after it was completed, and that the Boston Museum of Fine Arts could have acquired it for $800, and didn't. Clarke acquired it almost instantly once it arrived on the

island of Manhattan. Downes never included this information in his 1911 biography of Homer. The location of this note is not disclosed in *RWWH*.

68. The exact time and spot on the graph paper at which the sun is highest in the sky is known as the meridian passage ("Mer. Pas."). Longitude is a measure of time, but latitude is determined by a formula (latitude = zenith ± declination). Ideally, a navigator took observations not only of the sun at local noon but of other celestial bodies, specifically morning and evening stars. If the weather conditions permitted all three readings on a reliable basis, then the navigator could ascertain the ship's position with great accuracy, since he had three lines of position to advance by dead reckoning (distance = time × speed). The principal difference between an octant and the more common sextant is that the octant is based on one-eighth of a circle and the sextant is intrinsically larger since it is based on one-sixth of a circle. A sextant permits a navigator to take an observation at a higher altitude over the horizon than an octant allows. Taking observations correctly is particularly difficult when a vessel is unstable, for example, in a storm. But an octant's somewhat more compact design made it more practical than a sextant for doing so. As ships became more stable, the advantages of sextants over octants became more pronounced. Even by the time Homer painted these pictures, the octant was something of an antique. But Homer valued it regardless, and owned the instrument that he depicts. It hung over his fireplace at his home and studio in Prouts Neck, and is now in the collection of the Portland Museum of Art. David Pratt of Prouts Neck has been extremely helpful in explaining the intricacies of celestial navigation, for which the author gives many thanks.

69. *RWWH*, IV.2, p. 192, a November 26, 1886, letter to Mattie, location undisclosed.

70. Letter from Winslow Homer to Charles S. Homer, Sr., dated December 5, 1886, Bowdoin College Museum of Art, 1964.69.28. Sir John Franklin (1786–1847) was a renowned British naval officer who died of starvation, icebound like his entire crew, on his third attempt to identify the Northwest Passage from the Atlantic to the Pacific through northern Canada.

71. James Boswell, *Boswell's Life of Johnson*, ed. George B. Hill, revised and enlarged edition, ed. L. F. Powell, entry for September 19, 1777, vol. 3, p. 167 (1934). What Johnson (1709–1784) wrote was: "Depend upon it, Sir, when a man knows he is to be hanged in a fortnight, it concentrates his mind wonderfully."

72. Letter from Winslow Homer to Mattie, dated December 21, 1886, Bowdoin College Museum of Art, 1964.69.32.

73. New York City directories, and February 7, 1889, Passport Application for Samuel Thorndyke Preston, filed in Philadelphia but citing a Mount Eden Township ranch. Although the passport application suggests that he intended to return to the United States "within two years," the *Boston Daily Globe* (June 1, 1899, p. 2) suggests that he elongated his stay. He had arrived on the bark *Samuel H. Nickerson* with "a cargo of hides and kips from Buenos Ayres." The paper went on to say that "Mr. S. T. Preston . . . has been in business in Buenos Ayres for the past 12 years." He died of heart failure on November 16 that year in West Townsend, Massachusetts.

74. *RWWH*, IV.2, p. 192, a November 26, 1886, letter to Mattie, location undisclosed.

75. Jervis McEntee Diaries, February 5, 1887, Archives of American Art, Smithsonian Institution. Two months later, on April 6, he writes that he returned to the Century and saw Homer, Perry, the painter Richard William Hubbard (1816–1888), the engraver and poet William James Linton (1812–1897), and likely the sculptor John Q. A. Ward (1830–1910). Later that month, on April 29, McEntee, Perry, and Homer were three of the sixteen artists who gathered at the hotel and "eating house" of the onetime artist Joseph Pelligrini, at Fourteenth Street and Irving Place. The other artists dining together included George Henry Hall, Thomas Moran (1837–1926), and Platt P. Ryder.

76. Letter from Winslow Homer to Charlie, dated September 25, 1887, Bowdoin College Museum of Art, 1964.69.30.

77. *RWWH*, IV.2, pp. 448–49, CR 1383.

78. *RWWH*, IV.2, p. 518, a May 14, 1888, letter to Chase, location undisclosed.

79. The author is grateful to Marc Simpson for his observation on this unusual case. The small number of impressions seems a tangible expression of Homer's paralytic state at the time.

80. Jervis McEntee Diaries, January 3, 1888, Archives of American Art, Smithsonian Institution. The next day he wrote from the Union Square Hotel to Eastman Chase, seeking to "square up accounts" prior to a southern sojourn of several months. See *RWWH*, IV.2, p. 197, no location disclosed. The details of Homer's early 1888 trip south are unknown.

81. North Woods Club Trustees Meeting Minutes, January 28, 1888, p. 105. Homer is recorded as formally becoming a member on February 8, 1888, the date he received his share certificate.

82. Terry became a member on July 16, 1887. He provided the Century's address (109 East Fifteenth Street, New York) as his own, just as Homer did.

83. Two obvious questions are whether Jimenis was tied either to Santiago de Cuba, or to U.S. mining interests in El Caney. There is no evidence that the answer to either question is affirmative, inasmuch as Jimenis was born in Matanzas (fifty miles east of Havana) and immigrated at seventeen years of age to New York not from the south coast of the island but from Havana. He became a naturalized U.S. citizen in New York on March 9, 1892.

84. Letter from Winslow Homer to Mattie, dated February 19, 1888, Bowdoin College Museum of Art, 1964.69.36.

10. A FLOURISHING CONDITION (1889–1893)

1. "The Old Year," *Portland* (Maine) *Daily Press*, p. 2.

2. *RWWH*, IV.2, p. 519.

3. "At the Hotels," *Boston Post*, April 18, 1889, p. 8.

4. Ritchie had just moved to new premises at 89 West Fourteenth Street after years at 109 Liberty Street.

5. See *RWWH*, IV.2, pp. 515–21, for Abigail Booth Gerdts's comprehensive overview of Homer's etching oeuvre, and pp. 471–72 for her discussion of *Saved* (CR 1403) specifically. It is notable that restrikes were made of the other five plates, and numerous ones—and by the Metropolitan Museum of Art, among others. Homer undoubtedly destroyed the one plate in his possession to avoid such an occurrence.

6. This figure of twenty-five is a best guess; see *RWWH*, IV.2, pp. 471–72 and 515–21.

7. Those two other Centurions were the merchant Edward Day Page (1856–1918) and the physician Henry McMahon Painter (1863–1934), a nephew of the wool merchant Frank Kitching. Page seemed to have had some interest in art; see his lengthy obituary in *Obituary Record of Yale Graduates, 1918–1919* (New Haven, CT: Yale University, 1919), pp. 1141–42. Painter and his wife were likely the only other members with Homer on his 1899 visit.

8. This writer's focus has been on the members and their families who overlapped with Homer, but one must acknowledge that among the members who did not overlap with Homer were two men of much greater wealth and considerable interest in art: Henry Clay Frick (1849–1919) and Andrew W. Mellon (1855–1937). Frick joined on February 25, 1896, and Mellon on December 12, 1898; another accomplished Pittsburgh resident, Philander Chase Knox (1853–1921), preceded them but seems to have resigned about the time they joined. Neither of these two Pittsburgh barons appears to have ever visited when Homer did, and this writer knows of no evidence that Homer ever met Mellon. But Homer's brief letter to Knoedler on December 3, 1907,

strongly suggests that he did know Frick. Knoedler's extensive correspondence with Frick includes only passing reference to Homer in a letter on February 15, 1899 (Frick Collection, New York, Series IV: Correspondence 1895–1921, M. Knoedler & Co, 1899, Folder 3). Future research may unveil more about this relationship. None of the dozen houses the members built prior to Homer's death in 1910 (or since) approach the rustic ostentation of Great Camps built elsewhere in the Adirondack region; a Hoboken, New Jersey, civil engineer, Charles Benjamin Brush (1848–1897), commissioned the largest house at the North Woods Club, which is far from shabby but pales relative to the grandeur of many Great Camps. Brush appears to have been the principal force behind the club's egalitarian "cluster housing" subdivision plan. He also seems to have led the construction of the current club road from Route 28N, which obviated the need for the arduous journey from Aiden Lair. One may deduce that for all the members, from Morse to Terry to Homer to Frick, the low-key ethos of the club that Brush and other early members helped form was part of its attraction. That character survives to this day.

9. Yalden was the first president of the Association of International Certified Public Accountants (AICPA, a new name as of 2021 for the national professional organization of U.S. CPAs, which has previously been known as the American Association of Public Accountants, the Institute of Public Accountants, the American Institute of Accountants and, most recently, the American Institute of Certified Public Accountants). See Norman E. Webster, *American Association of Public Accountants: Its First Twenty Years, 1886–1906* (New York: American Institute of Accountants, 1954), esp. pp. 24–55. Yalden would not only lead the association but then found the first American vocational school for accountants. See Elliott L. Slocum and Alfred R. Roberts, "The New York School of Accounts—A Beginning," *Accounting Historians Journal* 7, no. 2 (Fall 1980): 63–70.

10. See, for example, *The Wheel: A Journal of Cycling* (Official Organ of the League of American Wheelmen and the Cyclist Touring Club in America) 4, no. 17 (July 27, 1883): 4. In addition to the other members mentioned in the text, it is noticeable that a W. F. Adams (possibly a brother to Edwin W. Adams, but whose dates and biographical data are elusive) appears often when Homer is at the Clearing. The younger Yalden's friend A. E. Dormin (again, without useful dates and other data) also appears regularly as a guest, as does Rear Admiral George Augustus Bicknell (1846–1925), a frequent guest of Kitching's.

11. The register suggests that the Brooklyn silversmith George W. Shiebler (1846–1920) did overlap with Homer, but did not sponsor him as his guest, which several scholars have concluded he did (see Tatham, 1996, op. cit., p. 105; and *RWWH*, IV.2, pp. 199–200). The register is challenging to read but a magnifying glass will confirm that Shiebler was sponsoring Julia F. Seidel (born 1854, and appearing in his household in the 1892 New York State census), whose name is just underneath Homer's—but not Homer himself.

12. A very brief overview of logging in the Adirondacks appears in Jerry Jenkins with Keal, op. cit., p. 87.

13. See Henry Solon Graves, *The Woodsman's Handbook* (Washington, DC: Government Printing Office, 1903), pp. 56–60.

14. This sheet won special praise in an insightful review published by *The Sun*, March 3, 1890. "It is needless to say at this late date that Mr. Homer is a master of water-color painting, but the simplicity and force of his brush were never better exhibited than here. Especially remarkable from the purely technical point of view was a study of a jam of logs on a river," the unsigned critic wrote (p. 4). The review went on to a detailed and admiring exposition on both *Two Guides* and *Camp Fire*, each 1877, so a dozen years old. Clarke had just purchased the former off Reichard's gallery walls; he would shortly purchase the latter. See *RWWH*, III, pp. 63–69, including a robust discussion of the review. Homer's unexpected coloration of the cliff reflects his obser-

vant eye on that distinctive formation. It is composed not of granite (as one might suppose) but probably of a metamorphic rock that has undergone a period of high heat, high pressure, or both. Such processes occur where tectonic plates collide—something that would have impressed Homer. One source describes the rock as "layered metasediments"; see Jenkins, 2004, op. cit., p. 13.

15. "Mr. Homer's Watercolors," *New-York Daily Tribune*, February 26, 1890, p. 6. The watercolor that the reviewer describes is *A Good One*, listed in *RWWH*, IV.2, p. 482, as CR 1413.

16. Gourlie has the distinction of proposing more new members for the Century than anyone else in its history. He gave Homer the book on March 25, 1872, a year after its publication.

17. The Roman Catholic Church and the Eastern Orthodox Church both regard the Song of the Three Holy Children (sometimes called the Song of the Three) as canonical. This is due to its inclusion, along with the Prayer of Azariah, between Daniel 3:23 and 3:24 in the Septuagint version of Daniel (an early Greek translation of the book). See notes by Amy-Jill Levine and David A. Lambert in *The Jewish Annotated Apocrypha*, ed. Jonathan Klawans and Lawrence M. Wills (New York: Oxford University Press, 2020), pp. 325–31. For a variety of reasons beyond the purview of this biography, Protestant churches, including Anglican ones, place both the prayer and the song in the Apocrypha. Nevertheless, Anglican churches around the world have a long tradition of including the canticle in the Service of Morning Prayer. U.S. Episcopal summer chapels such as St. James in Prouts Neck were especially likely during this period to use that liturgy as their primary form of worship and to include in it this canticle. The author is grateful to Professor Joanna Kline of Gordon College for her counsel on this matter.

18. George Chaplin Child (later George Chaplin Child-Chaplin), *The Great Architect: Benedicité, Illustrations of the Power, Wisdom, and Goodness of God, as Manifested in His Works* (New York: G. P. Putnam and Sons, 1871), p. 53.

19. Elizabeth Johns, *Winslow Homer: The Nature of Observation* (Berkeley: University of California Press, 2002), p. 130. To the best of this author's knowledge, Johns was the first scholar to recognize the importance of this book to Homer. See also pp. 138–39. Although she seems not to have access to Homer's annotations in his copy of the book, her insightful analysis of the text itself is entirely consistent with those annotations and their implications. This author is profoundly grateful for her book as a whole, and particularly for her understanding of the ways that Child-Chaplin and other natural theologians shaped Homer's life and art. Natural theology is distinct from, yet easily confused with, natural religion. That, by contrast, is essentially pantheistic, while natural theology is rooted in orthodox Christian faith. The foundational case for natural theology in Homer's era was that of William Paley in his *Natural Theology: Or, Evidences of the Existence and Attributes of the Deity, Collected from the Appearances of Nature* (Philadelphia: John Morgan, 1802). More recent and highly readable statements of natural theology include those of John Polkinghorne in his *Belief in God in an Age of Science* (New Haven, CT: Yale University Press, 1998) and of N. T. Wright in his *History and Eschatology: Jesus and the Promise of Natural Theology* (Waco, TX: Baylor University Press, 2019).

20. Child-Chaplin, op. cit., p. 27.

21. Ibid., pp. 17 and 11.

22. Ibid., p. 75.

23. Ibid., p. 80.

24. "Mr. Homer's Watercolors," *New-York Daily Tribune*, February 26, 1890, p. 6.

25. "Water Colors by Winslow Homer, N.A.," *New York Times*, February 18, 1890, p. 4.

26. "Mr. Homer's Watercolors."

27. See W. Patrick McCafferty, *Aquatic Entomology: The Fishermen's and Ecologists' Illustrated Guide to Insects and Their Relatives* (Boston: Jones and Bartlett, 1998), pp. 91–123.

28. *RWWH*, IV.2, pp. 486–87, CR 1417.

29. The murkiness with which Homer describes the seated figure leaves his identification ambiguous. It is possible that the man is an Adirondacks guide rather than Terry himself, but at this time in the season, the number of guides seems to have been limited.

30. See chapter 7 text and notes and Grinnell and Roosevelt, op. cit.; and Annie Ronan, "Capturing Cruelty: Camera Hunting, Water Killing, and Winslow Homer's Adirondack Deer," *American Art* 31, no. 3 (Fall 2017): 52–79, for more discussion of this important topic.

31. "Mr. Homer's Watercolors."

32. The watercolor is *Waiting for the Start*, which is owned by the Museum of Art, Rhode Island School of Design. See *RWWH*, IV.2, pp. 502–503, CR 1433.

33. "Art Notes," *Evening Post*, February 19, 1890, p. 6.

34. Letter to Thomas B. Clarke, February 16, 1890, Archives of American Art, Smithsonian Institution.

35. *RWWH*, V, p. 76, CR 1447.

36. Letter to Charlie of May 28, 1890, Bowdoin College Museum of Art, 1964.69.89.

37. These were *Summer Night* and *Signal of Distress* (both discussed in the next chapter), *Winter Coast* (CR 1461, Philadelphia Museum of Art), and *Sunlight on the Coast*.

38. "Four New Pictures by Winslow Homer," *The Studio* 6 (January 24, 1891), cited in *RWWH*, V, p. 93, CR 1463.

39. The antlers seem to have belonged to Homer's friend Eliphalet Terry, but no documents survive to explain who shot the buck and when. Buck antlers are as distinctive to the individual of the species as are human fingerprints.

40. Roosevelt was elected to the Century on April 4, 1884, at the age of twenty-five years. He was very well acquainted with the membership, as his father (also Theodore [1831–1878]) was elected in 1864, a year before Homer, and was well known in those circles. Homer's name does not appear in *Index to the Theodore Roosevelt Papers* (Washington, DC: Manuscript Division, Library of Congress, 1969).

41. See chapter 7 text and notes and Grinnell and Roosevelt, op. cit.; and Ronan, op. cit. While no letters between TR and Homer survive, TR was very close to his contemporary Lawrence Fraser Abbott (1859–1933), who in 1889 married Lawson Valentine's daughter Mary (1861–1899). Homer and TR probably crossed paths in multiple ways, but the tight bonds between the Valentine family and both TR and Homer are especially notable. It is reasonable to speculate that the family would have fostered conversation between the two men.

42. "Notes for the New Year," Alfred Trumble, *The Collector* 3 (January 1, 1892): 71.

43. *RWWH*, V, pp. 100–101, CR 1471.

44. Letter to Arthur of June 17, 1891, written from New York's Union Square Hotel, Bowdoin College Museum of Art, 1964.69.40.

45. J. Ernest Grant Yalden arrived a week later with two friends, Arthur Evans Dornin (1870–1904), then a Columbia undergraduate, and Edwin J. Alport (1873–1954), a St. Louis–born Buffalo high school student.

46. Letter to Charlie of October 15, 1891, written from the Adirondack Preserve Association (which changed its name to the North Woods Club in 1895), Bowdoin College Museum of Art, 1964.69.49.

47. Letter to Mary Woodbury Blanchard (1857–1943), November 5, 1891, written from Prouts Neck, Archives of American Art, Smithsonian Institution. "Midie" Blanchard was one of three daughters of Homer's first cousin Clara Benson Thurston (1828–1906). She lived in New York and appears to have interacted often with both Winslow and his brother Charles and his wife, Mattie.

48. Letter to Mattie of December 29, 1891, written from Prouts Neck, Bowdoin College Museum of Art, 1964.69.45.

49. "An Anecdote," Bryan Burroughs, *Metropolitan Museum of Art Bulletin* 28, no. 3 (March 1933): 64. For the scathing letter to Clark, see Smithsonian Institution, Archives of American Art, Winslow Homer Collection, Box 1, Folder 2, letter from Prouts Neck to Thomas B. Clarke, December 11, 1892. It follows an important related letter (Smithsonian Institution, Archives of American Art, Winslow Homer Collection, Box 1, Folder 2, letter from Prouts Neck to Thomas B. Clarke, October 25, 1892) in which Homer describes the painting to Clarke prior to Homer's completing it. Homer explains his plan in that letter a) to copyright it; b) to publicize it through *Harper's Weekly*; and c) to "have Klackner publish it as a print & then exhibit it for sale first in Boston (at $2000.) with my watercolors." Although he never did make an etching based on the painting (or use *Harper's* "to make it known"), the scheme is a window into his appetite for commercial experiment. See *RWWH*, V, pp. 131–34, CR 1507.

50. See "Yalden, James Ernest Grant, Scientist, Educator," in *The Encyclopedia of Biography*, ed. Winfield Scott Downs (New York: American Historical Society, 1938), pp. 18–21, for the most reliable and complete treatment. *J. Ernest Grant Yalden, 1870–1937* (New York: New York Community Trust, n.d.) is engaging but error-prone. A wide variety of obituaries of this good-hearted polymath appeared following his death on February 22, 1937, in publications as wide-ranging as *Popular Astronomy* 45, pp. 296–98; *Science* 85, pp. 325–26; and *The New York Times*.

51. "Yalden, James Ernest Grant, Scientist, Educator," op. cit., pp. 19–20.

52. Ibid., p. 19. See J. Ernest Grant Yalden, "The Problem of Industrial Education," *Journal of Education* 68, no. 13 (October 8, 1908): 367; and J. Ernest Grant Yalden, "The Short Course Trade School," *Annals of the American Academy of Political and Social Science* 33, no. 1 (January 1909): 68–77.

53. Letter to Alice Patch Homer of December 29, 1892, written from Prouts Neck, Bowdoin College Museum of Art, 1964.69.43.

54. See H. Barbara Weinberg, "Thomas B. Clarke: Foremost Patron of American Art from 1872 to 1899," *American Art Journal* 8, no. 1 (May 1976): 52–83.

55. Clarke's "Memorandum Book 1872–1879," at the Henry Francis DuPont Library, Winterthur Museum, provides a fascinating window into the formation of this extraordinary American collector.

56. With a population of 1,099,850 in the 1890 census, Chicago just edged out Philadelphia (with a population of 1,046,964). New York, of course, handily beat both, at 1,515,301. By contrast, Boston was at 448,477 and Portland was at 36,425.

57. See William Cronon, *Nature's Metropolis: Chicago and the Great West* (New York: W. W. Norton, 1991), p. 341; Donald L. Miller, *City of the Century: The Epic of Chicago and the Making of America* (New York: Simon & Schuster, 1996), p. 488.

58. *RWWH*, V, pp. 138–40, CR 1511.

59. Ibid., pp. 102–103, CR 1472. Florence Maud Lord (Smith College Class of 1895) would go on to become one of the founders of the Consumers' League. Her husband, Landreth H. King (1859–1944), was secretary of the New York Central Railroad. Mrs. King's 1929 letter in which she takes credit for unwittingly serving as Homer's model is in the curatorial files of the Addison Gallery of American Art, Phillips Academy, Andover, Massachusetts. See the *New York Times* obituary (April 11, 1973, p. 51) for her daughter, the writer Ruth Rodney King Manley. Note that Mrs. King reappears in Homer's watercolor *The Outlook, Maine Coast* (1894), by which time she presumably knew well that she was modeling for him. She was a rising Smith senior when she posed for that sheet, to the left of a middle-aged and slightly shorter woman. Mrs. King is wearing the same hat and dress in that watercolor as in *The West Wind* of two years earlier, and which she herself described as distinctive to her.

60. *RWWH*, IV.1, pp. 106–108.

61. *RWWH*, V, pp. 374–76, CR 1764. The records for *Murray Hill* (*RWWH*, V, pp. 145–46, CR 1513) suggest that Homer intended to lend that picture to the World's Columbian Exposition as a sixth entry directly from him, but that something went awry. Homer's February 20, 1893, letter to Reichard from which Abigail Booth Gerdts quotes is presumably in the Goodrich / Gerdts Homer Archives at the National Gallery of Art, but could not be located.

62. Note that the catalogue shows fourteen Homer entries, not fifteen, as *A Huntsman and Dogs* was evidently a late entry from Hooper (consigned to Reichard), who seems to have tried to sell the picture over the ten remaining years of his life after the purchase. His daughter Mabel, wife of John La Farge's son Bancel, inherited it in 1901.

63. *Official Catalogue of Exhibits, World's Columbian Exposition, Department K, Fine Arts* (Chicago: W. B. Conkey, 1893), p. 15 (Cox); p. 17 (Eakins); p. 18 (Gifford); p. 20 (Inness); pp. 24–25 (Sargent); p. 27 (Vedder); and p. 29 (Wyant). Homer's works appear on pp. 19–20. Whistler, interestingly, had only six entries (p. 28).

64. Lucy Monroe, "Chicago Letter," *The Critic* 23, no. 598 (August 5, 1893): 91–92.

65. Ibid., p. 92.

66. Gallery 8 (the location of *Eight Bells* depicted in the photograph) was a square room on the northeast corner of the ground floor of the Fine Arts Building, which was located in Jackson Park next to Lake Michigan, just south of Fifty-seventh Street.

67. Margaretta M. Lovell, "Picturing 'A City for a Single Summer': Paintings of the World's Columbian Exposition," *Art Bulletin* 78, no. 1 (March 1996): 53.

68. For the purposes of this calculation, this author excludes the west coast of Florida, whose parts may include some very slightly west of Pittsburgh.

69. *RWWH*, V, p. 141. The thorough analysis of *Fox Hunt* (CR 1512) is on pp. 141–44. Mention must be made of a mysterious large painting whose development seems to have been in parallel with that of *Fox Hunt*, but which is now unlocated, and which Homer himself may well have destroyed. See *RWWH*, V, pp. 145–46, for an analysis of that picture, *Murray Hill*, whose title suggests a connection to the Jacksonville neighborhood of that name, rather than to the neighborhood of the same name in New York. A group of northern investors led by James R. Challen (1834–1905), William J. Harkisheimer (1838–1899), and John Talbott (possibly 1801–1884) acquired land there in 1884 and planned to create a subdivision called Edgewood. The plan never materialized. The author is grateful to Marc Simpson for making this connection.

70. "The Fine Arts. Winslow Homer's Latest Picture. *The Fox Hunt* at Doll & Richards," *Boston Daily Evening Transcript*, June 30, 1893.

71. *RWWH*, V, p. 142. The letter to Reichard from which Abigail Booth Gerdts quotes is presumably in the Goodrich / Gerdts Homer Archives at the National Gallery of Art, but could not be located.

72. *RWWH*, V, p. 142.

73. Ibid., p. 143.

74. "Some Reminiscences of Winslow Homer," op. cit.

75. *RWWH*, V, p. 136, CR 1509.

76. Letter to Boyer Gonzales, December 20, 1893, Box I, Folder 1, Gonzales Family Papers, op. cit.

11. THE LIFE THAT I HAVE CHOSEN (1894–1898)

1. Letter to Mattie of April 16, 1892, written from Prouts Neck, Bowdoin College Museum of Art, 1964.69.46. The name of the manufacturer of "Chapin's shoes" eludes this writer.

2. Otis and Lucy Ann were both born to an older sister of Charles S. Homer, Sr. Otis's mother was Mary Cunningham Homer (1790–1869), wife to Otis Norcross, Sr. (1785–1827); Lucy Ann's

mother was Sarah Ann Merritt Homer (1792–1862), wife to George Lane (1788–1849). Otis does not appear to be closely related to two other important Norcross figures in Massachusetts history: the brothers James Atkinson Norcross (1831–1903) and Orlando Whitney Norcross (1839–1920), who were born in Maine, bred in Salem, and settled in Worcester. They served as contractors for many of the most recognizable buildings constructed in the United States during Homer's lifetime, such as H. H. Richardson's Trinity Church on Boston's Copley Square and Marshall Field Warehouse in Chicago; McKim, Mead & White's Symphony Hall in Boston; and Shepley, Rutan & Coolidge's Art Institute of Chicago.

3. *RWWH*, IV.2, p. 389.

4. "Package for Oils, Etc.," No. 380,894, issued on April 10, 1888.

5. Child-Chaplin, op. cit., p. 206.

6. Ibid., p. 207.

7. Ibid., p. 206. Newton's deathbed utterance is found in the unsigned "Life of Isaac Newton" included as a lengthy preface to *Newton's Principia: The Mathematical Principles of Natural Philosophy* (New York: Daniel Adee, 1846), p. 58: "I do not know what I may appear to the world; but to myself I seem to have been only like a boy playing on the sea-shore, and diverting myself in now and then finding a smoother pebble or a prettier shell than ordinary, while the great ocean of truth lay all undiscovered before me."

8. *Harper's New Monthly Magazine* 86, no. 515 (April 1893): 740–52. The clipped paragraph quoted is on p. 744.

9. Letter to Louis Prang of April 9, 1893, written from Prouts Neck, Archives of American Art, Smithsonian Institution.

10. Letter to Louis Prang of December 30, 1893, written from Prouts Neck, Archives of American Art, Smithsonian Institution.

11. *RWWH*, V, pp. 176–79, No. 1553.

12. Letter to Louis Prang of May 19 [1894], written from Prouts Neck, Archives of American Art, Smithsonian Institution.

13. Letter from Winslow Homer to Charlie, dated September 25, 1887, Bowdoin College Museum of Art, 1964.69.30.

14. Abigail Booth Gerdts cites four letters from Homer to Prang in *RWWH*, V, p. 23, all from the fall of 1895, dated October 8, October 29, November 6, and November 22. The first requests that Prang send the lithographic stone to him in Prouts Neck, while the second says, "I opened the box of lithographic things yesterday, and found everything all right. I made the tracing on the stone, and shall finish the drawing today. It seems to me only yesterday that I was doing the same thing at Bufford's. I will send it in a day or two." She does not cite the present location of these letters, but logically deduces from them that the lithograph is correctly dated 1895. However, the last of these letters suggests that he was not completely satisfied with the lithograph as it then stood and intended to "fix it in an hour" while visiting Boston at Thanksgiving. He didn't like all the "lithographic things" Prang had sent him, and wrote, "It appears to me that your printing ink is not black. It's a dirty gray." The fixing process may have continued into the following year; Homer signed "1896" on the one extant impression known to this author.

15. Letter from Winslow Homer to Charlie, dated February 28, 1898, written from Prouts Neck, Bowdoin College Museum of Art, 1964.69.73.

16. Letter from Winslow Homer to Mattie, dated April 20, 1895, written from his hotel room in Boston, Bowdoin College Museum of Art, 1964.69.62.

17. "Four New Pictures by Winslow Homer," *The Studio* 6 (January 24, 1891): 74–75, cited in *RWWH*, pp. 88–90.

18. "Art at the Columbian Exposition," *Review of Reviews* 7, no. 41 (June 1893): 554. Knaufft

taught at Princeton and Purdue, and was the nephew of Bret Harte. See his obituary in *The New York Times*, April 23, 1942, p. 23.

19. "Chicago Art Gossip; Paintings by Winslow Homer; A Distinctively American Artist—His Work in Tropical Countries—Loan Exhibition Next Month at the Art Institute—Drawing by Walter Shirlaw," unidentified reviewer, likely in *Chicago Herald*, likely on or near December 16, 1894, but date is as yet unidentified. Homer clipped it for his scrapbook on page 101 (Green), which is in the collection of the Bowdoin College Museum of Art. See also *RWWH*, V, pp. 173–74. In a version of the scrapbook accessible to Lloyd Goodrich, he noted that Homer wrote in the margin of the article a chuckling comment about the reviewer's reading of the picture: "No moon about this 2 p.m. Sun in a Fog." In defense of the anonymous reviewer, O'Brien gave it the title *Moonlight Fog*.

20. Ibid.

21. Letter to John Calvin Stevens of June 26, 1901, written from Prouts Neck, Bowdoin College Museum of Art, 1988.38.12.

22. Earle G. Shettleworth, Jr., and William David Barry, "'Brother Artists' Winslow Homer and John Calvin Stevens," *Bowdoin* 61, no. 4 (Fall 1988): 16–19. See also Earle G. Shettleworth, Jr., and John Calvin Stevens II, *John Calvin Stevens: Domestic Architecture, 1890–1930* (Scarborough, ME: Harp Publications, 1990).

23. Letter to Thomas B. Clarke of February 23, 1895, written from Prouts Neck, sold by Swann Galleries as Lot 165, Sale 1930, on April 11, 2002.

24. Letter to Thomas B. Clarke of January 19, 1896, written from Prouts Neck, Winslow Homer Collection, 1863, Archives of American Art, Smithsonian Institution.

25. Letter to Thomas B. Clarke of March 17, 1896, written from Prouts Neck, Winslow Homer Collection, 1863, Archives of American Art, Smithsonian Institution.

26. Both father and son were Yale graduates. Edward was home-schooled and entered the Sheffield Scientific School as a seventeen-year-old junior. Within a year, he was elected president of his class; he earned his Ph.B. in 1875, just after his nineteenth birthday. See "Obituary Record of Yale Graduates, 1918–1919," *Bulletin of Yale University* 15, no. 11 (August 1919): 1141–42. For Leigh, see W. F. G. Swann, "Leigh Page, 1884–1952," *Science* 117, no. 3038 (March 20, 1953): 289–90.

27. David Tatham, "Winslow Homer in Quebec," in Junker, 2002, op. cit., pp. 125–59.

28. Letter from Winslow Homer to Charlie, dated June 19, 1895, written from Prouts Neck, Bowdoin College Museum of Art, 1964.69.47. The letter begins, "Your sprain I know all about as I had the same thing only above my knee. I slipped on Father's pebbles in front of his house [drawing of steps and stones beneath them] at that angle and threw my other leg back as if I was on a level. Since turned black on both sides."

29. "Angling in Canada," *Forest and Stream* XXXIV, no. 17 (May 15, 1890): 333.

30. Junker, 1990, op. cit., p. 57. See also Goodyear, op. cit., pp. 53–56.

31. J. M. Le Moine, *Historical and Sporting Notes on Quebec and Its Environs* (Quebec City: L.-J. Demers et Frere, 1889), pp. 101–15.

32. William Henry Harrison Murray, *The Doom of Mamelons: A Legend of the Saguenay* (Quebec City: Morning Chronicle Office, 1888), p. 156.

33. Serge Gagnon, *L'Échiquier touristique Québécois* (Sainte-Foy: Presses de l'Université de Québec, 2003), p. 158.

34. Eugene McCarthy, *The Leaping Ouananiche: What It Is, Where, When and How to Catch It* (New York: Forest and Stream Publishing, 1894).

35. Ibid., p. 14.

36. Ibid., p. 41.

37. Ibid., pp. 148, 155.

38. Until the recent publication of Melissa Otis's important book *Rural Indigenousness: A History of Iroquoian and Algonquian Peoples of the Adirondacks* (Syracuse, NY: Syracuse University Press, 2018), scholars believed that no indigenous settlements survived in the Adirondacks, at least into the mid-nineteenth century. Yet Homer inscribed a watercolor of 1894, *Indian Village, Adirondacks* (Harvard Art Museums, 1960.669). See *RWWH*, V, p. 155, CR 1525.

 Otis's dedicated research and persuasive writing illuminate the reality of the continuing presence in the Adirondacks of Abenaki, for example. Her chapter 3, "The Trustiest Guides in All the Wilderness," brims with insight into Mitchel Sabattis (1823–1906) and two other indigenous guides from Long Lake (about ten miles west of the Clearing). The chapter, on pp. 103–144, is replete with insight into the complex relationships between those who had lived in the Adirondacks for generations and those who had arrived more recently—both as sportsmen and as nonindigenous loggers, trappers, and farmers. While most indigenous people had vanished from the Adirondacks long before 1894, and not one of the numerous Adirondack experts who this author has contacted has been able to identify the site of Homer's watercolor, nevertheless his inscription may well mean just what it says. If so, it validates Otis's thesis and is yet another case of Homer's offering unexpected illumination of his time and place.

39. *RWWH*, V, p. 22, location of letter undisclosed. The indigenous inhabitants of the region around Lake St. John are the Ilnu, whom French colonial settlers called Montagnais. The Mashteuiatsh Reserve is home today to about 2,200 Ilnu people. They speak the Ilnu-Aimun dialect, which is part of the Cree language group. A second regional tribal group, the Innu, live farther north and speak Innu-Aimun, a different dialect of the same language. Neither dialect is related to the languages of the Inuit, some of whom live in surrounding areas. The reserve is located on the southern edge of the traditional homeland of the Ilnu (covering a vast region of Quebec, Newfoundland, and Labrador), which they call Nitassinan, or Our Land.

40. *RWWH*, V, p. 184, CR 1559.

41. Letter from Winslow Homer to Mattie, dated December 25, 1895, written from Boston, Bowdoin College Museum of Art, 1964.69.57.

42. "Winslow Homer's Drawings," *Boston Evening Transcript*, December 4, 1884, p. 4.

43. The studies for *The Signal of Distress* are at the Cooper Hewitt (1912–12–213, 1912–12–214, and 1912–12–43). Christian Klackner published the photogravure in 1891. The illustration published in the *Century* in 1899 shows the inverted American flag more clearly than does the photogravure upon which it is based. See *RWWH*, V, pp. 82–85 and 222–23, CR 1456 and CR 1601. As noted in the magisterial Kelly/Cikovsky 1995 retrospective catalogue, the connections appear strong between the oil painting in its two manifestations and the *Parthia*'s railing in *Marine* (1881) at Bowdoin College, illustrated in chapter 8; her officer in *Taking an Observation* (1881, private collection, CR 1018); the same officer in *Taking an Observation* (1884, Portland Museum of Art, CR 1253); and the railing in the study drawing for *The Signal of Distress* at the Cooper Hewitt (1912–12–43). Abigail Booth Gerdts disagrees and notes the possible connections to *The Wreck of the "Iron Crown,"* which is set on the coast rather than in midocean. There also appear to be connections between *Passing a Wreck—Mid-Ocean (Tense Moments)* and at least two undated Cullercoats drawings that were exhibited at the same Doll & Richards show where the Colby College drawing first appeared. These are *A Dark Hour* (Sheldon Gallery of American Art, University of Nebraska, *RWWH*, IV.1, p. 137, CR 1147) and *The Last Boat In* (Addison Gallery of American Art, Phillips Academy, *RWWH*, IV.1, p. 138, CR 1149). Kathleen A. Foster's *Shipwreck!* (2012, op. cit.) addresses the important role of the *Parthia* in several respects and gives an excellent description of Homer's development of the *Signal of Distress* on pp. 83–86.

44. Letter from Winslow Homer to Charlie, dated December 10, 1890, written from Prouts Neck, Bowdoin College Museum of Art, 1964.69.42.

45. See *The Paintings of John Calvin Stevens*, by Earle G. Shettleworth, Jr., and Paul S. Stevens (Portland, ME: Greater Portland Landmarks, 2015). Note especially the timeline on pp. 32–33 and the list of Stevens's works exhibited by the Portland Society of Art (pp. 35–39).

46. *RWWH*, V, p. 170, CR 1548. As Abigail Booth Gerdts points out, this watercolor is assuredly not Homer's last, despite assertions to the contrary.

47. *RWWH*, IV.2, pp. 420–21, CR 1353.

48. *RWWH*, V, p. 228.

49. *RWWH*, V, pp. 227–29, CR 1609, and p. 257, CR 1649.

50. Cecilia Beaux, *Background with Figures* (New York: Houghton Mifflin, 1930), pp. 211–12. Note that her recollections appear more reliable than do those of Frank Duveneck, transmitted through Beatty. The date inscribed on the verso of the drawing noted as CR 1649 confirms Homer's story of arriving earlier than the other jurors, whereas the Duveneck story depends on their sharing a train ride together.

51. *RWWH*, V, pp. 32–32.

52. Letter from Winslow Homer to Charles S. Homer, Jr., dated February 21, 1895, written from Prouts Neck, Bowdoin College Museum of Art, 1964.69.5.

53. Letter from Winslow Homer to Charles S. Homer, Sr., dated February 24, 1898, written from Prouts Neck, Bowdoin College Museum of Art, 1964.69.70.

54. Wright was born in August 1866, according to the 1900 Federal Census, and appears in each census of 1900, 1905, 1910, 1915, and 1920 in New York City with his wife, Margaret (born October 1864), and daughter, Ruth Wright (born January 1892). He is variously listed as a valet or a coachman.

55. Letter from Winslow Homer to Arthur, dated August 26, 1898, written from Prouts Neck, Bowdoin College Museum of Art, 1964.69.71.

12. ALIVE WITH A REPUTATION (1898–1902)

1. Helen A. Cooper, *Winslow Homer Watercolors* (New Haven, CT: Yale University Art Gallery, 1986), pp. 208 and 217, citing *The Nassau Guardian*, December 14, 1898.

2. Note that he also exhibited *Shark Fishing* (CR 1270, private collection, see *RWWH*, IV.2, pp. 326–27) at Reichard's; it, too, remained unsold and he did not send it to Boston for the Doll & Richards show the following year. It, too, is an essential precursor to *The Gulf Stream*.

3. The one exception is especially interesting and astonishingly vibrant: *Under the Coco Palm*, which Homer gave in 1901 to Henry Wingate Stevens (1869–1937), architect and partner to his much older brother John Calvin Stevens (1855–1940). The sheet depicts a Bahamian boy seated in the shade of a palm as he drinks from a coconut. Homer painted the boy's legs in a highly cursory way, and then next to those legs a closely observed shred of bark from the tree, which resembles the tail of a fish. The sheet is an excellent example of Homer's highly constructed geometric composition, with its centerpoint at the tip of the boy's silhouetted right thumb on the skin of the coconut.

4. The species that these boys are harvesting is the green sea turtle (*Chelonia mydas*), as identified by Annabelle Brooks, a scientist at the Cape Eleuthera Institute. The species is now recognized as endangered and is protected in most jurisdictions. The color designation refers not to the turtle's carapace, which ranges from olive to black, but to the fat beneath it, which is green.

5. *RWWH*, V, pp. 280–81, CR 1678. It is notable, but misleading, that on July 5, 1902, Homer himself inscribed in his daybook "After the Tornado—Texas" near a sketch that undeniably describes this watercolor dated 1899. As Abigail Booth Gerdts notes (and contrary to the views of two authors of an article in the magazine *Antiques* in November 1977), the watercolor is not a homage to the 1900 hurricane that decimated Galveston, but Homer reflected that event in his

notation three years after making it. Homer does not appear ever to have visited his brother Arthur in Texas over the more than three decades that Arthur made the state his home.

6. Peter Dow Bachelder and Mason Philip Smith, *Four Short Blasts: The Gale of 1898 and the Loss of the Steamer* Portland (Portland, ME: Provincial Press, 2003).

7. This author is grateful to Peter H. Wood for drawing attention to the very close timing between this storm and Homer's departure to begin the process of creating a picture so closely tied to threatening weather forces of all kinds.

8. *RWWH*, V, p. 284, CR 1684. In this case and in the case of another sheet (*The Sponge Diver*, Museum of Fine Arts, Boston) Homer gave to his New York physician William Allen Bartlett (1858–1921), he inscribed the date of 1889. In the case of the other sheet, the date is provably inaccurate (the Whatman paper's watermark includes the date 1898), but in this case, one must rely on common sense to deduce Homer's likely inadvertent, and widely accepted, transposition. Homer never exhibited it.

9. Alain Locke, *Negro Art: Past and Present* (Washington, DC: Associates in Negro Folk Education, 1936), pp. 45–46. This is Bronze Booklet Number 3, the basis for Locke's 1940 pathbreaking volume, *The Negro in Art: A Pictorial Record of the Negro Artist and of the Negro Theme in Art* (New York: Hacker Art Books, 1940).

10. Peter H. Wood, *Weathering the Storm: Inside Winslow Homer's* Gulf Stream (Athens: University of Georgia Press, 2004), p. 59.

11. Ibid.

12. Locke, 1936, op. cit., p. 46.

13. M. F. Maury, *The Physical Geography of the Sea* (New York: Harper & Brothers, 1855), p. 25.

14. For an invaluable instruction on the importance of this letter to the foundations of Western culture, see Rona Goffen, "Masaccio's *Trinity* and the Letter to Hebrews," in *Masaccio's* Trinity, ed. Rona Goffen (Cambridge: Cambridge University Press, 1998).

15. Marie George, "What Would Thomas Aquinas Say About Intelligent Design?," *New Blackfriars* 94, no. 1054 (November 2013): 676–700. She cites (n. 18) *Scriptum super Sententiis* (Paris: Lethielleux, 1956), Bk. 2 dist. 10, q. 1, a. 3 ad 1.

16. Child-Chaplin, op. cit., p. 18.

17. Maury, op. cit., p. 54.

18. Patricia Jahns, *Matthew Fontaine Maury & Joseph Henry: Scientists of the Civil War* (New York: Hastings House, 1961), p. 188.

19. Matthew Fontaine Maury to William Lewis Herndon, April 20, 1850, published in Donald Marquand Dozer, "Matthew Fontaine Maury's Letter of Instruction to William Lewis Herndon," *Hispanic American Historical Review* 28, no. 2 (May 1948): 217. See also Matthew J. Karp, "Slavery and American Sea Power: The Navalist Impulse in the Antebellum South," *Journal of Southern History* 77, no. 2 (May 2011): 283–324, and Matthew J. Karp, *This Vast Southern Empire: Slaveholders at the Helm of American Foreign Policy* (Cambridge, MA: Harvard University Press, 2016). For Maury and Wigg in Liverpool, see letter from Charles Francis Adams (U.S. Minister to the United Kingdom) to Earl Russell (U.K. Foreign Secretary), December 28, 1863 (No. 64), contained in *The Case of Great Britain as Laid Before the Tribunal of Arbitration, Convened at Geneva Under the Provisions of the Treaty Between the United States of America and Her Majesty the Queen of Great Britain, Concluded at Washington, May 8, 1871*, Vol. II (Washington, DC, Government Printing Office, 1872), Second Edition, p. 598.

20. Letter to Knoedler of February 1902, cited in *RWWH*, V, p. 288, without footnote.

21. Maury, op. cit., p. 53.

22. Hamilton S. Morris, *Confessions in Art* (New York: Sears Publishing, 1930), p. 63. In *RWWH*, V, p. 287, Abigail Booth Gerdts points out that Morris's quotation of Homer on the same page as

writing "Don't let the public poke its nose into my picture" relates to a letter of December 1904 and refers to *Kissing the Moon*, not to *The Gulf Stream*.

23. *RWWH*, V, p. 286, location of letter undisclosed.

24. Simpson, Marc, "'If You Can Read This . . .': Winslow Homer's *The Gulf Stream* and the Viewing of His Pictures," *Panorama: Journal of the Association of Historians of American Art* 4, no. 1 (Spring 2018).

25. Letter from Winslow Homer to M. Knoedler & Co. from Prouts Neck, undated but in response to (and on the back of) a typed Knoedler letter to him of November 19, 1907, Getty Research Institute, M. Knoedler & Company Archives, Series VI, Correspondence 1878–1971, General Correspondence (Homer, Winslow, 1907), 2012.M.54, Box 353, Folder 4.

26. *RWWH*, V, pp. 285–90, with exhibition details on p. 290.

27. Derek Walcott, *Omeros* (New York: Farrar, Straus & Giroux, 1990), chapter XXXVI, pp. 183–84.

28. Letter from Winslow Homer to Thomas B. Clarke, February 25, 1895, cited in *RWWH*, V, p. 21, location of letter undisclosed.

29. Abigail Booth Gerdts notes in *RWWH*, V, p. 68, n. 36, that upon the closure of his gallery, Reichard had space at the Constable Building, 111 Fifth Avenue, at the corner of Eighteenth Street. In the New York City directories, Reichard appears at the 226 Fifth Avenue address through 1894, and then at 20 West Thirty-fourth Street beginning in 1902 and continuing until 1911. Thereafter he shifts to space next door at 18 West Thirty-fourth Street, where he continues to appear in the directories through 1917, the year of his death.

30. The other commercial galleries with which Homer continued to do business included Gill's in Springfield, Massachusetts, Macbeth and Montross in New York, and Reinhart and J. W. Young in Chicago. See *RWWH*, I, pp. 28–32.

31. The first entries for Homer's work in the Knoedler stockbooks appear to be in 1874 and 1875. On p. 168 of the second volume of the stockbooks (covering April 1873 to August 1878), an entry appears that is likely for the picture that has been called *Cernay la Ville—French Farm* (and which Homer called *Picardie, France*, now at the Krannert Art Museum at the University of Illinois). It is valued at $100. On June 24, 1874, the gallery acquired another picture, called *The Hammock* (almost certainly what is now called *Girl in a Hammock*, 1873, listed in *RWWH*, II, p. 206, as CR 425), for $125 from Joseph Abner Harper (1833–1910) of the publishing family Homer knew so well (p. 172 of the same volume).

32. Agnes Penot, "The Perils and Perks of Trading Art Overseas: Goupil's New York Branch," *Nineteenth-Century Art Worldwide* 16, no. 1 (Spring 2017): 56–70.

33. The firm and the three brothers remained closely connected to France. All three died there, the youngest of them in Lyon on February 16, 1944, while it was occupied by Nazi soldiers and their Vichy collaborators during World War II ("Chas. L. Knoedler, Art Dealer, Dead," *New York Times*, March 7, 1944).

34. Weinberg, op. cit., p. 68.

35. Letter from Winslow Homer to Thomas B. Clarke, dated February 25, 1899, written from Enterprise, Florida, private collection, sold on April 11, 2002, at Swann Auction Galleries, New York, Sale 1930, Lot 166.

36. This chronology is based on the assiduous research of Helen Cooper, who found mention of Homer's arrival and departure in *Royal Gazette*, December 12, 1899, and January 23, 1900.

37. *Royal Gazette* 72, no. 48 (November 28, 1899): 2. The First Battalion arrived on November 21, 1899, to replace the 2nd Battalion, Worcestershire Regiment. Beginning in 1901, captured Boer soldiers would be incarcerated in a newly constructed prisoner of war camp on the island.

38. *Bermuda Pocket Almanack*, 1899, p. 85, as cited in Cooper, op. cit., p. 222.

39. Although some art historians have deduced from these seven watercolors that Homer took a

second trip to Bermuda in 1901 (e.g. Cooper, op. cit., pp. 218 and 227), his chronology is well-enough established to conclude that he went to Bermuda only once. The chronology found in *RWWH*, V, pp. 36–39, is correct. The works themselves can be found in this volume on pp. 291–300 (CR 1687–1697) and 316–22 (CR 1712–1718). Homer's copy of the *Bermuda Pocket Almanack* (1899, now in a private collection) includes an inscription of his lodging at Mrs. Swan's Country Boarding House. It was located on Scaur Hill in Somerset, overlooking Ely's Harbor, near Bermuda's westernmost edge. Ireland Island and the Royal Navy Dockyard seen in *Opposite Ireland Island* are at the east end of the fish hook shape of Somerset's extension northeast, which encloses Bermuda's Great Sound. Gibbet Island is just north of Flatt's Village near the center of Bermuda. What Homer called Natural Bridge was known as Natural Arches, and located on the south shore of the island near its east end in Tucker's Town. However, in 2003, Hurricane Fabian destroyed this notably beautiful limestone formation.

40. Letter from Winslow Homer to M. Knoedler & Co., dated September 17, 1901, written from Prouts Neck, Box 4, Folder 1, Artists' Letters and Manuscripts, Crystal Bridges Museum of American Art, Bentonville, Arkansas.

41. *The Pioneer*, *RWWH*, V, p. 301, CR 1698. Homer's warning to Clarke against purchasing "any old Pictures of mine" is located in Smithsonian Institution, Archives of American Art, Winslow Homer Collection, Box 1, Folder 4, letter from Prouts Neck to Thomas B. Clarke, December 20, 1901.

42. Letter from Winslow Homer to Mattie, dated June 21, 1900, written from the North Woods Club, Bowdoin College Museum of Art, 1964.69.87.

43. Undated letter cited without a footnote or location name in *RWWH*, V, p. 42.

44. The author gives thanks to Steve Rosenthal—photographer, friend, and observant ornithologist—for his understanding of this watercolor, and for Marc Simpson's patient, thorough, and insightful analysis of this sheet and of so much else of Homer's work.

45. Letter from Winslow Homer to M. Knoedler & Co. from Prouts Neck, dated December 3, 1907, Getty Research Institute, M. Knoedler & Company Archives, Series VI, Correspondence 1878–1971, General Correspondence (Homer, Winslow, 1907), 2012.M.54, Box 353, Folder 4.

46. *RWWH*, V, p. 333, CR 1731. Note that the sheet carries an inscription on the verso: "Roberval." Andrews was the president of the Hyde Windlass Co. (Bath, Maine), and a maker of windlasses, deck winches, and other deck machinery for U.S. Navy vessels and other ships.

47. Child-Chaplin, op. cit., p. 300.

48. Murray, 1888, op. cit., p 108.

49. Casey E. Greene, "Smokestack Industries Brought Prosperity, Problems to Isle," *Galveston News*, May 25, 2014.

50. Ida (1854–1919) died in Somerville, Massachusetts, on September 29, 1919, the day after her brother died in Scarborough. Tryphena (1864–1951) in 1905 married Oren Abijah Burbank (1864–1941); at the age of forty-two she gave birth to a daughter, Tryphena Burbank Gorton (1906–1999). The purchase by Ira Foss's mother of the land on which he would build the Checkley is documented in CCRD Book 443, p. 163, December 28, 1876, including her declaration of an intent to build a dwelling house on the site. Silas J. Libby issued a quit-claim on February 5, 1878 (CCRD Book 440, p. 355), which may indicate the completion of the process of building the Checkley during 1877.

51. "Report of the Selectmen on the Investigation & Survey at Prout's Neck, Presented and Accepted at the Special Town Meeting Held on August 27th, 1898," *Annual Report of the Town of Scarboro, 1898–1899*, op. cit., p. 14.

52. Ibid., p. 16.

53. "Report of John S. Hodgson, Civil Engineer, to the Joint Committee on Sewerage of Prout's Neck, August 20th, 1898," *Annual Report of the Town of Scarboro, 1898–1899*, op. cit., p. 3.

54. "Chapter 490: An Act to Incorporate the Prouts Neck Water Company," *Acts and Resolves of the Seventeenth Legislature of the State of Maine* (Augusta, ME: Kennebec Journal Print, 1901), pp. 828–30. This author knows of no published scholarship that has focused on the importance of the Foss water system in permitting the development of Prouts Neck. That said, the ever-insightful John Cromie has recognized the pivotal role of Ira Foss and his water system, and in his lectures to the Scarborough Historical Society and in his discussions with this author has made an excellent case for scholarship to share in that recognition.

55. CCRD, Book 498, pp. 490 and 492, September 1, 1883, with Ella O. Libby and Mary E. Libby as sellers.

56. Letters Test., New York State, Filed March 19, 1898, Book 117, p. 97 (Clark) and p. 98 (Library).

57. CCRD, Book 547, p. 44, May 18, 1888, with James Pennell, John Cloudman, and Leander Valentine as sellers.

58. See his entry in Arthur Nicholas Hosking, *The Artists' Year Book* (Chicago: Art League Publishing Association, 1905), p. 137. The Helen Farr Sloan *Philadelphia Inquirer* Notebooks (MSS 0562, Special Collections, University of Delaware Library) include a clipping from the May 17, 1886, issue of the *Philadelphia Evening Call* entitled "Mr. and Mrs. Moss Move Their Studios to New York."

59. CCRD, Book 529, p. 141, July 13, 1886, with Ella O. Libby and Mary E. Libby as sellers.

60. A more romantic but less likely story suggests that it memorializes the new house built for a local family whose house was struck by lightning around the time the husband lost his leg in a hunting accident. See Philip C. Beam, *Winslow Homer at Prout's Neck* (Boston: Little, Brown, 1966), p. 185. Lisa N. Peters in an unpublished note on the drawing suggests that the story might relate to Samuel Libby (1835–1902) and his wife, Lucy Ann Hunnewell (1842–1902). That couple lived in Portland, where Samuel worked as a clerk; no Samuel Libby appears in the Scarborough deed records during the relevant period. Beam cites many stories, most of which appear to be figments of his imagination or the imaginations of his interlocutors.

61. *RWWH*, V, pp. 304–305, CR 1705.

62. Child-Chaplin, op. cit., p. 134.

63. Letter to Thomas B. Clarke of January 16, 1901, written from Prouts Neck, sold by Swann Galleries as Lot 18, Sale 1912, on November 1, 2001. The letter in its entirety is not accessible, but the auction house quotes these excerpts including that cited in the text with original spelling and syntax: "I have received your two letters & I highly appreciate the attention that you have given me in this matter. I also remember with pleasure and gratitude the many years that you have been doing the same thing, but do not bother to send me any more clippings as I am sure to get them through a friend who has a clippings from some agency sent to him & after looking them over sends them to me . . . I depend on my brother as art critic & he writes me after seeing my pictures that the 'West Point: Prouts Neck' is one of the enterprising pictures of modern art when one considers the pillar of salt (formerly Lot's wife) in connection with that sunset glow."

64. Letter from Winslow Homer to M. Knoedler & Co., dated April 16, 1901, written from Prouts Neck, Box 4, Folder 1, Artists' Letters and Manuscripts, Crystal Bridges Museum of American Art, Bentonville, Arkansas.

65. Letter to Boyer Gonzales on December 29, 1902, written from Prouts Neck, Box 1, Folder 9, Boyer Gonzales Papers, 1893–1907, MS90–0001, Rosenberg Library, Galveston, Texas.

13. TIDE TAKEN AT THE FLOOD (1903–1910)

1. Letter from Winslow Homer to M. Knoedler & Co. from Prouts Neck, dated March 20, 1903, Artists' Letters and Manuscripts, Box 4, Folder 3, Crystal Bridges Museum of American Art,

Bentonville, Arkansas. Another similar letter, written from Prouts Neck to Ben Foster on March 26, 1903, is in the Joseph Halle Schaffner autograph collection, 1683–1948, Houghton Library, Harvard University, #hou00776, Series I, Boxed Manuscripts.

2. Letter from Winslow Homer to Arthur, dated December 5, 1903, written from New York, Bowdoin College Museum of Art, 1964.69.104. That day was a Saturday, so he is referring in the letter to a sailing the next day. "Shipping and Foreign Mails," *New York Times*, December 6, 1903 (p. 18), refers to the *Sabine* as arriving on November 27, 1903, from Galveston. "Shipping and Foreign Mails," *New York Times*, December 28, 1903 (p. 10), refers to the *Sabine* as arriving on December 19 from Mobile. Each of these mentions is a reminder of the tight connections shipping provided between these southern ports and the northern ports of New York and Boston where Homer lived for large parts of his life. This is an especially interesting case, as the *Sabine* would continue on from Key West to Galveston. The route shows how easily Homer could have visited Arthur over the three decades of his brother's residence there, yet appears never to have done so.

3. Junker, 2002, op. cit., pp. 172–74.

4. Letter from Winslow Homer to Grenville Norcross, October 11, 1907, Massachusetts Historical Society, Norcross Papers.

5. Letter from Winslow Homer to Arthur, undated but clearly January 1904, written from Homosassa Inn, Bowdoin College Museum of Art, 1964.69.105. When Arthur received the letter, he jotted down on it a note to Charlie: "Chas here's something interesting."

6. *RWWH*, V, pp. 367–68, CR 1760. The common and reasonable assumption is that *Diamond Shoal* was Homer's last watercolor, preceded the previous year by the Homosassa fishing sheets exhibited at Knoedler's in 1904 and 1905. But as Abigail Booth Gerdts observes, it is more precisely accurate to say that the exhibition of this watercolor, which she believes occurred in April 1907, was the last date on which Homer exhibited a watercolor as a fresh work. Neither she nor this author has been able to identify newspaper reports or other documentary evidence of that exhibition, entitled "Watercolors by Winslow Homer." *Hard-a-Port* appears in *RWWH*, V, pp. 304–305, as CR 1705. *In the Jungle, Florida*, appears in *RWWH*, V, p. 357, as CR 1750.

7. North Carolina's Underwater Archeology Branch has invested in significant scholarship to assist in knowledge of these sites. Its database tallied 927 submerged sites and more than 5,000 historically documented shipwrecks as of December 2008. See Richard W. Lawrence, "Forty Years Beneath the Waves: Underwater Archeology in North Carolina," *The Archeology of North Carolina: Three Archeological Symposia*, ed. Charles R. Ewen (North Carolina Archeological Council Publication Series, Publication 30, 2011).

8. H. A. Marmer, "The Gulf Stream and Its Problems," *Geographical Review* 19, no. 3 (July 1929): 457–78, makes extensive reference to contemporary understandings of these currents and the important role of Maury's analysis of them.

9. The Diamond Shoals Lightship LV 71 is well documented, in part because she was sunk by a German submarine on August 6, 1918. The author thanks the Outer Banks Lighthouse Society (Morehead City, North Carolina) for its research into the lightship.

10. Letter dated March 28, 1904, Cumberland Club Archives. The author is grateful to Earle G. Shettleworth, Jr., for identifying this letter.

11. Letter from Winslow Homer to M. Knoedler & Co. from Prouts Neck, dated May 5, 1904, Sterling and Francine Clark Art Institute, 1955.2632.6, cited in *RWWH*, V, p. 44. Note that as of this date only the recto of the letter's first page is digitally accessible through the Clark website.

12. Louis A. Pérez, Jr., "The Meaning of the *Maine*: Causation and the Historiography of the Spanish-American War," *Pacific Historical Review* 58, no. 3 (August 1989): 293–322.

13. Letter from Winslow Homer to M. Knoedler & Co. from Prouts Neck, dated December 30, 1901, Artists' Letters and Manuscripts, Box 4, Folder 1, Crystal Bridges Museum of American Art, Bentonville, Arkansas.

14. "Art Exhibitions. American Pictures at the Union League Club," *New-York Daily Tribune*, January 11, 1902, as cited in *RWWH*, V, pp. 324–26, CR #1721.

15. *RWWH*, V, p. 324.

16. "A Club Exhibition," *New York Evening Sun*, January 11, 1902, as cited in *RWWH*, V, pp. 324–26, CR 1721.

17. Letter from Winslow Homer to M. Knoedler & Co. from Prouts Neck, dated January 14, 1902, Artists' Letters and Manuscripts, Box 4, Folder 2, Crystal Bridges Museum of American Art, Bentonville, Arkansas.

18. *RWWH*, V, p. 325.

19. Letter from Winslow Homer to M. Knoedler & Co. from Prouts Neck, dated November 8, 1904, Artists' Letters and Manuscripts, Box 4, Folder 4, Crystal Bridges Museum of American Art, Bentonville, Arkansas.

20. Letter from Winslow Homer to Charlie, October 7, 1904, written from Prouts Neck, Bowdoin College Museum of Art, 1964.69.112.

21. Letter from Winslow Homer to M. Knoedler & Co. from Prouts Neck, dated November 2, 1904, Artists' Letters and Manuscripts, Box 4, Folder 4, Crystal Bridges Museum of American Art, Bentonville, Arkansas.

22. See Davis, op. cit. She points out that the use of such geometric systems was standard practice both in formal drawing schools such as those run by the National Academy of Design and in the grammar schools such as Homer attended in Cambridge.

23. The picture seems to depict the sunset, not the sunrise, but the sentimental value of the title overcame cartographic scruples. Some have speculated that Homer might have seen it in Montreal. See Patricia Vervoort, "'Sunrise on the Saguenay': Popular Literature and the Sublime," *Mosaic: An Interdisciplinary Critical Journal* 21, nos. 2/3 (Spring 1988): 123–38; and Ellen L. Ramsay, "Picturing the Picturesque: Lucius O'Brien's 'Sunrise on the Saguenay,'" *RACAR: revue d'art canadienne / Canadian Art Review* 17, no. 2 (1990): 150–57, 203.

24. Phillips Collection, Washington, DC. The picture was owned by Alexander Morten, a New York collector, prior to its purchase by Phillips. See entry in Elizabeth Broun, *Albert Pinkham Ryder* (Washington, DC: Smithsonian Institution, 1989), pp. 260–61, and Walter Pach, "The Field of Art: On Albert P. Ryder," *Scribner's Magazine* XLIX, no. 1 (January 1911): 125–28. Records of the picture's exhibition history prior to Pach's article are not available.

25. Letter from Winslow Homer to M. Knoedler & Co. from Windsor Hotel, Jacksonville, dated December 7, 1904, Artists' Letters and Manuscripts, Box 4, Folder 4, Crystal Bridges Museum of American Art, Bentonville, Arkansas.

26. *RWWH*, V, p. 47, Charles S. Homer, Jr., letter to George Van Felson, May 21, 1905, location undisclosed.

27. Sprague, 1988, op. cit., pp. 151–52.

28. Since Homer's time, these houses have received new street numbers and street names. "Black Rock" is now 18 Winslow Homer Road; "Fearn-y-Breeze" is 19 Winslow Homer Road; "The Coop" is 17 Winslow Homer Road; and "Briarwood" is 16 Jocelyn Road. Note that Charlie also hired Stevens in 1908 to build another house, "The Walnuts," on a lot contiguous with that of "Briarwood" at 18 Jocelyn Road. "Kettle Cove" is 31 Winslow Homer Road. Of the six houses, four were built approximately at once, in 1900–1901, to the designs of John Calvin Stevens. Only "Kettle Cove" appears to have had significant input from Winslow Homer in its design.

29. *RWWH*, V, pp. 48, 218–19, and 324–26. The discussion of *The Gulf Stream* on pp. 285–90 in-

cludes conflicting evidence on the timing of the Hearn gifts, but the recent digitization of some of the museum's records makes clear that those donations preceded the purchase of *The Gulf Stream.*

30. Letter from Winslow Homer to Arthur, January 21, 1907, written from Prouts Neck, Bowdoin College Museum of Art, 1964.69.128.

31. Letter to William Macbeth, March 9, 1907, Smithsonian Institution Archives of American Art, Winslow Homer Collection.

32. Ibid. The Rokowski-owned drawings, passed down to his son Joseph Frank Rokowski (1916–1976), include CR 86, CR 87, CR 138, CR 166, CR 177, CR 779, and CR 1728.

33. *RWWH*, V, p. 51, letter location undisclosed.

34. *RWWH*, V, pp. 374–76.

35. *RWWH*, V, p. 53, letter location undisclosed.

36. Letter from Winslow Homer to Charlie, December 8, 1908, written from Prouts Neck, Bowdoin College Museum of Art, 1964.69.139.

37. Theodore E. Stebbins, Jr., "*Driftwood*, Winslow Homer's Final Painting," *Antiques*, July 1996, pp. 70–79.

38. Ibid., p. 75.

39. Letter from Winslow Homer to Arthur, January 18, 1910, written from Hotel Seville, New York, Bowdoin College Museum of Art, 1964.69.147.

40. *RWWH*, V, pp. 327–30, CR 1724–1726, relating to the three watercolors Homer requested in his letter of August 26, 1904, and CR 1727, which Homer requested a month later. The oil is CR 1761, pp. 368–70, *Shooting the Rapids, Saguenay River.* Homer dated the letter to Prang October 18, 1905; it is quoted in *RWWH*, V, p. 369.

41. Letter to Arthur of June 17, 1891, written from Union Square Hotel, New York, Bowdoin College Museum of Art, 1964.69.40.

42. "Standard Time," *Boston Globe*, September 29, 1910, p. 16. Prouts Neck tides precede Boston's by fourteen minutes. Dead low tide would have been at 2:22 p.m. in Boston and 2:08 in Prouts Neck.

EPILOGUE: MYTH AND MEMORY

1. Goodrich, op. cit., p. 201.

2. William Howe Downes, *The Life and Works of Winslow Homer* (Boston: Houghton Mifflin, 1911), between pp. 224 and 225.

3. Letter from Winslow Homer to William Howe Downes, cited in *RWWH*, V, p. 60, location unidentified.

4. William Howe Downes, *Twelve Great Artists* (New York: Little, Brown, 1900), pp. 105–106.

5. Ibid., p. 105.

6. Ibid., p. 106.

7. Ibid., p. 109.

8. Ibid.

9. Letter from John La Farge to Editor of the *New York Herald*, as quoted in Gustave Kobbe, "John La Farge and Winslow Homer," *New York Herald*, December 4, 1910, Magazine Section, p. 11.

10. Goodrich, op. cit., p. 202.

11. Ibid.

12. Ibid., p. 204.

13. J. Eastman Chase, "Some Recollections of Winslow Homer," *Harper's Weekly*, October 22, 1910, p. 13.

14. Walt Whitman, *Leaves of Grass* (Boston: Thayer and Eldridge, 1860), p. 103.

BIBLIOGRAPHY

AN EXPLANATORY NOTE

The scholarly literature on the work of Winslow Homer is voluminous. The following is a selective guide to the analysis of Homer's work and of the enigmatic man behind it. With a few especially notable exceptions, this list omits articles and books that address narrow segments of Homer's oeuvre, of his biography, or of the world in which he lived; this author has endeavored to include references to such scholarship in the notes. For a more comprehensive bibliography, look to that in *Record of Works by Winslow Homer*, which Abigail Booth Gerdts completed in 2014 and which is listed below. This catalogue raisonné was a nearly eighty-year project begun by Lloyd Goodrich and is the starting point for any detailed investigation of Homer's art and life. As the acknowledgments, text, and notes suggest—but cannot state repeatedly enough—this author is profoundly indebted to both Mrs. Gerdts and Mr. Goodrich, and to the many art historians and other scholars without whose long and diligent labors this biography would not have been possible.

Adams, Henry. "Mortal Themes: Winslow Homer." *Art in America* 71 (February 1983): 112–26.

Adler, Margaret C., Jennifer R. Henneman, Diana Jocelyn Greenwold, Claire M. Barry, and Peter G. M. Van de Moortel. *Homer | Remington*. New Haven, CT: Yale University Press, 2020.

Andrus, Lisa Fellows. *Measure and Design in American Painting, 1760–1860*. New York: Garland, 1977.

Athens, Elizabeth, Brandon Ruud, and Martha Tedeschi. *Coming Away: Winslow Homer and England*. New Haven, CT: Yale University Press, 2017.

Atkinson, D. Scott, Jochen Wierich, and Sue Taylor. *Winslow Homer in Gloucester*. Chicago: Terra Museum of American Art, 1990.

Beam, Philip C. *Winslow Homer at Prout's Neck*. New York: Little, Brown, 1966.

Beam, Philip C., Lois Homer Graham, Patricia Junker, David Tatham, and John Wilmerding. *Winslow Homer in the 1890s: Prout's Neck Observed*. New York: Hudson Hills Press, 1990.

Bedell, Rebecca. *Moved to Tears: Rethinking the Art of the Sentimental in the United States*. Princeton, NJ: Princeton University Press, 2018.

Blaugrund, Annette. *The Tenth Street Studio Building: Artist-Entrepreneurs from the Hudson River School to the American Impressionists*. Southampton, NY: Parrish Art Museum, 1997.

Burns, Sarah. "Barefoot Boys and Other Country Children: Sentiment and Ideology in Nineteenth-Century American Art." *American Art Journal* 20, no. 1 (1988): 24–50.

———. *Inventing the Modern Artist: Art and Culture in Gilded Age America*. New Haven, CT: Yale University Press, 1996.

———. "Revitalizing the 'Painted-Out' North: Winslow Homer, Manly Health, and New England Regionalism in Turn-of-the-Century America." *American Art* 9, no. 2 (Summer 1995): 20–37.

Burns, Sarah, and John Davis. *American Art to 1900: A Documentary History*. Oakland: University of California Press, 2009.

Cikovsky, Nicolai, Jr., et al. *Studies in the History of Art* 26, Symposium Papers XI: Winslow Homer: A Symposium. Washington, DC: National Gallery of Art, 1990.

Cikovsky, Nicolai, Jr., and Franklin Kelly. *Winslow Homer*. New Haven, CT: Yale University Press, 1995.

Colbert, Charles. "Winslow Homer, Reluctant Modern." *Winterthur Portfolio* 38, no. 1 (Spring 2003): 37–55.

Conrads, Margaret. *Winslow Homer and His Critics: Forging a National Art in the 1870s*. Princeton, NJ: Princeton University Press, 2001.

Cooper, Helen A. *Winslow Homer Watercolors*. New Haven, CT: Yale University Art Gallery, 1986.

Cross, William R. *Homer at the Beach: A Marine Painter's Journey 1869–1880.* Gloucester, MA: Cape Ann Museum, 2019.

Curry, David Park. *Winslow Homer: The Croquet Game*. New Haven, CT: Yale University Art Gallery, 1984.

Davis, Elliot Bostwick. "American Drawing Books and Their Impact on Winslow Homer." *Winterthur Portfolio* 31, nos. 2/3 (Summer–Autumn 1996): 141–63.

Demarest, Robert J. *Traveling with Winslow Homer: America's Premier Artist/Angler*. New York: Apple Trees, 2003.

Denenberg, Thomas A. *Weatherbeaten: Winslow Homer and Maine*. New Haven, CT: Yale University Press, 2012.

Downes, William Howe. *The Life and Works of Winslow Homer*. Boston: Houghton Mifflin, 1911.

Forsberg, Diane, Martha Hoppin, David Tatham, and Sarah Burns. *Winslow Homer: The Nature and Rhythm of Life, from the Arkell Museum at Canajoharie*. Cooperstown, NY: Fenimore Art Museum, 2014.

Foster, Kathleen A. *American Watercolor in the Age of Sargent and Homer*. New Haven, CT: Yale University Press, 2017.

———. *Shipwreck! Winslow Homer and* The Life Line. Philadelphia: Philadelphia Museum of Art, 2012.

Gardner, Albert Ten Eyck. *Winslow Homer: American Artist*. New York: C. N. Potter, 1961.

Gelman, Barbara. *The Wood Engravings of Winslow Homer*. New York: Bounty Books, 1969.

Gerdts, Abigail Booth, and Lloyd Goodrich. *Record of Works by Winslow Homer*, 6 vols. New York: Spanierman Gallery, 2005–2014.

Glasscock, Ann, and Ronald G. Pisano. *The Tile Club: Camaraderie and American Plein-Air Painting*. Madison, WI: Chazen Museum of Art, 2018.

Goodrich, Lloyd. *Winslow Homer*. New York: Macmillan, 1944.

Goodyear, Frank H., III, and Dana E. Byrd. *Winslow Homer and the Camera: Photography and the Art of Painting*. New Haven, CT: Yale University Press, 2018.

Greenhill, Jennifer A. *Playing It Straight: Art and Humor in the Gilded Age*. Berkeley: University of California Press, 2012.

Haltman, Kenneth. "Antipastoralism in Early Winslow Homer." *Art Bulletin* 80, no. 1 (March 1998): 93–112.

Hendricks, Gordon. *The Life and Work of Winslow Homer*. New York: Harry N. Abrams, 1979.

Johns, Elizabeth. *Winslow Homer: The Power of Observation*. Berkeley: University of California Press, 2002.

Junker, Patricia, and Sarah Burns. *Winslow Homer: Artist and Angler*. New York: Thames and Hudson, 2002.

Kelly, Franklin, Nicolai Cikovsky, Jr., Deborah Chotner, and John Davis. *American Paintings of the Nineteenth Century, Part I*. Washington, DC: National Gallery of Art, 1996.

Kobbé, Gustav. "John La Farge and Winslow Homer." *New York Herald*, December 4, 1910, p. 11.

Lévy, Sophie, ed. *Winslow Homer: Poet of the Sea*. Chicago: Terra Foundation for American Art, 2006.

Mayer, Lance, and Gay Myers. *American Painters on Technique: The Colonial Period to 1860*. Los Angeles: J. Paul Getty Museum, 2011.

Murphy, Kevin M. "Painting for Money: Winslow Homer as Entrepreneur." *Winterthur Portfolio* 37, nos. 2/3 (Summer/Autumn 2002): 147–60.

Naeem, Asma. *Out of Earshot: Sound, Technology, and Power in American Art, 1860–1900*. Oakland: University of California Press, 2019.

Novak, Barbara. *American Painting of the Nineteenth Century: Realism, Idealism, and the American Experience*. New York: Praeger, 1969.

———. *Nature and Culture: American Landscape and Painting, 1825–1875*. New York: Oxford University Press, 1980.

———. *Voyages of the Self: Pairs, Parallels, and Patterns in American Art and Literature*. New York: Oxford University Press, 2006.

Prown, Jules David. "Winslow Homer in His Art." *American Art* 1, no. 1 (Spring 1987): 30–45.

Prown, Jules David, and Kenneth Haltman. *American Artifacts: Essays in Material Culture*. East Lansing: Michigan State University Press, 2000.

Reed, Christopher. "The Artist and the Other: The Work of Winslow Homer." *Yale University Art Gallery Bulletin* (Spring 1989): 68–79.

Robertson, Bruce. *Reckoning with Winslow Homer: His Late Paintings and Their Influence*. Cleveland: Cleveland Museum of Art, 1990.

Sheldon, George W. *American Painters*. New York: D. Appleton, 1879.

———. "American Painters: Winslow Homer and F. A. Bridgman," *Art Journal* 4 (1878): 225–29.

———. "Sketches and Studies. II. From the Portfolios of A. H. Thayer, William M. Chase, Winslow Homer, and Peter Moran." *Art Journal* 6, New Series (1880): 105–109.

Simpson, Marc. "'If You Can Read This . . .': Winslow Homer's *The Gulf Stream* and the Viewing of His Pictures." *Panorama: Journal of the Association of Historians of American Art* 4, no. 1 (Spring 2018).

———, ed. *Winslow Homer: Paintings of the Civil War*. San Francisco: Fine Arts Museums of San Francisco, 1988.

———. *Winslow Homer: The Clark Collection*. Williamstown, MA: Sterling and Francine Clark Art Institute, 2013.

Spassky, Natalie, Linda Bantel, Doreen Bolger Burke, Meg Perlman, and Amy L. Walsh. *American Paintings in the Metropolitan Museum of Art*. Vol. 2, *A Catalogue of Works by Artists Born Between 1816 and 1845*. New York: Metropolitan Museum of Art, 1986.

Staiti, Paul. "Winslow Homer and the Drama of Thermodynamics." *American Art* 15, no. 1 (Spring 2001): 10–33.

Tatham, David. *Winslow Homer and His Cullercoats Paintings: An American Artist in England's Northeast*. Syracuse, NY: University of Syracuse Press, 2021.

———. *Winslow Homer and the Illustrated Book*. Syracuse, NY: University of Syracuse Press, 1992.

———. *Winslow Homer and the Pictorial Press*. Syracuse, NY: University of Syracuse Press, 2003.

———. *Winslow Homer in London: A New York Artist Abroad*. Syracuse, NY: University of Syracuse Press, 2010.

———. *Winslow Homer in the Adirondacks*. Syracuse, NY: University of Syracuse Press, 1996.

Tedeschi, Martha, and Kristi Dahm. *Watercolors by Winslow Homer: The Color of Light*. New Haven, CT: Yale University Press, 2008.

Van Rensselaer, Mariana Griswold. "An American Artist in England." *Century Illustrated Monthly Magazine* 27 (November 1883).

Wilmerding, John. *American Light: The Luminist Movement, 1850–1875.* Princeton, NJ: Princeton University Press, 1989.

———, ed. *In Honor of Paul Mellon: Collector and Benefactor*. Washington, DC: National Gallery of Art, 1986.

———. *Winslow Homer.* New York and London: Praeger, 1972.

Wilmerding, John, and Linda Ayres. *Winslow Homer in the 1870s: Selections from the Valentine-Pulsifer Collection*. Princeton, NJ: Princeton University Art Museum, 1990.

Wood, Peter H. *Near Andersonville: Winslow Homer's Civil War*. Cambridge, MA: Harvard University Press, 2010.

———. *Weathering the Storm: Inside Winslow Homer's Gulf Stream*. Athens: University of Georgia Press, 2004.

Wood, Peter H., and Karen C. C. Dalton. *Winslow Homer's Images of Blacks: The Civil War and Reconstruction Years*. Austin: University of Texas Press, 1988.

ACKNOWLEDGMENTS

To do justice to the life of a man as complex as Winslow Homer is possible only through the expert assistance of a broad and deep range of specialists. First thanks are due to Lloyd Goodrich and Abigail Booth Gerdts, whose painstaking efforts over eight decades created an indispensable catalogue raisonné in the *Record of the Works of Winslow Homer*. The magisterial knowledge and honesty of Kathy Foster, the deep insights of Beth Johns, and the wise and constructive counsel of Marc Simpson shaped, improved, and inspired immensely. Adam Hochschild, David Tatham, and Ted Widmer proffered generous encouragement and guidance. Charlie Brock cleared paths to address abundant practical challenges, and Peter H. Wood to comprehend the moral force of Homer's witness. Elliot Bostwick Davis, Ethan Lasser, and Martha Tedeschi were early and pivotal advocates for the project. Elliot, Kathy, Frank Goodyear, Adam, Ray Shepard, Earle Shettleworth, Marc, Edu Vivanco, Caroline Welsh, and Alexi Worth each read the entire manuscript and offered astute admonition and judicious direction.

Others read sections of the book and assisted in understanding aspects of Homer's life. For insights on his childhood in Boston and Cambridge, Charlie Sullivan at the Cambridge Historical Commission, Maggie Hoffman at the Cambridge Historical Society, William McCarthy and Peggy Bendroth at the Congregational Library and Archives, Garth Rosell at Gordon-Conwell Theological Seminary, Lorna Condon at Historic New England, and Dan Hinchen at the Massachusetts Historical Society were all most helpful. On the foundations Marc and Peter laid in exploring Homer's Civil War years, others built: Robert Hancock at the American Civil War Museum, Michelle Krowl and her colleagues at the Library of Congress, Les Jensen at the West Point Museum, and the Virginia military experts John Cummings, Bob Krick, Ed Longacre, David Lowe, Scott Mauger, Gordon Rhea, Phil Shiman, Julia Steele, and Bob Trout. For Homer's first trip to Europe, Henry Adams, Pamela Fletcher, Erica Hirshler, and Hélène Valance were all important interlocutors.

The middle of Homer's life, during which he lived primarily in Manhattan but spent catalytic summers away, has emerged from shadow through the insights of local, regional, and material culture experts: the costume historians Lynne Bassett and David W. Rickman; Crane Davis and Jonathan Palmer of Greene County, New York; Viola Opdahl, Lorna Smedman, and Gail Whistance of Hurley, New York; and Cape Ann's Lise Breen, Trenton Carls, Leon Doucette, Martha Oaks, and Erik Ronnberg. As a painter George Nick offered uniquely valuable counsel; Roy Perkinson and Judith Walsh also did, as deeply experienced paper conservators. Judith Cohen and Josh Kendall provided vital insights

on several chapters, while Tim DeWerff at the Century Association and Roger Lawson at the National Gallery of Art opened exceptionally significant archival portals.

Betsy Athens at the University of Connecticut; John Cromie of Ballston Spa, New York; and Prouts Neck's tireless Phil von Stade illuminated Homer's pivot of the early 1880s and what followed in Maine and beyond. Brad and Ann Willauer, David Pratt, and Clare and Mike Graham generously shared familial, geographic, and technical insights. The degree to which this book expresses Homer's profound love for the Adirondacks and the Laurentians is due largely to those who share that passion today. They include Peter Dean, Dorothy Fayerweather, George Lee, and Caroline Welsh at the North Woods Club; TommyLee Leroux Gagnon at the Musée du Fjord; Ivy Gocker at the Adirondack Museum; Tony Goodwin at the Adirondack Mountain Club; Margaret Hawthorne at the Keene Valley Library; the matchless Macauley Lord; and Louise Siméon at the Musée amérindien de Mashteuiatsh.

This book is a story of formation—of one person's pursuit of a flourishing life that included both success and failure. My parallel work at the Yale Center for Faith and Culture (Miroslav Volf, director) and Citizens by the Sea (Jay Bothwick, chair) has deepened my understanding of Homer's singular life. The biography's origins lie partly in a 2019 exhibition I curated at the Cape Ann Museum (Gloucester, Massachusetts), made possible only through the courage and vision of the museum's leaders, including the board chairs John Cunningham and Charles Esdaile; the directors Ronda Faloon and Oliver Barker; the generous donors led by John F. Haley, Jr., and Anne Rogers Haley, the Mr. and Mrs. Raymond J. Horowitz Foundation for the Arts, Wilber and Janet James, and John S. Rando, Jr.; thirty-three public lenders and twenty private lenders; and the dedicated museum staff and consultants who summoned up their considerable talents to usher into reality a long-held dream for the museum.

The pursuit of my elusive subject also has origins in a more distant past. As a boy in New York in the 1960s I observed that objects have power, that tales arise from long looking, and that the world is wider than it appears. My path was circuitous and often lonely but honored by my parents, Bill and Sally Cross; my sister, Polly Reeve; my brother, Fred Cross; and my grandmother Polly Smith. Others illuminated my way through encouragement, challenge, and correction: high school teachers Amos Booth, Jake Congleton, Warren and Micheline Myers, Al Olson, and Hugh Sackett; and later torch-bearers Beekman Cannon, Sam Chauncey, Bob Coles, Tom DeLong, Nabil el-Hage, Bart Giamatti, Alex Gorlin, George Hersey, Nicholas Penny, Ted Pillsbury, Bill Poorvu, Jules Prown, Vincent Scully, Liz Tate, Eustace Theodore, and Christopher White. Then, over thirty-one years in the investment business, many mentors honed my understanding of the principle and practice that value is an arbitrage between perception and truth: John Baker, Landon Clay, Tom Faust, Dozier Gardner, Peter Kiely, Joe McCullen, Alan Patricof, Laurie Reineman, Duncan Richardson, Lew Solomon, and Barclay Tittmann.

As Homer discovered beauty and rhythmic order in his world, and forged his idiosyncratic faith, so have I on the granite precipice my family and I call home, in the waves that pound against it, and through the rhythms of tides, sun, moon, storm, and season that illuminate this place and regularly shape it anew. Companions at the intersection of faith and art have included Roberta Ahmanson, Sandra Bowden, Paul Edwards, Mako Fujimura, Marleen Hengelaar, Bruce Herman, Ed Knippers, Ted and Cathy Prescott, Fleming Rutledge, and Ross Wright. Kindred cheerleaders include Dan and Kathelen Amos, Barry and Nancy Barnett, John and Sally Carton, Pearce and Phoebe Coues, Jack and Robin Davis, Jon Dorfman and Anne Blumberg, Mike, Joan, Rebecca, and Zack Even, Nigel Hamilton, Bruce and Meg Herman, Adam and Arlie Hochschild, Carla Knobloch, Laurie Matson, David and Nancy Mering, Jim and Beth Pocock, Joel and Nancy Poznansky, Ben and Janet Pyne, Steve and Kit Rosenthal, Ernst and Gail von Metzsch, George and Penny Wingate, and Bob and Blaikie Worth. My fellow Taverners and Boston Biographers have been fonts of affirmation and advice. The daily companionship of Jim Hammond, Maura McHugh, George Putnam, and Jennifer Whitney has rescued me from canine confinement and a broken bone. The illustrations and maps have been made

possible through the support of Mr. and Mrs. Charles W. Cook, Jr., Linzee Coolidge, Peter and Sally Dean, Gwen Krause, George and Cynthia Lee, and anonymous donors. Robin Davis has performed incomparable yeoman service, for which no words can express the depths of my gratitude.

Many libraries and archives have shared their resources for this book, in some cases heroically overcoming the strictures of the pandemic. These include the special collections of the Archives of American Art, Smithsonian Institution; Boston Athenaeum; Boston Public Library; Bowdoin College Museum of Art; Colby College Museum of Art; Crystal Bridges Museum of American Art; Frick Art Reference Library; Getty Research Institute; Harvard Business School; Houghton Library, Harvard University; Indiana University; Massachusetts Historical Society; National Gallery of Art; New York Public Library; Portland Museum of Art; Rosenberg Library; Vedder Research Library (Greene County); and Watson Library, Metropolitan Museum of Art. Connie Brown's maps manifest her collaborative dedication and inimitable artistry. Anne Levine impeccably organized permissions and photographs from 113 image owners and managed a seemingly endless stream of payments to these institutions and intermediaries. And the unparalleled research skills of Henry Shull shone throughout.

My tireless and determined literary agent, Carolyn Savarese of Kneerim & Williams, has been an ideal advisor. I give thanks for my editor Jonathan Galassi's vision and wisdom and for the fortitude of FSG's team, exemplified and coordinated by the brilliant Katie Liptak.

All those who have shared in this project deserve credit for whatever good may be found in it, but the blame for its deficiencies is mine and mine alone.

Last but far from least, I thank my wife, Ellen, to whom I dedicate this book. Her love has sustained me to and through this project, and shines onward for the years to come.

MANCHESTER, MASSACHUSETTS, DECEMBER 21, 2021

INDEX

ILLUSTRATION CREDITS

Illustrations of original works by Winslow Homer that are listed in Lloyd Goodrich and Abigail Booth Gerdts, *Record of Works by Winslow Homer* (New York: Spanierman Gallery LLC and The Goodrich-Homer Art Education Project, 2005–2014) include parenthetical notation for their Catalogue Raisonné (CR) numbers.

44 Museum of the City of New York, Photo Archives, X2010.11.2987

45 Cooper Hewitt Museum, gift of Charles Savage Homer, Jr., 1912 (1912–12–225) (CR 1518). Photograph courtesy of Cooper Hewitt, Smithsonian Design Museum

47 © Connie Brown

50 St. Louis Art Museum, Eliza McMillan Trust, 19:1940 (CR 50)

51 Private collection, California (CR 45)

51 Private collection, Michigan (CR 48)

54 Mount Vernon Ladies' Association, purchase, 1956. Conservation courtesy of the Founders, Washington Committee Endowment Fund, EV-328 (CR 63)

55 Art Institute of Chicago, gift of Arthur and Hilda Wenig, 2001.775

59 Museum of Art, Rhode Island School of Design, Providence, anonymous gift, 48.156 (CR 60). Image courtesy of the RISD Museum, Providence, RI

61 Art Institute of Chicago Gift of Arthur and Hilda Wenig, 2001.782

63 National Gallery of Art, Avalon Fund, 1986.31.254

65 © Connie Brown

66 Cooper Hewitt Museum, gift of Charles Savage Homer, Jr., 1912 (1912–12–137) (CR 78). Photograph courtesy of Cooper Hewitt, Smithsonian Design Museum

68 Art Institute of Chicago, gift of Arthur and Hilda Wenig, 2001.787

69 Yale University Art Gallery, gift of Samuel Rossiter Betts, B.A., 1875, 1930.15 (CR 503)

71 National Gallery of Art, gift of Edmund Louis Gray Zalinski II, 1996.121.7.a (CR 168)

75 Art Institute of Chicago, gift of Arthur and Hilda Wenig, 2001.790

78 National Gallery of Art, Patrons' Permanent Fund, 1997.72.1 (CR 189)

80 Museum of Fine Arts, Boston, gift of Charles Greely Loring, M13837 (CR 202-G)

82 Harvard Art Museums / Fogg Museum, Acquisition Fund for Prints, 2017.118.6 (CR 203-U). Photograph © President and Fellows of Harvard College

84 Cleveland Museum of Art, Mr. and Mrs. William H. Marlatt Fund, 44.524 (CR 238)

85 Private collection, Manchester, MA

86 Art Institute of Chicago, gift of Arthur and Hilda Wenig, 2001.795

87 Portland Museum of Art, gift of Barbro and Bernard Osher, 3.1993.3 (CR 187). Image courtesy of Meyersphoto.com © The Trustees of the Portland Museum of Art, Maine

88 Archives of American Art, Smithsonian Institution, Winslow Homer Collection, 1863, written from Prouts Neck, February 19, 1896, p. 4.

90 Cooper Hewitt Museum, gift of Charles Savage Homer, Jr., 1912 (1912–12–272) (CR 213). Photograph courtesy of Cooper Hewitt, Smithsonian Design Museum

92 Detroit Institute of Arts, Founders Society purchase and Dexter M. Ferry Jr. Fund, 51.66 (CR 260). Photograph © Detroit Institute of Arts / Bridgeman Images

93 Terra Foundation for the Arts, Daniel J. Terra Collection, Chicago, 1994.11 (CR 251). Photography © Terra Foundation for American Art, Chicago

93 Michele and Donald D'Amour Museum of Fine Arts, Springfield, Massachusetts, gift of Mr. Louis Cutler Hyde, 79.09 (CR 257). Photograph by JohnPolakPhotography.com

95 Sterling and Francine Clark Art Institute, acquired by Sterling and Francine Clark, March 21, 1942, 1955.4450

96 Metropolitan Museum of Art, gift of Mrs. Frank B. Porter, 22.207 (CR 282)

97 Metropolitan Museum of Art, gift of Mrs. Frank B. Porter, 22.207 (CR 282)

99 Harvard Art Museums / Fogg Museum, anonymous gift, 1939.229 (CR 272). Photograph © President and Fellows of Harvard College

100 Newark Museum, gift of the heirs of Horace Kellogg Corbin, 66.354 (CR 280)

102 Art Institute of Chicago, gift of Arthur and Hilda Wenig, 2001.811

107 National Gallery, London, Turner Bequest, 1856, NG538. © National Gallery, London / Art Resource, NY

110 Tate Britain, London, gift of Graham Robertson, 1940, N05065. Photograph: Tate Britain

112 Art Institute of Chicago, gift of Arthur and Hilda Wenig, 2001.815

114 Fine Arts Museums of San Francisco, gift of Mr. and Mrs. John D. Rockefeller III, 1962, 1979.7.56 (CR 263)

115 Metropolitan Museum of Art, gift of George A. Hearn, 1894, 94.27

116 New-York Historical Society, Robert L. Stuart Collection, gift of his widow, Mrs. Mary Stuart, S-225

117 Musée d'Orsay, RF592. © RMN-Grand Palais / Art Resource, NY. Photograph: Patrice Schmidt

118 Metropolitan Museum of Art, H. O. Havemeyer Collection, gift of Horace Havemeyer, 1933, 33.77

119 Metropolitan Museum of Art, gift of Mary Goldenberg, 1899, 99.11.3

120 Metropolitan Museum of Art, gift of Peter H. B. Frelinghuysen, and Purchase, Mr. and Mrs. Richard J. Bernhard Gift, by exchange, gifts of Mr. and Mrs. Richard Rodgers and Joanne Toor Cummings, by exchange, and Drue Heinz Trust, the Dillon Fund, the Vincent Astor Foundation, Mr. and Mrs. Henry R. Kravis, the Charles Engelhard Foundation, and Florence and Herbert Irving Gifts, 1999, 1999.442

121 Cooper Hewitt Museum, gift of Charles Savage Homer, Jr., 1912 (1912–12–58) (CR 296). Photograph courtesy of Cooper Hewitt, Smithsonian Design Museum

122 Bowdoin College Museum of Art, gift of the Homer Family, 1964.69.185a

123 Baltimore Museum of Art, given in memory of Joseph Katz by his children, 1964.52.2 (CR 302)

124 Krannert Museum of Art, University of Illinois, Champaign, gift of Merle J. and Emily N. Trees, 1940–1–3 (CR 306). Courtesy of Krannert Art Museum, University of Illinois Urbana-Champaign

125 Crystal Bridges Museum of American Art, Bentonville, Arkansas, 2010.14 (CR 316). Photography by Edward C. Robison III

129 Museum of the City of New York, Photo Archives, X2010.11.4222

131 Cooper Hewitt Museum, gift of Charles Savage Homer, Jr., 1912 (1912–12–127) (CR 342). Photograph courtesy of Cooper Hewitt, Smithsonian Design Museum

132 Collection of Max N. Berry (CR 345)

133 Art Institute of Chicago, gift of Arthur and Hilda Wenig, 2001.830

134 Art Institute of Chicago, gift of Mrs. Richard E. Danielson and Mrs. Chauncey McCormick, 1951.313 (CR 343)

136 Metropolitan Museum of Art, Harris Brisbane Dick Fund, 1933, 33.21.2(1)

137 Museum of Fine Arts, Boston, bequest of Grenville H. Norcross, 1937, 37.486 (CR 351). Photograph © 2022 Museum of Fine Arts, Boston

138 Metropolitan Museum of Art, gift of Mrs. William F. Milton, 1923, 23.77.2 (CR 364)

140 Smith College Museum of Art, Northampton, Massachusetts, 50.99 (CR 387)

141 © Connie Brown

142 Vedder Research Library, Greene County Historical Society, Loeffler Stereograph Collection, PC-0000–0021–0068

143 Yale University Art Gallery, bequest of Stephen Carlton Clark, B.A. 1903, 1961.18.26 (CR 389)

145 Art Institute of Chicago, gift of Arthur and Hilda Wenig, 2001.863

146 Smithsonian American Art Museum, 1996.63.160

147 Art Institute of Chicago, gift of Arthur and Hilda Wenig, 2001.846

149 © Connie Brown

150 Library of Congress, 2014645393

151 Metropolitan Museum of Art, Arthur Hoppock Hearn Fund, 1955.177

154 Museo Nacional Thyssen-Bornemisza, Madrid, 591 (1983.25) (CR 392)

156 Private collection, Manchester, MA

156 Private collection, Manchester, MA

157 Worcester Art Museum, gift of Dr. and Mrs. Richard Kinnicut, 1946.9 (CR 378). Photograph © Worcester Art Museum / Bridgeman Images

159 St. Louis Museum of Art, Museum Purchase, 123:1946 (CR 388)

160 National Gallery of Art, collection of Mr. and Mrs. Paul Mellon, 2014.18.19 (CR 414)

162 The Butler Institute of American Art, Youngstown, Ohio, 919-O-108 (CR 419)

163 Metropolitan Museum of Art, gift of Christian A. Zabriskie, 1950, 50.41 (CR 418)

164 Art Institute of Chicago, gift of Arthur and Hilda Wenig, 2001.837

169 © Connie Brown

170 Worcester Art Museum, Purchase, Sustaining Membership Fund, 1911.1 (CR 441). Photograph © Worcester Art Museum / Bridgeman Images

171 National Gallery of Art, collection of Mr. and Mrs. Paul Mellon, 2014.18.15 (CR 458)

244 Private collection (CR 982)

248 Bowdoin College Museum of Art, bequest of the Honorable Augustus F. Moulton, Class of 1873, A.M.1876, L.L.D. 1928, 33.1 (CR 1017)

251 © Connie Brown

252 Cleveland Museum of Art, bequest of John L. Severance, 1942, 647

253 Hirshhorn Museum and Sculpture Garden, Smithsonian Institution, gift of Joseph H. Hirshhorn, 66.2488 (CR 1019). Image: Lee Stalsworth, Hirshhorn Museum and Sculpture Garden

256 Private collection. Image courtesy of Martin Beisly Fine Art, London

262 Private collection, extended loan to the Baltimore Museum of Art, R.8613.2. (CR 1087)

263 Private collection, England. Photograph courtesy of James Alder Fine Art, Hexham, Northumberland, England

264 Private collection. Image courtesy of Anderson & Garland Auction House, Newcastle Upon Tyne, England

265 Collection of John Wilmerding, Promised Gift to the National Gallery of Art (CR 1037)

267 National Gallery of Art, bequest of Julia B. Engel, 1984.58.3 (CR 1100)

270 Milwaukee Art Museum, Leighton Art Collection, gift of Frederick Leighton, L99 (CR 1101). Photograph: John R. Glembin

271 Harvard Art Museums / Fogg Museum, 1943.296 (CR 1084). Photograph © President and Fellows of Harvard College

272 Myron Kunin Collection of American Art, Minneapolis, MN (CR 1162). Photograph: Dan Dennehy

274 Private collection (CR 1170)

276 © Connie Brown

277 Bowdoin College Museum of Art, gift of the Homer Family, 1964.69.177.25

280 Bowdoin College Museum of Art, 1964.69.177.27

283 Art Institute of Chicago, Mr. and Mrs. Martin A. Ryerson Collection, 1933, 1247 (CR 1212)

284 Cooper Hewitt Museum, gift of Charles S. Homer, Jr., 1912–12–253 (CR 1213). Photograph courtesy of Cooper Hewitt, Smithsonian Design Museum

285 Bowdoin College Museum of Art, gift of the Homer Family, 1964, 1964.69.177.10

285 New Britain Museum of American Art, Charles F. Smith Fund, 1940.2 (CR 1214)

287 Philadelphia Museum of Art, George W. Elkins Collection, 1924, E1924–4–15 (CR 1218)

289 Bowdoin College Museum of Art, gift of the Homer Family, 1964.69.153.11

290 Bowdoin College Museum of Art, 1964.69.179.7

292 © Connie Brown

295 National Gallery of Art, collection of Mr. and Mrs. Paul Mellon, 1994.59.20 (CR 1275)

296 Minneapolis Institute of Art, William Hood Dunwoody Fund, 15.137 (CR 1266)

297 Brooklyn Museum, gift of the Estate of Helen Babbott Sanders, 78.151.4 (CR 1295)

298 Peabody Essex Museum, gift of Charles A. Coolidge, Jr., M23384 (CR 1305). Photograph courtesy of the Peabody Essex Museum, Salem, MA

299 Philadelphia Museum of Art, gift of Dr. and Mrs. George Woodward, 1939, 1939–7–2 (CR 1307)

300 Private Collection (CR 1308). Image courtesy of Menconi + Schoelkopf Fine Art, LLC

302 © Connie Brown

305 Hagley Museum and Library, E. Tunnicliff Fox Collection, 61.47.301. Image courtesy of Hagley Museum and Library

306 Art Institute of Chicago, Mr. and Mrs. Martin A. Ryerson Collection, 1937.1039 (CR 1323)

307 Museum of Fine Arts, Boston, anonymous gift with credit to the Otis Norcross Fund, 94.72 (CR 1324). Photograph © 2022 Museum of Fine Arts, Boston

309 Private collection (CR 1325)

311 Worcester Art Museum, Museum Purchase, 1911.19 (CR 1333). Photograph © Worcester Art Museum / Bridgeman Images

314 Sterling and Francine Clark Art Institute, acquired by Sterling and Francine Clark, 1924, 1955.4 (CR 1348)

316 Portland Museum of Art, bequest of Charles Shipman Payson, 1988.55.3 (CR 1253). Image courtesy of Meyersphoto.com © The Trustees of the Portland Museum of Art, Maine

317 Addison Gallery of American Art, Phillips Academy, Andover, MA, gift of an anonymous donor, 1930.379 (CR 1354). Photograph © Addison Gallery of American Art/Bridgeman Images

320 Bowdoin College Museum of Art, gift of Susan L. and Donald M. Zuckert, Class of 1956, in honor of A. LeRoy Greason and Polly Greason as tribute to their thirty-eight years of service to Bowdoin College, 1990.69 (CR 1400)

321 North Woods Club

323 National Gallery of Art, gift of John W. Beatty, Jr., 1964.4.10 (CR 1403)

325 © Connie Brown

326 North Woods Club

328 Dallas Museum of Art, Dallas Art Association Purchase, 1961.11 (CR 1425). Image courtesy of Dallas Museum of Art

329 Norton Museum of Art, bequest of R. H. Norton, 53.83 (CR 1426). Image courtesy of Norton Museum of Art, West Palm Beach, Florida

332 Museum of Fine Arts, Boston, Warren Collection—William Wilkins Warren Fund, 99.24 (CR 1417). Photograph © 2022 Museum of Fine Arts, Boston

333 Museum of Art, Rhode Island School of Design, Providence, gift of Jesse H. Metcalf, 94.005 (CR 1433). Image courtesy of the RISD Museum, Providence, RI

334 Colby College Museum of Art, gift of Miss Adeline F. Wing and Miss Caroline R. Wing, 49.001 (CR 1447)

335 Toledo Museum of Art, gift of Edward Drummond Libbey, 1912.507 (CR 1463)

338 Philadelphia Museum of Art, George W. Elkins Collection, 1924, E1924–3–8 (CR 1471)

339 Museum of Fine Arts, Boston, Hayden Collection—Charles Henry Hayden Fund, 23.443 (CR 1499). Photograph © 2022 Museum of Fine Arts, Boston

340 National Gallery of Art, gift of Stephen C. Clark, 1947.11.1 (CR 1507)

341 Art Institute of Chicago, Mr. and Mrs. Martin A. Ryerson Collection, 1933,1237 (CR 1493)

342 Smithsonian American Art Museum, gift of John Gellatly, 1929.6.66 (CR 1504)

343 Memorial Art Gallery of the University of Rochester, gift of Dr. and Mrs. James H. Lockhart, Jr., 1984.51 (CR 1492)

346 Worcester Art Museum, Theodore T. and Mary G. Ellis Collection, 1940.60 (CR 1508). Photograph © Worcester Art Museum / Bridgeman Images

347 Smithsonian Institution Archives, Record Unit 95, Box 61, Folder 11, Image No. SIA_000095_B61 _F11_019

348 Bowdoin College Museum of Art, bequest of Mrs. Charles S. Homer, Jr., 1938.2 (CR 1514)

350 Pennsylvania Academy of Fine Arts, Joseph E. Temple Fund, 1894.4 (CR 1512)

351 Maine Historical Society, gift of H. W. Bryant, 1992.93.1 (CR 1509)

356 Collection of Alvin Snowiss (CR 1547). Photograph courtesy of the Palmer Museum of Art at Penn State

357 Smithsonian American Art Museum, gift of William T. Evans, 1909, 1909.7.29 (CR 1553)

358 The Art Students League of New York, Permanent Collection (CR 1590)

359 Portland Museum of Art, gift of William D. Hamill, 1991.19.3 (CR 1557). Image courtesy of Meyersphoto.com © The Trustees of the Portland Museum of Art, Maine

360 Musée d'Orsay, Paris, France, RF1977.427 (CR 1460). © RMN-Grand Palais / Art Resource, NY. Photograph: Hervé Lewandowski

362 Memorial Art Gallery of the University of Rochester, R. T. Miller Fund, 1941.32 (CR 1551)

364 Worcester Art Museum, Museum Purchase, 1908.3 (CR 1533). Photograph © Worcester Art Museum / Bridgeman Images

366 © Connie Brown

367 Bowdoin College Museum of Art, gift of the Homer Family, Homer Memorabilia 38.6

368 Sterling and Francine Clark Art Institute, acquired by Sterling Clark, 1917, 1955.1492 (CR 1568)

369 Collection of the Paine Art Center and Gardens, Oshkosh, WI, gift of Nathan and Jessie Kimberly Paine, 1946.156 (CR 1558)

370 Brooklyn Museum, bequest of Helen Babbott Sanders, 78.151.2 (CR 1570)

371 Yale University Art Gallery, bequest of Doris M. Brixey, 1984.32.17 (CR 1636)

371 The Huntington Library, Art Museum, and Botanical Gardens. Gift of the Virginia Steele Scott Foundation, 83.8.24 (CR 1560). Image courtesy of the Huntington Art Museum, San Marino, California

372 Brooklyn Museum, Museum Collection Fund and Special Subscription, 11.541 (CR 1559)

373 Colby College Museum of Art, Lunder Collection, 2013.146 (CR 1228)

375 Museo Nacional Thyssen-Bornemisza, Madrid, 588 (1980.71) (CR 1601)

376 Carnegie Museum of Art, Museum Purchase (Gallery Fund), 96.1 (CR 1609). Photograph © 2021 Carnegie Museum of Art, Pittsburgh

378 National Gallery of Art, Corcoran Collection, Museum Purchase (Gallery Fund), 2014.79.48 (CR 1650)

380 Portland Museum of Art, bequest of Charles Shipman Payson, 1988.55.2 (CR 1652). Image courtesy of Meyersphoto.com © The Trustees of the Portland Museum of Art, Maine

381 Bowdoin College Museum of Art, gift of the Homer Family, Homer Memorabilia 32

384 Spencer Museum of Art, University of Kansas, Lawrence, William Bridges Thayer Memorial Collection, 1928.1785 (CR 1675)

385 Art Institute of Chicago, Mr. and Mrs. Martin A. Ryerson Collection, 1933.1235 (CR 1678)

386 Art Institute of Chicago, Mr. and Mrs. Martin A. Ryerson Collection, 1933.1241 (CR 1684)

387 Metropolitan Museum of Art, Catherine A. Lorillard Collection, Wolfe Fund, 1906, 06.1234 (CR 1686)

391 Bowdoin College Museum of Art, gift of the Homer Family, 1964.69.179.9

394 Metropolitan Museum of Art, Amelia B. Lazarus Fund, 1910, 10.228.12 (CR 1697)

395 Masterworks Museum of Bermuda Art, 03019 (CR 1695)

396 Masterworks Museum of Bermuda Art, 927 (CR 1712)

397 Addison Gallery of American Art, Phillips Academy, bequest of Candace C. Stimson, 1946.119 (CR 1722). Photograph © Addison Gallery of American Art / Bridgeman Images

398 Private collection

399 Collection of Arizona State University Art Museum, gift of Oliver B. James, 1953.158.000 (CR 1701)

400 Sterling and Francine Clark Art Institute, acquired by Sterling and Francine Clark, before 1955, 1955.1502 (CR 1731)

401 Museum of Fine Arts, Boston, from the Estate of Henry O. Underwood, bequest of Francis W. Davis, 1978.345 (CR 1724). Photograph © 2022 Museum of Fine Arts, Boston

403 Bowdoin College Museum of Art, gift of the Homer Family, 1964.69.153.1

405 Prouts Neck Historical Society, Dimond 103

406 Courtesy of Avery Galleries and Debra Force Fine Art (CR 1719)

407 Bowdoin College Museum of Art, gift of the Homer Family, 1964.69.98

408 Sterling and Francine Clark Art Institute, acquired by Sterling and Francine Clark, 1954, 1955.6 (CR 1707)

409 Sterling and Francine Clark Art Institute, acquired by Sterling and Francine Clark, 1941, 1955.7 (CR 1709)

410 Bowdoin College Museum of Art, gift of the Homer Family, 1964.69.153.2

412 © Connie Brown

413 Metropolitan Museum of Art, Amelia B. Lazarus Fund, 1910, 10.228.11 (CR 1740)

414 Harvard University Art Museums, gift of Edward W. Forbes, 1956.210 (CR 1735)

415 Art Institute of Chicago, bequest of Brooks McCormick, 2007.115 (CR 1753)

416 Harvard Art Museums / Fogg Museum, gift of Mrs. Charles S. Homer, Jr., in memory of the late Charles S. Homer and his brother Winslow Homer, 1935.50 (CR 1746). Photograph © President and Fellows of Harvard College

417 Private collection (CR 1760)

419 Metropolitan Museum of Art, gift of George A. Hearn, 1906, 06.1282 (CR 1721)

420 Addison Gallery of American Art, Phillips Academy, Andover, MA, bequest of Candice C. Stimson, 1946.19 (CR 1758). Photograph © Addison Gallery of American Art / Bridgeman Images

421 Artists' Letters and Manuscripts, Winslow Homer Collection, Box 4, Folder 4, Letter #73, written from Prouts Neck, November 8, 1904 (p. 6), Crystal Bridges Museum of American Art, Bentonville, Arkansas

423 Cooper Hewitt Museum, gift of Charles S. Homer, Jr., 1912–12–196 (CR 1756). Photograph courtesy. of Cooper Hewitt, Smithsonian Design Museum

423 The Phillips Collection, Washington DC, Acquired 1924, 1708

423 Myron Kunin Collection of American Art, Minneapolis, MN (CR 1757). Photograph: Midwest Art Conservation Center

425 Phillips Exeter Academy Library, Exeter, New Hampshire

426 Freer Gallery of Art, Smithsonian Institution, Washington, DC, gift of Charles Lang Freer, F1908.14a-b (CR 1764)

427 National Gallery of Art, gift of the Avalon Foundation, 1951.8.1 (CR 1767)

428 Museum of Fine Arts, Boston, Henry H. and Zoe Oliver Sherman Fund and other funds, 1993, 1993.564 (CR 1768). Photograph © 2022 Museum of Fine Arts, Boston

430 Brooklyn Museum, Museum Collection Fund and Special Subscription, 11.537 (CR 1726)

431 Metropolitan Museum of Art, gift of Charles S. Homer, 1911, 11.57 (CR 1761)

436 Boston Athenaeum, Prints and Photographs Dept., AA 5.4 Hom.w.(no.1)